Table of Contents

Rhapsody Playlists of Musical Selections

Chapter 5

http://app.rhapsody.com/playlists/playlist/mp.174956275
Track 1: "Black Snake Moan" — Blind Lemon Jefferson
Track 2: "Pony Blues" — Charley Patton
Track 3: "A Spoonful Blues" — Charley Patton
Track 4: "High Water Everywhere, Part 1" — Charley Patton
Track 5: "High Water Everywhere, Part 2" — Charley Patton
Track 6: "Death Letter Blues" — Son House
Track 7: "Preachin' Blues" — Son House
Track 8: "Hard Time Killin' Floor Blues" — Skip James
Track 9: "Devil Got My Woman" — Skip James
Track 10: "Hellhound On My Trail" — Robert Johnson
Track 11: "Sweet Home Chicago" — Robert Johnson
Track 12: "Me and the Devil Blues" — Robert Johnson
Track 13: "Terraplane Blues" — Robert Johnson

Chapter 6

http://app.rhapsody.com/playlists/playlist/mp.176933456
Track 1: "Eternity" — Eureka Brass Band
Track 2: "Maryland, My Maryland" — Eureka Brass Band
Track 3: "Stock Yards Strut" — Freddie Keppard
Track 4: "Dippermouth Blues" — King Oliver
Track 5: "Maple Leaf Rag, St. Louis Style / Maple Leaf Rag, New Orleans Style" — Jelly Roll Morton
Track 6: "Billy Goat Stomp" — Jelly Roll Morton
Track 7: "Black Bottom Stomp" — Jelly Roll Morton
Track 8: "Cake Walkin' Babies from Home" — Clarence Williams (with Sidney Bechet and Louis Armstrong)
Track 9: "Dixie Jass Band One-Step" — Original Dixieland Jazz Band
Track 10: "Livery Stable Blues" — Original Dixieland Jazz Band

Chapter 7

http://app.rhapsody.com/playlists/playlist/mp.180727478
Track 1: "Snake Rag (Version 1)" — King Oliver's Creole Jazz Band
Track 2: "Gutbucket Blues" — Louis Armstrong and His Hot Five
Track 3: "West End Blues" — Louis Armstrong and His Hot Five
Track 4: "Heebie Jeebies" — Louis Armstrong and His Hot Five
Track 5: "Weather Bird (Rag)" — Louis Armstrong and Earl Hines
Track 6: "Singin' The Blues" — Bix Beiderbecke

Chapter 8

http://app.rhapsody.com/playlists/playlist/mp.182129136
Track 1: "Rhapsody in Blue" — CSR Symphony Orchestra
Track 2: "Sweet Sue" — Paul Whiteman
Track 3: "Copenhagen" — Fletcher Henderson
Track 4: "Carolina Shout" — James P. Johnson
Track 5: "Black and Tan Fantasy" — Duke Ellington
Track 6: "East St. Louis Toodle-Oo" — Duke Ellington
Track 7: "Mood Indigo" — Duke Ellington
Track 8: "Tea for Two" — Art Tatum

Chapter 13

http://app.rhapsody.com/playlists/playlist/mp.174956368
Track 1: "Katie Mae Blues" — Lightnin' Hopkins
Track 2: "Mojo Hand" — Lightnin' Hopkins
Track 3: "I Can't Be Satisfied" — Muddy Waters
Track 4: "I Feel Like Going Home" — Muddy Waters
Track 5: "(I'm Your) Hoochie Coochie Man" — Muddy Waters
Track 6: "Boogie Chillen" — John Lee Hooker
Track 7: "Dimples" — John Lee Hooker
Track 8: "Boom Boom" — John Lee Hooker
Track 9: "Moanin' At Midnight" — Howlin' Wolf
Track 10: "Smokestack Lightnin'" — Howlin' Wolf
Track 11: "Caldonia" — Louis Jordan
Track 12: "Dust My Broom" — Elmore James
Track 13: "Good Morning School Girl" — Sonny Boy Williamson I
Track 14: "Eyesight To the Blind" — Sonny Boy Williamson II (Rice Miller)
Track 15: "Walter's Boogie" — Big Walter "Shakey" Horton
Track 16: "Louisiana Blues" — Muddy Waters (with Little Walter Jacobs)
Track 17: "She Moves Me" — Muddy Waters (with Little Walter Jacobs)

Chapter 14

http://app.rhapsody.com/playlists/playlist/mp.181319996
Track 1: "Godchild" — Miles Davis
Track 2: "Moon Dreams" — Miles Davis
Track 3: "One Bass Hit" — Modern Jazz Quartet
Track 4: "Love For Sale" — Shelly Manne
Track 5: "Groovin' High" — Art Pepper
Track 6: "Bernie's Tune" — Gerry Mulligan
Track 7: "The Song is You" — Gerry Mulligan
Track 8: "My Funny Valentine" — Chet Baker
Track 9: "Four Brothers" — Woody Herman
Track 10: "Desafinado" — Stan Getz
Track 11: "The Girl From Ipanema" — Stan Getz

Chapter 15

http://app.rhapsody.com/playlists/playlist/mp.181494735
Track 1: "Daahoud" — Clifford Brown-Max Roach Quintet
Track 2: "Moanin'" — Art Blakey and the Jazz Messengers
Track 3: "Milestones" — Miles Davis
Track 4: "Senior Blues" — Horace Silver
Track 5: "St. Thomas" — Sonny Rollins
Track 6: "Back at the Chicken Shack" — Jimmy Smith
Track 7: "Four On Six" — Wes Montgomery with the Wynton Kelly Trio

Chapter 16

http://app.rhapsody.com/playlists/playlist/mp.174956520
Track 1: "Three O'Clock Blues" — B. B. King
Track 2: "It's My Own Fault" — B. B. King
Track 3: "The Thrill is Gone" — B. B. King
Track 4: "I Got Some Outside Help I Don't Need" — B. B. King
Track 5: "Born Under A Bad Sign" — Albert King
Track 6: "Snatch It Back And Hold It" — Junior Wells (with Buddy Guy)
Track 7: "Born In Chicago" — Paul Butterfield
Track 8: "Red House" — Jimi Hendrix

Chapter 21

Chapter 22

Chapter 23

Brown Foundational Elements—Appendix A

About the Author

Jeremy Brown

mybrownmusic.com

Dr. Jeremy Brown is a jazz drummer, composer, and educator living in southern California. He is the chairman of the music department and has directed the Menifee Jazz Ensemble at Mt. San Jacinto College since 2007. He released a debut *Jeremy Brown Quartet* jazz recording in 2014. Jeremy has written articles for *Modern Drummer* magazine on contemporary jazz drumming and published an iBook on *The Pearl Jam Drummers*. Other recent projects include *Kid Songs*—a suite of big band compositions inspired by his sons—and musical settings of the poetry of Tennessee Williams in *Experiment in a Glass*. Today, Jeremy is active in music performance and education in southern California, working with many of the finest musicians and educators.

Before moving to California, Jeremy earned a Bachelor of Music Education degree from Baylor University; and a Master and Doctor of Musical Arts from the University of Texas at Austin. In the busy music scene of Austin Jeremy was in high demand as a drummer and percussionist, working nightly with Austin's finest musicians in jazz, blues, rock, classical, and beyond including Tony Campise (Stan Kenton), guitarist Eric Johnson, Mitch Watkins, Seth Walker, Drew Smith, and Grammy award-winning saxophonist/arranger Mace Hibbard. He toured with *Chicago – The Musical* during his last year in Texas.

Jeremy was a member of Disney All-Star College Bands in Florida and in Paris. He was awarded a scholarship to attend the Henry Mancini Institute in Los Angeles. Jeremy has shared the stage with internationally known musicians and composers such as Kenny Garrett, Herbie Hancock, Quincy Jones, Christian McBride, Jerry Goldsmith, Eddie Daniels, and Mike Stern.

Image courtesy Joseph Carroll Photography

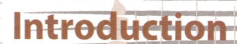

Introduction

To the student . . .

Jazz and blues are two uniquely American musical styles that have led to far-reaching consequences throughout relatively brief cycles of evolution. Both are primarily African American music styles with roots in the slave songs and church music of early America. Both have enjoyed brief stints at the top of the pop charts and have spent most of their existence as a kind of "niche" music—fans put jazz and blues on a pedestal as art to be studied and revered while the general public puts them on a shelf to be largely ignored. This is no real surprise, but the importance of jazz and blues goes far deeper than their popularity.

Contained in jazz and blues are messages; sometimes thinly veiled messages. By examining jazz and blues, we can learn immeasurable truths about American culture and about other world cultures that have adopted them. Take the lyrics of a song performed by Billie Holiday, "Strange Fruit." What would possess someone to write a song about fruit? Surely there's a deeper meaning, and the audience is left to pretty easily make the connection to the atrocities of lynching, so common in southern states throughout the 1800s and early 1900s. Or what might Charley Patton be signing about in "Spoonful Blues" or "High Water Everywhere"?

Take instrumental jazz music. Without lyrics, jazz musicians use improvisation to express implicit meaning through unique sounds and pitch choices. Do a YouTube search or find a concert DVD for tenor saxophone player John Coltrane and watch him perform a solo. Even if a saxophone student learns to play Trane's solo note-for-note as it would be written out on sheet music, they will still miss the *point* of that solo. The intensity of the music goes beyond musical notation on a page. What is he trying to express in his music? Why does his face contort like it does? Why does he push the instrument until it fails to produce a conventional sound? Why do his drummer, pianist, and bassist look so eager to push the intensity further and further? It's because something *deep* is being expressed. We in the audience don't know what that message is. In fact, we're encouraged to find our own message in the music. The message has something to do with the human condition, with struggle. Coltrane was an African American living in the early 20th century, a turbulent time. Coltrane was also a deeply spiritual man who had conquered his own personal demons by seeking union with a higher power. His music reflected his connection with a higher spiritual plane.

But is all jazz and blues so serious? Not at all. Do another YouTube search for tenor saxophonist, Joshua Redman. Most likely you'll find examples of joyfulness and fun. Instrumental music is capable of expressing a full range of ideas and emotions.

So, the messages in jazz and blues are typically hidden from view; either masked in metaphorical lyrics or expressed without words by a virtuoso. Still these abstract messages deal with the culture in which the music was created. Through their evolution through various styles, jazz and blues have mirrored the progression of American culture.

This book is meant to address jazz and blues from a couple of different perspectives. One of these is the cultural perspective—examining how jazz and blues mirrored the changes and movements of the American people throughout the 20th century.

A second perspective is the purely musical view—valuing the great performers and performances, tracing the development of style from one sub-genre to another, and laying the ground rules for judging and debating the quality of the art form.

Before we can move forward with the musical perspective, the student will need to understand a few musical concepts. This textbook includes an Appendix (A) that explains the foundational concepts of music, for those students who approach this book without formal music training or need to brush up on musical concepts and terms. Pitch, rhythm, texture, timbre, instrumentation, and form are defined and explained to give the non-music student a primer in these concepts. It's difficult to appreciate what makes Charlie Parker's ideas so revolutionary (particularly at warp speed) if the listener does not understand scales and arpeggios. It's difficult to comprehend the simple beauty of the blues without first understanding what makes the blues scale unique, or the impact of vocal timbre.

The first two chapters of this text introduce the styles of music that led to jazz and blues: European art and folk music, African American slave music, gospel, minstrel songs, and ragtime.

The book then progresses from the earliest appearances of blues and jazz, decade-by-decade, covering their evolution in separate chapters. Their development through the 20th century takes some interesting turns. Sometimes jazz and blues were intermingled. Other times they seemed to move separately as divergent or parallel streams crossing paths with other music styles (most notably rhythm & blues and rock & roll). Sometimes they reacted to the surrounding culture and other times they nudged cultural traditions to evolve.

The evolution of jazz and blues will be traced from their beginnings, through various stylistic movements, until the present. Although we cannot hope to predict which of today's artists will be historically consequential, the historian who throws up his or her hands and ends the discussion twenty years in the past is only telling part of the story. Music develops today at lightning speed. Technological progress has catapulted its rate of change forward. As technology progresses exponentially, so does music. We cannot ignore the impact of today's jazz giants like Kenny Garrett, Esperanza Spalding, Robert Glasper, and Joshua Redman; or important blues performers like Keb' Mo' and Gary Clark Jr.

In short, the aim of this book is to lead the reader to a broad understanding of these essential art forms and to promote questions of their future development. The aim is to examine their cultural impact and glean lessons from their interactions with American life.

I urge the reader to resist the temptation to read, read, read, and then *eventually* get around to listening. These musical styles can only be fully understood by *experiencing* them. **Listen to the music . . . right now.** Dial up the playlists that accompany this book. Begin listening through a pair of good headphones or speakers. Listen deeply. Spend time *just* listening. The first amazing listening experience I can remember was in college at the library at Baylor University. I had heard from several sources that I should listen to Miles Davis's live recording *Four and More*. With some time to kill after dinner I went up to the music library, checked out the vinyl record, and sat down at a carrel with a turntable. From the first note, I was captivated. My vision was blocked on all sides by the tall desk and all I could do was sit, read liner notes, and listen. The level of detail I could hear with other senses reduced was remarkable! That sound still sticks with me today.

Better yet, go see a live performance of a major jazz or blues act, or a well-respected local artist. While sitting in the audience while the music is being made, you'll hear the air being blown through the horns, you'll see a drummer drop a stick at an exciting moment, you'll see musicians smile at each other after connecting musically. There's no substitute for listening to this music.

I leave you with that. Get ready to listen . . . and enjoy!

To the instructor . . .

This text is designed for use in various kinds of courses—History of Jazz and Blues, Jazz Appreciation, or Blues Appreciation. It can be both accessible to the non-music major and enlightening for the music major. In its entirety, the book is designed with the general education student of humanities in mind. Appendix A on foundational elements of music provides a background for the musical concepts covered in the book. The chapters of the book cover the music in depth and tie in important cultural movements.

For the common Jazz History class geared toward general education, the instructor can simply omit whatever portion of the blues chapters he or she decides is not necessary to cover. (A basic Jazz History plan might be to cover only the points that relate directly to jazz in chapters 1, 4, and 5, and to omit chapters 14, 17, 21, and 23.) For a class on just Blues History, omit most of the jazz chapters.

Playlists have been developed at Rhapsody.com to give the student easy access to the musical examples discussed in the textbook. Rhapsody has an enormous library of music. It provides the instructor the opportunity to develop supplemental playlists and it provides the student a broad landscape of recordings to explore after they have listened to the assigned material.

My ultimate hope is that the material found on these pages will inspire students to continue the search for great jazz and blues after they have read the book and completed the course. Now go on, listen, and find some music to enjoy!

Dr. Jeremy Brown

PART I

Jazz and Blues Basics

CHAPTER 1

Musical Elements of the Blues

NOTE: It is strongly recommended that students refer to Appendix A for an introduction to general musical principles and terminology before reading this section on the peculiarities of the blues. Also, get in the habit of listening to the music described in this text *while* you read. Find this Chapter's playlist and listen to the music that is illustrated in the text. Try to focus on each instrument you hear on the track, and listen carefully for subtle nuances in the best performances. We understand music best by experiencing it, not just by reading about it.

In this chapter, we will cover:

- Pitch: unique aspects of blues melody and harmony
 - **blue notes**
 - **blues scale**
- Form:
 - **12-bar blues**
 - **turnaround**
- Blues lyrics:
 - **AAB poetic form**
 - content
- Instrumentation and timbre:
 - guitar
 - piano
 - drums
 - bass (acoustic/electric)
 - harmonica
 - others—violin, jazz instruments
- Call and response
- Analyze a blues performance

The blues is an American musical style that originated in African American communities of the southern states. Its unique musical attributes have impacted virtually all forms of American music. Jazz, pop, country, rock, soul, rap, and even American orchestral music traditions have incorporated the sounds of the blues, making African American music a unifying factor among the nation's diverse musical landscape. The sound of the blues has reached a huge portion of the worldwide population, as American styles of music spread across the globe during the 20th century. Because the blues has become so entrenched and widespread, we hear it in our daily lives. It has become commonplace and can easily be taken for granted. But the blues has musical and cultural riches that deserve our attention. A close look at the history of the blues reveals a history of America told from the African American perspective; from the Jim Crow South to the urban center of Chicago. Its tones and rhythms have evolved along with the migration of the music, technological advances, and the musical taste of each passing generation. Before we delve deep into the history and progression of the blues, it is important that we address a few of the musical elements that make the blues unique.

BLUES MELODY

The blues has a flexible approach to melody, compared with other, more European-influenced forms of music. The *blue note* is a pitch that is bent or lowered by varying degrees. A blue note may occur at the 3rd, 5th, and sometimes 7th scale degrees, meaning that when a blues singer or

blue note

instrumentalist plays one of these pitches, they might play the note slightly flat or completely lower the pitch to the next lowest half step. In the example below, blue notes (colored black) have been added to the pitches of the C major scale (colored white).

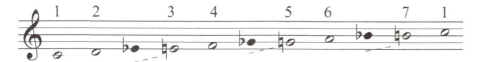

In the key of C, the 3rd scale degree is E, so a blues singer will often lower the E to an Eb, or they may bend the pitch between the lowered and raised versions. They may also sustain a pitch between E and Eb. Music theorists call these in-between pitches "microtones." Many of the musical traditions of the world including Africa and Arabic-speaking regions are based on systems that incorporate microtones, dividing the octave into more than the 12 tones of Western music. Skilled blues artists display finely-tuned control of pitch when they manipulate these pitches slightly to create dissonance and draw a kind of emotional essence from them. They are not purposefully incorporating a musical technique from an African nation, but their flexibility in pitch may naturally have grown from this African practice.

The *blues scale* is a series of six pitches that incorporates the sound of blue notes. Although blues musicians do not always use just one scale to construct melodies and improvise solos, the blues scale appears constantly and serves as the basis for countless songs. The blues scale can be understood as a variation of the minor scale (discussed in Appendix A). See the minor scale below.

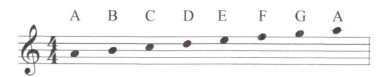

To turn this minor scale into a blues scale, we remove the 2nd and 6th scale degrees. (The resulting 5-note scale is called the "minor pentatonic.") Then we add a pitch between the original 4th and 5th scale degrees, creating a kind of slide between the 4th and 5th. This is the blues scale.

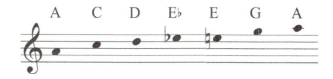

blues scale

These six notes make up the bulk of many blues solos, and can be heard incorporated into jazz, country, and rock.

12-BAR BLUES

Most blues songs are based on a repetitive form of just 12 measures—or bars. These 12 are broken into three phrases of four bars each. Although

several variations of blues chord progressions are used over these three phrases, the most basic blues uses only three chords—the I, IV, and V. Usually these chords are played as dominant 7ths (major chords with a minor 7th added). Here is a very basic blues progression:

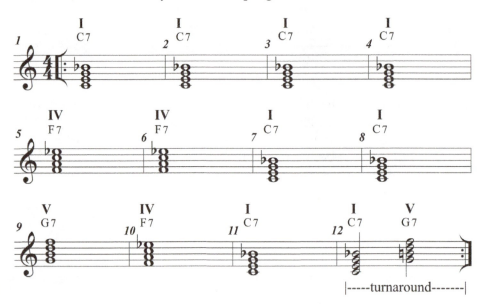

turnaround

|-----turnaround-------|

The most striking feature of this progression (and a good tip-off to the listener identifying the sound of the blues) is the movement from the I chord to the IV chord and back to I (during the first 8 bars of the form). This emphasis of the IV chord is a unique trait of African American blues. Styles that grow from European music tend to emphasize the I and V chords instead. It is also interesting to note that in the most basic form, the chord changes occur more rapidly as the song moves toward the end of the 12 bars. The first four measures stay on one chord, in the second phrase the chords move twice as fast, and the last phrase has four or more chords. This gives the blues a natural forward momentum, a kind of acceleration.

The final measure (or two) of this accelerating form has a special name—the *turnaround*. "Turnaround" refers to the group of chords at the end of the form that propel the song back to the top. Turnarounds occur not just in blues, but in all repetitive song forms. Musicians often have signature licks they like to play over these chords. Listen, for example, to Muddy Waters's "I Feel Like Going Home." At the end of each chorus, he slides on his guitar from the 3rd scale degree up to the 5th. This is a turnaround that Muddy used on several songs.

BLUES LYRICS

Form of Blues Poetry

Although the lyrics of blues songs can take on a variety of structures, blues lyrics are based on a standard form like most other forms of poetry. Each stanza (or verse) is composed in three lines that align with the 12-bar musical form. The three lines have an **AAB** pattern, meaning the first two lines are identical (often with improvised changes such as "mm-hmm" "well …" or words omitted from the line). The third line answers or

completes the idea set forth in the first two lines. This A vs. B relationship is one instance of *call and response* in the blues, and most likely connects to the call and response found in slave songs and to West African poetry and songs. This blues lyric is based on traditional blues lyrics, and uses call and response.

"Ghost Blues"

A: *I woke up at midnight; blues walkin' in my head*

A: *Yes, I woke up at midnight; blues walkin' in my head*

B: *Couldn' find my girl this mornin', visits my dreams instead*

–Jeremy Brown

Veiled Meaning

The lyric content in the blues often used coded messages, metaphor, and double entendre to hint at taboo subjects or subjects that could put the singer's life at risk. Like spirituals used the Moses story or images of heaven to communicate the message of blacks' escape from slavery, blues lyrics were used to complain about their boss or describe sexual activity. An entire subgenre of blues called *hokum* spent entire songs describing sexual acts through innuendo. Songs like "It's Tight Like That" by Tampa Red and Georgia Tom (later credited as the inventor of modern gospel music!), "I Need a Little Sugar in My Bowl" sung by Bessie Smith, and "Let's Get Drunk and Truck" sung by Lil Johnson are all barely disguised references to sex. More mainstream blues writers took more care to disguise sexual content, often waiting until a third, fourth, or fifth verse to bring in the hot lyric (listen closely to Robert Johnson's "Traveling Riverside Blues"). It's no wonder that the blues were decried by churchgoing people as sinful and "the devil's music."

Beyond the bawdy subjects, blues lyrics dealt with other truths. From the blues, we learn about the attitudes, experiences, humor, and perspectives of an oppressed people. Southern blacks reported about life events through their music. This reporting is extremely important to the preservation of African American culture. If the classic phrase were true—"History is written by the victors"—the implications would be troubling. But the blues stands firmly against the old adage. The blues is a history of a people forced to the bottom rungs of society for centuries. African Americans could not expect a fair trial in the court of public life in the year 1900, or the year 1950 for that matter. Charley Patton complained how easy it could be for his listeners to be thrown in a dark jail cell in "High Sheriff Blues."

When the message in the report was an incendiary one that might cause trouble for the singer, we'll see that they often used a kind of code to hide their subject in a thin veil. Contemporary blues artist Taj Mahal has said that complaints about "my woman" were actually code for "my boss." But in the case of "High Sheriff Blues," the veil is almost non-existent. Although Patton does not "fess up" to any crime, he paints the picture of extreme punishment as the song wears on. There is no doubt that several of his listeners at the time could relate to his feelings about being in prison.

Although paired with a musical style meant for leisure, blues lyrics have functioned as a social tool that caused the African American story to be spread across the United States and around the world. The blues demonstrates the resilience of a people living habitually on the underbelly of American society. It shows their hopes, their sorrows, and their humanity.

CALL AND RESPONSE IN THE BLUES

The combination of the AAB lyric form with the chord progression of the 12-bar blues has provided the formula for thousands of successful songs. It is greatly due to the characteristic of **call and response** that the simple lyric and musical structures combine to create such a powerful and enticing product. Call and response shows up in a couple of different ways in blues lyrics. First, the singer normally leaves space in between each of the lines. In Chapter 5 you will hear many of the country blues artists answer themselves with a repeated guitar riff or improvised solo. Blind Lemon Jefferson's "Black Snake Moan" is a great aural example of this. Here is my "Ghost Blues" as a country blues guitarist would interpret it:

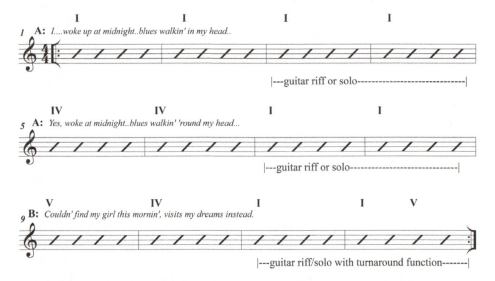

A second level of call and response exists in the lyrics themselves. The third line *responds* to the call issued by the first and second lines. Notice also how the lyrics interact with the basic 12-bar blues chord changes. Although the second line is a repeat of the first, it is sung over a new chord (the IV chord) which provides variety and tinges the lyric with a subtle dramatic arc. The singer may change his delivery of the second *"I woke up at midnight; blues walkin' in my head"* by changing the words or melody a bit, leaving off part of the phrase, or keeping the two lines virtually identical and letting the chords provide the variety. Listen through the blues recordings on this book's playlists to hear how each blues singer's delivery of the second line gives them a special identity.

INSTRUMENTATION

Instrumentation simply means the instruments used in a musical setting.

The blues band is a unit of musical instruments that has become commonplace in other popular styles of music. The instruments are classified in

terms of how they produce sound—strings, woodwinds, brass, and percussion. Blues bands are primarily a mixture of strings (guitar and bass) and percussion instruments (drum set and piano), with less emphasis placed on brass and woodwinds.

The **guitar** is the predominant instrument of the blues. The majority of important blues bandleaders have played the guitar—Robert Johnson, B.B. King, Son House, Stevie Ray Vaughan, Robert Cray, and Muddy Waters. This historic marriage of the blues with guitar may be attributed to the portable nature of the instrument, the ease with which a performer can move the guitar from place to place. It's a lot harder to wheel a piano from gig to gig then it is to pick up your guitar and walk. The earliest traveling country blues musicians could set up in any populated location to perform

Acoustic guitar

and make a bit of money—a juke joint, a tent show, or a street corner. The guitar's six strings are capable of playing a wide range from bass up to treble, creating a variety of textures, and quickly changing roles between playing solo lines and background chords. This gives the guitarist the ability to be a kind of one-man-band—singing the melody, playing bass lines and chords on the strings, and even tapping or hitting the body of the instrument or stomping their feet to bring in the sound of a drummer. The strings of the instrument are plucked with fingers or a pick. The guitar can either be a purely acoustic instrument (as in early country blues) or an electric one. When electrified, the guitar is attached to an amplifier that makes the instrument louder and shapes its tone color, or *timbre*. Today's electric guitarist may also shape his sound using effects pedals that make adjustments with a quick switch on or off.

Electric guitar

Piano

The **piano** is another of the most common and most versatile instruments. The piano is often classified as a percussion instrument, or more specifically aligned with the keyboard family (along with organs, harpsichords, synthesizers, and other keyboard instruments). The piano produces sound when a white or black key is pressed down, causing a soft hammer to strike a metallic string like a stick hits a drum. The hollow, wooden box that surrounds the inner workings of the piano gives the instrument volume and resonance. The piano has an even wider range than the guitar. Its 88 keys span more than eight octaves, covering higher and lower territory. A drawback, however, is that the instrument is very heavy and cannot be easily moved from place to place. While the blues was being created, pianos could be found in a number of venues, so a pianist could reasonably count on being able to find work.

The **bass** provides rhythmic drive and the foundation of the chords. Both electric and acoustic basses have been used in the blues, with the stand-up acoustic bass normally backing up the acoustic guitar and the

Acoustic bass

electric bass matching the electric guitar. Bass players typically play a pattern that repeats throughout a song and changes to fit the chord progression.

The **drum set** is simply a collection of multiple drums and other percussion instruments. The instrument has the distinction of being the only one created in the United States. The others existed in Europe before their appearance in the Americas. The drum set will be described in more detail in Chapter 2, since it took a more central role in the development of jazz.

Drum set

The **harmonica** is a wind instrument (technically a woodwind) that is more commonly seen in blues than in any other musical style. Unlike other wind instruments, the harmonica produces sound when the player exhales through the instrument *and* when they inhale. Harmonica players ("harpists") typically play a secondary role in a blues band, interjecting brief melodies between the singer's lines and acting as a second soloist. However, some of the best harmonica players have led bands, singing and playing harmonica alternately. The instrument is often amplified and, like the electric guitar, the amp works with the sound of the instrument to shape a player's personal timbre.

Harmonica

In addition to these instruments, violin and common jazz wind instruments (saxophone, trumpet, and trombone) have appeared in blues bands, typically as secondary instruments. The wind instruments will be discussed in more detail in Chapter 2.

ANALYZE A BLUES PERFORMANCE

When you listen to this recording—one of the truly great blues records—listen for the musical elements outlined in this chapter. Muddy Waters had one of the most monumental outfits in the history of the blues; a band that defined the sound of Chicago blues. The lyrics of this slow, swinging tune amount to a sermon on the horse-sense proverb "You Can't Lose What You Ain't Never Had." The form is a 12-bar blues with very typical blues riffs and turnarounds in the guitars and piano. Like all recordings discussed in this

text, do your best to focus on each individual instrument in this recording. Muddy Waters's bands had an ability to improvise an accompaniment in the moment with a special kind of give-and-take. No instrument seemed to get in the way of another, even though guitar and piano might be filling in musical space at the same time.

The graphic below outlines the form and arrangement of the song.

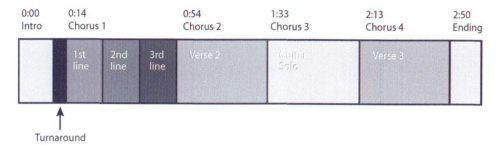

Turnaround

"You Can't Lose What You Ain't Never Had"
(1964)

Personnel: Muddy Waters, guitar/vocal; Willie Dixon, bass; Clifton James, drums; Buddy Guy, guitar; Otis Spann, piano

0:00	**Introduction:** Muddy Waters sets the tempo on his guitar with bent **blue notes** in the upper register. He is joined by backing guitar, bass, piano, and drums.
0:09	**Turnaround:** This is the part of the chord progression that turns back around to tonic, or home base. Essentially, the turnaround transports the song to the beginning of the next section. Both guitars and the piano play simultaneous licks that function as a turnaround.
0:14	**Chorus 1, section 1: Call and response**—After Muddy's opening lyric (on the I chord), Otis Spann answers with an intense piano roll, played in the space between lyric lines.
0:26	**Chorus 1, section 2:** Muddy's same lyric, this time over the IV chord. Again, Otis Spann responds, as does a guitar with a high bent note (probably Muddy Waters).
0:40	**Chorus 1, section 3:** (V chord) Muddy answers his first two lyric lines with an extended version of the song's title. This time, Otis Spann's answer on piano *is* the turnaround to the next chorus.
0:54	**Chorus 2:** The band follows the same pattern, with Spann's piano answering Muddy's vocals, and the other band members keeping the slow shuffle groove steady.
1:33	**Chorus 3:** Slide guitar solo (probably Muddy) with bent **blue notes** throughout. Notice how the other instruments interact with the soloist, especially Otis Spann's piano rolls in the low register. The guitar solo is played over the same 12-bar chord progression as the sung choruses.
2:13	**Chorus 4:** Muddy sings a third verse, much like the first two.
2:50	**Ending:** The band ends quickly on the final chord of the chorus with a common blues rhythmic figure.

Discussion Questions

1. Name and describe two unique characteristics of melody in the blues (pitch, scales).

2. In Muddy Waters's "You Can't Lose What You Ain't Never Had," find three instances of blue notes in the melody and write the minute and second they occurred in the recording (i.e., 1:03). What words did Waters sing on the blue notes?

3. Think about the group of instruments commonly used in the blues. In what style/genre of music do we find a similar group of instruments today? Of the common instrument families—strings, woodwinds, brass, percussion—which family is least represented in a typical blues band?

4. Describe the kinds of subject matter often covered in blues lyrics. What value can we expect to glean when we listen closely to blues lyrics?

5. Listen to Muddy Waters's "You Can't Lose What You Ain't Never Had" while looking at the diagram in the Call and Response section of this chapter. Does the track conform to the pattern of call and response illustrated in the diagram? Which instrument(s) answer the vocal line with a riff or solo?

Musical Elements of Jazz

NOTE: In this chapter, be sure to listen to the musical selections as they are described in the text. Learning about music is all about *listening*!

The selections for this and all chapters are arranged in playlists at Rhapsody.com. Find the link to each chapter's playlist beginning on page xi.

Be sure to refer to Appendix A if you run into terms and concepts that you do not understand.

In this chapter, we will cover:

- Five characteristics of jazz
- Rhythm: unique aspects of jazz rhythm
 - What is **swing**?
 - What is **syncopation**?
- Timbre: unique approach to tone color related to the blues
- Instrumentation/Orchestration:
- Instruments of jazz (**brass, woodwinds, rhythm section**)
- Form: Typical forms in jazz (**blues, ragtime, song forms**), vocabulary
- Texture: **polyphonic, monophonic, homophonic**
- Analyze a jazz performance

Jazz is like no other music. Jazz performers draw their sounds from a musical toolbox full of original techniques and ideas. Jazz is also misunderstood. Ask a crowd of people, "what is jazz?" and you'll get a wide range of responses from the serious to the casual, from the cool to the hot, from the smooth to the edgy. Is it Frank Sinatra or Miles Davis? Kenny G or Kenny Garrett? Michael Bublé or Esperanza Spalding? Duke Ellington or Cab Calloway? Or do all of them fit under a large umbrella of jazz? In this chapter we will lay some ground rules for understanding and defining jazz.

Jazz first developed in the southern United States from the culmination of a number of musical styles that were commonplace in America during the late 1800s—particularly blues, ragtime, European classical music, and American church music. Its unique musical elements developed over time from a mishmash of ingredients from these styles.

Jazz is a *broad* category of music. From early jazz known as "Dixieland," to experimental music known as "Avant Garde," to funky jazz known as "Fusion," the genre has many faces and is often difficult to pin down. In fact, jazz fans today still debate "Is this jazz, or isn't it?" Here is a list of important characteristics that all jazz has in common. Each style or *sub-genre* of jazz may focus on each characteristic to a larger or lesser degree, but all jazz shares the following to some extent.

FIVE CHARACTERISTICS OF JAZZ

1. Improvisation

Improvisation is the act of composing music while performing it. Spontaneous musical composition is difficult, but if you think about it, everybody improvises from time to time. When we make conversation among friends or speak in public, we all improvise. You formulate sentences that describe subjective or abstract pictures or ideas in your mind. You decide whether to answer a question seriously or to make a facetious remark. All of us improvise inside or outside unwritten social guidelines. Jazz musicians use their instruments in the recording studio or in live performance to make up melodies, chords, and rhythms that express abstract ideas. They are capable of creating moments of great drama in their solos, often building up tension over several minutes and strategically releasing the tension to elicit a reaction from the audience. They follow the rules of music theory, or break those rules. When you go to a jazz performance, you're seeing improvisation on a number of levels happening *on the spot*. A saxophonist decides what pitches will best communicate an idea over the chords of a song. At the same time the saxophonist chooses rhythms that will fit the *groove* laid down by the accompanying instruments.

Quoting—Playing a familiar melody while in the act of improvisation, often for comedic effect.

A special tool of the improviser is the **quote**. A soloist sometimes plays a familiar melody in the midst of a solo, often for comedic effect. (Listen for a nursery rhyme quote at the beginning of Thad Jones's trumpet solo in "April in Paris," 1:16)

No other musical style so prominently features improvisation. However, we know that the great European masters J. S. Bach, Wolfgang Amadeus Mozart, and Ludwig van Beethoven were adept improvisers, often making up variations to popular themes of their time. It was commonplace in classical music for a concerto performer to improvise the cadenza near the end of the first movement of a work, much like we see a rock and roll guitarist or drummer playing an open solo near the end of a concert.

Improvisation is the characteristic that sets jazz apart from all other musical styles of today. Because the improvised solo is the centerpiece of a jazz performance, improvisation has developed to an extremely high level. Great jazz musicians have developed various styles and techniques to shape their solos. One soloist might develop a solo from a **motive**, a short melodic cell that is repeated and reconstructed as a central idea. Another soloist may take a harmonic approach, playing vertical patterns that outline the chord progressions. Another may take a more lyrical approach, constructing song-like melodies and passing through the form with subtle reference to the chord changes. Another may use technical patterns, repeating short groups of pitches at a rapid pace that are usually tailored to the particular instrument. John Coltrane's "sheets of sound" used patterns that raced up and down the saxophone and fit far more conveniently on the saxophone than on the trumpet. Some soloists are most effective when exploring various timbres, or colors, that their instrument can create, often doing a great deal with just a few notes. We'll see all kinds of improvisers throughout the history of jazz whose inventions and stylistic approaches have formed the broad language of today's jazz. We'll see that the nature of improvisation in jazz has taken on varying portions of tradition and

innovation. More than any other characteristic, the nature of improvisation has driven the evolution of the genre.

What kinds of improvisation do you hear in a jazz solo?

1. **Lyrical approach**—the soloist uses song-like melodies and phrases that can be easily sung. Note durations are often varied from long/slow to short/fast notes.
2. **Harmonic approach**—the soloist creates melodies completely based on the chord progression, often in arpeggios (skipping up and down the chord tones).
3. **Motivic approach**—the soloist creates melodies based on variations of a short group of pitches.
4. **Pattern-based approach**—the soloist rapidly repeats short groups of pitches.
5. **Timbral approach**—the soloist explores various timbres (tone colors) the instrument can create.

2. Interaction

The best improvisers are able to interact with their accompanying musicians at the same time that they develop their own musical ideas. In fact, they may borrow and incorporate musical ideas from one another. In the moment, soloists feed off of the energy they feel from the other musicians on stage. They might copy a melody they hear played immediately before, they might line up with a rhythmic idea played by the drummer or pianist, or they might hear a new chord played by the pianist and adjust their melody to fit. Although interaction takes place on a subtle level between musicians in classical, rock, and other styles of performing groups, interaction is paramount in jazz. When you listen and watch jazz performances, strive to watch for moments when interaction between a soloist and a backing musician builds tension to a climax. Quoting plays a role in interaction. You may hear a soloist pay their respect to the previous soloist by starting with the previous soloist's ending material, or one soloist may poke fun at the other. In heated on-stage battles between tenor saxophonists, Dexter Gordon liked to play the show tune from *Annie Get Your Gun* "Anything You Can Do (I Can Do Better)." Wayne Shorter liked to use the theme from *Star Wars* when the band took the music to new territory.

3. Rhythm

The basic rhythmic feel in jazz is different from most styles of music. Almost all music has pulse (see the Foundations appendix), but what makes jazz special happens between the pulses.

Swing

Most styles of music divide the pulse into two parts, or subdivisions. This is called "straight eighths" or "even eighths" because the division is written using eighth notes.

Even eighths

Swung eighths

Most jazz is not straight. Instead the eighths are **swung eighths**, an uneven subdivision alternating between *long* and *short* notes.

Here's another way to look at the swing subdivision. The graphic below illustrates where subdivisions fall in relation to the beat. Each of the four beats has two lines below, indicating the division. Look closely at lines that fall in between each beat. The *even* division falls exactly halfway between beats, but the *swung* division happens a little bit later.

The Beat	1		2		3		4	
Even Eighths								
Swung Eighths								

To understand the swing subdivision, divide the pulse into three parts instead of two. We call these *triplets*. The jazz musician creates swing by playing the 1st and 3rd parts of the beat.

Listen for the long-short, long-short, long-short pattern in the recording of "The Chess Players" by Art Blakey and the Jazz Messengers. The opening melody uses a mixture of triplets and swung eighth notes. The drummer, pianist, and bassist line up their rhythms together on swung eighths. To contrast this with the sound of straight eighths, listen to the Art Blakey recording of the ballad "You Don't Know What Love Is." Although Blakey sounds at times like he *wants* to swing the ride cymbal, the piano lays down the prevalent straight eighths rhythm. Not all jazz uses swing eighths, but even straight-eighth jazz is grounded in—and evolved from—swinging music.

Syncopation

Another important rhythmic aspect in jazz is called **syncopation**. Syncopated music emphasizes rhythms away from the pulse, or off-beat rhythms. European classical music tends to emphasize the pulse. Its melodies begin and end on a strong beat, and rhythms between pulses are not often emphasized. Jazz—and its ultra-syncopated ancestor, ragtime—lives for the upbeat. Percolating above the ground pulse, syncopated rhythms affect the music with a kind of forward motion that is at the same time danceable, anxious, and pleasing. Without the syncopation we hear in jazz, American music would be far less energetic. Listen to Franz Joseph Haydn's beautiful European masterpiece *Symphony No. 94 in G Major "Surprise," Mvt. II Andante*. The melody tip-toes from pulse to pulse, only throwing the listener off kilter with loud outbursts on strong beats. Now listen back again to "The Chess Players." The loudest, most emphasized notes mix on-beat and off-beat rhythms resulting in a kind of rhythmic tension that keeps the listener on guard. Plenty of examples of European art music have syncopation, but American musical languages like ragtime, jazz, and even rock, funk, and hip hop incorporate syncopation as an essential ingredient.

4. Creative Edge

Jazz lives on the edge between comfortable tradition and brave exploration. When we listen to jazz we should expect to hear the tension between the two. Even when jazz musicians cover old standard tunes, they are engaged in a quest for a new sound. Good jazz has never rested on its laurels or simply rehashed earlier successes; rather, the musicians strive to create something new, something fresh. This creativity can be heard in the melodic choices of the improvised solo, the groove created by the backing musicians, and the singer's delivery of the melody and lyrics. This means that the jazz musician strives to bring something new every time they perform.

5. Unique Approach to Sound

Jazz can be distinguished from other styles of music by a few aspects of its sound. Jazz musicians tend to use **dissonant** sounds. Dissonant music sounds unpleasant and disagreeable, but jazz musicians bring these sounds into a context where they create tension in the music. Pianists may strike two keys next to each other creating a **tone cluster**. Listen carefully to Thelonious Monk's "Brilliant Corners." Monk plays tone clusters in the opening seconds of the track, setting up the angular melody played by the dissonant saxophones of Sonny Rollins (tenor) and Ernie Henry (alto) in their low registers. These harsh and ugly sounds would be undesirable in many settings, but in jazz the dissonance adds to the big picture. An advanced improviser may also play pitches that do not fit the chords played in the background (often called "playing outside"). In jazz, this is acceptable because the dissonance creates tension that can be built up and later released.

Jazz musicians often produce tone colors (*timbres*) on their instruments that would be unacceptable by classical standards. Rather than striving for a pure tone, a jazz trumpeter or saxophonist uses "dirt" in their sound on purpose. They may growl while they produce a tone on the instrument or they may let air escape their mouth to create a "breathy" sound. Trumpet players often use half-valve fingerings and other techniques to produce unique sounds on their instruments (refer to Lee Morgan's solo on "The Chess Players" 4:02). In jazz, a musician's use of dissonance and imperfections becomes a part of a personal identity.

INSTRUMENTATION

Jazz is primarily an instrumental style of music. Although its history is full of wonderful singers, instrumentalists have been the bandleaders who made the most transformative impact on the genre. Jazz bands tend to use a standard group of instruments. We can see the instruments of a band split between two groups with two separate functions. Usually on the front edge of the bandstand is a group of horns, or wind instruments. Wind instruments are split into two families, called the **brass** and **woodwinds**. Behind these wind instruments is the **rhythm section**. The horn players usually play the main melody, while the rhythm section's primary role is to support the front line horns. Although there are plenty of examples of harmonica jazz, violin jazz, even bassoon jazz, most jazz groups contain a mixture of some of the following wind instruments.

Brass

The instruments in the brass family are made of metal alloys and the musician creates sound on the instrument by buzzing his lips into its mouthpiece. The body of the brass instrument is essentially an amplifier and a sound-shaper. It turns the buzz from the lips into a pleasing sound.

Trumpet and Cornet

The **trumpet** is the instrument that usually plays the highest pitches in the front line. Its piercing sound cuts through the sounds of the other instruments, making it a natural bandleader's instrument. The instrument has three valves that are pressed down to change pitch. In the beginning of jazz, the **cornet** was the chief sound, and the cornet player was normally the leader of the group. The trumpet and cornet are substantially different from one another, but their particular sounds may be difficult to distinguish in early jazz recordings, largely due to poor sound quality. The physical difference is in the shape of the tubing that winds around to create the instrument. The cornet has a conical bore; in other words, the diameter of its tubing is tapered very gradually from the mouthpiece to the bell. The trumpet has a cylindrical bore, so its diameter stays the same across most of the instrument. The difference in shape causes the trumpet to sound more aggressive, edgy, bigger, and more open than the cornet. Louis Armstrong impacted the cornet/trumpet society when, in 1926, he switched from cornet to trumpet.

Trumpet

© Furtseff, 2014/Shutterstock, Inc.

Cornet

© mkm3, 2014/Shutterstock, Inc.

Flugelhorn

© Horatiu Bota, 2014/Shutterstock, Inc.

Occasionally a trumpeter plays a larger instrument called the "flugelhorn" instead. The **flugelhorn**, often used in ballads and mellow jazz pieces, has a warmer tone than the trumpet.

Mutes—Trumpet players often attach a **mute** to the bell of the instrument to shape its sound. A number of different mutes made of different materials and shapes give trumpeters a varied toolbox from which they can draw. Miles Davis may be the most famous example of a muted trumpet sound. He liked to use a Harmon mute without a stem to transform the trumpet's jarring holler into an intimate whisper.

Straight Mute

© Horatiu Bota, 2014/Shutterstock, Inc.

Harmon Mute

© Horatiu Bota, 2014/Shutterstock, Inc.

Trombone

The **trombone** plays the lowest pitches of the front line horns in a jazz band. It is made of a longer piece of metal tubing, and opens into a bigger bell. Most trombones do not have valves, and instead they manipulate the pitch with the use of a slide. When the trombonist moves the slide away from her body, it increases the length of the instrument and lowers the pitch. Besides the difference in pitch, listeners can distinguish the trombone from other instruments by the slurring, or bending, often heard from one pitch to the next. All the other instruments change pitch by pushing down a button of some kind, immediately changing pitch. The trombone moves from one pitch to the next as fast as the player moves her arm. It is capable of bending pitch from low to high, and high to low, called a *glissando*. Less often than trumpeters, trombonists shape their sound with the same types of mutes used by trumpeters.

Trombones: Tenor and Bass

© Vereshchagin Dmitry, 2014/ Shutterstock, Inc.

Woodwinds

The woodwind family includes instruments that produce sound when the player blows air into a mouthpiece with a single reed attached (clarinets and saxophones), a double reed mouthpiece (oboe and bassoon), or across a hole on the instrument's body (flutes).

Saxophones (left to right): baritone, tenor, alto, soprano

© Vereshchagin Dmitry, 2014/Shutterstock, Inc.

The **saxophone** is the most common woodwind heard in jazz. Four different varieties of saxophones are commonly used, named like the voice parts that make up a choir. Most saxophone players choose either the tenor or alto saxophone as their main instrument because of their versatility and the strong tradition built up by musicians who played them such as John Coltrane, Sonny Rollins, and Dexter Gordon on the tenor, and Charlie Parker, Cannonball Adderley, and Kenny Garrett on alto. The baritone saxophone is the largest and plays the lowest pitches. It is primarily used in big band settings, filling out the lower end of the saxophone section. The soprano saxophone is normally straight in shape and is less commonly used in a big band context. A number of soloists have used the soprano's high pitch and piercing sound to great effect—John Coltrane and Sidney Bechet.

The **clarinet** was one of the primary instruments in early jazz combos, but is not seen as often today. The instrument was most prominent in New Orleans and Chicago jazz bands of the 1910s and 1920s, and some of the main bandleaders of big band swing played clarinet—Benny Goodman and Artie Shaw. The clarinet's black wooden cylinder produces a more mellow and pure timbre than the saxophone.

Doubles—Saxophone players in today's jazz bands, particularly in large jazz orchestras, are regularly expected to **double** on other woodwind instruments. Clarinet, flute, and bass clarinet are most common doubles played by today's saxophonists.

Clarinet Bass Clarinet Flute

Rhythm Section

The instruments of the **rhythm section** are responsible for framing the primary soloist's sound by establishing the groove—or rhythmic feel—of a performance, propelling the music forward and coloring the background sound with harmony. The Rhythm Section Triangle below illustrates the jobs of the rhythm section players.

☐ Rhythm Section Triangle

BASS
1. steady pulse
2. harmony

DRUMS
1. steady pulse
2. syncopated rhythms

PIANO/GUITAR
1. harmony
2. syncopated rhythms

Each member of the rhythm section plays a couple of roles in the typical jazz band, and each role is shared by two members of the team. Listen to "B'da b'da b'da b'dat" by the Jeremy Brown Quartet for an example of the standard jazz rhythm section sound.

The **bass** used in jazz is the same instrument found in an orchestra's string section. Bassists do not normally use a bow in jazz. Instead they pluck the strings (*pizzicato*) to create a percussive sound, attacking the front end of

the note. In a swing context, the bassist plays a **walking bass line**. He plays a note on every beat, choosing from the notes of the chord. Walking bass is the essence of the groove in jazz. It links in with the other rhythm instruments, providing a foundation for tempo and harmony. Notice in the rhythm section triangle that the bass shares the harmonic function with the piano/guitar by outlining the notes in each chord, while they share the steady pulse function with the drums.

The **drum set** is the youngest instrument in the jazz ensemble. Percussion instruments were combined early in the 20th century into a conglomerate of instruments that has dominated the rhythm of contemporary American music. The instruments of the drum set include drums and cymbals. The **ride cymbal** is the biggest cymbal and is the main voice of the jazz drummer's sound. It has a sharp attack with a washing resonance, and drummers sometimes create a *sizzle* in the sound of the ride by inserting metal rivets in holes on the cymbal. The **high hat** is a pair of small cymbals, one overturned on the other. The drummer stomps on a

Drum set

pedal to lower the top cymbal, clapping the two cymbals together and creating a "chick" sound that deepens the groove of the ride pattern. The drums usually fulfill the syncopation role in the band. The high-pitched **snare drum** and low **bass drum** often seem to have an off-beat conversation behind the cymbals' steady groove. Drummers like Art Blakey and Elvin Jones famously lit fires under the band with aggressive rhythms played on the drums. The **tom-toms** are used sparingly in jazz, usually to expand the sonic palate of the drum set during drum solos and fill-ins. Every drummer has his own preferred set up that may include flat ride cymbals, Chinese cymbals, cowbells, shakers, and even water gongs and triangles, but the standard jazz drum kit has just two tom-toms, a snare drum, bass drum, hi hat, ride cymbal, and crash cymbal.

The drummer in a jazz band is the chief of rhythm. The drums establish the steady pulse with the **ride pattern**—a repetitive rhythm played on the ride cymbal and punctuated by the hi hat. These two cymbals work together to produce the primary component of a jazz drummer's sound. The "spang spang-a-lang spang-a-lang" of the ride pattern has a note played on every pulse (like the bass line) and occasional skip beats, or notes played in between pulses on the 3rd triplet of the beat. The hi hat typically lands on every 2nd and 4th beat, deepening the groove of the ride pattern. Every drummer has his own personal touch and interpretation of the ride pattern, and over time the ride pattern has evolved along with jazz itself, moving around the drum set and varying its rhythm.

The drummer fulfills his second role, syncopated rhythms, creating rhythms on the snare drum and bass drum independent of the ride pattern. These rhythms can vary between standard shuffling patterns and random, jarring, spotlight-stealing chatter, and can move around the tom-toms. Sometimes drummers use **brushes** instead of sticks to soften their sound. Brushes are made of metal strands and are drawn across the snare drum head to create a *swishing* sound.

The **piano** is the harmonic chief of the jazz band. The pianist plays the chords of a jazz tune, putting her own personal stamp on the harmonic progression. At the same time, she shapes the rhythmic character of a performance by playing syncopated rhythms along with the drummer. This style of piano playing is called "**comping**"—short for "accompanying." When a pianist comps with the rhythm section, the goal is to cooperate with the bassist and drummer to create a supportive and exciting accompaniment. The pianist's sharp attack carries on a conversation with the drummer's snare drum, sometimes lining up with the drummer's rhythms and other times contrasting what comes from the drums. The piano comes from a pedigree in the European classical tradition of great technical virtuosity and incredibly diverse repertoire.

Occasionally, the **guitar** replaces the piano in a jazz band. Since the guitar is capable of playing multiple pitches at once, it can easily fulfill the piano's harmonic function and comp using similarly syncopated rhythms. When a band has both piano and guitar, each instrument alternates between comping and solo roles, negotiating the harmonic space.

Listening Exercise

Can you identify the musical instruments used in jazz by their sound? Listen to the Listening Exercise and try to name each instrument. You may hear trumpet, trombone, clarinet, soprano saxophone, alto saxophone, tenor saxophone, baritone saxophone, piano, guitar, or bass. (Find the answers on the last page of this chapter.) Find the Listening Exercise @ www.msjc.edu /JeremyBrown/Pages/Tracks.aspx

1. _____	2. _____
3. _____	4. _____
5. _____	6. _____
7. _____	8. _____
9. _____	10. _____
11. _____	12. _____
13. _____	14. _____
15. _____	

TEXTURE

Texture refers to the arrangement and roles of instruments in a performance. We describe food by its texture; the way it feels on our tongue is caused by the consistency and construction of its ingredients. In music, **texture** is defined by its density and complexity, by the number of melodies that occur at a given moment, and by the kind of accompaniment, all coming together to form the foundation. Music of nearly every kind—symphonies and operas, electronic dance music, jazz and blues—can be described by one of three basic textures.

1. Monophony

Monophonic music has the simplest of forms. From Greek roots *mono* ("one" or "single") and *phon* ("sound"), it has only a single melodic line and no accompaniment. Often in jazz and blues, monophony occurs when a solo instrument plays alone, like Louis Armstrong in the opening of "West End Blues" (written by Joe "King" Oliver). Also, when multiple instruments play a melody in *unison* (together) without accompaniment, this is monophonic texture.

2. Polyphony

Polyphonic music has multiple melodies performed simultaneously, with or without accompaniment (*poly*—"many" or "multiple"). When the clarinet, trombone, and cornet weaved together melodies on the frontline of an early jazz band, this collective improvisation created a polyphonic texture. Listen to King Oliver's "Dippermouth Blues." Other instances of polyphony have appeared throughout jazz history—from Gerry Mulligan to Ornette Coleman, to interesting moments in contemporary big band music.

3. Homophony

The most common texture used in all music is homophony. Homophonic music has one main melody and can have a variety of accompanimental textures (*homo*—"same"). Art Blakey's "This Is For Albert" (written by Wayne Shorter) is a good example of a couple of different kinds of homophony. After a brief rhythm section introduction, the beginning melody is played by trumpet, tenor saxophone, and trombone, sometimes in unison and sometimes in harmony. Meanwhile, the rhythm section plays a variety of rhythmic figures (0:21). This is homophonic texture, one important melody against an arranged accompaniment. Although the three-horn group of trumpet, tenor saxophone, and trombone sometimes play three different pitches, we hear the collective as a main melody. Then when Wayne Shorter plays a tenor saxophone solo (1:14), the rhythm section supports him with standard swing comping, a contrasting sound, but still a homophonic texture with one prevalent melody supported by accompaniment.

FORM

The form of a song is its structure, its overall make-up, its pattern of similar or contrasting sections. The chord progression and melody work together to define the beginning and ending of each phrase. From blues to symphonies, all music is based on a basic form. The entire repertoire of **jazz standards**—hundreds of songs performed by jazz groups everywhere— is based on just a few forms. Not surprisingly, many of the jazz standards are based on the **blues form**. Chapter 1 illustrated the basic blues form in detail. Twelve bars, or measures, are organized into three contrasting phrases of four bars each. In the setting of a blues song, that simple 12-bar form is repeated from the beginning to end. When jazz bands perform 12-bar blues songs they may make any number of modifications to the

chord progression, but the essential ingredients are the same as basic blues. Common jazz-blues songs are "Blue Monk," "Blue Trane," "Basin Street Blues," and "Now's the Time."

Other common forms are the **ragtime form**—a 5-part form described in detail in Chapter 3—and **32-bar song form**. Tunes written in 32-bar song form often come from musical theater and film like "I've Got Rhythm," "The Days of Wine and Roses," and "Just in Time." The song form is divided into four phrases of eight bars each. The most common phrase structure is AABA, where the 1st, 2nd, and 4th phrases (designated "A") have the same chord progression, and the 3rd, 8-bar phrase (designated "B"), has different chords. This contrasting section—called the **bridge**—usually sounds like it moves to a new key. Other common phrase structures used in 32-bar song forms are ABAB and ABAC. Even songs that have 36 or 40 bars are oftentimes just 32-bar song form tunes with an extended section or two.

ARRANGEMENT

Most jazz performances follow a standard template of arrangement. Whatever the phrase structure, whether 12-bar blues or AABA song form, the full form of a song is called a **chorus**, and a jazz performance is built by repeating the chorus with different events happening at each repetition. During the first chorus, the band usually plays the **head** (or "melody") of the song. The head returns during the very last chorus. (Imagine a bandleader tapping his head to signal to the other musicians to begin playing the melody.) Between these bookends, a procession of solos takes place. From one soloist to the next, every player solos over a few or several choruses and then signals to the next soloist to begin. This simple soloist-driven form puts the spotlight on improvisation and leaves room for a great deal of interaction between the musicians. In an orchestra, variety and contrast come in the form of different instrument groups being featured from one moment to the next. In jazz, a single player has to hold the attention of their listener, hopefully providing contrast in style from the approach of the previous and the following soloist. In this way, jazz is subtler than classical orchestral music.

Sometimes, however, jazz bands rely on a couple of tools to provide contrast. While one musician plays a solo, the other horns might play simple riff-based melodic phrases called "**backgrounds**," usually to signify the last chorus of a solo. After the last soloist is finished, the drummer might engage in a new game with all the soloists called "**trading 8s**." In trading, the soloist who played the first solo of the piece begins another solo, only playing over the first eight bars of the form. Then the drummer will solo for eight bars. Next, the second soloist plays the 3rd 8 bar phrase … followed by the drummer … followed by the 3rd soloist … and so on … until the band is ready to finish the song by playing the final head. Trading, backgrounds, and other tools of the trade give the jazz musician opportunities to build excitement without having to plan an arrangement ahead of time.

At live performances, most jazz bands either play the music from memory, or they use a **lead sheet**, a short-hand representation of the basic ingredients of the song. A lead sheet usually fits on just one or two pages, and includes the head and chord changes along with a few symbols that

help delineate the form. The lead sheet above is a song composed in AABA form with an extended final A section. Instead of 32 bars, this song has 40. Besides that, it can be performed like a typical 32-bar song form. First, the head is played, then solos are played over repeated choruses, and finally the head returns.

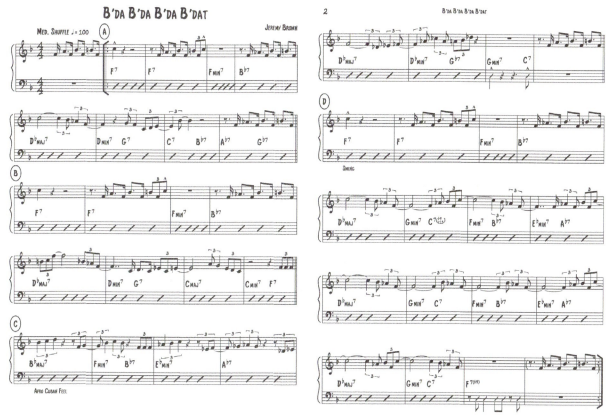

ANALYZE A JAZZ PERFORMANCE

One of the major challenges of listening to instrumental music of any kind is hearing how it is organized. In vocal music, and particularly pop music, lyrics and melody delineate the form and provide obvious signals to the listener where one section ends and the next section begins. In jazz we must listen closely to abstract sounds, making sense of chords and melody and finding landmarks and arrival points. Also, most popular music is written in a verse-chorus form that has an obvious "hook" at a repetitive chorus. Jazz and blues have cyclical forms, forms with only one section that repeats again and again. Hearing and understanding this organization takes practice. Practice listening for form. Listen to the songs in this chapter and see if you can hear the top of the form, or the first measure. Regularly you'll hear the pianist or other chordal instrument play a turnaround figure during the last measure or so, perhaps not as obviously as a blues guitarist but to the same effect. The drummer may also signal the top with a busy fill-in leading to a crash cymbal near the top of the form.

Listen for form and other musical elements we've covered in this chapter when you analyze "1239a." This track is a great example of

straight-ahead, mainstream jazz played by a small group. The quintet format (trumpet, tenor saxophone, piano, bass, drums) has been a standard instrument grouping since the first bebop bands of the 1940s. The Harper Brothers' arrangement of this minor-key vehicle is a clear example of how jazz works, and showcases the impeccable talent of each musician in the band.

0:00	0:39	2:00	3:53	5:48	7:38	7:56	8:15
Head	Solo #1	Solo #2	Solo #3	Solo #4	Shout	Head	Coda

A	A	B	A	Tenor Saxophone Solo	Trumpet Solo	Piano Solo	Drummer Trading 8's & Full Chorus	A	A	B	A	A

Music Analysis

"1239a"
(1991)
Personnel: Philip Harper, trumpet; Winard Harper, drums; Javon Jackson, tenor saxophone; Kevin Hays, piano; Nedra Wheeler, bass

0:00 **Opening head:** Melody played in octaves—trumpet high, tenor saxophone low. Rhythm section answers the horns' melody playing blues figure in the holes.

0:20 **Bridge:** Higher melody with rhythm section landing on offbeats in the background.

0:29 **Last A section:** Return to the opening arrangement, ending on a brief pause.

0:38: Javon Jackson starts during the rhythm section's pause the last measure of the head, called a **solo break**. His opening 3-note motive may be a quote of John Coltrane's famous solo in the classic "Acknowledgement" from *A Love Supreme*. He alternates between motivic and harmonic approaches, at some times developing a simple idea and at others moving at cutthroat pace through the chord changes.

1:20: Jackson's second chorus builds tension with a rapid blues pattern, then continues the varied path established in his first chorus. He holds over into a third chorus by just a few bars, dovetailing into the trumpet solo.

1:58: After Winard Harper brings the volume lower with only his ride cymbal and hi hat audible, trumpeter Philip Harper begins his solo decisively at a lower volume. He develops an idea in the low range of the horn through the first couple of A sections, then moves to the middle range during the bridge, building intensity.

2:35: Harper's second chorus opens with an upper range stab. Harper is able to manipulate the brassy edge of his instrument, and in this chorus he moves from his earlier mellow timbre to an aggressive call to attack. He uses a half-valve effect to shape his sound and bend the pitch in a couple of instances.

3:15: The third trumpet chorus increases the intensity again, opening with a trilling long note in the upper register. Brother Winard spurs him onward to a climax (3:24) with explosive snare drum and crashing cymbals. Philip lowers the intensity again at the bridge, only to return to his hard-edged sound for the last A section.

3:54: Kevin Hays's piano solo picks up on the intensity of the previous solo with complex rhythms and disjunct melodic lines. His solo primarily consists of single, horn-like lines punctuated at times by octave doubling. Listen for rhythmic "hook ups" between piano and drums (4:21).

4:31 **Piano chorus #2:** Trumpet and tenor saxophone play simple 4-note background figures over the A sections of this chorus. The backgrounds seem to give Hays something to play against, forcing him to raise the volume and intensity.

5:11 **Piano chorus #3:** Hays actually lowers the level of intensity during this chorus, playing fewer notes per bar and returning to more "inside" and conventional melodic ideas.

5:47 **Trading 8s:** Phillip's trumpet opens the section of trading with a high trill. Winard's drum solos are an onslaught of aggressive syncopations moved around the drum set, often pushing the rhythm over bar lines. (His first 8-bar section actually goes on for nine bars, stretching into the beginning of the tenor saxophone solo.) Harper shows his affinity for orchestration on the drums, focusing on different parts of the drum set for each solo. The athleticism of his impressive gimmicks and tricks are better appreciated in person, by sight, but the aural result is an exploration of sounds that can be created on the drums. The solo licks and technical display never get in the way of the deep rhythmic swing.

7:02 **Full Chorus Drum Solo:** Harper uses a rhythmic idea from his last eight bars as a motive, returning to the snare drum/low tom from time to time during his full chorus solo. He ends the solo by distorting the meter with a long string of cross rhythms (7:30), finishing with a long roll.

7:38 **Shout:** Instead of returning to the head, the band plays a shout figure over the first two A sections.

7:56 **Bridge:** The band returns to the head, starting on the bridge and playing the last A section.

8:15 **Coda:** The band plays a final A section that varies slightly from the head, ending on a sustained chord.

MUSICAL ELEMENTS IN JAZZ AND BLUES

Between jazz and blues there is a strong correlation of style and musical characteristics. This is not surprising since, as we'll see in future chapters, the two genres were developed around the same time period and region of the Unites States. Although blues and jazz are separate musical languages each with its own approach, each developed its vocabulary by borrowing ideas from the other. The cousins came from the same family but developed distinct personalities.

Interaction and improvisation are essential to both genres, although jazz tends to allow more freedom for these properties to take over a musical performance. The rhythmic elements of syncopation and swing are common in both styles. The swing rhythm is used in some, but not all early and contemporary blues songs; and syncopated rhythms dominate. Both jazz and blues instrumentalists tend to play with a unique "jazz sound," uncharacteristic of the pure instrumental tones heard in classical music. Personalized tones are more important than conventional timbre. When the wind instruments of jazz (trumpet, trombone, saxophone) are used in a blues context, they inject a jazz flavor into the blues language. The jazz rhythm section is essentially made up of the same instruments as the blues backing band, so the differences in timbre between the two styles are subtle, at least at first listen. Texture separates the two styles at various stages. Because the blues is primarily a vocal genre, almost all blues is performed in homophonic texture—one melody with a background accompaniment of chords and rhythm. More textural variety has taken place in jazz, where experimentation often becomes the trend. At different times in jazz history, polyphonic and homophonic textures were the norm, and monophony has been used for variety.

What makes a study of jazz and blues fascinating is the way the two musical cousins have changed over time, sometimes taking on the same

musical elements and at other times contrasting sharply. Even though both jazz and blues emanated from similar southern roots, the changes that took place throughout the 20th century took them in very different directions.

Listening Exercise Answers
1. tenor saxophone
2. alto saxophone
3. soprano saxophone
4. baritone saxophone
5. clarinet
6. trombone
7. flugelhorn
8. trumpet
9. trombone
10. piano
11. acoustic bass
12. guitar
13. piano
14. alto saxophone
15. tenor saxophone with active drums

Discussion Questions

1. List the five important musical elements of jazz. How do they compare or contrast to the blues?

2. Listen carefully to the Harper Brothers' "1239a." Write the minute/second where interaction was apparent between two or more musicians in the band and describe what you heard.

3. Instrument Identification: When you took the Listening Quiz, which instruments were most difficult to identify? Why do you think you had difficulty?

4. Name three basic forms used by jazz musicians. Which form has a bridge, and what is its function?

5. Listen again to Thelonious Monk's "Brilliant Corners" and give a play-by-play musical analysis like the one written for "1239a." Be sure to listen for interesting musical moments where musicians interacted or individuals did something remarkable.

Roots of Jazz and Blues

In this chapter, we will cover:
- Music in Europe
- Music in Africa
- Slave Songs
- Spirituals
- Reconstruction
- Minstrelsy
- Ragtime

We can learn a great deal about a musical genre by looking at its roots. Blues did not just appear one day in a southern juke joint. Jazz was not hatched in a single Prohibition-era speakeasy by a team of adventurous entertainers. Musical genres are the product of influence, of connections being made from one musician to the next. They were cobbled together by hundreds of hands playing a diverse mixture of musical styles since the colonization of the Americas, each style leading to the next new sound and developing the next musical techniques with the next mechanical or technological advance until the United States had a music it could call its own.

The deepest roots of jazz and blues were the ancestors of the people who lived in the cities and on plantations in southern states. Colonization and slavery brought Europeans and Africans together who had almost opposite musical backgrounds. Aspects of African culture were limited by varying degrees in different states, and African musical traditions persevered most strongly in the southern colonies. Portugal enslaved African workers as early as the 1400s to work on their own plantations in Europe, and began shipping slaves to colonies in Brazil in the 1500s. Soon the New World was home to a network of plantations with slaves harvesting sugar, coffee, tobacco, and cotton for Caribbean and South American colonies owned by Portugal, Spain (Cuba), Britain (Barbados and Jamaica), and France (Saint Domingue, now called Haiti). African musical styles stewed south of the area that would become the United States until 1619 when the first slaves were shipped to Jamestown, Virginia. Colonization and slavery produced undeniably adverse effects, tearing apart the fabric of African society, family, and tribal identity. But the world we inhabit today reaps the benefits of those cultural by-products. The paradox is impossible to avoid: without hundreds of years of slavery, jazz and blues would not exist.

MUSIC IN EUROPE

Europeans from England and the British Isles, the Netherlands, Portugal, Spain, and France colonized the Americas, bringing their own musical traditions to the New World in social gatherings, churches, and concert settings; and infusing the young American musical culture with a number of musical characteristics. They established a kind of European baseline for the development of music in the New World. As masters of European art music emerged and produced major works in the 1700s and 1800s—the symphonies and operas of German masters Wolfgang Amadeus Mozart, Franz Joseph Haydn, and Ludwig van Beethoven—European musicians immigrated to America, taught American musicians, and set standards of excellence for professional musicians. Trumpets, clarinets, oboes, pianos, and other European orchestra instruments became standard in America. Art music and musical theatre productions were performed at concert halls in American cities like New Orleans and New York City. Musicians became adept readers, interpreting printed musical

notation on sheet music for a growing number of professional settings. Reading music was an important part of public education, church, and other aspects of American life. Instrumentalists and singers developed technical facility to a level that prepared even the supporting members of an orchestral string or woodwind section to be able to perform virtuosic solo music. The **virtuoso**—such as celebrity violinist Niccolo Paganini and pianist Franz Liszt—pushed the limits of musical accomplishment in Europe and motivated American musicians to keep moving forward.

European folk and religious music also lent traits to the music of America. British folk music traditions included the ballad and the fiddle tune. **Ballads** were informal storytelling songs that were sung across the British colonies. Like we hear in African music and other folk music styles from across the globe, many of the ballad melodies used pentatonic scales. Also a common thread with African music, the ballad singing style was more casual than the art music performed in concert halls. Although we should be careful not to draw a parallel with the blue notes and other melodic characteristics that make African melody impossible to properly write on sheet music, ballad singers also approached melody with flexibility, bent pitches, subtle melodic embellishment, and somewhat dirty timbres. Folk singing styles may have laid the groundwork for the two cultures to make connections in America. The violin was prevalent among rural American communities. Settlers played **hoedowns** on their fiddles for dancing. Hoedowns were derived from reels and hornpipes—dance music forms of the British Isles. Irish jigs, Scottish schottisches (a possible antecedent to the swing rhythm), and central European waltzes also would have been performed at parties. The best dance fiddlers were able to produce a diverse array of rhythmic feels to satisfy the partygoers. In the days of slavery, it was not uncommon for a Negro slave to provide the entertainment on the fiddle. Several writers noticed that African Americans seemed to have a natural ability for developing musical skill on the fiddle.

European religious tradition lent America a great deal of its early music. American Protestant churches carried a tradition of singing from Europe that involved "calling out" each line of a song just before the congregation sang it. This practice, carried on in absence of printed hymnals, represented an Anglo form of call and response. In this case, however, the response was a repetition of the call instead of the answer to a question. As we will see, blacks were educated by white churches and enthusiastically learned these hymns, incorporating them into their musical traditions. African American slaves would have been exposed to all of these settings where European-American music was made. They were often among the most talented performers of these styles. For example, plantation owners were known to have hired violinists to entertain guests at their parties. In various ways, African Americans rearranged well-known songs and personalized them with musical characteristics from their culture.

MUSIC IN AFRICA

Africa is itself a diverse land with national borders obscured by crisscrossing tribal regions and kingdoms. To generalize the music of these peoples is to ignore the panoply of musical characteristics special to each one. However, we can draw a number of conclusions by connecting the African

Virtuoso—Any musician who transcends the accepted norms of technical mastery.

Ballad—A storytelling song.

Hoedown—Dance tunes created in early America and related to the dance songs of the British Isles. The songs are most often played in duple meter.

regions from which the slaves were taken to the American colonies where their music managed to take root. Slaves were primarily taken from nations on the west coast of the African continent—Senegal, Guinea, Sierra Leone, Liberia, Ghana, Togo, Benin, Nigeria, and Angola to the south. West coast inhabitants belonged to tribes named the Fon, Yoruba, Fulani, Ashanti, Mandingo, and several others. Each group of people had its own music with unique features, but music that the first African Americans brought with them eventually merged into an American music with subtler differences. Several African characteristics are hard to miss in today's American music.

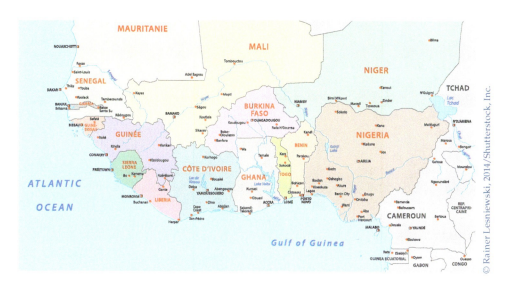

© Rainer Lesniewski, 2014/Shutterstock, Inc.

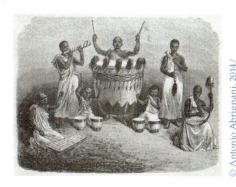

© Antonio Abrignani, 2014/Shutterstock, Inc.

Perhaps the most striking feature of African music is its rhythmic complexity. Where European musical styles are dominated by melody and driven by harmonic intricacy, African music is dominated by rhythm. African music often employs refined **polyrhythms**—a layering of multiple contrasting rhythms. Polyrhythm is a specific kind of **syncopation**. While syncopation can refer to any rhythm that pulls against the basic pulse or emphasizes rhythms that land off the beat, polyrhythms are rhythmic patterns that conflict with each other over extended periods of time.

Polyrhythm—A rhythmic texture constructed of two or more contrasting rhythms.

Listen to the recording of "Ghana—African Drums Conga Drums and Bongos" and notice the rhythmic sophistication. The piece has a meter of twelve quick beats per measure. Since the number **12** can be divided into two, three, four, or six, it is possible to create polyrhythms with several contrasting pulses. One group of players feels four pulses per measure, and another group feels three slower pulses per measure. See the diagram below. In both example #1 and #2, the drum playing the notes on the top staff accents (>) the first of every three eighth notes, resulting in four pulses in the measure. This is the common thread as the track progresses. The bottom two parts shift the pulse underneath from example #1 to #2. The

middle drum plays six beats in the first, then four in the next. The bottom drum plays six beats, then it moves to a rhythm of three pulses. This is only a snapshot of the complex rhythms you will hear throughout the track.

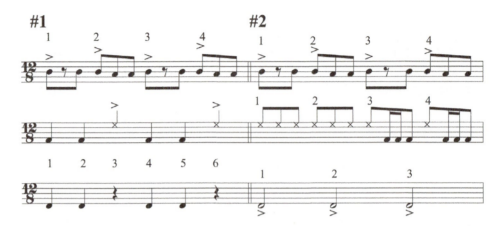

Having addressed rhythm, let's take a look at the African approach to the musical element of *pitch*. The African approach to melody and harmony is totally different from the music of Europe. Harmony is either nonexistent or typically *static* (meaning that it stays in one place) in African music, and is mainly relegated to secondary singing parts that move up and down with the main melody, much like the background singing heard in American R & B. Melodies tend to be simple. Instead of the 7-note scales used in the European diatonic system of music, African melodies are most often constructed from **pentatonic scales**. Pentatonic scales are made of only five ("pent-") tones, and can be configured in a number of ways. Have a look at the musical keyboard:

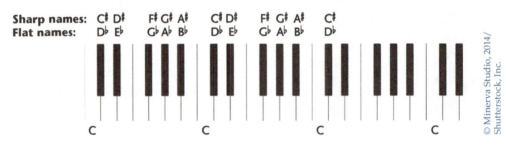

In each octave (between C and C) there are five black keys. Starting on any black key and playing consecutive black keys moving up or down, a pentatonic scale will sound. Notice that the scale has wider spaces between D#/F# and A#/C#. These differences in space give the scale its character and a major or minor quality. The blues scale—which makes up the bulk of blues melodies and improvisations—may have derived from the minor pentatonic scale. Add just one pitch between the F and G, a half step from each at F#, to change a C minor pentatonic scale (C, Eb, F, G, Bb) to a C blues scale (C, Eb, F, F#, G, Bb).

The foundation and formal structure of African songs are often based on an ostinato. An **ostinato** is a rhythm or melody that is repeated for an extended period. The ostinato can occur in one or several instruments. In "Ghana—African Drums Conga Drums and Bongos," the part notated on

Ostinato—A melodic or rhythmic pattern that is repeated over an extended duration, forming a background character for the performance.

the top staff of both #1 and #2 (above) is the ostinato. At the same time the ostinato gives a sense of unity to the composition and it creates tension with the other conflicting parts. In the 20th century and today, repeated melodies and bass lines have been the driving force of soul, blues, and nearly all popular music.

Africans used a variety of instruments, many of which have nearly parallel relationships to orchestral instruments found in Europe and the United States—the string, wind, and percussion families. What distinguishes African instruments is that they are most often handmade instruments, built from material and objects found in the musician's environment.

Talking drum

These homemade instruments are often elaborately decorated with carved designs and painted patterns. Also the tones produced on the instruments are unique. African timbres tend to mimic natural and vocal sounds, not clean and pure. Wind instruments create human cries and shouts, and drums are literally used to communicate ideas between people. The **talking drum** is one of few drums that is able to change pitches and produce melody. The drummer hits the drum with an elbow stick by pointing the flat tip directly at the drumhead, making the pitch of the drum more pronounced. The performer holds the hourglass shaped drum under his arm and squeezes the cords that extend from the top head to the bottom head. Squeezing the drum raises the pitch and letting go lowers it, making the drum capable of mimicking subtle pitch variations in human speech.

Talking drum player

Just as rhythm dominates African music, the dominant instruments used are the percussion instruments that communicate only with rhythm. **Membranophones** are the drum family of instruments with a kind of skin, or *membrane*, stretched across the body of the instrument. The membranophone creates sound when struck on its membrane. Most membranophones are not designed to produce a definite pitch.

African membranophones

Ideophones make sound when the body of the instrument itself is struck. Pitched keyboard percussion instruments such as the xylophone, shakers, and bells are common ideophones.

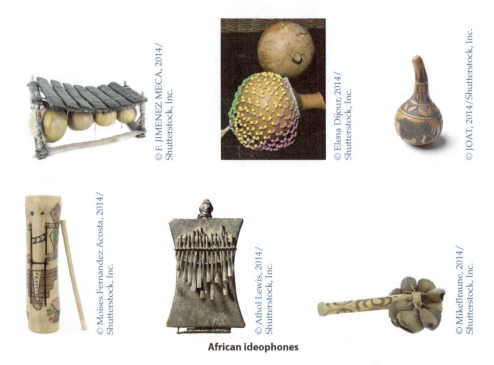

African ideophones

Chordophones are stringed instruments such as the violin and guitar, and are commonplace in African societies. West Africans played an early version of the banjo and continued the practice as American slaves. African banjos (called *banjar* or *bania*) had bodies made of a hollow gourd and were strung with a material made from animal intestines. In America, the banjo became a metal-stringed instrument with a plastic head stretched across its metal body. Variations of a harp-like instrument called *kora* are widespread.

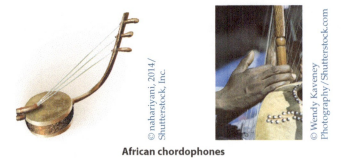

African chordophones

Aerophones are wind instruments, producing sound when air is blown into or across the instrument. Africa has several kinds of trumpet-like and flute-like instruments.

African aerophones

In contrast to European music, African music is not written down on paper. Instead, pieces are passed from person to person and generation to generation through an oral tradition. A new musician learns his parts by listening to the veterans play them, and relies on the memory to preserve the song. This is often called "learning by rote," and can still be observed today in musical settings that are primarily African-American. Black gospel choirs often learn their music by rote. A music leader sings the soprano part; the sopranos repeat until they have mastered the part, then the leader does the same with altos, tenors, and basses. The same is true for the blues and rock and roll. It is rare for blues bands to read music from paper. Although reading music notation is a more time-effective method of learning music, memorization often results in greater interaction and unity among the performers. The repetitive forms of blues, rock, and African styles also lend themselves to the rote method.

Improvisation and Interaction

African music creates a great deal of energy positioning repetitive patterns against unpredictable improvisations. Improvisation occurs in a number of ways, but most obvious are the drum solos the **master drummer** plays over the ostinato. The improvising soloist embarks on a series of rhythmic explorations on a high-pitched drum, and signals changes in tempo and meter to the full group. A great deal of interaction takes place in the form of **call and response**, where the leader plays a rhythmic phrase and the full group answers with a planned rhythm. Call and response can show up in many forms—in formalized back-and-forth rhythmic dialog, in short, musical reactions from backing musicians, or in vocalized hollers from onlookers. Examples of vocal music may provide an important root of the blues. As we covered in Chapter 1, most blues lyrics follow an AAB formula. The second line is a repeat of the first. This harkens back to the African practices of responsorial singing, where a solo lead singer alternates phrases with a group chorus. The group will often repeat and emphasize a line sung by the soloist, resulting in the form ABB where the second line is repeated. Rearranged in responsorial form, the song "Jingle Bells" would be sung like this:

Soloist: *Jingle bells, jingle bells, jingle all the way,*
Soloist: *Oh what fun it is to ride in a one horse open sleigh!*
Chorus: *Oh what fun it is to ride in a one horse open sleigh!*

Simply changing the repeat scheme to AAB, repeating the "Jingle bells" line instead, results in AAB blues form:

A: *Jingle bells, jingle bells, jingle all the way,*
A: *Jingle bells, jingle bells, jingle all the way,*
B: *Oh what fun it is to ride in a one-horse open sleigh!*

It's not far-fetched to speculate that the first blues singers, whose names are now long forgotten, may have been repeating a lyric line in their solo performances to maintain the chorus's response function, a practice carried from Africa through the period of American slavery.

The Role of Music in Africa

In African societies of the 1600s, music accompanied just about every significant event in life. Various accounts of music from regions across western Africa attest to the importance of music. Specific songs or types of music were performed for a range of ceremonial and casual activities that included childbirth, marriage, death, hunting, work, battle, and all kinds of royal functions. Africans held the professional bard in high esteem—a singer whose job it was to preserve the people's history. Bards were called *jillikea* in regions inhabited by Mandingo people, and **griots** in Senegal and Gambia.

The **work song** illustrates a significant shift in the aesthetic of African music as it crossed the Atlantic. Work songs were often sung in Africa to coordinate the workers into a rhythm of movement and to celebrate the benefits resulting from hard work. Agriculture and construction involve a great deal of hard labor, often done under a hot sun. But a song reminding the worker about the villagers who will appreciate the food produced and shelter built can lighten the load. In the Americas, however, work songs took on a solemn tone. Celebration turned to grief when the outcome of slaves' hard work benefitted their owners. In America, work songs became mournful and sometimes directed thinly veiled protests at their white bosses.

African musical performances are collaborative and communal. Dance is such an integral component of the performance that it seems to be blended into one dance-music art form. In one form of Senegalese percussion music, African musical performers encourage a great deal of participation from their audiences with stomping, clapping, singing, and dancing. The boundary between performer and audience is much more blurred than in the European concert setting, where applause and other noises are relegated to the pauses between musical pieces. In Africa the audience makes sounds that become part of the musical piece, much like in the stadium rock concerts in the United States today where clapping hands and screams of the audience feed the energy of the performance. Sound is also closely linked with dance. Musicians themselves often move together in lock-step choreography, and several dancers often join the musicians in more elaborate group dance moves and individual improvisations.

Drumming in Senegal—The Author's Account

Years ago, I had the opportunity to experience the music of Senegal firsthand. I worked as a musician on a small cruise ship that spent most of its time in Europe. In October, we began to cross the Atlantic headed for the Caribbean, but our last stop on the way out was the harbor of Dakar, Senegal. We briefly walked in the city. I bought a handmade djembe from a street vendor, but the most exciting brush with Senegalese culture happened on the ship. A professional drumming group was invited to perform for the passengers during our normal cocktail hour.

A group of around 30 participants was dressed in colorful robe-like garbs in green and white. The men carried big and small drums slung over their shoulders with a strap, mainly played with the palms of their hands. The master drummer held a small drum with one hand and a stick in the other. The women were dressed more beautifully than the men, and they did not play instruments. They were the singers and the main dancers. But everybody danced! The men lifted their heavy drums moving back and forth while they played, sometimes spinning around. Women danced the most intricate group dance, and at times a solo dancer would step forward and improvise wildly. This was an athletic music-dance performance. Strength, dexterity, and agility were highly developed. The visual component alone demonstrated a sophisticated and intense art form.

But the sound and progression of the music was what struck me most. Watching from my perch one deck above the floorshow (and sitting with my new African drum, hands outstretched on the shaved antelope skin, feeling like a spy as I did my best to commit to memory the complex rhythmic language), I was engulfed by the sounds of pounding hollow drums, stamping unison feet, and joyful melodies and shouts. All of these elements combined to create a palpable kind of nervous energy grounded in a base groove.

The master drummer was a true leader. He directed traffic and issued verbal and rhythmic signals that caused the group to change gears to a new tempo or a new piece altogether. Rhythmic grooves were deep, closer to the feeling of the great R&B or salsa bands than the ostinatos played in orchestras and more European-style percussion ensemble pieces I had performed. The various hand drums created a dialog between low-pitched groups and high-pitched groups, and the master drummer with his piercing hand-held drum improvised constant drum solos that never got old.

The performance followed a pattern. The master drummer would direct the group to start a particular pattern often by playing the first half of a singular phrase (*bi dip dip dip di dip dip* . . .) then answered by the men on their big drums (*bah dum dum*). It seemed that the master drummer's phrase was code for the name of the song ("play #2!") and the group drummers acknowledged with their *bah dum dum*. This would launch the group drummers into the agreed upon piece, locked into its new tempo, and the master drummer began improvising almost immediately while dancers added the visual aspect.

This went on for several pieces. Each time the master drummer was ready to make a change, he might yell something to get everyone's attention, play the signal rhythm, then the group would change tempo and ostinato on a dime. For me the experience was too brief, but unforgettable. When I play music today and the music allows it, I still channel what I saw that day into my own improvisation and groove. I'm sure I barely scratch the surface of the depth and complexity of the rhythms played by those Senegalese drummers, but that sound has enriched my own walking soundtrack with diverse and joyful sounds.

When you listen to the recordings of African music in this chapter's playlist, my hope is that you can imagine what I saw, that the excitement of the visual aspect and the overwhelming power of the music will add new dimensions to what you hear on Rhapsody.

SLAVE SONGS IN THE NEW WORLD

When Africans were forced to immigrate to the New World, they held onto many of their musical traditions but also assimilated the music that surrounded them. Even through the ugly business of the slave trade, the

violence they encountered, the separation from families, and the loss of many of their musical instruments, African Americans kept making music. Much of that music was Anglo-American in origin. [Eileen Southern's *The Music of Black Americans: A History* is a treasure trove of reporting on musical activities before the development of the blues.] Several accounts from northern and southern colonies describe African enthusiasm for singing and exceeding talent for instrumental music, particularly for fiddle playing. Much of that music also reverberated with some of the aspects of the African sound. Slaves were permitted regular days of leisure. They observed yearly holidays such as the celebrations around Christmas and Easter, special African American holidays, Pinkster Day spring celebrations, and Lection Day, where they chose governors and put on a parade with fifes and drums. Slave music was still rhythmically alive and syncopated, improvised, and mainly pentatonic. It was strongly associated with movement and dance, and the functional song forms—such as the work song—were maintained. The oral distribution and preservation of the Africans' music—rather than by musical notation—likely saved it, since it is unlikely that songbooks would have made it across the Atlantic in slave ships.

But a number of things certainly were lost. Much of the unique musical flavor of each separate culture in Africa, from Senegal to Ghana or Nigeria, would have been homogenized into a somewhat uniform southern, African American sound when slave traders put slaves in groups without regard for tribal allegiances or geography. Surely, not all the differences were erased, but African music became much more "same" in America. Also, musical instruments were left in Africa. Drums were outlawed in some colonies because they were known to have the ability to send messages from one slave group to another. Most notorious was the Stono Slave Rebellion, where slave groups marched carrying banners that read "Liberty" and played drums.

Other instruments survived. Slaves typically made their own instruments, and stringed instruments seem to have taken precedence. Homemade violins were prevalent (some slave owners also purchased violins for slaves who could entertain at social functions), and a commonly made instrument was something like a banjo with a body made of a hollow gourd.

The first slaves arrived on American shores in 1619. At this time, the nature of slavery was not a lifetime prospect. Rather, slaves were freed after a specified amount of time. But America crept toward a system in which slaves were eventually bought and sold into a life of captivity. Slaves made up an overwhelming portion of the American population—the first U.S. census in 1790 counted a population of 3,893,635 with nearly 700,000 listed as slaves, or about 20%. Some regions had populations with considerably more blacks. More than 50% of the 10,000 people living in Charleston, South Carolina, were black slaves.

Early accounts of the black workers' behavior in the colonies describe them as being very musical, with singing accompanying a range of activities. Scholars have collected songs into a few specific forms that foreshadow the sound of the blues. **Field hollers** were improvised cries that reflected the solitude of the lonely worker. Individuals regularly sang while they worked, often rising melodic lines in *melismatic* style—moving between multiple pitches per syllable. The monophonic cries sometimes joined with other singers, often a good distance away. Field hollers typically floated

Field holler—A solo song improvised by a worker in free tempo.

free of any regular rhythmic pulse. The recording of "Arwhoolie (Cornfield Holler)" was made in Mississippi after 1935, long after the advent of blues, so it is impossible to determine whether this song shows the influence of blues, or vice versa. But based on written accounts of hollers heard in the pre-blues South, this recording seems representative of the form, an ancestor of the blues. **Work songs**, like the ones sung in Africa, were group songs built from call and response. A lead worker issued the call and established the melody and pace of the song and then the full group of workers answered him with a repeated phrase. The steady pulse felt throughout the song was meant to coordinate the movements of workers. Vocal harmonies erupt spontaneously in "Rosie (Big Leg Rosie)," and the basic melody pivots between just two pitches—the 1st and 3rd pitches often emphasized in blues songs, as well.

> **Work song**—A musical genre performed by groups of African-American slaves and sharecroppers to coordinate their work.

RELIGIOUS MUSICAL ACTIVITY

Large numbers of African American slaves converted to Christianity and began attending white Protestant churches as well as forming their own. The Christian evangelical mission was a powerful incentive for whites to mingle with blacks. This mingling led the church to provide the backdrop for the earliest known musical fusion of Anglo- and Afro-musical traditions. Slaves were brought into white protestant churches, and some slave owners brought ministers onto plantation grounds. A huge number of conversions were reported from camp meetings during the *Great Revival* (also called the "Second Awakening") between the years of 1800 and about 1830. Religious activity surged at this time with thousands of people gathering in wide-open spaces to worship with singing. At Cane Ridge in Kentucky (1801) a camp meeting lasted six days, involved several preachers, and emphasized an outpouring of spiritual manifestations such as loud cries and shouts, uncontrollable laughter, and frenzied movement resulting in collapse. A great deal of interaction occurred between Afro- and Anglo-Americans at these camp meetings, exposing each group to the others' customs and musical styles. This presents a chicken-or-the-egg scenario where one must ask, "who influenced whom?" But certainly the Great Revival presents us with a vivid picture of how cross-pollination could take place between African and European musical developments. The **spiritual** is a religious song form that resulted from this cross-pollination—of white American choral songs and African American musical characteristics.

> **Spiritual**—A sacred song form that originated from the blending of white American choral singing and African-American musical characteristics.

As early as the 1700s, white reverends wrote about the pride they experienced watching African Americans singing from Protestant hymnals and singing in harmony. They created their own musical versions of Christian songs in celebratory shouts that incorporated dancing and singing. These shouts developed into songs that were eventually published, most famously in the 1867 book, *Slave Songs of the United States.* Several of these songs became standard sacred repertoire sung by whites, but were most deeply preserved by blacks. Some of the popular spirituals were based on Bible stories about Moses and the deliverance of the Israelite slaves from the hands of the Egyptians, as well as other Biblical characters who fought battles and were rewarded by a merciful God. It's no wonder how African American slaves could identify with deliverance stories, given their

captivity in America. Spirituals provided an outlet by which African Americans could express their immediate yearnings. A song about a journey to Jerusalem or Jericho could literally be a coded message about locations of meetings at other plantations or of escape to the North.

Fisk University was established in Nashville, Tennessee after the Civil War to educate the throngs of newly-freed black people and to help them rise to the challenge and responsibility of living as free Americans. The Fisk Jubilee Singers were the great cultural export of that university. The student choir was charged with raising funds to support the college, and through their performances across America and in Europe they preserved and spread the sound of the Negro spiritual.

Characteristics of Negro Spirituals

Spirituals point to the convergence of white and black musical characteristics. Lyrics are constructed via call and response using short repetitive phrases. The lyrics of the spiritual famously quoted by Dr. Martin Luther King in his "I Have a Dream" speech illustrate this African connection. See an early version of the song below:

Chorus: *Free at last, free at last,*
I thank God I'm free at last;
Free at last, free at last,
I thank God I'm free at last.

Verse:	*'O Way down yonder in the graveyard walk,*	[soloist or section]
	I thank God I'm free at last,	[full choir]
	Me and my Jesus goin' to meet and talk,	[soloist or section]
	I thank God I'm free at last,	[full choir]

Verse: *On a my knees when the light pass'd by,*
I thank God I'm free at last,
Tho't my soul would rise and fly,
I thank God I'm free at last,

Verse: *Some of these mornings, bright and fair,*
I thank God I'm free at last,
Goin' meet King Jesus in the air,
I thank God I'm free at last.

Notice the repetition of the phrase "free at last" throughout the chorus and verses of the song. Call and response is evident in each verse. The first line might be sung by a solo singer or one section of the group, either men or women, then the full group would sing the response "I thank God I'm free at last." Also, the message of the song presents us with coded messages that appeared in African American folk styles. The lyrics describe episodes in a personal relationship with Christ, leading to salvation and the soul's eventual escape to "the air." The song's hook embeds an obvious double meaning that spoke to the Negro experience—freedom from the captivity of slavery and all its ugliness and dehumanization. Dr. King brought the dual meaning into the 20th century in 1964, when he evoked the Negro spiritual to inspire freedom from segregation.

Some of the same musical characteristics evident in secular slave songs (work songs and field hollers) appear in these spirituals. The melody of "Free at Last" is not constructed of the exact blues scale described in Chapter 2, but the song's major scale does dip into the blues sound on its highest pitch, the lowered 7th. Looking forward to jazz theory, this set of pitches (major scale with a lowered 7th) is called the *mixolydian* mode. The melody also emphasizes notes found in a pentatonic scale; again, not by exactly conforming to the 5-note pitch set, but only briefly meandering to non-pentatonic pitches. (Remember, the major pentatonic scale uses the 1, 2, 3, 5, and 6 scale degrees of the typical major scale).

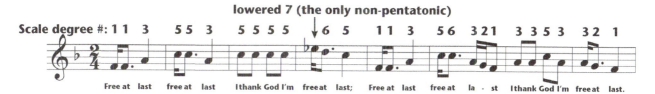

Ring Shout

Another expression of religious fervor was the **ring shout**. Often after church services or in mid-week praise nights, dancers (called "shouters") formed a circle and moved around with a walking-dance often described as a "shuffle step." Separated from the dancers (called "shouters") often along the outer walls of the room, a group of singers clapped, stomped their feet, slapped their thighs, and sang religious songs with great passion for hours on end. The singers (joined to some extent by the shouters) repeated the refrains of spirituals, and tempo and volume were known to increase gradually to a fever pitch. The dancing and music began slow and relaxed but gradually worked its way into a frenzy. Dancers were known to move faster and faster with increasingly wild movements until they collapsed, sometimes replaced by another dancer. In some cases a solo dancer stood in the middle of the ring and danced until she dropped to the ground from exhaustion. The ring shout was widespread in the colonies in various forms, and appeared in both religious and secular settings.

RECONSTRUCTION

Slavery continued in the United States until 1865 when, after the closing of the American Civil War, the 13th Amendment to the Constitution was ratified. This opened a period of transition in the relationship between blacks and whites in the South, and the relationship between the former Confederacy vs. the Federal government. Southern states enacted a series of laws called **black codes**. These laws extended from black code laws that had governed the behavior of slaves, and were enacted to maintain control over the newly freed blacks, essentially replacing the slave laws with a new system that limited African Americans' freedom without enslaving them. The codes created a conflict between state law and national law when Congress passed the Civil Rights Act of 1866, granting citizenship and legal equality to every person born in the United States. The Civil Rights Act was not ratified by the states until two years later. African Americans strongly resisted

Black codes—A variety of laws enacted in the United States during the Reconstruction period limiting the actions of Black Americans.

these black codes, and a series of riots across the South enflamed support in the North for protections for former slaves. Although the Reconstruction set important precedents for black freedom and opportunities (such as equal access to public education), the era came to a close with the election of 1877, when leaders of the Reconstruction agreed to halt their political actions if their presidential candidate Republican Rutherford B. Hayes could be granted the presidency.

Through the Reconstruction and the period that followed, the blacks that stayed in the South had to find work. The most common industry for African Americans at the time was to continue the trade they had toiled at throughout slavery—agricultural work. A new system called "**sharecropping**" replaced slavery. White landowners needed laborers to work their land, to plant, and bring in the harvest. They could not do it themselves, so they made agreements with blacks designed to mutually benefit landowners and workers. Landowners would supply seed, farming equipment, and a place to sleep, and would be in charge of selling the crops; black laborers would take care of the physical labor. Potentially, this provided a chance for blacks to stand on their own two feet, receiving a share of the revenue. In reality, the system heavily favored the landowners, who were also in charge of the bookkeeping. Any expenses incurred by the workers—food, clothing, and equipment—were charged against their earnings, and in a lean year the harvest might not bring in enough money to cover the debt. Even if profits were good, a dishonest landowner could "cook the books" to keep the workers' family in debt. Also, some plantations paid the workers in special currency that could only be spent at stores on or near the grounds. This made it difficult for workers to leave and find another plantation if they were unsatisfied with their employer.

For many of the blacks who stayed behind in the South after the Civil War, the end of slavery meant a new kind of misery that hearkened back to the feudalistic societies of middle-age Europe, where serfs lived in economic captivity working the fields of their lords. Reconstruction was only a small step forward in the immediate lives of southern African Americans. The black musical tradition, full of sorrow and yearning, would continue to be fed by depression for the next several decades as the people continued to live under institutionalized racism. The work song, the field holler, and the spiritual would still be heard into the early 20th century where African American song evolved into new musical forms—blues, ragtime, black musical theater, and jazz.

MINSTRELSY

The minstrel show was a strange and enduring institution of American theatrical entertainment from the mid-19th century that provided some of America's first original popular music at the same time that it proliferated racial stereotypes.

Listen to "De Boatmen's Dance" in the playlist for this chapter. The modern-day recording recreates the sound of minstrel show music. Several of the musical elements we find in jazz and blues were already brewing about half a century earlier. The rhythms are syncopated and bouncy. The banjo, tambourine, and bones (a dry "clackety-clack" sound) play the role of an early rhythm section. These joyful instrumental sounds shaded

minstrel music with a bright optimism not unlike the swing jazz of the 1940s. But packaged with the spirited melodies and bouncy rhythms, were lyrics and images that grossly mischaracterized African Americans.

Minstrelsy developed in the mid-1800s as a kind of variety show that could include any manner of musical numbers, dances, and comic sketches. Each scene was its own short act, so that a full evening's show transported the audience through several different songs, topics, and performance media. The central ingredient of a minstrel show was the ridicule of aspects of African American life and persona. White performers exaggerated the dark hues of Negro skin by performing in **blackface,** applying jet black makeup that was often made of burnt cork. They spoke with exaggerated Negro accents, poked fun at naivety and just plain clumsy mishaps of different "types" of Negroes whom the audience-member might encounter in a trip to a southern plantation. Negroes were characterized in these plays as being foolish, exotic, animalistic, deceitful, idiotic, pompous, immoral, and, above all, hilarious. Two main caricatures used since the early days of minstrelsy stayed with American racial vernacular as racial code words. Zip Coon was a city Negro who wore a striped tuxedo and tried but failed to fit in with upscale urban life. Jim Crow was the bumbling, foolish country plantation fool.

The Christy Minstrels formed in the 1840s and performed on Broadway in New York City for several years, standardizing the format of the genre. The first act of a typical minstrel show included several musical performers on stage with prescribed roles. An *interlocutor* led the proceedings and dressed in formal clothes. A fiddle player and banjo player stood in the middle of a semicircle formed by the other players. Extending from one side of the musicians were tambourine players (called Mr. Tambo), and on the other were the bones players (Mr. Bones). The bones were actual rib bones from an animal, held in pairs and rattled together to create a sound not unlike Spanish castanets or spoons played in Ireland. This group of instruments constituted one of the first rhythm sections in professional American music.

The fiddle and banjo represent two interesting crossroads in American music. The fiddle is actually the same instrument as the European violin, but played in a completely different manner from its use in classical music. The American version grew from the party music of the British Isles. Jigs and reels of the English, Scottish, Welsh, and Irish were played more forcefully and with less vibrato than in classical violin. Long before minstrelsy, some of the best violinists were said to be African Americans. Talented slaves were sometimes asked by their plantation owners to play for entertainment at their parties. So the American tradition of violin represented an early intersection of Euro and Afro musical styles. The banjo, the other principal instrument of minstrelsy, has even more striking beginnings. Though it became associated throughout the 20th century with bluegrass and folk rock music, it originated in Africa. As early as the 1820s, a white musician named Joel Sweeney learned to play the banjo from slaves in Virginia, starting a trend that eventually landed on the minstrel stage. Sweeney is said to have designed the modern banjo, with early models being made of wood and calfskin.

Minstrel Show Songwriters

Minstrel shows were so popular during the middle decades of the 19th century that a large number of companies sprung up to meet the demand for entertainment across the country. This meant employment for actors, musicians, and composers of songs called "Ethiopian songs" or "coon songs." One of the United States' first important composers, **Stephen Foster**, had many of his famous songs performed at minstrel shows. Songs like "Oh! Susanna" and "Camptown Races" evoked southern Negro dialect in their lyrics, even though Foster had barely set foot in the South. Oddly enough, Foster was a northerner whose only trip to the South was to New Orleans in 1852.

Stephen Foster

© Stocksnapper, 2014/Shutterstock, Inc.

Other notable minstrel show composers were **Daniel Emmett** (who composed "Dixie," which later became the theme song of the Confederate States of the U.S.) and **James Bland**, a black songwriter.

Ironically, after the American Civil War when slaves were freed and left to find a livelihood, minstrelsy could be a successful career path for many African Americans. Black minstrel shows cropped up around the country, and often, black performers even performed in blackface themselves!

The minstrel show trivialized the American Negro experience and institutionalized an image of black America that would prevail in media several decades after the end of minstrelsy's heyday. Honest portrayals in the media would be the exception rather than the rule until the civil rights era a century later. Later, popular films like *The Jazz Singer* (1927, the first full-length talking film) and even Disney cartoons used blackface for light entertainment.

Pianola, or a "player piano"

© Ronald Caswell, 2014/Shutterstock, Inc.

RAGTIME

By the time jazz's closest antecedent arrived, African Americans had for many decades contributed to the music of America by changing features of well-known songs and styles to fit their sensibility. Famous music became ultra-syncopated by black dance bands and solo performers across the continent. In ragtime, this custom of personalization became a dominant sound, a thing that could be identified, published, and incorporated into the next musical styles to come, and eventually a craze.

During the last decades of the 19th century, ragtime music was primarily performed on piano in an improvised and informal manner without the aid of written music. When African Americans were freed at the close of the Civil War, many of them

purchased small organs or pianos for their homes. Soon, black performers were playing the music for public entertainment in restaurants and bars. Before piano rags were written out on paper and published, the sound of ragtime emerged in popular songs used in minstrel shows and in instrumental dance band music. Rhythmic vitality is the most distinctive feature of ragtime (short for "ragged time," a characterization of its syncopated melodies). The bubbly groove is produced by a kind of tension between the steady pulse played by the left hand in the low register and constant syncopation in the right hand's high notes. The left hand seems to mimic the *boom chick boom chick* of stamping feet or bass drum and cymbal, while the right hand channels the obstinate drive of banjo patterns. The same kind of rhythmic clash would be evident a few decades later in country blues and early jazz recordings.

Specifically, the right hand thrives on a special kind of syncopation called **hemiola**, a rhythm that crosses over the basic pulse by accenting every three subdivisions instead of every two. This is also called a 3:2 cross rhythm because it layers a three-grouping over the established two-grouping.

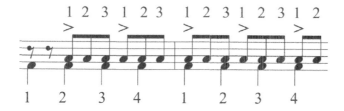

This sound reaches all the way back to the days before the Civil War, when slaves danced to jigs played on banjos and fiddles. The syncopated right hand echoes the instrumental melody played a century earlier, while the left hand bass mimics the clapping hands and stomping feet. A dance called the **cakewalk** was often performed on plantations to this pre-rag music. In a cakewalk, couples competed for a prize cake. In some plantations the couples danced with pails of water on their heads. The couple with the most water left in their pails won the prize. Cakewalks emerged in popular entertainment as a featured act in minstrel shows, and its accompanying music was syncopated piano music (not yet called "ragtime"). This music staked its claim on the American musical landscape at large when the cakewalk dance became a nationwide craze, participated by whites and blacks alike. Cakewalk music soon became big business for music publishing companies that published and distributed the music as sheet music in the 1890s.

The burgeoning American appetite for ragtime sheet music was linked at the hip with a piano-manufacturing boom that occurred around the turn of the century. American companies were creating some of the world's finest pianos (chief among them was the Steinway Company in New York). American pianos were exported abroad and sold to American concert venues and homes. From 1890 to 1900, the number of pianos produced doubled (from 72,000 to 171,000) and again in 1910 (to 374,000). The piano was becoming a commonplace article of middle class homes, a movement that had occurred a century earlier in Europe. Regular folks were learning to play music at keyboard instruments. Along with the European classical piano repertoire, ragtime was showing up in home musical

libraries everywhere. The music expanded its reach and transformed its aesthetic from an off-the-cuff downtown vernacular to a contemporary classical format, primed for middle-class living room entertainment.

Universal Exposition in Paris

Composers found a lucrative market for ragtime music, and (as was the case for W. C. Handy's orchestra and the blues) marching band conductors like the eminent John Philip Sousa began incorporating rag into the wind band format. This instrumental music found its way to Europe at the dawn of the 20th century when John Philip Sousa's band performed a cakewalk at the Universal Exposition in Paris, spreading the influence of ragtime to composers like Claude Debussy who would incorporate ragtime into their palate of ideas for composition (listen to Debussy's "Golliwog's Cakewalk.")

Marches and piano rags evidently traded a number of ideas. Many ragtime songs were written in the form of a typical march. Each letter in the standard diagram below stands for a melodic strain of (most often) 16 measures.

AA BB A CC

In ragtime form, a couple of prominent themes alternate (the As and Bs) until a completely new section called a "Trio" takes over (Cs). This form is complex compared with cyclical structures like blues and most common song forms. The rag form was not carried into the blues, but many of the tunes performed by 1910s and '20s jazz bands were rags.

Scott Joplin

Of all the professional composers of ragtime music in the early 1900s, **Scott Joplin** created the most enduring works and deserves much credit for elevating the casual music to a level of artistry approaching the great European composers. His well-crafted melodies, variety of textures, and harmonic progressions indicate a composer of great logic and understanding of classical conventions of composition. Joplin was called the "King of

Scott Joplin

Ragtime," largely because of the popularity of his "Maple Leaf Rag." To this day, "Maple Leaf Rag" and "The Entertainer" are the go-to piano ragtime pieces. Joplin is recognized as an icon today largely because of a resurgence of his work in 1973, when the seven-time Oscar-winning film *The Sting* caused a return of ragtime music to popular culture with its soundtrack of Joplin's rags arranged for band.

But Scott Joplin was clearly interested in leaving behind a legacy of musical artistic accomplishments far more than worldwide celebrity. Joplin was a working musician and a serious composer. Growing up in Texarkana, Texas, his early musical training with private instructors gave him great respect for the European concert tradition. He moved to St. Louis in 1885 or '87 (sources disagree), working in the saloons and trying his hand at composition with some light songs and piano pieces. In 1894 he arrived in the major industrial center and railroad hub of Sedalia, Missouri. Joplin was an active member of Sedalia's music and entertainment scene, singing in a double quartet, performing on piano in dance orchestras, and playing solo piano at dances, bordellos, and black social clubs. One of these clubs was called the Maple Leaf Club, the setting of his breakthrough song and the namesake of the hit that would jumpstart his career. Local publisher John Stark heard Joplin play "Maple Leaf Rag" and made a deal to publish the piece for monthly royalties. Soon after the sheet music was distributed, "Maple Leaf Rag" became a ubiquitous American song and a piece every pianist of the time would play to show their mettle. Although sales figures are debated today, at the very least, the piece brought in enough money in royalties to partially support his endeavors through the rest of his life. The popularity of "Maple Leaf" also raised Joplin's public profile. He was beginning to be called the *King of Ragtime Writers,* and his fame generated enough royalties from sales of compositions like "Easy Winners" and "The Entertainer" that he could focus on composing as his chief means of income, rather than playing piano in saloons.

After the turn of the century, Joplin moved back to St. Louis and later to New York where he focused on composing serious music. He composed a couple of operas and a ballet, but these large-scale works would turn out to be his downfall. Joplin experienced significant financial losses on the tour of *A Guest of Honor,* and to make matters worse the musical score and *libretto* (the opera's story) disappeared. He set opera aside, redirecting his efforts on ragtime. It was around this time that Joplin demonstrated concern that his rags were being played too quickly and, we can infer, in a manner that obscured the compositional genius of his works with a flashy, athletic approach. Although the origins of ragtime were in an improvised and casual style, Joplin's music elevated the piano form with a high degree of intricacy, using shifts in texture throughout a piece, strong bass lines, and effective countermelodies. Joplin may have been bothered at the sound of these elements when the tempo became too fast. Whether or not this is

true, Joplin's tempo indication reveals that he was a meticulous composer who wished to garner respect for his art.

Music Analysis

"Maple Leaf Rag"
Piano roll created 1916
Composer: Scott Joplin
Performer: Scott Joplin, piano roll
Form: Modified march form **[AA BB A CC DD]**

Although this piano roll recording gives us a somewhat genuine example of ragtime in the way Scott Joplin conceived it, the performance was not entirely under his control. At this point in his life, Joplin was not at the top of his game. His health affected his coordination to a point that, when early jazz and ragtime musician Eubie Blake heard Joplin perform, Blake was saddened by the sharp decline in his skills, likening the performance to something a child might produce. It was possible to edit a piano roll, however, so a technician would have taken Joplin's performance with the tiny holes cut into the roll and fixed any mistakes or inconsistencies for public consumption, not unlike today's recording engineers' ability to use computer software to wipe away out of tune singing and rhythmic errors. It is also unlikely that Joplin played "Maple Leaf Rag" this fast. In the later years of his life, he cautioned performers against playing his pieces too fast. The brisk tempo of this recording probably does not reflect the composer's wishes.

Get to know the melodies of this rag and try to find brief moments where Joplin improvises. He plays the opening A sections as composed, almost exactly between the first and second A sections. Note the strain added to the end of typical march form (D). In the C and D sections, Joplin becomes freer with improvisation, occasionally moving his right hand to higher pitches and improvises connecting bass lines.

0:00	**A theme:** the main theme. Note the driving pulse from the low notes of the piano. Right hand plays the memorable melody that crosses over the beat in groups of three eighth notes, a **hemiola**.
0:22:	Repeat of the **A** theme.
0:44	**B theme:** right hand rises to a higher register.
1:06:	Repeat of the **B** theme.
1:27:	Return of the **A** theme.
1:48	**C theme:** Joplin's piano roll speeds up slightly and the right hand plays a rhythm that would later be known as the "Charleston."
2:09:	Repeat of the **C** theme.
2:30:	The **D** theme is a bit calmer than the previous material.
2:50:	Repeat of the **D** theme.

Nearly a decade later he poured his energy into a second opera, *Treemonisha*, almost right up until the end of his life. It is a stretch to label *Treemonisha* a ragtime opera. Joplin essentially reserved his use of ragtime elements for events and characters that could benefit from a racial underscoring. Otherwise, the music is most at home in traditional opera, showing the influence of Richard Wagner and other standard operatic composers. The opera's score combined ragtime syncopation with European dramatic gestures, telling an African American story with a fusion of musical styles. He also wrote the *libretto*, or text, of the opera. Joplin set his opera on a secluded plantation in Arkansas across the border from his boyhood home in Texarkana, Texas. The story is one of African American nobility through education and self-reliance, a theme close to Joplin's heart that may have been autobiographical to some extent. Joplin worked tirelessly on the

music, but could not find a publisher to distribute his piano score or sufficient financial backing for a full production of the opera. He attempted to mount a production in Atlantic City, New Jersey, but the performance fell through. Joplin continued the work alone. He worked to revise the opera and eventually he rented a hall in Harlem for a private one-night show, playing the orchestra's parts at the piano. The one-and-only staging of the opera failed to attract enough attention for a follow-up production. He died in New York a few years later, succumbing to syphilis. He was a financial failure, and largely forgotten by a public whose interest in ragtime was waning. He had made a lot of progress toward his grand idea of elevating ragtime beyond its barrelhouse origins, but his culminating operatic works were hidden from view during his lifetime.

But Joplin's work has been appreciated after his death. Along with a resurgence of traditional jazz (or Dixieland) in the 1940s, ragtime music found public appreciation both in band forms and on the piano. *Treemonisha* was resuscitated in the 1970s and performed in a number of locations in the United States, winning Scott Joplin a Pulitzer Prize in 1976. His contributions to jazz and American classical music—for "Maple Leaf Rag" and his more ambitious works—are central to the curriculum of music studied in American university systems. And, largely because of Joplin, ragtime is considered by many to be among the most important American contributions to the world's art music. Further, ragtime's influence can be felt in just about every American musical style from jazz and blues to electronic dance music and hip hop.

CONCLUSION

The wide range of musical traditions extant in America during the years leading up to jazz and blues' first appearances primed American society for completely new musical forms. Most of the music discussed in this chapter was heavily derived from its ancestors in Europe and Africa. But blues and jazz (and to some extent, ragtime) represent a clear departure from earlier musical styles. The crossroads of the 20th century saw a deeper integration of the various cultures present in America, although not without incredible racial tension. The optimistic sounds of ragtime bands and piano-smiths filled the air with a bright outlook rooted in a rhythmic energy unmatched in other cultures. Jazz and blues were drawn from the sounds and traditions of spirituals, the slave songs and African American leisure music, dance music, songs of minstrelsy, and ragtime. But both jazz and blues would emerge from this musical soup to build entirely distinct traditions, and both would eventually reach out to affect new music styles across the globe.

Discussion Questions

1. Describe three forms of European music that influenced American music.

2. Name and define eight musical characteristics of African music.

3. Explain how the emotional content of the work song changed when Africans were transported to America, and how that change affected the development of the blues.

4. Minstrelsy is a controversial theatric genre. Did minstrelsy result in a net gain or loss for race relations in America? Why? Give specific examples.

5. Which musical elements of Scott Joplin's ragtime were most influential to jazz and blues?

PART II

Early Blues
(From the Beginning to the 1930s)

Birth of the Blues and Classic "Vaudeville" Blues

In this chapter, we will cover:

- Understanding blues aesthetic
- Earliest appearances of blues in history
- W. C. Handy's contribution
- Classic "Vaudeville" blues singers: Mamie Smith, Ma Rainey, and Bessie Smith

Sometime between the Civil War and the dawn of the 20th century, the blues sprung up in African American communities in the South. At its core, the blues preserves and delivers the story of the African American experience. In this way, it is essentially a *folk music* style. It developed as a casual, informal musical style played for an audience of peers, not necessarily for the consumption of the outside world. It is important to keep this function of the music in mind as we compare it to other musical styles. Think about the 19th century musical styles we covered in Chapter 3. Ragtime, according to Scott Joplin's conception, was art music meant to elevate the American music tradition to the level of artistry reached by European classical music. However, in addition to its *art music* function, it took on the *popular music* (or "pop music") function as throngs of Americans bought ragtime sheet music to perform in their homes and the music was played by dance orchestras across the country. Blues music has worn the "pop" and the "art" hats at different points in its history, but all of that is secondary to its origin as folk music, a people's music.

UNDERSTANDING THE BLUES AESTHETIC

In Chapter 1 we studied how blues music is constructed and how it is performed. We covered its unique approach to melody, harmony, and lyrics. All of these specific musical aspects connect strongly to early African American musical styles covered in Chapter 3, particularly slave songs and religious music, and they reach back further to diverse traditions of music made in Africa. In addition to these specific elements, the blues is connected to its ancestral musical forms through a couple of non-musical aspects that speak to the aesthetic of the blues.

First is the emotional content of the blues. Stemming from the downtrodden condition of African American laborers in the post-slavery South, the blues communicates an intense and complicated brew of solitude, loss, and resilience despite inhumane circumstances. Although the common topics covered by blues performers have changed over the course of decades, emotional intensity and depth are always present in blues songs and performers who make contributions to the genre. Slavery changed the emotional content of the African work song from a joyous celebration of the benefits of hard work to a painful exploration of strife and injustice. Newly freed share-croppers of the late 1800s still found themselves with their backs against a wall, and their songs illustrate their will to stand up against oppression even through tears and pain. Even for groups of people who have not suffered as intensely as those African Americans, the blues relates at least through metaphor to the human condition. All humans suffer at one time or another, and the emotional content of the blues relates to everyone with a memory of suffering.

Second, the blues tells a story. Specific musical moments during improvisation are a result of the storytelling aspect of the blues. For example, great blues soloists like Albert Collins and B. B. King take their time in their guitar solos, entering and exiting with phrases that seem to be timed randomly and leaving space between these gestures. This organic approach is often compared to the rhythms of human speech. Jazz soloists, for that matter, often take a similar approach. The legendary Texas bluesman Lightnin' Hopkins was known to change from one chord to the next whenever he felt like it, sometimes leaving his backing bassists in the dust. These "random" gestures have the effect of teasing the audience, bringing them in to the fold with a conversational style. Compared with the European classical music of Mozart and Beethoven (who had other means of communicating impactful ideas through their music), this improvisational approach is difficult to analyze and finding logic in these solos can be difficult. But the logic in these gestural solos is in the story they tell. Think about the last good story someone told you. Rarely is a story told in a perfectly logical progression, in a rhythm that moves along in a steady beat. Instead, great storytellers build excitement with a variety of phrase lengths and melodies. They may stutter, and they may pause for effect or by accident. The pitch of the storyteller's voice rises and falls with the drama of the story. Blues performers—whether purposefully or not—mimic these and other storytelling traits. Every improviser has a different personality, a different way of telling the story. Stevie Ray Vaughan would let loose a barrage of incredible phrases on his guitar, but Albert Collins (who influenced Vaughan) tended to leave space and walk a tightrope with surprising musical ideas.

These non-musical aspects of the blues—the emotional content and the storytelling approach—are essential parts of any blues performance. Both are created through the manipulation of specific musical elements like rhythm, melody, and volume. Like all great music, the effect is visceral and can be understood by musicians and non-musicians alike. While the blues changed over the course of the 20th century, these aspects still guide the newest reinventions of the genre. To understand how the blues works today, it is imperative to look into its earliest recorded history.

FIRST APPEARANCES OF THE BLUES

Several explanations have been offered why the word "blues" came to describe this African American music. The word "blues" has stood for an emotional state of melancholia or feeling low-spirited for centuries, in literature and in typical English parlance. Theories have even been posited that the term may be connected to a West African death ritual carried over to American and Caribbean plantations where they harvested the indigo plant. In their funeral ceremonies, mourners dyed their clothes blue with indigo to symbolize suffering. Ma Rainey claimed to have been the first to label the music "the blues" after she was introduced

Indigo plant

© N NGUYEN, 2014/Shutterstock, Inc.

to the music in 1902 in a small Missouri town when she performed with a touring show. She heard a girl from town singing a "poignant" song about a man leaving her. Rainey learned the girl's song and began singing it in her show as an encore. The song became a staple of her show, and when fans asked her about it, she told them, "It's the *Blues.*"

Did Ma Rainey invent the blues? Absolutely not, even though she was one of the first singers to record it. Even Rainey reported to have picked up the style from a nameless townsperson. Like most musical styles, there is no way to identify the very first inventor of the blues. No documentary film-maker or journalist stood in the room. So the earliest known accounts were told sometime after its inception. Most of those early accounts of the blues come from the **Mississippi Delta** region—a land of fertile soil and hard agricultural work. The specific region of the Mississippi Delta is the plain surrounded by the Yazoo and Mississippi rivers. The Delta includes cities like Clarksburg and Vicksburg where important moments in blues history took place, and cities that lie just outside the geographic border of the Delta (such as Memphis, Tennessee) also made important contributions to the genre. Here are a couple of the earliest appearances of the blues in history.

Harvard's Hired Hands

In May of 1901 an archaeologist from Harvard, Charles Peabody, excavated Native American burial mounds of the Choctaw tribe in the Mississippi Delta. One of these mounds was on a plantation in Clarksdale (later the home of blues legend Muddy Waters). Peabody was not looking for indigenous southern music, but he found it. He hired African American workers from Clarksdale to excavate. While they worked, they sang songs. Peabody saw cultural value in the music he heard and recorded his findings in an article called "Notes on Negro Music" for the *Journal of American Folk-Lore*. His description of the Negro music has several elements in common with the Delta blues.

He heard different kinds of songs, sacred and secular, Methodist hymns and ragtime. Peabody mentioned the use of the guitar to accompany some of the singing. Like the blues, the harmonies were simple and used only three chords. Peabody mentioned strange manipulation of the pitch, which might have been the blue notes we hear in the blues.

The lyrics dealt with "hard luck tales" and "love themes." The lyrics he heard had the same mixture of the downtrodden, the comic, and the irreverent as the blues we know today. Here are a few examples:

"They had me arrested for murder
and I never harmed a man."

"The reason I loves my baby so, 'Cause
when she gets five dollars she give me fo'."

"Some folks say preachers won't steal;
But I found two in my cornfield
One with a shovel and t'other with a hoe,
A'diggin' up my taters row by row."

Peabody told stories about a particular old male performer who was employed at a plantation owned by John Stovall in Stovall, Mississippi. This would have been the same plantation where Muddy Waters lived as a sharecropper and recorded for Alan Lomax decades later. Charles Peabody focused on the strangeness of his singer's sound as if he was listening to something foreign or alien. He compared the sound to "a bagpipe played pianissimo," "not far from Japanese." The meaning of the music seemed to him "to throw off their sorrows in song."

He wrote about a woman he heard singing a baby to sleep. He was impressed by her beautiful voice but, again, in a way that seemed other-worldly—"weird in interval and strange in rhythm; peculiarly beautiful." He compared it to Greek singing. It was common among those who first reported on the blues to describe the music as "strange" or "alien."

Peabody described the singers' tendency to pronounce words with a lack of consonant sounds. Today's listeners will notice in recordings of early blues singers the deep southern accent that lessens the pronunciation of consonants but thrives on the vowel sound. To the listener accustomed to classical singing (and probably to Peabody himself), the blues singing style comes across as unclear and unpolished.

Peabody also hinted at a primacy of rhythm instead of melody, linking the syncopation he heard to ragtime. He described their style of improvisation in detail: "Improvising sometimes occurred in the general class, but it was more likely to be merely a variation of some one sentiment." From his description of men's voices, the quality of sound was mediocre but the tempo was impressive, indicating rhythmic strength. This is not surprising. If we judge the blues singing sound from a strictly European classical perspective, the technique would be described as "mediocre."

Charles Peabody's description of the music he heard in "Notes on Negro Music" could easily apply to 1920s and '30s recordings of the music of Charley Patton, Robert Johnson, or even Muddy Waters from the '40s. From Peabody's account in 1901, we can draw the conclusion that the blues was already a part of African American life at the beginning of the 20th century, and that its sound had a great deal in common with the earliest blues singers recorded in the 1920s. His account also points to more questions. Did the blues "spring up" at the dawn of the 20th century? Of course not. The development of the blues must have stretched years back into the 1800s, but how far? Peabody's report of these songs performed while digging in burial mounds also provides us with a strong link backward into the work songs of the days of slavery, and even further backward to Africa.

W. C. HANDY

Our second major account of the early blues comes from the first of many controversial figures. **William Christopher "W. C." Handy's** autobiography is titled *Father of the Blues*. We know that he did not *father* the blues, but he did play an indispensable role in bringing the music from its southern cradle to the world. Handy, a musically trained performer and bandleader, deserves credit for being one of the first people to compose and publish the blues, to write it down on paper in a form that could be distributed. Handy built the blues into an international commodity, shipping it across county and state lines in sheet music form, and eventually spreading the music across continents. Before Handy's entrepreneurial hands took hold of the blues, the music was only passed from person-to-person by word of mouth. Handy also redesigned the blues so that it could be performed not just by singers with simple accompaniment, but by any instrument group. Because of Handy, blues compositions were written for dance bands,

W. C. Handy

marching bands, and pianists. The sound of the blues developed into something new because of these changes. Here is how Handy claimed in his autobiography to have discovered the blues:

In 1903, W. C. Handy accepted a job directing a dance orchestra called Mississippi's Knights of Pythias in Clarksdale, Mississippi. In a railroad station in Tutweiler he was waiting for a train that had been delayed for nine hours. He awoke from a nap to the sound of a guitar being played with a knife pressed on the strings, creating a sound that he compared to Hawaiian music. The Negro guitarist sang the same line three times "Goin' where the southern cross the dog."

Handy found the music remarkable, saying that he couldn't forget the "weirdest" music he had ever heard. But he was not yet ready to incorporate it into the sound of his commercial orchestra. It was later when his group performed at a dance in Cleveland, Mississippi, that he saw the music's value. At the dance, the audience convinced Handy to let a local group of musicians get up and play a few songs. The trio played guitar, mandolin, and bass music that sounded similar to the "monotonous" sounds he heard at the Tutweiler train station. Not initially impressed by the music, he changed his tune when the crowd began throwing large amounts of money at the performers' feet. Handy, excited by the commercial potential of the music, wrote arrangements for several plantation songs within the next couple of days and programmed them in his orchestra's sets.

From that moment on, the blues would make W. C. Handy one of the most important, popular and prolific songwriters. He wrote his first big hit for E. H. Crump's mayoral campaign. His "Mr. Crump" became "Memphis Blues" after the campaign. "Memphis Blues"—one of the first blues compositions—was wildly popular. But Handy sold the rights to the song for very little money. Determined to make a business of the blues, he rented a room in the Beale Street district and began writing a new song. "St. Louis Blues" went on to become one of the most performed and recorded songs in history.

"St. Louis Blues"

"St. Louis Blues" is a pop song that uses several elements of traditional blues. W. C. Handy was far more versed in popular dance music styles than he was in the blues, so it's not surprising that his blues song borrows a number of features from contemporary pòp music. The form of "St. Louis Blues" is a hybrid of blues and pop. Instead of a 12-bar strand that repeats indefinitely, "St. Louis Blues" has a series of two 12-bar sections, a 16-bar bridge in the minor mode ("St. Louis woman, with her diamond rings"), and a chorus ("Got the St. Louis Blues just as blue as I can be"). All of this is sometimes preceded by an introduction.

The 12-bar blues sections open with a dominant 7th chord (a brave step into the blues for the pop music of its time). The melody pulls the piece strongly into blues territory, rampant with blue notes and pivoting on the lowered or minor third. The 16-bar bridge moves completely into the minor sound, and incorporates a Latin-flavored habanera rhythm which cleverly links the song to another popular style of the day. The chorus's melody lands the piece solidly in the blues, using the minor and major third in succession. This "flexible" third is perhaps the most obvious hallmark of the blues, a complete departure from the ragtime-based pop music of the day. It seems Handy's goal may have been to take his audience gradually into the blues. Instead of diving head first into the unfamiliar waters of the blues, listeners get a chance to stick their toe in first.

Handy's blues lived on to become an enormous hit, and now a treasured historical artifact of American music. It has been performed by Bessie Smith, Billie Holiday, Louis Armstrong, Nat King Cole, Stevie Wonder, Herbie Hancock, Dave Brubeck, and arranged by Bob Brookmeyer for the Thad Jones/Mel Lewis Orchestra.

Soon he moved his operation to New York City, where the blues became big business. He advertised his own arrival in *The Billboard*, reminding the public that the composer of "Memphis Blues" and "St. Louis Blues" was now in town. After he arrived in New York the number of pop blues songs and recordings grew rapidly. But this was no traditional blues. While the country blues continued to develop as its own genre, it was largely confined to the South. The style spawned by W. C. Handy borrowed heavily from the harmonic and melodic character of the blues with plenty of lowered thirds, but it retained enough of the aesthetic and musical characteristics of pop music that the mainstream public adopted it. Most of his songs used the 12-bar blues form as only part of a more complicated form, often alongside 16-bar sections more akin to ballads and dance forms. The songs became a vehicle for a group of primarily female pop singers performing in the Vaudeville theater circuit, and his new genre has since been labeled "Classic Blues" or "Vaudeville Blues."

CLASSIC "VAUDEVILLE" BLUES SINGERS

W. C. Handy's new musical genre presents us with a clear convergence of blues and jazz. Unlike traditional country blues singers who accompanied themselves on guitars, classic blues singers were usually accompanied by a full band including rhythm section and horns. Several of the sidemen—or backup musicians—hired to play these sessions were important jazz artists. The list of Bessie Smith's sidemen alone reads like a who's who of early jazz: Louis Armstrong, Fletcher Henderson, Coleman Hawkins, Jack Teagarden, and Benny Goodman. On these recordings, the jazz rhythm section played behind the singer, while a soloist often filled in the spaces between melodic statements. Some songs left an entire chorus of solo space for a jazz soloist to leave his mark.

Characteristics of Classic "Vaudeville" Blues
- Female singer
- Accompanied by instrumental group
- Theatrical singing style
- Blues form combined with popular song forms

In 1920, **Mamie Smith** and her Jazz Hounds (possibly including the famous stride pianist Willie "The Lion" Smith on piano) made the first recording of an African American singing blues. "Crazy Blues" startled the recording industry when the OKeh label sold 75,000 copies within the first month of the song's release, and more than one million within a year. Record companies saw potential for big sales to a new market. When Okeh and other record companies discovered that African Americans had purchased a large number of those million copies, they immediately began scouting for more black female singers to replicate the success of Mamie Smith. These and other records by black performers for black consumption began to be sold as a more general label—**race records**.

Prior to "Crazy Blues," Mamie Smith's background was light on blues training and apprenticeship. Like many of the other famous classic female blues singers, Mamie Smith worked as a touring entertainer with Vaudeville companies, and sang in Harlem night clubs. She would have sung

Music Analysis

"Crazy Blues"
(1920)
Personnel: Mamie Smith, vocals; Johnny Dunn, cornet; Dope Andrews, trombone; Ernest Elliott, clarinet; Leroy Parker, violin; Willie "The Lion" Smith or Perry Bradford, piano

Musical Details:
With impressive sales figures, "Crazy Blues" opened the floodgates for blues recordings by black artists.

The band plays an early Chicago jazz style with collective improvisation throughout the track, although some passages sound pre-composed. The trombone seems to take the lead with definitive chord roots and walking bass lines. Piano stays in the background with simple chords played mostly on the beat.

Mamie Smith's Vaudeville theatre-style delivery—wide vibrato, belting high notes—is tinged with hints of bending blue notes. The form is typical of blues songs composed by Tin Pan Alley-style pop songwriters, using the 12-bar blues only as a middle section of a larger form. This form switches back and forth between 16-bar and 12-bar sections.

0:00	**Intro:**	Teeter-tottering ragtime pattern in the horns is dominated by tailgate trombone glissandi.
0:09	**Section 1:**	This 16-bar section is not a blues chorus. It lacks the opening blues chord movement from the I to the IV. Instead, the blues sound is in the melody. Mamie Smith subtly bends the first note up to a major 3rd, and on the lyric "... man I love ... " she slides downward.
0:46	**Section 2:**	The 12-bar blues arrives.
1:14	**Section 3:**	Another 16-bar section and the arrival of the chorus.
1:49	**Section 4:**	12-bar blues—The trombone doubles the voice on hard quarter notes walking upward.
2:16	**Section 5:**	12-bar blues—same as Section 4.
2:42	**Section 6:**	16-bar chorus (same as Section 3).
3:14	**Brief ending:**	The cornet plays triplets descending chromatically followed by two final chords.

very little blues music, except songs that were written by professional Tin Pan Alley song writers. "Crazy Blues" is no exception. Its melody contains just a few blue notes, and Smith sings it straight, without any additional blues inflections. Her brilliant voice is more akin to the belting, theatrical singing style of Vaudeville than the classic blues singers that followed. Like "St. Louis Blues," the form of "Crazy Blues" only inserts 12-bar blues as a chorus surrounded by other sections drawn from the Tin Pan Alley playbook. Still, Mamie Smith's song opened the door for black females to sing and sell the blues, and it created a broader precedent by demonstrating the potential for large profits in race records. Over the course of her career, she was labeled "Queen of the Blues" touring the United States and Europe, releasing several other influential recordings, and appearing in films.

Mother of the Blues

One of the first beneficiaries of Mamie Smith's breakthrough was **Gertrude "Ma" Rainey**. Rainey grew up in Georgia and heard country blues as a child. In fact Rainey told one of history's first accounts of the appearance of the blues, having discovered it in a small Missouri town in 1902. The song she heard became a signature song in Rainey's act, along with other blues songs. After marrying William "Pa" Rainey in 1904, she took the name "Ma" and the two became a package deal in the entertainment world.

Music Analysis

"Black Eye Blues, Take 1"
(1928)
Personnel: Ma Rainey, voice; Georgia Tom Dorsey, piano; Tampa Red, guitar

This performance is one of many examples of songs recorded in the 1920s with "blues" in the title, but which did not use the blues form. Still, Rainey sings plenty of blues thirds in her melody, and lyrics portray a witty strength characteristic of the blues. Her backing musicians were a remarkable pair of men who made important contributions to American music in their own right. Tom Dorsey would later be named the "Father of Gospel Music," and Tampa Red became a major player in the development of country blues.

Rainey was one of the first female performers to integrate the blues into variety shows along with other styles, earning her the title "Mother of the Blues." Particularly influential were her early recordings for Paramount in 1923 of songs like "See See Rider," "Ma Rainey's Black Bottom," and several others.

Rainey was able to achieve a singing style on her blues songs that sounded authentic. Her voice was dark and husky. In "Jealous Hearted Blues," and "New Boweavil Blues," she demonstrates a knack for bending her way up the scale to a long holler on a held pitch, then slurring strongly away from it. Sometimes she sings so strongly that her tone audibly breaks up. The sound is almost masculine. In many of her recordings, she was supported by a band of important jazz musicians of the day—Louis Armstrong, Fletcher Henderson, and Coleman Hawkins.

Empress of the Blues

In 1912, Rainey was touring with the Moses Stokes Company when **Bessie Smith** joined the group as a dancer. It is unclear whether Rainey mentored or competed against young Bessie Smith while the two worked for the same company. Whatever their relationship, Bessie Smith must have benefited from watching Rainey's striking blues performances. Though her voice sounded less husky than Rainey's, both singers tended to holler their long notes loudly. Both singers had command of blue notes, and both singers chose a repertoire that mixed the straight blues about lost love with sexy double entendre ("Need a Little Sugar in My Bowl").

Bessie Smith had a tough young life. Growing up in Chattanooga, Tennessee, she lost both of her parents before the age of ten. Around that time, her older brother Clarence joined the Moses Stokes Company, the same company that would provide Bessie's early professional work. In 1923, the same year "Ma" Rainey" first recorded, Smith

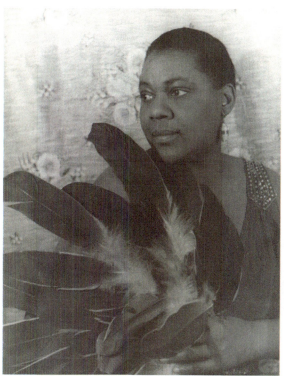

Bessie Smith

was recorded by Columbia. "Down Hearted Blues" and "Gulf Coast Blues" sold 780,000 copies. She sold more than four million records in the next few years, catapulting her into stardom and earning her title "Empress of the Blues." Her expressive quality was unmatched by any other singer in the 1920s. She was featured in the film *St. Louis Blues* in 1929, and her career moved along with successful recordings and live performances until the mid 1930s when swing music took the spotlight as the most popular musical style.

Music Analysis

"St. Louis Blues"
(1925)
Personnel: Bessie Smith, voice; Louis Armstrong, cornet; Fred Longshaw, organ

In W. C. Handy's "St. Louis Blues," Bessie Smith's control of pitch and blues inflection are on display. She has solid control of her voice, manipulating the vibrato on long notes, and growling the down-home blues scale on the final stanza, where the word "blues" works its way into the lyrics. The impact of her vocal style was summed up by one of her backing musicians, Louis Armstrong, who said, "She used to thrill me at all times, the way she could phrase a note with a certain something in her voice no other blues singer could get. She had music in her soul and felt everything she did. Her sincerity with her music was an inspiration." Note Armstrong's command of the blues when he fills in holes between Smith's vocal lines, while Fred Longshaw's organ persistently pumps the chords.

Bessie Smith's Death and Legacy

The circumstances of Smith's death are still a mystery today. She was badly injured in a car accident before dawn on September 26, 1937, near Clarksdale, Mississippi. Her driver ran into a truck on the trip from Memphis to a gig in Darling, Mississippi. In addition to serious internal injuries, Smith's arm was nearly torn from her body and she lost a great deal of blood. An ambulance picked her up, and that is where stories of the event diverge. A tale of racist neglect emerged—that Smith was turned away from a white hospital when her ambulance arrived there. This story feeds a narrative that blacks were criminally mistreated in the South. But several accounts contradict the story. Some claim that a black ambulance would never take Smith to a white hospital, particularly when the black hospital was within a half mile of the white hospital. Whatever the case, Smith's end was a tragic loss to female black artistry. Bessie Smith's popularity, strong performance skills, and unbridled independence paved the way for black female performers like Billie Holiday (whose popularity arrived on the heels of Smith's death). Her persona and fame created an archetype for the strong, black female entertainer in charge of her own destiny that would be emulated by marginalized peoples many decades to come.

Impact of the Classic Blues Singers

The female classic blues singers accomplished several things with their music. They were the first class of black musicians to create successful blues recordings, thereby pointing to a viable business model for the music

industry and a pathway to more recorded blues. Through live performance, they spread the sound and performance practice of the blues across the country, and encouraged the development of blues scenes in Memphis, the Mississippi Delta, Arkansas, Louisiana, Missouri, and elsewhere. By singing about all subjects, especially taboo subjects, they set the expectation for uncompromising truth in blues recordings. With their musicianship they set the expectation that all singers who would strive to repeat their success must continue the tradition of excellence in musical technique. They fearlessly presented a picture of female sexuality that would counteract the genteel avoidance of such subjects common to mainstream society at the time. And they elevated the image of the black woman in the popular American psyche. Young black women, or any person from an ethnic minority, could look at these singers and see the possibility for their own success.

Discussion Questions

1. After reading the various accounts of the earliest blues in this chapter, what can we infer about the origin of the blues? Where might it have been born, and what musical characteristics combined from other traditions to create the blues?

2. Debate: Was W. C. Handy's nickname "Father of the Blues" an appropriate one? Why or why not?

3. Listen to the tracks in this chapter by Mamie Smith, Ma Rainey, and Bessie Smith. Compare and contrast the three vocalists. How did each singer approach the blues style?

4. What stylistic features of W. C. Handy's "St. Louis Blues" may have caused it to become such an important standard of American popular song?

5. What musical elements are shared between Jazz and Classic "Vaudeville" Blues?

Country Blues

THE SHIFT FROM CLASSIC TO COUNTRY BLUES

In 1926 the commercial music industry shifted its attention toward country blues, a direct descendant of the prehistoric blues heard by W. C. Handy, Ma Rainey, and others who propagated the blues. This traditional format differed greatly from the classic blues of Bessie Smith. Classic blues singers were primarily female Vaudeville performers who incorporated blues as part of a broader stage act; the vast majority of country blues singers were men who performed a mixture of blues, religious songs, and other popular styles in a wide variety of settings. As itinerant performers, they traveled from town to town playing in juke joints (bars), neighborhood picnics and dances, and street corners. Where classic blues was accompanied by a full band, country blues singers accompanied themselves on their guitars. Of course, there are exceptions to this formula. Charley Patton sometimes performed with fiddler Harry "Son" Sims, with other guitarists Willie Brown and Son House, or with female pianist Louise Johnson. But the foundation of any country blues performance was the solo guitarist/singer. Because of the flexible nature of a solo performer accompanying him or herself, the form of a country blues song was less predictable than its band-accompanied counterpart. Country blues singers regularly added a measure or two, or sometimes just a couple of beats, to each chorus of 12-bar blues. In any given stanza they may add words to the composed verse, or jump early into a new line. When we listen today with ears accustomed to 12-bar blues form, we are kept on our toes by this improvisational approach to phrasing and form.

In this chapter, we will cover:

- recording industry shift from Classic to Country Blues
- contrast Classic vs. Country Blues
- Texas Blues Artists: **Blind Lemon Jefferson, Lead Belly**
- contrast Texas vs. Mississippi Delta Blues
- Mississippi Delta Blues Artists: **Charley Patton, Son House, Skip James,** and **Robert Johnson**

Characteristics of Country Blues

- Primarily male singers
- The only accompaniment is typically the singer's guitar
- Intimate singing style
- Simple, yet flexible 12-bar blues form

TEXAS BLUES

Blind Lemon Jefferson

Around the mid-1920s record companies intensified a search for down-home, rural blues performers. They sent their own scouts into the field of southern musical centers, and they accepted audition tapes from local private engineers who recorded would-be blues stars in their make-shift studios.

The record companies had been using marketing campaigns that connected to southern style, railroad work, and the laborer's soul to promote their rosters of urban Vaudeville-connected celebrities. In 1926, the first commercially successful recordings of the country blues style were made. **Blind Lemon Jefferson**, a Texas singer and guitarist, recorded religious songs and other folk material, but it was his blues songs like "Black Snake Moan" and "Matchbox Blues" that awakened the record companies to the possibility that down-home traditional blues could outsell classic blues. Blind Lemon Jefferson created a demand for country blues, and the record companies responded to this demand by searching for new talent in the South. Just like Mamie Smith created a business need for more classic blues singers in 1920 with "Crazy Blues," Blind Lemon Jefferson did the same in 1926 with his first recordings.

Blind Lemon Jefferson may have been blind since birth. He is one of a handful of blind blues musicians to have achieved success in country blues (Blind Willie Johnson, Blind Blake, Blind Willie McTell). It is likely that blind men were drawn to blues because other money-earning opportunities such as field labor were not available to them. For many blues stars the music provided a way to avoid poverty, and the blind would have been destined for an especially severe level of poverty without even the hope of earning the meager income of a sharecropper. Blind Lemon Jefferson was born near Wortham, Texas, and began his career playing various events in central Texas towns and cities around Waco and Dallas. In the mid-1910s, he settled in Dallas and performed in Deep Ellum, a commercial district that served African Americans and European immigrants. Here, he would have the chance to play for a larger, more diverse audience, and ultimately be discovered by talent scouts. A demo recording was sent to Paramount, and Jefferson was brought to Chicago in 1925 to record. After his first blues recordings were released in 1926, he continued to record and travel throughout the South, St. Louis, and Chicago until his death in 1929.

Jefferson is credited today as one of the fathers of Texas Blues and opened up the market for country blues recordings from Mississippi, Louisiana, Arkansas, Tennessee, and the rest of the South. He directly influenced fellow Texas bluesmen Leadbelly, T-Bone Walker, and Lightnin' Hopkins, who went on to influence B. B. King, Buddy Guy, Jimi Hendrix, Stevie Ray Vaughan, Kurt Cobain, and The Beatles.

Music Analysis

"Black Snake Moan"
(1926)
Personnel: Blind Lemon Jefferson, guitar/voice

Musical Details:

Jefferson's guitar part alternates between a basic country-style strumming pattern behind the vocal, and a single-string lick that sounds close to a jazz style of improvisation. Listen for the improvised single-string lines Jefferson plays on his guitar between each lyrical line. This is a clear example of call and response (singing answered by guitar).

The melody of each "A" phrase opens on a long high note and falls down a blues scale into the singer's lower register. The meaning of the double entendre lyrics becomes gradually more obvious with each passing verse.

Music Analysis *(continued)*

What is most striking about Jefferson's style is his use of single-string improvised lines in between each vocal line. His guitar part moves back and forth between a basic strumming pattern behind the vocal and breaking into licks that sound closer to jazz than the group of blues guitarists working in the nearby Delta, who showed their creativity with a variety of accompanimental textures.

0:00	**Introduction:** Solo guitar plays chords moving down by half-steps that arrive at the tonic (this lick appears just before every new verse), followed by a single-string line moving upward in triplets, then a series of notes played in swing rhythm, and settling on a basic country strumming pattern.
0:12	**Verse 1, line 1:** Guitar accompaniment rests or fades to the background for Jefferson's first phrase. The guitar then plays a swinging melody.
0:23	**Verse 1, line 2:** Guitar accompaniment again rests or fades during Jefferson's phrase, this time answering with a quirky triplet-based lick that falls into the next chord.
0:31	**Verse 1, line 3:** This time, Jefferson plays the answering guitar lick on the low strings that sounds similar to the introduction.
0:40	**Verse 2:** Voice and guitar continue the question/answer relationship with similar ideas. Sometimes exactly the same guitar lick happens from verse to verse. Other times there is variety.
1:08	**Verse 3**
1:39	**Verse 4:** This is the first verse that does not open with "aaaahhh" or "mmmmm." The guitar doubles the vocal melody more strongly, playing a tremolo with the first note of each phrase. Otherwise the guitar continues with the same character.
2:06	**Verse 5**
2:32	**Verse 6:** A new guitar lick—fast 16th notes high on the fretboard—signals the last verse. The song ends abruptly at the end of this verse.

Lead Belly (Huddie Ledbetter)

John and **Alan Lomax** were professional ethnomusicologists financed by the U.S. Library of Congress to archive American folk music by traveling around the country and recording the music they found. Their story figures strongly into the big picture of American folklore by shaping our understanding of local musical styles, and their activities helped build the careers of an impressive list of folk and blues musicians: Son House, Muddy Waters, and Fred McDowell. One of the Lomax's most important finds was a prisoner at the Louisiana State Penitentiary at Angola, **Huddie** (pronounced "Hyoo-dee") **Ledbetter**, who went by the name **Lead Belly**.

Lead Belly was born in Louisiana, but grew up in Texas. He toured the Dallas area with Blind Lemon Jefferson and learned to play the 12-string guitar, which became an important element of his sound. (The 12-string guitar doubles each of the six strings found on a typical guitar. Each additional string is pitched an octave above the original string.) Known for his short temper, Lead Belly was incarcerated at prisons in Texas, Louisiana, and New York for assault and murder. After the Lomaxes discovered him in the Louisiana prison, he eventually joined John in New York and became his driver (needing a job to support his parole). In New York, Lead Belly entered the most consequential phase of his career, becoming an active participant in the budding folk music scene around Greenwich Village.

His musical repertoire included far more than blues music. Although he was certainly a strong blues artist, Lead Belly became most famous for his spirituals and country-style ballad songs such as "Goodnight, Irene" and "Where Did You Sleep Last Night." He brought to light "Rock Island Line," which was later covered by British musicians who played *skiffle* music, a style that influenced the British incarnation of rock and roll. Lead Belly played a more direct role in spreading the blues overseas in 1949, as the first country blues singer to perform in France. This set a precedent for more blues artists like Lonnie Johnson and Big Bill Broonzy to take the blues to Great Britain and France, establishing a passionate audience for the blues in Europe that would heavily influence the young rock musicians. Just a decade later, the Beatles, Rolling Stones, the Who, and others would "invade" the United States with their own version of rock infused with American blues and would pay tribute to American blues musicians in the media.

The seminal recordings of Blind Lemon Jefferson and Lead Belly served as a springboard for the innovations of later bluesmen across the Lone Star State—T-Bone Walker, Lightnin' Hopkins, Albert Collins, brothers Johnny and Edgar Winter, and brothers Jimmy and Stevie Ray Vaughan.

MISSISSIPPI DELTA BLUES

The Mississippi Delta is home to its own enduring tradition of blues music. Great incentives encouraged blues musicians to hone their craft. A blues musician could pull together a good deal of work in juke joints and on street corners. One night's performance could yield several times more dollars than a day of field labor. The incredibly fertile soil of the Delta was not easy to work. The weather was hot and humid, and working conditions were terrible. One of the most egregious examples of oppression was Parchman farm, a prison that was once the home of blues legends Son House and Bukka White.

Parchman was no ordinary penitentiary. Prisoners were treated much like slaves had been treated on pre-Civil War plantations. The prison had no cell blocks, no prison walls, and no guard towers. The warden lived in a typical plantation mansion. Prisoners were expected to work the rich farmland of the plantation's 20,000 acres. A prisoner who misbehaved or failed to work properly was punished by one of the "trustees"—older convicts who were given benefits in exchange for keeping the other prisoners in line. Trustees often doled out corporal punishment using Black Annie, a three-foot-long leather strap. A prison's goal should not be to benefit the state financially; else the state will have an incentive to keep the prison full. But Parchman's prisoners generated more dollars for the state of Mississippi than any other source, besides the income from taxes. This is just a sample of the hard lives lived by the Mississippi poor. John Lee Hooker, who left the Mississippi Delta to begin his music career, said of the state: "I know why the best blues artists come from Mississippi. Because it's the worst state. You have the blues all right if you're down in Mississippi." Hooker's tough words reflect a dark sense of humor that tints even the most downtrodden blues lyrics. But his "worst state" award comes from a desperate truth. African Americans who lived in early-20th century Mississippi were accustomed to a life of intense suffering.

Characteristics of Mississippi Delta Blues

Suffering is a requisite element of the blues, so it stands to reason that Mississippi residents would have a handle on the emotional content that drives the art form. Mississippi Delta blues singing style was more emotionally drenched and sung with a grittier, or strained tone than its counterparts in Texas and other southern states. Listen to Charley Patton's voice in "Pony Blues," or Son House's "Death Letter Blues." They sing with the power of a preacher, with a vocal quality that would be judged far from proper by classical standards. This grit is not just a casual style of singing that ignores good technique; these singers manipulate their voices for maximum expressive effect. At first listen, Patton's voice in particular may strike the listener as "ugly," but with more open ears we can hear that he is pushing his voice to the point that he nearly produces multiple audible tones. Listen to recordings of post-WWII singer Howlin' Wolf to hear this technique perfected (with the benefit of the far-superior recording quality of Wolf's albums).

The guitar style in the Delta was grounded in repeated rhythmic figures that often contrasted the rhythms of the voice, creating complex cross rhythms. Texas guitar playing tended to sound more akin to country music of the day, with melodic picking and lightly swinging rhythms. Whereas Texas blues music was full of guitar solos of single melodic lines, the guitar played a different role in Delta blues. Delta guitarists crafted an accompaniment with prominent melodic hooks, introductions, brief riffs, and single lines that doubled the vocal melody. Delta guitarists are revered for their exploration of textures and sounds, and the intricate dialogue between the voice and the guitar accompaniment.

Delta blues guitarists also relied heavily on the **bottleneck slide guitar** technique, where they would put a cylinder of metal, plastic, or glass on a finger of their left hand and slide up and down the neck of the guitar, aggressively bending the pitch. A guitarist might actually fashion their own slide from the neck of a beer bottle. The slide produced a completely different sound than the player's fingers on the fret board.

These elements gave Mississippi Delta blues great staying power as it reappeared throughout history in new genres—Chicago blues, rhythm and blues, and rock and roll. It is also remarkable that the vast majority of blues giants were connected to the Delta—Robert Johnson, Charley Patton, Son House, John Lee Hooker, Muddy Waters, Howlin' Wolf, and B. B. King.

Charley Patton

If the most fruitful home of the blues was the Delta, then **Charley Patton** deserves his often-bestowed title of "Father of the Blues." Although there was at least a generation or two of blues artists before him, Patton's music was the first Delta blues music recorded commercially and his music and lifestyle influenced countless bluesmen and women who spread the music across the nation.

Patton developed a performance style of flamboyant showmanship and compelling musical skill at parties and juke joints in and around the Delta. Emitting from Patton's small frame, his gravelly voice could cut through the crowd noise of juke joints in a day when amplification was not yet commonplace. He was known for playing the guitar behind his head

and other acrobatics that would become tricks of the trade in the rock and roll era. Some of his contemporaries bemoaned his guitar playing, but recordings demonstrate his high level of artistry and technique. Just listen through the "hiss" and "pops" that disrupt the quality of any record from this age, to the wide variety of textures and sounds Patton used on "Pony Blues." His swift movement between bass lines and high register licks that sometimes double the voice, and the rhythmic tension between the basic pulse and the highly syncopated vocal melody all show a level of sophistication that continues to inspire blues artists today.

Music Analysis

"Pony Blues"
(1929)
Personnel: Charley Patton, guitar/voice

Musical details:

One of Patton's most popular songs, "Pony Blues," demonstrates many of his special characteristics. Note the rhythmic independence between the voice and guitar. Listen for Patton's foot stomping the pulse throughout. His guitar tends to play downbeat-based patterns while his voice is syncopated, arriving before the downbeat and stretching over it. Most vocal phrases end with a growling long vowel sound. Patton randomly drops and adds beats at phrase endings, resulting in a blues form that is always less or more than 12 bars. The tempo speeds up throughout the piece by about 30 beats per minute.

0:00	**Brief introduction:** Simple chords strummed on the guitar.
0:03	**Verse 1:** Patton plays a bass note on the guitar followed by a repeated blues lick on high strings with bent blue notes. -Vocal melody begins with wide leaps upward and downward, followed by smaller movement that settles on the tonic pitch.
0:37	**Verse 2:** Patton begins an octave higher than the first verse, doubled in the guitar by short eighth notes played one octave higher. -2nd phrase—guitar mirrors the voice on the low strings played on downbeats, then the low strings walk downward to the next chord.
1:06	**Verse 3:** same accompaniment as verse 2.
1:33	**Verse 4:** Guitar accompaniment is similar to verse 1, this time with a more energetic blues lick on the upper strings and at a much faster tempo.
2:02	**Verse 5:** like verse 2.
2:27	**Verse 6:** like verse 4. Patton ends the song on the guitar with sliding notes in the upper and middle range, then a quick bass walk-up to the fifth and a leap down to the tonic.

Charley Patton's childhood story was filled with episodes that were common to the lives of many blues artists. He was brought up in a sharecropping family on Dockery Farms near Cleveland, Mississippi. Although the identity of his birth parents is disputed, Patton probably descended from a mixture of black, white, and Native American ancestors. His father, Bill, was a hard worker and a sometimes preacher who shared a common belief that the guitar was the devil's instrument. He showed his disdain for Charley's chosen hobby at times through violent means, including a beating with a bullwhip. But Charley continued the sinful life of a musician— late night house parties, frequent drinking, loose women, and neglecting farm work. Charley renounced his own hedonistic lifestyle from time to

time, even taking up preaching for a time. Eventually, the call of the blues—and the road—won out. Patton began a kind of apprenticeship under an older bluesman named Henry Sloan, traveling with him from town to town and learning the craft.

It was a businessman named **H. C. Speir** who gave Charley Patton his big break and in many ways established a corridor through which the talent in the Delta could reach the world. Speir ran a recording business out of his Jackson, Mississippi music store. Speir's shop specialized in selling the records of black artists to primarily black clientele. He recorded blues musicians in his store, offering to record a demo for any aspiring artist who could pay a fee. At the same time, he served as a talent scout for established record labels in other parts of the country such as Paramount, Gennett, and OKeh. Speir deserves credit for exposing the world outside the Delta to an all-star list of blues artists—Charley Patton, Robert Johnson, Skip James, Tommy Johnson, Willie Brown, and Ishmon Bracey.

Charley Patton introduced himself to Speir with a simple letter advertising his skills. Speir soon travelled to Dockery Farms to meet him. The meeting went well, Patton delivered on his claims of musical greatness, and impressed Speir with his original songs. Speir arranged for Patton to make his first recordings for Gennett records in Indiana.

A Close Look at Patton's Music

At least a couple of remarkable characteristics are evident in Patton's first recordings. First, the dialogue between his voice and guitar is unmatched. Second, he tends to pair innocent-sounding melodies with lyrics on subjects that were certainly taboo, even offensive, to any listeners with a Victorian slant. He uses double entendres of sly sexual references in "Pony Blues." He uses a familiar signal for an affair with a married woman in "Banty Rooster Blues," setting a rooster at the back door to warn the couple that the woman's man might be coming home. He sings explicitly about trouble with the sheriff in "Tom Rushen Blues."

In "Spoonful Blues," he delivers a disturbing monologue on drug abuse. "Spoonful" is not actually a blues, at least in its musical form. A series of four chords repeats over and over, each with a flexible duration of between about four to seven beats. The chord progression creates a feverish kind of forward motion, over which Patton delivers a schizophrenic vocal performance. His perspective shifts every few lines from talking about various characters' need of a spoonful, to his own desire. Also notice, except the first line sung, he finishes every line with a missing word. "about a _____" "is a _____" The missing word is filled in with the guitar's two notes played with the slide. It's almost as if the guitar is filling in the blanks with the word "spoonful," no doubt a reference to an addictive substance. To make the already complex scene more convoluted, he speaks in between sung lines with braver admissions of guilt. The singing character is a bit careful with the subject, the guitar fills in the blanks, and the speaking character removes all doubt that he is afflicted. The listener is left with an impression of a man coming unglued because of his need for a _____.

Patton's musical depth did not end with these recordings. In recordings for Paramount, he performed "High Water Everywhere." The lyrics virtually take the form of a news report about the great Mississippi flood of 1927, the most devastating in America's history. The flood was caused by

huge amounts of rainfall on a region that was insufficiently protected by levees. The flood affected states up and down the Mississippi River, but Arkansas and Mississippi were among the worst hit with waters breaking through the levees in excess of the volume of Niagra falls. More than 600,000 residents lost their homes, and between 250 and 1000 died. The flood highlighted the country's racial divide when African Americans were rounded up at gunpoint to raise the levees, and many were swept away by the flood. African Americans migrated in droves to the north after the neglect they experienced in the relief efforts.

In Patton's two-part blues, his solid-as-a-rock guitar playing accompanies his extremely strained voice, making palpable the resident's panic and discontent. He beats on the hollow box of his guitar from time to time, enhancing the rocking groove underneath the tragic story. In part one, he takes the listener through his panicked thought process of trying to find some shelter from the flood (Leland, Greenville, Vicksburg, Rosedale). In the slower part two, he gives accounts of people stranded in the flooded country. Charley Patton, in these first days of recorded country blues, was using the blues to tell the story of the downtrodden and neglected. He fulfilled an important function of this music, to contribute to history from the perspective of the underclass, to ensure that the ugly truth would not be painted over by the passage of time.

Son House

One of Charley Patton's travel companions, **Eddie "Son" House**, was a singer of extraordinary charisma and depth whose career far outlasted his mentor's career. Videos can easily be found today on the internet illustrating his expressive powers. In performance, House looked like he was channeling a spirit or revisiting a painful memory while he played. Admirers say he was gone to another time and place while he performed. His guitar style was completely different from Patton's. If Patton designed textures on his guitar with an architect's mind, House attacked the six strings with the conviction of a martyr. On a video of Son House playing "Death Letter Blues" during the 1960's blues revival, he snaps the strings, pulling his hand far off the instrument, then wallops the strings when his hand returns. To be fair, his technique had weakened over a long hiatus by the 1960s and a long life of alcoholism had left him with trembling hands. But the general feeling of a violent intensity is a good representation of the man's approach throughout his career.

House's deep feeling for the blues came from origins of the most pious and the most downtrodden. He was a convicted murderer, sent to Parchman Farm penitentiary (he claimed) after shooting a man at a house party in self-defense. There are as many questions as answers regarding his imprisonment, however. Much of the fire in his belly came from the church. Like Charley Patton, Son House left the blues for preaching multiple times over the course of his career. In fact, the church was his first calling. He despised the blues and the sinful lifestyle it encouraged in his early days. His affinity for preaching is made clear in his recordings of "John the Revelator" and "Grinnin' In Your Face." He puts down the guitar as if to preserve the sanctity of these sung sermons, and claps along instead. "Preachin' the Blues" reveals a cynical take on religion. (see the lyrics at *http://www.lyricsfreak.com/s/son+house/preachin+blues_20295100.html*)

Even in blues songs with dark and lowdown themes, House sang with the conviction of a preacher. Listen to "Death Letter Blues" and closely follow the lyrics, in which he illustrates the gory scene of how he found his lover's dead body, and the loss of his soul after experiencing the loss.

Early in Son House's life he was influenced by the bottleneck slide work of Rube Lacy and Blind Lemon Jefferson's recordings. House is an important link in the story of the blues. He rambled from town to town with Charley Patton along with Willie Brown and Louise Johnson and recorded with them for the Paramount company. He was an important influence on two blues icons—Robert Johnson and Muddy Waters—and was an important part of the blues revival of the 1960s.

Music Analysis

"Death Letter Blues"
(circa 1965)

Musical Details:
The simplicity of this piece is deceiving. Son House leaves a powerful impression with very little variety from verse to verse. He builds and maintains incredible tension through his choices of pitch (compare the first pitch of every verse), the sound of his voice, and the churning energy of his guitar. Notice Son House's forceful approach to the guitar. His powerful straight-eighth rhythm doesn't sound too far from today's rock and roll.

Time	
0:00	**Introduction:** Guitar begins the pattern that accompanies the voice throughout the recording.
0:04	**Verse 1:** While singing, House omits the jumping high notes of the guitar pattern. They re-enter in between each lyric line.
0:33	**Verse 2:** House opens this verse on a higher note than the first verse.
1:01	**Verse 3**
1:28	**Verse 4:** House's voice has built to a boiling point here. He opens this verse on the highest note yet, one step higher than in verse 2. -Underneath his voice, House adds on his guitar a chromatic falling line on each beat.
1:55	**Verse 5:** Underneath his voice, House strengthens the strummed chords.
2:22	**Verse 6:** Again, House keeps the energy rising with the opening high note. On the low notes of the melody, he stirs up the energy with a growled double-time phrase
2:50	**Verse 7:** House opens this verse on the same high note as the previous verse, but then makes this verse sound more final by elongating some notes and slowing down the pace against the steadily rocking guitar.
3:17	**Ending:** House draws attention to his slide-work during a few solo bars.

In between productive periods, Son House would put away his guitar and escape the music profession altogether. He claimed that his first hiatus was caused by the death of his peers. Charley Patton died in 1934, Robert Johnson in 1936, and Blind Lemon Jefferson passed away in 1929—all before age 40. He was scared that he was next! He was rediscovered back in the Delta by **Alan Lomax** and recorded for Lomax and the Library of Congress in 1941 and 1942. After those recordings he disappeared again until 1964, when a group of fans including Al Wilson (soon to be the leader of blues-rock band Canned Heat) tracked him down in Rochester, New York. This was a time of great potential for aged Delta bluesmen. A blues and folk music revival was underway in the United States. House had

forgotten so much of his own material by this time that Al Wilson had to remind him how to play it. Dick Waterman made important connections that then re-launched his career by securing a recording contract with Columbia records and lining up the king-maker John Hammond as his producer. He performed at the 1964 Newport Folk Festival along with other blues greats Skip James and John Hurt, who were also resuscitating their careers. This final phase of his career ended in 1976 when he retired for health reasons. He lived his final years in Detroit, dying from cancer of the larynx in 1988.

Skip James

One of the most unique of the Delta musicians was **Skip James**. Like Charley Patton, he approached music store owner and talent scout H. C. Speir to record his music. Like Patton, he was sent to Grafton, Wisconsin to record for Paramount. But here the similarities end between James and Patton. At first listen, Skip James seems to have been transported to the Delta from another time and place—another planet maybe. Instead of the gravelly, gritty howls of Patton and Son House, Skip James sang high floating melodies in a falsetto voice—not a feminine sound, an otherworldly and haunting sound. The uniqueness of his voice was compounded by the special guitar sound he achieved with E minor open string tuning. Since the strings were tuned to an E minor chord—E/B/E/G/B/E—the guitar would play an E minor chord with no fingers placed on frets, maximizing the sound of open strings. He also pulled a unique sound from the instrument by plucking with his fingernails instead of the fleshy part of his fingers.

Skip James had an incredible ability for songwriting at both the piano and the guitar. At his Paramount session in 1931, when asked how many songs he would be recording, his response was: "As many as you want." The session resulted in eighteen songs, an impressive number when it was common for an artist to record as few as four or less in a session. The subjects of these songs varied from the love sick "Devil Got My Woman" to the euphoric "I'm So Glad."

His "Hard Time Killin' Floor Blues" paints a disturbing portrait of life during the Depression. As is the case with many of his songs, "Killin' Floor" does not use the 12-bar blues form. Instead its form is a repetitive 8-bar structure based on variations of just one chord. Each phrase of the melody begins high and winds its way down a minor scale. In between most lines is a mournful "oooohhhh." The bleak melody is a perfect marriage with lyrics that could have described the hopelessness of living through the Great Depression, evoking the image of a slaughterhouse.

James was far more than a blues practitioner with a strange and eerie approach. He impacted the approach of blues artists of the future, most notably Robert Johnson who emulated elements of James' style. In fact, James's impact on the genre may have been even more consequential had he jumped at an offer to record for the OKeh label in 1927, two years before Charley Patton. He turned down the opportunity! Had he accepted, Skip James would have been the first authentic Delta blues recording artist.

Music Analysis

"Devil Got My Woman"
(1931)
Personnel: Skip James, guitar/voice
Musical Details:
This blues song does not follow the blues form, rather, the progression alternates between just two chords. Skip James sings over the V chord, then resolves on the I chord. Note James' use of **melisma**—singing multiple pitches on one syllable. Most every phrase ends with melisma.

The timbre, or color, of Skip James's voice gives the piece an eerie quality. Unlike the masculine and gritty sounds of other Delta singers, James sounds otherworldly. There is no slide guitar on this track, and James plucks with his fingernails.

0:00	**Introduction:** This intro is lengthy compared to other Delta blues tracks. Skip James showcases his unique picking style. His guitar voicing positions two adjacent pitches together, setting the stage for Skip James' eerie dissonance.
0:22:	Line 1
0:36:	Repeat of line 1.
0:58:	Line 2
1:11:	Repeat of line 2.
1:26:	Line 3, a contrasting short melodic fragment is added to the beginning of this line. He opens on the highest pitch of the song.
1:46:	Repeat of line 3.
2:02:	Line 4, again a short fragment is added to the beginning of the line.
2:22:	Repeat of line 4.
2:34:	Line 5
2:45:	Ending, middle string triplet ideas cluster together dissonant pitch combinations over a sustained pair of low notes (called a "pedal point").

Robert Johnson

The story of **Robert Johnson** is shrouded in myth. Ask a group of music fans, "What do you know about Robert Johnson?" Inevitably the first response is, "Wasn't he the guy who sold his soul to the devil?" This myth was widespread even in his day—that he made a deal with the devil for incredible guitar skills in exchange for his soul. It seems likely enough considering his death at the age of 27, the mystical age of death for several pivotal American rock musicians (Kurt Cobain, Jim Morrison, Janis Joplin, Jimi Hendrix). In fact several aspects of his biography are still unconfirmed today. Even the location of his grave is up for debate. Three different sites have Robert Johnson headstones. But the truth reveals more lessons about the development of talent and about the dangers of Johnson's lifestyle than the myths. The myth of Robert Johnson is widespread today because his music has impacted so many. His influence has loomed large over the blues since his death, and musicians from other genres (Eric Clapton, Jimi Hendrix) have listed him among their top influences.

An Elusive Blues Hero

Passionate blues scholars and fans debate just about every detail of Johnson's life, even today, beginning with his birthdate. He was most likely

born in 1911, but various sources put his birth as early as 1907 or as late as 1912. His upbringing would have caused a crisis of identity in his formative years. Born in Hazelhurst, Mississippi, he was the child of Julia Majors Dodds and her brief boyfriend Noah Johnson. Julia's husband, Charles Dodds, had left for Memphis around 1909 to escape local white landowners after a dispute, changing his last name to "Spencer." Eventually Julia and children joined Charles, his mistress, and her children in Memphis. This would certainly have been a complex and dramatic family life—Robert living in Memphis with mother and siblings, his father, a mistress, and her children. By the time Robert was 10 his mother left again and married Dusty Willis. When Robert joined them, he was called "Little Robert" Dusty, but then in his teens, he took the name Robert Spencer. Finally, he took Johnson has as his last name, perhaps when he learned who his real father had been.

With such constant changes in his identity, it's no surprise that he had a strong tendency in his adult years to "ramble," or to move around from town to town. If an unconfirmed story is true, an intensely tragic personal episode may have also shaped Johnson's feeling for the blues and acted as a catalyst for his rambling ways. When he was seventeen Johnson and his first wife, Virginia, moved in with Johnson's half sister and her preacher husband. Under the advice of the host family, Johnson attempted to become a sensible family man, settling into a routine of daily farm work with only an occasional music gig. When Virginia became pregnant and moved in with her own family for care, Robert left the farm to play music on the road. When he returned to visit his wife, he was told that the child and mother had died during labor. Any man could be sent into a tailspin by such a turn of events—absent during the birth and death of his new family.

Driven to the Woodshed

As a boy Johnson demonstrated musical talent on the harmonica, Jew's harp, and as a singer. He built himself a three-stringed diddley bow, a simple instrument made by attaching wire between two nails and played much like a slide guitar by moving a piece of metal or glass up and down the strings. Friends remember him avoiding farm work, making music instead.

In his late teens, Robert Johnson became influenced by **Son House** and **Willie Brown**, showing up regularly at their performances. When Johnson would pick up a guitar and try to play, House would scold him saying, "Don't do that Robert. You drive the people nuts. You can't play nothing." Johnson's response to such humiliation is a running theme among many of the blues and jazz giants in their early careers. Instead of giving up music or continuing in mediocrity, they go into the "woodshed" (a time of intense practice). Johnson, Charlie Parker, and Dizzy Gillespie all suffered public humiliation at the hands of more seasoned musicians. All of them seemed to be motivated by the experience. They practiced their craft, filled in gaps in their technique, and returned to the scene as conquerors.

Sometime after Johnson's public failure he left the Delta for a period of time between six months and two years and lived in Hazelhurst, Mississippi, his birthplace. When he returned, Johnson was outplaying everybody. He had seemingly acquired super-human musical skills. Here is

where the biggest myth of Robert Johnson comes in. It became a widespread story that Johnson went to a crossroads at midnight and waited for the devil or his messenger to arrive. He offered the devil his soul in exchange for a magical transformation into the greatest blues guitar player in the land. The devil or his messenger tuned his guitar for him, and the deal was done. The truth? Johnson most likely studied in Hazelhurst with a guitar teacher named **Ike Zimmerman** (or Zinermon), and may have also fallen under the influence of another well-known blues artist who also claimed to have made a deal with the devil, Tommy Johnson.

Robert also studied records of Delta and non-Delta blues during this time, and constructed his own songs. Although some blues fans may believe that Johnson's famous songs must have been handed to him by the devil along with his skills, a quick listen to popular blues recordings of the day reveals a great deal of material from which Johnson must have borrowed. Georgia's Kokomo Arnold, a slide guitarist, was a strong influence. Perhaps Johnson's most famous song today, "Sweet Home Chicago" essentially plagiarizes Arnold's "Old Original Kokomo Blues" with its numerical lyrics. The songs use nearly the same lyrics in their hook verses, except when each song arrives at its title. Also, Johnson's "Milkcow's Calf Blues" has a great deal in common with Arnold's "Milk Cow Blues." It seems Johnson may have even paid tribute to Arnold, naming his song as the offspring of Arnold's. Skip James was another strong influence. Both had songs about guns (James's "22-20 Blues" and Johnson's "32-20 Blues), and "Hellhound on My Trail" and "Come on in My Kitchen" may have been influenced by James's own devil song, "Devil Got My Woman." Johnson also emulated Peetie Wheatstraw, Leroy Carr, and Lonnie Johnson in various songs of his repertoire.

The Crossroads Myth

Even the sold-his-soul-to-the-devil story had other origins. Common in African folklore was a story about a trickster-God who would meet a person at a crossroads to make a deal like the one Robert Johnson claimed to have made. To African Americans in the Delta, this would have tied into deep-seated mystical beliefs. Robert may have even borrowed the spooky story from other musicians he met during his time in Hazelhurst. Tommy Johnson, who settled nearby at about the same time, had used a similar story years before to draw attention to himself. Tommy's brother, Reverend LeDell Johnson delivered Tommy's explanation advice for developing musical skills:

> . . . *you go to where a road crosses that way, where a crossroad is. Get there, be sure to get there just a little 'fore twelve o'clock that night so you'll know you'll be there. You have your guitar and be playing a piece sitting there by yourself. You have to go by yourself and be sitting there playing a piece. A big black man will walk up there and take your guitar, and he'll tune it. And then he'll play a piece and hand it back to you. That's the way I learned to play anything I want.*

Robert Johnson and his teacher Ike Zimmerman may have held some of their guitar lessons at a cemetery at midnight. Devil myths were all around Robert Johnson. It captivated audiences and tied into their folklore.

Rather than taking credit for his hard work during his hiatus to Hazelhurst, Johnson cultivated the devil myth in his song lyrics. In "Me and the Devil Blues" his relationship with the devil seems almost casual, as if they were roommates. In fact, the real story seems to be about demonic possession, or the ultimate in devil-made-me-do-it alibi.

Impact of Robert Johnson

Devil or no devil, Robert Johnson's music has strongly impacted the American musical landscape, particularly through his recordings. In 1936 and 1937, Johnson played recording sessions in San Antonio and Dallas, Texas that resulted in 29 songs. H. C. Speir figures into Johnson's story here, as he had with Charley Patton and Skip James. After Johnson played for him, Speir was impressed enough to pass his name along to an associate at the ARC label, who eventually tracked Robert down for the Texas sessions. In these recordings, the listener is struck by a large vocabulary of guitar techniques played with great ease and clarity. Boogie patterns are mixed with high range licks and bass lines. Vocally, his expressive range is impressive. Like Charley Patton, he seems to play various characters by singing in different styles from the high-floating Skip James style to the down-home growl of a Charley Patton or a Son House. He displays amazing independence between his voice and his guitar. In fact, it is hard to believe that only one person is behind the microphone.

His "Terraplane Blues" was a hit race record during his lifetime, making him a somewhat recognizable figure when he rambled from town to town. His other songs, reissued in a 1960s compilation and again in the 1990s, have become standards of the blues, rock, and jazz worlds. During his travels, he taught his mistress's son Robert Lockwood how to play. Lockwood (nicknamed "Robert Jr.") went on to become an important voice of the next blues generation. He is credited with clarifying the blues and fusing it with a more commercial approach that eventually made the blues palatable to the general public.

The mystery surrounding Robert Johnson's death continues to haunt blues researchers in an unending pursuit of truth. Ultimately, his lifestyle caught up with him, apparently poisoned by the husband of his lover. Had he lived longer, there is a strong chance that he would have been a major force in the development of future blues styles and other genres.

Music Analysis

"Hellhound on my Trail"
(1937)
Personnel: Robert Johnson, guitar/voice

Musical Details:
Text painting: Johnson engages in a musical technique commonly heard in European classical music, where the instrumental accompaniment (guitar) is written or performed in a way that it enhances the literal meaning of the text. Lyrics are often taken as literal directions to instruments. When the lyrics equate the blues with falling hail, Johnson's guitar plays accented falling notes on the pulse. (See lyrics at http://www.lyricsfreak.com/r/robert+johnson/hell+hound+on+my+trail_20214234.html)

Music Analysis (continued)

Johnson's guitar accompaniment doubles his voice at times, and at other times it gets active in the spaces between phrases.

The form is a modified 12-bar blues. Each 4-bar phrase is extended with repeated lyric fragments and guitar riffs. Where a traditional blues should arrive at a IV chord (in bar 5), Johnson returns to a I chord.

0:00	**Introduction:** typical chromatic *turnaround* with falling chords.
0:10	**Verse 1:** Johnson's voice sounds stressed, even panicked, with high vibrato in the high-register. Johnson uses the range of his voice to express fear in his story. His voice descends with the guitar when the lyrics evoke a falling image.
0:25	**Verse 1, Phrase 2**
0:38	**Verse 1, Phrase 3:** Johnson's B phrase explains his need to escape with the image of a hellhound, over a simple low-string bass note. The *falling* motive comes back again, this time as a turnaround into the next verse, keeping the song moving.
0:52	**Verse 2:** similar musical material as in verse 1.
1:11	**Verse 2, Phrase 2:** Johnson answers his lyrics in spoken voice. Vocal asides are typical in country blues.
1:26	**Verse 3:** The lyric refers to the hoodoo practice sprinkling hot foot powder across a door frame, meant to banish Robert Johnson from his own home.
1:59	**Verse 4:** More text painting appears here. Johnson wiggles a high string after plucking it, causing the pitch to tremble.

CONCLUSION

The legacy of early country blues cannot be overstated. While Blind Lemon Jefferson, Lead Belly, Charley Patton, Son House, Skip James, Tommy Johnson, Robert Johnson and others rambled from town to town, their recordings set the stage for an expansion of the form outside the race record market. Country blues provided much of the foundation for rock and roll after it was reinvented in Chicago and other regions of the country. The classic blues singers such as Mamie and Bessie Smith, and Ma Rainey would form a new template to be repackaged in the jazz and pop worlds. Through them the blues became an essential ingredient for pop success, and generations of performers were shown how the blues could be repackaged into various musical settings. Through country and classic blues artists, the unique sounds of blue notes, the blues scale, the chord progression of the 12-bar blues form, and the African American story were preserved, resurfacing again-and-again when future generations looked to them for inspiration. The Great Depression was a dividing line that weakened the market for the blues, and discouraged record labels from actively pursuing more blues artists. Much of the commercial activity subsided that had been building throughout the 1920s blues-scape, but the genre would come back stronger than ever in better days.

Discussion Questions

1. Compare and contrast the Classic "Vaudeville" Blues and Country Blues styles. Choose one track from each style to illustrate.

2. Contrast Texas Blues from Mississippi Delta Blues styles. Choose one track from each style to illustrate.

3. This chapter describes a number of events and institutions of African American life in the Mississippi Delta of the early 20th century. Describe two of these and explain how they relate to the content of blues lyrics.

4. Dispel the Robert Johnson myth. Describe the popular tale that accounted for his virtuosic musical talent, and explain the likely truth about how he developed into a mature musician and compiled such a successful set of songs.

5. Describe the impact of the Classic and Country Blues recordings on the recording industry and on American society at large.

PART III

Early Jazz
(From the Beginning to the 1930s)

New Orleans and Early Jazz

In this chapter, we will cover:

- New Orleans history
- Racial make-up of New Orleans
- Musical history of New Orleans—**Congo Square, brass bands**
- Birthplaces of jazz—**Storyville, the Battlefield**
- Instrumentation and arrangement of early jazz
- Cornet Kings—Buddy Bolden, Freddie Keppard, Joe "King" Oliver
- Other important New Orleans musicians—Jelly Roll Morton, Sidney Bechet

The Crescent City has a tumultuous history, full of tragedy at the hands of natural disaster and economic ups and downs. As recent as August 29, 2005, hurricane Katrina flooded an alarming portion of the city, breaching levees off Lake Borgne and overflowing Lake Pontchartrain. Refugees fled to towns and cities all across the southern United States. Just after the hurricane, the jury was out on whether New Orleans could be revived. Compounding the city's misery, a second hurricane swept through the Gulf of Mexico only a month after Katrina subsided, luckily with far less violent effects. (Go to http://www.nola.com/katrina/graphics/flashflood.swf to see an interactive graphic that illustrates the flood.)

Aftermath of Hurricane Katrina, New Orleans, Louisiana

© Pattie Steib, 2014/Shutterstock, Inc.

But the New Orleans comeback story has been an inspiring tale of survival, grit, and perseverance. Much of the credit for the city's survival after Katrina is owed to its cultural contributions to American society at large. Although the Federal relief effort was widely criticized, a nationwide community of volunteers was mobilized like never before. Unprecedented media attention held the attention of the public who responded to the tragedy in great numbers, contributing dollars through service organizations and volunteering to help. Wynton Marsalis and other jazz musicians were featured on nationwide network television broadcasts, publicizing New Orleans culture and performing benefit concerts. Celebrities Brad Pitt, Sean Penn, and John Travolta got their hands dirty, rescuing victims and rebuilding homes. Oprah Winfrey, Steven Spielberg, and George Clooney joined an outpouring of financial support from the entertainment community. Comparing Katrina relief to the great flood of 1927 (discussed in Chapter 5), the benefit of far-reaching coverage by news outlets is clear. The Corporation for National and Community Service, an arm of the Federal government, sited 1,150,000 volunteers working a total of 14 million hours in the two years after Katrina hit the New Orleans levees.

Katrina was not the first devastating catastrophe experienced by the city. The wide economic swings and tough treatment from nature resulted in a people who are resilient and who appreciate

the here-and-now. New Orleans culture is joyous, rich, and flourishing. New Orleans people are known to stand up against the city's misfortunes and walk forward with bouncing feet, informed by the deep blues of loss and the understanding that life is fleeting. This chapter will provide a brief commentary on New Orleans history as it relates to musical culture, describe musical forms special to New Orleans, and illuminate the major jazz musicians that emerged from the vibrant music scene.

NEW ORLEANS HISTORY

It is often said that New Orleans exemplifies the "melting pot" metaphor of America's multi-ethnic culture. The cultural riches in New Orleans were largely the result of the various nations that owned the city and how quickly it changed hands between them. Have a look at the timeline of New Orleans's nationality below.

New Orleans Timeline

1699—French colony of Louisiana established
1718—New Orleans founded
1763—Spain takes New Orleans in the Treaty of Paris
1800—France takes New Orleans back from Spain (Treaty of San Ildefonso)
1803—United States acquires Louisiana Territory from France (Thomas Jefferson from Napoleon Bonaparte) for a bargain price

During the five years around the beginning of the 1800s, New Orleans belonged to three different nations! To this day, aspects of French and Spanish culture are evident in the architecture and design, the culinary conventions, and the way of life in New Orleans. In fact, the famous French Quarter looks more Spanish than French. After a devastating fire in 1788, the Spanish rebuilt the neighborhood in a style much like their other colonies to the south, with stucco walls placed right up against the sidewalks. The detailed ironwork for which the district is famous today was added later, another sign of Spanish renovation. The dominant religion was Catholicism, stemming from the Black Codes adopted in 1724, which declared Roman Catholicism as the official religion of the region. New Orleans was far

French quarter design. The wrought iron decorative structures are a Spanish addition to the charm of the French Quarter.

© Colin D. Young, 2014/ Shutterstock, Inc.

more accommodating to the integration of various cultural traditions than the Protestant states. For example, Catholics did not place the same restrictions on dancing as Protestants. Protestant traders traveling down the Mississippi River would reach their destination in New Orleans, receive their pay, and look for entertainment and escape at the end of their journey. The looser definition of "sin" in Catholic New Orleans allowed an early tourism and entertainment industry to flourish. New Orleans was viewed by outsiders as an exotic city, a gateway to the Caribbean. At Mardi Gras, a celebration that precedes the Catholic observance of Lent, a decadent party atmosphere erupted in the city. Mardi Gras reflected the Caribbean and South American influence with their "Carnival" celebrations. Dance was a central pastime of New Orleans residents. Balls were held

every night at several ballrooms throughout the city. The dances were often delineated along racial lines—white dances, slave dances, and unique events called "quadroon balls," where white men and free women of color were invited.

Also important were the waves of immigrants from parts of Europe other than France and Spain, namely Germany and Ireland in the mid-1800s and Italy in the 1870s. Italian musicians would contribute to the musical blueprint of New Orleans, and thereby to the blueprint of jazz. Their impeccable instrumental technique and their lyric tradition—melodies from operas and songs—can be traced to the music made by the first jazz bands. A look at the history of New Orleans before the appearance of any identifiable American music styles provides some insight into the aesthetic of America's first artistic capital.

St. Louis Cathedral in Jackson Square, the first town center of New Orleans

Ups and Downs

A topsy-turvy economic climate affected New Orleans society as well. The city's position as the southernmost major stop on the Mississippi River resulted in a fantastic boom when steamboats began carrying goods up and down the river after the Louisiana Purchase. The city captured large amounts of revenue supplying a great deal of the world's cotton. But the windfall profits enjoyed during these years were short-lived. The Union Army captured the city near the beginning of the Civil War in 1862. And by the close of the Civil War, railroads running east and west had replaced the steamboat, moving the dollars away from New Orleans. The city's health history paints an even bleaker picture. African Americans in New Orleans could expect to live an average of thirty-six years in 1880, and whites tended to live ten years more. Infant mortality rates were also disturbing. Forty-five percent of black infants died before their first birthdays in the 1880s. Yellow fever and cholera regularly plagued the city. In 1853, yellow fever killed about 8,000 people, nearly ten percent of the population! Hygiene and sanitation were not among the city's strong points. New Orleans was one of the last American cities to survive without a sewage system, holding out until 1892, and the city's drinking water was substandard. Despite these bleak conditions, the people of New Orleans are known to carry on with a *joie de vivre*, and their reputation for jubilation is well-documented. New Orleans music interacts with dance, party, and personalities that tend to be positive. But this flies in the face of adversity. The city, schooled in misfortune as any American town, learned long ago to enjoy each moment, to have fun, and to celebrate anything worth celebrating.

RACIAL MAKE-UP OF NEW ORLEANS

New Orleans had a great deal more racial integration, particularly in musical functions, than were found in other parts of the country. Negro slaves made up a third of the population in 1803, and the remaining people had a unique ethnic mixture that reflected the quick turnover of its nationality. Creoles—American-born offspring of European immigrants from France

and Spain—made up a large portion of the city population and colored the music, food, and other artistic culture of the city.

"**Creoles of Color**" were offspring of these Creoles with black partners, also called "Free Persons of Color" (and later, confusing the matter being called only "Creoles"). The social position of these mixed race people was completely different from what it would have been in the American colonies to the North. A person with any portion of Negro blood would have been labeled a Negro in other states and would be resigned to a lower social class and whatever burden was typically placed on blacks in their respective state. In New Orleans, Creoles of Color could live among white society. Even though they identified as mixed race peoples, they were more likely to claim their European ancestry than their African. Musically speaking, Creoles of Color tended toward the European tradition of virtuosic technique, conventional orchestral sounds, and instruction that emphasized reading music. Creoles of Color played in orchestras that accompanied the productions at the French Opera House, and they populated the numerous ballrooms with European-style dance music and popular tunes.

> **Creoles of Color—**New Orleans residents whose parents were a combination of Europian American and African American.

Black bands played a style often described as "hot." They emphasized individualistic phrasing and timbre over conventional skill. The black bands' preference of playing music from memory, rather than from the printed page, resulted in musical performances that could be different from night to night and increased reliance on group interaction. The black bands also were known to play with a blues conception of melody, using blue notes and gritty tone colors. They did not play actual pieces in 12-bar blues form, but they brought the sound of the blues into New Orleans instrumental ragtime music (the New Orleans musicians did not call it "jazz"). Blues songs were called "slow drags," ragtime songs played at a slower, sexier tempo that got the young people to dance. Without recordings of this music, we can only imagine what the music must have sounded like, based on the accounts of some of the people who were there when it was made. What is clear is that Creoles and Negroes each had distinct approaches to making instrumental ragtime music, and each had strengths and weaknesses.

When the **legislative code of 1894** redefined a Negro as a person with any fraction of African American blood, Creoles of Color were knocked down to the same social stratum occupied by pure blood Negroes. This legislative code was one of a slew of laws enacted after the reconstruction. Uniformly called "Jim Crow laws," they were meant to establish control of freed blacks. In 1894, Creoles of Color were no longer able to distinguish themselves from blacks, or to join the company of whites. They could no longer claim their European ancestry.

The 1894 legislative code was inextricably linked to *Plessy v. Fergusson*, an 1896 U.S. Supreme Court decision which strengthened the color barrier nationwide and upheld the "separate but equal" American value. Negroes did not have to be fully integrated as long as they were given an equal measure of government services. In *Plessy v. Fergusson*, Homer Adolph Plessy tested a recent Jim Crow law that required non-whites riding on trains to sit in a separate passenger car from white passengers. Plessy, a resident of New Orleans who was 7/8 white, boarded a white train car and was arrested. The ensuing court case was appealed to the U.S. Supreme Court, and encouraged municipalities and businesses across the nation to

separate and discriminate in terms of education, employment, and government services.

The result of the legislative code of 1894 for mulatto musicians was that they now had to find work in the less "schooled" black bands. This forced alliance between the two groups led to an important part of the New Orleans musical culture, and thereby, to jazz. Black bands tended to emphasize a loose individuality and unfettered spontaneity. Creoles of Color gleaned from their European training superior musical technique and sight-reading ability. The combination imbued early New Orleans jazz at the dawn of the 1900s with a balance of pedigree and invention, of sophistication and wit. Jazz would reflect the strengths of both the Creole and Negro performers.

MUSICAL HISTORY OF NEW ORLEANS

What musical aspects in New Orleans contributed to jazz?
- Individuality
- Respect for a high level of instrumental technique
- Mixture of styles from Creole and black musicians
- Brass band format
 - Second line drumming
 - Collective improvisation

The European Influence

In the 1800s, New Orleans was the musical capital of America, and the musical forms that flourished there ranged from high art to grassroots folk. The first permanent American opera was established there in 1812, and up to three opera companies were in operation at once. Many of the musicians who worked at the opera house had studied their instruments in Europe. By teaching other New Orleans musicians, they gave a kind of legitimacy to the music scene. Young clarinetists, cornetists, and violinists, white and black, were learning virtuosic European techniques. There was plenty of work for New Orleans musicians in street parade bands, concerts, plays, and dances.

Congo Square

Only a short 5-block walk from the French Opera House was **Congo Square** (now adjoined with Louis Armstrong Park). Congo Square was a large area in downtown New Orleans established to allow Africans to express aspects of their ethnic traditions. On Sunday afternoons, thousands of onlookers observed as many as 500 or 600 Negroes congregated in the square. Multiple tribes met in groups, each with its own instrumental musicians and dancers. The bands used drums made of hollowed out trees with sheepskin heads, banjos, and jawbone rattles, instrumentation not all that different from the common Minstrel show band. In Congo Square, bands played from the middle of the ring for the dancers that spun around them. Descriptions of the dancing style sound similar to the ring shouts

that occurred in religious settings. The slave dances of Congo Square occurred from sometime in the mid-1700s until the city ended them in 1843. At that time, African Americans surely continued to celebrate the music of their heritage. Music of the slaves would re-emerge after the Civil War, when freed slaves could find musical work in the city and develop their own approach to the music made for dancing and other Creole forms of entertainment.

Congo Square

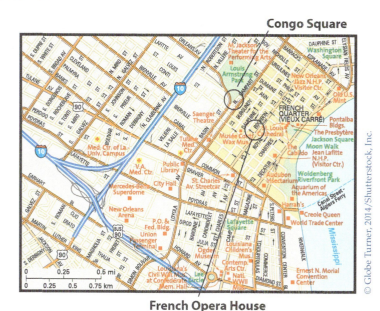

French Opera House

New Orleans Brass Band

A trademark of New Orleans culture is the street parade. Residents of the city would say that a parade could be planned for any event. The brass band, a tradition that was strengthened in New Orleans by the German immigrants, played an important role in the parade. A small brass band might include any combination of cornets, alto and baritone horns, clarinets, snare drum, and bass drum. Similar bands were popular across the United States, particularly after the Civil War when brass and percussion instruments were in high demand to coordinate Union and Confederate troops. Special occasions and casual celebrations were marked by the sound of brass bands in marching and concert settings across the nation. But New Orleans had a remarkable appreciation of brass bands. New Orleans bands tended to be smaller than those found in other parts of the country—fewer than a dozen players.

The funeral procession was an important function of the New Orleans brass band. Bands were employed by funeral societies, clubs that guaranteed a proper funeral for their members. This practice originated in African societies residing in Nigeria and Benin who established secret societies as a kind of burial insurance policy. In New Orleans, these societies provided a great deal of employment for musicians playing in brass bands. On the way to the burial site, the band would play a **dirge**, a slow and mournful song. A striking feature of the dirge is the wailing sound of the trumpet's wide vibrato and slurring trombones. After the body was interred,

the band picked up the tempo beginning with a **cadence** (a drum beat that set the tempo for the proceeding music) and followed by a medium tempo march. African American bands picked up this tradition, and in the syncopated musical surroundings of New Orleans, the German march took on a more ebullient rhythm that became called the **"second line groove"** or **"big 4"** because it emphasized beat four instead of the downbeat. The second line music incorporated the sound of piano ragtime, with its steady beat in lower register instruments and its obstinate syncopation in the right hand. An important New Orleans drummer, Warren "Baby" Dodds, described the brass band's special approach to the funerals.

We'd play the same popular numbers that we used to play with dance bands. And the purpose was this: As the family and people went to the graveyard to bury one of their loved ones, we'd play a funeral march. It was pretty sad, and it put a feeling of weeping in their hearts and minds and when they left there we didn't want them to hear that going home. It became a tradition to play jazzy numbers going back to make the relatives and friends cast off their sadness. . .

Music Analysis

The Eureka Brass Band
(1958)
Personnel: Percy Humphrey, Willie Pajeaud, George Colar ("Kid Sheik")—trumpets; Sonny Henry, Albert Warner—trombones; Joseph "Red" Clark—sousaphone; Manuel Paul—tenor saxophone; Ruben Roddy—alto saxophone; Alfred Williams—snare drum; Robert Lewis—bass drum

These recordings are representative of the New Orleans brass band sound in the first half of the 20th century. The Eureka Brass Band was one of the finest in the city. By the time of this recording, saxophones had taken the place of the clarinet and alto and baritone horns heard in traditional brass bands. Also note the presence of a sousaphone in this group. The sousaphone is essentially a marching tuba, reshaped so that it winds around the shoulders of the player and becomes portable. Besides this contemporary instrumentation, "Eternity" and "Maryland, My Maryland" are good examples of the music that evolved into jazz. Most important for our purposes is the role each of the songs would play in a funeral setting.

"Eternity" is a dirge, an extremely slow number meant to evoke feelings of sorrow as the funeral processional walks to the gravesite. Notice the wailing tone and wide vibrato of the lead trumpeter, Willie Pajeaud (oftentimes doubled by alto saxophone). The trombones' "wwwwop" sound contributes to the sorrowful effect. The band's timbre is far more about painful expression than beauty in this piece.

"Maryland, My Maryland" (from same recording session as "Eternity") is what the band would play returning from the gravesite. "Maryland" has been a New Orleans standard since at least the dawn of the 20th century. In this recording, the bass drummer plays a brief cadence to set the tempo (often the snare drummer plays a cadence instead), the band plays a quick introduction, and they're off into a jovial bounce-step. The two drummers contrast each other in their *second-line* rhythm. The bass drummer primarily plays downbeats and is probably playing the clanging cymbal at the same time, usually striking upbeats (or backbeats). Bouncing around the bass drummer's steady pulse, the snare drummer plays a syncopated groove with press rolls and rim shots. Throughout the piece, the other musicians play a mixture of clearly written out parts and loose improvisation based on the main melody of the song. The trumpets sometimes play harmony parts, and the other instruments either play along in their own octave, or they create a simple accompaniment part. At 1:28 the texture changes to trumpet soloist vs. the drummers. This becomes a descant, or alternate melody, on top of the familiar "Maryland" melody, entering at 1:47 (the listener might recognize the same melody as "Oh Christmas Tree," or "Oh, Tannenbaum").

(Dodds remarked that one of the most common songs played on the return, "Didn't He Ramble," was played as an inside joke. The band typically played the song when they learned that the deceased was a philanderer.)

BIRTHPLACES OF JAZZ—STORYVILLE AND THE BATTLEFIELD

Louis Armstrong speaks in his biography *Satchmo: My Life in New Orleans* about growing up around a crowded district called the Battlefield, where all different kinds of people lived, including "the roughest." Jazz was being made on resorts off Lake Pontchartrain at dances, picnics, street parades, baseball fields; just about any gathering of people might include a jazz band.

Storyville has often been claimed as the birthplace of jazz, although it is doubtful that the music thrived in a band format. The Restricted District was called "Storyville," named after Mr. Sidney Story, the city alderman who set the District apart as a red light district by city ordinance in 1897. Prostitution was legal in the District and could be watched and managed by authorities. It was a *sin* district. Most of the bordellos of Storyville probably only hired solo pianists or duos or trios of stringed instruments, but the cabarets and Storyville's dance halls hired larger bands. The inventors of jazz probably played in venues outside Storyville that operated under threat of legal trouble, where the influence of Storyville encouraged a *loose* atmosphere, rife with drinking, sensual dancing, and hot music. Storyville was closed under federal order in 1917, when the U.S. Navy sited Storyville and red light districts in other cities as health risks for their sailors. Navy men were contracting sexually transmitted diseases in the brothels, a threat to national security!

INSTRUMENTATION AND ARRANGING IN EARLY JAZZ

What Did Early New Orleans Jazz Sound Like?

Since no recordings exist of the earliest jazz groups in New Orleans, we can only gather clues about their sound, makeup, and performance practices through personal accounts and photographs. They called their music "ragtime"; the *jazz* label did not exist until the music migrated to other American cities. The first professional jazz recordings were made around Chicago a decade or two later, when the music had already made its way north and lived through enough time to have already evolved significantly. Alphonse Picou, an important clarinetist in the New Orleans scene, recalled his introduction into the environment of working dance bands. He painted a picture of the musical style developing from the interaction between band members who could read music, and those who were more comfortable learning by ear. Picou described a rehearsal process in which one of the musicians who could read music would learn a piece from sheet music and then teach the melody to the band by playing it for them, then having the band copy him when they were ready. Inevitably, variations

would splinter off from the correct melody as the musicians who couldn't read would improvise out of necessity. But the sound of the music seems to have been essentially a **unison** conception of melody (all pitched instruments played the same pitches together) with rhythm section accompaniment. The bands would often repeat just the chorus of the song, and would make subtle changes like playing the 2nd repeat at a soft volume.

The instruments of the first jazz groups grew from the brass bands and dance bands of New Orleans. The **front line** instruments, the musicians who played the melody, were common to the brass bands—cornet, clarinet, trombone, and often the addition of a violin. The most common rhythm section instruments reported in early New Orleans jazz bands were guitar and an early version of the drum set that combined the parade band's snare drum and bass drum. In addition, some groups did include bass or tuba, mandolin, banjo, and sometimes piano, but these were not as commonplace as guitar and drums.

Front line—The group of wind instruments in a New Orleans ensemble that are not a part of the rhythm section, typically comprised of a trumpeter or cornetist, a clarinetist, and a trombone.

At some point in the embryonic stage of jazz, the unison melodies played by front line horns developed into a *polyphonic* style through a practice known as **collective improvisation**. In the standardized sound as it arrived later in Chicago, each instrument took on a particular character or job. The cornet and leader of the group stayed close to the song's melody (often doubled by violin) and played brief improvisations in the rests between phrases. The clarinetist's job was to play obbligato lines that wound around the melody and reached up to the highest pitch range in the band. New Orleans had a rich tradition of clarinet study led by Creole clarinetists such as Alphonse Picot, George Baquet, and a clarinet dynasty led by brothers Louis Tio and Lorenzo Tio, Sr., and Lorenzo's son Lorenzo Tio, Jr. Clarinetists typically studied with a Creole master, working on technique-building pieces such as "High Society" which developed their ability to play arpeggios, leaping up and down the chord tones in single pitches. The third front-line instrument, the instrument that played the low notes in the ensemble, was the trombone. New Orleans trombonists made use of the instrument's natural ability to play a **glissando**—to slide from a low pitch to a higher one, or vice versa—so much that it became a kind of gimmick. Glissandi played on the trombone came to be called **tailgate trombone**, named for the tailgate of a horse-drawn wagon where trombonists sometimes needed to sit in order to make room for the potentially dangerous motion of its long slide.

Collective Improvisation— A dense musical texture created when multiple instruments improvise simultaneously.

CORNET KINGS

In New Orleans at the onset of jazz, the cornet was king. Because of their role as the primary melody instrument, and because of the cutting tone of the instrument, cornet players were seen as the kings of the band, a natural lead instrument. Here are a few of the most significant *cornet kings* who developed the hot, improvisational, bluesy brand of jazz:

Buddy Bolden

The first of these kings was **Buddy Bolden**. And if anyone can be credited with inventing jazz, Bolden is the strongest candidate, at least the strongest that we know of. But we know far less about Bolden than we would like to. Donald Marquis did remarkable research, tracking down surviving

members of Bolden's family for his 1978 book *In Search of Buddy Bolden: the First Man of Jazz*. He settled many of the unconfirmed facts about Bolden, and substantiated the existence of the legendary cornet player. But researcher Samuel Charters is skeptical of all but the basic facts about Bolden in his book, *A Trumpet Around the Corner: The Story of New Orleans Jazz*. With good reason, the more prudent researchers have been careful not to attribute Bolden with a Messianic quality. It is far more likely that hints of the jazz sound, a mixture of instrumental ragtime with tinges of blues melody and simple improvisation, were emerging from the music of several dance bands around the time Bolden's band was in operation. In this way, the name "Buddy Bolden" must also symbolically represent several anonymous inventors of jazz around the first decade of the 20th century.

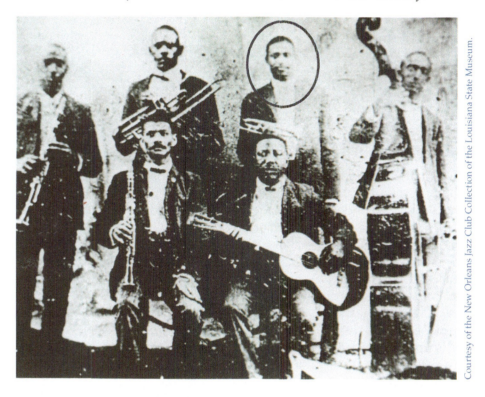

Courtesy of the New Orleans Jazz Club Collection of the Louisiana State Museum.

There are no known recordings of Buddy Bolden, and only one photo with his band. The historical record of Bolden's "invention" of jazz has been collected from the accounts of several musicians who knew him, or knew *of* him. We know that Buddy Bolden was born in 1877 and died in a mental institution in 1931 after struggling with alcoholism and a mental disorder. He began playing the cornet in the mid-1890s and became a full-time musician in about 1901. By 1906 symptoms of his mental instability were showing up. He was arrested for hitting his mother-in-law with a water pitcher, and in 1907 was sent to an insane asylum. During his brief career he worked in string bands playing dances and marching brass bands around New Orleans, and over the course of that time the band's style shifted toward what we now identify as a jazz conception. Although his band probably did not improvise in the way we think of jazz improvisation, the band was described as having a loose feel with more freedom than other groups.

People who knew Bolden have said that his band played a brand of dance music that loosely incorporated the blues. The group played a variety

of social functions, including appearances at the city's two baseball fields, Lincoln Park and Johnson Park. Amid the band's repertoire of typical dance songs (polkas, waltzes, and quadrilles) were slow blues tunes for which Bolden became famous. Stories of Bolden's music place him at Kenna's Hall (affectionately nicknamed "Funky Butts Hall"). The band played from evening until 4 a.m, and during the early morning hours the tempos were said to have gotten slower, and the sound of the blues became prominent. Probably his "blues" songs were not actually played in 12-bar blues form, but they had slow tempo and improvised figurations that may have linked the music to the blues music hovering around at the time. According to Louis Armstrong and his bassist Pops Foster, Bolden played very loudly. He played in an aggressive style that sounded less polished than classical masters, but more individualistic. He crafted a personality on his horn, instead of playing the conventional cornet.

Much of the band's popularity was due to a hit song written by the band's trombonist Willie Cornish. The song went by several different titles—"Funky Butt," "I Thought I Heard Buddy Bolden Say"—and was said to have raunchy or politically flammable lyrics. Sidney Bechet recalled that police "whipped heads" when they heard people singing the song.

Freddie Keppard

Other than Buddy Bolden, the only early jazz performers to achieve worldwide acclaim and fame were those who left New Orleans and helped the spread of jazz. Wonderful performers stayed behind in New Orleans (their legacies preserved in Samuel Charters's exhaustive work *Trumpet Around the Corner*), but the ambassadors of New Orleans musical culture would cause several waves of popular interest in the style on the West Coast, Midwestern urban centers Chicago and Kansas City, New York, and the Northeast. Jazz would soon emerge as a popular music style in Europe and Asia, as well. Had the best New Orleans musicians stayed home, without today's internet-based industry of music consumption, the fate of New Orleans jazz is uncertain. **Freddie Keppard** was one of the first New Orleans cornet players to reach out to a nationwide audience.

Keppard had an undeniable impact on pre-Louis Armstrong jazz. He was among the finest cornetists of his day, capable of playing comfortably in the lower and upper ranges of his horn as well as great dynamic range, from the loudest louds to the softest softs. He was the first to leave New Orleans, and according to legend, he may have been the first offered the opportunity to make a commercial recording, an opportunity he turned down. Keppard claimed that a company approached his group with a recording contract, but Keppard turned down the offer for fear that people would steal his sound. It has been said that Keppard often draped a handkerchief over his cornet when he played to hide his fingers. The offer to record has not been substantiated by reporting or documentation; it may have been a conflated claim Keppard used to exaggerate his reputation. Still, it begs the question; what would have happened if the first jazz recording had been made by Keppard at the top of his game? Most recordings of Keppard give us only a shadow of his sound and his abilities.

Born in 1890, Keppard worked the rounds of parade bands and dance jobs and formed the Olympia Band in 1907 with himself on cornet, a valve trombonist, clarinet, drums, and guitar. He traveled to Los Angeles in 1914

to join bassist Bill Johnson (who would figure largely into the story of early jazz, recording with both King Oliver and Louis Armstrong). Johnson made his first exploratory trip to Los Angeles with a string band in 1907 and established viable moneymaking opportunities in California cities as far north as Oakland. Soon, other important New Orleans musicians would follow his lead toward Los Angeles including pianist Jelly Roll Morton and trombonist Kid Ory. The band Keppard joined with Bill Johnson was called the Original Creole Orchestra, and its front line consisted of violin, cornet, trombone, and clarinet.

In August of 1914, the Original Creole Orchestra was asked to perform for Pantages Vaudeville show, although their act was probably more Vaudevillian than New Orleansian. The group sang and danced in blackface. Alex Pantages ran theaters across the Pacific Northwest and into Canada, and during the next couple of years the Creole Orchestra toured to Chicago and New York. Their act mixed instrumental ragtime numbers with songs during which they backed a singer or a comedy routine. In the Vaudeville setting, in an act that blended minstrel conventions and theater songs with real New Orleans music, Keppard and the Creole Orchestra were responsible for spreading the sound of early jazz across the nation.

Known to imitate a horse whinny on his cornet, Keppard can be heard on his recordings "ripping" up to sustained high notes. He played a staccato style, heard in "Stockyard Strut." In many of his recordings he plays the main melody, then the band members typically take brief solo breaks, with a few extended solos.

Joe "King" Oliver

Each time a New Orleans musician left town to seek better opportunities, another player was ready to take his place. Such was the case with Freddie Keppard. When he vacated the Olympia Orchestra to head to Los Angeles, **Joe Oliver** took his place. From there, Oliver's career moved quickly. In 1915 he was leading his own group at the Big 25 that included outstanding clarinetist Sidney Bechet. It was about this time that Oliver and his wife took the young upstart Louis Armstrong under their wing. The relationship would eventually be a catalyst for the next important phase of development in jazz.

Oliver was described in these days as having a well-crafted sound on the cornet and had excellent technical ability. But what made him unique was his skillful use of mutes to affect the sound of his horn with vocal effects. Laughter, guttural growls, baby cries, all were gimmicks that Oliver would use to make his instrument sound completely like something else. Fellow musicians called him "Harmonica," comparing the wah-wah he created with his hand over the mute to the blues harp.

Fed up after being arrested when the police raided the cabaret where he was playing, Oliver moved to Chicago in 1918. In Chicago, he found himself with plenty of playing work to do, with two venues needing him in their bands. At one of the cafés, Bill Johnson, the man who brought Freddie Keppard to LA, was Oliver's employer. Between the two venues, Oliver's work schedule was a grueling one. Playing 9:30 p.m. to 1:00 a.m. at the first club, then 2:00 to 6:00 at the next would be physically taxing for any instrumentalist, and the thin mouthpiece of the cornet would surely have challenged Oliver's endurance.

At his early gig, Oliver lost his patience with the band's unreliable clarinetist, took over leadership of the band, and brought in one of the most important New Orleans clarinetists to replace him, Johnny Dodds. With his new band he moved to San Francisco and toured California's Vaudeville theaters. It was at this time that he brought on board Johnny Dodds's brother, drummer Warren "Baby" Dodds. (With these personnel changes, Oliver was inadvertently drawing together musicians who would accompany Louis Armstrong on his essential Hot Fives and Hot Sevens recordings. The Dodds brothers, Oliver's pianist at the time Lil Hardin, and Louis Armstrong himself would revolutionize the sound of jazz.)

After about a year in California, Oliver moved back to Chicago to work at Lincoln Gardens. In 1922 he decided to align with the conventions of the Chicago scene and add a second cornet player. Oliver was also experiencing trouble with his embouchure stemming from gum pain, and needed a supporting cornetist, so he alerted Louis Armstrong. Armstrong had been working steadily in New Orleans, but when his idol asked him to join the band, he hopped on a train and headed north.

The relationship between Oliver and Armstrong will be discussed in the next chapter, but in his own right, King Oliver would turn out to be a highly individual cornetist and bandleader. His innovative use of mutes and natural style became hallmarks of the black New Orleans sound, and would be emulated in important groups for the next few decades.

Music Analysis

"Dippermouth Blues"
(1923)
Personnel: Joe Oliver and Louis Armstrong, cornet; Johnny Dodds, clarinet; Honore Dutrey, trombone; Bill Johnson, banjo; Lil Hardin, piano; Warren "Baby" Dodds, drums

Joe Oliver wrote this brisk blues with Louis Armstrong in mind. According to Baby Dodds, the band, except for Lil Hardin, was nervous at these Gennett sessions in Richmond, Indiana. The balance between the horns on this recording is good compared to many recordings from this era. Occasionally, the stronger 2nd cornetist Louis Armstrong overtakes his hero Oliver. In these days, musicians were placed at various distances from the large horn that took in their sound. Reportedly, Armstrong had to be put far behind Oliver to avoid covering up the 1st cornet. A funny moment happens near the end of the track. Baby Dodds forgot to play what was supposed to be his drum break, and Bill Johnson acts fast and shouts "Oh, play that thing!" Johnson's vocal became a standard part of the piece, repeated whenever it was performed.

The recording quality obscures the sound of the rhythm section instruments. Baby Dodds plays marching rhythms on a woodblock throughout, and Lil Hardin's piano and Bill Johnson's banjo basically plod along together playing steady quarter note pulses. It's oftentimes impossible to distinguish the piano from the banjo in the recording.

0:00	**Introduction:** Dual cornets play cascading lines in diminished harmony, joined by Johnny Dodds and Dutrey's downbeats.
0:05	**First Chorus:** A model of New Orleans polyphony through *collective improvisation,* clarinet winds up and down arpeggios and trombone moves slowly through chord tones while Oliver and Armstrong play the main melody (the most difficult part to hear because of the recording quality).
0:21	**Second Chorus:** More collective improvisation over the basic melody, this time played more freely.

Music Analysis (continued)

0:37 **Third and Fourth Chorus:** Clarinet Solo. Johnny Dodds plays over **stoptime** rhythm section and background brass.

1:10 **Fifth Chorus:** Louis Armstrong plays an open cornet solo hinting at the basic melody while Oliver rests. Armstrong's solo repeats a rhythmic idea almost all the way through.

1:25 **Sixth and Seventh Choruses:** Joe Oliver plays a solo in his trademark muted style. His famous opening wah-wah on a blue third is beautiful in its simple human-like quality. His second chorus moves up slightly.

1:59 **Eighth Chorus:** Oliver takes one last chorus, this time rising to the highest pitches on the instrument yet.

2:12 **Eighth Chorus, end:** Oliver's last chorus is cut short with a break, meant for a drum solo. Instead, Bill Johnson hollers "Oh! Play that thing!"

2:14 **Ninth Chorus:** Last head, this time led by Armstrong.

2:30 **Tag:** Typical with New Orleans jazz forms, the band repeats the last four bars and ends abruptly (with a choked cymbal crash from Dodds).

OTHER IMPORTANT NEW ORLEANS MUSICIANS

Jelly Roll Morton

Cloudy truths seem to abound in the stories of the founding fathers of jazz. Like Buddy Bolden, the biography of pianist **Jelly Roll Morton** has been told in a number of different versions. However, where Bolden was elusive to public life, Morton was hungry for media attention. Many of the mistruths came from his own mouth. Important jazz musicians tended to exaggerate when they gave interviews, but Jelly Roll takes the cake. In a letter to *DownBeat* magazine from 1938, about the time of a resurgence of popularity for early jazz music, Morton claimed to have *invented* jazz in 1902. (He would have been 12 years old at the time!)

Although we know his claim is false, that there were certainly several inventors of jazz, Morton's contributions to the form are impressive nonetheless. Morton was born on October 20, 1890, named Ferdinand Joseph Lamotte. Among the many inconsistencies in his biography was his family heritage. Morton claimed to have descended from the original French immigrants to New Orleans, but his sister presents a more likely contradiction, that the family was part Jewish. In 1894 his mother married William Mouton (Ferdinand changed the spelling to the more English *Morton*). When Morton was 14 years old his mother passed away and he moved in with his grandmother. During this period Morton began to eavesdrop on the activities taking place in Storyville, and eventually was offered a job as a **piano professor**, a solo brothel pianist. Morton told his grandmother that he was being switched to the nightshift at the barrel factory where he was supposed to be working, and brought home the same wages he had earned in the menial job. After his grandmother discovered that Morton was playing music in Storyville, they had a falling out and he left New Orleans. Soon in legal trouble, Morton was sentenced to work on the city chain gang but was saved by entertainer William Benbow. Morton left with Benbow

> "It is evidently known, beyond contradiction, that New Orleans is the cradle of jazz, and I, myself, happened to be creator . . ."
>
> —Jelly Roll Morton, *DownBeat* Magazine, August 1, 1938

Piano professor—The house pianist at a New Orleans brothel.

and performed with his traveling Vaudeville show, appearing in blackface and engaging in plantation humor. From this point on, Morton lived an itinerant life more akin to a country blues musician than a jazz artist. His career brought him across the United States and briefly into Canada and Mexico through St. Louis, Las Vegas, Wyoming, and extended stays in New York, Los Angeles, and Chicago.

He tended to work as a solo pianist, occasionally augmenting his sound with a couple of wind instruments, but his chief means of garnering income was gambling and playing pool. Morton would sometimes even earn money pimping. He was flamboyant to the extreme in matters of his appearance. He enjoyed wearing suits and silk shirts (sometimes changing multiple times per day), and had a diamond inlaid in one of his front teeth and pinned onto his underwear. From about 1917 to 1923, Morton lived in Los Angeles but continued playing cabaret and restaurant gigs up and down the west coast.

Jelly Roll Morton's compositions and recordings display a progression from sophisticated Scott Joplin-era ragtime to a looser syncopated piano form. Blues melodic ideas and adventurous improvisational phrases are played in octaves in the right hand, and the left hand often creates a dialogue with its own melodies. All of this intricacy is heightened with a solid swinging rhythmic feel. In recordings for the Library of Congress, interviewed by Alan Lomax, Morton claimed that jazz must have a "**Spanish tinge**," at least hints of the Spanish and Cuban habanera rhythm. (Listen to the Spanish rhythmic figure in the background of the Red Hot Peppers' "Billy Goat Stomp.") Jelly Roll's style is more indicative of the sound of solo piano in New Orleans than the instrumental rag sound that would soon be called "jazz." But in his recordings with bands, we hear his approach adapted to the instrumental setting.

Music Analysis

"Maple Leaf Rag, St. Louis Style / Maple Leaf Rag, New Orleans Style (1938)

Personnel: Jelly Roll Morton, piano

This recording was made by Alan Lomax, one of many he made for the Library of Congress to document American music. Morton uses Scott Joplin's "Maple Leaf Rag" to demonstrate the difference between ragtime and the New Orleans style of piano music that led to jazz. The recording opens with Morton's rendition of St. Louis-style ragtime, probably at a much faster tempo then Joplin intended the piece to be played. Then he explains the shift to a New Orleans style and immediately begins to play. Morton's New Orleans version is only loosely based on the "Maple Leaf Rag." He follows the basic chord changes of the piece, but the melody is completely reinterpreted. The most obvious feature of the New Orleans version is that it swings. Morton's new rhythmic feel lays a staggering triplet-based right hand rhythmic feel against a stomping pulse, a clear link to swing jazz.

0:56: Morton's version opens with an introduction pulled from the second part of Joplin's A section. It is possible that Morton forgot the beginning of the piece. The rhythm is radically changed from the original version, but the melody follows essentially the same contour. The same can be said about Morton's approach throughout most of the piece.

1:07: The full A section appears here. The right hand is close to Joplin's, but the bass line takes prominence.

1:29: In the B section, Morton's right hand is far closer to Joplin's version, but again, the rhythms are changed. The left hand bass takes the improvisational lead this time, with open octaves moving up and down the scale, often with syncopated rhythm.

Music Analysis (continued)

1:50: He re-enters the A section, again starting halfway through Joplin's A section.

2:10: After slight hesitation, Morton moves into the second half of the piece. In the C section, the left hand is basically the same as Joplin's version, with occasional "Spanish" rhythm. The right hand is largely improvised with open octaves.

2:30: In the repeat of the C section, again the right hand is improvised.

2:50: The D section. Morton completely ignores Joplin's melody here and improvises based on the chords of the original.

3:30: Morton's final three chords are very close to Joplin's, only with slight rhythmic variance.

In 1923 Morton made a series of important recordings at Gennett Records in Richmond, Indiana, for Walter and Lester Melrose, who were publishing his piano compositions. The men recorded Morton on solo piano as a promotional tool for sheet music sales. The Melrose brothers also asked Morton to collaborate with one of the hottest white bands in Chicago, the **New Orleans Rhythm Kings**. These recordings would become the first interracial recording of jazz music for commercial release. He recorded with NORK on arrangements of his compositions, "Mr. Jelly Lord," "London Blues," and a song, "Milneberg Joys," for which he shared composer credit with other NORK band members. (Morton added a four-measure introduction and bridge to the song.)

In 1926 the Victor Talking Machine Company offered Morton a recording contract and the ensuing recordings would become his most revered, and are considered a high water mark for recordings made in the New Orleans jazz style. A band was formed for the sessions, made up primarily of New Orleans musicians who were busy playing in Chicago. Many of them also appeared on Louis Armstrong's important Hot Five and Hot Seven recordings and also worked with King Oliver. Trombonist Kid Ory, banjo player Johnny St. Cyr, clarinetist Omer Simeon, cornet player George Mitchell, bassist Johnny Lindsay, and drummer Andrew Hilaire joined the Red Hot Peppers for the sessions. Besides the excellent playing of the band members, a number of things make these recordings special. Morton's orchestrated introductions and breaks give the tracks a series of events, a sense of organization not normally heard in early jazz. We can also hear in the rhythm section a clear organization of roles, and definite rhythmic figures and patterns. Technology also plays a role in the excellent sound of the recordings. Victor used the new electrical process to make these recordings, which captured a more realistic tone from each of the instruments, and was able to handle a broader range of sounds. The Red Hot Peppers are some of the first jazz recordings in which we can clearly distinguish the instruments from each other, and we get a better representation of what the group would have sounded like in person.

Sidney Bechet

One of the most recognizable sounds in early jazz was the aggressive clarinet and soprano saxophone of **Sidney Bechet** (pronounced "Bash-ay"). He developed a reputation for having a volatile temper, an intensity that he seemed to channel into a hard-edged tone and jackknife vibrato on his

instrument. The scandals of his life—two deportations from Europe after violent episodes during the 1920s—threaten to overshadow his musical importance, but his influence on jazz was profound, performing with both Duke Ellington and Louis Armstrong. One of his most important contributions was emerging from the collective improvisation texture of early jazz and playing solos with a high level of variety and melodic strength. Along with Louis Armstrong, Bechet ushered in the new era of the jazz soloist.

Born in 1897 in New Orleans, Bechet was raised on the parade band tradition of New Orleans, sometimes doubling on cornet. He played parades with Louis Armstrong when the two were learning the trade, and performed for Freddie Keppard and other important bandleaders. He took clarinet lessons with Lorenzo Tio, Jr., a leader of the rich clarinet tradition in New Orleans. Bechet was among the first class of musicians to leave New Orleans in 1916, touring with different bands. In 1919 he connected with composer Will Marion Cook in Chicago. Cook had been hailed as one of the first important Negro composers, producing an important *Afro-American Symphony*, but was most successful writing for musical theater. Cook had studied composition under the Czech master of the orchestral medium Antonin Dvořák, and in the process influenced Dvořák Cook's Southern Syncopated Orchestra was an all-black group made up of both instrumentalists and singers that played a mixture of light classical pieces, ragtime, spiritual, and a variety of other styles.

Bechet joined the Southern Syncopated Orchestra on a tour that brought him to England, winning critical acclaim as a soloist in the orchestra. The group performed for King George V and Edward, Prince of Wales (and later, King of England). The group afforded Sidney Bechet considerable solo space and he drew the attention of respected musicians. The Swiss conductor Ernest Ansermet praised Bechet as an important milestone in the development of music, an "artist of genius."

Bechet purchased a straight soprano saxophone while in England, an instrument that would increase the volume he could produce and intensify his already biting tone. When Cook left Europe, Bechet stayed behind with some of the other musicians, playing in England and Paris. Several important jazz artists would follow Bechet's lead over the next few decades by moving to Europe to perform for a more welcoming public.

Back in the United States, Bechet performed for a time in 1923 with the Duke Ellington Orchestra in its earliest days, and joined Clarence Williams' Blue Five in 1924, sharing the front line with Louis Armstrong. It is in recordings of the Blue Five that we hear the beginnings of the *soloist* conception of jazz.

In 1925, Bechet returned to Paris, and then on to Russia. Upon returning to Paris, he was arrested and spent several months in jail after a gunfight in the streets near Montmartre. After his release, Bechet's career would continue this restless trajectory until it took a downturn along with the economy during the Great Depression. The '30s were essentially a lost decade for Bechet, but like many early jazz musicians, he found an audience again in the 1940s with the revival of *trad jazz*.

TO CHICAGO

Jazz arrived in Chicago July 17, 1915. A white band led by trombonist Tom Brown was hired to play dances at Lamb's Café in the Loop District

(midway between the North and South sides of Chicago), and with the eventual success of this first New Orleans import, other Chicago cabarets, café's, and clubs followed suit. Jazz became a must-have in Chicago, instantly coloring the city's entertainment sphere with the sounds of the South. Several of the finest New Orleans musicians headed north, staking their claim on a larger and more cosmopolitan clientele. New Orleans bands worked in white clubs and black clubs spreading the sound of jazz. While these migrating musicians spurred the next wave of change in the music, they also benefitted from greater exposure and increased wages.

The ODJB

The first jazz band to make a commercial recording came together during the first musicians' exodus to Chicago, but quickly passed on to New York. Cornetist Nick LaRocca and clarinetist Larry Shields formed a band in New Orleans in 1908, and both were active freelancing musicians on the New Orleans scene. At the same time, LaRocca and trombonist Eddie Edwards practiced together, improvising duets. One booking agent, Jack Laine, managed the lion's share of music jobs in New Orleans and, like the vast majority of notable white musicians, the three worked regularly for Laine. LaRocca was first brought to Chicago along with other New Orleans musicians in March 1916 to perform dance music at Schiller's Café, and Shields was brought up by another group. By this time, **"jass"** bands were already becoming something of a commodity, and with nightly full crowds, these first Chicago/New Orleans bands negotiated for pay increases and traded players amongst a number of venues. Eventually, La Rocca joined with drummer Tony Sbarbaro, trombonist Eddie Edwards, pianist Henry Ragas, and clarinetist Yellow Nunez and formed the **Original Dixieland Jass Band**. They judiciously decided to call themselves a "Dixieland" band, linking the band to the South, but not specifically Louisiana or New Orleans. The band moved into Casino Gardens, owned by their agent Harry James in the North Side of Chicago, and after several disagreements between LaRocca and Nunez, Larry Shields replaced Nunez on clarinet. After less than a year Max Hart, New York booking agent and father of the legendary Broadway lyricist Lorenz, found a new engagement for the band at the 400 Club Room in Reisenweber's Restaurant in the Upper West Side of Manhattan.

Jass was an early label for the music we call "jazz" today.

The band opened its first night with the standard "Tiger Rag" to a tentative response, but as the evening drew on they won over the dancers and on subsequent nights the dance floor was packed and a line was out the door. The next month, they recorded their first single for the Victor company with "Dixie Jass Band One Step" and "Livery Stable Blues," a novelty number that caught on like wildfire. The single sold more than a million copies during the first year after its release to listeners eager to hear the band play sound effects—the clarinet's rooster coo, the cornet's horse whinny, and trombone's mooing cow. The ODJB's first recording was both panned as a cacophonous mess and hailed as the finest dance music ever made. In these first sides, Larry Shield's wiggly clarinet is featured more prominently than the other instruments, a new virtuosity that would have struck most listeners as a completely alien sound. The next class of important clarinetists, Johnny Dodds and Benny Goodman among them, sited Shields as an important influence.

Music Analysis

"Dixie Jass Band One-Step"
(1917)
Personnel: Nick LaRocca, cornet; Larry Shields, clarinet; Eddie Edwards, trombone; Henry Ragas, piano; Tony Sbarbaro, drums

The most prominent sound on this recording, and the featured member of the group, was clarinetist Larry Shields. Cornetist Nick LaRocca is difficult to hear in this recording, although this is likely due to recording techniques and placement of the musicians in the room. In concert, LaRocca was reportedly more prominent. The song is organized by a typical ragtime form with a third repeat of the extended C section.

0:00	**A section:** A start-stop rhythm opens each phrase, possibly meant to evoke a marching drum cadence. Then the full band plays ragtime rhythms in collective improvisation.
0:08	**A section:** The same pattern is repeated.
0:16	**B section:** This strain opens with two measures of **stop-time**. Larry Shields plays the melody over the silence, then the full band reenters.
0:24	**B section:** The same pattern is repeated.
0:32:	A section and repeat
0:47:	B section and repeat
1:02	**C section:** The song moves to a new key center, and collective improvisation texture continues. Larry Shields plays an oscillating two-note figure and Eddie Edwards slides between chord roots in **tailgate trombone** style. Sbarbaro becomes more active on the drums, moving to a woodblock and cowbell. The piano and cornet are difficult to hear, but seem to play a simpler style than the other musicians.
1:33	**C section:** The same music is repeated.
2:03	**C section:** The band plays the same music a third time, using essentially the same melodic idea heard in earlier repetitions.
2:34	**Coda:** The final measure is repeated for a short ending.

Before the group disbanded in 1925 they brought jazz to Europe. In 1919 they performed in France for the celebration of the signing of the Treaty of Versailles. They also played a concert for the King of England at Buckingham Palace.

Name _____ **Date** _____

Discussion Questions

1. Explain how the Legislative Code of 1894 caused creole and black styles of music to mingle and create jazz.

2. Listen to "Dippermouth Blues" and describe the nature of collective improvisation. What role does each instrument play—clarinet, trombone, 1st and 2nd cornet?

3. Describe the contributions each of the three cornet kings (Buddy Bolden, Freddie Keppard, and King Oliver) made to the development of early jazz.

4. Jelly Roll Morton's recording of "Maple Leaf Rag" illustrates the New Orleans approach to ragtime that led to jazz. Listen to the track and describe the contrast between the two styles in terms of specific musical characteristics.

5. What bands and musicians were responsible for spreading New Orleans jazz to other regions of the United States, and eventually, worldwide?

Migration and Proliferation: Jazz in Chicago

THE GREAT MIGRATION

At the outset of America's involvement in World War I, weapons, supplies, and other machinery of war were built in cities in the Northeast and Midwest. African-American workers flooded into urban centers north of the Mason-Dixon line in response to the increased demand for laborers, escaping racist mistreatment and meager wages. This massive movement of millions of African Americans over several decades of the 20th century was called the **Great Migration**. Musical activity was highly concentrated in three of the urban centers: Chicago, New York, and Kansas City. A major jazz scene developed in each city, where a boom of performing work presented itself to the top rungs of a competitive field of musicians.

South Side Chicago became home to an enormous number of African-American immigrants, partly due to articles, political cartoons, and advertising campaigns published in the *Chicago Defender*, a weekly newspaper that catered to an African-American audience. The population of black Americans in Chicago grew by more than 400% from 1910 to 1930. More black Chicagoans meant an expanded audience for hot jazz as African-American workers made enough income to enjoy both live and recorded music, resulting in the growth of the South Side jazz scene. When prohibition began, saloons transitioned to Vaudeville-style cabarets and incorporated song-and-dance floorshows in order to attract customers. A loophole in the federal liquor law allowed patrons to walk in with their own liquor supply in hip flasks (an origin of the label "hipster"), so venues provided "set ups" at the bar—mixers with glasses of ice. Musicians performed their own music for dancing and enjoyment, but they also backed singers, professional dancers, comedians, and other performers.

In this chapter, we will cover:

- The Great Migration
- The Roaring '20's
- **Louis Armstrong**
- White Chicago Jazz—**The Austin High Gang**, **Bix Beiderbecke**, and **Frank Trumbauer**
- Boogie-Woogie Piano
- Demise of Chicago Jazz

Great Migration—From 1910 to 1930, the black population of Chicago grew from 44,103 to 233,903 (U. S. Dept. of Commerce, Bureau of the Census, *Negroes in the United States 1920–1932* p. 55).

THE ROARING '20s!

Social Change During the Roaring '20s

Nicknames prescribed to the decade that followed World War I paint an optimistic and energetic picture—"the Roaring '20s," "the Golden '20s," "the Jazz Age." Certainly, it was a time of optimism. The United States economy was booming, and middle class young people of both sexes were

hungry for entertainment. A common picture was the freewheeling lady of the 1920s, the **flapper**, dressed in a short skirt and wearing a bobbed hairstyle. The new kind of youngster demanded more from life than their parents. They were born into more privilege and wealth, and they lived in a world of modern inventions of convenience, such as the washing machine, the vacuum cleaner, and the automobile.

Chicago youths could find distinct types of entertainment in different districts. Large dance halls in North Side Chicago tended to feature the music of white bands playing a "sweet" brand of music. Sweet music was more linked to the popular styles of dance performed in front of the band and stuck close to the notes written on the musicians' sheet music. In the South Side community, however, bands played in cabarets often dubbed "**black-and-tans**" for the multi-racial integration that went on inside. Black performers were hired to entertain both white and black patrons with music that derived from Vaudeville traditions and southern ragtime, essentially a new blend of Afro- and Euro-American music. The bands performed for floor shows and backed singers, dancers, and comedians. The music on the South Side linked more strongly to the "hot" style tinged by the blues and improvisational approach. At the black-and-tans, whites and blacks sometimes danced together, certainly a taboo at the time. Professional dancers demonstrated the steps, and then the patrons moved to the dance floor and imitated the professionals.

This integration, however, occurred against a backdrop of social volatility. In July 1919, race riots erupted after white police were accused of gross negligence. White young people stoned a black teen and drowned him in Lake Michigan. When police refused to arrest the white instigator, black gangs attacked white gangs on the South Side. By the time the dust cleared, twenty-three African Americans had been killed and 1,000 lost their homes to fires set during the riots. The volatility was only amplified by corruption that revolved around prohibition. In 1920, the **Volstead Act** became active, outlawing the production and sale of alcoholic beverages. Chicago mayor Big Bill Thompson enforced the law unevenly. Alcohol flowed at clubs the mayor selected as essential entertainment venues. Royal Gardens, for example, became the entertainment center when Thompson managed to bring the Republican National Convention into the city. Other clubs had to deal with intense pressure from police. Performers at the Sunset Café claimed to have been rounded up just about every night by the cops.

> **Black-and-tan**—A nightclub that caters to multi-racial patrons.

> The **Volstead Act** made Prohibition a reality, federally banning alcohol across the U. S.

Jazz: The Soundtrack for the Roaring '20s

In Chicago during the 1920s, for the first time a critical mass of musical activity and audience support coalesced to spawn a new style of jazz, a style which we now recognize as an embryonic stage for the swing music that took the nation by storm in the 1930s and '40s. Generally speaking, Chicago jazz (also called "jass" at the time) developed into a form that maintained the collective improvisation and many of the song forms of New Orleans jazz, but the new exponents of the form played a more frantic, even angst-driven brand of jazz. The large dance halls of Chicago resulted in changes of instrumentation. A second cornet was added to provide a harmony part to the principal cornetist, and eventually, saxophones were used in the place of clarinets.

The new youth class inadvertently planted the seeds of a social revolution with jazz. Black musicians who had emigrated from New Orleans entranced a group of middle class, white Chicagoans. The youngsters rebelled against the Victorian values of their parents by going "slumming" in clubs where they could observe and absorb the music made by their heroes. In this friendly exchange over musical admiration, the racial boundaries between white and black were weakened. The most significant New Orleans jazz artists flourished in Chicago, most notably Joe "King" Oliver and Louis Armstrong, and a new group of key musicians made significant contributions to the form—Earl Hines, Bix Beiderbecke, and later, Benny Goodman. After about a decade of bustling activity, Chicago jazz demonstrated how suddenly a jazz boom could bust only to watch the music take hold in cities to the east.

Jazz Changes Due to Outside Pressure

A moral fear of dancing caused a major change in the music. The Juvenile Protection Association, a group determined to monitor the behavior of Chicago youth, had their eye on Chicago dance halls. The JPA was concerned that couples dancing in the clubs were stirring up lustful urges. Slow blues from New Orleans was deemed too sexy and encouraged dance styles that were far too intimate for JPA approval. The JPA met with a group of dance hall managers, advising them to require their bands to speed up the tempos. Faster, peppier tempos wouldn't give the dancers a chance to get "fresh." In 1921, the club owners put the JPA's list of standards in place with the intent to increase the amount of space between dancers. Cabarets hired JPA staff as hostesses and chaperones so they could keep an eye on the dancers. Although we listen to the early Chicago jazz recordings for an approximation of the sound of New Orleans, the tempos heard on the ODJB's "Dixie Jass Band One Step," and Joe "King" Oliver's "Dipper Mouth Blues" were probably not common to New Orleans. Sure enough, both pianist Earl Hines and banjoist Johnny St. Cyr (a New Orleans native) claimed that a slow tempo in Chicago would be considered fast by New Orleans standards.

Record Companies Impact Jazz

Picture this: the Chicago Coliseum, at Wabash Avenue and 14th through 16th Streets, was a frequent site of Republican national conventions and future home of the Chicago Blackhawks professional hockey team. On February 27, 1926, it was filled with fans of race records for a special event titled "OKeh Race Record Artists Night." OKeh Record company, the organization that had already helped give rise to the race record industry with Mamie Smith's "Crazy Blues," publicized a concert in Chicago featuring a host of big names in race records: Joe "King" Oliver, Clarence Williams, and Bennie Moten. The main event, however, featured up-and-coming superstar Louis Armstrong and his Hot Fives alongside blues guitarist Lonnie Johnson. The gimmick—Armstrong, Johnson, and company would demonstrate how a record was made. The band played a number while recording technicians captured the performance on disc. The technician then turned around and played the record for the audience, surely to no shortage of "ooohhhs" and "aaaahhhs."

This was, of course, the company's way to stir up excitement around the new process of sound recording, featuring the newest celebrities on their roster. More importantly, it demonstrates a real shift in the way jazz was made, and its purpose, through the medium by which it was consumed. Record companies played an important role in how music was perceived and preserved during the 1920s, they played a role in how jazz artists would make a living, and they played a role in what music would stand the test of time or what would be forgotten as mere statistics in history books.

Record players were becoming more common. The OKeh company had been keeping track of the sale of record players, and sales in African-American communities were so strong that profits drove record companies to focus their attention on jazz race records. Music in New Orleans was social. It was functional. It was created at dances and casual events where the band could take their time with the music, and where a moment of brilliance was fleeting. In Chicago, when companies like OKeh recorded these bands, moments of brilliance and failure were cut into the shellac disc, preserved for posterity. Performance duration was limited to approximately three minutes because of the size of the wax discs being used in the studio. The recording artist was born. Those jazz musicians who survived the forward march of history were the ones who mastered the art of recording, who could condense their performances down to just a few seconds instead of stretching out over as many minutes as needed. Other adjustments were made as well, often limited by the inadequacies of recording technology of the time. Performers played into a single recording horn in front of them, and the distance from each instrument to the recording device determined the balance between instruments.

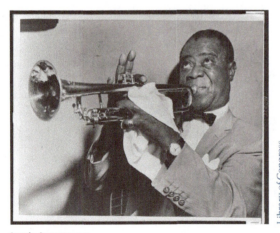

Louis Armstrong

Library of Congress

LOUIS ARMSTRONG

In the history of jazz, no name is more familiar, no character more famous, than **Louis Armstrong**. He is an icon we identify with jazz. His joyful character, his smile, and his gravely singing voice gave him a level of celebrity unmatched by any other jazz musician. Louis Armstrong was a brilliant entertainer whose work has brought more attention to jazz than any artist, during any period. And in general, jazz musicians and historians are comfortable elevating him as a kind of patron saint of jazz. They recognize that Armstrong was able to accomplish something almost no other jazz artist has accomplished. He was an intensely famous mainstream celebrity whose body of artistic work reached the highest echelon. Armstrong is one of only a handful of musicians who have been able to entertain the entire world while they revolutionized their art form.

We also appreciate Louis Armstrong because his life story is the ultimate object lesson for what can be accomplished in America. He embodies and illustrates the "self-made man" and the "melting pot" clichés that are so often used to describe the American experience. Armstrong arose from extreme poverty and ethnic disadvantage—an African American at the dawn of the 20th century in a southern city—and gained acceptance and

success in an America that often looked upon his ilk with distain and hostility. His artistry is the strongest explanation for his success. And to many, his music was proof enough that any human, regardless of race, was capable of great genius. Charles L. Black, Jr., was a lawyer who worked on the *Brown v. Board of Education* (1954) case in the U.S. Supreme Court. Black claimed that witnessing Armstrong's genius at a concert at an Austin, Texas, hotel in 1931 was instrumental in forming the foundation of his belief in human equality. His work on the *Brown* case with Thurgood Marshall's NAACP Legal Defense and Education Fund resulted in a unanimous Supreme Court decision against the notion of "separate but equal" in the field of public education. Louis Armstrong's artistry and genius went beyond mere popularity and lofty artistic merit to actually lay the groundwork for societal change in America.

Louis Armstrong's Early Life

Armstrong's humble beginnings in New Orleans and his unheralded arrival in Chicago make the path to his significance that much more impressive. He claimed in a couple of autobiographies that he was born on the most patriotic of days, July 4, 1900. In fact, he was born a year later. Armstrong grew up in the roughest of rough neighborhoods in New Orleans. His father was absent. His mother lived in black Storyville, and may have worked as a prostitute. He lived for a time with his grandmother in an area called "the Battlefield" where crime and violence thrived alongside wholesome families. Armstrong's earliest exposure to music-making may have been in church, singing gospel music. He remembered being happy as a child, despite living in one room with his mother and sister and having to work at a very young age to help support them. He developed a fondness for a Jewish family, the Karnofskys, which gave him respect at an early age for people of other races. The Karnofsky family gave him work, fed him, and even loaned him the money he needed to buy his first cornet. The family left such an impression on Armstrong that he wore a Star of David throughout his life.

It was around this time that Armstrong would have heard early ragtime-blues cornetists Buddy Bolden, Joe Oliver, and Bunk Johnson as he stood outside the Funky Butt dance hall and observed the sounds and sights of black Storyville. These early influences would become formative to his later career, but most particularly Oliver, who would later become Armstrong's mentor and bandleader. At twelve, Armstrong made a mistake that changed the course of his life for good. Firing off a pistol loaded with blanks on New Year's Eve, he was arrested and sentenced to spend the next few years at the Colored Waif's Home for Boys. The regimented daily schedule at the Waif's Home required discipline from its tenants, but it also gave Armstrong his only opportunity to study music seriously. Armstrong joined the twenty-piece Waif's Home Brass Band and brought his fellow students to attention playing bugle calls. In the school band, Armstrong played traditional songs like "When the Saints Go Marching In" and "Maryland, My Maryland" along with arrangements of classical works by European composers such as Franz Liszt, J.S. Bach, Gustav Mahler, and Franz Joseph Haydn.

After his time in the Waif's Home, Armstrong reentered a life caring for his immediate family and playing music late at night, often in raunchy

Louis Armstrong is a connecting figure to the earliest jazz musicians Buddy Bolden, Joe Oliver, and Bunk Johnson.

honky-tonks. During this time, he apprenticed with the cornet player Joe "King" Oliver. When Oliver left town in 1918, Armstrong took his place in trombonist Kid Ory's band, now making a decent wage and building a real reputation as a cornerstone New Orleans musician. The next year, he left Ory to join Fate Marable's band on a steamboat that worked the Mississippi River between St. Louis and Minneapolis. Armstrong was required both to improvise and to perform music from the written page without much rehearsal. Marable gave Armstrong daily sight-reading lessons on the boat, and performances challenged Armstrong to play difficult passages that were originally written for clarinet and other woodwinds. He also joined up at this time with drummer Warren "Baby" Dodds and bassist George "Pops" Foster, two musicians who would accompany him just a few years later on his first recordings as a leader. A cold he picked up during his time on the boat may have been the origin of Armstrong's trademark grumbly speaking and singing voice. He returned to New Orleans and joined the famed Tuxedo Brass Band until, in 1922, he was called up to the big leagues by his old mentor, Joe Oliver. A quick look at the timeline of Armstrong's early career demonstrates just how quickly things happened for him during the next few years:

> **Mississippi riverboats were an important source of employment for early jazz musicians.**

> ### Louis Armstrong's early professional career
>
> 1916–1922—New Orleans clubs and informal events, Mississippi River boats with Fate Marable
>
> 1922—with Joe "King" Oliver in Chicago
>
> 1924—with Fletcher Henderson in New York City
>
> 1925—with Lil Hardin in Chicago, begins recording his Hot Fives

King Oliver's Understudy

Joe "King" Oliver's Creole Jazz Band accepted a steady engagement playing dances at Lincoln Gardens in Chicago, the largest cabaret on the South Side. It was *en vogue* at the time for bands to use two cornets. Also, Oliver's deteriorating dental health was weakening his playing and he needed a strong second to mask the shortcomings in his own playing. Recordings reveal the affects Oliver's health took on his sound at the same time that they showcase Armstrong's power and clarity. The bandmembers confirmed that Oliver played directly into the recording horn, the single apparatus that picked up the sound. Armstrong stood behind the rest of the band in order to balance the two players. Still, when we listen to "Dipper Mouth Blues," Louis Armstrong's sheer volume obscures the leader's lead melody at times.

At Lincoln Gardens, Oliver and Armstrong developed a trick that made their audiences believe they must have a telepathic connection. They became famous for their **breaks**, a common practice in early jazz where the musicians stop playing after beat one and a soloist continues through the silence. Most often, breaks happened during the last two measures of an eight- or four-measure phrase. What made Armstrong's and Oliver's approach unique was that they played their breaks as a duet. Oliver's recording of "Snake Rag" offers a hint of what audiences heard (at 2:12 and 2:47

> **Break**—A musical passage during which the rhythm section rests while the soloist continues playing in tempo.

on the recording). The two cornets sound uncannily in sync. Live audiences were mystified when they heard the bottom drop out of the band's sound and two cornets continued with a harmonized line in rhythmic unison. The truth behind their duet breaks demonstrates an unmatched level of interaction and communication between the two cornet kings. During the phrase of collective improvisation that preceded a break, Oliver played a melody to Armstrong that would reappear during the break. It seems Armstrong took the signal from Oliver, absorbed his improvised line even while Armstrong continued playing, and was ready at the break with his own harmonized version of the idea!

The College of King Oliver's Creole Jazz Band

While Armstrong was busy making a name for himself in Chicago performing with Oliver and other notable bandleaders, he worked hard during these years to perfect his playing. Armstrong was influenced by Oliver's natural approach to melody, even though he had difficulty mimicking his idol's wah-wah mute effect. Melodic clarity would be one of Armstrong's most lasting traits in later recordings under his own name. At the same time, he was studying harmony. At least a couple of the musicians in the Creole Jazz Band studied music theory and harmony twice a week in order to play notes within the chords. The ease with which Armstrong navigates chord changes in his improvisations is a hallmark that separates him from the pack of Jazz Age cornet players. Pianist **Lil Hardin** may have been one of his theory teachers at this point, having attended Fisk University in 1914 and earned a teaching certificate from Chicago Musical College in 1928. Although other pianists would outshine her playing, Hardin turned out to be as important an influence as Joe Oliver. Lil saw great potential in Louis and took steps to change his image and help his musicianship so that he could reach greater heights. She became his second wife. (His first, Daisy, was a New Orleans prostitute. In his autobiography *Satchmo*, Armstrong wrote several accounts of her physical abuse—bricks thrown at his head, a knife at his throat.) Lil urged Louis to leave Oliver's band in order to come out from the shadow of his mentor. Soon, a call came from New York bandleader Fletcher Henderson to join his organization, an opportunity with greater potential for nation-wide and world-wide recognition. After only two short years in Chicago, Armstrong left for New York in 1924. He would soon return to Chicago and make his mark as a bandleader.

Armstrong's Impact in New York City

Fletcher Henderson's group was a typical dance band at the time, playing written arrangements at the Roseland Ballroom for a white audience in Harlem. As was the practice in the Chicago music scene, these dance bands often brought a "hot" soloist into their stable, and Henderson selected Louis Armstrong for this purpose. With Henderson, Armstrong introduced the southern conception of swing rhythm and blues language into the urban dance environment. With Henderson, Armstrong was able to impact the face of contemporary music in New York, a platform that introduced him to the world. Armstrong's band mates began to copy his style of solo improvisation. Coleman Hawkins, who would soon usher in the tenor

saxophone and become an important bandleader in his own right, copied Armstrong's improvisational approach sitting in the band with him night after night. Armstrong's rhythmic ideas, his dictionary of melodic phrases, and his conception of swing heavily influenced not just Hawkins, but also Henderson's arranger Don Redman. Redman began writing in the style of Louis Armstrong, so that the Fletcher Henderson Orchestra became a kind of conduit of various aspects of Louis Armstrong's playing. In just fourteen months with Henderson, Armstrong made an important impact on the cosmopolitan music center of New York Center. Moonlighting with a number of record companies, Armstrong also recorded as a sideman on race records with Bessie Smith and other female blues singers, and a series of head-to-head recordings with the great soloist Sidney Bechet.

Hot Five and Hot Seven

In 1925, Armstrong was back in Chicago. Lil arranged a steady gig for him at the Dreamland Café, billed as the "World's Greatest Cornet Player." Lil, herself, was the bandleader. Armstrong immediately entered a recording studio for the OKeh label, producing what are considered today some of the most important jazz recordings of all time. Accompanied by **Johnny Dodds** on clarinet, **Kid Ory** on trombone, **Lil Hardin** on piano, and banjo player **Johnny St. Cyr** (pronounced *seer*), Louis Armstrong's Hot Five recordings preserved some of the finest playing of the day and introduced a fresh approach to jazz.

On the first track released, **"Gut Bucket Blues,"** several characteristics are already apparent to the listener that became hallmarks of Armstrong's new approach. Much has been made of Louis Armstrong's place in history as jazz's first true soloist. Although Sidney Bechet deserves at least a piece of that title, the arrangement of musical events in Armstrong's Hot Five recordings weighted solo improvisation much more strongly than collective improvisation, and Armstrong emerged as the primary instrumental soloist of the age. "Gut Bucket Blues" begins with a short introduction from St. Cyr's banjo (all the while, spurred on by Armstrong's spoken encouragement). The head, a blues, is played in collective improvisation, but after that point a succession of soloists draws the listener's attention from one character to the next in an order that builds in intensity from polite Lil Hardin to raucous Kid Ory to highwire Johnny Dodds to the commanding sound of Louis Armstrong, who rounds up the band for a closing tutti chorus. True, the handoff-of-soloists approach appeared on earlier recordings by other jazz bands, particularly on recordings of blues songs, but Armstrong's statements were more salient and unambiguous. There is a feeling that the other musicians on Hot Five recordings supported a greater whole, Armstrong standing solidly at the front of the company. Notice Armstrong grabbing the final spotlight during a short break at the very end, as if to make it clear that *he* is the one to remember while the band leaves the stage.

An important moment in the Hot Five sessions was Armstrong's singing on **"Heebie Jeebies."** Louis had sung in live performances with Fletcher Henderson's Orchestra and on other occasions, and he had been **scat singing** since he was a boy, singing melodies with wordless syllables and essentially using the voice as an instrument. Recording "Heebie Jeebies," Armstrong claimed to have accidentally dropped his lyric sheet in the

Scat singing—The act of improvising with the voice using wordless syllables, imitating the sound of a jazz instrumentalist.

studio, forgotten the lyrics, and immediately started scatting in place of the lyrics. Armstrong's claim is plausible, since he begins singing lyrics clearly and at one point makes a shift into a cross between nonsense and real words. Armstrong was surprised when the recording staff loved the take, and the record was a successful seller in the race record industry. Scat singing caught on as a popular trend, and Armstrong's singing voice elevated him to a level of celebrity that no other jazz musician would reach.

Armstrong's Hot Five and Hot Seven recordings made clear the contributions of his new musical concept:

Louis Armstrong's New Conception of Jazz

- Changed the focus from *collective improvisation* to *solo statements*
- His melodic ideas become standard jazz vocabulary
- Mastered trumpet technique, evident in his use of the high register and control in all registers
 Listen to **Cadenza** on "West End Blues"
- Mastered syncopation
 Listen to **Stoptime** chorus on "Potato Head Blues"
- Popularized Scat Singing
 Listen to "Heebie Jeebies"
- Became the first worldwide celebrity of jazz

Armstrong connected with key members of the next iteration of the Hot Five when he left Lil Hardin's group (also splitting up their marriage) and joined Carroll Dickerson at the Sunset Café. Dickerson's pianist **Earl Hines** and drummer **Zutty Singleton** became his close friends and professional partners on the Chicago scene. At the Sunset, Armstrong began working for his next hype-man. Joe Glaser, an associate of crime boss Al Capone, ran the Sunset Café and became Armstrong's longtime manager. Armstrong eventually took over leadership of the Sunset orchestra when Dickerson was fired.

Music Analysis

"West End Blues"
(1927)
Personnel: Louis Armstrong, trumpet; Jimmy Strong, clarinet; Fred Robinson, trombone; Mancy Carr, banjo; Earl Hines, piano; Zutty Singleton, drums

A truly quintessential jazz recording, "West End Blues" was actually composed and recorded by Armstrong's mentor and former employer, Joe Oliver, just a couple of weeks prior to this Hot Seven version. Armstrong's "West End Blues" flows clearly through its chain of events, from one soloist to the next, beginning with a **cadenza** that places the focus solely on Louis Armstrong.

0:00	**Trumpet Cadenza:** Armstrong opens the song with an unaccompanied solo that begins in the style of a classical trumpet showman, such as Herbert L. Clarke of John Philip Sousa's band. After a few staccato notes played in straight eighths, he winds an arpeggio upward to a high pitch.
0:05	**Trumpet Cadenza:** Armstrong follows with a bouncy, bluesy line that finally settles on a held low note, answered by the full ensemble holding a dominant chord.

(continued)

Music Analysis (continued)

0:15 **Head:** Armstrong plays the tune's melody harmonized by Jimmy Strong's clarinet. Fred Robinson and the rhythm section play simple accompaniment.

0:51 **Trombone Solo:** Earl Hines plays tremolo (rolled) chords behind Robinson's *smearing* solo.

1:24 **Clarinet/Vocal Duet:** Strong restates the melody in simplified form, using the low range of the clarinet, called the *chalumeau* register. In the spaces, Armstrong answers with a lullaby-like style of scat singing.

2:00 **Piano Solo:** Hines is left alone playing a solo made up of a brilliant succession of musical styles. Hines begins with a cascading finger pattern, followed by a bluesy lick played in double time, and doubled at the octave (2:12). He returns at 2:22 to the cascading pattern and tinkly little melodies that opened the solo.

2:33 **Trumpet Solo:** Armstrong walks up to a long, high note, holding it four measures. Then he brings the pristine solo into the gutbucket with a repeated and rhythmically laid-back blues lick (2:45).

2:57 **Coda:** Earl Hines interrupts with a falling pattern played in voiced chords, answered by Armstrong's closing melody.

Louis Armstrong and Earl Hines

Armstrong's subsequent work in the studio made clear the rapport between him and Earl Hines. Hines's training in classical piano repertoire produced a level of technique and showmanship rarely seen in jazz piano at the time. He was also an experimenter. Hines proudly pushed rhythmic exploration to extreme lengths, sometimes using cross rhythms to obscure the meter or launching into double time, sometimes dropping the pulse altogether, only to land catlike on his feet. Hines had a wide vocabulary of accompanimental styles ranging from ragtime to rhapsodic classical textures. He was known to double his melodic lines at octaves to cut through the loud cacophony of horn bands, a sound called "trumpet style" for its ability to elevate the piano to play a melodic lead role.

Hines would go on to further historic significance in jazz, surviving the swing and bebop eras with bands that incorporated the sounds of both styles. But his work with Louis Armstrong—particularly "Weather Bird" and "Skip the Gutter"—showcased him at his prime and revealed his sharp wit for interaction.

> Earl Hines was known for playing melodic lines in double octaves in his right hand, an approach called the **trumpet style**.

Armstrong's Next 40 Years

Before Louis Armstrong turned thirty, his career and his recorded output had already reshaped the course of American music. Future generations of jazz musicians have pointed to the Hot Five and Hot Seven recordings as the first truly essential classic jazz recordings. The musical phrases that came out of his trumpet bell in the heat of improvisation are still ingredients of the contemporary jazz vocabulary. Even after he had accomplished this important body of work, Armstrong's career continued to reach a broader audience through the selection of popular songs for his repertoire, and a renewed focus on vocal numbers. Armstrong's mannerisms in

Music Analysis

"Weather Bird"
(1928)
Personnel: Louis Armstrong, trumpet; Earl Hines, piano

"Weather Bird" finds Armstrong and Hines playing what sounds like an informal duel, revisiting the jam sessions that may have taken place in the days they played together at the Sunset Café. This tune was originally recorded as a full-band rag at the same Joe Oliver sessions that produced "Dipper Mouth Blues," though Armstrong claimed they made it up on the spot. Hines plays many of his trademark melodic and rhythmic ideas. He expertly changes textures behind Armstrong's solo, even laying out at some humorous spots, and launches confidently into his own solo passages. Especially enjoyable is the ending jaunt where the pair seems to be teetering on the edge of collapse through a series of trades, somehow coming together for a final chord.

0:00	**Introduction:** Hines sets up the feel of the song by pounding ragtime quarter notes behind Armstrong.
0:05	**A section/Trumpet:** Louis Armstrong plays the tune with bubbly swing phrasing.
0:23	**B section/Trumpet:** In the second half of the theme, Hines plays around Armstrong's melodies in "trumpet style" doubled octaves.
0:42	**B section/Piano:** Armstrong lays out while Hines plays a solo, again in doubled octaves.
0:59	**A section/Trumpet:** Armstrong repeats the opening strain.
1:19	**Send off:** This added four-bar phrase functions as an announcement of the next solo section.
1:24	**Piano Solo:** Hines plays a swinging solo in ragtime style.
1:43	**Trumpet Solo:** Hines drops out as Armstrong opens a solo that consists primarily of leaping arpeggios. Hines plays with the pulse behind the soloist, pounding chords that shift on and off the beat.
2:01	**Dueling Trumpet/Piano:** At this point, Armstrong and Hines seem to be attempting to trade, but play against each other instead. Listen for Hines's rhythmic trickery at 2:10.
2:20	**Trading Trumpet/Piano:** Armstrong and Hines trade two measure sections, then accelerate the trading by cutting to one measure sections.
2:34	**Trumpet Break:** Armstrong plays staccato notes moving upward in half steps and arriving on the final note of resolution. Hines plays a final flourish underneath the majestic trumpet.

singing and his approach to the melody of a song—often reducing it down to only the essential pitches and lyrics—were picked up by singers as far-reaching as Billie Holiday, Ella Fitzgerald, and Bing Crosby.

After his last Hot Seven recording, Armstrong began to tour in earnest, making his way in various outfits to Detroit, New York City, Los Angeles, and European sites. He joined up with the Luis Russell Orchestra at the height of the Swing Era and appeared in several films. In 1947 when swing was on its way out, Armstrong formed the All Stars and began playing a style that hearkened back to the New Orleans and Chicago styles of his younger days. Dubbed "trad jazz" along with the music of several 1920s musicians making comebacks, Armstrong turned away from the evolutionary path jazz seemed to be headed down. He criticized the abstract and off-putting style of bebop and instead retreated to earlier styles, although not without excellent musical quality. The All Stars reunited him

with Earl Hines and brought on board trombonist Jack Teagarden, Barney Bigard (clarinetist with Duke Ellington), and drummer "Big" Sid Catlett. The All Star bands carried Armstrong through the remainder of his career.

His last two musical successes seemed to come from nowhere. When jazz was completely out of public favor and the rock bands of the British Invasion had taken over in 1964, Armstrong returned to mainstream success, scoring a hit with "Hello, Dolly!" His vocal version of the song was released the same year as the hit Broadway show and became a #1 hit on the billboard charts, dethroning the Beatles who had completed a string of three #1 hits in a row. The song was awarded a Grammy for Song of the Year. Five years later, Armstrong joined Barbara Streisand on the big screen to sing the song.

> Louis Armstrong's recording of "Hello Dolly" landed at #1 on the Billboard charts in 1964, removing the Beatles' "Can't Buy Me Love."

Fifteen years after his death from a heart attack, July 6, 1971, a song was unearthed from his catalog of recordings to close the poignant war film *Good Morning, Vietnam.* "What a Wonderful World" featured Armstrong's easily recognizable voice and returned the iconic figure to popular memory. Surprisingly, the song entered the Great American Songbook with little fanfare. George David Weiss and Bob Thiele composed it as an antidote for the dark times of the late 1960s—after the assassination of President John F. Kennedy and amid U.S. involvement in the Vietnam conflict—and Armstrong was said to have identified with the song's optimistic message while he was dealing with the heart condition that eventually killed him. But record executives were not interested in promoting the song in the United States. Although the song met some success in the United Kingdom, it wasn't until the release of *Good Morning, Vietnam* in 1987 that the world was reintroduced to Armstrong's message—his stubborn optimism in the face of adversity.

WHITE CHICAGO JAZZ

Some of Chicago's young jazz enthusiasts actually managed to become professional jazz musicians themselves. A group of die-hard jazz fans called themselves the **Austin High Gang**, after the high school some of them attended in the sleepy subdivision of Austin, just outside West Side Chicago. In 1922, Jimmy McPartland (cornet), Richard McPartland (guitar/banjo), Bud Freeman (tenor saxophone), Frank Teschemacher (clarinet), Dave North (piano), and Jimmy Lannigan (string bass/tuba) gathered at the Spoon and Straw soda fountain and listened obsessively to early jazz albums. Jimmy McPartland claimed they taught themselves to play the style by listening and playing along with "Farewell Blues" by the New Orleans Rhythm Kings, each player picking out his own part. The young musicians of the Roaring '20s were some of the first beneficiaries of the recording industry to be able to learn a musical style in this manner—by listening to a recording instead of having to actually witness the style being played live. Although the Austin High Gang never recorded an album together as a full unit, the clique meandered out into the greater Chicago jazz scene finding work in various settings. They strove to break from the gentile sounds of white dance bands at the time, instead incorporating hot jazz and wild improvisation. They religiously sought out the New Orleans Rhythm Kings, Joe Oliver, and Louis Armstrong in various clubs. Other

notable musicians became associated with the group—drummers Davey Tough and Gene Krupa, banjo and guitar player Eddie Condon, and the clarinet man who would eventually earn the title "King of Swing," Benny Goodman.

Bix and Tram

Leon "Bix" Beiderbecke was a kind of enigma in jazz history who came from the most unlikely of places and joined the top rung of the professional jazz world. Beiderbecke grew up in Davenport, Iowa, just off the Mississippi River within earshot of Louis Armstrong when he worked the steamboats with Fate Marable. He was exposed to the piano through his mother, a church organist. His piano teacher had a hard time teaching him anything because he would not focus on reading sheet music. Instead, his ear would lead him to the notes he needed to play. Beiderbecke became enamored with the sound of the Original Dixieland Jass Band when he listened to records his brother brought home from World War I. The ODJB's cornetist Nick LaRocca provided him the inspiration to find a cornet and teach himself to play. As a result, he played with unorthodox technique that may have caused his unique tone and phrasing. He also hung out at the Davenport Coliseum and watched the orchestra. Interestingly, some of the musicians he saw there soon formed the next band that influenced him, the New Orleans Rhythm Kings. Bix's conservative parents were afraid jazz would take him down an unscrupulous path and enrolled him in a boarding school called Lake Forest Academy. However, the academy was located near the jazz mecca of Chicago, quite an oversight on his parents' part. Within the first year, he was expelled. He broke curfew along with some classmates to sneak into Chicago clubs and watch their idols like the New Orleans Rhythm Kings at the Friar's Inn. After leaving school, Bix took playing jobs throughout the Midwest and then joined the Wolverines, a young white band modeled after the NORK.

In 1925, Bix joined saxophonist Frank Trumbauer's band and for the rest of Bix's life, the pair made some of the most consequential music of the age. **Frank Trumbauer** (or "Tram") was the antithesis of Beiderbecke. Bix had already succumbed to the alcoholism that would later kill him, but Tram was straight-laced and barely drank. Tram benefitted from intense musical training, able to play just about any common instrument. Tram was quiet; Bix was outspoken. Tram was mellow; Bix was wild. The yin and yang yielded some highly unique musical results that deviated sharply from the jazz styles of the day. Both men cultivated a laid-back improvisational approach, a subtle tone and melodic ideas that took careful and meaningful pathways through chord changes. Meeting Bix's unconventional approach to the cornet, Tram played the C-melody saxophone, an instrument not often played today that was constructed in size, tone, and pitch between the alto and tenor saxophones.

Bix and Tram joined Jean Goldkette, and later, Paul Whiteman's famous orchestra, the highest-profile gig in the United States. Over the course of their tours with both groups, they entered studios to record their own music with small groups which, along with Hot Five and Seven recordings, make up the canon of must-listen records from the Roaring '20s. Their music influenced important Swing Era tenor saxophonist Lester Young, and foreshadowed the cool jazz genre that became popular during the 1940s

and '50s. Bix tragically fell into the substance abuse habits that would also shorten the careers of so many cool jazz musicians. He was in and out of the hospital in 1928 and 1929 for pneumonia and other complications, and he finally died in New York on August 6, 1931.

Music Analysis

"Singin' the Blues"
(1927)
Personnel: Leon "Bix" Beiderbecke, cornet; Frank "Tram" Trumbauer, C-melody saxophone; Eddie Lang, guitar; Jimmy Dorsey, clarinet/alto saxophone; Don Ryker, alto saxophone; Miff Mole, trombone; Paul Mertz, piano; Chauncey Morehouse, drums

This performance has a palpable impression of tranquility and melancholy brought on by the unique characters of Bix and Tram. The full group follows their approach to the swing feel, straightening the eighth notes in this moderate tempo. Also striking is the sense of economy with which this track is arranged. Only Bix, Tram, and guitarist Eddie Lang are noticeable through most of the song, creating an intimate setting. The trombone, clarinet, alto saxophones, drums, and piano are almost absent until the final chorus.

Notice each soloist's treatment of the break at the same point in each repetition of the chorus.

0:00	**Introduction:** The woodwinds and brass open with a homophonic ensemble passage.
0:06	**Head/C-melody Saxophone:** Tram plays the melody with smearing slurs and relaxed phrasing until his final triplet phrase. Eddie Lang plays a prominent role in accompaniment, filling in spaces with melodic fills and arpeggios.
1:02	**Trumpet Solo:** Bix Beiderbecke's classic solo continues the peaceful mood set up by Tram. Not until his double-time moment during the break (1:28) does he pick up steam. Following, he rips up to a high note, but soon relaxes the momentum again.
1:59	**Collective Improvisation:** The full group of horns join in, most prominently Jimmy Dorsey and Miff Mole.
2:14	**B Section:** Jimmy Dorsey takes a solo, mainly leaping octaves on the root of the chords.
2:29	**Collective Improvisation and End:** The full group reenters to close the performance. Eddie Lang takes the last break at 2:46.

BOOGIE-WOOGIE PIANO

While small-group jazz thrived in dance halls and cabarets, a new form of piano developed from ragtime roots and caught a foothold in Chicago. **Boogie-woogie** originated in northeast Texas in the late 1800s, developed in logging camps across the South, and migrated with southern workers to Chicago, Kansas City, and other urban centers in the Midwest. Like ragtime, boogie-woogie is a solo piano form that superimposes syncopated rhythms over straight ones. But boogie is a more blues based style than ragtime. The right hand plays repetitive blues licks with slip-finger blue thirds (slipping from minor up to major) and block chord voicings. The left hand plays a pattern with eight notes in every bar, a rolling bassline instead of the bouncing "oom-pah" quarter notes of ragtime. Blues forms are most common, instead of the multi-part rag form. The most important boogie specialists performed in Chicago at some period of their careers; Jimmy Yancey, Albert Ammons, Clarence "Pine Top" Smith, and Meade Lux Lewis among them. The boogie-woogie style found its strongest jazz exponent in the swing music of William "Count" Basie.

DEMISE OF THE CHICAGO JAZZ SCENE

The end of the Roaring '20s signaled the virtual end of Chicago jazz. A large share of the musicians that built Chicago jazz left for New York City as business dried up. Police raids in South Side clubs intensified and owners and operators of the cabarets closed down or moved to the outskirts of town in order to avoid governmental pressure. Federal judges closed the loophole in prohibition laws that allowed customers to bring their own liquor. Two hundred musicians lost their playing jobs by March of 1928 as a result of the crackdown on alcohol. Some cabarets aided the development of boogie-woogie piano by retreating into private homes, creating bedroom saloons. These small rooms had no real prospect of hosting full bands and instead hired a single pianist to entertain. Even movie theaters, where so many musicians found work playing soundtracks for films and intermission music, replaced orchestras with pipe organs and mechanical sound machines. National booking agencies, such as the Music Corporation of America (MCA) shifted the power center of the music to New York, as they preferred to bring in New York bands, limiting opportunities for the South Side bands. The spread of radio hastened the nationalization of entertainment. Nationwide networks NBC and CBS replaced many local radio stations that had promoted local acts. Chicago music lived on in large dance halls like the Regal Theater inside the massive Savoy center, but they featured sterilized and highly arranged dance music that lost the grit of South Side cabaret music.

Still, over the course of its existence, the Chicago scene exposed to the nation its own version of the New Orleans style. Primary artists like Louis Armstrong, Bix Beiderbecke, and Earl Hines may have stayed hidden had Chicago never emerged as a musical center, ensconced inside a rural or remote community and lost to history. Chicago was the platform to the world for early jazz. The Chicago style produced musicians who would soon repackage the music into swing, the only jazz style that would become the world's most popular music for a time. A new generation of black and white youths united over the music, as white would-be jazzers made their admiration clear to black musicians. Louis Armstrong, himself, was outspoken in his appreciation of Bix Beiderbecke's talents. The mutual respect in terms of artistry weakened boundaries of prejudice between the two groups.

Discussion Questions

1. Describe the factors that caused the growth of a jazz-based music scene in Chicago.

2. Compare and contrast New Orleans and Chicago jazz styles.

3. Listen to both "West End Blues" and "Weather Bird" from the perspective of a 1920s music fan or musician. In what moments does Louis Armstrong display his musical genius? In what moments does Earl Hines display *his* musical genius?

4. Compare and contrast the playing styles of Louis Armstrong and Bix Beiderbecke.

5. How did boogie-woogie piano come to take the place of cabaret jazz in Chicago? What elements does boogie-woogie have in common with blues?

Migration and Proliferation: Jazz in New York City

In this chapter, we will cover:

- Tin Pan Alley
- The Dance Craze
 - Vernon and Irene Castle
 - The Savoy Ballroom
- James Reece Europe and pre-jazz
- Jazz Composition and Arranging
- The Harlem Renaissance
- Important Pre-Swing Bandleaders
 - Paul Whiteman
 - Fletcher Henderson
 - Duke Ellington
- Harlem Stride Piano

THE WORLD STAGE

Of the urban centers that spawned and supported jazz, New York City was the most important in terms of establishing jazz as an international phenomenon. New York City was a window to the world, so to speak. Most of the artists who developed widespread reputations and played an important role in the evolution of jazz either began their careers in New York or eventually migrated there. Louis Armstrong, Duke Ellington, Count Basie, and Benny Goodman; all of the iconic leaders of pre-WWII jazz made their headquarters in the city at some point. It is also significant that most of the phases through which jazz evolved, its future sub-genres, were created primarily in New York City—swing, bebop, cool jazz, hard bop, and avant-garde. This chapter will focus on the components that came together around 1920 and the important performers, composers, and bandleaders that laid the groundwork.

TIN PAN ALLEY

Many of the songs that make up the standard repertoire of jazz were composed in the New York City songwriting district called **Tin Pan Alley**. The offices of several publishing companies were located within a city block on West 28th street beginning in the 1890s between Broadway and Sixth Avenue. Each of these publishing houses was between three and five stories high, and inside were rows of offices where staff composers played pianos while they wrote and demonstrated their new songs. The neighborhood got its name when a reporter for the New York Herald walked toward the district and compared the cacophony he heard to the sound of tin pans being banged together.

The publishing industry spread as some of the initial companies moved out of the Alley and new companies cropped up elsewhere. Tin Pan Alley became a term that enveloped the broader pop music publishing industry to include music written for the musicals on Broadway and, later,

> **Tin Pan Alley**—The name of the popular music publishing industry in America during the early 20th century. Tin Pan Alley began in the office buildings of a single Manhattan city block.

for film. Publishing companies also sold the songs to the public market in the form of printed sheet music. Tin Pan Alley publishing companies distributed the music of the United States' most significant composers of popular song—George Gershwin, Irving Berlin, Jerome Kern, Hoagy Carmichael, and Cole Porter—and jazz composers like Duke Ellington, Fats Waller, and James P. Johnson found a revenue stream in popular music. Many of these composers earned their living as **song pluggers**, by demonstrating their songs in various public places to sell sheet music. Some had their music arranged by the new jazz dance bands. A few, like George Gershwin, would have their works performed by string orchestras in concert halls.

> **Song pluggers** were hired by publishing companies to play piano and sing their songs in public in order to sell sheet music.

FORERUNNERS OF THE NEW YORK JAZZ ORCHESTRA

Before New York emerged as the center for jazz activity in America, several people and institutions established a framework. The pre-jazz style played by New York dance orchestras was devoid of some of the essential ingredients of jazz, such as the blues and the southern style of improvisation. In the decades leading up to the Roaring '20s, the developments of popular song and jazz were intertwined with dance trends.

Vernon and Irene Castle were a pair of celebrity dancers who appeared in films and guided fashion trends, beginning about 1912. At their dance school, "Castle House," and at various appearances in front of middle-class audiences, they introduced the country to several dances, such as the Charleston, the shimmy shake, and the fox trot. The Castles preferred ragtime music to accompany their dancing, and their chosen bandleader was James Reese Europe and his Society Orchestra.

Library of Congress

Vernon and Irene Castle

James Reece Europe's musical experience was immense. A pianist and violinist, he moved to New York from Alabama and worked in black musical theater. With dance on the rise in 1910, he developed a booking agency, orchestra, and chorus—called the Clef Club—to find and mold African-American musical talent and to contract musical work. Europe made some of the first ever recordings by a black ensemble for the Victor Record Company in 1914. Fighting in World War I, he formed a band in the 369th Infantry called the "Hellfighters," a group that caused a stir across France and other nations of Europe. Before the onset of jazz, the Hellfighters were playing a syncopated brand of concert and marching band music that laid the groundwork for instrumental ragtime in the Northeast. Other

bands replicated the Hellfighters' format and found success across the U.S. and Europe, most notably Will Marion Cook's Southern Syncopated Orchestra, featuring the New Orleans clarinetist Sidney Bechet. James Reese Europe's success was tragically short-lived. He was murdered by one of his drummers in 1919, soon after his return to the United States.

COMPOSITION AND ARRANGING

While popular music thrived in the city, jazz composition developed into a mature field of expertise. A jazz band's library of performance music could include any mixture of rags, dance numbers, Tin Pan Alley tunes, and blues in order to satisfy the tastes of audiences at different venues. Some bands tended to play music on the **hot** side of the style continuum, energizing audiences with a strong and sometimes raunchy blues component and palpitating syncopation. Others played a **sweet** style of jazz, favoring smooth and sophisticated tones and polite dance rhythms. (A side note: Louis Armstrong's Hot Five and Hot Seven actually represent a mixture of the hot and sweet. "West End Blues" betrayed a stronger influence of sweet music than his earlier blues numbers and rags.) Working bands used music from a combination of different sources. They purchased **stock arrangements** of the music played by other well-known bands, or they hired a composer and/or an arranger, who was often an instrumentalist within the band.

A jazz **composer** constructs the melody, chords, form, and rhythmic properties of a piece. An **arranger** begins with that composition and adapts it to a particular group or instrumentation. The arranger orchestrates the melody, choosing which instrument or instruments will play it, and they add other features to make the most of their ensemble. For example, in order to arrange Joe Oliver's piece "West End Blues," the arranger of the Paul Whiteman Orchestra (a group with several woodwind, brass, and stringed instruments) might write the main trumpet melody for woodwinds—alto saxophone, three clarinets, and a baritone saxophone. Then, the arranger might also harmonize the alto saxophone melody by selecting different pitches of the chord for clarinets and bari saxophone to create a richer sound. Next, he or she might write simple, slow-moving chords underneath the main melody and assign this figure to a group of two trombones and two trumpets. The arranger might direct the trumpets to use straight mutes, too. The arranger makes all of these decisions to bring the composer's song to life. Some of the early developments in composition and arrangement occurred in Chicago (the New Orleans Rhythm Kings and Jelly Roll Morton's Red Hot Peppers were especially influential), and it was in New York that many of the early conventions of jazz composition and arranging took hold.

> **Stock arrangements**—Big band arrangements of popular swing hits that were available to any musical group, forming some of the common repertoire of the day.

> A **composer** invents the melody, chords, and other basic elements of a musical work.

> An **arranger** adapts and customizes a song or other musical work to a specific instrumentation with varying degrees of personalization.

THE HARLEM RENAISSANCE

During the Great Migration from the late 19th century to the early decades of the 20th, more than 200,000 African Americans gathered in the neighborhood of Harlem. Springing up from this mini-city of African Americans was a flowering of cultural and intellectual achievement. The arts were the chief means of expression that the leaders of the **Harlem**

Renaissance celebrated and rewarded, held up as sources of African-American pride and proof of the potential for the creation of a flourishing society that would reflect African-American excellence. The Renaissance took its philosophical inspiration from key figures like W.E.B. Du Bois (editor of the African-American periodical *Crisis* in 1910) and Marcus Garvey (a proponent of African Nationalism which urged people of African descent to unite and act as a nation for political and economic advancement). Organizations were established to codify their ideals and to take action, organizations like the National Association for the Advancement of Colored People (NAACP, founded in 1910) and Garvey's United Negro Improvement Association (1917). Harry Pace built Black Swan Records in 1921, the first black-owned record company, to capitalize on the budding craze for race records. Alain Locke's collection of essays called *The New Negro* was instrumental in reshaping the African-American self-image, calling upon blacks to celebrate achievement and to create a cultural life blacks could call their own. Langston Hughes and Zora Neale Hurston made their mark on poetry, fiction, and other literary forms. The opening of *Shuffle Along* (1921) on Broadway marked the arrival of black musical theatre in mainstream society and introduced the music of Noble Sissle and Eubie Blake and performers Adelaide Hall and Josephine Baker.

The Downside of the Renaissance

Ted Gioia, in his quintessential and thoroughly researched narrative *The History of Jazz*, offers a view of the Harlem Renaissance that balances the "cultural flowering" view of the period with the real crisis occurring in the African-American community. The community of Harlem had serious problems. Blacks who arrived from the South traded lives of intense racism and indentured servitude for deplorable living conditions and a rent/income differential that returned blacks into lives of continual debt. Tenants used a number of strategies to "make rent," such as subleasing their bed to multiple shifts of nappers. **Rent parties** crowd-sourced the hosts' living expenses. In exchange for a fee, attendees enjoyed food, drink, and often the exciting flamboyance of a stride pianist (see below). While the thinkers behind the Harlem Renaissance proudly promoted the artistic output of writers and visual artists, jazz and blues were neglected. It was the underclass of Harlem that supported the development of jazz-flavored music, largely through the medium of stride piano. The leaders of Negro culture did not recognize the abilities of jazz and blues to edify and express until Duke Ellington's talents came to fruition.

DANCE IN HARLEM

The city's hunger for dance only intensified after World War I and throughout the 1920s. Countless dance halls sprung up to meet the demand for America's new favorite pastime. The **Savoy Ballroom**, "Home of Happy Feet," was the largest and most famous of dance venues. A racially integrated dancehall located in the heart of Harlem, it introduced white clientele to black culture. The Savoy sported a huge dance floor and two bandstands, so that one band could start immediately when the other took a break. Many of the best bands battled each other on these twin stages—Count Basie, Benny Goodman, the house band led by Chick Webb, and a

Kansas City band led by Jay McShann and featuring a young Charlie Parker (who would reinvent jazz twenty years later). The Cat's Corner was a special section of the dance floor that provided space for the most talented dancers to show their stuff. A couples' dance called the "Lindy hop," and later, the "jitterbug," began at the Savoy and along with other dances, spread across the nation.

PAUL WHITEMAN AND SYMPHONIC JAZZ

Paul Whiteman led the most popular band of early jazz. Although ultimately jazz evolved in a direction that left Whiteman's style behind, his conception of the music was highly influential to jazz musicians of the day. Growing up in Denver, Colorado, Whiteman worked as a viola player in the Denver and San Francisco Symphony Orchestras. Although his background was in classical music, he saw commercial potential for jazz and built his first dance band in 1918 in San Francisco. Moving his operation to New York in 1920, he formed a group of excellent ensemble players on various instruments and jazz soloists. The Paul Whiteman Orchestra was a multi-faceted organization that blended elements of orchestral music with jazz. Arrangers Ferde Grofé and Bill Challis shaped the orchestra's sound—both sweet and expansive; Bix Beiderbecke, Frank Trumbauer, guitarist Eddie Lang, and violinist Al Venuti played legitimate jazz solos; and Bing Crosby and other singers added a lyrical dimension. Whiteman was also a master of public relations, crowned by the press as "King of Jazz." His recordings of "Whispering" and "Japanese Sandman" sold more than a million units in 1920.

February 24, 1924, Paul Whiteman initiated an important crossroads between jazz and classical music. He commissioned George Gershwin, the great American composer and Tin Pan Alley songsmith, to write a piece for his group to be performed at the Aeolian Concert Hall. Gershwin returned with **Rhapsody in Blue**, a large-scale one-movement work fashioned after the classical **concerto**. The concerto featured Gershwin, himself, on piano and added a string section to Whiteman's group. Whiteman aimed with the program to demonstrate potential for the elevation of jazz into the refined class of art music in America. The program was titled "An Experiment in Modern Music," and was designed to educate the audience on various aspects of music, contrasting jazz with orchestral music. *Rhapsody in Blue* was the centerpiece of the concert. Its orchestral sound was "Americanized" with jazz syncopation and tinges of the blues, most obviously, the exaggerated blue note **glissando** played by the clarinet at the top of the work.

Symphonic jazz did not point the way forward to the next stage of development for jazz. It did not become responsible for elevating jazz to the artistic heights of the American orchestra. Other New York bands were far more consequential in the history of jazz music, but the idea of blending jazz and the orchestra was resuscitated in the 1940s and '50s in a trend named "**Third Stream**." Without using Paul Whiteman as a model, Third Stream composers and bandleaders arrived at similar results as Whiteman's more artistic works, producing music that was a remarkable blend of jazz and classical, but again, did not point the prevailing way forward for jazz.

Paul Whiteman and his organization created **symphonic jazz** by blending classical music, sweet jazz, and Tin Pan Alley pop.

Concerto—An extended musical passage during which a soloist plays, most often without a consistent tempo, while the rhythm section rests.

Music Analysis

"Sweet Sue, Just You"
(1928)
Key Personnel: Bix Beiderbecke, cornet; Jack Fulton, vocals; Lennie Hayton, celeste; Bill Challis, arranger

"Sweet Sue" is an example of Paul Whiteman's blending of jazz into what was essentially a pop orchestra. Some highlights are the solo work of Bix Beiderbecke and the rich, "showbiz" orchestration of the introduction. The tempo and key changes (or **modulations**) that occur throughout were hallmarks of classical music of the day. The chain of events, "tucking away" the vocalist in the middle of the track, was also common on recordings at that time.

0:00	**Introduction:** Note the diverse orchestration in this introduction. A homophonic brass fanfare followed by a variation in muted trumpets shifts to a **rubato** section, during which the oboe and violin trade the melody and various woodwinds and celeste provide a backdrop.
0:34	**Introduction, part B:** This section is transitional, foreshadowing the eventual tempo. Again, the melody passes between muted brass, woodwinds, and strings.
0:47	**Head:** Muted trombones carry the melody in harmonized homophony. Banjo and tuba carry the chords and rhythm forward.
1:41	**Interlude:** A return to melodies and textures heard in the opening, with rapidly shifting soloists. Celeste again leads back into the tune.
2:21	**Vocal Chorus:** Celeste and piano accompany Jack Fulton's sweet falsetto delivery. Lennie Hayton sneaks in subtle hints of the blues at 2:33 and 2:47.
3:15	**Interlude:** This brief smattering of muted brass serves only to modulate to the original key and accelerate the tempo.
3:22	**Trumpet Solo:** Finally, Bix Beiderbecke steps forward for a solo. He stays close to the melody, but renovates it with colorful pitches and tasteful rhythmic alterations.
4:00	**Coda:** The symphonic style of the introduction and interludes closes the piece.

FLETCHER HENDERSON

The next bandleader to leave his mark on New York jazz took the genre in a totally different direction, but actually formed his band with the goal to emulate Paul Whiteman's Orchestra. **Fletcher Henderson**, a classically trained pianist, moved to New York from Georgia and intended to build a career on his education in chemistry. A music career found him, instead, as he began song-plugging for W. C. Handy's publishing company. This led to recording work with Bessie Smith and other blues performers, a steady engagement at the Club Alabam, and later in 1924, to the famous Roseland Ballroom. It was in these dance settings that Henderson formed the band that would redefine jazz.

Henderson's playbook consisted of songs that accompanied the various dances of the era spread by the Castles and other instructors, but his music featured a number of key African-American soloists who impacted the nature of jazz improvisation. His star woodwind player, Coleman Hawkins, was destined to bring the tenor saxophone into prominence, and it was Henderson that brought Louis Armstrong to New York. (Armstrong turned him down once when he was a youngster living in New Orleans, and then accepted a second offer while he lived in Chicago.)

Although Fletcher Henderson was a fine arranger in his own right, **Don Redman** deserves credit for the arranging innovations that made the

band unique and for causing a transition from the New Orleans and Chicago early jazz styles to the music of the Swing Era. Redman learned to play several different instruments growing up in West Virginia. Henderson added Redman to his orchestra as its primary arranger at the start of the Roseland Ballroom engagement.

Redman put into place many of the arranging procedures that are still common fare today. He and Henderson essentially created *the section*, approaching brass instruments (trumpets and trombones) and reeds (clarinets and saxophones) as separate groups that could be used in a variety of ways. Often they were pitted against each other in call-and-response, or they could be combined as a group in **tutti** fashion, playing together as a unit. The reed section might play a melody in **unison** or octaves, or they might be arranged in **block chord voicing**. These shifting textures brought a new aesthetic into the large jazz ensemble, creating partnerships and battles all occurring on top of the forward motion of a galloping rhythm section. This expanded the sonic possibilities of the band. Redman also incorporated the rhythmic style of Louis Armstrong, thus ushering in the southern sound through loose, spring-board patterns. The reed section gradually shifted prevalence from clarinets to the saxophones under Redman's regime, and the rhythm section moved toward a more established set of jobs, although this shift took place in a large group of working bands during the time period. The Redman/Henderson partnership is the primary ensemble that caused the transition from early styles (often grouped together under the term "Dixieland jazz") to the swing styles typified by Benny Goodman, Glenn Miller, Count Basie, and the like.

> **Block chord voicing**—An orchestration (voicing) of a chord for a group of instruments that includes each pitch of a chord.

Don Redman left the Henderson organization in 1927, joining McKinney's Cotton Pickers and later leading a band called the Chocolate Dandies. He showcased important jazz performers—Coleman Hawkins and Fats Waller—and wrote popular songs ("Gee Baby, Ain't I Good to You?") and other tunes that found their way into the dance books of Count Basie and other leading performers of the Swing Era. Future generations of Redmans embody perhaps his greatest legacy. His nephew Dewey Redman was a prominent saxophonist during the 1960s and '70s avant-garde movement, and Dewey's son Joshua (also a saxophonist) remains a major force in contemporary jazz. These three generations of Redmans impacted disparate forms of jazz, illustrating the great diversity and unity of jazz.

Music Analysis

"Copenhagen"
(1924)
Personnel: Elmer Chambers, Howard Scott, Louis Armstrong, trumpets; Charlie Green, trombone; Buster Bailey, clarinet; Don Redman, arranger, clarinet/alto saxophone; Coleman Hawkins, clarinet/tenor saxophone; Fletcher Henderson, piano; Charlie Dixon, banjo; Ralph Escudero, tuba; Kaiser Marshall, drums

This song was written by bandleader Charlie Davis and recorded first by the Wolverines and later the same year by several other performers. Don Redman's arrangement changes up the multi-themed ragtime form, so that the Wolverines' opening phrase becomes an interlude between a solo and closing material. Note how Redman trades melodic material among different sections in the band, orchestrating brass against reeds, and soloists against background figures. This performance goes by very quickly, but listen carefully for brief solo appearances by Louis Armstrong, Coleman Hawkins, and Don Redman.

(continued)

Music Analysis *(continued)*

0:00 **A Section/8-bar phrase:** Muted brass open the song with a rising/falling chromatic figure, voiced in block chords. The eerie phrase is answered by driving rhythm section and the same brass group playing a syncopated swing melody patterned after Charleston-like dance rhythms.

0:09 **A Section/repeat:** Clarinets play the rising/falling chromatic figure this time, answered by the same Charleston figure.

0:17 **B Section/12-bar blues:** The reed section plays the new theme, all on clarinets and in block chord voicing. The rhythm section plays a driving two-feel pattern.

0:29 B Section/repeat: The 12-bar blues melody is repeated.

0:42 **Trumpet Solo/12-bar blues:** Louis Armstrong plays a quick one-chorus solo consisting of standard Armstrong phrases. Note the blues sounds he brings into the song at this point, pitch choices from the blues scale (the lowered 7th and 3rd), and shaky vibrato at the ends of his long notes.

0:55 **C Section/8-bar phrase (tutti interlude):** The full group of reeds and brass play a swing figure together punctuated by the drummer's cymbal, then they mimic the driving Charleston figure from the introduction.

1:11 **D Section/8-bar phrase (closing material):** The trumpets play a harmonized (again in block chords) quarter-note-bounce phrase for six bars, answered this time by a shortened version of the opening rising chromatic figure. The brass figure is then repeated, this time continuing the full eight bars and omitting the reeds.

1:28 **A Section:** The same A melodic material reappears here, this time played by the reeds in a high register.

1:37 **A Section/repeat:** A repeat of the original B phrase, in low register.

1:44 **Trombone/Alto Saxophone Solo (new material over 12-bar blues B Section):** This time a solo is written into the trombone in place of the melody. After four bars, Don Redman's alto saxophone launches into a dog-fight of fast arpeggiated eighth notes juxtaposed over the brass section's backgrounds.

1:57 **Trombone/Alto Saxophone Solo (12-bar blues):** A trombone plays another simple melody, followed by a soaring alto saxophone note, again over brass section backgrounds.

2:09 **Solos Over D Section Closing Material:** A clarinetist plays over a closing series of chord changes reminiscent of the closing material from a minute earlier. After a brief banjo break, Coleman Hawkins plays a solo of his own, this time on the tenor saxophone.

2:28 **Coda-Restatement:** The ending material is a collage of introduction, interlude, and a final falling chromatic sequence based on the interlude rhythm.

Henderson's orchestra fell apart in the mid-1930s, but he continued to be involved in the music of the Swing Era, contributing arrangements to Benny Goodman. He reformed his group in 1936 for just a few years and produced a hugely popular swing tune, "Christopher Columbus." The long list of musicians who graced Henderson's bandstand includes a remarkable share of African-American jazz luminaries from the 1920s through the 1940s.

Key Musicians in the Fletcher Henderson Orchestra

Trumpet	Reeds	Drums
Louis Armstrong	Coleman Hawkins	"Big" Sid Catlett
Rex Stewart	Benny Carter	Art Blakey
Roy Eldridge	Lester Young	
Henry "Red" Allen	Ben Webster	
	Chu Berry	
	Russell Procope	

EDWARD KENNEDY "DUKE" ELLINGTON— PART 1

While jazz developed into a mature big band format in the hands of Fletcher Henderson, another character was busy creating a singular voice of expression using the common tools of jazz. Like Henderson, Benny Goodman, and Louis Armstrong, **Duke Ellington** got his start during the pre-Swing Era and led a band through the coming boom of swing. Ellington, however, moved ahead of the pack in terms of artistic achievement. Ellington is to jazz composition what Louis Armstrong is to jazz improvisation. Duke was not the first composer, but he looms larger than any other composer in early jazz. He is crowned the most accomplished composer in jazz history, and in fact, is in a class of only the most elite composers in any genre of American music along with Aaron Copeland, George Gershwin, and just a handful of others. Ellington composed an enormous number of works in a broad range of formats. He led a band for five decades, a band with an immediately identifiable sound. Although there were more accomplished pianists in his day, his performance work carried the signature of his compositional sound (listen to his piano playing on *Money Jungle* and *Duke Ellington & John Coltrane*). Over the course of his career, Ellington embodied what Harlem Renaissance philosophers were looking for when they hoped to find a model of genius among Negro art music composers.

Duke's Path to New York

Ellington exuded an air of class and dignity. Although he was not the first jazz artist whose nickname ascribed royalty, "the Duke" seemed to fit his personality more than the "Kings" Buddy Bolden and King Oliver or "Count" Basie. As a boy, his family was friendly with upper-crust Washington, D.C., society. His father worked as a butler to a wealthy doctor, and his doting mother constantly affirmed his exceptionality. So many of the important figures in jazz came from broken families, but Ellington's childhood was relatively comfortable. He admired his dad and adored his mom. Ellington could have stayed in Washington, D.C., and led a comfortable life in music. He showed early interest in the Harlem stride style, and in fact, honored James P. Johnson by playing "Carolina Shout" for him during Johnson's trip to Washington. Before he turned twenty Ellington was composing music, performing dance gigs around the city, and leading his own band. He even operated as a booking agent, keeping four or five bands active in a single night and making appearances at each event.

Ellington moved to New York to join his friends, drummer Sonny Greer and reed player Otto Hardwick, working Vaudeville shows with Wilbur Sweatman. Sweatman's shtick was playing three clarinets at the same time, but his saxophone playing on "Down Home Rag" made some early strides toward recorded jazz in 1916. Ellington's stay in New York City was brief. The band failed to make a decent living and he, Hardwick, and Greer retreated home. Before he returned to Washington he made valuable acquaintances with Harlem stride pianists Fats Waller and Willie "The Lion" Smith. It was on a second move just a year later that Ellington settled in New York City for good.

Ellington joined banjo player Elmer Snowden with a band of six players billed "The Washingtonians" at the Hollywood Club, a visible location just a couple blocks off Times Square. The Hollywood suspiciously burned in 1924 and reopened as the Club Kentucky with a new log-cabin interior décor, likely meant to represent a southern slave's quarters. Soon, Ellington took Snowden's place as bandleader, and over the next four years at the Kentucky the group developed a steady audience and began shaping a new approach to jazz. His musicians were not the finest technicians with the purest sounds or most refined skills on their respective instruments. But Ellington's calling card was writing music to fit the particular characters of sound in his band. The most unique of these characters was **James "Bubber" Miley**, a cornetist in the mold of Joe Oliver who manipulated his gritty tone with a straight mute and toilet plunger to imitate vocal gestures and cries. According to Ellington, "Bubber" Miley was the catalyst that caused the Washingtonians to shift from a sweet band to a hot one. Peculiar sounds also emitted from the bell of trombonist, Charlie Irvis, who was later replaced by another mute master, **Joseph "Tricky Sam" Nanton**. Listening to early Ellington recordings, Nanton's sound can be identified by the "yah-yah" heard when he pulls his plunger away from the bell, as opposed to most plunger mute players, who make a "wah-wah" sound.

Mute Masters: The muted brass sounds of cornetist "Bubber" Miley and trombonist "Tricky Sam" Nanton were essential to Duke Ellington's special sound.

The Cotton Club Years

During his tenure at the Club Kentucky, Ellington connected with businessman **Irving Mills** who became his manager and found him an opportunity to audition for the elite **Cotton Club**, a gig that would ultimately change the course of Ellington's career. But the band would have to battle some unseemly conditions in order to take advantage of the high-profile residency. The Cotton Club was, like so many jazz venues in Chicago and Kansas City, run by corrupt and dangerous characters. The owners were heavily involved in organized crime, and during Prohibition this meant control of alcohol distribution, which made the Cotton Club a default meeting place for the mob. The Cotton Club was also something of a haven for whites who wanted a comfortable place to go slumming. Opened as a whites-only cabaret, the Cotton Club gave its some-700 attendees a taste of "exotic" African-American life while solidifying the line between themselves and the African Americans. And just think of the name, "Cotton Club"! The Club was a grotesquely exaggerated version of the log cabin décor in the Kentucky Club. It was decorated to look like a southern plantation, with a bandstand built like the porch of a white mansion and slave quarters painted onto the backdrop. A big part of Ellington's job was to write music that supported the all-black cast performing acts that titillated white audiences with dancing, exotic, jungle humans of Africa. The Cotton Club set Ellington in the uncomfortable intersection between increased celebrity and compromised racial integrity. But after four years, Ellington's career benefitted from his ability to maintain a tactful balance.

Ellington's band had to accompany other performers in addition to coming up with new music to keep his band sounding fresh six nights per week. The challenge forced him to refine his compositional and arranging skills, and not surprisingly, he composed an enormous amount of music during this time. He also expanded the band with a few new musicians, each of them becoming essential ingredients in Ellington's sound.

Music Analysis

"East St. Louis Toodle-oo"
(1927)
Personnel: James "Bubber" Miley and Louis Metcalf, trumpet; Joe "Tricky Sam" Nanton, trombone; Rudy Jackson, clarinet and alto saxophone; Otto Hardwick, clarinet and tenor saxophone; Harry Carney, clarinet and baritone saxophone; Duke Ellington, piano; Fred Guy, banjo; Bass Edwards, tuba; Sonny Greer, drums

In this piece, listen for Ellington's use of instrumental colors, "Bubber" Miley's highly original approach to the melody, and the sequence of events from minor to major melodic sections. The form of the work is closer to a multi-part rag than any other jazz forms, like blues and song forms, which repeat a single chorus from end to end. Most of this piece is not improvised, at least not in a jazz sense. Ellington's pieces mix composed and solo improvisation in unique ways, but even in the fully composed sections, the personalities of his sidemen emanate from the music. The piece's progression from minor to major sections is characteristic of Ellington's **jungle sound** that he later made popular at the Cotton Club.

0:00	**Introduction:** Saxophones play a spooky ensemble passage in a minor key, "smearing" up and down from one chord to the next. The most prominent rhythm section sounds are tuba and banjo alternating each beat.
0:11	**Head, A Section:** "Bubber" Miley, who shared composer credit with Ellington on this song, probably contributed this opening melody. This is a good example of the colorful personality he injected into this song with his muted trumpet, played with very free rhythm.
0:36	**Head, B Section:** Miley continues with a new melodic character, now in a major key. His rhythmic approach is more straightforward now. "Tricky Sam" Nanton's trombone plays a counter melody to Miley's melody, creating a polyphonic texture.
0:46	**Head, B Section:** Two measures transition back to the minor key with the saxophones lining up with Miley's melody (shifting to a homophonic texture).
0:49	**Head, A Section:** Repeat of the A material.
1:01	**Head, C Section:** Where most jazz songs would simply repeat the AABA form of the piece, Ellington introduces a new theme and switches again to a major mode. "Tricky Sam" Nanton takes over the main melody here, punctuated by Sonny Greer's cymbal. Nanton's concept of swing rhythm is labored and heavy, but the highlight of the solo is the melodic peak he reaches at 1:13.
1:28	**Clarinet solo:** A clarinetist solos over the A section, arriving at a pre-conceived lick at the midpoint (1:42) where Sonny Greer fills a space with his choked cymbal.
1:52	**Soli Section, Brass:** The trumpets and trombone play a harmonized ensemble section together over the C section.
2:21	**Soli Section, Clarinets:** The reeds play an ensemble passage, also over the C section. The brass join them at 2:35.
2:48	**Head Out, A Section:** "Bubber" Miley closes the tune with his muted trumpet.
2:59	**Ending:** This brief cadence is borrowed from Chopin's funeral march. (Ellington would borrow a longer sample of the same Chopin work at the end of his "Black and Tan Fantasie.")

Saxophonist **Harry Carney** joined the group on baritone saxophone. Although the instrument normally only functioned to provide bass notes for the other saxophones, Carney often played the main melody. **Johnny Hodges's** alto saxophone added yet another strong character voice to the band. His most recognizable trait was the long glissando (sliding pitches) from a low to a high pitch, described as **smearing**. **Barney Bigard** joined the band on clarinet. Ellington replaced "Bubber" Miley in 1929 with **Charles Melvin "Cootie" Williams**, a trumpeter with more refined technique and an equally expressive mute man. The same year, he added

Smearing—A wide glissando, or pitch bend, famously used by alto saxophonist Johnny Hodges in Duke Ellington's band.

Puerto Rican trombonist **Juan Tizol**, who would also turn out to have a knack for composition. Tizol's "Caravan" and "Perdido" are jazz standards today often mistakenly attributed to Ellington.

The Duke's Unique Instrumental Colors

Many of Ellington's compositions took on an "exotic" quality to match the *mise en scène* at the Cotton Club and the subject matter of theatre acts. Pieces written in Ellington's "**jungle sound**" teeter-tottered between two tonalities; one section in a minor mode followed by another in a major mode, usually in the key a minor third higher (listen to "East St. Louis Toodle-oo" and "The Mooche"). He emphasized the muted trumpet and trombone, along with Barney Bigard's unique clarinet sound. And Sonny Greer sometimes used the tom-tom drums and other percussion to create a mysterious ambience and evoke the sound of African percussion.

Elements of Duke's Jungle Sound

- Muted brass instruments
- Exotic percussion such as tom-tom drums
- Harmonic modulation between major and minor modes

Cross-sectional voicing—An arranging texture used in jazz big bands that creates a unique timbre by grouping together instruments from different sections (trumpets, trombones, saxophones), instead of the common practice of grouping together instruments of the same section. The instruments may be grouped in unison or they may voice a chord using different pitches.

An important part of the Ellington band's unique timbral identity was his **cross-sectional voicing**. While jazz arrangers were developing their typical practice of splitting up the band into sections—trumpets, trombones, and saxophones—and pitting them against each other in call-and-response fashion, Ellington created unusual sounds combining instruments across sections. In "Mood Indigo," for example, he orchestrated the main melody with a trio of muted trumpet, muted trombone, and clarinet. The registers in which these instruments played also contributed to the otherworldly sound, with the clarinet voiced in its low, *chalumeau* register and the trumpet and trombone floating quietly above. A more conventional choice would have been to voice trombone as the bass instrument in the trio.

Key Musicians in the Early Duke Ellington Orchestra

Trumpet	Trombone
"Bubber" Miley	"Tricky Sam" Nanton
"Cootie" Williams	Juan Tizol (valve trombone)
Freddie Jenkins	
	Bass
	Wellman Braud
Reeds	
Otto Hardwick	**Drums**
Barney Bigard	Sonny Greer
Johnny Hodges	
Harry Carney	

Duke Ellington left the Cotton Club in 1931, replaced by the "Hi De Ho Man," Cab Calloway. Ellington had already appeared in films, beginning in 1929 with *Black and Tan* and the next year with *Check and Double Check*. Spurred on by manager Irving Mills, Ellington actively sought to spread his music to the far reaches of the country already exposed to his music through his radio broadcasts. With the nation nose-diving into the Great Depression in 1931, Ellington ended his long run at the Cotton Club

and toured the United States. Over more than a year, he traveled the cities of the Northeast and Midwest, and would soon take his music to Europe, too. Ellington spent the next several years on the road, intermittently returning to the Cotton Club and recording prolifically. He would continue to create striking instrumental colors in his orchestra and to compose based on his band members' personal sounds, even when new players replaced his veterans. The remainder of his career, through the trends of swing, bebop, and beyond, Ellington maintained his musical identity even as he pushed his compositions into new territory.

STRIDE PIANO

Accompanying the first whispers of big band jazz, a new piano style emerged in Harlem that influenced the work of pianists as far-reaching as Duke Ellington, Art Tatum, Thelonious Monk, and 21st century jazz artist Jason Moran. **James P. Johnson**, known as the "Father of Stride Piano," created a modernized version of ragtime piano music better suited to his ultra-urban surroundings. The style got its name from the striding (or rather, leaping) motion of the pianist's left hand. Where the typical ragtime left hand moved subtly back and forth between a bass note on beat one and a three-note chord on the next beat, the stride left hand covered a wider range, resulting in visually impressive, side-to-side arm movement. Stride energized the ragtime style with an additional share of showmanship. Stride piano surpassed ragtime as the style by which a pianist could prove his worth as James P. Johnson's "Carolina Shout" replaced Scott Joplin's "Maple Leaf Rag" as the test piece for solo pianists of the age. Johnson recorded a definitive version of "Carolina Shout" in 1920. He also made a serious effort, like Scott Joplin before him, to bring the African-American piano art form onto the concert stage with large-scale orchestral works (*Harlem Symphony*) and an opera with libretto by Harlem Renaissance poet Langston Hughes (*De Organizer*).

Stride masters continued to play ragtime forms, but they also incorporated the current pop hits of Tin Pan Alley. Some, like Thomas "Fats" Waller and Eubie Blake, became successful songwriters themselves. Pianists honed their skills at **cutting contests**, where they battled against one another and tried to play the fastest, employ the best tricks, and play the newest musical innovations. This athletic approach was bolstered at Harlem **rent parties**. In more cities than just Harlem, it was common practice in those days for a tenant to throw a party at their home in order to make money toward their rent, entertaining with food and music. Attendees were expected to pay for entrance and/or tip the musicians. Harlem pianists made the rounds at rent parties and often showed up for a battle at parties where their rival might have been hired.

Cutting contest—A musical setting that involves multiple soloists improvising against each other in a competitive manner.

Lineage of Important Stride Pianists

James P. Johnson
Willie "The Lion" Smith
Luckey Roberts
Eubie Blake
Thomas "Fats" Waller
Art Tatum

No one brought more attention to stride piano than **Thomas "Fats" Waller**. A consummate entertainer, Waller's handle was totally appropriate. He proudly paraded his ability to consume copious amounts of food and alcohol. Beyond his innate ability to bring joy to a crowd, Waller was a brilliant performer capable of incorporating classical music, ragtime, and boogie-woogie into his solo stride performances. Many of his songs are essential standards of the American songbook, with "Ain't Misbehavin'," "Honeysuckle Rose," one of the first jazz waltzes "Jitterbug Waltz," and the hilarious "Your Feet's Too Big." His "Viper's Drag" ("viper," a 1920s word for marijuana smoker) predated the technique often used by Duke Ellington of mixing a section played in a minor tonality with another one section in a major tonality.

Art Tatum

Art Tatum stands out as a god among men. "Fats" Waller even said as much when the young pianist walked into a room where he was performing. Listening to Tatum's recordings, his virtuosity seems super-human even by today's standards. Compounding his feats of speed and dexterity and his innovative approach is the fact that he was almost completely blind. He had only partial vision in one eye. He moved to New York City from Ohio in 1932 and took the stride piano society by storm. Tatum made more than 600 recordings. Directed by Norman Granz, he undertook an exhaustive series of recordings in the final years of his life consisting of about 200 standard songs. Although not a composer, Tatum's strength was in the reinterpretation, and sometimes the definition of standards.

In Art Tatum's work we can hear the roots of bebop, a style built on instrumental innovation. Among Tatum's forward-looking ideas was his use of **reharmonization**, or chord substitution, where the player replaces the original harmony of a song with a new chord or set of chords. Tatum seemed to morph the tempo into hyper drive by doubling the harmonic rhythm. He substituted two chords in the place of one, for example, a D minor to G dominant seventh progression was fit into the space of one G dominant seventh chord. The **tritone substitution** is another example of Tatum's reharmonizations still employed by today's musicians. The player selects the chord a tritone (seven half steps) away from the original chord. (Instead of chords progressing D minor – **G7** – C major, Tatum would play D minor – **C#7** – C major.) But more generally speaking, Tatum demonstrated the potential for innovation based on virtuosity that was later

Reharmonization—
Substituting a new chord or set of chords for the original chords of a piece.

Tritone substitution—
Substituting a chord whose root is the interval of a tritone, or six half-steps, away from the original root. B7 to F7, for example.

Music Analysis

"Tea for Two"
(1949)
Personnel: Art Tatum

This famous performance of Tatum's demonstrates his ability to transcend the confines of a musical piece with extreme skill and a number of harmonic and rhythmic tricks. For example, listen for reharmonization at 0:28 and 1:13 (chords with chromatically descending bass notes). Listen for double time rhythms in the right hand at 0:52-1:05 and 1:16-1:27, and triplets accented every fourth note, creating a polyrhythm at 1:30.

picked up by bebop artists of the mid-1940s. More than any musician of his day, Tatum challenged the improvisational community to continue pushing the limits of instrumental technique.

WHAT'S NEXT FROM NEW YORK?

In the global music market of New York, a number of standards and trends developed and carried on to the next age. The size of the band grew, adding numbers to each wind instrument in order to increase the volume. As dance halls expanded in New York City, bands could not rely on electrical amplification to fill the room with sound. This need for additional wind instruments created the **section**, multiple players per instrument. The cornet/trombone/clarinet three-horn front line of a New Orleans or Chicago combo grew in New York to three to four trumpets or cornets, two to three trombones, and up to five clarinets or saxophones. The saxophone became the dominant reed instrument. As small combos grew to big bands, jazz arrangers became an important organizing force, foregoing collective improvisation for organized written section work. In Don Redman's hands, sections battled against each other in a composed call-and-response, which grew from subtler practice in Chicago-style jazz. The musical battles that occurred between reeds and brass were tailor-made to become the soundtrack for the World War II era.

Radio sales skyrocketed during the Great Depression, with the percent of households owning a radio increasing from 45% at the close of the 1920s to 80% just a decade later. This caused a lot of Americans to spend their leisure time indoors, but it also collected the nation's entertainment activities in cities where the radio stations' offices were located. New York City entertained the entire nation, as Duke Ellington could attest. The notoriety he gained from the Cotton Club broadcasts spun his career forward. New York also continued to incorporate the strengths of other regions. Already benefitting from the musicians imported from Chicago imports, New York City drew in a new tradition of big band music from Kansas City and the rural territories that connected to it. While Chicago's jazz life was drawing down, Kansas City's was on the rise. New York became the beneficiary of the nation's brand new jazz traditions, incorporating them into a romping, ebullient force called "swing."

Discussion Questions

1. What did Tin Pan Alley contribute to the development of a New York City style of jazz?

2. What was the Harlem Renaissance? How does it relate to jazz music?

3. Compare and contrast the music of Paul Whiteman and Fletcher Henderson. How did each bandleader contribute to the development of a New York City style of jazz?

4. How did the instrumentation and arranging techniques in New York City differ from those in Chicago and New Orleans?

5. What aspects made Duke Ellington an important composer and band leader?

6. Name three important stride pianists and list their accomplishments.

CHAPTER 9

Migration and Proliferation: Jazz in Kansas City and the Territories

In Kansas City, Missouri, a jazz style formed somewhat hidden from the gaze of the other major urban centers. Full of blues-influenced improvisation and a joyous and blustering swing feel, a handful of Kansas City bands provided the missing link that helped complete the evolution of jazz from its origins to the swing style that was so ubiquitous during World War II. Kansas City was also the training ground for three jazz giants, without whom the music may sound wholly different today. Count Basie was responsible for establishing Kansas City jazz in New York as a legitimate contributor to the form. He drew several of the key musicians out of Kansas City into New York with his orchestra in the mid-1930s. Basie's tenor saxophonist, Lester Young, challenged Coleman Hawkins's supremacy on the instrument. Scores of future soloists relished and emulated Young's approach to improvisation. In the early 1940s, alto saxophonist Charlie Parker made a lonely trip from Kansas City to the Big Apple that resulted in a complete overhaul of jazz, called "bebop." A pedigree of important improvisers, bandleaders, and businessmen prepared the way for these three iconic figures and a dangerous environment somehow protected its development. As in Chicago and New York, vice bred jazz. The Kansas City story is one of corruption, of scandal, of fortune and misfortune, and cutthroat competition. Indeed, a kind of cutthroat misfortune offed the man most responsible for the development of Kansas City jazz, robbing him of his chance to reap the benefits on the national stage.

Kansas City is an unlikely home of a unique and impactful jazz style. New York and Chicago are obvious candidates—the number one and two most populous cities in the United States, respectively, with 5.6 million and 2.7 million inhabitants in 1920. Little more than 300,000 lived in Kansas City, making it

In this chapter, we will cover:

- Kansas City Politics—the Pendergasts
- Early Kansas City Music Tradition
- Important Territory Bands—Walter Page's Blue Devils, **Andy Kirk** and **Mary Lou Williams**
- Important Kansas City Bands—**Bennie Moten** and **Count Basie**
- Kansas City Singers

Globe Turner/Shutterstock.com

145

only the 19th largest city. On the edge of the western frontier straddling the Kansas/Missouri border, it would seem too remote to become the headquarters of any significant American musical style. Why, then, does Kansas City figure so prominently in the jazz story? After all, the missing link for the budding Swing Era could have come from Philadelphia or Boston, couldn't it? Or, if distance was not a problem, why not Los Angeles?

The answer involves a complicated web of factors that came together to set the stage for original jazz in Kansas City. Geography, interstate commerce, technology, political horse-trading, top-notch musical training, and above all, a penchant for competition created an entertainment culture that awarded individuality and grit.

AN UNLIKELY BOOM TOWN

Two states of affairs converged to lay the foundation for jazz in Kansas City. Firstly, the city became a commercial center around the turn of the 20th century. Like New Orleans and Chicago, geography created economic opportunities. The Missouri and Kansas riverways make a wishbone formation with Kansas City at their crux, funneling money and goods into the city. This favorable setting was enhanced in 1869, when the first bridge over the Missouri River was built in Kansas City, connecting the city to Chicago by rail. By 1900, Kansas City was both a river town and a railway hub with a healthy circulation of population and business. Entrepreneurs found success, and an entertainment industry sprung up based on Vaudevillian shows and boogie-woogie piano, blues, and dance bands, all of which took root in the city's nightclubs and theaters.

Kansas City was also a place where African Americans held a considerable stake in the city economy. Blacks owned businesses and worked in middle class professional fields. There was a black-owned baseball team—the Monarchs—and a newspaper—the *Kansas City Call*. The Lincoln Theatre at 18th and Vine was managed by African Americans and enriched the culture by programming films, plays, and musical theatre productions.

THE PENDERGASTS—CORRUPTION BREEDS MUSIC YET AGAIN

Working hand-in-hand with the influx of commerce, lawlessness was the second state of affairs that created an entertainment market primed for the development of jazz. The city had a reputation for being the Midwest capital of vice. Jim Pendergast built Kansas City's famous sin district as early as 1881 when he opened a saloon and hotel that became a hub for gambling and prostitution. Next, he opened another saloon for businessmen and light-of-day types—politicians, businessmen, and other influential people. He gained political influence exchanging favors and money for votes for the Democratic Party and was elected alderman of the First Ward. His political and business empire grew until he needed to enlist the help of family members to manage it.

By the time of Jim Pendergast's death in 1911, his younger brother Tom was ready to take the reigns of the city government. The new Pendergast regime that plunged Kansas City into corruption for more than two

decades. **"Boss" Tom Pendergast** profited from the relaxed enforcement of prohibition laws by creating T. J. Pendergast Liquor Wholesale Company, the city's top liquor supply source. The Pendergast machine had the city police force in its pocket, so the nightclubs that played by Tom Pendergast's rules (including his own Jefferson Hotel) could afford to ignore the cabaret and liquor laws that limited other clubs. City manager, Judge Henry McElroy, allowed gambling to spread freely. During Prohibition, mobster Johnny Lazia was simultaneously the leader of the North Side Democratic Club and the boss of a multi-million dollar bootlegging industry. Lazia held sway with all sides of the city because he claimed to have the ability to keep Al Capone out of Kansas City. It seems Lazia was the least of many evils and was able to collect and dole out power. He managed liquor and gambling in the city and had a hand in police hiring practices. Lazia may have even had an office for a time in the police station.

Jazz thrived in this all-night environment, as it had done in Chicago's and New York's mob-run speakeasies. Nightclubs stayed open twenty-four hours a day. An early morning tradition of **cutting contests** developed. As late as 3:00 or 4:00 a.m., after the dance bands finished their last sets, jam sessions began where long strings of soloists would try to outplay each other in front of an audience often full of informed musicians. As one night's party ended at the Sunset Cafe, the staff cleaned up for the next. A strip of several clubs extended down 12th Street, and 14th Street was home to a notorious red light district. A characteristic musical style developed in these jam sessions and in Kansas City nightclubs, combining a stronger blues approach than what was heard in Chicago and New York, and an arranging style based on improvised riffs repeated to the extreme. Beauty-through-simplicity describes the general approach of the Kansas City style, but that's only part of the musical story.

> A **cutting contest** is a competitive musical setting where soloists try to outplay each other.

Characteristics of Kansas City Jazz

- Reliance on solo improvisation more than orchestration or collective improvisation
- Heavy influence of blues
- Arranging style based on riffs, initially improvised in performance
- Riffs used as background figures behind soloists
- Walking bass lines propel the time feel
- Established the medium swing tempo

EARLY KANSAS CITY MUSICAL TRADITION

Many of the characteristics that made Kansas City jazz unique could be found in musical styles commonly heard around town. The city had a hand in the ragtime and boogie-woogie piano styles that spilled over from the end of the 1800s. Traces of walking bass, one of Kansas City's most important contributions to modern jazz, can be found in the compositions of popular Kansas City pianist John William "Blind" Boone. His "Southern Rag Medley No. 2" (1909) changes from a typical **two-feel** bass rhythm to a doubled-up **four-feel** pattern which simultaneously evokes boogie-woogie and looks forward to the walking bass patterns of bassist Walter Page, later carried on by scores of swing and bebop bassists. Blues shouter Big Joe Turner spoke of

the city's blues roots. Born in 1911, Turner recalled a childhood memory following a blues singer on the street and in restaurants. An early source of formal musical training was Major N. Clark Smith, director of bands at Lincoln High School in Kansas City. Several of the key players in the Kansas City scene progressed through his music program. Smith's militaristic approach to discipline and expectation for perfection in fundamentals and musical knowledge produced solid musicians who could hold their own with the finest New York City and Chicago musicians.

Although the strongest impact came from the black bands in Kansas City, one white band was particularly successful in contending with white bands of national prominence and fame. The **Coon-Sanders Original Night Hawk Orchestra** showed the potential for what could arise from the Midwest. Formed in 1919, their radio broadcasts on WDAF made them a household name. Moving to Chicago in 1924, they rivaled Jean Goldkette and even Paul Whiteman's orchestra in popularity.

Foundation of Kansas City Jazz

- Ragtime and boogie-woogie piano styles
- Prevalence of blues
- Excellent musical training in public schools
- Far-reaching radio coverage

Even more than Chicago and New York groups, Kansas City bands had to rely on radio and a national jazz press in order to reach the widespread recognition. Several independent and major recording companies located near Chicago and New York helped spread the influence of bands that worked each metropolis, but Kansas City did not have that luxury. Without a healthy recording industry in Kansas City, its music scene was essentially a hidden asset. Radio often made the difference, with stations broadcasting from Kansas City nightclubs. Coverage areas varied, but under the right conditions the signal reached households in Canada, Denver, Chicago, and across the South. Count Basie even benefitted from a high-fidelity station broadcasting his nightly shows from the Reno Club in 1936. W9XBY was an experimental station created by the federal government with twice the normal bandwidth, made available to a radio engineering school. Additionally, a couple of key players in media championed bands in Kansas City through the press. Dave Dexter proudly extolled the hidden treasures of Kansas City nightclubs he frequented in *Down Beat* magazine, both before and after he became an associate editor. In the 1960s, Dexter would prove his nose for finding talent outside the jazz world when he helped Capitol Records contract The Beatles. And John Hammond had already established himself as a kingmaker by elevating Benny Goodman to stardom when he began promoting Count Basie and the duo of Pete Johnson and Joe Turner to music management companies in New York City. These business partners were indispensable factors to the success of Kansas City jazz.

> Kansas City jazz was discovered by outsiders through radio broadcasts.

THE TERRITORY BANDS

> **Territory band**—A jazz group that performed at venues on various circuits (or territories) outside the urban centers around the time of the Swing Era.

Territory bands travelled away from the buzzing cities stringing together one-nighters at a variety of performance venues in rural areas and smaller

cities. Every band battled bitterly to dominate its territory, and so, competition kept the quality high. As loose and improvisational as many bands were, the territories bred versatility and excellence in the bands that persevered. A top band protected its territory. A band that belonged to one territory could not just march into another. It was expected that a band from the Southwest would request permission from the leading band of the Northwest in order to play there, and vice versa. A band that hoped to hop from one territory to another had to be versatile. When a band played a region that favored sweet music, a band had to be prepared with a book of schottisches and waltzes. When they played a region that appreciated a bluer, hotter musical style, a working band had to be ready.

The **Southwest Territory**, a touring circuit focused in Texas and Oklahoma, provided income and performance opportunities for Kansas City bands and local groups, many of whom hoped to work their way into the urban centers. The most famed of the Southwest Territory bands was **Walter Page's Blue Devils**, led by multi-instrumentalist and godfather of jazz bass playing. Kansas City was a true hub for the territories, especially when work began drying up at the onset of the Great Depression. Bands came in from the cold to Kansas City to reload and sometimes to find steady work. The musically rich nightclub district anchored at the corner of 18th Street and Vine acted as a magnet for many of the musicians working the territories. A couple of large dance halls opened to white patrons in 1927 and supplied employment for black bands, only intensifying the attraction for territory musicians. The Pla-Mor entertainment complex had a ballroom large enough for 3,000 plus dancers, and the El Torreon held up to 2,000 dancers. Even famous acts like Fletcher Henderson, Louis Armstrong, and Duke Ellington came into Kansas City to play the Pla-Mor and El Torreon halls.

In this way the territories played a dual role, providing work for travelling Kansas City bands and providing Kansas City bandleaders with a steady supply of musicians accustomed to a high level of competition. Like in New York, a competitive atmosphere found its way inside Kansas City venues like Paseo Hall, where two bands could do battle against one another on its dual stages.

WALTER PAGE'S BLUE DEVILS

In the early 1920s, the Blue Devils were the leading band in Oklahoma and Kansas. According to alto saxophonist Buster Smith, the band's strength was in their soloists, himself and trumpeter Oran "Lips" Page. But Walter Page, the man who formed the band from a skeleton of an earlier aggregation of Blue Devils, no less than revolutionized the jazz bass and infused territory swing with a 4/4 walking bass line that separated it from the jazz bands of the East. Page played tuba and bass drum as a child and learned the double bass when Major Smith at Lincoln High School recommended that he give it a try. Page's primary influence on bass was Wellman Braud, a New Orleans musician from the earliest class of jazz musicians who played on some of Duke Ellington's recordings during his Cotton Club years. Page was known for his powerful sound that could cut through the noise of a band in the days before amplification. Before Walter Page, many bands had to rely on the tuba to fill a large dance hall. His **walking bass**

lines incorporated chromatic tones between chords, still a standard practice among today's bass players.

Beginning in 1921, Page briefly studied music at University of Kansas in Lawrence, expanding his skills to piano, voice, violin, saxophone, and developing composition and arranging skills. He played with Bennie Moten during his summers, and at the beginning of 1923, he joined the Blue Devils on a tour to California. Soon, the band lost their Los Angeles engagement and resorted to touring across the Southwest. In 1925, the band went defunct and Page assumed leadership, pulling together some new members who would soon become key players on the Kansas City scene. Alto saxophonist Buster Smith had already joined just before Page took over, adding compelling solo work. Soon trombonist and guitarist Eddie Durham enlisted with the band, followed by trumpeter Oran "Lips" Page, singer Jimmy Rushing, and pianist Bill Basie. This remarkable cast of characters moved one-by-one into the Bennie Moten band, and less than a decade later, many of them formed the core of the Count Basie Orchestra.

William "Count" Basie joined the Blue Devils on Independence Day, 1928. Basie grew up in Red Bank, New Jersey and taught himself to play the piano, finding work accompanying silent films in a local theater. He moved to Harlem in the mid-1920s and became closely acquainted with stride piano masters James P. Johnson, Willie "the Lion" Smith, and especially Fats Waller, who became something of a mentor to Basie. He toured across the United States on the TOBA circuit with a show led by Gonzelle White. The show went through some extremely hard knocks, including a harrowing run-in with the great flood of 1927. The company finally collapsed, leaving Basie stranded in Kansas City. Walter Page and Basie had already developed a rapport when Basie sat in with the Blue Devils, so when Basie needed a lifeline Page was ready to take him in.

Page was already hoping to relocate the band to Kansas City from Oklahoma. On October 28, 1928, the band made their debut at Paseo Hall and won over an enthusiastic crowd. But Bennie Moten began peeling away key members of the Blue Devils in 1929—Eddie Durham (who had left Page to join the Blues Serenaders), Oran "Hot Lips" Page, Jimmy Rushing, and Buster Smith. By 1932, Walter Page left the Blue Devils himself, citing financial hardship.

BENNIE MOTEN

During its heyday, the Kansas City scene orbited around **Bennie Moten**, a hometown pianist who grew up in the 18th and Vine district. A benevolent leader, Moten was known for paying his band members fairly and encouraging their individuality. The group operated as a kind of workshop for musicians that went on to lead bands of their own like Count Basie, Oran "Hot Lips" Page, and Eddie Durham. Moten spent more time running the business side of the band than actually performing with it, but this proved to be a successful strategy. Under his leadership, Moten's Kansas City Orchestra became the top group in Kansas City and the first to win national recognition. Like the Coon-Sanders band, Bennie Moten had the invention of radio to thank for his notoriety. On March 23, 1923, radio station WHB first broadcast the Moten band into homes across the country. Moten recorded

for OKeh that year and again in 1924. He became the manager of the Paseo Dancing Academy and built the facility into a bedrock performance room, entertaining more than 2,000 patrons. In this larger venue, he added an extra saxophonist and cornet player for volume. The move created sections instead of the single-horn front line and brought the band's sound closer to Fletcher Henderson's and other New York groups. In February 1927, the band played a double bill with Fletcher Henderson at Paseo Hall, and in December he toured the Midwest to begin one of many failed attempts to conquer New York City.

Of the new members Moten swiped from the Blue Devils, Bill Basie was perhaps the most consequential. Moten accepted Basie largely on the merit of the compositions he contributed to the band. Although not a trained arranger, Basie worked closely with Eddie Durham to write out his ideas. Oddly, Basie joined Moten's group as its third pianist. Bennie's relative Buster "Bus" Moten was actually the conductor, fronting the band on piano and accordion (a novel aspect of the band's sound, no doubt). Bennie spent his time at performances dealing with financial matters and

Music Analysis

"Moten's Swing"
(1932)
Key Personnel: Bill Basie, piano; Walter Page, bass; Eddie Durham, guitar; Eddie Barefield, alto saxophone; Oran "Hot Lips" Page, trumpet; Ben Webster, tenor saxophone

Written to the chord changes of the popular tune "You're Driving Me Crazy," Basie's and Durham's composition is representative of the changes Kansas City bands were instituting in jazz. The true melody of the song does not appear until near the end of the performance. A series of saxophone solis, brass riffs, and solos propel the song forward until the melody finally arrives.

0:00	**Introduction, first A section:** Basie opens the song with an unaccompanied piano solo over the first A section. Most introductions are separate from the opening head, usually consisting of a few bars that lead into the real measure #1. Basie's solo, instead, is part of a greater whole.
0:10	**Piano solo, second A section:** Basie continues on the second A section, now joined by the rest of the rhythm section—guitar, drums, and bass.
0:19	**Brass and Woodwind Riffs, B section:** The raucous brass section interrupts the dainty piano solo with an off-kilter rhythm. The saxophones answer with a unison, staccato line that moves upward by half steps.
0:28	**Piano solo, last A section:** The volume drops as Basie continues in the previous fashion playing bouncy lines in the right hand.
0:38	**Saxophone soli:** The saxophones play a block chord passage over the first two A's of the form.
0:57	**Guitar solo:** Eddie Durham takes over during the bridge with his own guitar solo. Basie plays a boogie-woogie pattern in the mid-range of the piano. The saxes re-enter and repeat their second A section.
1:15	**Alto saxophone solo:** Eddie Barefield plays a gliding solo with loud trumpet backgrounds. The backgrounds foreshadow the true melody of the song as Barefield takes a rest at 1:45.
1:55	**Trumpet solo:** The key changes for "Hot Lips" Page's solo over polite saxophone backgrounds. Ben Webster takes a brief tenor saxophone solo over the bridge, and Page returns on the last A section.
2:34	**Head:** Finally, the full band enters to play the harmonized theme.
3:10	**Tag:** A short clip of the melody repeats three times. Notice the bells that mark this ending section.

drumming up business. With Bus Moten busy conducting the band and leaving the piano to play accordion, there was room for yet a third pianist in the band when Bill Basie began contributing arrangements. Basie's and Durham's arrangements reformed Moten's orchestral sound. Not only did the orchestration and voicing styles more closely resemble the New York bands, but also the Basie/Durham conception introduced a new approach to writing melodic ideas. Basie and Durham wrote **"Moten's Swing"** in 1932 to satisfy the owner of a Philadelphia theater who complained that they had limited selection of styles. The piece is a model of their new big band sound, which mirrored what was happening in live performances.

Moten's Musical Style

Saxophonist Eddie Barefield explained the sound of the band at this time, based on **head arrangements** with improvised riffs, which defined the Kansas City jazz style. Sometimes during performances, the band would create an arrangement as a team. If a band member knew the particular melody they wanted to play, they opened the song with that melody. Then the group would progress through improvised solos, each of which might go on for anywhere between 10-20 choruses. Building momentum behind the soloist, the band would begin setting up **riffs**—short, repetitive melodic figures. These riffs were improvised, themselves, invented in the moment by various band members. For example, during a trumpet solo, a saxophonist might play a riff and repeat it throughout a chorus. Then, the entire saxophone section would play the same, either in unison or a harmonized version. While the saxes repeated the riff over another chorus, the trombone section would enter with a riff invented by someone in their section and so on, and so on, until the activity built to a fever pitch with all winds playing a loud final chorus together. This loud ending was called a **shout section**, with trumpets "shouting" in the upper register. This live construction of an arrangement represents a new kind of collective improvisation, one that varies from the New Orleans style. Instead of continuous polyphony, the participants in Kansas City improvised ideas together in homophonic texture and built them to a dynamic climax.

Head arrangement—A big band piece constructed without written music, instead with a progression and layering of improvised melodies, or riffs. Most often one section (for example, the saxophones) devises a melody that is then repeated over subsequent choruses while other sections (trumpets and trombones) add their own melodies.

Riff—A short musical phrase that is repeated several times, either as the foundational pattern of a song or to build momentum over time.

Shout section—A section near the end of a big band song when all instruments play simultaneously and the band plays at full volume.

Basie's Coup d'Etat

The life of the Moten band after Basie joined them reads like a tabloid scandal. The first breakup of Moten's Kansas City Orchestra began in 1932, when a former trombonist in the group, Thaymon Hayes, exacted revenge on Moten. After leaving Moten, Hayes hired strong musicians from other bands—most importantly, the talented musical director and composer Jesse Stone. Stone conditioned the band for a battle at Paseo Hall, March 7, 1932, and reportedly swept the floor with them. Moten's band, drunk out of their minds, essentially threw the match. As a result, the Hayes band won the Fairyland Amusement Park summer gig that had been a steady source of income for Moten. Moten booked a tour of the East starting in June 1932, but the Great Depression made conditions almost unbearable. Meanwhile Hayes and other local Kansas City bands stayed close to Kansas City, shielded from the effects of the Depression. Moten's band returned home after a tough tour, but without local gigs set up, was forced to tour the territories around Kansas City. Still, Moten continued building a lineup of

powerful soloists. He hired Buster Williams along with tenor saxophonists Hershel Evans and Lester Young.

In 1933, Franklin D. Roosevelt was sworn in to the Presidency. He followed through on campaign promises to ease restrictions on alcohol sales, and the Cullen-Harrison Act legalized the sale of beer and wine with low alcohol content. This caused a sea change in the Kansas City entertainment industry. Opulent new venues opened to meet the demand for larger crowds—the Cherry Blossom, Crystal Palace, Sunset Club, and Club Ritz. Later the Roseland Ballroom (modeled after the famous dance hall in New York City) and the Reno Club opened. Paseo Hall, stalwart of the African-American jazz community, renovated and reopened as the Harlem Night Club, for a time an all-white venue. In July, Moten moved into the Cherry Blossom, but in September he began discussing another move that caused dissention in the ranks. Accounts disagree on exactly how actively Bill Basie pushed to have Moten voted out of his own band, but regardless, after the vote Moten was out and Basie took over leadership. Moten walked out amicably but then built another group, soon joined up with a competitor and became the Moten-Lee band. The new Moten band became a powerhouse again, and Basie's band, although initially a success, folded because Basie failed to line up additional gigs. But before Basie's first band broke up, he was host to one of the most exciting moments in cutting contest history.

Showdown: Lester Young vs. Coleman Hawkins

Fletcher Henderson's band came to Kansas City for a few weeks in December 1933, when the Roseland Ballroom opened. The performance was not well attended, and when the musicians were dismissed early from the gig, they went to the Cherry Blossom where Count Basie's band was playing, just across from their hotel. Coleman Hawkins was not known for getting involved in cutting contests, but this time he was excited enough to bring his tenor saxophone with him. Coleman Hawkins was in the process of building a reputation as the Father of the Tenor Saxophone, to establish the tenor as the leading solo voice in jazz. The cutting contest that followed became legendary. As the home crowd reported it, Hawkins took on soloist after soloist. He threw off many players calling tunes in difficult keys. Then, Lester Young took the bandstand and, with his creative and imaginative approach, defeated Hawkins. Hawkins fought on into the morning, apparently arriving late to a noon performance with Henderson's band in St. Louis. Not long after the famed cutting contest, Coleman Hawkins left Henderson's band to pursue a solo career and Lester Young was his chosen replacement. However, Young's tenure with Henderson would be short-lived. His light tone disoriented the reed section where Hawkins's thick sound had anchored it. Young left within a few months and joined Andy Kirk's band, swapping places with Kirk's tenor man, Ben Webster. Each of the three tenor saxophonists involved in this complicated chain of events—Webster, Young, and Hawkins—became a major force during the Swing Era.

Scandal and Moten's Ultimate Misfortune

For the next year and a half after Basie's band collapsed, Basie and drummer Jo Jones worked small gigs together. The Moten band came together

again in 1935. Preparing for a tour back to New York, they played regional tours around Tulsa. In March they played the musicians ball at the Paseo, which had reverted to an African-American nightclub. The band left for a gig in Denver, but Moten stayed behind to plan the New York trip and have his tonsils taken out to fix his ongoing throat infections. Moten's friend and respected surgeon Dr. Herbert W. Bruce performed the procedure. Like so many other controversial stories, accounts differ on what caused the horrific scene that followed. Moten and Bruce may have been out drinking the night before, leaving Bruce with a dilapidating hangover and clumsy hands. Moten may have made a sudden, frightened move during the operation. Whatever the case, the surgeon's knife cut an artery in Moten's throat and he died on the operating table from rapid bleeding. Moten's own band had to finish the Denver performances and were unable to make it back for the funeral. The band tried to continue under Bus Moten, but key members soon left the band and ended Moten's Kansas City Orchestra for good.

MARY LOU WILLIAMS WITH ANDY KIRK'S TWELVE CLOUDS OF JOY

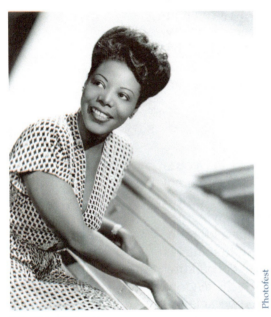

Mary Lou Williams

Mary Lou Williams, "The Lady Who Swings the Band," was the most important female composer and pianist in early jazz and swing, at a time when the jazz field was almost completely a man's world. Beginning her music career in Pittsburg, she toured the TOBA circuit with a Vaudeville-style revue. While on the road, Williams socialized with Duke Ellington's band members and played for Fats Waller and Jelly Roll Morton. Williams began to win notoriety for her piano playing and compositions when she joined the Clouds of Joy, one of the few territory bands to reach nationwide success. Her work with Andy Kirk and his Twelve Clouds of Joy led to a career writing and arranging songs for greats like Benny Goodman, Tommy Dorsey, Louis Armstrong, and Earle Hines, as well as artistic works. Her *Zodiac Suite* was a series of themes characterizing each of the twelve astrological signs. First recorded at the piano, the New York Philharmonic performed a fully orchestrated version suite at Carnegie Hall in 1946. Besides her contributions to the piano and the pencil, Williams mentored some major players in modern jazz after the Swing Era.

When Williams began playing piano for Andy Kirk, he had taken over leadership of the band from its underhanded leader Terrence "T" Holder who called the band his Dark Clouds of Joy. The group moved to Tulsa in 1927 and entered a consistent working schedule managed by the Southwest Amusement Company. The next year, Holder was exposed stealing the band's pay and asked to leave. Kirk was a clear successor. Andy Kirk dropped "Dark" from the band name and made his group more versatile in order to play more lucrative gigs. He moved the band to Kansas City when they were offered a steady gig at Pla-Mor playing for white audiences. Also around this time, Kirk connected with Fletcher Henderson

and was impressed by his band's two-feel (Kirk's tended to play a four-feel) and his arrangements of show tunes. Henderson contributed some charts to Kirk's library and arranged for the Clouds of Joy to sub for his Orchestra at the Roseland Ballroom in New York, January of 1930.

When Mary Lou Williams joined the group in late 1929 as a fill-in pianist, she also brought in her talent for composition. She offered a unique approach that contrasted the typical stock arrangements the band was accustomed to playing. She contributed "Walkin' and Swingin'" in 1936. Written in the style of Basie-Moten, Williams juxtaposed brass riffs against a unison saxophone melody and orchestrated a long ensemble passage of varying melodic ideas in block chord style. (Interestingly, modern jazz pianist Thelonious Monk may have "lifted" some of the melodic material from his friend's ensemble melody for his 1957 composition "Rhythm-n-ing.")

Andy Kirk led his Twelve Clouds of Joy from the bass saxophone and tuba, two relatively inconspicuous instruments, so Mary Lou Williams and other soloists got considerable exposure in the band. Several notable jazz soloists worked for Kirk throughout the band's two-decade lifespan, including trumpeters Howard McGee and Fats Navarro, alto saxophonist Charlie

Music Analysis

"Walkin' and Swingin'"
(1936)
Personnel: Harry Lawson, Paul King, Earl Thomson, trumpets; Ted Donnelly, Henry Wells, trombones; John Harringong, John Williams, alto saxophones; Dick Wilson, tenor saxophone; Claude Williams, violin; Mary Lou Williams, piano; Ted Robinson, guitar; Booker Collins, bass; Ben Thigpen, drums

Listen for Mary Lou Williams's progression of swing melodies arranged throughout the band on this song. Her piano solo is in line with the burgeoning Kansas City style influenced by boogie-woogie and ragtime, and looking ahead at swing. The melody is worth looking at from an analytical perspective, using the descending half step as a cell that unifies the piece. The saxophones play the descending half step at the very beginning, play a rising melody that ends at the descending half step, and then returns to the lower version. Challenge yourself and see if you can hear instances of the descending half step.

0:00	**Head, first and second A sections:** Williams orchestrated the saxophones in unison (octaves) for the opening melody, along with brass riffs.
0:20	**Head, B section:** The brass riffs smartly morph into the harmonized B melody, played almost completely off-beat. The saxophones answer in the rests.
0:30	**Head, last A section:** The opening saxophone phrase is repeated, this time with a transitional tag at the end.
0:42	**Ensemble chorus:** A full chorus of ensemble work begins here in a new key with the full saxophone section playing underneath the prominent lead trumpet.
1:22	**Piano solo:** Mary Lou Williams plays a two-handed solo in typical modern rag style. Saxophone soli: The saxophones play a block chord passage over the first two A's of the form.
1:42	**Tenor saxophone solo, B section:** Dick Wilson plays a solo against saxophone backgrounds.
1:51	**Piano solo, A section:** Mary Lou Williams concludes her solo, interrupted by loud brass at 2:00.
2:02	**Ensemble chorus:** The brass play a unison melody with saxophone riffs in the background. Brass and saxophones line up at 2:10, with saxes interjecting a short riff between the hits.
2:19	**Ensemble chorus, B section:** The brass and saxophone sections play against each other for the remainder of the song, brass playing loud chords and saxes playing eighth note lines in primarily block chords.
2:37	**End:** Saxophones and brass join for an abrupt ending. Notice that the head does not return at the end of this performance.

Parker, and tenor saxophonists Don Byas, Ben Webster, and Lester Young. Williams's piano solos became an integral part of Kirk's songs. In live performances, audiences expected her to play the solos from the album instead of improvising new material. The band's 1936 recording for the Decca company of the vocal number "Until the Real Thing Comes Along" became a huge hit. However, Williams complained about the conditions the band continued under, even with a chart-topper under their belt. She was exhausted by the one-nighters the band played, moving to a different city every night and sometimes with long driving distances in between. Williams claimed the band sometimes travelled five to six thousand miles per week!

BLUES SINGERS IN KANSAS CITY JAZZ

Jazz bands in Kansas City often included a blues singer on their roster who could give the instrumentalists a break and add a new element to the group. Without the benefit of a microphone or megaphone, these singers, often called **blues shouters**, developed strong "pipes" that could project their tone over the volume of the band. Kansas City was a mecca of these singers, producing a number of singers who reached greater fame during the Swing Era and even during the early days of rock and roll.

Blues shouter—A singer in the blues idiom who projects his or her voice without amplification over the volume of a band.

Jimmy Rushing is the only blues shouter who graced the stage with the complete triumvirate of Kansas City bands—Walter Page's Blue Devils, Bennie Moten's Kansas City Orchestra, and the Count Basie Orchestra. Rushing had a knack for phrasing popular standards and singing blues. After working on the TOBA circuit as a young man, Rushing traveled to Chicago early in the 1920s and listened to the South Side Chicago bands. He sang in Los Angeles with former New Orleans musicians Jelly Roll Morton and trumpeter Mutt Carey. After working in Kansas City for several years, he became a household name when he followed Count Basie to New York City. Rushing's nickname "Mr. Five-by-Five" described his rotund figure and outlined the self-deprecating humor that characterized Kansas City jazz and blues.

Kansas City Blues Singers
- Jimmy Rushing
- "Big" Joe Turner
- Walter Brown
- Jimmy Witherspoon
- Joe Williams

BIG JOE TURNER AND PETE JOHNSON

The ultimate blues shouter, **Big Joe Turner** worked as a singing bartender at the Hawaiian Gardens in 1932, a gangster-owned nightclub that served white and black patrons on separate balconies. Pianist **Pete Johnson** led the Hawaiian Gardens Serenaders with a rollicking boogie-woogie blues style while Turner entertained the audience with his shtick, literally serving drinks from behind the bar while he sang. Pete Johnson took over leadership of the Hawaiian Gardens band when the previous leader

accidentally shot off his own toes with the pistol he brought to work for self-defense. Johnson and Turner worked as a team in several different Kansas City nightclubs until John Hammond discovered them during his visit to meet Count Basie. In 1938, Hammond invited them to New York City to perform at his *From Spirituals to Swing* concert that showcased him at his famous concert at Carnegie Hall. The performance caught the attention of New York listeners and catapulted them to fame. After the hey day of the Swing Era, Turner recorded one of the first ever rock and roll songs, "Shake, Rattle, and Roll" before Bill Haley and his Comets co-opted the song and sold a million copies.

Music Analysis

"Walkin' and Swingin'"
(1938)
Personnel: Big Joe Turner, vocals; Pete Johnson, piano

From John Hammond's *Spirituals to Swing* concert, Joe Turner and Pete Johnson brought down home blues and boogie-woogie into the most refined of concert halls. Notice the incessant groove punctuated by the sound of Johnson's shoe slamming the floor. Johnson opens the song with right hand single-line melody and a progression of chords we come to expect from Count Basie, and then he gallops into a heavy-handed boogie-woogie bass line. Turner's voice rings throughout the hall on this blues, and Johnson seems to find just the right accompaniment to keep the groove percolating without getting in the way of Turner's voice during the verses.

TRANSITION TO THE SWING ERA

The Kansas City jazz scene ended in earnest when "Boss" Tom Pendergast helped stir up democratic votes to elect Lloyd Stark to the Missouri governorship in 1936. Stark betrayed Pendergast when he entered office, ushering in crackdowns on the illegal activities in nightclubs. Gov. Stark was looking ahead at a United States Senate run, so it was necessary that he clean house. In early 1938, state agents descended on Kansas City clubs, cleaning up the 18th and Vine district where music and vice had worked hand in hand. They tightened restrictions and required venues to follow the law. They shortened operating hours, closing clubs at 2:00 a.m. and staying closed on Sundays. Club owners saw a sharp decrease in profit and hired fewer live musicians or dismissed them altogether. Jukeboxes took the place of working musicians in many cases.

But Kansas City left its mark on the development of jazz. Count Basie's band acted as an ambassador to the Swing Era, continuing in the tradition of Bennie Moten and Walter Page's Blue Devils and preaching the gospel of rhythmic swing and blues. Basie became a star in his own right during the Swing Era, but furthermore, his band's approaches to rhythm and instrumentation were essential ingredients in the swing style. After Basie departed, pianist **Jay McShann** continued the tradition of blues-inflected swing and looked forward at both bebop and rhythm and blues in his jazz band of the 1930s and '40s. The band gave bebop engineer Charlie Parker his first entrée to the New York professional music scene. His blues hits with singer Walter Brown bridged to the popular rhythm and blues style.

Discussion Questions

1. Describe the factors that set the stage for the development of the Kansas City jazz style.

2. How was the Kansas City music scene fed by the Southwest Territory?

3. What aspects of Walter Page's bass playing make him important to the future of jazz?

4. Describe musical aspects that make Mary Lou Williams important to jazz history.

5. Describe the Kansas City sound as exemplified by Bennie Moten and Count Basie.

PART IV

Pop Jazz: The Swing Era
(1930s–Mid 1940s)

CHAPTER 10

The Big Bands

AN INFRASTRUCTURE FOR SWING AS POPULAR ENTERTAINMENT

During a turbulent time in American history, conditions were just right in the mid-1930s for a new business model to unfold in the performing music industry, which led to the popularization of swing and the celebrity of leading musicians. The Great Depression caused the downfall of the Chicago scene and forced paying audience members indoors, but conversely, it actually helped to solidify the big band format. People were losing their jobs left and right during the Depression, musicians included. This swayed the scale of supply/demand toward the supply side of working musicians. Bandleaders had their pick of the litter and could afford to hire a large band for less money.

The 1930s were particularly tough for African Americans, who were among the hardest hit by the Great Depression. A great deal of steady work for musicians dried up during the transition from silent film to sound film. When "talkies" became popular, more than 3,200 pit musicians in New York alone found themselves out of work. The musician's union lost a strike in 1937, when they tried to force theaters to bring back live music.

The earliest films with sound were called **talkies**.

Record sales plummeted by more than ninety percent during the first few years of the depression, while the number of households with a radio continued to rise. Americans could find entertainment at home by simply turning the dial. This phenomenon created an infrastructure for popular entertainment. The entire country could tune into a radio broadcast from just a single club. Duke Ellington's broadcasts from the Cotton Club were an early example of a jazz band's ability to virtually monopolize a broad audience through radio. But most broadcasts were being conducted from ballrooms where only white bands were hired. Many white bands did not play real jazz. Most of the white admirers of hot jazz so far in the story have been underground groups in Chicago and New York. But now the stage was set for a white jazz artist to take advantage of the airwaves and enter nationwide stardom. With the right business acumen and the right set list, clarinetist **Benny Goodman** became a true celebrity, an Elvis Presley or a Michael Jackson of his day. Goodman brought the whole genre of jazz along with him to the throngs of white teenagers that clamored to hear his music. He elevated jazz to the height of the pop music world under its new name—"swing."

Characteristics of Swing

- Provided a soundtrack for dancing during the years of WWII
- Rhythmic feel based on swung eighth notes and consistent two-feel or four-feel pulse
- Big band instrumentation
- Group operates in sections: trumpets, trombones, saxophones (reeds), rhythm section
- Arrangement built from a progression of events: full ensemble, soloists, soli or section features, shout section

BENNY GOODMAN

Benny Goodman's rise to prominence can be explained by a couple of factors. One, he benefitted from the economic and social changes that caused the emergence of swing, essentially being in the right place at the right time. The second factor speaks to the classic American fable of the self-made man. Benny Goodman was recognized as a great musician because he made himself into one. More than just a figurehead of pop-jazz, Goodman was unmatched in terms of his expressive and technical abilities on the clarinet.

Goodman grew up in a tough neighborhood of Chicago in a family of Jewish immigrants from Eastern Europe. Goodman picked up the clarinet at ten years old and began rehearsing a band at synagogue and taking formal lessons from the notable educator Franz Schoepp. While in high school, Goodman began exploring the Chicago jazz scene with members of the Austin High Gang and was influenced primarily by Bix Beiderbecke and clarinetists Jimmy Noone, Frank Teschemacher, and Frank Ropallo. Goodman joined a dance band run by Ben Pollack in 1925. In four years with the ensemble Goodman had numerous opportunities to record and tour into New York City, eventually moving there to pursue better musical opportunities.

Goodman's Early Career

In New York, Goodman became a busy session musician recording with singers Bessie Smith and Billie Holiday, tenor saxophonist Coleman Hawkins, and Teddy Wilson, the pianist who would eventually make headlines with him at the Congress Hotel in Chicago. Goodman also became acquainted with impresario **John Hammond** at this time. Hammond had an incredible influence on American pop music as an advocate for great leading musicians. He produced recordings by Bessie Smith and Billie Holiday, and he would eventually help Count Basie, Aretha Franklin, Bob Dylan, Stevie Ray Vaughan, and Bruce Springsteen find notoriety. A firm believer in racial equality, Hammond guided some of Goodman's personnel choices toward integration. As a businessman (he was a Yale

dropout who descended from the ultra-wealthy Vanderbilt dynasty), Hammond helped Goodman find work in high-profile settings.

American Music Icons Connected to John Hammond
- Bessie Smith
- Billie Holiday
- Benny Goodman
- Count Basie
- Aretha Franklin
- Bob Dylan
- Stevie Ray Vaughan
- Bruce Springsteen

Goodman formed a big band that turned out to be quite versatile. He played arrangements of current popular songs, but also hired well-known black arrangers to contribute to his playbook. Fletcher Henderson, who was struggling financially to keep his orchestra afloat, wrote about half of Goodman's material. With a book comprised of sweet and hot numbers, Goodman could work a number of different angles. When he was invited to perform every week on NBC radio's show *Let's Dance*, the Fletcher Henderson material won Goodman popularity across the nation. Goodman surrounded himself with a cast of characters that, like Ellington's Orchestra, contributed to the identity of the band. Most notably, drummer **Gene Krupa** became a celebrity in his own right. Although Krupa was not the most cutting-edge of drummers, he drove the big band and played with an abundance of panache that off-set Goodman's dry persona. Other key members were trumpet soloist Bunny Berigan, pianist Jess Stacy, and singer Helen Ward.

Palomar Ballroom—The Birth of the Swing Era

Goodman hoped to capitalize on the popularity of the *Let's Dance* show by taking the band on a nationwide tour, but disastrous concerts in Denver and other locales gave the band members a crisis of confidence. However, on the band's arrival in Los Angeles on August 21, 1935, they found a wildly appreciative audience at the **Palomar Ballroom**. During the first part of the night, the band played the stock arrangements of pop songs, more conventional choices for a dance hall setting. After an underwhelming audience reaction, Gene Krupa told Goodman to bring out the hot charts arranged for the band by Fletcher Henderson and other black arrangers. The crowd recognized this music from their *Let's Dance* broadcasts and welcomed the change. This music had been lost on crowds on the East Coast where Goodman had aired at 1:00 a.m., too late for the average listener to hear his music. In the Midwest, too, Goodman's radio audience would have been small. The West Coast had been listening to Goodman's set three hours earlier, during primetime, and when Goodman showed up in town they came out in droves to see their favorite New York band in person. The Palomar gig ignited the Swing Era, a decade of crazed fans and huge audiences dancing to big band jazz. In fact, "swing" was the label used in place of "jazz" throughout the next decade, and Benny Goodman was crowned "King of Swing."

Music Analysis

"King Porter Stomp"
(1935)

Personnel: Bunny Berigan, Nate Kazebier, Ralph Muzzillo, trumpet; Red Ballard, Jack Lacey, trombone; Benny Goodman, clarinet; Toots Mondello and Hymie Schertzer, alto saxophone; Dick Clark and Art Rollini, tenor saxophone; Frank Froeba, piano; George Van Eps, guitar; Harry Goodman, bass; Gene Krupa, drums

This Jelly Roll Morton composition shows the lineage of jazz composition and arranging up to this point, arranged by Don Redman for Fletcher Henderson, who rearranged it for Goodman. Notice the progression through different orchestration types. The sequence of events provided much of the excitement of swing music. Also, listen carefully to the bass changing from a **two-feel** (playing a note on every first and third beat of the four-beat measure) to a **four-feel** (a bass note on every beat). This track was recorded July 1, 1935, just seven weeks before the band's arrival at the Palomar Ballroom.

0:00	**Introduction, trumpet solo:** Bunny Berrigan plays over saxophone and trombone backgrounds.
0:31	**Interlude:** The trumpet section enters with a loud announcement of the main melody. The alto saxophone trills take over in volume.
0:37	**Main melody:** The saxophone section plays over a two-feel rhythm section.
0:58	**Clarinet solo:** Benny Goodman plays a rousing solo over the chords that accompanied the main melody. The rhythm section plays in a four-feel. Listen for elements of the blues in Goodman's playing.
1:41	**Trumpet solo:** Bunny Berrigan plays trumpet over the same chords, with a new set of saxophone backgrounds.
2:02	**Trombone solo:**
2:23	**Ensemble section:** The full band plays a climbing melody figure, harmonized across the winds. Gene Krupa "catches" the off-beat kicks on his snare drum.
2:42	**Shout section:** The trumpets play a loud riff, answered by the woodwinds and spurred on by Gene Krupa's drums. The song ends with a circus-like group of rising chromatic chords.

Racial Integration in a Small Group Setting

Goodman took a brave step in 1935 at a performance at Chicago's Congress Hotel. With his eye on quality and perhaps prodded by John Hammond, Goodman featured the black pianist from Austin, Texas, **Teddy Wilson,** in a trio setting with Gene Krupa, pushing back against the implicit rule in entertainment that segregated white and black musicians on stage. The interracial trio had already recorded together in the studio and the recordings had been selling well during the weeks that led up to the concert. But Goodman was the first well-known, white bandleader to perform with a black musician on stage, first bringing on Wilson as a special guest during his big band's break between sets at the Congress Hotel in Chicago. Goodman was motivated by his desire to perform with the best musicians more than a desire to make history, but the move changed the culture and opened up opportunities for black bands to perform at white venues. Goodman further integrated his band by hiring vibraphonist **Lionel Hampton**, guitarist **Charlie Christian** and later, Duke Ellington's trumpet player, **Cootie Williams**.

Lionel Hampton had played drums behind Louis Armstrong. At Armstrong's suggestion, he played the **vibraphone** during a recording

session making him the first recorded jazz improviser on the vibraphone. Hampton, along with Red Norvo and just a handful of others, elevated the vibraphone from its place as a novelty instrument in the back of an orchestra to the front line of the jazz band, capable of a range of expression right along with the best trumpeters and clarinetists.

Just as Hampton introduced the vibraphone to jazz, **Charlie Christian** brought the electric guitar to the front of the jazz band. From Oklahoma City, Christian was one of the first electric guitarists in jazz and developed a remarkable improvisational vocabulary that later played an important role in the development of bebop. John Hammond was instrumental in linking Christian with Goodman. Tipped off by Mary Lou Williams, he arranged a meeting in California between Goodman and Christian, and after a long jam on "Rose Room" Goodman was convinced that Charlie Christian could be a valuable member of his organization. Goodman featured the country boy at locations as posh as Carnegie Hall, and when the band was in New York City Christian spent long hours at jam sessions where the new style of bebop was being created. Like so many artists who were ahead of their time, Charlie Christian died far too soon in 1942, defeated by tuberculosis.

Music Analysis

"Rose Room"
(1939)
Personnel: Benny Goodman, clarinet; Lionel Hampton, vibraphone; Fletcher Henderson, piano; Charlie Christian, guitar; Artie Bernstein, bass; Nick Fatool, drums

The Benny Goodman Sextet grew from the trio Goodman featured at his concerts with Teddy Wilson. The sextet format gave soloists a chance to be heard. This particular tune was Charlie Christian's audition piece when he first came to play with Goodman.

0:00	**Introduction:** Goodman and Charlie Christian play a triplety riff to set the tone of the song.
0:06	**Head:** Goodman plays the melody of the tune, with Hampton doubling him briefly. His shimmering vibraphone sound envelops the band.
0:37	**Guitar solo:** Charlie Christian makes his way through the chord changes with ease, playing common melodic figures and arpeggiating some of the chords.
1:52	**Vibraphone solo:** Lionel Hampton plays a good deal of blues material over the first half of the form.
2:19	**Piano solo:** Fletcher Henderson plays a simple stride style.
2:32	**Collective solo:** Goodman, Henderson, and Hampton play a final section together, ending the song abruptly.

Benny Goodman's career continued on through the ups and downs of swing and he was still performing in the mid-1980s. He made his legacy on excellent musicianship, commissioning classical works by important contemporary composers such as Béla Bartók, Paul Hindemith, and Aaron Copland. In the 1940s he was reluctant to accept the new approach of bebop ushered in by Charlie Parker and Dizzy Gillespie, accusing them of pretending to play. But eventually he reconciled his distaste for modern jazz and formed a seven-piece bebop band in 1948 with the popular tenor saxophonist Wardell Grey.

COUNT BASIE

Return to the Kansas City Saga

Picking up the saga of Kansas City jazz where Chapter 9 left off, **Count Basie** was a beneficiary of Bennie Moten's the bloody demise (in a failed throat operation). After the Kansas City bandleader died, stranding his musicians with unfulfilled gigs, Count Basie formed his own orchestra with many of the key musicians from Moten's band. Basie found a gig at the Reno club in Kansas City where a radio station broadcasted his shows with a signal strong enough to reach to Chicago and across the South.

Count Basie

Here is where John Hammond plays a role in bringing Count Basie out of Kansas City to the widespread jazz market. Behind the scenes, John Hammond seems to have been an omnipresent influence on the rise of swing. He was responsible for jumpstarting the careers of two of the "big three" jazz orchestras of the 1930s and '40s—Benny Goodman and Count Basie (the third being Duke Ellington). Following a tip from *Down Beat* writer, Dave Dexter, Hammond listened to one of these radio broadcasts in Chicago. The Basie orchestra impressed Hammond enough that he wrote about Basie in *Down Beat*. Dexter had hoped that Hammond would go an extra step and actually visit the club and help to accelerate Basie's career. When Hammond let the subject rest, Dexter wrote a *Down Beat* article publicizing Basie band's great potential, and encouraged action from other operatives in the music business. The article was enough to nudge Hammond forward, but Joe Glaser (Louis Armstrong's manager) went to Kansas City the same day as Hammond. The race was on to unearth Kansas City talent!

Glaser spent his time courting Andy Kirk's Twelve Clouds of Joy while Hammond headed to the Reno Club. Basie's key musicians at this time were **Buster Smith** (alto saxophone), **Lester Young** (tenor saxophone), and **Walter Page** (bass). In a *Down Beat* article about his night at the Reno, Hammond showered superlatives on every member of the rhythm section—drummer Jo Jones, Basie, and Walter Page—along with Lester Young and trumpeter Oran "Lips" Page. He was impressed enough by what he heard that he convinced management at MCA—the same booking company that managed Benny Goodman—to sign Basie to their roster. MCA planned a tour to the east for Basie, beginning at Chicago's Grand Terrace.

Basie reformed the band before they left for Chicago, replacing "Lips" Page with Buck Clayton and, on the advice of Hammond, improving the brass section. Caughey Roberts replaced Buster Williams on lead alto, but the band continued to use Williams's arrangements for the time being. The band had a rough start. They had expanded from nine to twelve members, but all of their arrangements were written for only nine. New members had to improvise their parts and caused bad intonation in the group.

Fletcher Henderson, whose orchestra had played at the Grand Terrace just before Basie, came to the rescue and loaned Basie his arrangements.

Basie's first recording sessions happened under dubious circumstances. Hammond had hoped to sign the Basie band to Brunswick records, but an associate of the Decca company in New York City swooped in first. Posing as a friend of Hammond, they convinced Basie to sign a recording contract. Hammond, determined to preserve the band on record, brought a small group comprised of Basie's rhythm section and only Lester Young and trumpeter Carl Smith into a studio in Chicago during the morning hours after their Grand Terrace gig. To skirt the Decca contract, they recorded under the fictitious name "Jones-Smith Incorporated." The three-hour session was thrown together haphazardly; Jo Jones's drum set had no bass drum, forcing him to comp with only the snare drum. But Hammond's recording captures a raw quality that would influence the craft of small-group recording for years to come.

Music Analysis

"Shoeshine Boy"
(1936)
Personnel: Lester Young, tenor saxophone; Carl Smith, trumpet; Count Basie, piano; Walter Page, bass; Jo Jones, drums

The highlights of this Jones-Smith Incorporated recording are the interaction between members of this small group and Lester Young's melodic inventiveness. Listen for moments when Jo Jones connects with the soloist. The form is a 32-bar song form in AABA configuration.

0:00	**Introduction:** Count Basie plays an opening solo.	
0:45	**Tenor saxophone solo:** Lester Young takes a couple of solos and showcases his brilliance at compositing great, swing melody on the spot. During the bridge (1:00), Jo Jones catches Young's accents on the snare drum.	
1:16	Tenor saxophone solo, chorus 2:	
1:47	Carl Smith takes a muted trumpet solo that lasts just one chorus. Young plays a simple background figure.	
2:18	**Trading twos:** Basie, Young, and Smith take two measures each beginning with **stop-time** from the drums.	
2:34	**Drum solo:** The always-smiling Jo Jones takes a solo over the bridge.	
2:42	**Shout section:** All band members join in for a rousing last A section of the head.	
2:49	**Tag Ending:** The players trade brief solos and end quickly.	

After a string of one-nighters, the band arrived in New York to play the Roseland Ballroom, splitting the bill with Woody Herman. The group had greatly improved its sound, but still did not have the arrangements they needed. At recording sessions the band played for Decca around the Roseland gig in January 1937, John Hammond brought in **Freddie Green** to play rhythm guitar, solidifying the legendary rhythm section. Green earned the nickname "Father Time" over the years because of his rock-solid, yet understated "chuck chunk" on every pulse. With Green in place, the four-man rhythm section became the best such unit in all of jazz.

The Count Basie Rhythm Section

The unit that formed during the Decca recording years reinvented the rhythm section sound of jazz. They established the breakdown of roles (see the rhythm section triangle in Chapter 2), roles endured through the Swing Era, through bebop, and even until today. The Basie swing sound is still the foundation for the contemporary jazz rhythm section.

- **Walter Page (string bass)**—Walking bass lines played the quarter note pulse and established the harmony. Page broke away from the two-feel played by other bands.
- **Freddie Green**—Staccato chords aligned precisely with Page's walking bass.
- **Count Basie**—Sparse chords played off the beat provided syncopation and established the harmony. Basie broke away from the stride style of piano that filled every beat with sound.
- **Jo Jones**—He played the steady pulse on the hi hat (playing the rhythm known as a **ride pattern**) and syncopated rhythms on the snare drum and bass drum. Jones broke away from the conventional style in which the pulse was played on the bass drum and snare drum propelled the rhythm forward.

Hammond went a step further in late March, introducing Basie to the up-and-coming singer **Billie Holiday**. Basie was immediately entranced by her beauty and her distinctive singing style and hired her to join the band alongside singer Jimmy Rushing. Eddie Durham joined the band as the staff arranger and improved the band's sound immensely. The Decca recordings of the tunes "Smarty," "One O'Clock Jump," "Listen My Children," and "John's Idea" are evidence of the band's improvement from its beginnings in Kansas City to its expansion and arrival in New York.

Music Analysis

"One O'Clock Jump"
(1937)

Personnel: Buck Clayton, Ed Lewis, Bobby Moore, trumpet; George Hunt and Dan Minor, trombone; Earl Warren, alto saxophone; Herschel Evans, tenor saxophone/clarinet; Lester Young, tenor saxophone; Jack Washington, baritone and alto saxophones; Count Basie, piano; Freddie Green, guitar; Jo Jones, drums; Walter Page, bass

Collectively composed by Basie, Buster Williams, and Eddie Durham in a hotel basement in Kansas City and originally titled "Blue Balls," "One O'Clock Jump" became the Basie band's theme song. At just three minutes, this performance is an abbreviated version of what the band played in a live setting. Each soloist takes only one chorus of blues with **backgrounds** immediately in the picture. Most likely, all soloists took longer solos in a live setting, and backgrounds would have entered after at least a couple of choruses.

0:00	**Introduction:** Basie sets up the tune with a rumbling boogie piano intro.
0:10	**Piano solo:** Basie plays a simple single-line solo over the blues.
0:45	**Tenor saxophone solo:** The band changes to a key a major third lower and Hershel Evans plays a one-chorus solo. Muted trumpets play backgrounds.
1:02	**Trombone solo:** Dan Minor plays a solo over saxophone backgrounds.
1:19	**Tenor saxophone solo:** The always-inventive Lester Young plays a solo over a new version of the previous trumpet backgrounds.

(continued)

Music Analysis *(continued)*

1:35 **Trumpet solo:** Buck Clayton plays over a new set of saxophone backgrounds.

1:53 **Piano solo:** Basie plays a "splanky" solo consisting of two note chords with plenty of space between.

2:10 **Full ensemble:** Each section plays a riff. Notice the trombones playing an accent repeatedly on the fourth beat.

2:27 **Head:** As in "Moten Swing," the saxophone section finally plays the melody of the song for the first time at the end.

2:44 **Head, Theme 2:** The saxophone section changes to a new riff that signals the end of the song.

The New Testament Band

Count Basie's band starting in 1952 has been described as the "New Testament Band" for its wholesale change in personnel and in style. Basie hired excellent arrangers who reformed the band's sound with charts that were more complicated than the head arrangements played by the Old Testament Band. Neil Hefti, Thad Jones, Quincy Jones, Frank Foster, and other notable arrangers contributed a mammoth's supply of new material. Among the most famous arrangements was "April in Paris," arranged by Wild Bill Davis. The melody and ensemble parts are passed around beautifully from section to section, and ample space is opened for individual soloists. The fake ending at the end of the tune shows the band's sense of humor. Basie's bands of the 1950s and '60s were loaded with brilliant soloists and leaders—lead alto saxophonist Marshal Royal, a modernist trumpet player Thad Jones (who would lead his own important big band in the late 1960s), and tenor saxophonists Eddie "Lockjaw" Davis, Frank Foster, and Frank Wess. The Basie legacy lived on by influencing just about every big band that came after him, and the bebop rhythm section style was fashioned after his band. The Basie style still perseveres though the Count Basie Orchestra **ghost band**, swinging its way into towns around the world.

Ghost band—A jazz band that continues to perform after its leader has passed away.

DUKE ELLINGTON— PART 2

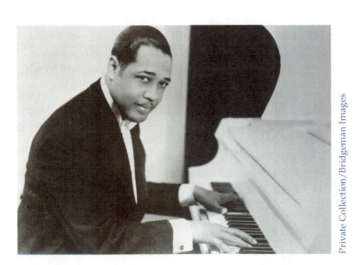

Private Collection/Bridgeman Images

Having cultivated a brand as America's most sophisticated black composer and purveyor of elite artistry, Duke Ellington's cultural significance helped keep his orchestra afloat through the Great Depression. Ellington's reaction to the dance craze attached to swing music was to delve deeper into his own creative being and to produce heavier and more diverse compositions, rather than to kowtow to the trend. Although he was dropped from his recording contract with the RCA Victor company when they were in the process of shoring up their accounts and

maintaining only sure-thing artists, Ellington's orchestra drew a considerable paycheck when they played live performances. The orchestra's triumphant tour of England, Holland, and France in 1933 only solidified his reputation back home. The orchestra entered the recording studio soon enough, and Ellington continued to compose at an unimaginable rate. He was known to write music on the train, the private Pullman compartment that he and the band rode through the South. Ellington actually drew inspiration from the sound of the train that took him cross-country. A famous example of one of his train pieces is "Daybreak Express" (1933), where Ellington creates the sonic illusion of a train starting gradually using the instrumental sounds at his disposal and mimics a steam train's whistle.

Five Categories of Ellington's Compositions

1. **Jungle Sound**—Mainly written around the Cotton Club years. Featured exotic instrumental colors and shifts in tonality from minor to major. ("East St. Louis Toodle-Oo")
2. **Pop Songs**—Short songs that reached the pop charts, often with lyrics added later. ("In A Sentimental Mood" and "It Don't Mean a Thing")
3. **Programmatic Pieces**—Songs that mainly explored orchestral colors to create a mood or to evoke an image of a specific place or thing. ("Mood Indigo")
4. **Concertos**—Pieces written to feature particular soloists in his band. ("Concerto for Cootie" and "Jack the Bear")
5. **Large-Scale Works**—Suites and other multi-movement works. These were a focus of Ellington's output during the middle and late periods. (*"Black, Brown and Beige"* and Sacred Concerts)

Contemporary classical composers Percy Grainger and Aaron Copeland lauded praise on the unique quality of Ellington's serious works, and at the same time he was composing hit popular songs published by his manager Irving Mills. The Great Depression was a good time for Ellington as a songwriter. He was a genius of creating orchestral timbres and had an inimitable harmonic identity.

Melody, however, was not his strong suit. Many of the songs which became pop hits—"Mood Indigo," "It Don't Mean a Thing (If It Ain't Got That Swing)," "Sophisticated Lady," and "In a Sentimental Mood"—were actually collaborations with his band members. Ellington might hear a trumpeter play a melody he liked during an improvised solo. Ellington would ask him to play it back again, and then he would co-opt the fragment into a piece that he would introduce in rehearsal the next day. Sometimes Ellington credited the original melody writer as a co-composer, and for others he kept credit for himself. Ellington has been criticized for a creative process that bordered on plagiarism, but his genius was in arranging his band members' short and simple melodic ideas into a larger whole. Oftentimes, Ellington used a band member's tune as the A section and then composed a contrasting B section to go along with it, as was the case with Juan Tizol's "Caravan" (1936).

"Swee' Pea" and the Next Phase

At a concert in Pittsburg in 1938, Ellington met a young fan backstage. Teenage, bespectacled **Billy Strayhorn** played a couple of Ellington's songs

on the piano—"Sophisticated Lady" and "Solitude." Then, he followed with "Lush Life," his original composition that later became a jazz standard. Thus began one of the most important partnerships in jazz history. Ellington brought him into the organization early in 1939 and delegated a great deal of the composing work to him. The pair collaborated on just about every composition over the next three decades. Demonstrating remarkable early songwriting talent with "Lush Life," Strayhorn developed quickly into a master orchestrator. He had a strong understanding of modern orchestral composers, and familiarized himself with Ellington's system of orchestral color, a sound he called the "**Ellington Effect**." He assimilated Ellington's compositional style and became an ideal compliment to the master (or as Strayhorn liked to call him, the "Monster"). Early in his association with the Duke, Strayhorn contributed "Take the 'A' Train" and the song became Ellington's concert theme. Other important works attributed to Strayhorn were "Chelsea Bridge," Johnny Come Lately," "Passion Flower," "Raincheck," and "Upper Manhattan Medical Group."

The Blanton-Webster Band

A couple of new musicians lent their considerable skills and character to the sound of the Ellington organization in 1939. **Jimmy Blanton** joined the band in St. Louis when Johnny Hodges heard him playing with Fate Marable (Louis Armstrong's employer just before he joined King Oliver in Chicago). A classically trained bassist, Blanton essentially reinvented jazz bass technique and brought the bass to a front-and-center role as a soloist. Blanton performs two functions on recordings of "Jack the Bear" and "Sepia Panorama" from this period. At times he joins the horns playing composed and improvised melodies, and at other times he joins the rhythm section with a solid walking bass line.

Music Analysis

"Take the 'A' Train"
(1941)
Personnel: Rex Stewart, cornet; Wallace Jones and Ray Nance, trumpet; Lawrence Brown and Joe "Tricky Sam" Nanton, trombone; Juan Tizol, valve trombone; Barney Bigard, clarinet; Otto Hardwick, alto and bass saxophones; Johnny Hodges, alto saxophone; Harry Carney, clarinet/baritone saxophone; Duke Ellington, piano; Fred Guy, guitar; Jimmy Blanton, bass; Sonny Greer, drums

Billy Strayhorn's signature composition shows us his ability to bridge the gap between artistry and commercial appeal. Many Strayhorn compositions challenge the listener with dissonant melody and unconventional voicing techniques. This song is arranged in the classic big band style, approaching the trumpets, trombones, and saxophones as separate sections and juxtaposing them against one another. "'A' Train" quickly became the Ellington band's theme song.

0:00	**Introduction:**	Ellington's four-bar piano introduction.
0:05	**Head, A sections:**	The reed section plays the melody. Trumpet and trombone sections each play an independent and interlocking background figure. Jimmy Blanton's walking bass can be heard subtly driving the song forward.
0:29	**Head, B section:**	Reeds continue to play unison melody while trombones play a harmonized counter-figure.
0:39	**Head, last B section:**	Reeds continue, trumpets and trombones plays as one larger section.

Music Analysis *(continued)*

0:51 **Muted trumpet solo:** Ray Nance plays a muted solo with saxophone backgrounds in block chord voicing.

1:37 **"Shout" transition:** Unison trumpets vs. saxophones mark a transition to a new key.

1:44 **Open trumpet solo:** The reed section sets up a dialog with the soloist, trading four-bar phrases with Nance's open (non-muted) trumpet. Sonny Greer increases the volume of the band using his sticks on a ride cymbal and **chopping wood** playing every beat 2 and 4 with his stick placed across the snare drum.

2:05 **Open trumpet solo, bridge:** The other sections join in with written material, culminating at a brief stop-time trumpet call.

2:17 **Head, last A section:** The reeds bring the melody in again with staccato brass "stabs." The band repeats and fades. Sonny Greer begins playing brushes on the snare drum.

2:48 **Ellington ending:** This walk-up melodic fragment has become a standard ending for swing jazz songs.

Ben Webster had long coveted a job with Duke Ellington's organization. Coming from Kansas City, he had already performed with a long list of the most important black bands led by Fletcher Henderson, Andy Kirk, Bennie Moten, Cab Calloway, and Teddy Wilson. His style was a combination of many influences. He culled his tone from Coleman Hawkins and his melodic approach from Lester Young, but also cited Ellington's chief soloist, alto saxophonist Johnny Hodges as an important influence. After his time with Ellington, Webster went on to become one of the primary tenor saxophone soloists in jazz.

Key Additions to the Duke Ellington Orchestra—1940s and Beyond

Arranger/Piano	**Trombone**
Billy Strayhorn	Lawrence Brown
Trumpet	**Bass**
Clark Terry	Jimmy Blanton
Cat Anderson	
	Drums
	Sam Woodyard
Tenor Saxophone	Louis Bellson
Ben Webster	
Paul Gonsalves	

With his new lineup in order, Ellington recorded several tracks in the coming months that catapulted his group to greater acclaim and showed Ellington's approach to swing. The breadth and depth of the band's creations during the Blanton-Webster period from 1939-1942 is staggering. "Concerto for Cootie" featured trumpeter "Cootie" Williams. The angular melody of "Cotton Tail" (borrowed from a warm-up that Williams liked to play) looked forward at modern jazz and featured the handiwork of Ben Webster. "In a Mellotone" became one of the most recognizable jazz standards with its simple, motivic, unison saxophone melody. "Ko-Ko," "Take the 'A' Train," "Flamingo," and "I Got it Bad & That Ain't Good" reached the Billboard pop charts. And Billy Strayhorn's masterpiece "Chelsea Bridge" reemphasized Ellington's penchant for instrumental colors.

The peak of the Blanton-Webster band was short-lived, however. "Cootie" Williams left the band in November of 1940, replaced by Ray Nance, a trumpeter who doubled fluently on the violin. Barney Bigard left the band in 1942, and Jimmy Blanton died of tuberculosis that same summer. Ben Webster left just a year later, allegedly throwing a drunken temper tantrum and quitting the band. Juan Tizol joined Harry James's band in 1944. Soon after Tizol departed, "Tricky Sam" Nanton died of a stroke, likely a casualty of long-term alcohol abuse. Trumpeter Rex Stewart left in 1945, and Duke's original reed player Otto Hardwick left in 1946. With so many key members trailing off, it seemed it was time for Ellington to change course. At the same time, tastes were turning against jazz. Swing was out, replaced in the pop field by jump blues and rock and roll.

Duke's Revival

Ellington's bands of the 1940s and 1950s went through a rough patch, no doubt. But in 1956 the orchestra's performance at the Newport Jazz Festival resuscitated Ellington with a burst of creative energy. The highlight of the band's performance was an old tune entitled "Diminuendo and Crescendo in Blue." Ellington had added an open section of blues choruses for tenor saxophonist Paul Gonsalves through various iterations over the years. Over the course of twenty-seven choruses, Gonsalves whipped the audience into a frenzy that recalled the long-past Swing Era and at the end, the band re-entered with trumpeter Cat Anderson screaming at the top. The visceral response to Ellington's brand of swing was remarkable enough that the word spread outside of the fences at Newport. *Time Magazine* featured Duke Ellington on its cover August 20, 1956, and the recognition heralded the next wave of the Ellington organization.

Music Analysis

"Diminuendo and Crescendo in Blue"
(1956)
Personnel: John Cook, Ray Nance, Clark Terry, William "Cat" Anderson, trumpets; Russell Procope, clarinet/alto saxophone; Johnny Hodges, alto saxophone; Jimmy Hamilton, clarinet/tenor saxophone; Paul Gonsalves, tenor saxophone; Harry Carney, clarinet/baritone saxophone; Duke Ellington, piano; James Woode, bass; Sam Woodyard, drums

Although the blues are the basis of this piece, its form is somewhat **through-composed**, meaning that it does not follow a standard formal template. The conflict between composed sections and solo improvisation in "Diminuendo and Crescendo in Blue" creates some surprising moments in the piece. Duke originally conceived only the fully-composed material, but after tinkering with the layout of the sections over years, the piece arrived at this version that features Paul Gonsalves's famous tenor saxophone solo. The sequence of events in this live performance culminated in an energy so phenomenal that it caused a revival in Ellington's career.

0:00 **Piano solo:** Ellington pounds the keys in his opening 12-bar blues solo in E-flat, along with bassist's walking bass line and drummer's swinging hi hat and **chopping wood** on the snare drum.

1:00 **Blues choruses:** Ellington pits the sections against each other in two composed blues choruses.

1:30 **Modulating choruses:** The band plays through a section that changes rapidly between various swing riffs and blues fragments in ever-shifting keys.

Music Analysis (*continued*)

2:34	**Saxophone soli:** The saxophones establish the key of D-flat.
3:19	**Piano solo:** Ellington plays a solo like the opening, this time in D-flat.
3:47	Tenor saxophone solo: Now begins Paul Gonsalves's 27 choruses. Listen to his ability to maintain listener's interest with constant intensity and a variety of melodic ideas.
10:09	**Piano solo:** Ellington and rhythm section bring the intensity down, and modulate abruptly through blues in F and E, arriving at A-flat.
11:04	**Ensemble figures:** The saxophones play a unison melody, beginning in A-flat blues, then settling in E-flat. Trombone and trumpet sections take the focus at time with their own riffs.
13:12	**Shout section:** The full group of horns joins together, with lead trumpeter Cat Anderson screaming over the top until the final chord.

Ellington's Multi-Movement Works

In 1943, Ellington began to focus in earnest on writing large-scale works that he hoped would elevate his music to a level of artistry equivalent with the Beethoven's and the Tchaikovsky's of classical art music history. He had already tested the waters of more serious compositional forms with *Creole Rhapsody* (1931) and *Reminiscing in Tempo* (1935). These were early forays into an approach to big band writing more symphonic in nature, but they exposed Duke's lack of training in the form and structure of large-scale works. Critics panned the *Rhapsody* and other attempts as random mosaics of disparate ideas.

It wasn't until the 1940s that Ellington began to develop a mature approach to writing longer pieces that demonstrated an understanding of pacing and unity. In 1943, at Carnegie Hall, his orchestra premiered *Black, Brown and Beige*, a suite that illustrated in sound the history of African Americans. Ellington continually described his music in the press as an expression of the Negro soul, and large-scale works were a setting to which he often returned to explore this dimension of his creativity.

Although critics did not look more favorably on *Black, Brown and Beige* than on his earlier attempts, Ellington's first multi-movement work would lead to several others throughout the remainder of his career (with varying degrees of cooperation from Billy Strayhorn). Some of the best suites focused on geographic locations, such as the *Far East Suite* (1966) and *New Orleans Suite* (1970). Others tackled classical literature and music. *Such Sweet Thunder* (1957) was based on William Shakespeare's classic works. Ellington's *Peer Gynt Suite* (1960) was based on the ballet whose musical score was composed by Edvard Grieg; and *The Nutcracker Suite* (1960) reworked the ubiquitous classic ballet composed by Peter Tchaikovsky. The impact of these works is still being realized today, but even in their time the suites produced several jazz standards: "Come Sunday" from *Black, Brown, and Beige*, "Isfahan" from the *Far East Suite*, and the title movement from *Such Suite Thunder*.

Ellington's most notable achievement after the death of Billy Strayhorn in 1967 was his *Second Sacred Concert*, a suite of religious music performed at New York's Cathedral Church of St. John the Divine. Ellington believed it was the most important work of his career. One highlight of the

thirteen movements was a beautiful ballad entitled "Heaven," sung by Alice Babs and featuring Johnny Hodges's smearing sensitivity on the alto saxophone. In 1969, President Nixon invited Ellington to the White House to present him with the Medal of Freedom. At the end of a career in which he accomplished all anyone could hope to accomplish, Ellington died of pneumonia after fighting lung cancer in 1974.

GLENN MILLER

During the United States' involvement in World War II from December of 1941 to September of 1945, swing music only gained popularity. Sixteen million American soldiers fought in the war, and the scores of family members and factory workers who produced weapons and supplies formed a support structure that involved an unprecedented proportion of American citizens. War touched every American and shaped the American way of life. The aesthetic of swing was a match for a military society. Like American soldiers, bands were dressed to the nines and even made coordinated movements with their instruments on stage. The optimistic rhythmic bounce (or "stomp") and powerful trumpets and drums seemed the perfect soundtrack to the existential battle against the Axis nations. Soloists were the height of humanist achievement, and sections battled each other in heated call-and-response fashion.

More than any swing band, the **Glenn Miller Orchestra** was identified with World War II. Miller hailed from the Midwest and had made his way as a sideman and arranger in some of the same circles as Benny Goodman. However, his musical compass pointed him further toward the sweet bands than Goodman's. Glenn Miller formulated a distilled brand of jazz, putting catchy melody and tight ensemble playing front-and-center and largely ignoring the elements of the African-American approach that had created swing music. His most popular songs—"Moonlight Serenade," "Pennsylvania 6-5000," "Chattanooga Choo Choo," and especially "In the Mood"—all caught the public's attention with perfectly crafted melodic hooks, but with little to no improvisation. Miller's calling cards were his saxophone section led by a vibrato-laden clarinet (listen to "Moonlight Serenade") and a group of singers led by the band's tenor saxophonist Tex Beneke.

You have to hand it to Miller's band, they were a tight ensemble and their songs were infectious. (Who can resist shouting along with "Pennsylvania 6-5000"?) The band's edgeless approach to jazz and reluctance to rely on improvisation virtually remove it from the curve of creative jazz, but Miller's formula imprinted swing onto the psyche of every American alive during WWII. The Glenn Miller Orchestra remains one of the most visible touring *ghost bands* today. Miller's own death was a true celebrity scandal of its day. He joined the military in September of 1942, leading the forty-two-piece Glenn Miller Army Air Force Band. Just a couple of years later his plane disappeared over the English Channel, and his death was ruled an accident.

OTHER IMPORTANT SWING BANDS

A number of other bands contributed significantly to the Swing Era including black groups led by **Cab Calloway** and **Jimmy Lunceford** and white

groups led by **Artie Shaw**, and the brothers **Tommy and Jimmy Dorsey**. **Chick Webb and His Orchestra** was the house band for several years at the Savoy Ballroom in Harlem. Webb's was the band to beat in the cutting contests that took place at that giant hall. A small man who was diagnosed with tuberculosis of the spine as a child, Webb ran one of the most swinging black ensembles during the earliest days of swing until his death in 1939. He is also credited with having given Ella Fitzgerald her first shot as a professional singer.

Brothers **Tommy Dorsey** (trombone) and **Jimmy Dorsey** (clarinet) ran a successful big band that split when an onstage sibling's feud, possibly a disagreement over the tempo of a song, caused Tommy to walk off stage and ended their partnership. Jimmy Dorsey kept the old band, and Tommy started his own which eclipsed the fame of the original band. Tommy's big band featured drummer Buddy Rich and iconic pop singer Frank Sinatra. Arranger Sy Oliver, who also worked with Jimmy Lunceford, brought a legitimate swing approach into the band with the well-known song "Opus One" and others.

Artie Shaw was a clarinet virtuoso whose technical prowess rivaled Benny Goodman's. Cole Porter's tune "Begin the Beguine" was a major hit for Shaw, but it proved both a financial blessing and an artistic curse. Shaw bemoaned the fact that he had to play the song at every performance to satisfy his audience, but his passion was to make music of a broader scope. His band was one of the finest of the era, and as a white bandleader he deserves credit for having hired African Americans Billie Holiday and Roy Eldridge as central contributors to his band's performances in the late 1930s and early '40s.

CONCLUSION

Between 1935 and 1945, the "big three" bands of swing—Benny Goodman, Count Basie, Duke Ellington—provided a framework for success that left its mark on future styles of jazz. Although all three featured incredible soloists, the simple and blues-based arrangements of Basie's band featured and challenged his improvisers more than the other two. Goodman established the trend of swing and exposed the music of expert black arrangers and soloists to a broad white public. He set a high standard for musical quality. Ellington stubbornly worked to establish a bridge between the *pop* function and the *art* function of jazz. The public view of jazz as an art music has sustained the genre through the valleys of small club audiences and abysmal record sales. And although no trend lasts forever, the small group soloists and spotlight singers who found celebrity helped keep jazz in the broad sense moving along toward modernism.

Discussion Questions

1. How did Benny Goodman break the color barrier in jazz?

2. Describe Benny Goodman's role in the beginning of the Swing Era.

3. What musical aspects did Count Basie bring from Kansas City to the global jazz scene of New York?

4. Explain the compositional relationship between Duke Ellington and Billy Strayhorn.

5. Outline the five categories of Ellington's compositions. To which category does "Caravan" belong? "Daybreak Express"? *Black, Brown and Beige*?

Soloists and Singers

Swing had many faces. The music established itself as a means to keep patrons on the dance floor and keep the energy rolling with a churning rhythm section and brass and wood-wind sections juxtaposed in constant battle. Alternately, a number of solo performers—some singers and some instrumentalists—emerged as stars, capable of demanding a listener's attention with captivating delivery of a blues-laden melody and inventive improvisations.

The function of the singer changed gradually during the Swing Era. Most bands featured their singer in the middle of a set for a couple of numbers, and even then, often a few minutes of a vocal chart might pass before the singer would step up. As WWII neared its close, swing bands held the public's attention by focusing more and more on the singers.

SMALL GROUPS AND SOLOISTS OF THE SWING ERA

While vocalists began to steal the spotlight, so to speak, a group of important soloists emerged from the ranks of the swing bands to which they belonged, and the small group jazz that developed was largely responsible for keeping the art form moving forward. For the sake of variety (and sometimes economy), several of the big bands also performed in small group settings both in recording studios and during live concerts. While big bands were enjoying fame during the zenith of swing, their small band offshoots were causing a transition to bebop, the next evolutionary stage of jazz where the small group format would become primary. Benny Goodman's trio with Gene Krupa and Teddy Wilson in 1935—and its expansion to a six-piece ensemble with Lionel Hampton, Charlie Christian, and Cootie Williams—was an influence on Charlie Parker and some of his compatriots. Other big bands followed suit and John Hammond set a standard for production of small group recordings with his bare-bones sessions with Count Basie and just a few of his musicians in 1936. Without ten or twelve horns to contend with, the small group setting favored solo improvisation over group arrangement, and thus, the recordings and performances of these groups exposed several great soloists.

John Hammond, again, played a role here. When **jukeboxes** became commonplace in American drugstores, ice cream parlors, saloons, and restaurants from 1934 to 1939, Hammond spotted the demand for recordings of popular music geared toward black listeners, a kind of race record market

for jukeboxes. He worked with the management of Brunswick Records to record pop songs in pared down settings, just a singer and a few instrumentalists instead of the big band or orchestral accompaniments that were common at that time. This loose approach would cost less money to produce, since fewer musicians on the payroll also meant little arranging was necessary. In the process, recordings by Billie Holiday, Teddy Wilson (often the band leader at these sessions), Helen Ward, and Ella Fitzgerald took on an intimate quality that instrumental small group jazz artists of the 1950s and '60s would continue to propagate.

THE RISE OF THE TENOR SAXOPHONE

Coleman Hawkins

Even before the Swing Era was underway, a couple of tenor saxophonists who were musical opposites drew significant attention to their individual exploits. Known as the "Father of the Tenor Saxophone," **Coleman Hawkins** had toured with Mamie Smith as early as 1921 and was a major force in the Fletcher Henderson Orchestra nearly since its inception. Not long before the time of his fateful Kansas City battle with Lester Young (described in Chapter 9), he began recording as a leader with small groups and in 1934 he embarked on a tour of Europe that made him an international jazz star.

On his return from Europe, Hawkins attended jam sessions where he faced his tenor saxophone rivals whose stars had risen while he was overseas—Lester Young, Ben Webster, and Chu Berry. Entering the studio, Hawkins gave an inspired performance of "Body and Soul." Surprisingly, Coleman Hawkins's "Body and Soul" was extremely popular despite the fact that it lacked a recognizable melody statement. His solo was considered one of the most important in all of jazz history, and Hawkins's melodies became so imprinted on Johnny Green's chord progression the two were almost inseparable.

Music Analysis

"Body and Soul"
(1939)
Personnel: Coleman Hawkins, tenor saxophone; Joe Guy and Tommy Lindsay, trumpet; Earl Hardy, trombone; Jackie Fields and Eustis Moore, alto saxophone; Gene Rodgers, piano; William Oscar Smith, bass; Arthur Herbert, drums

0:00	**Piano Introduction:**
0:10	**Head:** Hawkins "tunes up" the first note, then plays the opening notes of the melody.
0:16	**Head:** He plays a figure that is essentially an accelerated bass figure, playing the bass notes of passing chords.
0:18	**Head:** He hints at double time, then moves up to the high notes of this section of the phrase.
0:23	**Head, A section:** Again hinting at double-time, he essentially plays the melody interspersed with arpeggiations of chords.
0:27	**Head, A section:** This last portion of the opening phrase, Hawkins plays arpeggio figures on the chord progression.
0:33	**Head, 2nd A section:** From this point, Hawkins only briefly arrives at pitches in the written melody, instead maintaining a double-time feeling with phrases based on arpeggios.

Music Analysis (continued)

0:52	**Head, B section:**	Same double-time approach.
1:12	**Head, last A section:**	
1:33	**First and second A section:**	The horn section enters politely as Hawkins continues with a variety of double-time ideas.
2:13	**B section:**	
2:33	**A section:**	Hawkins reaches a climax here with high "squawks" and agitated articulation.
2:50	**Coda:**	The tempo slows to a halt and Hawkins plays a brief cadenza, closed with a final chord from the horn group.

Hawkins's 1939 recording of "Body and Soul" reveals some of his most influential traits. His wide-open sound and his long notes ending with fast vibrato are giveaways to the Coleman Hawkins approach on recordings. His ability to build a solo based largely on arpeggiations (playing up and down the pitches of each passing chord) cast him as a *harmonic* or *vertical* player. He ushered in a new rhythmic approach using **double time** phrases on ballads. Future artists would apply the same technique to faster tempos.

"Body and Soul" carried Hawkins through the next iterations of the jazz genre as he could be found performing in a variety of settings—big band, traditional New Orleans-style jazz, and bebop. He took on a paternal role with the modernists of the bebop style. He hired Thelonious Monk, notorious for being a difficult sideman, to play piano in his small group and made some of the first recordings of Monk's forward-looking songs. He supported the work of modernists Dizzy Gillespie and Don Bias when so many veteran jazz musicians retreated into classic styles of jazz.

> **Double time feel—** One or more musicians play twice the speed of the established tempo while the other musicians keep the pulse the same.

Lester Young

Lester Young was the antithesis of Coleman Hawkins. Introverted to an exaggerated extent and full of strange mannerisms, Young crafted a completely unique tenor sound, an impeccable sense of swing, and a broad improvisational vocabulary. Countless leading musicians of the future bebop and cool jazz styles credited Young as a primary influence in the development of their style. Lester had a number of eccentricities in addition to his unorthodox playing style. He was known to hold the bell of his horn up and off to the right side of his body when he played. His vocabulary of American language was as unique as his work on the horn, perhaps even more so. He invented colloquial terms in his everyday speech that spread into the American lexicon and resurfaced in the slang and 'jive' talk of later generations. He may have invented the use of the word "cool" in the place of "good." "Bread" meant "money." He "felt a draft" when he saw an instance of racial prejudice. White people were "grey boys." Police were "Bing and Bob." Just about anyone, man or woman,

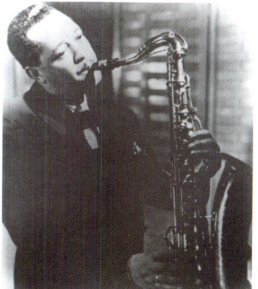

Lester Young

Photofest

could be nicknamed "Lady" (much like Louis Armstrong's common nickname for people, "Pops").

Young's Long Apprenticeship in Professional Music

Young was raised in New Orleans during some of the earliest days of jazz, though any influence of this deepest root is likely linked to the later stages of his upbringing, since he was busy by age ten working with his father's band touring with the circus and at various theaters on the TOBA circuit, living as far north as Minneapolis. His early jazz influences included Frank Trumbauer, Jimmy Dorsey, and Benny Goodman. Citing a turbulent relationship with his father, Young left home several times during his teens and performed with various territory bands. He settled in Kansas City after a stint playing under Buster Smith and the Blue Devils. He earned a reputation as a tenor-toting killer in Kansas City jam sessions with a gift for melodic invention and an ability to play chorus after chorus without getting stale. Young made big news when he took Coleman Hawkins's place in Fletcher Henderson's band in New York when Hawkins left for Europe. Sadly, Henderson's saxophone section rejected Young's lighter approach and, under pressure from the band's veterans, Henderson was forced to fire him. Onlookers (John Hammond included) recognized Young's talent. Before Young returned to Kansas City to briefly join Andy Kirk's band, he developed a friendship with Billie Holiday that would be the most steadfast, platonic partnership of his life. Holiday nicknamed him "the Pres," as in President of the saxophone. Young nicknamed her "Lady Day."

In Kansas City, Lester Young joined Count Basie's band and would accompany the Basie group when they made their successful move to New York City. The contrast between Young and the band's other tenor player, Herschel Evans (a Coleman Hawkins disciple), provided much of the excitement responsible for the band's success. While the Basie band toured the northeast, John Hammond brought him into the recording studio regularly for sessions with Billie Holiday and Teddy Wilson. Young left Basie's band in 1941. He led bands in recording sessions and on live dates and moved for a time to Los Angeles to co-lead the Esquires of Rhythm with his brother Lee, a drummer.

In 1944, a budding career as a solo artist was interrupted when Lester Young was drafted into military service. As soon as the eccentric, alcoholic, jazz musician entered basic training, a disastrous process began. Young went AWOL, only to be returned by his brother the same night as his escape. He was injured during a training exercise. He suffered withdrawal symptoms (Young was known to ingest debilitating amounts of whiskey and other drugs). Army psychologists declared him unfit for duty and dishonorably discharged him, sending him to military prison for a year in Camp Gordon, Georgia. Young never described what happened to him in Georgia with any detail, but it was clearly a dark time for him in a vulnerable mental state. He was released within a few months of the end of WWII to the safety net of a recording contract Norman Granz arranged with the Philo record label (later called Alladin).

The Pres's Second Term

Norman Granz would provide work for several important jazz artists over the years, many of whom had befallen hard times. His **Jazz at the**

Philharmonic series (or **JATP** for short) featured great jazz artists in all-star jam sessions performing only in venues that, by Granz's insistence, had to be integrated. Granz was responsible for hundreds of records and performances by Lester Young, Coleman Hawkins, Charlie Parker, Dizzy Gillespie, Max Roach, and Buddy Rich. He was particularly instrumental in promoting the careers of singers Ella Fitzgerald and Billie Holiday, and pianists Oscar Peterson and Art Tatum. Granz produced the first JATP concert in July 1944 at the Los Angeles Philharmonic Auditorium. A benefit concert for a legal fund used in defense of wrongly accused Mexican-Americans, the audience filled the venue's 2,800 seats. Granz continued the series on the success of the first concert and took the JATP on tour, first throughout California, and later into Europe.

Young continued to work under the auspices of Norman Granz and JATP throughout the remainder of his life, but in 1955 his health and his playing began to decline. Lester finally died in 1959 in his room at the Alvin Hotel across the street from the Birdland club where his influence was being heard nightly. Young was just forty-nine years old.

Pres's Language of Improvisation

Lester Young's brilliant melodic invention and some of his tricks of the trade appear on the Count Basie's "Shoeshine Boy" and "One O'Clock Jump," covered in Chapter 10. We have to look back to Louis Armstrong to find a soloist who can rival his logical construction of melodic ideas—in his repetition and variation of simple ideas and in his movement between riffs and free-flowing material. One of Young's crowd-pleasing tricks was his use of **alternate fingerings** for some pitches on his horn that played a tone with a changed timbre and slightly varied intonation. Young liked to

> The saxophone can produce the same pitch using a variety of **alternate fingerings**, and each different fingering has a different tone color. Soloists use these color changes in their solos.

Music Analysis

"Body and Soul"
(1942)
Personnel: Lester Young, tenor saxophone; Nat "King" Cole, piano; Red Callendar, bass

Like Coleman Hawkins's famous version recorded three years earlier, Young plays a few notes of the original melody and then improvises around it. Young departs from the melody sooner than Hawkins's version from three years earlier. Young's sound is more tranquil and his vibrato more smoothly blended into his tone than Hawkins's. He uses a similar double time rhythmic approach on this recording.

0:00	**Introduction:** Nat Cole's piano solo.
0:10	**Head:** Played by Lester Young's tenor saxophone.
1:46	**Piano Solo, A sections:** Nat Cole uses a technique known as **planing**, in which the pianist plays a dense chord structure underneath a lead line and moves the structure upward and downward along with the contour of the melody.
2:37	**Bass Solo, B section:** Red Calendar's bass.
2:59	**Piano Solo, last A section:** A similar approach to the earlier piano solo.
3:23	**Tenor saxophone solo:**
4:13	**Piano solo, B section:**
4:37	**Tenor saxophone solo, last A section:** Like Hawkins's version, the saxophonist's solo runs into the end of the song without statement of the melody, only with a briefer cadenza before a final chord.

alternate between the regular and the alternate fingering with fast eighth-note rhythms, almost using his horn like a drum with two distinct drum-sticks. It is instructive to listen to Young's approach to the ballad "Body and Soul" after hearing Coleman Hawkins's performance of the same tune.

Chu Berry

Another tenor player in the Fletcher Henderson lineage, **Chu Berry** made a name for himself as one of the primary practitioners of the big horn. He died an untimely death in a car accident in 1941, while working with Cab Calloway's group. Because of his career's early end, fewer recordings survive of his work than the other great players of his day and he is far less remembered. But bebop inventor Charlie Parker and other pivotal musicians of the next class looked to him as one of the finest of his day.

Ben Webster

Like Chu Berry, **Ben Webster** was formed in the Coleman Hawkins ilk. But where Hawkins excelled at a harmonic approach to improvisation and strength of sound, Webster explored the wide array of timbres capable on the tenor saxophone with great control. On some performances he sounds like a harder-edged version of Lester Young; on others, he sounds like a slightly more reserved Coleman Hawkins. Webster did his early work in Kansas City and played in both Bennie Moten's and Andy Kirk's bands. According to Mary Lou Williams, he was in the room the night Lester Young locked horns with Coleman Hawkins. He added to that impressive resume when he moved to New York City in 1934 and worked with Fletcher Henderson (as Lester Young's replacement) and Cab Calloway. His tenure with Duke Ellington from 1940 to 1943 is hailed as the pinnacle of that band's long history, and as one of the band's chief soloists he played an important role in its success. His solo on Ellington's "Cotton Tail" is an important link to the oncoming style of bebop. The song's melody shares its shapes and rhythms with bebop melodies.

JAZZ IN EUROPE: DJANGO REINHARDT AND STEPHANE GRAPPELLI

Among the most arresting recordings of pre-bebop small group jazz were made by a group of Parisian musicians led by guitarist **Django Reinhardt** and violinist **Stephane Grappelli**, a group that called themselves the **Quintette du Hot Club de France**. The unique instrumentation of the group—three guitars, violin, and string bass—distinguished it from the wind instrument dominated sound of swing. Their music and the style it spawned came to be known as "**gypsy jazz**," named for some group members' Roma—or gypsy—roots. The Quintette performed primarily American jazz songs, but also incorporated classical pieces and folk music into their repertoire.

Both Reinhardt and Grappelli found careers after the Quintette du Hot Club disbanded at the onset of WWII. Grappelli brought a decidedly classical sense of rhythmic phrasing into the group, but collaborated with a diverse array of American performers including jazz vibraphonist Gary

Gypsy jazz—A genre of small group jazz with gypsy roots created in Europe. Gypsy jazz groups primarily consist of stringed instruments (guitars and violins) and emphasize solo improvisation.

Burton, classical cellist Yo-Yo-Ma, and pianist Earl Hines. Reinhardt's career was cut short by a brain hemorrhage in 1953, but his accomplishments during his abbreviated career are impressive. The guitar community, in particular, ascribes him the kind of mystical reverence given to Jimi Hendrix, largely because of his incredible guitar technique despite a significant disability.

Django Reinhardt was born in Belgium and raised in a gypsy community that lived outside Paris. In 1928, his caravan caught on fire and burned two fingers on his left hand (the hand that moves up and down the fretboard) and his right leg, leaving him with only an index and third finger. Despite his lack of digits (and perhaps in some way, because of it), Django tended to play single-line melodies in his improvisations, much like Charlie Christian would introduce along with Benny Goodman. Reinhardt had an immaculate clarity in his melodies, and was capable of keeping up with the finest of improvisers. When he toured the United States in 1946, Duke Ellington featured his playing at Carnegie Hall.

SINGERS OF THE SWING ERA

The swing singer was a phenomenon in the big bands that spelled the end of the swing craze at the same time that it increased its popularity. **Bing Crosby** was one of the earliest examples of singers to emerge from a jazz orchestra (Paul Whiteman's) to win stardom in his own right. By 1939, Crosby was the second-most played artist on jukeboxes in America, according to *Billboard's* weekly Record Buying Guide, only trailing Glenn Miller. Other popular groups at the time were Guy Lombardo's sweet orchestra, the Andrews Sisters, and Artie Shaw. Vocalists continued to sell records, which incentivized record companies to shift more and more of their promotional efforts away from instrumental bands. The vocalists with the hot bands began to command more public attention than their bandleaders.

Ella Fitzgerald

Arriving on the Harlem jazz scene shortly after winning Amateur Night at the Apollo Theater, **Ella Fitzgerald** became one of the most beloved and bright figures in jazz vocals. Arranger and alto saxophonist Benny Carter lobbied Chick Webb to bring her on as his band's vocalist at the Savoy Ballroom in Harlem. Webb balked at first, but her voice and popularity with local crowds won him over. Her signature number, a jazz version of the nursery rhyme "A-Tisket, A-Tasket," was a perfect match for her cutesy voice and bubbly persona. The song became a major hit in 1938 and introduced her to a broad audience.

Fitzgerald's talents went far beyond her knack for singing novelty numbers. Influenced by Louis Armstrong's performance of "Ain't Misbehavin'," Fitzgerald had a natural command of the jazz idiom. Her sense of timing and her approach of paraphrasing written melody were matched with a wide vocal range and a solid sense of pitch intonation. She was one of the best scat singers of all time, able to hold her own with great instrumental soloists.

Music Analysis

"A-Tisket, A-Tasket"
(1938)
Personnel: Ella Fitzgerald, voice; Mario Bauza, Taft Jordan, Bobby Stark, trumpet; George Matthews, Nat Story, Sandy Williams, trombone; Garvin Bushell, clarinet/alto saxophone; Louis Jordan, alto saxophone; Ted McRae, tenor saxophone; Wayman Carver, tenor saxophone/flute; Tommy Fulford, piano; Bobby Johnson, guitar; Beverley Peer, bass; Chick Webb, drums

0:00	**Introduction:** Boogie-woogie figure in the trombones and saxophones, followed by harmonized trumpets.
0:12	**Introduction:** The saxophones play a unison lead-in riff. Its rhythm is a hemiola, superimposing a three-beat pattern over the four-beat meter.
0:18	**Verse 1:** Ella Fitzgerald introduces the nursery rhyme in child-like voice, backed by woodwinds and trombones.
1:04	**Interlude:** A repeat of the introduction, this time modulating to the minor mode.
1:21	**Verse 2:** Begins in a minor mode with a new saxophone background. The key changes back to major after one phrase. Band members chime in, vocally answering Fitzgerald's lyric.
2:30	**Coda:** Chick Webb's rim shots announce a very brief trumpet shout ending.

Characteristics of Ella Fitzgerald

- Bright vocal quality
- Incredible scat singing ability
- Wide vocal range

When Chick Webb died in 1939, Fitzgerald took over leadership of his orchestra. When the group disbanded a few years later, Fitzgerald's career took flight with recording work and live performances. She joined Norman Grantz's Jazz at the Philharmonic tour and recorded a number of beloved albums, each of which focused on the music of a particular composer. She covered the music of Cole Porter, George Gershwin, Jerome Kern, Harold Arlen, Johnny Mercer, and Irving Berlin. Her duet albums with Louis Armstrong in 1956 and '57 were among the highlights of a career built on vocal excellence.

Billie Holiday

Just as Lester Young represented the polar opposite to Coleman Hawkins on the tenor saxophone, **Billie Holiday's** style was an opposite of Ella Fitzgerald's. The two singers began singing in front of big bands at about the same time and both cited the recordings of Louis Armstrong as a major part of their musical education, but their styles and contributions to the form could scarcely be more different from one another. Holiday's strength was her delivery and an amazing ability to express emotion through the sometimes banal medium of popular songs. Like her friend Lester Young, the blues informed her phrasing and style. Holiday's voice was small and her range was shallow—about an octave and a half, compared with Fitzgerald's four octaves. But with these modest tools, she crafted definitive versions of the songs she performed.

Holiday's upbringing and her professional life were filled with misfortunate and troubling anecdotes that may have served as a well of experience from which she could, like a great actor, pull the emotional content for a performance. She was born Eleanora Fagan to parents who had only had a brief teenage fling. Her father Clarence Holiday—absent from the family picture—was a guitarist with the Fletcher Henderson Orchestra. Billie's upbringing in Baltimore was unstable, to say the least. When her mother left for New York City she lived with various relatives, some of them abusive. At ten years old she was sent to an orphanage. A year later she returned to her mother and new boyfriend, Wee Wee Hill. The family migrated back to New York. At some point in her teenage years, she worked in a brothel, and was reportedly arrested at age 14 for prostitution. But at the same time, she was developing a love of singing and finding opportunities to get in front of audiences in New York City nightclubs.

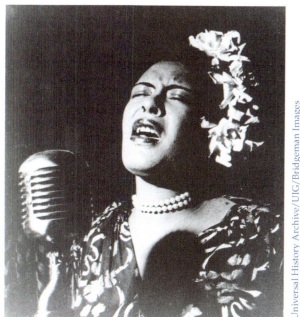

Billie Holiday

Universal History Archive/UIG/Bridgeman Images

Characteristics of Billie Holiday

- Dark vocal quality
- Unmatched talent for emotional expression
- Deep sense of the blues
- Narrow vocal range

In 1933, she was singing at a nightclub in Harlem when John Hammond discovered her and wrote a glowing review in *Melody Maker*. With Hammond on her side, Holiday found herself in the company of the jazz elite. She sang with big bands led by Benny Goodman, Count Basie, and Artie Shaw. She recorded with Teddy Wilson's small groups, filled with all-star sidemen. All of these elevated her status as a jazz star with a formidable reputation.

By 1939 she was performing regularly at a progressive, interracial nightclub in Greenwich Village called Café Society. The owner urged her to add a song to her act that would bring her into the fold with the African-American struggle for civil rights. **"Strange Fruit"** described in macabre terms the lynching of a southern black man, making a surreal turn by comparing his swinging body to the fruits that the onlooker expects to see hanging from the tree. In 1939, singing such a song would require a good measure of bravery, even in New York.

Like so many jazz artists of the mid-20th century, a lifetime of substance abuse weakened her abilities and ultimately unnecessarily shortened her lifespan. As a teen she developed a taste for cigarettes and marijuana. She smoked as many as fifty cigarettes a day. She was a heavy drinker and became addicted to heroin while married to Jimmy Monroe. Holiday was sent to a women's prison in 1947 after being convicted of drug offenses. She lost her cabaret card as a result. A **cabaret card** was a professional license to perform in New York clubs. Without it, a musician lost the

Cabaret card—A professional license to perform in New York nightclubs.

income and notoriety they received from playing live gigs, and they either had to rely on touring outside the city or recordings to make a living.

Billie Holiday's Late Stage

By 1952, Holiday's drug abuse had caused her career to decline sharply. But Norman Granz stepped in, signed her with his record company, and resuscitated her career by pairing her with all-star musicians from his own stable, much like Hammond had done years before. Holiday's recordings in the 1950s represent a new phase in her artistry. Her instrument had been ravaged by decades of severe drug abuse. The tone of her voice had noticeably lost its youthful vibrancy, replaced by a whiskey-drowned rasp. But while many of her fans longed for the sound of young Lady Day, others praised her deepened abilities for subtle expression. A 1957 television appearance arranged by Norman Granz called *The Sound of Jazz* (easily found on YouTube or other outlets) reveals this heightened sense for expression. Backed by a smattering of jazz stars including Ben Webster and Gerry Mulligan, Holiday sits alone on a stool and mourns her way through her composition "Fine and Mellow." After a couple of chilling blues verses, Ben Webster stands up to solo, feeding off of the intense melancholy with his own brash, bluesy playing. Lester Young follows, jumping up from his stool (likely a dubious feat for him, given the state of his health at the time) and playing a somber melody that sounds more content than anguished. Pres and Lady Day had grown somewhat estranged at this point, but his solo is a match for the sleepy melancholy she unrolled in her verses.

Until her death in 1959, Holiday struggled on and off stage. Her liver was ravaged, and she developed a kidney infection while she was under treatment. Her drug problems followed her to the hospital where police put her under house arrest, suspecting that she would find a way to get heroin.

Music Analysis

"Solitude"
(1952)
Personnel: Billie Holiday, voice; Charlie Shavers, trumpet; Oscar Peterson, piano; Barney Kessel, guitar; Ray Brown, bass

Billie Holiday is at the height of her expressive power on this melancholic ballad. She had recorded a definitive version of Duke Ellington's standard in 1941, and again in 1947. This 1952 version captures her late approach. She is accompanied here by a band of top freelance jazz musicians. Oscar Peterson and Ray Brown were particularly well-known as bandleaders.

0:00 **Introduction:** Barney Kessel and Oscar Peterson trade the harmonic role beautifully on this recording. Kessel takes this introduction on his guitar.

0:12 **1st and 2nd A sections:** Holiday sings, answered by Charlie Shavers's muted trumpet, recreating the relationship heard on Bessie Smith records with Louis Armstrong. Shavers's melodic choices are far more contemporary, however.

1:15 **B section:** The band continues similarly.

1:45 **Last A section:**

2:15 **B section, repeat:**

2:45 **Last A section, repeat:**

3:04 **Coda:** Oscar Peterson holds out a chord for Holiday's last statement, then continues with an ending passage.

Frank Sinatra

Sinatra is a difficult artist to classify. Most jazz historians are careful not to call him a true jazz artist, in line with the unanimously accepted Ella Fitzgerald and Billie Holiday. Some jazz histories omit him from the story altogether, along with Bing Crosby. True, his star rose along with the watering down of swing jazz, when the form became more formulaic and improvisation gave way to pristine sounds and solid arrangements. Sinatra's on-the-beat delivery seemed to have as much in common with Hollywood and Vaudeville as it did with the jazz tradition. Listening to a Louis Armstrong, Big Joe Turner, or Jimmy Rushing recording after one by Frank Sinatra exposes a lack of connection with legitimate jazz and blues. But Sinatra built a persona and a musical style that resonated with people and brought

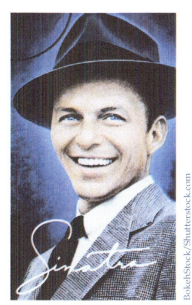

Frank Sinatra

many of them into the fold of jazz. His collaborations with the Basie band (heard on *Frank Sinatra at the Sands* and *Frankly Basie*) prove that he could operate and even shine within the confines of the swingingest stompers in the land. He carried the tradition of his idol Bing Crosby, and tempered his approach with Billie Holiday's expressive interpretation of lyrics.

Sinatra garnered an international audience with Harry James and Tommy Dorsey between 1939 and 1942, and achieved a level of fame known

Music Analysis

"Pennies From Heaven"
(1962)
Personnel: Frank Sinatra, voice; Al Aarons, Al Porcino, F. P. Ricard, Sammy Cohn, Thad Jones, trumpets; Benny Powell, Henry Coker, Rufus Wagner, trombones; Marshall Royal, Charles Fowlkes, Eric Dixon, Frank Foster, Frank Wess, saxophones; Count Basie, piano; Freddie Green, guitar; Buddy Catlett, bass; Sonny Payne, drums

This 1960s performance demonstrates Frank Sinatra's approach to medium tempo swing numbers in the second half of his career. This album was a musical highlight of Sinatra's career, backed by the great Count Basie Orchestra, with arrangement by Neil Hefti.

0:00	**Piano Introduction:** A typical "splanky" entrance from Count Basie.
0:11	**Head:** Sinatra's lazy delivery swings nicely against the rhythm section's solid four-beat feel. The background orchestration changes between muted trumpet fills, saxophone and trombone section chords, and a figure from muted trumpets.
1:10	**Tenor saxophone solo:** Frank Foster blazes in before the top of the chorus with double-time material.
1:44	**Ensemble section:** The full band enters during the second half with hair-raising volume.
2:15	**Head:** Sinatra sings the verse again, this time with more playful and energized phrasing.
3:15	**Coda:** Along with Sinatra's closing high note, the band drives the song home with a bluesy riff (using a minor 3rd over the major 3rd in the chord).

by very few. Sinatra's celebrity carried him to a Hollywood film career appearing in movies beginning in the early 1940s and winning an Oscar in 1954 for his work in *From Here to Eternity*. After a downturn in his career after World War II, Sinatra remade his public image, striking the playboy pose for which will always be remembered. He recalibrated the type of music he was singing, moving from ballads to medium- and up-tempo swinging tunes engulfed in the arrangements of Nelson Riddle. He sang with conviction and ribbed his audience with playful banter. Most incredibly, Sinatra remained a relevant performer able to sell out large concert venues throughout his life.

Sarah Vaughan

Of all the vocalists to emerge from the big band setting, **Sarah Vaughan** was the one most capable of blending the swing aesthetic with the ingenuity of the coming bebop era. Nicknamed "The Divine One," Vaughan embodied the ideal qualities of post-swing jazz. Earl Hines, compatriot of Louis Armstrong in Chicago, hired Sarah Vaughan in 1942 to sing and play backup piano in his big band, along with some of the key modern players—Dizzy Gillespie and Charlie Parker. Vaughan soaked up the new melodic approach and harmonic language of the bebop musicians. An adept pianist herself, she had a solid understanding of the theory behind the new innovations. She had an incredibly wide range with particular warmth in her low register and could replicate the bebopper's angular melodies, wide leaps, and changes in timbre with her voice. The first recorded version of the famous bebop song "Night In Tunisia" was titled "Interlude" instead, and featured Vaughan's vocal. After leaving Hines in 1944, she joined Billy Eckstine's group (also an early bastion of bebop) and from there her career progressed along a path to more widespread popularity. Her recordings of the 1950s and later revolved around the songbooks of great American theater composers (Gershwin, Berlin, and others).

THE DECLINE OF THE SWING ERA

Since Benny Goodman's triumphant arrival at the Palomar Ballroom in Los Angeles in 1935, swing had roared on as America's popular music. The best big bands paired their popularity with musical relevance—music well played, compositions well written, the spirit of jazz maintained. But a decade is a long time for any trend in America, and swing's time had come by the end of World War II. Economy had been the primary driver of the swing craze. When economic conditions changed, other genres emerged.

The black bands were the first to fold in the late 1930s, even during the height of the swing craze. Black bands were already paid far less than white swing bands, even despite the popularity of Duke Ellington, Cab Calloway, Count Basie, and Chick Webb. The musician's union actually set the pay scale lower for Harlem dance halls—where black bands mainly worked—compared with other New York halls. Radio broadcasts were potentially a lucrative income stream due to the advertising dollars and publicity for albums, but the hotels from where these shows were broadcast were often white-only establishments. Black bands just did not have access to the same opportunities for revenue as the white bands, so the business

model for a black band involved playing one-night engagements across large stretches of the American frontier.

During World War II, a decline in listenership began to appear. Although swing jazz provided the soundtrack to the war, particularly with the Glenn Miller Orchestra, these bands were doing a lot of their playing overseas and played to built-in audiences of American troops. In the United States, several musicians and dancers were drafted away to service. Fewer dancers made it out of their homes to the halls. Nightclubs, losing business, had last minute blackouts, cancelling their dances and leaving bands without a gig to play. The end of World War II spelled the end of the boom period for white bands. Rising food costs and hotel bills squeezed profits and made it more costly to run a band after World War II. The Federal government raised taxes on dance venues. Fewer people came out to hear music at the onset of the post-war recession. The introduction of the television and its rise in the 1950s gave potential audiences yet another reason to stay home for their entertainment (an apathy with which the purveyors of live entertainment still struggle).

The change in economics caused the small combo format to emerge as a more sustainable alternative to the big band. Count Basie's Kansas City Seven, Lester Young's recordings, Benny Goodman's trio and quartet, Coleman Hawkins's recordings and the like were canaries in a coalmine. They predicted the next movement in jazz. A new form of jazz was springing up in Harlem jam sessions that would look toward a new economic model. Jazz would never be as popular as it had been in the Swing Era, but a class of intellectual—if eccentric—musicians innovated a streamlined version of jazz that showcased genius over levity. The motivation for the evolution of jazz from big band swing to small group bebop was certainly a mixture of the financial and the artistic. Bebop was swinging jazz that required very little arrangement and few musicians. A bebop band could be formed in a snap if quality musicians were in the vicinity. The inventors of bebop were ready to leave the nickel-and-dime big band scene and to create something better.

Discussion Questions

1. What factors led to increased exposure for the soloists and singers in big bands?

2. Describe the innovations of Coleman Hawkins on his recording "Body and Soul."

3. Compare and contrast the tenor saxophone playing of Coleman Hawkins and Lester Young.

4. Compare and contrast the singing styles of Ella Fitzgerald, Billie Holiday, and Sarah Vaughan.

5. What factors led to the end of the Swing Era?

PART V

Modernism and Technology
(Mid 1940s–1950s)

Modern Jazz—The Language of Bebop

EVOLUTION THROUGH INNOVATION

Jazz musicians kept moving forward. At the high point of the Swing Era, when the most popular swing bands made their way across the nation providing a joyful soundtrack to the athletic dance and the mingling of a new cultural diversity, jazz musicians kept moving forward, developing, and evolving. The best improvisers did not rest on the popularity of big band swing. They continued to explore new ideas. To keep the air from getting stale in dance halls, big band leaders and arrangers kept solo lengths short, moving instead through a progression of musical settings—full-band shouts, woodwind section features, and a quick progression through multiple soloists. Many improvisers felt boxed-in by short solo lengths. Jazz musicians kept moving forward in after-hours jam sessions where the most innovative of them would stretch out and take as many choruses as they wanted.

The jam session put most of the onus on a single player to create excitement. The environment was informal and unrehearsed. A house rhythm section played standards and blues tunes for hours on end, often up until breakfast. The rhythm section accompanied a steady stream of soloists that could include an infinite number of saxophonists, clarinetists, trumpeters, and trombonists while they worked out new ideas on the bandstand. Discoveries were made. New chord substitutions and voicings were tried. Interaction was at a high point between soloists and rhythm section players. In cities across America, jam sessions became laboratories where a new jazz dialect would be cooked up. Mad scientists would build upon the sing-song language of the swing solo, expanding the possibilities for what directions an improviser could take. Musicians invented new tricks on their horns that mystified novices and listeners, they played faster tempos than they played at swing dances, and they pushed double time ideas beyond Coleman Hawkins's approach.

Bebop erupted a debate in the jazz press between the Modernists and the Moldy Figs. Modernists incorporated the new style into their music; Moldy Figs complained the music was becoming too cerebral and abstract. Coleman Hawkins was one of the Swing Era musicians who embraced bebop. Touring the world with his small group, Coleman Hawkins showcased bebop inventors and inventions even while his audiences craved "Body and Soul." Benny Goodman experimented with bebop and turned up at some of the early jam sessions where the style was being developed. But not all of the jazz elders were so welcoming. Louis Armstrong called the new form "Jujitsu music," complaining that bop was damaging the music he played such a central role in creating. The oft-quoted Chicago jazz banjoist and guitarist Eddie Condon downplayed the intellectualism of altered scales used in bebop when he was asked to describe the difference between his music and bebop: "The boppers flat their fifths—we consume ours."

ORIGINS OF BEBOP—BOP'S ENGINEERS AT MINTON'S PLAYHOUSE

Bird, Diz, Monk, and Klook are playful nicknames given the four geniuses that innovated the musical enhancements of bebop. Each contributed his personality and concepts, including innovations to specific musical characteristics. The work of these artists put them in the echelon of revolutionary thinkers in jazz that built upon the innovations of Louis Armstrong. The far-reaching works of Duke Ellington positioned jazz firmly in the realm of the cultural elite. Bebop built upon the work of these giants with a more athletic approach to musicianship and a purposeful, analytical study of music theory.

Innovations of the Four Bebop Engineers:

Thelonious Monk (piano)—harmonic approach. Monk contributed several of the earliest important bebop compositions.

Charlie Parker (alto saxophone)—phrasing. Parker had a unique approach to rhythm and melodic contour, and an aggressive tone.

Dizzy Gillespie (trumpet)—interpreter of Monk's and Bird's ideas. His piano skills helped him to process his colleague's ideas and explain them in the conventional language of music theory.

Kenny Clarke (drums)—his innovation was relegated to the drum set. He built on the innovation of Jo Jones, playing the steady pulse on the ride cymbal or hi hat. Clarke added an ever-changing dialogue of offbeat rhythms between his snare drum and bass drum.

A couple of Harlem clubs formed the cradle of bebop. In the back room of a fine restaurant adjoining the Cecil Hotel at 210 West 118th street, Minton's Playhouse became the first setting for informal jam sessions where the early bebop men engaged in their experiments. Henry Minton, a tenor saxophonist himself, opened his club in 1938 and hired bandleader Teddy Hill to develop a jam session. Hill asked his drummer Kenny Clarke to lead the house band, and Clarke brought in Thelonious Monk as house pianist, trumpeter and vocalist Joe Guy, and bassist Nicholas Fenton. Minton welcomed musicians by offering Monday night jam session participants a free buffet. Guitarist Charlie Christian and drummer Art Blakey were also present at these early sessions. Minton's became home to the bebop underground. Scores of musicians either living in New York or touring with big bands came through town and dropped by the club to blow off steam after their dance gigs and to join the experiment. The band played well-known standards like "Nice Work if You Can Get It," "Body and Soul," "Indiana," and "Sweet Georgia Brown." The jam sessions developed into a cutthroat, survival-of-the-fittest atmosphere and Bird and Diz rose to the top of the heap, soon becoming the most visible leaders of the underground jazz scene. They alienated the less talented players by playing a tangled web of complex chord substitutions. Dizzy and Monk, along with other modernists, spent afternoons cooking up the chord progressions that would confound the weaker players at the clubs. After jamming at Minton's, the hardcore bebop musicians spent the early hours of the morning until 7:00 a.m. at Monroe's Uptown House on 134th Street.

BEBOP VERNACULAR: WHAT DID BEBOP SOUND LIKE?

It's unfortunate that the American Federation of Musicians recording ban occurred during the early years of bebop. A few bootleg recordings made by jam session attendants leaked out in college radio broadcasts, only later collected into an album under Thelonious Monk's leadership titled *After Hours at Minton,* and another album co-led by Charlie Christian and Dizzy Gillespie called *After Hours.* The result of the boppers' experiments—an approach we can hear germinating in these recordings—was a musical style that broke radically from swing, even though it remained linked to its rhythms and song forms.

Music Analysis

"Sweet Georgia Brown"
(1941)
Personnel: Thelonious Monk, piano; Kenny Clarke, drums; Nick Fenton, bass; Roy Eldridge, Joe Guy, and/or "Hot Lips" Page, trumpet; Al Sears and Herbie Fields, tenor saxophone

This song was eventually made famous as the Harlem Globetrotters theme song, but the Minton's jam session band plays it here without its melody. This recording signals a number of changes in jazz in the early 1940s. Popular melodies were being peeled from their chords, and soon new melodies would be substituted. The soloists in this recording are playing a mixture of swing and modern sounds with the first trumpet soloist, in particular, hovering around altered tones. Also, listen for Clarke's offbeat bass and snare drum explosions, often called "dropping bombs." This recording is a prime example of what bebop sounded like before Charlie Parker's melodic approach took hold.

A number of characteristics illustrate how bebop changed the sound and function of swing.

Music for Listening

Bebop was not music for dancing. Instead most listeners sat and absorbed the creative activity happening on stage, taking in the music as a work of art rather than a soundtrack for their entertainment. Bebop rhythms bounced along the same uppity pulse that gave swing its kinetic energy, but the rhythm section changed its approach to accompanying soloists in a way that obscured the steady pulse.

Rhythm Section Approach

A new rhythm section approach redefined the roles of each member. The bass became the most important grounding force in the band, consistently walking the quarter note pulse (an approach developed by Count Basie's bassist Walter Page). Pianists and drummers made more extreme changes.

Drummers followed the lead of Kenny Clarke who was known for varying the snare drum and bass drum in a chatter that carried on underneath the steady ride cymbal and hi hat pulse. Clarke was allegedly fired from his big band job with Teddy Hill for obscuring the pulse instead of

pounding the bass drum on all fours. Clarke was not the first to shift the pulse from the bass drum to the ride cymbal, but with Clarke the ride pattern took on a new level of prominence. Drumming became more improvisational than in earlier styles as Clarke engaged in a stream-of-consciousness style of dialogue between his snare drum and bass drum. His improvisational rhythms formed phrases that often progressed toward a loud, slamming bass drum away from the downbeat, an approach his peers dubbed **"dropping bombs."**

The piano became less rooted to the pulse than ever before, although the new approach was signaled by Count Basie's sparse accompaniment. Pianists avoided dense structures and instead played three-note voicings that omitted the root (the bottom note) of each chord. Piano comping rhythms also became less dense, avoiding stride piano rhythms and instead engaging in a syncopated conversation with the drummer's comping rhythms in the snare and bass drum.

Tempo and Virtuosity

Although bebop musicians sometimes recorded very slow ballads, tempos were often pushed too fast for dancing. In jam sessions, these fast tempos were meant to intimidate weaker players. The chief soloists created the ultimate trial-by-fire environment throwing harmonic twists and turns and calling tempos that left no time for contemplation. These soloists had ultimate mastery of their instrumental technique, although the timbres they produced on their trumpets and saxophones were edgy and aggressive which was unacceptable by orchestral standards. People would comment that Bird seemed to fill every moment with sound, but somehow each note was meaningful. Time seemed to slow down for him so that he was making improvisational choices at a faster clip than everybody else.

Composition, Orchestration, and Arrangement

The bebop approach to composition sharply contrasted the Swing Era. Bebop composers wrote **contrafacts**, new melodies over existing chord progressions. This was most likely a natural outgrowth of the jam session environment. House bands played popular songs, often show tunes from musical theatre like "What is this Thing Called Love?" and "Indiana." A particular favorite was George Gershwin's "I Got Rhythm," which, in the decades since bebop, has lent its chords to a long list of jazz standards. Record companies favored this practice of composition since licensing laws protect melodies, but not chord changes. The record companies would have to pay George Gershwin, Cole Porter, and the other estates that held the copyrights in order to record their songs. When musicians rewrote the melodies record companies could record their new songs for free. Also, new harmonic substitutions were written in to some of these compositions. For example, Bird's version of the 12-bar blues sped up the chord progression by adding passing chords by inserting ii-V-I progressions during sections of the blues that remained stationary (listen to "Blues for Alice").

In instrumentation, bebop looked back to Chicago jazz and the small group offshoots of Count Basie's and Benny Goodman's orchestra. Bebop bands typically had just one to three horns in front of the standard rhythm

> **Contrafact—**A musical composition with a new melody written over an existing chord progression.

section. Trumpet and saxophone (either alto or tenor) were always present, occasionally augmented by a trombone. The music was arranged as simply as possible; two or three horns invariably played the melodies in lock-step unison or separated by octave. In some cases a more complex section was added as an introduction or as a coda, as in Dizzy Gillespie's "Groovin' High." On other recordings, like Charlie Parker's "Embraceable You," the head was completely omitted and the performer dove head first into solo choruses. This bare-bones arrangement style became the conventional format for straight-ahead jazz still used today. (See the musical analysis of "1239a" in Chapter 2).

Renewed Focus on the Soloist

Like Louis Armstrong had done with his Hot Five and Hot Seven recordings in the 1920s, bebop placed even greater emphasis on the individual soloist. Of course, the boppers found some new ways to hold the spotlight. A single soloist could go on for an infinite number of choruses, although recordings always limited their solo lengths to fit a performance on the disk. The new improvisational style, as exemplified by Bird, left the listener with at least a first impression of randomness. Melodic shapes were often angular, leaping between the low and high extremes of the instrument. Phrases were extended over bar lines beginning in the middle of a series of chords and stretching past the rhythm section's harmonic arrival points. Rhythms were not smooth; rather, they were broken up and restless. When the tempo was not lightning fast, soloists relied on double-time and quick triplet rhythms to catapult the music forward. Listen to Charlie Parker's legendary break at the beginning of his solo on "A Night in Tunisia." This modern phrasing gave the music a frantic quality, but also seemed to evoke a more natural conversational feeling. Soloists also explored color tones more than their predecessors had done. Altered 9ths and 13ths, and raised 11ths became much more commonplace in their solos.

Modernism

The achievements of the bebop engineers brought on a new era of **modern jazz**, a term that links the bebop's aesthetic values with those of modernist movements in classical music and in other arts. **Modernism** refers to an acceptance of experimentation, judging artists for their willingness to take risks more than their ability to follow conventions. Modernist trends emerged in the late 1800s and flourished in the early 1900s, represented in the art of Pablo Picasso who swung the pendulum toward abstraction. Literary figures T. S. Elliot, W. B. Yeats, Franz Kafka, and Ezra Pound (whose book title *Make It New* summed up a modernist goal) expressed the fears of violence brought on by World War I and valued truth and expression over beauty. Art music composers Igor Stravinsky and Arnold

Pablo Picasso's towering, unnamed sculpture in downtown Chicago

Schoenberg broke from the European classical tradition dominated by Beethoven and developed radically new sounds by experimenting with the construction of melody and by developing new concepts of rhythm and orchestration. Their exploration of dissonance left audiences feeling unfulfilled, even angry. (Famously, a riot broke out in Paris at the first staging of Stravinsky's ballet *The Rite of Spring.*) If the polite music of the Swing Era paralleled the conventions of Mozart and Haydn, bebop paralleled Stravinsky.

ENGINEERS OF BEBOP

Charlie Parker

It's no surprise that the inventor of bebop *melody* and *phrasing* would emerge from Kansas City where a vibrant music scene rewarded improvisational feats while remaining firmly rooted in the blues. **Charlie Parker** came from a pedigree of the most important bandleaders and soloists of the Southwest Territory. Buster Smith, a close peer of Lester Young, was Charlie Parker's mentor during the time that he formed his musical identity. But in the beginning of his life, Parker seemed an unlikely candidate for genius. No other jazz icon has a more captivating life story with more drastic swings between great success and utter devastation. We can learn at least a couple of valuable object lessons from Parker—the power of perseverance, practice, and apprenticeship in developing a skill and the dangers of drug and alcohol addiction. One cannot totally understand his musical approach and achievements without taking into account both his diligent work and his constant battle with substance abuse.

Childhood in Kansas City

Parker's first childhood home was in Kansas City, Kansas, about a mile from the crux of the Kansas and Missouri rivers. His father, Charles Sr., was a stubborn alcoholic who rarely spent time at home. When Charlie was about 10 years old, his doting mother Addie moved with Charlie to a house on the Missouri side of the city. Charlie was an undisciplined young teen when Rebecca, a pretty girl who would become his first wife, moved in to the Parker home along with her family. The two lovebirds snuck kisses in the house and enjoyed Westerns at the movie theater. While Charlie developed his skills as a saxophonist, he stopped attending high school and became ingrained in the city's swing music scene. When he married Rebecca at 15, his musical habit intensified and he followed the music where it took him. The next year his best friend Robert Simpson died and may have caused a disturbing turn in Parker's disposition. People who knew him well described him as being withdrawn. Music seemed to be his solace.

Parker spent a great deal of time escaping to jazz haunts like the Reno Club on Cherry Street, where Count Basie and His Barons of Rhythm held the stage. Parker was engulfed in the infectious mixture of swing and blues shouted out by Basie, bassist Walter Page, drummer Jo Jones, Lester Young, and trumpeter Oran "Hot Lips" Page. Parker saw his heroes at close range and even eavesdropped on them during their breaks. He followed them to after-hours jam sessions. He regularly stayed out all night and returned in the morning when the post-gig jam session came to a close. It was at one of

these jam sessions that Charlie Parker would fail his first real test as a musician.

Apprenticeship and Turning Points in Missouri

Jo Jones kept things moving at the Reno jam sessions by ringing the bell of his cymbal when it was time for a weak soloist to stop playing and make room for the next player. On the night Charlie Parker built the courage to play in that intimidating environment, he froze. He thought he had practiced his melodic ideas to a sufficient level of fluency, but fluidity was the problem. He got ahead of the form played by the rhythm section and had not yet developed the ability to react to what he heard and snap back into place. Parker was lost in the song form. Jo Jones rang the bell of his cymbal repeatedly, but Charlie played on until finally, Jones took a cymbal off its stand and threw it crashing and clanging onto the floor. Parker was publicly humiliated in a way that would have caused many to give up and find a new line of work.

Humiliating failure became a rite of passage for bebop achievement. It seemed to spur on players with the strongest willpower to go into the "woodshed," only to return triumphant. We've seen this take place in blues with Robert Johnson's *crossroad* story, and we'll see it again and again with the next generation of jazz icons. For Charlie Parker, the embarrassment focused his resolve and led him to discover the keys to rhythmic mastery that he heard in Lester Young's playing. Through rough and tumble lessons learned on the street, Parker would become a stronger player and raise his profile in the Kansas City jazz scene.

Over the next year, Charlie still in his mid-teens, a number of pivotal events converged in his life that would reset the trajectory of his life, accelerating its pace toward stardom and an untimely death. In 1936 on Thanksgiving Day, Charlie was working at Musser's Ozark Tavern in Eldon, Missouri, midway between Kansas City and St. Louis and not far from Scott Joplin's former home of Sedalia. He was riding in a car that slid off the icy road and rolled several times, destroying the car, killing a passenger, and landing Parker in bed for three months with cracked ribs and a broken spine. He may have become hooked on pharmaceutical drugs during his recovery. His wife Rebecca claimed that the doctor prescribed heroin to dull the pain.

The traveling gigs Charlie was working took him further and further from home and lessened the romantic ties between he and Rebecca. He dabbled in drugs and had relationships with other women at the same time that he honed his musical skills. In May 1937, Rebecca realized she was pregnant with Charlie's baby, but also discovered Charlie was mainlining the narcotic drug morphine. Another discovery made matters worse. While he was working out of town, Charlie was having an affair with a woman named Geraldine. During a fight the couple had over a letter Rebecca found from Geraldine, Charlie threatened Rebecca with a pistol pointed at her head. Charlie Parker's personality had changed. He did not turn out to be a repeat domestic abuser, but these episodes ruined his home life. Drugs caused him to develop habits that would clutter his work life throughout his career. He sold his wife's nice things and even his horn to afford a fix.

While Parker fell further into the throes of narcotic drugs, he benefitted from playing in a band with expert saxophonist **Buster Smith**. Smith

had developed a unique approach to phrasing on the alto (a sound that foreshadowed Charlie Parker's trademark bob-and-weave) and developed skills in composition over years touring the Southwest Territory with Walter Page's Blue Devils. Parker also picked up a great deal of technical facility from bandleader Tommy Douglas, and bassist Gene Ramey soon convinced pianist Jay McShann to hire Parker. During these years of apprenticeship Parker was mystified by tenor saxophonist Chu Berry, an alum of the Fletcher Henderson Orchestra, along with the virtuosic and versatile trumpeter Roy Eldridge. Charlie Parker was blending the approaches of these great musicians into a contemporary approach.

Bird . . . To and From the Big Apple

Soon he felt ready to make a run on the New York scene like Count Basie had successfully done with his orchestra just a couple of years earlier. Charlie left his family behind and hoboed to Chicago where he stayed and played for several months before hopping another train for New York City. Upon arrival, Parker lived with his mentor Buster Smith and spent every night out on the scene. He visited several clubs and usually ended up at Monroe's Uptown House. During this time Parker worked odd jobs, washed dishes in restaurants, discussed concepts of music theory with guitarist friend Biddy Fleet, and eventually found steady playing work in jazz bands. He also managed to beat back his addiction to drugs and alcohol. But just as he was getting his footing, news came that his father was murdered and he was expected to return to Kansas City for the funeral. Charlie, unable to reconcile with his wife Rebecca, moved in again with his mother and rejoined the nightwalkers of the Kansas City music scene. He resumed his drug habit, supplied by Tadd Dameron (a future important bebop composer and pianist). Parker rejoined the **Jay McShann Orchestra**, playing steady engagements at Fairyland amusement and other venues. Parker may have earned his nickname during this tenure with McShann's band. As Jay McShann tells it, chicken was Parker's favorite food. As the band toured, they often stayed in the homes of people who lived near the gig. On one particular car ride Parker spotted a yard full of chickens, or "yardbirds." When the car ran over a chicken that had escaped to the road, Parker told the driver to stop and let him out. He brought the dead chicken into the car, took it inside their host family's home, and asked the lady of the house to cook it for dinner. The name "Yardbird" was soon shortened to just "Bird."

The McShann band toured to New York City and made studio recordings during this time, documenting Parker's sound in its development toward frenetic bebop. Bird played a relaxed solo on "Hootie Blues" that hinted at the double-time flair and rhythmic flexibility he would pioneer in later years. The band played a battle of the bands against Lucky Millinder at the Savoy in 1942 and radio broadcasts introduced his sound to a broader American audience playing "Cherokee" at break-neck speed. It was during this time that he crossed paths with the other bebop engineers. **Dizzy Gillespie** began sitting in with McShann's band at the Savoy and during the next few years the pair developed a rapport, turning up at the jam sessions at Minton's Playhouse to play with **Thelonious Monk** and **Kenny Clarke**. Bird and Diz worked together in contemporary big bands that were open to their new approach—one led by Louis Armstrong's former pianist **Earl Hines** and the other by singer **Billy Eckstine**. In the spring of 1945 Bird

Charlie Parker earned a reputation playing in various settings in New York—the Savoy Ballroom, Minton's Playhouse, and the Three Deuces.

and Diz opened at a 52nd Street club called the Three Deuces with drummer **Max Roach**, pianist **Bud Powell**, and bassist **Curley Russell**. According to Gillespie, their new bebop style reached its peak during this engagement. The group split up in July. Dizzy pursued bebop in a big band format and Bird remained at the Three Deuces to lead a quintet.

Music Analysis

"Ko Ko"
(1945)

Personnel: Charlie Parker, alto saxophone; Dizzy Gillespie, trumpet and piano; Curly Russell, bass; Max Roach, drums

This track begins with a rejected rehearsal clip that shed some light on the process Bird and Diz went through in creating new music. The opening 32-bar section is independent of the "Cherokee" chord changes but the first four notes have the same melodic shape as "Cherokee," only played in a different key. The introduction then passes eighth measure solos from one soloist to the next. In the rejected rehearsal take, the band follows this introduction by playing "Cherokee" in unison, but someone in the studio interrupts them and shuts down the take, presumably because the recording company did not want to pay licensing fees to the original composer. The introduction to "Ko Ko" then became its main melody, followed by solos over "Cherokee" chord changes.

Rehearsal Take

0:00 **Introduction, part A:** Unison melody between trumpet and alto saxophone, accompanied by drums played with brushes.

0:06 **Introduction, part B:** Dizzy Gillespie's muted trumpet solo.

0:12 **Introduction, part C:** Charlie Parker's alto saxophone solo.

0:18 **Introduction, part D:** A brief harmonized melody between the two horns, a short "1, 2" (or "be-bop") then another winding unison melodic line draws down the intro.

0:24 **Head:** Curly Russell joins the group on bass to play the melody of "Cherokee" (with mysterious piano barely audible in the background. Could this be Gillespie, and Miles Davis on trumpet in this failed take? Davis was in the room to play the other tracks on this session.)

Final Take

0:40 **Introduction:** Played as described above, Gillespie's part B is almost note-for-note the same. Although Bird stumbles a bit, his part C is a new improvisation.

1:05 **Alto saxophone solo, A sections:** Max Roach switches from sticks to brushes, Curly Russell joins on bass, and Dizzy Gillespie moves quickly to the piano. Bird begins with an angular melodic line, followed by a kind of bird-call gesture (*Woody Woodpecker* had been on television since 1941). Melodic phrases begin and end on unexpected beats, and the melodic shape is somewhat random, smoothly ascending and descending in an arch shape, then leaping drastically upward or downward.

1:30 **Alto solo, B section:** Bird opens with a stuttering figure that ends in a cross rhythm, followed by a couple bars of space, then repeats the same idea. He follows with more winding melodic lines that stretch into the next A section.

1:43 **Alto solo, A section:** More winding lines.

1:57 **Alto solo, 2nd chorus, A sections:** Bird quotes a classic excerpt attributed to New Orleans clarinetist Alphonse Picou, called "High Society." He continues with more angular, winding phrases.

2:22 **Alto solo, 2nd chorus, B section:** Opens with a difficult arpeggio passage, then builds on the lick to increase momentum out of the bridge.

Music Analysis *(continued)*

2:35 **Alto solo, 2nd chorus, A section:** More winding lines, ending with a trademark Bird blues lick.

2:48 **Drum solo:** Max Roach plays a frantic solo completely on the snare drum for two A sections, ending on the typical bebop 2-note punctuation from snare to bass drum.

3:10 **Closing:** The band repeats the introduction. This time Dizzy Gillespie's 8-bar solo is improvised, and Bird's solo is completely different from the previous solos, although it ends with the same phrase heard in the failed rehearsal take.

Bird 'n Diz Out West

At the end of 1945, Dizzy Gillespie had an opportunity to take a small group to Los Angeles. The trip began a disastrous downward spiral for Charlie Parker's health, transplanting him to an unfamiliar drug culture in Los Angeles. The trip may have been the beginning of the end for Bird, but it also served to spread bebop to a new center of growth.

On the western journey, the group missed their connection with an express train in Chicago. They had to take a slow route that extended their journey by two days, causing Bird to run out of heroin. Bird nursed the effects of withdrawal with alcohol, a pattern that compounded heroin's debilitating effects on his health. At one point, drummer Stan Levey spotted Bird wandering outside the train searching for a fix, and carried him back to the train.

Bird 'n Diz's New York recordings heralded their arrival and created a buzz around local record stores. The group opened to a standing-room-only crowd at **Billy Berg's** club with a line of patrons stretched down the sidewalk. The band sparked a bebop craze among the musicians' community, even though the reception of the general public was less impressive. After their opening, audiences dwindled. Bebop did not make the lasting impact among general audiences that swing had made at the Palomar Ballroom a decade earlier. But Los Angeles already had its own rich jam session scene, and musicians like Dexter Gordon and Chet Baker soaked up the sounds and habits of their favorite bebop musicians. A number of L.A. musicians began using heroin. Since Parker's level of mastery was seen as unattainable, using his drug must have seemed like a way to come a few steps closer. The activity surrounding Parker's and Gillespie's Los Angeles visit laid the foundation for the west coast jazz movement of the 1950s.

Dizzy Gillespie scheduled a return flight to New York, but Parker did not show up at the airport. Instead, he sold his airplane ticket to buy drugs. He stranded himself in Los Angeles for an entire year. During his time in California, Bird was an active member of the L.A. jazz scene, making appearances at the clubs and recording several sessions for Ross Russell's **Dial** label. It was during a recording session for the standard ballad "Lover Man" that Bird's ultimate crash was expressed in music.

A few days before the session, trumpeter **Howard McGhee** had discovered Parker holed up in an abandoned garage, and drinking copious amounts of wine. McGee took him in, enabled his drug habit by supplying funds, and nursed Parker back into playing condition again. At a session for Dial records, Bird was exhausted and battling alcoholic muscle spasms. Russell's psychiatrist friend supplied phenobarbital pills to calm his shakes, but the medicine left him on the verge of collapse. Bird's breakdown is

Billy Berg's—The arrival point of New York bebop in Los Angeles.

Dial Records—An independent record label run by Ross Russell that recorded Bird while he stayed in L.A.

documented on "Lover Man." Bird stumbles through the head and has trouble standing in front of the microphone throughout his improvisation. Jazz fans hailed "Lover Man" as one of his best and most expressive recordings, but Parker regretted having ever recorded the track and never forgave Ross Russell for releasing it.

After the recording session he was returned to his room at the Civic Hotel and tucked in by a recording company employee. Parker was out of bed soon enough, and was spotted in the middle of the night walking naked in the lobby. He was arrested and sentenced to six months at the state mental hospital in Camarillo. Before his time was up, though, Parker became restless and begged Ross Russell to somehow get him released. Russell intervened with the hospital staff, and Bird was allowed to leave on the condition that Ross Russell would agree to take Bird into his custody. In return for Parker's release, Russell insisted that Parker sign a contract for more recordings with the Dial label. During the next couple of months in Los Angeles, Bird recorded several tracks for Russell with bands made up of L.A.'s finest including trumpeter Howard McGhee and tenor saxophonist Wardell Gray. Russell titled one of Bird's blues "Relaxin' at Camarillo" after the mental hospital where Bird had stayed. The recording won an international prize, the French *Grand Prix du Disque.*

Bird's International Celebrity, and his Ultimate Downfall

Parker returned to New York in 1947. Unfortunately, he left behind in Los Angeles whatever healthy equilibrium he had achieved after his rehabilitation. On the downside, his substance abuse intensified and his unreliable behavior at gigs continued. On the upside, Bird's reputation had soared and the legions of followers had grown. Although Dizzy Gillespie refused to put up with Parker's instability on the bandstand, Parker was able to find work as a bandleader at the Three Deuces on 52nd street and on cross-country tours with **Norman Granz's** series *Jazz at the Philharmonic. Metronome* magazine marked the jazz community's turn toward bebop, naming Parker the "Influence of the Year," and awarding Gillespie, trumpeter Howard McGhee, drummer Max Roach, and other modern players top honors in their respective instrumental categories. Parker's reputation as the leader of the bebop movement made him a top draw in live performances, even though his bad reputation was well known.

In 1949 Bird traveled to Paris to headline a jazz festival and was greeted with glowing reviews in the press, and a fury of enthusiasm among the French jazz crowds. The festival continued the Moldy Figs vs. Moderns debate pitting Parker's and Tadd Dameron's groups against traditional jazz icons Sidney Bechet and Chicago cornetist Jimmy McPartland. Bebop was gaining ground at this point among mainstream jazz listeners, not just as an insurgent offshoot but as an accepted stylistic direction for jazz. That same year a new jazz club opened on 52nd street, named **"Birdland"** in Parker's honor.

Birdland—A 52nd street jazz club named in Charlie Parker's honor.

Parker returned home from Paris to an abundance of work at clubs outside Harlem, and *Jazz at the Philharmonic* tours spread jazz in a live format across the country. Granz convinced Parker to record *Charlie Parker with Strings*, a new instrumentation for bebop that augmented Bird and a jazz rhythm section with a small string orchestra. The new guard of bebop purists panned these recordings of standards, and Parker's playing was certainly more understated in this setting and more constrained from

interaction by the fully orchestrated strings, oboe, and harp. But Parker was pleased with the recordings. He told pianist Lennie Tristano that "he had said as much as he could in this particular idiom" and was "tired of playing the same ideas." He was tired of pure bebop, ready to move forward yet again. This artistic turn in Bird's career should not have come as a surprise. He had shown interest in orchestral music early on, citing Stravinsky's *Rite of Spring* as an influence. Parker returned to the string format in live performances throughout the remainder of his career.

For the next few years, Bird's musical activity continued in much the same fashion. He performed in New York City, across the United States, and visited Europe as an icon of modern jazz. Jazz fans and press continued to bestow accolades. He helped modern jazz to grow on the west coast by mentoring Los Angeles jazz musicians like trumpeter Chet Baker. But his lifestyle made any sense of balance difficult to maintain. Heavy drinking and drug use made his behavior erratic. He was regularly kicked out of clubs (even Birdland!) and in 1951 lost his cabaret card, barring him from working in New York clubs near his home. His family life only added to the building sense of tragedy during these years. His companion Chan Richardson retold the storm and stress of living with Parker. Any state of domestic peace seemed to be destroyed by his habits and his musical career. Parker spun out of control when their daughter Pree, who had been born with a heart defect and diagnosed with cystic fibrosis, died in March of 1954. A few months later Parker attempted suicide by drinking iodine and landed in Bellevue hospital for psychiatric treatment. His health continued to decline until he finally passed away, March 22, 1955, while watching the Tommy Dorsey show on television. Physician Robert Freymann (who counted among his patients Thelonious Monk and possibly John Lennon and President John F. Kennedy) sited pneumonia as the cause of death and estimated Parker's age to be fifty-three. In truth, Parker was only thirty-four. The tremendous burden he had heaped on his body through substance abuse had sped the aging process.

Dizzy Gillespie

Despite his disappointment in Parker during the last half of his career, **Dizzy Gillespie** credited Bird as his partner in creating bebop. Almost an opposite personality, Gillespie was the extrovert of the pair. He cultivated a public persona appearing in a beret, horn-rimmed classes, and a goatee. In total contrast to Parker's stoic behavior onstage, Gillespie entertained audiences and irritated some deep listeners with silly gyrations and pranks. In television appearances and in print media Dizzy Gillespie's image was used to market modern jazz to the public. The name "bebop" was Gillespie's. An onomatopoeia, the term caught on when Gillespie sang his tricky melodies to band members using nonsense syllables. Some of these nonsense syllables became titles to his compositions ("Oop Bob Sh'bam"). Bebop's improvised melodies (and drummers' solo rhythms) often ended in two fast, short notes that sounded like "be-bop." The style came to be called "bebop," "rebop," or shortened to just "bop."

As differently as Gillespie acted from Bird, we find a number of parallels between their childhoods. Bird and Diz dealt with similar challenges. Growing up in Cheraw, South Carolina, John Birks Gillespie was exposed to music through his father, a part-time pianist. Gillespie's memories of his

father had less to do with his musical instruction, however, and more to do with physical abuse. Mr. Gillespie died when John was only ten years old. The trombone was the first instrument young Gillespie studied in the school band program, but he soon added the trumpet. Much like Bird's tale of public humiliation, Gillespie remembered a local trumpet player returning from steady work in Philadelphia and cutting Gillespie at a jam session. Gillespie believed he was the best trumpeter in town but he had only learned so far to play in one key. His rival called a tune in another key and Gillespie couldn't catch his footing. Gillespie reacted like Bird did to his episode of public failure, attacking his weaknesses with diligent practice and emerging with virtuosic technique and the ability to play in several keys. His musical skills were further enhanced when he began taking classes at the Laurinburg Institute in North Carolina, a preparatory school where he could focus on musical studies. He built skills in piano and developed a solid understanding of harmony. These abilities would make him an invaluable interpreter of ideas at the dawn of bebop. While he lived in the Carolinas, Gillespie found his role model trumpet player, Roy Eldridge, when he heard the Teddy Hill band's radio broadcast. Eldridge was a new brand of trumpet player known for his jagged melodic lines and attention-grabbing high notes.

Dizzy in the Northeast

The Gillespies moved to Philadelphia in 1935, a city that provided a springboard for the next stage of John's development. Philly was near enough to New York City that Gillespie had access to the center of the newest musical trends. Gillespie began working and travelling with various jazz bands and soon moved to New York City, sitting in with the famous **Chick Webb Orchestra** and replacing Roy Eldridge in Teddy Hill's band. Around this time he earned the name "Dizzy" for his silly behavior on stage.

In a couple of years, Dizzy joined one of the most popular bandleaders of his day, **Cab Calloway**, best remembered today for his sing-along hit "The Hi-De-Ho Man." Calloway was a masterful entertainer who created a brand for himself with white coattails, a wide smile, and eyebrows-up enthusiasm. Calloway's band exposed Dizzy to a broad audience and placed him in an elite class of professional musicians. But Dizzy's modern approach was not appreciated by the established musicians in the band or by the bandleader, who called his sound "Chinese music." Gillespie was experimenting with advanced harmonic ideas in his solos and toying with his sound in such a way that he did not fit the profile of the typical swing soloist. His behavior on stage was another problem. He was fired after Calloway caught Gillespie shooting spitballs behind Calloway while his back was turned talking to the audience. Still, Cab Calloway's influence was profound. Gillespie drew his flamboyance and fashion sense from him, and turned out to be one of the only bebop masters with a knack for playing the crowd.

Experiments in Latin Jazz

Also at this time, Gillespie was introduced to Afro-Cuban music through another trumpeter in the Calloway band. **Mario Bauzá** was a founding father of the Cuban-jazz hybrid, which led to the popular dance style called "salsa." Under Bauzá's influence, Dizzy developed a vision for jazz that

married it with Cuban rhythmic patterns. Bauzá educated him in traditional Cuban rhythms based on *clave*, a background rhythm often played on the percussion instrument called the "claves." Almost a decade after their time in the Calloway band, Bauzá introduced Gillespie to conga player **Chano Pozo**, who infused Gillespie's musical conception with Latin drumming and participated in the compositional output of the band by contributing to Latin-jazz standards like "Manteca," and "Tin Tin Deo." The style that grew from their collaboration (at the time called "Cubop") pointed the way ahead for further experimentation in Latin jazz.

Tragically, Pozo was murdered a little over a year after they performed an important concert together at Carnegie Hall, but their collaborations would bear fruit in the coming decades in artistic Latin-jazz hybrids and salsa dance music. Each instrument played a prescribed pattern that worked with the other instrument patterns building a complex and invigorating structure. In Cuban music, a piano *montuno* is layered on top of various drum patterns and bass lines, all behind a syncopated horn or vocal melody. The different patterns contrast each other but they all line up around the clave rhythm. Compared with swing, Latin music was more percussive and even more repetitive than the riff-based big band dance hits. Latin music was both hypnotic and kinetic at the same time. A trademark of Gillespie's Latin-jazz style was shifting rhythmic feels between straight-eighths patterns of the Latin style and the freer swing feel. Pozo's and Bauzá's collaborations with Gillespie caused an exciting collision of conflicting rhythmic styles that would spur the growth of Latin jazz.

Music Analysis

"Night in Tunisia"
(1947)

Personnel: Dizzy Gillespie, trumpet; Charlie Parker, alto saxophone; John Lewis, piano (barely audible); Al McKibbon, bass; Joe Harris, drums

One of Gillespie's most lasting compositions illustrates how Diz combined Latin and swing styles to create a new form. The song opens with a Cuban-inspired bass line, stays in a Latin style through the first two A sections, then switches to swing on the bridge and during solos. This concert at the prestigious Carnegie Hall reunited Bird and Diz after their disastrous Los Angeles trip. This small group split a bill with Gillespie's big band, introducing Chano Pozo on conga drums.

0:00	**Introduction:** Al McKibbon sets up the classic bass line on bass.
0:05	**Introduction:** Bird and drummer Joe Harris enter with their own repeated patterns.
0:15	**Head, A sections:** Gillespie plays the melody on his muted trumpet while the ostinati continue in saxophone, drums, and bass. Bird breaks into a double time bebop line at 0:23 and 0:35.
0:37	**Head, B section:** Bird plays the bridge over a swinging rhythm section.
0:50	**Head, A section:** Repeat of the previous A sections.
1:00	**Interlude:** Bird and Diz repeat a riff over rapidly changing chords, building momentum toward the first solo.
1:18	**Interlude, solo break:** Bird takes the first solo, beginning by playing a double-time break that echoed a studio-recorded version that was famous among his fans. (Hear the audience erupt in applause.)
1:24	**Alto saxophone solo:** Bird stays in double time for the majority of his A sections, and slows to play lyrical ideas during the bridge.

(continued)

Music Analysis (continued)

3:01 **Trumpet solo:** Gillespie's solo is marked by his exploration of color tones (9th, raised 6th, and raised 7th) and the extreme high range of the trumpet. He occasionally launches into double-time.

3:51 **Trumpet solo, 2nd chorus:** Diz plays his trademark chromatic (half-step) lick, then continues in similar fashion from his first chorus.

4:16 **Piano solo:** Gillespie's last eight bars are abruptly cut short to make room for John Lewis's brief piano solo (perhaps an audio edit cut a chorus or so, after the fact).

4:28 **Head, last A section:** The band returns to the head's Latin rhythms. They omit the first two A's and the bridge, shortening the arrangement.

4:38 **Coda:** Several **fermatas** (held notes) bring the song to a halt while Gillespie plays short cadenza phrases.

Dizzy's Compositional Style

Like the other bebop engineers, Gillespie was a skilled composer with an identifiable voice (although he often introduced "A Night in Tunisia" saying, "This is one of my earlier compositions. Matter of fact, one of my *only* compositions.") If he did not write original chord changes for a song as he did on "Tunisia," he created a contrafact, borrowing the changes of a popular song. He wrote "Salt Peanuts" to the chords of George Gershwin's "I Got Rhythm" and "Groovin' High" to the changes of "Whispering," an old song recorded by Paul Whiteman's orchestra. Several of his tunes are technical studies (like the *etude*, common to classical music). The melodies of his etudes repeat a particular pattern or trick, such as the sixteenth-note triplet turns in "Dizzy Atmosphere." Many of these songs come across as riff tunes, based on the repetition of a short melody, except with Gillespie these riffs involved challenging speed and required an advanced level of physical dexterity.

Building Dizzy's Bebop Empire

During the development of bebop at Minton's and Monroe's clubs, Gillespie was busy playing for bands led by **Ella Fitzgerald** (formerly the Chick Webb Orchestra), **Lucky Millinder**, **Fletcher Henderson**, and **Charles Barnett**. These bands did not afford him the flexibility needed to showcase his new approach and he moved back to Philadelphia for a short time, commuting to Manhattan to play bebop jam sessions. His character and experimentation were more appreciated in **Earl Hines's Orchestra** where he was in the company of fellow modernists **Charlie Parker** and singer **Sarah Vaughan**. Gillespie joined Hines in 1942, but after just a year he left the band with **Billy Eckstine**, Bird, and Vaughan. After another year as musical director and lead trumpeter for Eckstine's band, Gillespie landed a pivotal gig on 52nd Street, leading a small group at the **Onyx** club with drummer **Oscar Pettiford** and drummer **Max Roach**. Gillespie sharpened his artistic vision at this time and built a more mainstream following for bebop. 52nd Street was a famous musical district at the time and Gillespie's band became an anchor, followed at other clubs by bands led by Charlie Parker and Miles Davis. By the time the A.F. of M. recording ban was lifted, Dizzy and Bird were primed to bring the music into the studio

and reach out to listeners across the country. Although their trip to L.A. was a debacle, Gillespie seized the opportunity to capture a new audience. In the late 1940s he erected his Afro-Cuban influenced big band. Although a bebop big band was financially impossible to maintain for more than a few years, he would return to the Latin tinge throughout the remaining decades of his career.

During the 1950s Gillespie performed several concerts for **Norman Granz's** *Jazz at the Philharmonic* and traveled to the Middle East and Latin America on state-sponsored tours. Gillespie's group paved the way for other cultural trips sponsored by the U.S. government by Louis Armstrong and other jazz luminaries. Gillespie was proud of his international trips, claiming that musicians did more to bring the world together than politicians ever could. He continued throughout his career to feature sounds from across the world in performances at international jazz festivals. Gillespie was an active performer almost until the end of his life. He lived longer than the other bebop engineers, until the age of seventy-five.

Thelonious Monk—The Underground Genius

If Dizzy Gillespie was the pop icon of bop and Charlie Parker its tortured hero, **Thelonious Monk** was its reclusive mastermind. At the height of bebop, Monk was still a decade away from achieving any kind of public notoriety or sustainable financial success. Although Dizzy Gillespie would credit Monk with the development of harmonic innovations in bebop, Monk's compositions and performance style sounded worlds away from the hyperactive twists and turns of Bird, Diz, and their followers. Monk's music was an enigma. In his recordings we hear echoes of traditional swing, stride piano, and Ellingtonian compositional strength. At the same time his music stretches forward to the avant-garde. He used dissonant sounds to great effect, sometimes crunching two or more adjacent pitches together to create a **tone cluster**. Monk's rhythms often worked *against* the swinging groove established by his bassist and drummer, thriving on tension instead of comfort. As a composer he is second only to Duke Ellington in the long history of jazz. His compositions make up an incredible portion of the list of most-played jazz standards ("Blue Monk," "Round Midnight," "Well You Needn't," "Straight, No Chaser") and each year several of today's jazz musicians pay homage to Monk by resuscitating and reworking even his most obscure songs. But why was he overlooked during his lifetime like so many great artists? Why did he have such trouble finding work for long periods of time? Why was he the last of the bebop engineers to achieve critical success? Monk's odd behavior was off-putting, but it created a mystique that would eventually become part of his appeal. His funny hats and his spinning around during band mates' solos were certainly strange, but audiences were drawn to this bizarre behavior.

During the zenith of bebop, from about 1945–1955, Monk was not one of the leading performers, but popular bands were performing his compositions all around New York. Dizzy Gillespie's orchestra and other groups played his "52nd Street Theme" as a nightly show closer. Cootie Williams included Monk's "Epistrophy" and the ballad "Round Midnight" in his orchestra's repertoire. Although his music was certainly modern, his playing style did not fit the jazz community expectations for a modern jazz style that was frantic and lightning-paced with angular melodies designed

Tone cluster—A group of notes played simultaneously that are separated only by whole steps and half steps.

to challenge the listener. Monk's music, at first listen, was simpler and more traditional than the music of the other beboppers. He played fewer notes per bar, favored tempos that fell in between the typical mediums and fasts, and insisted that his soloists base their improvisations on the song's melody instead of engaging in the dog fights that blasted through the changes of most bop songs.

His playing style was unlike any other. Soloists complained that he comped behind them in a manner that competed for attention. He stabbed the keys with great force and played thick voicings. He was undependable, regularly showing up for gigs more than an hour after the downbeat. He chided the soloists in his band when they strayed too far from the melody during their solos, a practice more common to swing. Bebop improvisation was far more harmony-based, built on the tones of chords, instead of the shape of the melody. Much like Bird, Monk held stubbornly to his creative vision. And also like Bird, his background provides some clues to the reasons for his obstinacy.

Early Life in Music

Thelonious Sphere Monk was essentially a New York native with southern roots. His mother brought him to the city at age four. He was born October 10, 1917, in Rocky Mount, North Carolina, to a hard-working and close-knit family, but his mother made the decision to leave the South for a better future in the early 1920s when scores of southern black families headed to urban centers in the North during the Great Migration. Like Charlie Parker, Thelonious lived many of his formative years without his father. But Thelonious Sr. was not an absent father out of simple neglect. He stayed behind in North Carolina to take care of his mother's and his own fragile health.

Little Thelonious was constantly exposed to music in his New York City neighborhood of San Juan Hill. The neighborhood was famous for its extremely tough and unsanitary conditions and a history of race riots and tense ethnic relations. Southern blacks, Caribbean people from Cuba, Jamaica, and Puerto Rico, along with Irish, German, and Italian immigrants made up the population of San Juan Hill.

White and black residents threatened each other with daily aggression, but at the same time it was a musical place. Black families constantly made music with banjos, guitars, or pianos, and some earned part of their income playing and teaching music. Monk heard European orchestral music in a Central Park summer concert series and calypso music coming from apartments in his neighborhood and played at block parties. This may have been an important source for the Afro-Latin rhythms that tinged some of his compositions such as "Bye-Ya" and "Epistrophy." He was exposed to jazz by professional musicians living in his neighborhood—Fletcher Henderson's alto saxophonist and arranger Benny Carter, and members of the Duke Ellington Orchestra Bubber Miley (trumpet) and Russell Procope (reeds). The poor Monk family was given a player piano and Thelonious spent countless hours watching the piano roll turn and eavesdropping on his sister's lessons. By the time he was taking private lessons himself, Monk had a foundation for music reading and was also able to pick up a melody by ear. He learned traditional black Baptist hymns from his mother. Studying formally with a neighborhood pianist Simon Wolf, Monk studied classical works and was most drawn to Chopin and Rachmaninoff.

A misconception persists even today, that Monk must have been self-taught, that he lacked formal training, and that his natural ability accounted for a completely unconventional approach to playing and an extremely unique sound. But this view is a backhanded compliment. As with several masters of the music, often African Americans, the perception of natural ability detracts from the hard work and ingenuity that went into the development of their technique. It hints at a lack of logical and analytical thought. The vast majority of ingenious jazz musicians—Thelonious Monk, Bird, and Diz included—were the product of hard work and creative ability. Monk's oddball behavior later in his life would lead the public to believe the patronizing view but jazz history has taken a deeper look.

As a teenager, Monk put together a small jazz band with his friends that made a bit of money playing rent parties and participating in "Audition Night" at the Apollo Theater. He probably picked up some of the features of his sound around this time listening to pianist Herman Chittison who tended to play fast cascading melodic runs from the high to low registers and had a busy left hand that sometimes played countermelodies against the right hand. Monk soon found steady work that lasted more than two years in a church band accompanying the Reverend Graham, a female evangelist in the black Pentecostal church. Her troupe played revivals throughout the Southwest and took Monk through Kansas City during the height of the 1930s jazz scene. Kansas City musicians **Ben Webster** and **Mary Lou Williams** remembered hearing Monk play in Kansas City clubs. In the gospel setting, Monk would respond to the cadence of the minister, improvising his way through hymns and transitioning through various styles. He may have also developed a performance habit for which he later became famous in his years as a jazz musician. It was common for Pentecostal denominations to focus on supernatural manifestations of what they believed was the spirit of God. Congregants and performers may have regularly stood up and spun around when they felt moved to do so. In Monk's jazz concerts, he was known to stand up and dance or spin instead of comping behind a soloist, which played into the perception that he was out of his mind. The spinning may have simply been a remnant from his time with the evangelist. It may have just been his way of enjoying or getting into the music instead of the gyrations of a madman.

When he returned from the tour, Monk began working various gigs around New York and spent time at stride piano gatherings at the homes **James P. Johnson**, **Art Tatum**, and **Willie "The Lion" Smith**. Stride piano turned out to be an important influence as Monk's strong left hand is one of the most identifiable characteristics of his playing. According to Monk's son T. S., even Duke Ellington called him "the baddest left hand in the history of jazz."

Epistrophy

In 1941 Monk became the house pianist at Minton's Playhouse, the legendary birthplace of bebop. In the several years that he frequented the jam sessions, Monk was credited with applying harmonic innovations to the standards, but at the same time he was busy developing his compositional voice. One of the jazz tunes he composed during this period, "Epistrophy," is a standard jazz tune played by musicians to this day. Although drummer Kenny Clarke shared the composer's credit for the melody, the song foreshadows characteristics that appeared in Monk's works throughout his

Motive—A brief melodic idea that serves as the principal material for development.

creative life. The melody is based on a four-note **motive**, first rising, then leaping early to its high point and ending downward. This pattern is repeated in sequence, the second time a half step higher than the original. The bridge of the song changes character to a blues-based riff that morphs into a restatement of the original motive. The 2nd half of the A section is then repeated to close the head. Although Monk's oeuvre is diverse with various melodic strategies and shapes, he returned again and again to simple motives (listen to "In Walked Bud," "Thelonious," and "Rhythm-a-Ning") and chords moving upward or downward by half step.

In August 1942 Dizzy Gillespie lobbied bandleader Lucky Millinder to hire Monk. But that gig and a few other opportunities for steady work fell through. Monk's bandleaders claimed that he was undependable, arriving late and sometimes falling asleep on the job. Monk toiled trying to find work while Diz and Bird swiftly developed admirers. His lack of self-control and odd sleeping habits may have stemmed from the beginnings of bipolar disorder for which he would take medication later in his life. Whatever the cause, Monk's behavior was often the thing that kept him in a constant state of underemployment and kept him out of the limelight throughout the bebop era.

During this time when bebop was in its gestation period Monk met **Bud Powell**, the young man who gained recognition much sooner as the model bebop pianist. Monk's full-bodied, obtrusive comping style kept him from being hired as a first-call sideman while pianists who were more in vogue followed Powell, thinning out the texture of their voicings (sometimes playing as few as two or three notes in the chord) and leaving space between syncopated stabs. At the **Onyx** club on 52nd Street, Monk was a sit-in pianist in Dizzy Gillespie's group. Gillespie never considered hiring him because Gillespie wanted a pianist to support the band, not interject his ideas from the accompaniment role. Playing behind soloists, Monk was known to strike the keys forcefully and to create various textures. Sometimes he marked the pulse with a quasi-stride style of accompaniment, at other times he rolled chords, and at other times he interjected fast runs up and down the keyboard. To make matters worse, when Gillespie *did* hire Monk to play with his big band, Dizzy had to fire him only a month later because the pianist showed up late for a high-profile performance.

When the superstar tenor saxophonist **Coleman Hawkins** hired him to tour in 1944, Monk's peers would have been surprised. One would think the veteran tenor saxophonist and Fletcher Henderson alumnus might surround himself with a classic swing rhythm section, but he was interested in the new style Monk and the Moderns were developing. Hawkins's band played Monk's compositions and toured on-and-off from 1944 to 1946.

Small Measure of Success

Monk broke through to large-scale attention in 1947 when an article in *DownBeat* magazine credited his impact on modern jazz, titled "Genius of Bop." Soon after, the up-and-coming recording company **Blue Note** offered Monk the chance to record his first album as a bandleader. *The Genius of Modern Music* cleverly referenced the *DownBeat* article and was almost completely comprised of his original compositions. But with meager sales figures (Lorraine Lion resorted to loading up her car with records and trying to sell them face-to-face) the album failed to make significant in-roads to success. Except for the highlights of his studio recording and live

performances with Coleman Hawkins's band, for Monk the 1940s were a time of poverty and underground work that moved a snail's pace toward a fruitful musical career. After a gig at the Royal Roost in 1948, Monk was arrested for possession of a small amount of marijuana and charged to thirty days in jail. After the arrest his cabaret card was revoked for a year, barring him from making music in any Manhattan club that served alcohol. Monk also began dabbling with heroin around this time, although he never became a hard-core addict.

Mary Lou Williams's apartment was one of his regular haunts in the city. Williams was a leading composer and pianist in the Kansas City Jazz scene of the 1930s. Monk played her piano for hours on end and the two developed a platonic and musically fruitful friendship. (His song "Rhythm-a-Ning" borrows its basic riff from Williams's "Walkin' and Swingin'.") Monk also befriended drummer **Art Blakey** who would become an important sideman on Monk's early recordings. Steady employment was fleeting in those days for Monk but he composed "Round Midnight" and other tunes during this time that would become jazz standards. Monk also became a kind of mentor for younger modernists, forming a collective to rehearse original compositions. In the basement of Minton's Playhouse vibraphonist **Milt Jackson**, trombonist **J. J. Johnson**, and **Bud Powell** played his arrangements. Saxophonists **Sonny Rollins** and **Jackie McLean**, drummer **Art Taylor**, and pianist **Kenny Drew** began stopping by Monk's apartment in San Juan Hill to play.

The 1950s opened with another Blue Note recording (*Genuis of Modern Music, Vol. 2*) and another arrest for narcotics. August 9, 1951, Monk and Bud Powell sat with friends in a parked car outside Monk's apartment. A couple of narcotics officers walked up to the car and searched it, finding an envelope of heroin Powell had tossed out of his pocket. When the group was arrested and faced charges Bud Powell was sent to a psychiatric ward and Monk took the rap for illegal drug possession. He spent sixty days in prison at Rikers Island and lost his cabaret card again, this time for an extended period.

Building Momentum

Monk finally began to piece together a steady career in 1952 when he moved to **Prestige Records**. Although his Prestige recordings still did not reach a wide audience, they captured him in the groove of recording on a regular basis and paired him with **Rudy Van Gelder**, arguably the most important recording engineer and producer in classic jazz. Monk continued to record with his drummer on the *Genius* sessions, Art Blakey, but he added saxophonist Sonny Rollins and drummer Max Roach to some of the recordings. Each of these sidemen went on to make his own significant impact on the history of jazz as a bandleader.

In 1955, Monk began a three-year contract with **Riverside Records**. With Riverside he recorded a series of albums that brought his artistic vision into focus. Unlike the somewhat haphazard albums for Blue Note and Prestige, these recordings were more than a collection of tunes. Each recording makes a salient statement representing the state of the art. The Riverside recordings finally helped Monk to reach a broader audience of mainstream jazz listeners. The term "Monkism" entered popular jazz parlance when a *New York Times* reporter described his unique use of dissonance and off-kilter rhythms. The first Riverside recording was a trio

album absent of any Monk originals. Instead the album featured Monk's unorthodox approach in a conservative setting, playing all Duke Ellington pieces. Accompanying him were former Ellington bassist Oscar Pettiford and drummer Kenny Clarke, Monk's old compadre from his nights at Minton's. The resulting recording is a somewhat restrained version of Monk's character. He stays close to arrangements meticulously worked out at the studio, treating Duke's standards almost as classical works. Although critics praise Monk's use of space on this album, his hesitation might be evidence of Monk's discomfort playing some of Ellington's tunes. What is clear on the *Plays Duke Ellington* album is Monk's respect for the compositional high-points of Ellington's works. He comes across as a reverent admirer and reserves his pounding left hand and wild runs up and down the keyboard for only the rare outbreak. Throughout the homage to his hero, Monk's typical characteristics do emerge from time-to-time in his rapidly repeated notes, tiptoeing double-time ideas, tone clusters and doubled odd intervals (two notes played simultaneously), and fast runs of triads and whole tone scales. A follow-up trio album, *The Unique Thelonious Monk*, with Art Blakey replacing Clarke on the drums brought these elements to the forefront in more playful and witty renditions of jazz standards.

Brilliant Corners

These albums of cover songs prepared the way for the recording that marked Monk's true arrival among the elite visionaries of jazz. 1957's **Brilliant Corners** was an album of Monk's original compositions, musically challenging and revolutionary in its approach to form, melody, and rhythm. The title track is one of Monk's most complex compositions with its wide range, phrases of odd numbers of measures, and a head played in both medium slow tempo and double time. Alto saxophonist Eddie Henry, tenorist Sonny Rollins, and drummer Max Roach all give remarkable performances, but apparently they were frustrated by the stranger elements of the song. The other songs on the album demonstrate the great range of composition Monk had achieved up to that point. "Bolivar Ba-Lue Bolivar Ba-Lues-Are," is a low down blues with Monk's typically logical construction based on a simple melodic shape and landing on beat four. "Pannonica" is a beautiful mood piece named for his friend Pannonica de Koenigswarter, a baroness and heiress to the Rothchild financial dynasty. Its melody and harmony take unexpected twists and turns, and Monk adds an interesting timbre by playing a **celeste** (a keyboard instrument that sounds like a music box) with his right hand while his left plays the piano. The celeste plays the melody along with the horns and fills in the spaces between with rising arpeggios and repeated dissonant pairs of notes.

With all this brilliant musical activity, it must have come as a shock when Monk was taken to Bellevue Psychiatric Hospital. He was involved in a minor car accident and the police officer determined that Monk needed mental help. Although he left the hospital after three weeks without a diagnosis, Monk did display early signs of the bipolar disorder that would be diagnosed several years later. He could be unresponsive at some times and ecstatic at others. He seemed to do everything in streaks, either sleeping or staying awake for prolonged periods and practicing for hours on end. It may not be a coincidence that he was institutionalized not long after the devastating loss of his mother.

Like many great artists, Monk produced some of his most interesting works under duress. He composed much of the music for his next Riverside recording sessions for the 1957 album *Monk's Music* while battling the stress of his wife Nellie's health struggles, a condition that required that her thyroid be removed. He labored over his ballad "Crepuscule with Nellie" during the weeks leading up to the sessions, apparently searching for a solution to the bridge of the song. "Crepuscule" (a French word for "twilight") was a mood piece in line with "Pannonica" with its peculiar melodic shape and unorthodox harmonic changes. Like the celeste in "Pannonica," Monk uses the lower register of the piano in "Crepuscule" to answer the melody with rising arpeggios. But unlike "Pannonica," this new ballad was completely written out for the musicians to play. Monk foregoes any improvisation and instead plays the long head twice through, orchestrating the saxophones and trumpet at just a couple points during the second half. The sparse orchestration of his horn section is surprising considering the personnel involved—tenor saxophones **John Coltrane** and **Coleman Hawkins**, alto saxophonist **Gigi Gryce**, and trumpeter **Ray Copeland**. But the all-star tenor saxophones got plenty of action on songs like "Epistrophy," "Off Minor," and "Well, You Needn't."

Music Analysis

"Well You Needn't"
(1957)
Personnel: Ray Copeland, trumpet; Gigi Gryce, alto saxophone; John Coltrane, tenor saxophone; Coleman Hawkins, tenor saxophone; Thelonious Monk, piano; Wilbur Ware, bass; Art Blakey, drums

The album *Monk's Music* finds Monk recording comfortably with a band made up almost entirely of all-stars (most notably Coleman Hawkins, John Coltrane, and Art Blakey). Listen for the contrasting approaches between each soloist on this popular jazz standard.

0:00	**Introduction:** Monk's opening seems designed to trick his listeners (and his sidemen, judging by the banter that can be heard on alternate takes). He plays a cross-rhythm, or *hemiola*, that seems to establish a medium-slow tempo, but in reality, he emphasizes every third eighth note subdivision.
0:11	**Head, A section:** The angular melody riff is repeated and adjusted slightly. The final phrase of the A section is a shortened version of the first phrase, repeated and shifted to emphasize beat four. Tenor saxophones play simple chord tones that mark time underneath the syncopated alto saxophone and trumpet melody.
0:34	**Bridge:** The bridge motive is a continuation of the closing phrase of the A section, simply transposed up and down along with chord motion, and effectively speeding up the phrase statements. Art Blakey accentuates the acceleration by playing his hi hat in double time against the horns.
0:45	**Last A section:** Repeat of the opening A sections.
0:56	**Piano Solo:** Monk opens his solo with restatements of the melody and some blues-inflected chords.
1:39	**Chorus 2:** Stark chord voicings characterize the second chorus of Monk's solo.
2:01	**Chorus 2:** During the bridge, Monk launches into double time restatements of the theme, ending with "Coltrane, Coltrane."
2:23	**Tenor Saxophone Solo:** Coltrane opens his solo with angular melodic ideas, still emphasizing chord tones and leaving space.
3:05	**Chorus 2:** Coltrane plays a busier second chorus, based more on patterns and arpeggios than his first chorus.

(continued)

Music Analysis (continued)

3:47 **Trumpet Solo:** Ray Copeland tends to move up and down scales throughout his solo, constructing lyrical melodies and occasionally reaching up to the high register.

5:11 **Drum/Bass Duet:** This section sounds like it may have been a mistake, either Ware thought another soloist would follow Copeland or Art Blakey covered up his bass solo. Either way, the result is an interesting dialogue between two strong rhythm section players. During the first A sections, Ware walks time along with Blakey's ride cymbal while Blakey plays snare drum triplets with the stick crossed over the rim (a cross stick).

5:32 **Bridge and last A section:** Blakey and Ware trade triplet rhythms (Blakey still with a crossstick). Ware hangs over into the next chorus with two short notes, and Blakey picks up the two-note idea to begin his solo.

5:53 **Drum Solo, first two A sections:** While he maintains time on the ride cymbal, Blakey uses the 2-note hits as a motive. He moves the phrase around the drums and reduces the amount of space between each repetition, resulting in a steady stream of snare drum strikes.

6:11 **Bridge:** For the remainder of his solo, Blakey ceases the time on the ride cymbal and plays bebop triplet and 16th-note (double-time) phrases between snare drum and tom toms.

6:23 **Last A section:** Blakey delineates the return of the A section playing straight eighths on his snare, then moving to a wooden sound (probably the two sticks hit together.

6:33 **Drum Solo, Chorus 2:** Blakey returns to bebop 16th note (double-time) phrases first played in the bridge of his first chorus, ending in a barrage of eighths between his hands (snare and toms) and feet (Blakey links his bass and hi hat feet).

6:52 **Bridge:** Eighths between hands and feet become the basis of this section.

7:01 **Last A section:** Blakey changes frantically between different textures in this closing section. He repeats fast bebop ideas of early sections, plays a trick roll (jamming the tip of one stick into the snare drum head and wiggling the other stick between it and the drum head), and draws to an obvious close with his trademark pressroll. Still, only Coleman Hawkins gets the signal and enters correctly. Wilbur Ware plays wrong notes through the next several bars and Monk lays out until the bridge.

7:11 **Tenor Saxophone Solo 2:** Coleman Hawkins's rhythmic phrasing is more at home in the Swing Era than in this contemporary performance, but he navigates the chord changes easily with running swing eighth note ideas played up and down scales. Monk enters at the bridge with cross rhythms that echo his introduction, using an extremely wide chord voicing.

8:33 **Alto Saxophone Solo:** Gigi Gryce's improvisational approach is a cross between Ray Copeland's and Coleman Hawkins's. He is relatively conservative, with brief tinges of Charlie Parker.

9:52 **Piano Solo 2:** Gryce hangs over into Monk's first chorus by about one bar. Monk's final one-chorus solo is an embellished version of the original melody.

10:31 **Final Head:** The band repeats the arrangement of the head heard at the opening, with Art Blakey playing similarly active fills between melodic figures.

11:11 **Tag:** The band repeats the last two bars of the song to end the performance.

Also in 1957, Monk began a long-standing relationship with the **Five Spot Café**, a club in the East Village sector of Manhattan that had already become a hang out for modern artists and writers, and would eventually give rise to the cutting edge of jazz. Avant-garde pianist Cecil Taylor had been a regular there in 1956, and Ornette Coleman brought his controversial free jazz quartet there just a few years later. During six months at the Five Spot, Monk was able to build a strong rapport with his sidemen John Coltrane, bassist Wilbur Ware, and drummer Shadow Wilson that is evident in recordings. And beyond their musical interactions, audiences began to appreciate Monk's strange movements and spinning dances at the

Five Spot. Writers attributed Monk's eccentricities to an avant-garde aesthetic, a form of expression. His band members knew that his dancing was a sign that Monk was satisfied with the music. Another unorthodox aspect of Monk's work was his rehearsal process. Instead of giving his musicians sheet music with his complex compositions notated clearly, he wanted the players (and later his big band arranger Hall Overton) to learn his music by ear. Both John Coltrane and Charlie Rouse said Monk forced them to perform his songs from memory in front of a packed audience at the Five Spot without ample rehearsal time. The Five Spot was home base for Monk, and he developed a following that packed the house during long engagements over the next several years.

Thelonious Monk's Quartet at the Five Spot Café
- John Coltrane, tenor saxophone
- Monk, piano
- Wilbur Ware, bass
- Shadow Wilson, drums

Accolades
Monk entered a new phase of his career around this time. The 1958 *Down Beat* magazine critic's poll awarded him the top pianist of the year, a far cry from his period of near invisibility less than a decade earlier. He was being asked to perform at major jazz festivals and appear in documentary films. But again, just when things seemed to be taking off, a non-musical distraction sent him into a tailspin. Traveling through Delaware on the way to Baltimore with his friend Nica and tenor saxophonist Charlie Rouse, he stopped to ask for a drink at a motel and startled the owner's wife. She called the police and Monk was nonresponsive when they arrived, likely a symptom of his mental illness. When the police tried to arrest him he resisted by holding onto the car door. The police knocked Monk to the ground with a billy club and kept beating him while he was handcuffed in the back seat of the police car, ignoring Nica's pleas for mercy. He left the court with a misdemeanor assault charge and the incident caused another bout with serious depression. He was hospitalized and lost his cabaret card again.

But with his rising fame, Monk was less dependent on New York City clubs for employment. He was beginning to draw considerable crowds to concert settings. In 1959, Monk's compositions were arranged for a 10-piece big band for a concert at Town Hall. He was also busy with several jazz festivals produced by Newport impresario George Wein and touring Indiana, Detroit, and Los Angeles. He won the 1959 *DownBeat* critics' award and 2nd place in the readers' award for best pianist. The rise of the avant-garde jazz movement may explain the favor of the public at this time. When juxtaposed against Ornette Coleman's aggressively outside sounds, the cadre of jazz critics who had previously focused on Monk's eccentricities now wrote about his conservatism, his place in the mainstream. Oddly enough, Monk's music had encouraged the coming storm of avant-garde, but now he stood his ground against it and was reaching broad audiences. Monk's melodies were deliberately simple and accessible. When producer Teo Macero suggested Monk record free

form, or avant-garde music, he pushed back and explained that his music should be easy to grasp for listeners. Instead of challenging his listeners, he wanted to connect with them.

Monk recorded for the following companies from 1947–1968:

- Blue Note
- Prestige
- Riverside
- Columbia

In July of 1962 Monk signed a new, more lucrative recording contract with **Columbia**, the giant of the jazz industry that represented Miles Davis and Dave Brubeck. What was striking about the contract is that it required three albums per year from Monk. Even Miles Davis only averaged one or two albums per year during his Columbia contract in the 1950s and 1960s. Monk's output was about the same during his time with Columbia. Although he composed very little new music, the studio albums *Monk's Dream*, *Criss Cross*, and *Underground* are true classics due to the fine playing and pristine sound quality produced by Teo Macero. During the tumultuous mid-1960s, a time full of nationwide struggles for civil rights, Monk was hard to pin down on issues of race relations. He told reporters that his music would have sounded the same whether he was black or white but then later denied having made the statement, possibly for fear of appearing out of touch with the current movement for civil rights. He seemed more sensitive about his art, often correcting the popular record on his contributions to modern jazz. Potentially his biggest moment in the press, *Time* magazine published a cover story on him on February 28, 1964. Although the article increased Monk's public profile, it focused on his strange behavior and struggles with mental instability and drug use as much as his artistic genius. "Every day is a brand-new pharmaceutical event for Monk: alcohol, Dexedrine, sleeping potions, whatever is at hand, charge through his bloodstream in baffling combinations."

The International

Monk's time as a Columbia artist was marked by overseas performances and renewed success at home. In May of 1963 he took his quartet to Japan and then returned to New York to a residency at the new Five Spot. Around this time Leonard Bernstein called him a "crude pianist, but . . . so creative, so individual that he's a genius." He performed another big band concert arranged by Hall Overton on December 30 at the Philharmonic Hall in Lincoln Center. The press came out in droves for this event and the audience was packed to 1500. In 1964 Monk toured a broad swath of Europe including Amsterdam, Stockholm, Zurich, Marseilles, Brussels, Copenhagen, Milan, Paris, and West Germany. Monk regularly visited his old friend Bud Powell during these Europe trips. Powell was mentally unraveling at this time, and Monk showed signs of coming apart mentally himself. Monk's bouts of mental instability would increase throughout the remainder of his life.

Monk's *Underground* album seemed to point toward a new creative stride in 1966 with four new compositions. Monk was at the height of his

career performing at major venues in Los Angeles, San Francisco, Chicago, Boston, and New York, but his health was becoming a major problem. He went into a coma that may have been drug-induced in 1968 and reduced his alcohol consumption as a result. The civil rights movement was at a boiling point that year. Robert Kennedy was shot and riots broke out in more than 100 cities after the assassination of Dr. Martin Luther King. But Monk was in no shape to jump in for the cause. Instead, he continued making music. The 1968 album *Monk's Blues* pitted Monk against a big band arranged by **Oliver Nelson**. A recording that should have been a triumph turned out to be an artistic miss-fire when Oliver arranged Monk's music in a polished and commercial big band fashion instead of the colorful and experimental style Oliver had debuted in the early 1960s with the pivotal album *Blues and the Abstract Truth*. Monk sounds disconnected from the rest of the band on *Monk's Blues*, as if he was a guest artist playing in front of someone else's band.

Downturn

The 1970s were characterized by bad health and bizarre behavior from Monk. His band shifted personnel, he and wife Nellie were evicted from the apartment they had occupied for years, and Columbia dropped Monk from their roster. In October of 1970, he was admitted to a psychiatric hospital and administered shock therapy and heavy doses of medication. He had another episode during each of the next few years even though his public profile was still substantial. Monk toured around the world with a group George Wein put together called the *Giants of Jazz*. The *Giants* tours connected Monk with some of his former bebop peers and the new masters of the form—Dizzy Gillespie, Sonny Stitt, Kai Winding, Al McKibbon, and Art Blakey. The *Giants of Jazz* tours continued through the rest of his life, sometimes placing Monk on the same bill with B. B. King and top R & B acts. Monk performed fewer concerts in the passing years, just one per year in 1974 and '75. He was awarded a Guggenheim Fellowship in 1976 and performed a couple of times at Carnegie Hall, first with a quintet, then with a quartet. He became reclusive the rest of his life, staying in his apartment. He eventually separated amicably from his wife Nellie and moved in with his friend Nica Koenigswarter (the baroness whose apartment was also the final resting place of Bird). Complications from hepatitis caused Monk to have a stroke and he died February 17, 1982. More than 1,000 people attended Monk's memorial service at St. Peter's Church on Lexington and 54th Street.

Kenny Clarke

Kenny Clarke's impact on bebop is often overlooked. He laid the foundation for modern jazz drumming by keeping time on the cymbals, leaving the drums to develop a language of comping rhythms. He demonstrated the potential for a new level of expression by creating a dialogue between the bass drum and snare drum, often bringing a series of syncopated rhythms to a climax by **dropping bombs** with a bass drum kick.

In 1934, after receiving his musical training in Pittsburg, Clarke performed with Roy Eldridge, then moved to New York City to work with a commercial dance band. He joined Teddy Hill's big band in 1939, where his new drumming style grew somewhat out of necessity. Clarke had been

practicing snare/bass rhythms against the steady ride cymbal, and young musicians like Dizzy Gillespie encouraged his approach. When the Teddy Hill band played fast tempos, Clarke's tired right foot stopped pounding consistently on the bass drum, instead playing the new style. After band members complained, Teddy Hill fired him for weakening the time feel and failing to corral the big band. When he rejoined Roy Eldridge, he found a bandleader that appreciated the freedom created by the ride cymbal beat. In 1940, Hill rehired him to lead the small group at Minton's, a setting where a freer pulse was less risky.

As bebop developed, Clarke's career took him in and out of the creative center of New York. He joined the army in 1943, returned in 1946 to work briefly with Dizzy Gillespie's big band, recorded with Miles Davis' seminal *Birth of the Cool* band in 1949, and became a founding member of the Milt Jackson Quartet (later the Modern Jazz Quartet) in 1952. He left for Paris in 1956, where he continued playing jazz for the remainder of his life. Like many jazz musicians who expatriated to Paris in the 1950s, he felt more appreciated, better paid, and dealt with less racial discrimination than he had in the United States.

Max Roach, Art Blakey, Roy Haynes, and host of other modern drummers developed and expanded upon Clarke's snare/bass chatter during the 1940s. He also left his legacy co-composing a number of jazz standards with other founders of bebop: "Epistrophy" with Thelonious Monk and "Salt Peanuts" with Dizzy Gillespie.

OTHER IMPORTANT BEBOP MUSICIANS

Bud Powell

A child prodigy from a musical family, **Bud Powell** became the model pianist of the bebop movement. Although Thelonious Monk was his mentor, Powell's approach was completely different. He accompanied soloists with simple chord voicings, made up of just a few notes of the chord and played more sparsely than Monk. He favored a flowing single-line approach to improvisation, incorporating the agile lines of Charlie Parker. Powell was one of the only pianists capable of matching bebop soloists like Bird and Diz wit-for-wit with his formidable right hand. In bebop recordings with other pianists the instrument stays more closely to its supportive role, but Powell put the piano on equal footing with the horn players.

Powell grew up in the Bronx on a healthy diet of European classical piano repertoire composed by the likes of Bach, Beethoven, and Liszt. He became a professional pianist at age 15. He joined trumpeter Cootie Williams's band in 1942, and began sitting in at Minton's jam sessions. Thelonious Monk took Powell under his wing around this time. He brought Powell up on stage and insisted that the management take the teenager seriously. Monk seemed to be genuinely excited by Powell's brilliance. He was amazed how easily Powell could learn and remember Monk's compositions and unique elements of his harmonic language.

At the same time, he was showing signs of mental instability, which may have been exacerbated by a violent incident with Philadelphia police. Alcohol use and another violent episode only made matters worse, and Powell's condition plagued him throughout his career. He was sent to a mental institution for lengthy stays a few times. During a stint about a year

long in 1947, Powell underwent as many as forty rounds of electroshock therapy. Electroshock was a relatively new procedure, and potential side effects were not well-known. Powell suffered severe memory loss as a result.

Powell left an incredible legacy of recordings made in the late '40s and early '50s that influenced and essentially instructed budding pianists on how to play bebop. He made a number of important recordings as a sideman beginning in 1946, including Charlie Parker's "Cheryl," and recordings with Dexter Gordon and Sarah Vaughn. He recorded five volumes of *The Amazing Bud Powell* recordings in quintet and trio settings for Blue Note records at the close of the 1940s. These recordings featured his original compositions that employed many of the harmonic innovations and frenetic melodies of bebop, but also highlighted Powell's original voice. Songs like "Bouncing With Bud," "Dance of the Infidels," and "Parisian Thoroughfare" found their way into standard jazz repertoire. Powell also referenced his own mental struggles with titles like "Un Poco Loco" and "Hallucinations."

In 1959 Powell joined Kenny Clarke and a number of American jazz musicians who expatriated to Paris. He benefitted during this time from a community of friends and a new wife who kept him healthy and sane, and this likely extended his playing career. Tragically, he contracted tuberculosis a few years later and returned to the United States. On his arrival in New York he played a concert at Birdland and was given a seventeen-minute ovation before kicking off his first tune. But work did not persist and his health continued to be a problem. He died August 1, 1966, after struggling with tuberculosis, liver failure, and malnutrition.

Max Roach

Roach is often credited with originating the bebop style, which is true to a point. Kenny Clarke is the jumping off point for the style of drumming that thrives on a dialogue between snare drum and bass drum. Clarke was at Minton's in the beginning when Thelonious Monk and Dizzy Gillespie discussed new harmonic innovations. But **Max Roach** built on Clarke's foundation a new vocabulary that became truly influential to the next several generations of jazz drummers. He approached drum comping and soloing with a heightened sense of logic, using a more melodic approach than his predecessors.

The Roach family moved to Brooklyn, New York, from North Carolina when Max was four years old. He was surrounded by music as a child, learning piano from his aunt and playing drums with a gospel choir at age ten. Roach listened to drummer Jo Jones with the Count Basie Orchestra on the radio and soaked up Kenny Clarke's revolutionary style at Minton's jam sessions. At sixteen Roach played a brief stint with Duke Ellington and recorded with Coleman Hawkins. He became a central figure in bebop performing with both Charlie Parker and Dizzy Gillespie and would also play an active role in bop's next stages of development. In 1949 and 1950 Roach played drums on Miles Davis's recordings later released as *Birth of the Cool*, a recording that spurred the cool jazz movement. His quintet with trumpeter Clifford Brown ushered in yet another sea change in modern jazz during the mid-1950s, a new sub-genre termed "hard bop." Roach's abilities as a soloist took center stage at this time.

During the 1960s Roach was devoted to the struggle for the civil rights of African Americans and the people of Africa. *We Insist! Max Roach's Freedom Now Suite* (1960) was an aural expression of Afro-American injustice. In 1961 he protested Miles Davis's benefit concert at Carnegie Hall for the African Research Foundation by appearing on stage with a sign reading "Africa for the Africans."

THE IMPACT OF BEBOP

The bebop masters created a new language that was primed to be reshaped by individuals. Very shortly after Bird and Diz brought modern jazz across the United States, a new class of musicians took up the mettle and reshaped the music. The most important legacy of the bebop engineers was that they created a more pliable form of music than swing. Throughout the 1950s and 60s Max Roach, Sonny Rollins, Dexter Gordon, Miles Davis, Kenny Dorham, and other strong personalities splintered off from the basic sound of bebop to put their personal stamp on this music. Jazz took a turn toward the artistic, partly by necessity. It was far less profitable than swing and therefore the artists were not pressured by record companies to follow a template that would result in repeat successes. The artists who followed also made changes because of their creative will. Bebop shook up the art form of jazz and freed up the next generation to create.

Bebop quickly found its way to new media, as well. Although bebop's virtuosic melodic flights left the laborious trombone in the dust, J. J. Johnson, Kai Winding, and other trombone players developed new levels of technique to assimilate the new language. Composer and pianist Tadd Dameron wrote a number of important standards including "Good Bait," "Hot House," and the vocal number popularized by Sarah Vaughn "If You Could See Me Now." Dameron composed and arranged music for a variety of instrumentations, from small group, to nonet, to big band. Other jazz pianists—such as Hank Jones, Barry Harris, Tommy Flannigan, Red Garland, Wynton Kelly, Hampton Hawes, and the Canadian-born Oscar Peterson—made a number of important recordings in the jazz trio format accompanied by drums and bass. A thriving west coast jazz scene incorporated the innovations of modern jazz. Big band leaders who did not fear the new music transformed the stripped-down small group arrangement of the bebop band into a fresh conception of the jazz orchestra. Bands led by Woody Herman, Stan Kenton, and a host of others incorporated bebop's melodic and rhythmic approach in their own search for new sounds. Herman's second "Thundering Herd" orchestra featured a strong line-up of saxophonists—Stan Getz, Zoot Sims, Herbie Steward, and Serge Chaloff—in the Jimmy Guiffre composition "Four Brothers." The song voiced all four saxophones playing the bop melody. Kenton's brass-heavy orchestra released two albums in 1956 that integrated Cuban rhythms—*Kenton in Hi-Fi* and *Cuban Fire*—as Gillespie's big band had done in the 1940s. All of these pointed the way forward to further innovation in jazz.

Discussion Questions

1. Explain five characteristics of bebop that changed the sound and function of swing.

2. Look at the biographies of Charlie Parker, Dizzy Gillespie, and Thelonious Monk. What parallels can you draw that may have led to their innovations?

3. How did bebop reflect the modernist movements in other arts?

4. Listen to "Koko" and describe musical aspects that would have alienated the Moldy Figs, more traditional jazz performers and listeners.

5. Describe how Bud Powell and Max Roach built on the innovations of Thelonious Monk and Kenny Clarke. Find recorded examples on web sources (i.e., Rhapsody.com or YouTube.com) to support your answers.

Electric Blues of the 1940s and '50s

In this chapter, we will cover:

- Radio and King Biscuit Time—**Rice Miller** and **Robert Lockwood**
- Blues in Chicago—Chess Records
- Electric Blues pioneers—**Lightnin' Hopkins, Muddy Waters, John Lee Hooker, Howlin' Wolf, Little Walter, Willie Dixon**
- Jump Blues and the bridge to rock and roll
- The Harmonica

RADIO AND ELECTRIC BLUES

In the late 1940s, a Texas bluesman with ties to Blind Lemon Jefferson found an audience with his debut recording. Lightnin' Hopkins's "Katie Mae Blues" (1946) was a strong regional seller for the Aladdin company, and like the recordings of Mamie Smith and Blind Lemon Jefferson it perked up the ears of record labels to the marketability of the blues, opening doors to follow-up records that eventually led to nation-wide success. "Katie Mae Blues" arrived at a time when American music was in transition. Big band jazz was being replaced on the pop charts by jump blues while World War II drew to a close in 1945. The jazz community was turning to bebop as its next significant evolutionary stage, but despite great enthusiasm in New York and Los Angeles, bebop was a niche style that held the interest of a relatively small but devoted group of deep listeners. Rock and roll had not yet arrived even though white and black teenagers alike were listening to race records, then called "rhythm and blues." Deep blues, sometimes called "down-home blues," had faded from view. But a new audience was ready to digest the sound of deep blues repackaged for contemporary ears, and a new generation of blues musicians descended from a pedigree of country blues godfathers, ready to bring it back.

Electricity was changing the sound of the music. Before electric guitars were common, blues guitarists began "plugging in" by attaching pickups to their acoustic instruments. Working blues guitarists were amplifying their guitars to compete with the noisy environment of urban bars and busy street noise. **T-Bone Walker** and **Memphis Minnie** were among the first blues guitarists to record with an electric instrument, and this innovation led to the genre's next phase of evolution.

King Biscuit Time

The radio became an essential ingredient to a successful blues career during the 1940s. In Chapters 8–10 we saw how the development of radio through the Great Depression exposed Duke Ellington, Count Basie, and Benny Goodman to a national audience. Instead of an audience committing to purchase a particular artist's rec-ord, they simply had to dial up the radio station in their home and listen to a nationwide broadcast or travel to see them at a concert or a dance. Radio

© rj lerich, 2014/Shutterstock, Inc.

station programming managers and disk jockeys became the new authorities on musical taste. Blues artists in the 1940s tapped into local radio markets to build an audience for their live shows.

West Memphis, Arkansas

Helena, Arkansas

© Globe Turner, 2014/Shutterstock, Inc.

Two Arkansas towns just outside Mississippi played prominent roles in the development of Delta blues. **Helena** was a primarily black community of around 10,000 residents that boasted an incredible live blues-based music scene. North of Clarksdale and south of Memphis, the commute to Helena was an easy one for Delta blues musicians who could hop in a car and travel up and down Highway 61. **West Memphis, Arkansas**, was a town just across the Mississippi from Memphis, Tennessee, with a population similar to Helena's. The towns made up a rural touring circuit where blues artists often worked to expand their audience out of the Delta before some of them made a move to a larger city.

Helena had its own special brand of blues played in juke joints, at the boat docks, or out on street corners. In Helena, according to radio announcer Sonny Payne, some of the best blues in the world was being sung in informal settings by working-class folks. The typical solo guitar format was being augmented to feature a partnership between piano and guitar, along with drums, harmonica, and other instruments. These blues bands were developing a higher level of intimacy in their interaction than the Vaudeville classic blues of Ma Rainey and Bessie Smith, who were backed up by hired jazz musicians. In the blues bands from Helena and West Memphis, it is difficult to draw the lines between solo improvisation and collective improvisation as piano and guitar may take the primary voice at the same time. Harmonica may double the guitar, solo on its own, or any other combination.

Rice Miller and Robert Lockwood

In 1941, **Rice Miller** (harmonica) and **Robert Lockwood** (guitar) had worked the Helena scene for years. Both men had worked with the iconic Robert Johnson near the end of his life. (Johnson was something of a stepfather to Lockwood and gave him guitar lessons.) A new local radio station had been built, KFFA, and Lockwood and Miller launched a new program with the station that would mutually benefit the musicians, the radio station, and their new sponsor. Interstate Grocery Company agreed to sponsor a 15-minute blues show called "**King Biscuit Hour**." The musicians would play their music, promote their live performances, and advertise King Biscuit Flour on the air and at promotional shows in town. The results were tremendous. King Biscuit sales grew considerably, with Rice Miller's picture gracing the

packaging of some of their products. The radio shows drummed up larger audiences for Miller's and Lockwood's nighttime performances, increasing their notoriety and their earnings. They eventually expanded the on-air band to include drummer James "Peck" Curtis, pianist Robert "Dudlow" Taylor, and later a pianist who became one of the cornerstone pianists of the boogie-woogie style—**Joe Willie "Pinetop" Perkins**.

Robert Lockwood's legacy was solidified by the show. He popularized a style of lead guitar playing that would become the commonplace sound of blues guitar going forward: an electric instrument playing single-string, jazz-influenced melodies. His influence would reach the most important blues giants of the 1940s until today, Muddy Waters and B. B. King, making Lockwood an essential link in the chain of tradition from Son House and Robert Johnson to today's blues. Additionally, King Biscuit Time introduced a business model that was copied almost immediately by other radio stations as a means of reaching a wider audience.

> Rice Miller and Robert Lockwood broadcast their electric, band-oriented style of country blues on their radio show, King Biscuit Time.

The Helena scene drew several important musicians throughout the 1940s who later became important contributors to the blues including David "Honeyboy" Edwards, Elmore James, and future Muddy Waters band mates Jimmy Rogers and Little Walter.

ELECTRIC BLUES PIONEERS

Lightnin' Hopkins

The story of **Sam Hopkins's** early life is a familiar one in a study of blues and jazz lives. Hopkins was raised in the Jim Crow South (Centerville, Texas). His family was tied to the land under the unjust system of sharecropping. He remembered witnessing a lynching in front of the courthouse. His father was murdered and his oldest brother left town, leaving his mother to care for Sam and his other siblings. The family was poor and struggling. After leaving home himself, he rambled from town to town playing dances and street shows, sharecropped on plantations, and allegedly served time on a chain gang after getting in a fight.

At some point in his childhood, Hopkins met the famous Blind Lemon Jefferson. Jefferson, the first widely successful country blues recording artist, showed young Hopkins a career path that could help him avoid the toil of sharecropping that he had seen his relatives and friends struggle through. He was also a model of musical excellence for Hopkins, both in his guitar work and his singing.

> Lightnin' Hopkins's "Katie Mae Blues" demonstrated market potential for downhome electric blues in 1946.

Hopkins picked up the name "Lightnin'" around the time he recorded the first time for Aladdin records. He played as a duo with Wilson "Thunder" Smith. It was in these recording sessions that Lightnin's **"Katie Mae Blues"** was produced.

In "Katie Mae Blues," a couple of aspects of Hopkins's style were evident. Even in a band setting with bass and drums, he had a tendency throughout his career to shorten or lengthen the 12-bar blues form by varying degrees. Sometimes he delayed movement from the I chord to the IV, turning the first four bars into 5 or 5 ½ bars. We hear the same kind of flexibility in the work of Charley Patton and Robert Johnson. But what makes this remarkable in Lightnin's playing is that he maintained the same flexibility (and even exaggerated it) when he was accompanied by other musicians. It was clear in live performances (find video of his performance on

Austin City Limits on the web) that he changed the blues form on purpose. He would glare at his bass player while he held out a chord too long, daring them to "jump the gun." This keep-em-guessing performance style brought in an element of surprise to his performances that felt *real* and *spontaneous* to his admirers.

Hopkins also had a knack for playing multiple roles on guitar. With a pick on his thumb he would play bass and rhythm chords while the skin of his index finger would play a lead solo role.

Music Analysis

"Katie Mae Blues"
(1946)
Personnel: Sam "Lightnin'" Hopkins, guitar/vocals; Wilson "Thunder" Smith, piano; drummer unknown

Listen carefully to Hopkins's clever personality profile of Katie Mae on his first hit. With Thunder Smith playing lightly in the background (and a barely audible hi hat) Hopkins's multi-layered approach is on display. The back-and-forth between his bass/rhythm playing and his solos makes the trio sound at least as big as a quartet.

0:00	**Intro:** Triplet rhythms on guitar, played slightly ahead of the beat.
0:07	**Verse 1:** Rolling piano and guitar triplets improvise simultaneously in the pauses between the busy lyrics.
0:41	**Verse 2:** Guitar plays a lick after each short phrase landing on minor third. The first phrase is 3 ½ bars long, consisting of a quick outpouring of lyrics.
1:11	**Guitar solo:** Incessant triplets played first on high frets of high strings, then moving down through the guitar's range. Piano matches the triplets early in the solo.
1:40	**Verse 3**
2:11	**Guitar solo:** Again piano and guitar mimic each other on incessant triplets.
2:23	**Verse 4:** The "goodbye" lyric is sung over ambiguous chords (could be either I or IV chords).
2:51	**Ending:** Guitar, piano, and drums stumble into an ending, with piano playing the last few notes in the bass register.

Lightnin' typically performed his own songs, instead of the more common blues practice of playing traditional songs. His lyrics were a diverse mixture of slick humor and brave social commentary. Oftentimes he invented lyrics while he performed. His lyrics could be based on a current event, or something or someone he saw in the room. "Tom Moore's Farm" was written about the owner of a plantation Hopkins worked near the beginning of his musical career. Hopkins claimed that Moore threatened to kill him because the landowner realized the insulting lyrics were directed at him. Other signature songs had themes of voo-doo ("Mojo Hand") and witty characterizations of women ("Short Haired Woman," "Katie Mae Blues").

Hopkins's unique style was influential to an endless list of future jazz, rock, and blues icons. John Coltrane was influenced by Hopkins's special approach to form when he played on the same bill with him in 1962 at the Village Gate in New York City. According to his pianist McCoy Tyner, Coltrane was struck by Hopkins's movement through chord changes at a pace that seemed arbitrary. He moved to the dominant, or V chord, whenever he felt it was time to move. Coltrane felt he needed to approach form in a more

flexible fashion. He also realized the importance and origin of pentatonic scales and the blues scale. Tyner claimed that Coltrane's music was immediately affected by what he heard.

Miles Davis also claimed to have been influenced by Hopkins, as well as The Beatles. As a young man, Ringo Starr apparently had planned to move to Houston from England to live near Lightnin' Hopkins.

BLUES IN CHICAGO

Large-scale migration by blacks out of the South occurred in waves since the end of slavery. Migration out of the Delta in particular was solidified in 1944 when a mechanical cotton picker was introduced, replacing thousands of jobs held by black share croppers. Chicago companies advertised in black publications, such as the *Defender*, that they should move to Chicago for work. Some of these companies built machinery like the cotton picker that actually replaced their jobs back home. Chicago offered more than just steady work. Southern black workers could escape unfair treatment, a sharecropping system that kept black families indebted to their white landowners, and fears of lynching. They could receive legal representation, fairer payroll practices, and improved educational opportunities, among other advantages. Although Chicago living was not easy, the upgrade was clear. As Chicago became a new home for the black work force, musicians were also drawn by an expanded audience as well as greater opportunities to record their music for a label.

Muddy Waters

Alan Lomax, who had already rediscovered Lead Belly with his father John, took trips into the Delta to record and interview musicians for the Library of Congress. Among his archives are recordings of important bluesmen Son House (who brought Lomax to see a woman he claimed was Robert Johnson's mother), David "Honeyboy" Edwards, and a man who would become the strongest catalyst for change in the blues, **McKinley Morganfield**—nicknamed **Muddy Waters**.

Muddy ran a juke joint of his own on Stovall Plantation in the Delta, where musicians came through to perform, and eventually where a juke box played records by the best blues musicians. By the time Lomax recorded him, Muddy had already been strongly influenced by Son House, having watched him perform nightly. When Alan turned on his recording device, Muddy played "Country Blues" and "I Be's Troubled," both of which would go on to reinvent the blues in Chicago with updated sounds and new titles—"I Feel Like Going Home" and "I Can't Be Satisfied."

Muddy's Path to Chicago

Muddy Waters moved to Chicago after his grandmother passed away in 1943. He may have been reluctant to move as early as some other Delta blues artists. Robert Nighthawk and Robert Petway had made a move to Chicago and recorded songs that would become blues standards, but neither managed to build a lasting career in the city. Delta blues was not popular in Chicago, even among those who had relocated from the Delta. It may have reminded the black community of the tough conditions they left

behind, and at that time the optimistic sounds of swing and jump blues were in vogue, not the down-home blues. After all, Muddy had worked his way up the ladder of manual labor at Stovall—driving a tractor instead of picking cotton. And he would have received plenty of attention from boot-legging liquor and playing guitar. But when he heard his own voice on the Lomax recordings, he was convinced of his own potential for success. Even with the obstacles, Chicago seemed like his best move.

Blues researcher Robert Palmer, in his book *Deep Blues*, pointed to a transition that was taking place within the Chicago blues audience around the close of WWII, a transition that greatly benefitted Muddy Waters. Chicago blues fans did not like rural-sounding blues of the Mississippi Delta, but a great deal of it was being recorded there. Around this time, someone at a Chicago party broke Tommy McClennan's guitar over his head and threw him out because he sang about the southern African American experience. But recordings by primarily Delta musicians on the Bluebird label began to gain acceptance. Harmonica player and singer **John Lee "Sonny Boy" Williamson** led a class of rural bluesmen who fused the city sounds with country blues on tracks like Williamson's "Good Morning Little Schoolgirl" and Robert Nighthawk's "Prowlin' Nighthawk." Williamson developed an audience for their music in the Chicago club scene along with Big Bill Broonzy, Tampa Red, and Memphis Minnie. These advances of rural blues musicians paved the way for Muddy Waters's deep blues.

Upon arrival in Chicago, Muddy took a day job and worked his way into the local music scene, playing regularly with Sonny Boy Williamson. After a few unnoticed recordings as a sideman and a Columbia recording as a leader, Delta pianist Sunnyland Slim brought him to record for **Leonard Chess's** Aristocrat records. The Chesses were a family of Jewish immigrants from Poland. On Chicago's south side, blacks and European immigrants lived close to one another and shared many common experiences. Both groups were pursuing a new life in a new place, and both were treated as second class citizens, though not to the same extent as blacks had been treated in the Delta. The Chess family was a natural friend to the blues.

Muddy Joins the Chess Family

Muddy's relationship with Chess would prove to be one of the most consequential in the history of the blues, and played a big role in the beginning of rock and roll. The Chesses made a shift in instrumentation that affected the way blues music would be heard from that point onward. In typical recordings of the day, the piano had been the "lead" instrument in a band, setting up the music and supporting with chords. But in Muddy's recordings they allowed his guitar to become the main sound instead. The guitar had already been electrified and amplified in Chicago as technology had moved ahead, and the rural style was being performed in a louder setting. Through these changes, the Chicago Blues developed its own sound and Muddy became its leader.

Muddy's first big success was "I Can't Be Satisfied" and "I Feel Like Going Home." Both songs had been performed for Alan Lomax in the Delta, but this time he played an electric guitar accompanied by the string bass. The first pressing of the record sold out within the first 24 hours!

Music Analysis

"I Can't Be Satisfied"
(1948)

Personnel: Muddy Waters, vocals/guitar; Ernest "Big" Crawford: bass

Muddy sings right in the groove in his seminal Chicago blues hit. Each line of syncopated melody lands on beat one of most measures and is doubled by the guitar. A couple of recurring themes emerge in each verse. Muddy emphasizes the word "troubled" as a landing point every time it occurs, and he speaks the song's title with more ebullience in every passing verse.

 0:00 **Introduction:** Opening slide guitar riff emphasizes beats 1 and 3 (downbeats), plays the melody up an octave. Bass plays basic two-feel with hard, percussive plucks on beats 2 and 4.

 0:27 **Verse 1:** Vocal melody is doubled in various parts of the guitar, first up an octave, then in unison using low strings.

 0:53 **Verse 2:** Bass becomes more active, playing busy syncopated notes between the vocal melody statements. Activity complements the aggressive lyric of the 2nd verse.

 1:20: Guitar accompaniment without voice. Bass becomes still more agitated.

 1:45 **Verse 3:** Bass becomes simple like the opening.

 2:11 **Verse 4:** Bass again is agitated.

 2:33: Abrupt ending.

Music Analysis

"I Feel Like Going Home"
(1948)

Personnel: Muddy Waters, vocals/guitar; Ernest "Big" Crawford, bass

The beauty of this performance is the contrast between Muddy's frantic vocal melody and his settled guitar accompaniment. The guitar establishes a steady tempo with slide licks and long chords highlighting sympathetic vibrations of un-plucked guitar strings, while Muddy sings rhythms that bounce around the triplet and double-time triplet subdivision of the beat. Muddy delivers the lyrics with a nervousness that borders on panic, with racing pace and nearly breathless vibrato on some of his long notes.

 0:00 **Introduction:** Slide guitar with very simple quarter notes on the bass.

 0:37 **Verse 1:** Muddy sings in his upper register, opening with an attention-grabbing "Well now I git . . ."

 1:15 **Verse 2:** Muddy continues his frantic style, repeating "ocean, ocean."

 1:51 **Guitar solo:** Muddy digs in to the strings with trembling slide work.

 2:29 **Verse 3:** Falsetto "he he, well child" conveys the anxiety behind the lyric, "minutes seemed like hours, and hours seemed like days."

 2:59 **Ending:** Guitar and bass line up rhythmically, then bass plays the final note.

At sessions in the 1950s, the sound of the band became more substantial. Muddy Waters pulled together a band with **Otis Spann** on piano, drummer **Elga Edmonds**, and his musical right-hand-man on harmonica, **Little Walter**. Walter had spent his upbringing in Louisiana listening and playing along to Cajun, blues, and jazz records. On these Chess recordings, he seems to have developed a kind of telepathy with Muddy Waters's guitar. He echoes Muddy and sometimes plays in unison with an uncanny, natural sense of interaction.

Muddy matched his new aggressive sound with lyrics full of self-aggrandizement. Sexual innuendo and elements of African hoodoo mysticism (like mojo and the crossroads myth) had always been a part of blues lyrics, but Muddy Waters confronted his audiences with a new level of moxy. Much of this material was actually written by a gifted songwriter, bassist, and producer named **Willie Dixon**. Although the composer credit for the music and lyrics belongs to Willie Dixon, Muddy's delivery of those lyrics is an integral part of the song. In "(I'm Your) Hoochie Coochie Man," he tells the story of his greatness foretold before his birth by a gypsy. He makes his intentions obvious in "I Just Want to Make Love to You" and "I'm Ready."

Muddy's swaggering claim of his own prophetic birth in the first verse of "Hoochie Coochie Man" is not a far cry from hip hop songs in which the performer raps about his own innate greatness. This common theme must have traveled from Muddy and other similar blues artists, through rock and R & B to the hip hop of today. In the second verse of "Hoochie Coochie Man," Muddy dips into the subject of African spiritual beliefs, conjuring images of hoodoo talismans like a black cat bone, mojo, and John the Conqueroo. All of these were known to hold powers of sexual magic and other properties.

Music Analysis

"(I'm Your) Hoochie Coochie Man"
(1954)
Personnel: Muddy Waters, vocals/guitar; Little Walter, harmonica; Otis Spann, piano; Jimmy Rogers, guitar; Willie Dixon, bass; Fred Below, drums

Perhaps the most famous blues riff ever, "Hoochie Coochie Man" was composed by Willie Dixon who taught it to Muddy Waters during intermission at a show at Club Zanzibar on Chicago's south side. The song is an example of Dixon's gift for writing extremely simple songs that reach a broad audience. Muddy's trusty backup band is held at bay by the stoptime, 5-note riff while Muddy utters the prophetic lyrics. This 16-bar blues extends the typical opening part of the chord progression, staying on the I chord, then the rhythm section opens up for loud, swaggering improvisation during the last half of each chorus.

0:00	**Introduction:** the riff played in stoptime.
0:08	**Verse 1:** Rhythm section continues the simple riff behind Waters's vocal delivery. Little Walter occasionally jumps in ahead of the others with the first note of the riff.
0:33	**Chorus:** Rolling piano and Little Walter's solo statements answer the lyrics.
0:58	**Verse 2:** On the following verses and choruses, the rhythm section accompanies Muddy similarly, each time with a slightly looser approach.
1:24	**Chorus**
1:51	**Verse 3**
2:16	**Chorus**
2:37:	Guitar takes the forefront for a tight ending.

In the 1960s Muddy faced a dilemma. Should he move his sound toward the new rock music that had become so popular or to play music that looked backward to his Delta roots to appeal to a growing number of folk-blues fans? His response was to do both with his own unique brand. At the 1960 Newport Jazz Festival, his high-energy band and his rousing

performance of "I've Got My Mojo Working" were well received by the raucous crowd. He satisfied the audience by repeating the song as an encore. The next year at Chess records, he fulfilled the folk crowd's desire for authenticity with an album of traditional country blues, *Folk Singer*, accompanied by a young **Buddy Guy** on guitar. *Electric Mud* (1968) was a controversial album, going yet another direction. An effort by Leonard Chess to blend Muddy's voice with psychedelic rock, the album was panned by critics but sold well and served as a gateway for many young people from rock into the blues.

In the 1970s, Muddy recorded a series of albums in collaboration with the Texas blues rock performer **Johnny Winter**. Winter's career was on the rise, and like many young rockers he wanted to honor Muddy's contributions. *Hard Again* was recorded in 1976, resulting in a heavier electric sound and earning Muddy a Grammy award.

In 1983, Muddy Waters died of lung cancer. Like Robert Johnson, Muddy's music influenced generations of musicians, primarily leading to the development of rock and roll. With Muddy, Chicago blues became electrified, amped, guitar-band blues. He was among the first blues artists to transform the country blues—typically a solo act—into a guitar-led band setting while holding onto a sense of spontaneity and interaction. The instrumentation of his backing band—drums, harmonica, rhythm guitar, piano, and sometimes bass—would become the textbook instrumentation for rock and roll bands (usually minus the harmonica). He actually told the Chess brothers about Chuck Berry, one of the first rock and roll stars. The Rolling Stones idolized Muddy and honored him in the press and by inviting him to perform with them. Led Zeppelin borrowed heavily from his musical ideas, particularly the song lyrics he popularized with Willie Dixon. Muddy Waters's new, more aggressive approach to the blues refreshed the form, modernizing it for the post World War II audience.

John Lee Hooker

In the escape from the Delta, not all roads led to Chicago. Delta blues musicians spread the music throughout the United States on foot ever since the days Robert Johnson and others travelled as far as St. Louis, Chicago, New York, and Canada. Recordings were dispersing the music across the nation. And radio was reaching into living rooms over the airwaves, as exemplified by King Biscuit Time radio out of Helena, Arkansas, in 1941. Just about every region of the country had been exposed to the blues in one way or another, and audiences were primed for the new electric blues sound. A precedent was set for blues to be enjoyed in any city that would welcome the genre.

After years of moving between several cities in the South and the Midwest, **John Lee Hooker** found his audience in Detroit in 1943 with a special brand of what he called "**boogie**." His musical style was characterized by extremely repetitive, hypnotic, rhythmic grooves usually on just one chord. Many of his hit songs were recorded with only solo electric guitar, with his stomping feet providing percussive accompaniment. More than any other influential blues artist, Hooker's music is about *groove*. His "boogie" refers to a unique rhythmic feel in his guitar ostinato (repeated pattern). Much like a jazz musician works to refine his rhythmic swing feel, John Lee Hooker achieved a well-crafted, rhythmic feel that can be heard across his recorded catalog.

Hooker's Meandering Road

Hooker had taken a leisurely pace establishing himself as a blues artist compared with his more ambitious peers. Like so many Delta blues singers, Hooker had the church in his past. His minister father would not allow John Lee to keep his guitar inside the house. When his mother left home to move in with blues guitarist Willie Moore, all of John Lee's siblings stayed with their father. John Lee joined his mother and the bluesman who eventually taught John Lee to play. Moore was from Louisiana, which may explain Hooker's approach to the blues. His music certainly contained Delta blues aspects in his style of singing and guitar patterns, but his reliance on one-chord vamps instead of the 12-bar blues form, and his use of various lyric forms ignoring the AAB of typical blues, aligns more closely with the blues from Louisiana.

The blues was essentially a pastime for John Lee Hooker while he traveled to various cities working odd jobs. In 1933 he moved from Mississippi to Memphis, but his mother and stepfather found him and brought him home. He returned to Memphis after a few days, then moved to Knoxville, then Cincinnati where he played at a regular house party on weekends. In Detroit (the Motor City) he worked at several car manufacturers and played music at night. His music took up more and more of his time as he played parties and working class bars like the Apex Bar, Caribbean Clue, and Henry's Swing Club. His repertoire at this time already included his first signature tune "Boogie Chillen," as well as "Sallie Mae," "Crawlin' King Snake," and "Hobo Blues," although he also performed spirituals, folk songs, and old country blues.

Singular Recording Artist, Variety of Settings

Local record distributor **Bernard Berman** began to record Hooker with the hopes that his style would win national appeal on the *Billboard* charts. His first single "Boogie Chillen" found its way to **Modern**, a Los Angeles label run by the Bihari family. The song climbed to #1 on the R & B charts, and was a huge influence on the next generation of blues and rock musicians. Right away, Hooker began recording with great frequency for several different record labels. He ignored recording contracts, often recording under assumed names like John Lee Cooker or Booker, Delta John, The Boogie Man, and Texas Slim. He flooded the market with his own recordings, often becoming his own competition in the market.

Much of Hooker's appeal was in the authentic character of his recordings. Bernard Berman did not try to polish away the eccentricities of Hooker's style. Instead he emphasized them. Hooker spoke with a stutter. Instead of hiding Hooker's speech impediment, Berman encouraged the long stream-of-consciousness monologue. The loud tap of his foot figured prominently into the audio mix of his solo guitar recordings. There was no expectation to follow the blues form. Much like Lightnin' Hopkins, when he played blues with a backing band he often adjusted the blues form at will by extending or dropping beats. In "It's Been a Long Time Baby" (1952) the saxophonist, pianist, and drummer audibly have difficulty following Hooker through the blues form.

In the mid-1950s, Hooker moved into the Chicago blues scene, recording for **Vee-Jay** records. Vee-Jay recorded various kinds of albums aimed at

public appeal. They had made hits with Jimmy Reed's polished blues sound, and so the same band backed Hooker on his first Vee-Jay recording. Hooker's organic approach won out against Reed's slick sound. "Mambo Chillun" sounded like a cross between blues with a hint of Latin rhythms. "Dimples" was another example of Hooker's flexible approach to blues form. Songs like "Little Wheel" and "I Love You Honey" were aimed at the new rock and roll crowd. Soon he was invited to play at the 1960 Newport Folk Festival, where he played before the largest audience of his career.

After his Vee-Jay sessions, he signed with **Riverside**, a record company that had released early jazz records of Jelly Roll Morton and King Oliver as well as important albums by modern jazz artists Thelonious Monk, Bill Evans, and Cannonball Adderley. Riverside matched Hooker with top-notch jazz bassist Sam Jones and drummer Louis Hayes for his album *That's My Story*. But he continued his practice of moonlighting with multiple labels. His biggest hit during the 1960s, "Boom Boom," was recorded for Vee-Jay. He was backed up by the legendary Motown musicians James Jamerson on bass; drummer Benny Benjamin; pianist Joe Hunter; and guitarist Larry Veeder. Saxophonists Hank Cosby and Mike Terry were also called in for the session. "Boom Boom" was immortalized on the soundtrack of the movie *The Blues Brothers* in 1980, and was listed as one of the Rock and Roll Hall of Fame's *500 Songs that Shaped Rock and Roll*.

Hooker performed and recorded prolifically throughout his career, from large rock shows to the coffeehouse folk circuit. Late in the 1960s until the end of his career, he recorded several songs in collaboration with performers from various walks of musical life such as Carlos Santana,

Music Analysis

"Boogie Chillen"
(1948)
Personnel: John Lee Hooker, voice/guitar

Hooker's unique rhythmic feel—often called his "boogie"—is evident in this track. The guitar riff is one repeated bar with a few syncopated notes played in swung eighths with chromatic triplets moving upward at the end of the bar. The form is undefined with no real chord progression. For most of the song he stays on the I chord playing various shapes up and down the instrument. Hooker plays an indistinct IV chord underneath the opening vocal lines, but the IV does not have the same function as the IV in a typical blues form.

0:00:	Long guitar introduction.
0:22:	Verse 1, Line 1 is followed by plenty of musical space.
0:37:	Line 2, repeat of first line.
0:46:	Straight eighth notes stretch the rhythm before he sings the third line.
0:54:	Return to the guitar riff.
1:06:	Spoken monologue, mentions Henry's Swing Club, one of Hooker's haunts in Detroit. Hooker sings a 2nd line.
1:38:	After return of straight eighths in the guitar (stretching the timefeel), he shouts the song's title.
1:43:	Return to the guitar riff.
1:53:	Brief guitar solo with off-eighth notes.
2:05:	Return to the guitar riff.
2:15:	Verse 3: Spoken monologue, followed by a sung 2nd line.
2:39:	Improvisation on the guitar riff.
3:02:	Ending—Two guitar chords.

Bonnie Raitt, Van Morrison, Miles Davis, and the blues-rock band Canned Heat. In the year 2000 he was honored with a Grammy Lifetime Achievement award.

Howlin' Wolf

About a decade after Muddy Waters's arrival in Chicago, the Chess brothers brought another Delta transplant into their studio. Their new find would build on the full sound of the Muddy Waters band injecting the blues with a new level of aggression and intensity. **Chester Burnett**, nicknamed "**Howlin' Wolf**," had already made a name for himself through radio and performances in the well-established blues scene centered around Beale Street in Memphis.

Like Muddy Waters, Howlin' Wolf had strong ties to early Delta blues. He learned the blues watching Charley Patton when he lived near Dockery's plantation, and was influenced by his voice and showmanship. Patton taught young Chester and invited him to perform. As a young working man in the Delta, Chester Burnett began the itinerant life of a blues musician, playing juke joints and other informal locations to make extra money and hone his craft, even performing with Robert Johnson, Son House, and Willie Brown. Other than his voice, Wolf's primary instrument was the harmonica, an instrument he learned from another important Delta resident, Rice Miller (known as Sonny Boy Williamson II). He made an impression on the local blues scene. Johnny Shines, Robert Johnson's traveling partner, expressed his fear of Howlin' Wolf when he described his sound as being beast-like. Several videos of Howlin' Wolf found on the internet give a taste of his intimidating performance style, his large frame engulfing the harmonica and microphone, his often lewd body movements and wild facial expressions. Beyond showmanship, Wolf's voice and harmonica had a strong sense of character. His voice did seem to howl like a wolf's. Like Charley Patton, he was able to manipulate the "dirt" in his voice to varying degrees, emitting overtones with his husky growl, and answering with falsetto ooohhh's.

Wolf began to develop his band's unique sound soon after he settled in West Memphis, Arkansas, around 1948. West Memphis was a small community across the river from Memphis, Tennessee, with several clubs and bars where he could play. Wolf's first band included Willie Johnson and M. T. Murphy on guitar, drummer Willie Steele, Junior Parker on harmonica (who would later join Muddy Waters's band), and a piano player with the nickname "Destruction." Wolf's House Rockers were a cutting edge rock band with single-string lead guitar, heavy drums, and powerful amplification. At the same time, they held onto the Delta blues style with old-school harmonica playing and Wolf's ferocious vocals. The band was a great complement to Wolf's forceful delivery and stage antics. Blues researcher Robert Palmer recalled seeing a Howlin' Wolf show where he ended his set by climbing up the theater curtains while singing into the microphone held under one arm, then gracefully sliding down to cut off the band and left the stage, all at the age of 55!

Howlin' Wolf built his reputation for hard core blues around Memphis through his live performances and a radio show modeled after Rice Miller's and Robert Lockwood's King Biscuit Time in Helena. Advertising products seemed to be a sensible way to self-promote. As his reputation

Music Analysis

"Smokestack Lightning"
(1956)

Personnel: Wolf, vocals/harmonica; Willie Dixon, bass; Earl Phillips, drums; Hubert Sumlin, guitar; Hosea Lee Kennard, piano

One of Howlin' Wolf's signature songs, "Smokestack" is a great example of the power of Wolf's band complimented by the eerie quality of his voice and harmonica. Wolf's falsetto cry at the end of every lyric line is a remarkable contrast to his growling voice. Listen for the unison riff played in the guitar and low-register of the piano.

0:00: Verse 1, line 1
0:21: Wolf's "ooohhhh" is a kind of yodel beginning in his regular voice and "flipping" up into his falsetto.
0:37: Verse 1, line 2
1:00: Wolf moves to the harmonica, joining his back-up band.
1:09: Verse 2, line 1
1:35: Verse 2, line 2
1:56: Wolf moves to harmonica again.
2:05: Verse 3, line 1
2:31: Verse 3, line 2
2:55: Track fades out as Wolf moves to harmonica again.

grew, Wolf drew the attention of music industry characters, most notably **Sam Phillips** of the famous **Sun Records**. Phillips had already made history recording Ike Turner's seminal rock and roll hit "Rocket 88," and he would go on to discover Elvis Presley in 1954, but Phillips claimed he was most excited in 1951 by Howlin' Wolf's "Moaning at Midnight" and "How Many More Years." "Moaning" begins with Wolf's lone whimper, then guitar and drums bring in the riff. Like his later hit "Smokestack Lightnin'" and much of John Lee Hooker's music, the song is a one-chord vamp. The sheer power and mixture of eerie and down-home sounds made "Moaning at Midnight" a strong entrance for Wolf into the broader music world.

Chess Records and Modern Records were both interested in Wolf, and both labels had also courted Muddy Waters and John Lee Hooker. Wolf became a known commodity and, in 1952, moved to Chicago to record for Chess Records. (Chess actually asked Muddy Waters to let Wolf share an apartment with him.) Wolf scored a hit with "Smokestack Lightnin'" in 1956, and in the early 1960s with Willie Dixon-penned knockouts "Wang Dang Doodle," "Back Door Man," and "Spoonful." Like Muddy Waters, he was invited by The Rolling Stones to perform with them on stage in a high profile television show, *Shindig*. Wolf's approach to the blues, his heavily amped sound, and his unique performance style were strong influences to future generations of blues and rock musicians.

BRIDGE TO ROCK AND ROLL

In the 1920s, the blues played a foundational role in the development of jazz by providing its 12-bar blues form, its soulful approach to melody, and

a vocabulary of standard melodic phrases. In the 1930s, the popularity of jazz dwarfed the blues with its lively and cheerful big band swing style. In the 1940s, Chicago breathed new life into the blues, electrifying it and building a new class of blues stars such as Muddy Waters and John Lee Hooker. But again, a new style would overshadow the blues by energizing America's post-WWII class of teenagers. Rock and roll became America's popular music in the mid-1950s. Rock was a direct descendent of rhythm & blues music, which itself grew out of the blues. In the words of a Muddy Waters title, "The Blues Had a Baby and They Named it Rock and Roll."

On the way to rock and roll, several musicians with serious jazz and blues connections took the reigns of popular music and moved it toward rock. Saxophonist/singer **Louis Jordan and his Tympani Five** were the kings of **jump blues** (or "jump swing"), a hybrid of jazz and blues that scored countless hits on the rhythm & blues charts. Jump blues usually used the 12-bar blues form, but the instrumentation and overall approach were closer to the music of the big band era. Louis Jordan apprenticed with Chick Webb's big band in the late 1930s. As big bands waned in the 1940s, Jordan's smaller group of rhythm section and saxophone recorded a slew of popular hits characterized by shuffle rhythms, swing-style riffs played by a small horn section, and catchy and comical lyrics. Like big band music, jump blues was designed to keep the audience dancing. Throughout the '40s, Jordan virtually took over the rhythm & blues charts with hit songs like "Caldonia," "Nobody Here But Us Chickens," "Is You Is or Is You Ain't My Baby?" and "Choo Choo Ch'Boogie." Jordan's music was a direct influence on B. B. King from his formative years until he recorded a tribute album in 1999. He also profoundly influenced several pivotal rock and soul artists such as Chuck Berry, Bill Haley & His Comets, Little Richard, and James Brown.

While Muddy Waters laid down the Chicago sound, **Elmore James** crystallized the blues sound by clarifying some of the "dirt" in the southern sound. James had a big hit in 1951 with his "Dust My Broom," an updated version of Robert Johnson's "I Believe I'll Dust My Broom." James's song brought a triplet riff to the forefront, creating the "hook" of the song. Also in 1951, **Ike Turner** took his Kings of Rhythm into Sam Phillips's studio in Memphis, recording an early precursor to rock and roll. **"Rocket 88"** sounded like hyped-up jump blues with its steady up-tempo shuffle rhythm and predictable blues riff. At the time, the most striking part of the band's sound was Willie Kizart's distorted guitar. Today, distortion is a finely-tuned effect used by most rock bands. But Kizart's distortion was created by accident. During the car ride to Memphis the speaker cone of his amplifier was damaged, causing the sound to break up. This "ruined" guitar tone became the sound of rock. "Rocket 88" also featured Ike Turner's rollicking piano playing, tenor saxophone solos from Raymond Hill, and Jackie Brenston's solid vocal.

Cleveland radio personality **Alan Freed** was one of the most important contributors bridging blues to rock music. In 1951, on a late-night radio show that entertained a primarily white audience, Freed featured R & B race records. He was the first to call this black music "rock and roll," normally a term to describe sexual activity. His radio show increased demand for black music among a white audience, the largest demographic in the country, and created a market for white musicians who played their own R & B or rock music. Among the first rock stars were Bill Haley & His

> **Jump Blues**—A popular style of music in the mid-1940s that combined small-group swing jazz, blues forms, and boogie woogie.

Comets and Elvis Presley, who recorded bluesman Arthur Crudup's "That's Alright" at Sam Phillips's studio in Memphis in 1954. Around the same time, Chess records in Chicago was keeping up with the rock trend, introducing black rockers Bo Diddley and Chuck Berry. The business of popular music centered on rock, a style that essentially moved the blues into more upbeat territory with faster tempos, louder drums and guitars, energetic delivery, and fun lyrics about dancing, partying, and other lighthearted themes. While the blues continued to evolve as a separate entity during the rock and roll era, rock's repackaging of blues DNA passed along the essential ingredients of the blues to the next wave of music fans.

THE HARMONICA

Although the guitar is the primary instrument that led the development of the blues, the harmonica (also called the "harp," "mouth harp," or "mouth organ") has also played an important role in the hands of sideman soloists and bandleaders. Harmonica players paired up with guitarists in the early decades of the blues at informal performances, and the instrument appeared on blues recordings at least as early as Herbert Leonard's appearance on Clara Smith records in 1924. The harmonica was an integral part of the famous Memphis Jug Band in the mid-1920s. But it wasn't until the first recordings of Sonny Boy Williamson I that the art of harmonica playing reached a level of refinement fit for the limelight. In Memphis and Chicago harmonica players continued to develop the instrument, often alongside guitarists and singing greats like Robert Lockwood and Muddy Waters. Today, harmonica is used in blues, folk-rock, and jazz, among other styles.

About the Harmonica

The harmonica is a unique instrument shaped like a thick comb with several openings. Inside the harmonica is a plate of multiple reeds capable of producing a range of pitches. A harmonica can be diatonic or chromatic. Diatonic harmonicas are designed to only play in one key, and diatonic harpists carry around multiple keyed harmonicas. Chromatic harps can play every possible semitone or half-step in their range like the saxophone, trumpet, trombone, and every other instrument commonly used in jazz and blues.

Harmonica players produce different pitches by changing the direction of air flow, one pitch by blowing air out and another by drawing air in. They also use various techniques to create vibrato, tremolo, wah-wah, and to produce overtones. Since the days of Muddy Waters's Chicago blues band, harmonica players have also used amplification to compete with the growing volume of blues bands and to shape a personal sound.

The following are just a few of the early harmonica players who have been most influential.

John Lee "Sonny Boy" Williamson I

Two important blues harmonica players went by the name "**Sonny Boy Williamson**." In his short life of only 34 years, the first Sonny Boy made innovations that put the instrument in the spotlight as a lead instrument and set the stage for the next round of innovation by the next class of

harmonica stars. Williamson would quickly alternate between the harmonica and the voice, making it possible for a harmonica player to be the lead singer of a band and to hold the focus of an audience. On his "Good Morning School Girl," Williamson moves so quickly between the two roles that it is hard to imagine only one performer doing both, much like the great Delta guitarists. Williamson is also responsible for mentoring Muddy Waters and Jimmie Johnson at the dawn of their careers in Chicago.

Aleck "Rice" Miller ("Sonny Boy Williamson II")

Rice Miller actually claimed to have been the first Sonny Boy, and began using the title when broadcasting on the King Biscuit Time radio show in Helena, Arkansas. Along with Robert Lockwood, Miller's harmonica was heard by a large number of listeners within the reach of KFFA's signal. His face and instrument graced the cover of their sponsor's Sonny Boy Corn Meal, and his showmanship put him on equal footing with the guitarists who were his bandmates. Rice Miller was one of the first harmonica players to amplify the instrument, and mastered the ability to alternately sing and play. He used a great deal of "wah-wah" in his sound and liked to "spread" a chord by moving up or down the notes, sustaining each note while playing the next. Miller's work can be heard on his hit "Eyesight to the Blind" and a relatively subdued version of Elmore James's hair-raising electric blues hit "Dust My Broom." Near the end of his life, he toured Europe with other American blues bands as part of the 1963 American Folk Blues Festival. Over the course of his career Miller performed with Robert Johnson and Robert Nighthawk, as well as Eric Clapton and Jimmy Page.

Big Walter "Shakey" Horton

Like Sonny Boy I, **Big Walter** grew up near Memphis, Tennessee, and played around the Beale Street scene as early as 1920. He is known for his big sound, fast melodic lines, and tasteful use of space. He is less famous than the legends he influenced—Little Walter and Sonny Boy II. He recorded regularly for Sam Phillips in Memphis and the Chess family in Chicago, lending his sound to albums by B. B. King, Muddy Waters, Johnny Shines, Otis Rush, Big Mama Thornton, and Koko Taylor, and appeared with John Lee Hooker on the 1980 film *The Blues Brothers*. Although he never achieved popularity as a front man, Horton's peers place him on the top shelf of harp soloists. Listen to "Walter's Boogie" to get acquainted with Horton's sound.

Little Walter Jacobs

Little Walter was an integral part of Muddy Waters's first Chicago band. Walter revolutionized the harmonica with his overdriven, amplified sound, and originated a pedigree of important Muddy Waters harmonica players. As a teenager, he performed in Chicago with Tampa Red and Big Bill Broonzy before beginning a musical partnership with Waters that would serve as a textbook case of how interaction takes place in a blues setting. His forceful amplification helped him compete with the loud guitars of Waters and Jimmy Rodgers, as heard in 1951 recordings "Louisiana Blues"

and "She Moves Me." Walter consistently found tasteful places to add his harmonica in a song, either in call-and-response playing in the holes between Muddy's melody, doubling the guitar lead, or doubling the vocal melody. His style of swinging improvisation has been called "jazz-like" and compared to the approach of Kansas City tenor saxophonist Lester Young. Through his relationship with Chess records, Little Walter became an R & B star in his own right with the hit instrumental "Juke" and led with his voice on "My Babe" and several other hits of the 1950s.

In addition to these foundational artists of the modern blues harmonica, scores of other great players have made a considerable impact on the instrument and the music they play. Sonny Terry, James Cotton, Junior Wells, Paul Butterfield, Howlin' Wolf, Stevie Wonder, Kim Wilson, Toots Thielemans, Howard Levy and others have continued the development of harmonica playing across the genres of blues, rock, and jazz.

Discussion Questions

1. What musical characteristics made the music of the West Memphis and Helena scenes unique? Which important blues artists made an impact from these relatively small towns?

2. In what ways did Lightnin' Hopkins's music continue the Texas Blues tradition exemplified by Blind Lemon Jefferson? (Listen to recordings by each and compare.)

3. Lightnin' Hopkins, Muddy Waters, John Lee Hooker, and Howlin' Wolf each contributed to the development of an electric style of blues. Compare music of today with these artists and describe at least one musical aspect from each that seems to have survived in contemporary music.

4. Compare the early lives of Lightnin' Hopkins, Muddy Waters, John Lee Hooker, and Howlin' Wolf. What similarities can you find, and how might their backgrounds have contributed to their careers in the blues?

5. Chart the course of the birth of rock and roll from its blues roots. What important musicians and stylistic changes led to rock? Does the blues seem to have strengthened or weakened its connection with jazz during this transition?

Building on Bebop: Cool Jazz

THE PARKER PROBLEM

Charlie Parker, Dizzy Gillespie, Thelonious Monk, and company disrupted the trajectory of jazz evolution. Their work was so radically different from swing and required such skill to master that every jazz musician who hoped to make a contribution to the art form had to ask some difficult questions. Do I absorb the lessons of bebop and continue to forge on toward new vistas? Or do I slow the developmental rate of jazz and focus on buttressing the work of bebop's inventors with more recordings in the style? The answer for so many of the next generation of jazz artists, less than a decade after the beginning of bebop, was to push forward immediately. Young leaders like Miles Davis, Max Roach, Clifford Brown, Gerry Mulligan, and Milt Jackson built upon the language of bebop to create new dialects.

> **In this chapter, we will cover:**
> - Reactions to Bebop
> - Trad Jazz
> - Cool Jazz
> - Miles Davis's *Birth of the Cool*
> - Modern Jazz Quartet
> - West Coast Jazz
> - Gerry Mulligan
> - Los Angeles Progressive Big Bands
> - Stan Getz and Bossa Nova

TRAD JAZZ

But for a large share of legendary jazz musicians and many of the jazz-listening public, even bebop went too far too quickly. In agreement with the cautionary complaints of Louis Armstrong and several other traditional jazz musicians, a new trend arose supporting a backward artistic trajectory, a re-trenching of a jazz style that was tried and true. Traditional jazz—or "**trad jazz**," as it would come to be called—rose in popularity during the mid-1940s, about the time Charlie Parker and Dizzy Gillespie were reaching the pinnacle of their success. Trad jazz and bebop had at least one thing in common, though. Both styles were reactions to the formulaic pop music that swing music had become. Bop musicians embraced chaos and charted a path using melodic virtuosity. Trad jazz musicians retreated to—and in some of the best examples, perfected—New Orleans and Chicago-style collective improvisation and the sentimental songbook of the days before swing.

> **Trad jazz**—A genre of jazz modeled after the early New Orleans and Chicago "Dixieland" jazz bands.

Trad jazz revived several careers that had long sat on the shelf. Jelly Roll Morton saw a resurgence of his career beginning in the late 1930s. (It was at this time that he made the famous proclamation in *Down Beat* magazine that he had invented jazz in the crescent cradle of New Orleans, obviously hoping to capitalize on growing interest in the beginnings of jazz.) New Orleans stalwarts Kid Ory, Sidney Bechet, and cornetist Bunk

Johnson renewed their careers. Chicago musicians Eddie Condon, Pee Wee Russell, Bud Freeman, and Jimmy McPartland returned to the limelight too. A trad jazz scene developed in San Francisco, led by Lu Watters and the Yerba Buena Jazz Band. In 1947, Louis Armstrong abandoned his big band and formed the All Stars, a seven-piece combo of renowned artists of yesteryear—trombonist Jack Teagarden, drummer "Big" Sid Catlett, former Ellington clarinetist Barney Bigard, and Earl "Fatha" Hines. (Hines had already embraced bebop and given Bird and Diz their first steady gig together.) The All Stars remained Armstrong's touring band throughout the rest of his life, made some truly wonderful recordings, and stirred up a significant interest in the history of jazz.

MILES DAVIS AT THE FOREFRONT

Miles Davis found himself in a unique position in 1948. After joining Charlie Parker on the frontline of his bebop quintet, he was positioned to influence the direction of jazz as a bandleader. Since wind instrument players tended to lead bands, Miles was one of only a handful of potential

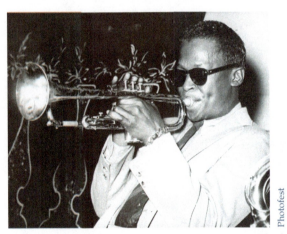

bandleaders who could say they had collaborated with the top artists on the cutting edge. Sonny Stitt, the supremely talented alto saxophonist who took Bird's place in Dizzy Gillespie's small group, had the same potential as Miles Davis. What separated them was their approach. Stitt was widely accused of being a Charlie Parker copycat. He represented the status quo of jazz, if such a new form as bebop could be the status quo. If the way forward was to make more music in line with Bird's innovations, Stitt stood to be the dominant new face of jazz. He switched to tenor saxophone and avoided some of the associations with Bird, but was unable to shake his reputation as an imitator, however great a player.

Davis avoided the Dizzy Gillespie association. Although it may have been Miles's technical limitations that made it impossible to imitate his idol, Miles developed a highly original voice on the trumpet. Beginning in 1948 with the *Birth of the Cool* recordings, Davis's extraordinary tone and intimate improvisational style guided jazz through its next few phases of evolution. The path of jazz was not governed by survival of the fittest in this case. Miles Davis was not the strongest trumpeter. But in an age that appreciated the artistry of sound, Miles rose to the top of the heap. Recording companies had enough faith in Davis to give him a wealth of opportunities to experiment in the studio and create new sounds. Every few years Davis would shift his style and ultimately create a new subgenre of jazz.

Subgenres Miles Davis Helped Create

- Cool Jazz
- Hard Bop
- Post Bop
- Fusion

Miles's Charmed Path to Jazz

The son of a well-to-do dental surgeon, Miles Davis had a charmed up-bringing in East St. Louis, Missouri, and was surrounded by jazz and blues. Davis's father bought him a trumpet at age thirteen, against the wishes of his mother who wanted him to play the violin. He joined the band at Lincoln High School and took trumpet lessons from the principal trumpeter in the St. Louis Symphony Orchestra. He played in a little swing band and was influenced at this time by trumpet players Harry James and Howard McGhee, and by Art Tatum and Duke Ellington recordings. Clark Terry—one of the finest trumpet players in Duke Ellington's band—mentored young Miles Davis and introduced him at St. Louis musical hot spots. Terry's tiptoeing touch and melodic approach sowed seeds in Miles's trumpet playing that would become recognizable traits.

In 1944 he had the chance of a lifetime to sit in for two weeks with Billy Eckstine's big band on their stop in St. Louis. Eckstine's band was a breeding ground of bebop talent including Dizzy Gillespie, Charlie Parker, Sarah Vaughan, and Art Blakey. Charlie Parker and Dizzy Gillespie lit the spark in Davis that resulted in his move to New York City. Upon graduation from high school, Davis made his parents proud with his acceptance to The Juilliard School of Music, the elite conservatory in New York City. His ulterior motive, of course, was to seek out Bird and Diz and in just a few months, Davis was so hooked into the Manhattan nightclub life that he dropped out of Juilliard. He became bored with school and was incensed when a music history teacher made disparaging remarks about the blues. Davis followed in Dizzy Gillespie's footsteps, sitting in at Minton's and other jam sessions alongside Dizzy and even filling in for him on some gigs. When Gillespie formed a bebop band separate from Charlie Parker (after Parker failed to make the plane flight back from Los Angeles), Parker formed his own band and brought in Miles as his trumpeter. Although his apprenticeship in bop developed Davis's musicianship and strengthened his resolve, Davis failed to become the next Dizzy Gillespie. Miles is strikingly forthcoming in his autobiography *Miles*, when he describes his frustrations at not having the technical ability to play high and fast bebop lines. Ultimately, Davis's technical weakness was his strength. Instead of aping the man at the top of the bebop heap, Davis formed his own language in the middle range of the trumpet and began using silence between melodic phrases to great effect. Davis's "cooler" approach prepared him for the partnership that resulted in the next step in the development of modern jazz.

Birth of the Cool

Upon ending his partnership with Charlie Parker in 1948, Miles developed friendships with a new generation of modern jazz musicians at Manhattan jam sessions. A few of these musicians had just left the Claude Thornhill Orchestra, a white, commercial big band with a few unique traits that left a strong impression on Miles Davis. **Gil Evans** was Thornhill's Canadian-born arranger and pianist who would turn out to be the most significant jazz composer since Duke Ellington and Billy Strayhorn. Evans directed much of the band's sound toward a modernist slant. His arrangements of Miles Davis's "Donna Lee" and Bird's "Yardbird Suite" integrated the

Characteristics of Cool Jazz

- Pure and serene instrumental timbres, likened to classical approach.
- Improvisation style more understated than bebop, but values logic and inventiveness.
- Dynamic level tends to be medium to soft with subtle contrasts.
- Instrumentation varied widely.
- Rhythm section style is understated. Values support over interaction.
- Arrangement and orchestration varies widely. Bands experiment with new settings and classical composition techniques.

horns in new ways and used a fresh palate of colors, a continuation of Ellington's and Strayhorn's cross-sectional voicing. Davis and Evans began meeting in Evans's apartment with several other forward-looking musicians, some of whom had also been members of the Claude Thornhill band. The sessions developed into a kind of arranging workshop with Gil Evans at the helm, and from this group Miles formed a nonet, a nine-piece jazz band modeled after Claude Thornhill comprised of a nearly equal mixture of white and black musicians.

Miles Davis Nonet's Unique Instrumentation (personnel on some instruments differed from session-to-session)

Trumpet—Miles Davis
Alto Saxophone—Lee Konitz
Baritone Saxophone—Gerry Mulligan
French Horn—Junior Collins, Sandy Siegelstein, Gunther Schuller
Trombone—Kai Winding, J. J. Johnson
Tuba—John Barber

Piano—John Lewis
Bass—Joe Shulman, Nelson Boyd, Al McKibbon
Drums—Max Roach, Kenny Clarke
Vocals ("Darn That Dream" only)—Kenny Hagood

Instrumentation was the most unorthodox feature of Miles's new band. Nine musicians put the band somewhere between a bebop combo and a big band, but the instruments operated in a manner unlike either setting. In front of a standard piano-bass-drums rhythm section were an alto saxophone, baritone saxophone, trumpet, trombone, and most curiously, French horn and tuba. Miles wanted the group of six wind instruments to operate like a choir—sometimes playing as a whole, sometimes exploring diverse colors by pairing up various combinations, and other times winding independent melodies against each other. Although Gil Evans was the group's master of composition and Davis the group's organizational leader, baritone saxophonist Gerry Mulligan contributed the lion's share of compositions that were eventually recorded.

Miles Davis secured a gig at the Royal Roost opening for the Count Basie Orchestra, but public response was anemic and the gig was short-lived. The band was recorded at three sessions between January of 1949 and March of 1950, but the singles went virtually unnoticed until 1957 when the twelve resulting tracks were compiled into a full-length LP titled *Birth of the Cool*. By the time *Birth of the Cool* was released, cool jazz had developed into a recognized sub-genre of jazz. The nonet had long since split up and many of the band members had moved on to more influential roles

Music Analysis

"Godchild"
(1949)

Personnel: Miles Davis, trumpet; Kai Winding, trombone; Junior Collins, French horn; John Barber, tuba; Lee Konitz, alto saxophone; Gerry Mulligan, baritone saxophone; Al Haig, piano; Joe Shulman, bass; Max Roach, drums

Gerry Mulligan does some of his finest arranging work on this tune, composed by George Wallington. Listen for his use of the low-pitched and high-pitched instruments, sometimes separately and sometimes combined into a six-horn unit. The sequence of events is far more structured than bebop, quickly moving between melody statements, ensemble figures, and improvised solos. This is a good example of the soft-edged tone quality musicians used in cool jazz settings. Notice that although the tempo is somewhat fast, the band maintains and keeps a lid on the intensity.

0:00	**Head, A sections:**	Tuba and baritone saxophone double the melody. As the melodic line moves to higher pitches, other instruments gradually take over—French horn (0:06), then trombone and alto saxophone (0:07), then trumpet (0:08). All horns end the phrase together on a chord (0:11). The passage is then repeated for a second A section.
0:23	**Head, Bridge:**	Miles Davis plays an improvised solo over simple **pads**, or slowly moving background chords from the other horns.
0:34	**Head, last A section:**	A repeat of the opening A section.
0:43	**Trumpet Solo:**	Miles plays a tentative-yet-lyrical solo over one chorus. His effective use of space is already appearing on this early recording.
1:27	**Ensemble figure, baritone saxophone solo:**	Miles Davis ends his solo and leads the group on an ensemble passage. Mulligan plays a tuneful solo until, interrupted by an ensemble figure, he launches into a brief onslaught of double-time material.
2:12	**Shout section, A sections:**	The full group repeats a simple harmonized melody. Max Roach fills in the holes between chords. Notice at the end of each phrase, the alto saxophone and trumpet are doubled and the other horns accompany with chords.
2:34	**B section, trombone solo:**	Kai Winding plays a brief solo.
2:45	**Shout section, last A section:**	A repeat of the first shout section figure.
2:57	**Coda:**	Mulligan refers to the opening melody with this ascending figure. His stubbornly off-beat rhythms create the effect of the band racing to a final collapse.

in cool jazz. In fact, even though cool jazz was developed in New York City, it failed to start a trend on the East Coast where jazz styles developed at lightning pace. Miles Davis, himself, moved onto the next project and became a founder of the hard bop style. Gerry Mulligan, the baritone saxophonist with the nonet, headed west to Los Angeles where his milky tone, so prominent on *Birth of the Cool* recordings, helped cool jazz to take root and form the identity of West Coast jazz. Alto saxophonist Lee Konitz did the same. Pianist John Lewis had already started a project in New York that was recasting cool jazz in another light.

The Miles Davis nonet was influential to cool jazz as a workshop where future cool jazz bandleaders experimented with songwriting and orchestration. The style of cool jazz, ultimately, reframed the innovations of bebop into a more controlled and reserved aesthetic. The musicians' sounds were grounded in the smooth approach of Lester Young, who had been influenced by Bix Beiderbecke and Frank Trumbauer. Cool jazz

Music Analysis

"Moon Dreams"
(1950)
Personnel: Miles Davis, trumpet; J. J. Johnson, trombone; Gunther Schuller, French horn; John Barber, tuba; Lee Konitz, alto saxophone; Gerry Mulligan, baritone saxophone; Al McKibbon, bass; Max Roach, drums

This ballad was the only Gil Evans contribution to the *Birth of the Cool* recordings. Earlier recordings of the Chummy MacGregor song—one sung by Martha Tilton and another played by the Glenn Miller Orchestra—are essentially pretty but banal recordings meant for popular consumption. Gil Evans's arrangement is truly a landmark work of orchestration. With very little improvisation, "Moon Dreams" is not typical of the music played by the nonet. Most of their music tended to balance improvisation with arranged sections. Gil Evans was inspired by the music Billy Strayhorn arranged with Duke Ellington. It is easy to hear the Strayhorn influence here, with the unique colors and subtle hand-offs of the melody from one player to the next.

0:00	**A phrase:** Miles Davis's trumpet is heard on top of the structure of the full group.
0:24	**B phrase:** Lee Konitz's alto saxophone takes over the melody, now accompanied only by baritone, trombone, and tuba playing a countermelody.
0:36	**B phrase, part 2:** The full group comes together with the melody, and trumpet takes the lead a couple of bars later. Notice the tuba playing a countermelody at the beginning of this passage.
0:51	**2nd A phrase:** This begins similarly to the first A section, but Miles lays out after a couple of bars and French horn takes the lead. Notice the brief double time figure at the end of this section.
1:17	**C phrase:** Alto saxophone takes over again. Gil Evans creates momentum by writing 16th notes in the alto saxophone, gradually joined by other instruments.
1:30	**C phrase, part 2:** The 16th note lines arrive at a sustained chord with Miles at the top, low register 16ths churning underneath in baritone saxophone, alto saxophone, trombone, and French horn. Tuba flutters a faster rhythm, simulating a musical dream sequence.
1:44	**C[1] phrase:** Gerry Mulligan improvises off of a written melody, which begins with the shape of the alto melody in the C section.
1:57	**C[2] phrase:** Miles Davis leads the full group of horns, again, with a melody that begins like the C phrase. This leads to a second "dream sequence," with rapidly ascending scales staggered between all instruments except trumpet. Alto saxophone doubles Miles's high note, and then is left alone. Konitz's excruciating sound and intonation at this point is either a scar of bad musicianship or a pricelessly painful moment of expression, depending on how the listener is inclined to hear it. Either way, it is the emotional climax of the piece.
2:13	**Coda:** Alto saxophone sustains while loud, shifting chords and scattered melodic figures slowly release the tension of the previous climax. Think about how the musical texture changes from Lee Konitz's lone high note, to the beginning chords of the coda, to the melodies that wind to a final resting point.

musicians tended to play their instruments with warmer tones and softer volume levels more akin to classical music. In contrast to the minimalist, two-horn, unison arrangement typical in bebop, cool jazz musicians experimented with various groups of instruments and arranged the heads of tunes in various ways. Although cool jazz bands could play break-neck tempos with the best bebop bands, cool jazz sounded most at home at medium and slow tempos. And even though cool jazz musicians could contend with the most virtuosic of bebop soloists in a jam session, innovative arrangement and compositional experimentation were often in focus more than improvisation in cool jazz performances.

MODERN JAZZ QUARTET

The group whose lifespan was longer than any other cool jazz group was formed as the rhythm section in Dizzy Gillespie's big band as early as 1946. **Milt Jackson** (vibraphone), **John Lewis** (piano), **Ray Brown** (bass), and **Kenny Clarke** (drums) founded the band that is most remembered today for infusing modern small-group jazz with elements of classical music and for elevating the image of jazz to that of a classical chamber music group. The group performed in concert halls and dressed in tuxedos in their concerts. They played their instruments with a light touch and gave special attention to creating delicate textures. The band underwent just a couple changes at the beginning of its forty-year tenure. First called the Milt Jackson Quartet, the band changed its name to the Modern Jazz Quartet (keenly maintaining its MJQ monogram). By 1955, the personnel had solidified with **Percy Heath** replacing Ray Brown, and **Connie Kay** replacing Kenny Clarke.

The trademark of the band (other than its abbreviation and its tuxes) was the polyphonic texture that resulted when Lewis and Jackson played simultaneous melodic lines. John Lewis and Milt Jackson had a relationship that has been unparalleled since. Lewis, who had written two of the arrangements on the *Birth of the Cool* recordings, infused the music of the

Music Analysis

"One Bass Hit"
(1956)
Personnel: Milt Jackson, vibraphone; John Lewis, piano; Percy Heath, bass; Kenny Clarke, drums

This track, from a definitive MJQ album *Django*, features Percy Heath's bass playing right off the bat. The form is based on a basic AABA structure, but the song essentially has no melody. Instead, the band plays pre-arranged "hits," as background figures to the bass solo. The A sections stay on one key center with occasional passing chords. The B section is borrowed from *rhythm changes*. Listen for dialogue between vibes and piano throughout the bass solo. Clarke often accentuates the hits with the bell of his cymbal.

0:00	**Introductory melody:** All four members of the quartet play the opening three phrases in unison. Then Heath continues with a bass solo that continues throughout rest of the recording.
0:08	**Chorus 1, A sections:** Kenny Clarke moves his brushes from the snare drum to the ride cymbal. Jackson and Lewis play the first background figure together.
0:32	**Chorus 1, B section:** The bridge background figure leaves more space for the soloist.
0:44	**Chorus 1, last A section:** A repeat of the opening A section.
0:55	**Chorus 2, A sections:** Jackson plays a trickle-down fragment on the vibes, echoed by Lewis.
1:19	**Chorus 2, B section:** No background figure interrupts the bass solo here.
1:30	**Chorus 2, last A section:** A repeat of the A material in this chorus.
1:42	**Interlude:** Jackson and Lewis play a series of rising chords, landing on the dominant chord. Percy Heath quotes "The Surrey With the Fringe On Top" from *Oklahoma!* (1:48).
1:53	**Chorus 3, A sections:** The backing figure here is based on the opening chorus.
2:16	**Chorus 3, B section:** Milt Jackson enters and repeats a busy, trilling fragment ending on a rising line in unison with Lewis.
2:28	**Chorus 3, last A section:** Jackson and Lewis hold the attention with composed material during this final A section.
2:39	**Coda:** Jackson, Lewis, and Clarke play hits with open space, filled by Heath's final phrases.

MJQ with a technique called "**counterpoint**" that was perfected by Johann Sebastian Bach and other Baroque-Era composers. While one musician played the basic melody of a song, another player accompanied it with an independent melody. While John Lewis and Milt Jackson often played against each other melodically, Connie Kay's drums and Percy Heath's bass played pre-arranged rhythmic figures.

Milt Jackson followed Lionel Hampton as the next important vibraphone player. He was an exciting and modern soloist, in contrast to Lewis's light and chilled touch on the piano. Jackson, nicknamed "Bags," brought the vibraphone out of the Swing Era and in line with bebop. He had stood in for Charlie Parker with Dizzy Gillespie's small group at Billy Berg's in Los Angeles and would later record with Miles Davis, Thelonious Monk, and John Coltrane. Coltrane, the most intense tenor saxophonist of his day, should have been a strange bedfellow for Jackson, but the *Bags and Trane* album shows Jackson holding his own against Trane's hard-edged sound.

WEST COAST JAZZ

A common overstatement about jazz on the West Coast after WWII is that it was all about cool jazz. True, much of the jazz made on the West Coast had a lot in common with the music Miles Davis's and Gil Evans's nonet created. Gerry Mulligan's exodus to Los Angeles after the *Birth of the Cool* was a big factor in the rise of the West Coast scene, and his restrained tone tempered his inventive running-eighth-note melodies with a coolness that defined the West Coast sound. But Los Angeles had its own jazz scene with a deep tradition of improvisation developed in the pressure cooker of a jam session setting in the mid-1940s. As far back as the 1910s, black and creole New Orleans jazz musicians the likes of Freddie Keppard, Pops Foster, Jelly Roll Morton, and Kid Ory travelled by train to Los Angeles and other cities in the west. In 1938, Los Angeles proved a fertile ground for swing when Benny Goodman brought his band to the Palomar Ballroom.

Modern jazz found its home on **Central Avenue** between 11th Street and 42nd Street, where a large concentration of middle class blacks supported the nightlife. Although the first phases of the Great Migration during the 1920s did not significantly increase the black population of Los Angeles, the 1930s migration brought 25,000 blacks largely from Texas and Louisiana and by 1940, more than 60,000 African Americans lived in Los Angeles. During World War II and up to 1950, the black population nearly tripled as defense companies built plants around Central Avenue and offered middle class jobs. Black-owned businesses sprang up on the blocks that flanked Central Avenue. Nightclubs like the Alabam attracted celebrities with floorshows in the same vein as the Cotton Club in Harlem. Many world-famous jazz musicians cut their teeth in the clubs that spotted Central Avenue near the Club Alabam. Perhaps the most consequential of these was the Downbeat where Howard McGhee's bebop quintet performed before the fated arrival of Bird and Diz. The Downbeat was also the setting of cutting contests between Dexter Gordon, Wardell Grey, and Teddy Edwards that were as legendary as the Kansas City showdown of Lester Young and Coleman Hawkins.

The Hollywood film industry and a flourishing big band scene provided a professional environment where musicians could make a steady

living at sound stages and dance halls. Those musicians who aspired to bebop greatness could heed the call of the night, congregating at clubs like the Lighthouse and Shelly's Manne Hole where jam sessions proved that Los Angeles jazz could take on the same intensity as New York jazz. At the Lighthouse on the Hermosa Beach pier in 1949, bassist Howard Rumsey ran a band of his "All-Stars," many of whom were culled from ranks of the Stan Kenton Orchestra. At various times in the band's history, Shorty Rogers (trumpet), Bob Cooper (tenor saxophone), Jimmy Giuffre (tenor saxophone), Shelly Manne (drums), Teddy Edwards (tenor saxophone), Bud Shank (alto saxophone), Stan Levey (drums), Conte Candoli (trumpet), Frank Rosolino (trombone), and Hamilton Hawes (piano) all graced the stage and developed personal approaches to their instruments. Even bebop legend Max Roach worked in the house band at the Lighthouse for a time, bringing in his friends Charlie Parker, Charles Mingus, and Miles Davis to make cameo appearances that stirred up the local jazz community. Los Angeles jazz was built on the same foundation as Chicago and New York, with plenty of room for experimentation and aggressive virtuosity. Although none would find worldwide notoriety from their Los Angeles base, Charles Mingus, Eric Dolphy, and Ornette Coleman, leaders of experimental jazz in the late 1950s and '60s, all developed their skills and tinkered with new concepts in Los Angeles clubs. Incredibly talented soloists, such as pianist Hampton Hawes and alto saxophonist Art Pepper, made significant impact on their instruments.

The great artists and bands of Los Angeles were fostered by a group of local record labels. Dial, Fantasy, Contemporary, Capitol, and Pacific recorded amazing albums of West Coast jazz, and while many of them sound like continuations of the Miles Davis nonet (listen to *Art Pepper + 11*), the variety of musical directions and instrumental experimentation recorded in the late 1940s and '50s is staggering.

Gerry Mulligan

Musical history has rarely arisen from low-pitched musical instruments, least of all the baritone saxophone, an instrument normally relegated to playing in a big band setting and doubling bass or trombone parts. One exception occurred, not surprisingly, in the Duke Ellington band where so many important melodies were written for baritone saxophonist Harry Carney. But **Gerry Mulligan** must have felt awfully fortunate when he got a good measure of solo space in Miles Davis's nonet, and surely he relished the opportunity to compose most of the band's material on recordings. But soon after the Miles Davis nonet broke up, Mulligan hitched a ride to Los Angeles and began courting Stan Kenton for a spot in his powerhouse jazz orchestra. Kenton declined, but did agree to record some of Mulligan's compositions.

Mulligan returned to New York, fronting a ten-piece ensemble, and then moved back to Los Angeles in 1952. He began playing at the Haig, a homely-looking restaurant that would bring celebrity status to West Coast jazz. The Haig was in the middle of the action. It was located on the major byway of Wilshire Avenue opposite the posh club Cocoanut Grove (inside the Ambassador hotel where Robert Kennedy was shot in 1968), and was just down the street from the famous Brown Derby. Like the Miles Davis group, instrumentation was what made Mulligan's band unique. His

piano-less quartet lacked an instrument that could play chords. No piano, guitar, vibraphone; only Mulligan's saxophone, drums, bass, and trumpeter **Chet Baker**. Baker was a Miles Davis-influenced improviser with an inventive melodic sense. Without a chordal instrument, Mulligan and Baker created the harmony on top of the bass using, like the MJQ, contrapuntal melodic lines. The two would solo at the same time in a manner more measured than New Orleans-based collective improvisation. Mulligan and Baker seemed to read each other's minds and have a natural ability to compliment one another in the heat of polyphony.

Chet Baker turned out to be, along with Charlie Parker, one of the truly tragic figures in jazz. He showed great promise in his work with Mulligan, both on the trumpet and as a vocalist. Baker had an immediately recognizable voice; a feminine, whispery tone that contrasted his heartthrob image. His signature song "My Funny Valentine" is a must-hear for any student of jazz singing, or anyone who appreciates 1950s pop culture. But a serious heroin habit marred his movie star looks and ruined his performing career. He was sent to federal prison multiple times on drug charges and eventually died after falling out of a window in Amsterdam with heroin and cocaine in his system.

Music Analysis

"Bernie's Tune"
(1952)
Personnel: Berry Mulligan, baritone saxophone; Chet Baker, trumpet; Bob Whitlock, bass; Chico Hamilton, drums

One of Gerry Mulligan's most played jazz standards, "Bernie's Tune" illustrates a few of the unique characteristics of the piano-less quartet. Although the melody has a great deal in common with bebop—its fast tempo and angular contour—Baker and Mulligan maintain a reserved energy level. Listen for moments of polyphony, where Baker and Mulligan improvise simultaneously without getting in each other's way.

0:00	**Head, A sections:** Chet Baker plays the minor-key melody while Gerry Mulligan follows along underneath with a harmony part. The bassist plays the melody during the syncopated part of each phrase, then walks under the long notes. Chico Hamilton plays the rhythms of the head with brushes on the snare drum and drops bombs on the bass drum when Whitlock walks the bass.
0:19	**Head, Bridge:** Chet Baker plays the melody, now in a major key. This time Mulligan plays a simple countermelody that leaves a great deal of space.
0:29	**Head, last A section:** A repeat of the opening A section.
0:38	**Baritone saxophone solo:** Mulligan plays in a lyrical style, showing his gift for melody.
1:16	**Trumpet solo:** Chet Baker plays a chorus with his own penchant for melodic inventiveness. Mulligan plays extremely soft long notes that stay in the background.
1:52	**Baritone saxophone/trumpet duet, A sections:** Mulligan starts a solo in his upper register, then Baker joins in. Both play solos of running eighth note rhythms that are phrased exactly in sync with each other.
2:10	**Drum solo, B section:**
2:19	**Baritone saxophone/trumpet duet, last A section:**
2:28	**Head, A sections:** The song closes with two repetitions of the A section, holding out the last note of the phrase.

LOS ANGELES PROGRESSIVE BIG BANDS

While big bands across the nation closed the shop at the twilight of the Swing Era, the West Coast continued to be a region where the format could flourish. In fact, now able to shake commercial expectations to create cookie-cutter retreads of swing hits, the big band moved toward experimentation and expressionism in the hands of a few visionary bandleaders. Although the change toward less income and more creativity took place in the big bands that still existed across the country (for example, Duke Ellington's persistent motivation toward artistic creation), some of the most interesting works were created in Los Angeles by **progressive big bands**, so named by one of the preeminent progressive bandleaders, Stan Kenton.

> **Progressive big band**—A large jazz ensemble that grew from the swing tradition but looked ahead at modern trends in jazz, incorporating bebop, contemporary classical, and new rhythmic styles such as Latin and rock.

Noteworthy Los Angeles Big Band Leaders of the 1950s

Roy Porter	Woody Herman
Gerald Wilson	Terry Gibbs
Stan Kenton	Bill Holman

The **Stan Kenton Orchestra** was an institution of creative big band music that incorporated swing, bebop, and contemporary classical sounds. Kenton featured many of the top arrangers of post-Swing Era big band—Bill Holman, Lennie Niehaus, Bob Graettinger, and Gerry Mulligan—and hired many of the best soloists in Los Angeles—Art Pepper, Bob Cooper, Shorty Rogers, Peter Erskine, and Maynard Ferguson. The band was known for its contemporary approach and intense brass playing. Kenton was a successful show bandleader in 1940 when he started a rehearsal band to play his own arrangements. The group grew quickly, finding steady performing work at the Rendezvous Ballroom in Balboa, California. Soon Kenton signed with Capitol Records and made the national press, winning *Down Beat* and *Metronome* polls for best big band. Over the course of three decades, the band continued the legacy of big band music past the Swing Era. One of the highlights of Kenton's long tenure was an album called *Kenton Hi-Fi*, recorded during a time that the band was incorporating Latin music.

Woody Herman's band was a veritable fraternity of talented jazz musicians that performed a modernized brand of swing. As early as the late 1930s, clarinetist and alto saxophonist **Woody Herman** built his group from the remaining members of the disbanded Isham Jones dance band. He scored a classic swing hit with "Woodchopper's Ball" in 1939, but it was his "Thundering Herds" of the next few decades that left an impact on the direction of big band music. The First Herd showed the influence of the Duke Ellington and Count Basie orchestras and incorporated the new sounds of bebop. Herman was one of just a few swing bandleaders to embrace bebop. In 1946, Woody Herman collaborated with the preeminent classical composer Igor Stravinsky, premiering his *Ebony Concerto* at Carnegie Hall.

The Second Herd, in 1947, was famous for its saxophone section. On a recording that pre-dated the *Birth of the Cool*, Herman's three tenor saxophonists (Stan Getz, Zoot Sims, and Herbie Steward) and one baritone saxophonist (Serge Chaloff) defined the sound of cool jazz in a big band

setting. Jimmy Giuffre, a talented composer and saxophonist in his own right, composed the band's most enduring big band standard "Four Brothers." The song demonstrates the improvisational strength of Herman's band, and its melody was one of the more memorable bebop heads. The arrangement features the saxophone section with solos from Sims, Chaloff, Steward, Getz, and Herman. Throughout the long tenure of the Thundering Herds (the band toured into the 1980s), Woody Herman remained a relevant fixture in jazz by embracing the rapid changes of style. The band covered rock and roll songs like the Doors' "Light My Fire" and the Beatles' "Hey Jude" in the 1960s, and in the 1970s they tackled modern jazz standards by John Coltrane, Eddie Harris, and Chick Corea. Herman's tendency to replenish his group with young musicians, sometimes just out of school, helped the growth of jazz education and trained new generations of professional jazz musicians.

Music Analysis

"Four Brothers"
(1947)
Personnel: Woody Herman, clarinet/alto saxophone; Sam Marowitz, alto saxophone; Herbie Steward, alto and tenor saxophone; Stan Getz and Zoot Sims, tenor saxophone; Serge Chaloff, baritone saxophone; Stan Fishelson, Bernie Glow, Marky Markowitz, Shorty Rogers, Ernie Royal, trumpets; Earl Swope and Ollie Wilson, trombones; Bob Swift, bass trombone; Fred Otis, piano; Gene Sargent, guitar; Walter Yoder, bass; Don Lamond, drums

0:00	**Head:** The saxophone section plays the bebop melody in block chord voicing, punctuated by sharp brass "stabs."
0:35	**Tenor saxophone solo:** Zoot Sims.
0:52	**Baritone saxophone solo:** Serge Chaloff.
1:09	**Tenor saxophone solo:** Herbie Steward.
1:27	**Tenor saxophone solo:** Stan Getz.
1:44	**Ensemble section:** The brass play a shout figure as a group, answered by written **soli** lines in the saxophone section.
2:02	**Clarinet solo:** Woody Herman solos over the bridge, playing mostly the root of each chord.
2:11	**Ensemble section:** Similar material as the previous ensemble section.
2:20	**Shout chorus, A sections:** The full group of horns plays simple riffs with Don Lamond's bombastic drums filling in the spaces.
2:37	**Saxophone shout, B section:** The saxophone section plays a repeated figure, with brass stabs.
2:46	**Shout chorus, last A section:** Repeat of previous shout material.
2:55	**Coda:** Four of the saxophone soloists cycle through brief solos again—Sims, Steward, Getz, and Chaloff. Then they join for a final written soli, and the band ends on a final sustained chord.

STAN GETZ AND BOSSA NOVA

Stan Getz is most known for his refined, lush tenor saxophone tone with a tentative vibrato and a breathy release. Influenced by Lester Young and his former bandleader, trombonist Jack Teagarden, Stan Getz's work with Woody Herman in the 1940s brought him notoriety that he was able to spin into a long career playing small group jazz. The "Four Brothers" band was

a known commodity and his solo work on the ballad "Early Autumn" established him as leading propagator of "cool." He recorded a number of successful small group recordings throughout the 1950s with elite figures in jazz, such as Dizzy Gillespie, Roy Haynes, and Oscar Peterson. At the same time, however, he struggled with a drug habit that had nagged him since he was a teenager. He was arrested in 1954 as a result of drug use and left the United States for Copenhagen, Denmark. On his return in 1961, he embarked on his next step, a multi-cultural collaboration that introduced him to a wider audience than any other jazz musician could hope to enjoy.

In the early 1960s, cool jazz culminated with a new musical movement coming out of Brazil. **Bossa nova** (the Portuguese term loosely translates to "new charm" or "new trend") is an updated version of Brazilian samba music that incorporates jazz-influenced harmony and improvisational style. Much like the origins of American jazz, Brazilian samba resulted from the colonization of Brazil by the European nation of Portugal and the importation of its African slaves. Portuguese and African musical characteristics combined to create a percussion ensemble musical tradition that provided the soundtrack for the parades at Brazil's yearly *carnaval* celebration. Samba music has a vocabulary of highly stylized and heavily syncopated rhythmic grooves, played with a level of nuance and flexibility that samba drummers learn over a lifetime of study. Samba has its own clave rhythm called the *partido alto*, a rhythm that shifts between repeated on-beat rhythms and repeated off-beat rhythms. Holding the floating syncopation together is a strong pulse emphasizing the 2nd of every two beats (beats 2 and 4 in a pattern of 4 beats).

Basic Samba Rhythm

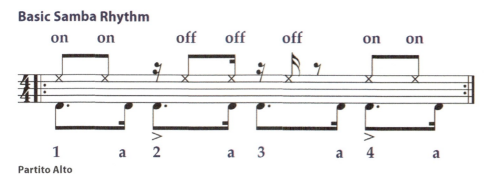

Partito Alto

Composer **Antônio Carlos Jobim** reinvented samba music into a relaxed and intimate style that was driven by the acoustic guitar instead of the drumming group. Jobim had written music for a play in Brazil based on the classic tale of Orpheus and Eurydice. The resulting album became popular in Brazil, and the music was performed in a variety of settings, most importantly in concerts by guitarist **João Gilberto**. Jobim's music found its way to France the next year when film director Marcel Camus remade the Brazilian play as *Orfeo Negro*, or *Black Orpheus*, with film score composed by Luis Bonfá. The popular film introduced Jobim's work to an even more widespread audience.

American jazz musicians began hearing bossa nova music on their travels to Brazil. Dizzy Gillespie and guitarist Charlie Byrd were among the first to introduce bossa nova in their live and recorded performances. Then entered Stan Getz. Charlie Byrd played tapes of bossa nova music for Getz and enticed him to record an album together. *Jazz Samba* was released

in 1962 and reached number one on the pop music charts, as a result of a radio hit that featured Getz's silky improvisation over Jobim's song "Desafinado." The success of *Jazz Samba* triggered a flood of jazz musicians recording in the bossa nova style. Getz himself followed up *Jazz Samba* with an album of bossa nova tunes in a big band setting. In 1963, he returned to the small group bossa nova format that had been so successful, but this time he collaborated with the genre's originators. He paired with the style's leading guitarist and named the album *Getz/Gilberto*. João played guitar and sang, Jobim played piano and supplied the songs. A surprise catch was João's wife Astrud, who had never before sung professionally. Getz asked her to sing English translations of Jobim's lyrics and the results gave Getz another success. "The Girl From Ipanema" reached number five on the Hot 100 pop charts and became one of the most requested and most recognizable jazz standards of all time.

Music Analysis

"Desafinado"
(1962)
Personnel: João Gilberto, guitar/vocals; Stan Getz, tenor saxophone; Antônio Carlos Jobim, piano; Milton Banana, drums; Sebastião Neto, bass

This is one of Jobim's finest compositions. Its chord changes move to unexpected places and its melody emphasizes dissonant and colorful pitches, appropriately "painting" the meaning of the Portuguese word *desafinado*, "out of tune." The form of the song follows a standard AABA pattern, but moves unpredictably within that guideline. With sixty-eight measures in a chorus, the song is far longer than the typical tune. The song features Gilberto's soft-natured voice (influenced by Chet Baker) and Stan Getz's improvisation.

0:00 **Introduction:** Just a few measures of the first chord and the bossa nova groove.

0:03 **Head, A sections:** Gilberto sings the melody in his native Portuguese. The song arrives at the bridge's new key early, during the second A section (0:49).

0:56 **Head, B section:** The bridge of the song moves through two key centers, the second arriving at 1:10.

1:22 **Head, last A section:** The form is extended by a tag, or a group of chords, that extends the previous phrase.

1:55 **Tenor saxophone solo:** Stan Getz plays a solo based on the written melody of the song. When he departs from the melody, his careful choice of pitches adds color to the already lush chord progression.

3:45 **Coda, tag ending:** In a closing tag, the rhythm section vamps and fades out on two alternating chords. Gilberto joins in singing wordless sounds with Getz's riffing melody.

After the bossa nova trend ran its course, Getz made excellent jazz quartet recordings with a strong group of sidemen. In particular, his quartet recordings with Chick Corea presented the young up-and-comer as the great pianist and wiz of composition that he turned out to be. Like Dexter Gordon, Sonny Rollins, and other mainstream jazz tenor players, Stan Getz's calling card was his extremely personal interpretations of standard songs.

Discussion Questions

1. Listen to "Godchild" and "Moon Dreams" from *Birth of the Cool*. How does Miles Davis differ from Dizzy Gillespie as a trumpet player?

2. What elements made Miles Davis's nonet unique from any other musical group?

3. What is trad jazz and what were the motivations behind its creation?

4. What makes Gerry Mulligan important to the development of cool jazz?

5. What musical elements did the Modern Jazz Quartet and Gerry Mulligan have in common?

6. Describe the style of bossa nova and its origins. What does it have in common with jazz?

Building on Bebop: Hard Bop

After cool jazz had held the main sway for just a few years, along came a new brand of small-group jazz, one that sought to revive the intensity of bebop with a newfound conviction. It's no surprise that drummers (Art Blakey and Max Roach) led the first bands identified with the hard bop movement. The reserved energy of the most celebrated cool jazz rhythm sections gave way in the mid-1950s to an extroverted and interactive accompaniment style that took the music to loudest and softest extremes of volume. Hard bop brought a new emphasis to soloists, clearing away much of the experimental and composer-oriented music of the previous era. And those soloists flooded the music with a virtuosic style informed by blues, gospel, and the youthful rhythm and blues genres. Hard bop musicians played with edgy and biting timbres. The new sound led jazz critics to describe the music as a more urban, East Coast sound in response to what was happening on the West Coast. The straight-forward presentation of melody and virile style of improvisation in hard bop established a new mainstream jazz sound, one that became a formula that record companies the likes of Blue Note, Atlantic, and Prestige produced with rising stars such as Sonny Rollins, John Coltrane, and Miles Davis. Although it is true that many of the hard bop bands were based on the East Coast, one of the first hard bop bands was actually created in Los Angeles.

> **In this chapter, we will cover:**
> - Important Artists of Hard Bop
> - Brown-Roach Quintet
> - Art Blakey and the Jazz Messengers
> - Miles Davis
> - Horace Silver
> - Sonny Rollins
> - Soul Jazz
> - Wes Montgomery

> **Characteristics of Hard Bop**
> - Standard bebop instrumentation—rhythm section and 2 or 3 horns
> - Melodies, chord structures, and accompaniment patterns influenced by gospel, blues, and R & B music
> - Wide dynamic contrasts
> - Virtuosic soloists
> - Hard-edged, brash timbres
> - Direct arrangement with unison or simply-harmonized melody

CLIFFORD BROWN-MAX ROACH QUINTET

Max Roach had been filling in at the Lighthouse on Hermosa Beach, California, when a promoter offered to let him form his own band at the California Club. The Lighthouse All-Stars were one of

the bastions of hardcore bebop on the West Coast, in contrast with the popular stereotype of a laid-back Los Angeles jazz style. It made sense, then, for bop master Max Roach to step in, and it made sense for him to continue along the same thread with his own band.

Roach chose trumpeter **Clifford Brown** as a partner, nearly a rookie on the scene, but already widely recognized as the next major voice of the jazz trumpet. Brown came from Wilmington, Delaware, by way of Philadelphia and had just recently taken his idol Fats Navarro's place in Tadd Dameron's band when Navarro died of drug abuse. Clifford Brown had already performed as a sideman with Lionel Hampton, Art Blakey, J. J. Johnson, and had led his own groups in recordings by the time he joined Max Roach. Although Brown was the heir apparent to Navarro, he presented the jazz community with a different prototype. Under the influence of Charlie Parker, a saddening majority of jazz musicians in the last decade had espoused the common saying, "If you want to play like Bird, you have to shoot up like Bird." Clifford Brown, on the other hand, was a teetotaler. He didn't do drugs, didn't drink, and didn't smoke. An incredible technician with never-ending melodic inventiveness, Brown proved that it was possible to play bebop sober. He led several of his peers to rethink their habits. In a turn of cruel fate, within a couple of years of his creating the quintet with Roach, he was killed in a car accident along with Richie Powell (Bud's brother) and Powell's wife.

In just a couple of years' time, the Brown-Roach Quintet created a body of work that reshaped the direction of jazz and created several new jazz standards in the process. Cover versions of standards were often played at breakneck tempos ("All God's Chillun Got Rhythm" and "Cherokee") and took treacherous rhythmic turns ("I Get a Kick Out of You").

Music Analysis

"Daahoud"
(1954)
Personnel: Clifford Brown, trumpet; Harold Land, tenor saxophone; Richie Powell, piano; George Morrow, bass; Max Roach, drums

Brown's original composition exemplifies the new breed of bebop melody, played on top of an intricate set of rhythmic kicks, unison lines, and rhythm section breaks. Brown's brilliant tone and unique articulation of running eighth note lines are on display on this performance. Roach's drum solo is a masterpiece of logical construction and technical prowess.

0:00	**Head, A sections:**	Brown and Land play the melody in unison, with Land joining the rhythm section's chromatic walk-down at the end of the A phrase.
0:16	**Head, B section:**	The rhythm section plays kicks along with most notes of the melody.
0:24	**Head, last A section:**	
0:31	**Interlude:**	After a drum break, the band plays a quick "send off" for Brown's solo.
0:37	**Trumpet solo:**	Brown's inventive lines skip across the beat with a marked phrasing.
1:41	**Piano solo:**	
2:12	**Tenor saxophone solo:**	
2:42	**Drum solo:**	
3:12	**Last Head:**	Exact repeat of the opening head with the interlude.
3:48	**Coda:**	After a brief drum solo, the horns play a unison line and arrive at a fermata chord.

Clifford Brown's original compositions "Joy Spring," "Brownie Speaks," "Daahoud," and "Sandu" reflected his mastery of the bop and blues idioms. Roach brought a new sense of melodicism into the drum set, creating melodic fragments between the snare and tom-toms. The band became a veritable all-star group when Sonny Rollins joined the band in November of 1955, strengthening the frontline. But Brown's death the next year spelled the end for the quintet. Roach made attempts to reform hard bop quintets with Kenny Dorham and later Booker Little playing Brown's role. But these groups did not have the same impact as the original quintet and Roach departed from the hard bop style, as evinced by the pianoless album *Deeds, Not Words* (1958) and the overtly activist *We Insist!—Freedom Now Suite* (1960).

ART BLAKEY AND THE JAZZ MESSENGERS

The most explosive drummer of his time and a dynamic leader, **Art Blakey** accomplished more than just about anyone in small-group jazz. He kept energy flowing relentlessly through countless performances with his shuffle rhythm and ignited the bandstand with buckshot drum fills and snare drum press rolls. Over the course of more than three decades, Blakey led quintets and sextets that defined the hard bop sound. As a bandleader he had a knack for selecting players in the adolescence of their musical development, just before they became important bandleaders themselves. The Jazz Messengers were an institution that graduated alumni whose success in jazz were rivaled only by Miles Davis's sidemen.

A Pittsburg native, Blakey learned to play the piano and led a swing band at age fifteen. His skill at the piano paled in comparison to Erroll Garner's, a youngster who grew to become one of the finest jazz pianists in history, recording the famous

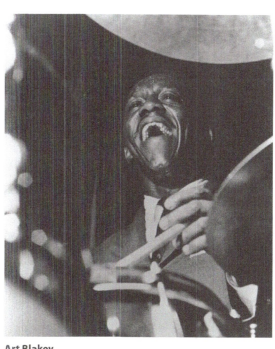

Art Blakey

Photofest

Music Analysis

"Moanin'"
(1958)

Personnel: Lee Morgan, trumpet; Benny Golson, tenor saxophone; Bobby Timmons, piano; Jymie Merritt, bass; Art Blakey, drums

In the quintessential Jazz Messengers performance, listen for the rhythm section's insistent groove propelled by Blakey's shuffle beat and the call and response written into the head (piano issues the call, horns respond in kind with an instrumental "Amen").

> **0:00** **Head, 1st A section:** Bobby Timmons plays the rolling gospel-blues melody against a stop-time "a-men" figure.

(continued)

Music Analysis *(continued)*

0:14 **Head, 2nd A section:** Horns trade roles with the pianist, playing the melody in unison while Timmons plays the answering figure.

0:29 **Head, B section:** Blakey brings up the volume and the rhythm section walks through the bridge, horns in unison.

0:43 **Head, last A section:** The volume lowers for a repeat of the 1st A section.

0:58 **Trumpet solo:** Blakey's **press roll** issues the signal to the band to raise the volume moving into Lee Morgan's gut-bucket blues solo. He showcases a variety of techniques in his solo—half-valve notes, lip slurs, flutter-tongue, and double-time ideas. He plays primarily blues ideas during A sections and double-time bebop ideas during B sections.

3:00 **Tenor saxophone solo:** Lee Morgan hangs over into the first couple bars of Golson's solo. Golson parrots the melody back to him, changing the last note to fit the chord. Golson continues with blues material and explores the full range of the horn with a great deal of double-time playing in his second chorus.

5:03 **Piano solo:** Timmons plays a solo in the gospel style.

7:00 **Bass solo:** Merritt plays eighth note lines in his solo, phrasing far behind the beat in straight eighth notes.

8:00 **Last Head:** Repeat of the opening.

8:56 **Closing Tag:** The band repeats the bridge with a crescendo, ending with Bobby Timmons's cadenza on a final gospel cadence.

"Misty." Blakey moved to the drums when Garner replaced him at the piano. In Blakey's early days of apprenticeship, he received instruction from the famous Savoy drummer Chick Webb, formed a band with Mary Lou Williams, and backed up Fletcher Henderson's Orchestra for several months.

Blakey Joins the Bebop Movement

In 1942, Blakey moved to New York where he joined Thelonious Monk's entourage with Bud Powell. Blakey played in Billy Eckstine's band with Bird, Diz, and Miles. After a trip to Africa in the late 1940s, he joined the ranks of several young musicians that converted to Islam around this time and took the name Abdullah Ibn Buhaina. His stay in Africa gave him first-hand knowledge of a polyrhythmic style of drumming, which he integrated into drum set solos and comping rhythms. Blakey took leadership of a short-lived big band, calling itself the Seventeen Messengers and recorded several pivotal bebop albums with Miles Davis, Thelonious Monk, and a host of other luminaries before the Jazz Messengers officially began at the Birdland club in 1954.

Hard Bop Dynasty

Blakey formed a quintet with Clifford Brown (trumpet), Lou Donaldson (alto saxophonist), **Horace Silver** (piano), and Curly Russell (bass). Horace Silver proposed to Blakey that they should form a partnership and they found Kenny Dorham (trumpet), Hank Mobley (tenor saxophone), and Doug Watkins (bass) to become the first line-up of Jazz Messengers. After just one successful, self-titled album, Horace Silver left the group to start

his own hard bop band. Although the loss of Silver's compositional talent left Blakey with a major weakness, he doubled down on Horace Silver's gospel-tinged piano style with his replacement Bobby Timmons. Timmons lent his gospel touch both on the piano and in his compositions, of which "Moanin'" became the band's standout hit. Blakey formed the band's repertoire from the compositions of talented writers who passed through his band—Benny Golson, Wayne Shorter, Cedar Walton, and a host of others.

Over the years Blakey's band went through numerous lineups of musicians, always infusing the Messengers with youthful energy. The band was at its peak from 1958 to 1964 with Lee Morgan or Freddie Hubbard on trumpet, Bobby Timmons or Cedar Walton on piano, Jymie Merritt or Reggie Workman on bass, and either Benny Golson, Hank Mobley, or Wayne Shorter on tenor saxophone. But in the decades that followed, new up-and-comers maintained the band's forceful energy and brought the influence of contemporary trends in jazz.

Key Members of the Jazz Messengers

Trumpet:
Kenny Dorham
Donald Byrd
Lee Morgan
Freddie Hubbard
Woody Shaw
Wynton Marsalis
Terence Blanchard

Trombone:
Curtis Fuller
Robin Eubanks
Steve Davis

Alto Saxophone:
Jackie McLean
Bobby Watson
Donald Harrison

Tenor Saxophone:
Hank Mobley
Benny Golson
Wayne Shorter
Billy Pierce
Branford Marsalis
Javon Jackson

Drums:
Art Blakey

Piano:
Horace Silver
Bobby Timmons
Cedar Walton
Keith Jarrett
James Williams
Mulgrew Miller
Benny Green
Geoffrey Keezer

Bass:
Jymie Merritt
Reggie Workman
Lonnie Plaxico

MILES DAVIS'S FIRST GREAT QUINTET

Miles Davis entered a new phase of his musical oeuvre in 1954 (the year of the first recordings by Brown-Roach and Blakey's Jazz Messengers) that foreshadowed his hard bop leanings. Even though his whispering trumpet sound was opposite the prototypical hard bop trumpet sound becoming prominent in the work of Clifford Brown, Kenny Dorham, and Lee Morgan, his recording of "Walkin'" from his album of the same name (1954) was a sharp turn from the cerebral chamber jazz exemplified in the *Birth of the Cool* sessions. Miles found a personal formula for artistry. He

Miles Davis First Great Quintet

- **Miles Davis**—trumpet
- **John Coltrane**—tenor saxophone
- **Red Garland**—piano
- **Paul Chambers**—bass
- **"Philly" Joe Jones**—drums

surrounded himself with musicians in his quintet and sextet sessions for Prestige that contrasted his persona. Sonny Rollins and John Coltrane as tenor saxophonists played the extrovert to Miles's detached and patient phrasing. Miles Davis's groups through the '50s and '60s would present a *yin and yang* of hard-core saxophonists and rhythm section players against Miles's introverted character. Adding to this updated hard bop approach, his small-group albums would also feature syrupy ballads, during which Miles sounded completely at home.

In 1957, Miles was in a position most jazz musicians would only dream of. With a few years left on a record contract with the Prestige label, he entered a new, more lucrative commitment with the powerhouse, Columbia records. His work for the labels went two different musical directions. In a hurry to finish the Prestige contract, Miles brought his quintet into the studio, threw together some quick arrangements of standards on the spot, and cranked out four albums' worth of excellent music. Jazz musicians today look at *Steamin'*, *Cookin'*, *Workin'*, and *Relaxin'* as textbook examples of small-group jazz. The no-frills arranging approach of simple introduction-unison head-solos-trading 8s-closing-head showcased the character of each soloist rather than any musical intricacies of a composer. Although Miles's approach to trumpet playing is far from being "hard," his First Great Quintet surrounded him with an energy that helped embolden the hard bop movement.

Miles's Renewed Partnership with Gil Evans

Not long after his Prestige marathon, Columbia supported Miles's collaborative vision with *Birth of the Cool* mastermind Gil Evans and produced a series of albums that set Miles in a more cerebral environment with big band instrumentation expanded with orchestral instruments. The Miles/Gil recordings are among the most musically creative works of his career, and somewhat of an enigma of jazz history. Evans's arrangements and instrumentation choices place the music in the **Third Stream** category, a genre described by Gunther Schuller as the combination of jazz and orchestral classical music. This is particularly true of *Sketches of Spain* (1959–1960), which opens with a Gil Evans reimagining of a Spanish orchestral work for classical guitar *Concierto de Aranjuez*. However, the projects can easily be construed as a continuation of the *Birth of the Cool* project, with *Miles Ahead* (1957) swinging along with modern voicings and Miles's mellow flugelhorn squarely in the lead. *Porgy and Bess* (1958) seemed to bridge the gap between cool and Third Stream, but truly, the Miles/Gil collaborations defy swift and easy categorization.

Looking Ahead

In 1958, Miles was in the midst of projects with Gil Evans and a European tour when he reformed a six-piece group and recorded an outstanding album in the hard bop style that also foreshadowed coming trends. *Milestones* reunited Davis with tenor saxophonist **John Coltrane**, whom Davis had fired in 1956 over his heroin addition. (Miles wanted to avoid temptation, himself a recovering heroin addict.) The cleaned-up Coltrane, fresh from a year of performing with Thelonious Monk, was pitted against a relatively new alto saxophonist on the scene. Many considered

Cannonball Adderley to be the successor to Charlie Parker's throne. The complementary relationship between the three-horn line-up is remarkable. Although Coltrane and Adderley had two very different musical approaches, they can be heard at times playing each other's material. Both men were among the top technicians on their instrument and Miles seems unfazed, moving more slowly in his solos and painting in broad strokes with long notes, careful pitch choice, and captivating **use of space**.

The rhythm section, carried over from the First Great Quintet, performed at its finest. Bassist Paul Chambers had incredible technique and tone quality on the instrument and was able to propel the fastest bebop tempos ("Dr. Jackyl"). His **bowed** solos elevated the string bass to the improvisational standing equal to any other melodic instrument in the band. Red Garland's light touch, catchy rhythmic kicks, and fluency with the jazz language offered a breath of fresh air between the intensity of the other soloists. "Philly" Joe Jones's solid time feel ignited a fire underneath every song on the recording. Jones's drum solos on *Milestones* and other albums from the period form the bedrock of modern jazz drumming along with the work of Max Roach, Art Blakey, and just a few others. The song "Milestones" looked forward with a chord progression based on **modes** rather than rapid successions of chords, a style that would come into fruition in Davis's 1959 album **Kind of Blue** (discussed at some length in Chapter 17). The band's work on the Thelonious Monk composition "Straight, No Chaser" demonstrates a mature hard bop sound.

> Paul Chambers was a master of **bowed** bass. Instead of plucking the strings with his fingers (*pizzicato*) he picked up a bow and drew it across the strings playing bebop melodic lines in his solos. The bow gave the instrument added volume.

HORACE SILVER QUINTET

After leaving Art Blakey by himself to lead the Jazz Messengers in 1956, **Horace Silver** formed a new quintet and managed to solidify and move the hard bop style forward. Silver is actually a controversial figure in terms of his reception among jazz connoisseurs. His right hand's sharp attack and left hand's busy comping rhythms have led informed listeners to describe him as being either "choppy" or "funky" (in fact, he is credited as an early inventor of funk). In his compositions, one might hear either brilliantly catchy, minimalistic blues and gospel motifs or a smattering of clichés masked by hip chord changes. His band's groove-based tunes heralded the **soul jazz** sub-genre of jazz, while noted critic Martin Williams compared his riffs to music of the Swing Era.

Silver grew up in Connecticut, his father of Portuguese descent from the African island of Cape Verde. Stan Getz hired Silver for some of his first professional jazz work, and as a sideman he backed luminaries of jazz history the likes of Charlie Parker, Lester Young, Howard McGhee, and Miles Davis (performing on his seminal hard bop venture *Walkin'*). A close look at his body of work as a bandleader from the mid-50s onward reveals a deep library of easy blues ("Doodlin'" and "Strollin'"), up-tempo Afro-Latin romps ("Nica's Dream" and "Nutville"), and a number of musical portraits with styles as diverse as gospel ("The Preacher"), six-eight African ("Senior Blues"), streamlined Brazilian bossa nova ("Song for My Father"), and jump blues ("Sister Sadie"). He also had an unmatched ability to write compositions with accessible melodies, colored by chord changes and formal structures interesting enough to engage some of the finest soloists in the period. Tenor

saxophonists Hank Mobley and Joe Henderson and trumpeters Kenny Dorham, Donald Byrd, Blue Mitchell, and Woody Shaw each had a highly personalized sound and was able to springboard from the Silver Quintet to esteemed careers as soloists.

SONNY ROLLINS

Sonny Rollins

Sonny Rollins thrived on solitude. One of the most iconic images in jazz is the lone tenor saxophonist standing on the walkway of the Williamsburg Bridge in New York in the middle of the night, practicing his craft. This was Rollins during a two-year hiatus from performing, escaping the chatter of jazz society in order to explore, to hone, and to recharge.

As mythical as this may sound, Rollins truly did some of his best work in the most lonesome of circumstances. He extended the **cadenza** (a passage of music in which the soloist plays without accompaniment of any kind) to become a freestanding form, playing entire solo pieces. Few instrumentalists in history have been able to create a meaningful statement for several minutes without the support of a band, but Rollins was at his best in this format. The backdrop of silence exposed his unmatched abilities for melodic development and variation. He could convey underlying chord changes without the assistance of a piano or guitar. He could create rhythmic momentum without an underlying pulse. His timbre—modeled after Coleman Hawkins—at times moved beyond brash to offensive, yet the saw-blade distortion added to the depth of his inventions instead of taking away from them.

Rollins brought the discoveries from his unaccompanied sessions into the band setting. Even in a small group he sometimes played without piano [*Way Out West* (1957)] or avoided the piano's dominance substituting a more understated guitar as the chordal instrument, as he did on his return album from his practice sessions on the bridge [*The Bridge* (1961)]. If the tightrope of sustained improvisation is what separates jazz from other forms of music, Sonny Rollins can be viewed as the ideal jazz musician. Although he composed several jazz standards—"Oleo," "Airegin," "Sonnymoon for Two," "St. Thomas"—the tunes themselves were only as distinguished as the masterful solo choruses that spun off of them. His choices of cover songs were peculiar ("I'm an Old Cowhand" from *Oklahoma!* and "Wagon Wheels" from *Ziegfeld Follies*) but again, he seems to have chosen them for the challenge of making something great out of an unremarkable tune. To this day he seems to relish in creating magic from banal materials. To those who follow Sonny Rollins, he is proof of the supremacy of improvisation over composed melody.

Rollins was born into a world of jazz in New York City, near the Savoy Ballroom and the Apollo Theater. His early models were Louis Jordan, Coleman Hawkins, and Charlie Parker. Like Art Blakey, Rollins was an apostle of Thelonious Monk, practicing with the eccentric genius. Since 1949 he had worked as a sideman for an incredible list of brilliant musicians including Monk, J. J. Johnson, Bud Powell, and Miles Davis. With

Music Analysis

"St. Thomas"
(1956)

Personnel: Sonny Rollins, tenor saxophone; Tommy Flanagan, piano; Doug Watkins, bass; Max Roach, drums

Rollins's most recognizable standard, "St. Thomas" showcases his tendency toward **thematic improvisation** against a simple melodic and chordal structure. Rollins adapted the melody from a Caribbean song called "Fire Down There" that he remembered his mother singing to him as a child.

0:00	**Introduction:** Max Roach plays a calypso beat between the snare drum and tom-toms, using rim clicks, cross-sticks, and other effects.
0:19	**Head:** Rollins plays the melody in staccato style, with separation between notes.
0:55	**Tenor saxophone solo:** Rollins sets up a motive of two notes, descending from the 5th to the 1st scale degree, then builds the first couple choruses of his solo by varying the idea.
2:28	**Drum solo:** Roach begins by playing the calypso groove from the introduction, then much like Rollins, plays various phrases on the drums that often return to the calypso groove as a motive.
3:54	**Tenor saxophone solo:** The rhythm section bursts into a swing feel in four-four time. Rollins plays a 2nd solo.
5:02	**Piano solo:** Tommy Flanagan takes a solo. Max Roach moves to the bell of a cymbal and continues his ride pattern in four-four.
6:09	**Head:** The band returns to the head, but remains in a swing feel.
6:27	**Head, repeat:** The band repeats the head over a calypso feel and ends on the last short note of the melody.

hard bop in vogue in 1956, Rollins erupted as an extremely prolific recording artist with a mature style. At least a couple of several recordings he made that year became jazz classics *Saxophone Colossus* and *Tenor Madness* (which squared him up against another tenor titan, John Coltrane). In 1955 and 1956, his work with the Clifford Brown-Max Roach quartet rejuvenated the seminal hard bop group (*At Basin Street*); his collaborations with the Modern Jazz Quartet in 1953 and 1958 were highlight recordings for the model cool jazz band. His recordings as a bandleader tracked the development of jazz trends, moving toward funk-jazz fusion in the 1970s and using contemporary electronic keyboard sounds in the 1980s. But throughout stylistic shifts, Rollins's personality and voice has consistently come through as the primary element. He has sustained this approach over a long career of over six decades. Most recently, in 2011 Rollins was bestowed a Kennedy Center Honor, the highest statement of recognition an artist can receive in the United States.

SOUL JAZZ

In the first Jazz Messengers recordings, we see the beginnings of a new sub-genre that became fully realized in the 1960s—**soul jazz**. Where hard bop often borrowed melodic gestures from blues and R & B and used more repetitive rhythm section figures than cool or bebop, soul jazz used both the melodic and rhythmic elements of soul music in far more of an explicit way. Soul jazz was a blend of bebop with the burgeoning black pop trend of *soul* (which, itself, was a blend of gospel and R & B). Horace Silver's "The

Preacher" is an early example. The upbeat blues-scale melody could easily have been pulled from the Ray Charles songbook, and Horace Silver's repetitive piano groove hints at the ostinatos that had become so prevalent in soul rhythm section parts.

Soul jazz scored some of the biggest commercial hits in all of jazz history. Lee Morgan's "The Sidewinder" (used on Chrysler television commercials at the time), Herbie Hancock's "Watermelon Man," and Cannonball Adderley's "Mercy, Mercy, Mercy" became big-sellers and introduced the legitimate jazz artists to a broad audience.

The **bass line** became as important as the melody in many soul jazz songs. Bassists composed ostinatos in the studio to complement the melody, and drummers constructed beats out of straight eighth-note patterns often called "**boogaloo**," instead of swing patterns. Melody was often relegated to simple "hooks," short statements designed to heighten the groove. The importance of the piano was also weakened in favor of

Dr. Lonnie Smith

the electric guitar and the organ, an instrument that had only been used in jazz as a novelty instrument up to that time by the likes of Count Basie and Fats Waller.

The **organ trio** became a prominent setting for soul jazz music. The Hammond B3 had a number of features that made it among the most versatile instruments, but also one of the most entertaining to watch in a live setting. Organs were primarily used in churches, attached to huge structures of pipes of varying sizes. The pipe organist was able to change the timbre of the instrument by pulling or pushing stops, knobs attached to specific pipes, to increase the air moving through a particular set of pipes and copy the sound of particular brass or woodwind instruments. Pipe organs also had two or three **manuals**, or keyboards, which could be set to play a different timbre on each one. Add to that a row of foot pedals at the bottom of the organ, and the player could sound like a one-man band. The Hammond company was a pioneer in electrifying the organ and replicating timbral changes without the use of pipes, making it a much more portable instrument. **Drawbars** replaced the more clumsy knobs, or "stops," on classical organs and sound emitted from **Leslie speakers**, large wooden boxes with oscillating fans inside that replicate a vibrato effect.

Components of the Hammond Organ

- Manual—the term for each of the two or three keyboards on the console.
- Pedalboard—the keyboard located at the player's feet. Capable of playing the role of a bassist.
- Drawbars—rows of bars that adjust the timbre of the instrument when pushed or pulled.
- Leslie speaker—amplifier and loudspeaker used most often for the Hammond organ. The speaker is capable of producing a tremolo sound effect through an oscillating mechanism inside its cabinet.

Jimmy Smith was the first organist associated with the soul jazz style. His organ trio changed the default instrumentation of a rhythm section by omitting the bassist. Smith played bass lines with his feet on the foot pedals while he comped chords with his left hand and played melody with his right! Smith's trios with a drummer and a guitarist established a new format of instrumentation in jazz, one that players like Jimmy McGriff, Shirley Scott, Larry Young, Joey DeFrancisco, Dr. Lonnie Smith, John Medeski, and Larry Goldings would use to continue the tradition of soul jazz and to invent new approaches to jazz altogether.

Music Analysis

"Back at the Chicken Shack"
(1960)
Personnel: Stanley Turrentine, tenor saxophone; Jimmy Smith, organ; Kenny Burrell, guitar; Donald Bailey, drums

Tenor saxophonist Stanley Turrentine is a guest artist with the Jimmy Smith trio on this classic blues tune. Listen for the various sounds Smith plays on the organ, playing bass lines, soloing, and comping chords. Donald Bailey plays a continuous shuffle rhythm on the drums with off-beat hi hat.

0:00	**Head:** Jimmy Smith plays the head the first time, followed by Turrentine. Kenny Burrell strums along subtly in the background.
0:53	**Organ solo:** Smith incorporates gospel and blues standard phrases in his solo.
3:35	**Guitar solo:** Kenny Burrell.
4:56	**Tenor saxophone solo:** Stanley Turrentine.
6:42	**Head:** The recording fades out while the band plays repeated heads.

WES MONTGOMERY

One of Jimmy Smith's regular partners in his organ trios, **Wes Montgomery** brought a fresh sound to the electric guitar around the time soul jazz was popular. Montgomery grew up in Indianapolis in a jazz household of musicians. His older brother, Monk, played bass and younger brother, Buddy, played piano and vibraphone. Wes taught himself to play guitar at twenty years old by practicing at night when he returned home from work. Apparently, his unique sound was born out of necessity when (in order to avoid his wife's complaints about the noise from his amplifier) he practiced without a plastic pick and plucked the strings with his thumb instead, often in the middle to low register of the instrument. The result was a mellow tone with a soft attack.

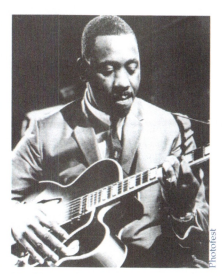

Wes Montgomery

Montgomery also moved between a variety of textures when he played. Besides the single-line bebop lines, he often doubled his melody at the octave (playing two same pitches in different registers) and mixed in fully voiced chords. He used a captivating catch-as-can rhythmic approach in his melodic solos, playing repeated off beats and accelerating to off beat triplets. Lionel Hampton was the first nationally known bandleader to recognize his talent, taking him

on tour in 1948. Montgomery soon returned to Indianapolis and formed a band with his brothers. On the recommendation of alto saxophonist Cannonball Adderley, Riverside records offered Montgomery a recording contract in 1959 and he moved to New York City.

Montgomery as a Recording Studio Artist

Montgomery dominated the jazz guitar community with a rich improvisational language and a personalized sound. His recordings for the Riverside company were hailed as guitar masterpieces and cast him in primarily small-group settings. When Riverside disbanded in 1964, Montgomery signed with Verve records (and later with A & M) and recorded a series of albums that attempted to diversify his music and achieve greater commercial appeal. Verve polished Montgomery's sound with pristine production and full orchestration including big bands and strings. He recorded current pop tunes in a manner clearly geared toward audiences that would not understand his mainstream jazz works (listen to "Tequila" and "California Dreamin'"). Albums like *Smokin' at the Half Note* (1965), which featured first-rate improvisation and small-group intimacy, gradually gave way to a commercialized approach. A & M records took the pop-jazz approach even further with studio orchestra arrangements of Beatles and Simon & Garfunkel songs. Although Don Sebesky's arrangements add a strong measure of creative orchestration, Montgomery was being presented more or less as a melodist, someone who could phrase a melody in colorful double-octaves but who didn't challenge his listeners with extended solos of his earlier period. Still, Montgomery's impact on jazz improvisation was considerable. His influence can be heard in the work of many jazz guitarist greats who followed, particularly George Benson and Pat Metheny. Montgomery did not live long enough to change the course of his recording career or to revel in the far reaches of his influence. He died in 1968 of a heart attack at just forty-three years old.

Music Analysis

"West Coast Blues"
(1960)
Personnel: Wes Montgomery, guitar; Tommy Flanagan, piano; Percy Heath, bass; Albert Heath, drums

Montgomery's composition has a modified blues form. Beyond its unexpected chord substitutions, the song is written in a meter with three beats per measure (instead of four).

- **0:00** **Head:**
- **0:28** **Head, repeat:**
- **0:57** **Guitar solo:** Montgomery structures his solo using a formula he commonly uses, beginning with single lines and changes to playing octaves several choruses later (2:48), then changes again to playing full chords (4:12).
- **5:09** **Piano solo:** Tommy Flanagan.
- **6:33** **Head:**
- **7:02** **Outro:** The band plays a pre-composed ending tag, coming to rest on a sustained color chord, a major #11 chord.

CONCLUSION

Music developed at an extremely fast rate after World War II. A look at the genres of bebop, cool jazz, hard bop, and soul jazz reveals a restless creative spirit in America's jazz community. To call any artist purely a "hard bop" artist or a "cool jazz" artist is to pigeon hole them. Mainstream jazz (which hard bop helped to establish) represented a mixture of multiple approaches. Art Blakey, Horace Silver, Miles Davis, Max Roach, and Clifford Brown made musical decisions in 1954 and '55 that resulted in a turn away from cool jazz. Hard bop represented an emphasis on the blues and a foreshadowing of the integration of black popular musical styles into the music. Soul jazz incorporated new R & B without watering down the creative fire of the bebop language in the best of cases. Even when R & B-influenced rhythmic grooves found their way onto recordings, they did so with a reverence to a kind of swinging, forward moving feel. Soul jazz was still jazz. Artists like Sonny Rollins, John Coltrane, Miles Davis, and Wes Montgomery included a variety of musical styles on their mainstream jazz recordings, essentially growing from the approach of hard bop but with varying amounts of experimentation. When we return to jazz in Chapter 17, we will examine a number of these approaches to experimentation and ultimately, with Ornette Coleman, a rebellion against any kind of conventionality in the music.

Discussion Questions

1. Describe the contrast between cool jazz and hard bop. Describe the differences between hard bop and soul jazz.

2. What role did drummers play in the new styles of hard bop and soul jazz?

3. Miles Davis covered a dizzying array of musical styles in the 1950s. What did he contribute to the hard bop style?

4. What musical aspects make Sonny Rollins such an important figure in jazz?

5. What is unique about an organ trio?

PART VI

The Sixties (1959–1969)

The Blues are Back

THE SHIFTING AUDIENCE OF THE BLUES

American culture in the 1960s was dominated by civil rights struggles. Largely due to the activism of African American community leaders like Dr. Martin Luther King Jr., African Americans fought to end practices of segregation, particularly in the South. Several events of non-violent protest—some by only a single individual—successfully drew the attention of the American public to the injustices African Americans dealt with on a daily basis. Rosa Parks's refusal to give up her bus seat to white patrons led to a substantial boycott of the bus system by blacks in Montgomery, Alabama. In North Carolina, four black students began a series of lunch counter sit-ins at Woolworth's store, leading to a series of sit-ins at other sites that involved hundreds of young people, including whites. These and other events built momentum toward a march on Washington, D.C., on August 28, 1963, where more than 200,000 Americans witnessed Dr. King's famous "I Have a Dream" speech. The successful protests led to the passage of Civil Rights Acts in 1964 and 1968, bringing to a close much of the inequity between blacks and whites in society.

Soul

During this time, the blues audience shifted toward **soul**, a new style of music that better matched the inspired mindset and narrative of the Civil Rights Era, of a black society that hoped to put the Jim Crow South in the past. For many, blues music was too strong a reminder of the depression they had lived through. New times called for a new music with a new energy. In soul, there was an optimism and a resilience that the blues lacked. Soul music grew from a mixture of R & B and upbeat gospel music. Ray Charles's song "What'd I Say" is one of the songs that announced the arrival of soul in 1959 (and his "I Got a Woman" set the stage a few years earlier). "What'd I Say" featured Charles's fervent vocals backed by call-and-response background singers and horns, and a hyperactive rhythm section groove punctuated by stoptime. At its most basic level, the song was just a souped-up 12-bar blues. Soon Berry Gordy Jr. built Motown records in Detroit and singers like Stevie Wonder, Smokey Robinson, the Temptations, the Supremes, and later Marvin Gaye made the music that would become the soundtrack of the '60s generation.

The blues were essentially neglected by the African American community during this time. But new audiences were being created among an unlikely demographic. Young white music enthusiasts in both the United States and England were finding the blues and incorporating it into their lives in different ways.

THE 1960s FOLK REVIVAL

From the late 1950s to the '60s, a change in musical tastes was taking place that reflected a broader change in aesthetics of American society. The early rock music that held on to the grit of the blues was replaced in the late 1950s and early '60s by smooth sounds that traded musical depth for slick production, and the young black audience had moved away from the blues toward doo-wop rhythm & blues acts like the Platters, the Coasters, and James Brown's first R & B cuts along with the rising soul sound of Ray Charles. But a growing number of listeners believed pop music had become too polished and pristine, emphasizing the teeny bopper image over creative grit. The new audience wanted authenticity, realism in music. This audience was full of people too young to have experienced the age described in blues and folk songs, but regardless, they were ready to romanticize and appreciate it for the "realness" it might bring to the present day. This search for authenticity was also brought on by an ideological youth revolt. Young people in the 1960s had not lived through a Depression or a World War, and so, with fewer reasons to join in with patriotism in support of mainstream nationalist values they questioned the older generations. These baby boomers—born in the years after WWII—were old enough to attend colleges and universities in the 1960s. And it was in American colleges and universities that the folk revival took hold.

At this time the function of the blues seems to have shifted, or expanded. From its birth to the 1950s, the blues was primarily a *folk* music style, created by southern blacks for the leisure and enlightenment of other southern blacks (and those who had moved to urban centers). It had also become a *popular* music style at times (Bessie Smith, Muddy Waters). But now more than ever the blues took on political and societal implications. The civil rights movement was underway, and a generation of white Americans was exploring the black culture from which it had long been segregated. The blues told the story of the people who were still being oppressed in various realms of society, and counterculture revivalists positioned the blues against mainstream culture much in the same way the blues lyrics challenged the establishment in the first half of the 20th century.

The Blues as Folk Art

In addition to its role as a political tool, the blues was increasingly seen as a form of *art* music at this time. Its new audience listened intently to the blues with respect for its artistry, much like fans of European classical music. This was supported by a rise in ethnomusicology, the study of the music of a particular ethnic or regional group. John Lomax had already contributed to our understanding of our roots through his trips into the South to record folk music. His son Alan continued the work with publications, radio and television shows, and his outspoken admiration for the early bluesmen. Harry Everett Smith, an avid record collector and avant-garde

filmmaker, compiled an influential album of his best country, folk, and blues recordings for Folkways Records. Released in 1952 on six discs, the *Anthology of American Folk Music* included performances by Mississippi John Hurt, Charley Patton, Furry Lewis, the Memphis Jug Band, and Blind Lemon Jefferson, inspiring a class of young folk guitarists and listeners around New York's Greenwich Village. Samuel Charters encouraged a flurry of interest in blues research with his 1959 book *The Country Blues*, and aficionados and businessmen went on scavenger hunts to unearth the humble bluesmen of the first recorded blues. Accompanying Charters's book was a compilation recording that gave the 1950s generation its first chance to hear Robert Johnson's "Preaching Blues," along with recordings by Blind Lemon Jefferson, Lonnie Johnson, and Bukka White. Old acoustic blues became fashionable, particularly among the counterculture youth who hung out in New York City's **Greenwich Village**. White college students gathered in coffee shops to watch Lead Belly and Big Bill Broonzy play. Pete Seeger's folk group, The Weavers, recorded a hit with Lead Belly's "Goodnight Irene," and their fans were excited to hear the originator's version. Researchers tracked down Booker "Bukka" White, Mississippi John Hurt, Skip James, Son House, and other country blues artists, particularly from the Mississippi Delta, and revitalized their careers. Alan Lomax discovered an important contributor to the blues revival in a Mississippi field in 1959 by the name of Fred McDowell.

One outgrowth of the revival was the **Newport Folk Festival**. **George Wein** had run a jazz festival every year since 1954 in Newport, Rhode Island, that featured the top names in jazz. Newport quickly became the place each year where new musical changes were showcased. Several of the most important turning points in jazz took place at Newport (a triumphant return of Duke Ellington in 1956, almost yearly performances by Miles Davis, the integration of funk, rock, and pop into the jazz festival format). Muddy Waters electrified a young crowd at Newport Jazz in 1960 with "Got My Mojo Workin'." In 1959 Wein founded a companion folk festival that highlighted the changes in the growing folk culture. At the 1963 festival Bob Dylan debuted; at the 1965 festival he broke a taboo among the traditional folk community by "plugging in" with an amplified band. At the '64 festival, Skip James made an unscheduled appearance at a daytime "workshop" where an audience of nearly 70,000 witnessed his return.

CROSS-INTEGRATION OF THE BLUES

While civil rights and the folk revival were reshaping American culture, the blues was going through a transition that resulted in greater diversity. Changes in music during the 1960s mirrored changes that were happening in American society. While marginalized groups fought for equal rights and integration, various trends took place in music that led to integration of styles. For decades, blues had been repackaged to create new musical genres—especially rock and country music. Country blues had evolved by incorporating technological advances (electric instruments) and by adding instruments to create a band-focused sound, rather than the performance of one primary singer/player. Now in the 1960s, the primary innovations came from outside of the blues. Blues musicians would increasingly incorporate the sounds of jazz, rock, and soul styles it had originally helped to

create. In the '60s, the blues completely crossed a racial divide. Black blues musicians found a new audience of primarily white folk music enthusiasts, while white musicians like Paul Butterfield found success and acceptance in the black blues world. Additionally, British rock bands paid tribute to American blues artists in the media while a new wave of blues infusion took place among the American psychedelic rock scene. These changes marked a cross-integration of black and white artists into genres that were traditionally segregated forms, illustrating an American society that was gradually shaking up long-held conventions that guarded against cultural and ethnic integration.

Many of these changes were signaled in the early hits of perhaps the all-time most recognizable icon of the blues—B. B. King. King found success with a new sound that incorporated jazz, jump blues, and gospel, and a stage persona that made his audience feel like they were an integral part of the party. His 1964 album *Live at the Regal* documented a culmination of these aspects of his music, and set forth a model for contemporary blues. He eventually found a loyal fan base in young white Americans. B. B.'s blues was not only a new and fresh sound, it was a testament to the legacy of blues. His background was steeped in tradition, growing up in the heart of the Mississippi Delta and making his career in a city steeped in its own blues history—Memphis, Tennessee.

MEMPHIS AND BEALE STREET

Memphis is located just north of the Mississippi Delta region. Not only has it served as a corridor to the rich musical centers of Chicago and Detroit, it has a musical culture of its own. Even before Charley Patton recorded "Pony Blues," Frank Stokes tried his hand at recording blues music in Memphis. His music may have even influenced W. C. Handy's first blues composition "Memphis Blues." In the 1920s and '30s a blues tradition was established along Beale Street, an area famous for live music. Among the countless musicians to make their mark on Beale Street and in recordings were Furry Lewis, Sleepy John Estes, and the especially remarkable **Memphis Minnie**.

In the male-dominated world of country blues, Memphis Minnie more than held her own. She was well respected by her peers, reportedly outplaying Big Bill Broonzy in a jam session. She recorded more than one hundred tracks in her career, many of them her own compositions. "Bumble Bee" and "Hoodoo Lady" are now standard songs of the blues songbook.

The city of Memphis supported a wide range of musical styles as early as the 1800s. Black and white orchestras performed in ballrooms and concert halls. The Swedish superstar Jenny Lind performed before an audience of 1,000, one eighth of the population of Memphis. Vaudeville and burlesque shows provided low-brow entertainment, an opera house was built on Main and Beale Street to support the high-brow, and European music enthusiasts celebrated Mozart, Mendelssohn, Wagner, and Beethoven in organized societies. Bessie Smith and Ma Rainey performed blues in Memphis's theaters, and W. C. Handy composed his famous songs and conducted his orchestra at events around Memphis. All of these cultural enrichments were borrowed musical forms from other regions, but Memphis had indigenous music, too.

One style of music native to Memphis streets was made by **jug bands**, groups that harkened back to the African practice of making music on homemade instruments. The jug band got its name from the low "hoot" of a large jug that could produce hollow bass sounds, playing the role of a tuba. The performer would blow across the opening of the jug to produce sound. In addition, these bands featured other simple instruments like kazoos, harmonicas, and often a chordal stringed instrument such as a guitar, banjo, or mandolin. Gus Cannon and Noah Lewis were leaders of a scene that included six prevalent jug bands that worked the Beale Street area. Noah Lewis astonished his audiences by playing two harmonicas at the same time, blowing one of them with his nose! The popularity of the jug bands waned around the 1940s, but jug bands can be found springing up to this day in cities across the nation.

Perhaps Memphis's most important contribution to American popular music was its role as a hub and a training ground for talent that eventually found its way to the national stage. Beale Street venues created a demand for live music that the city of Memphis still celebrates today. **Sam Phillips** was responsible for creating several national stars through his Memphis Recording Service and later his record label, Sun Records. It was at Phillips's studio that Howlin' Wolf recorded "Moaning at Midnight," catapulting him to worldwide notoriety in blues and R & B. Ike Turner and his Kings of Rhythm recorded their distorted guitar and incessant beat in "Rocket 88," some say the first rock and roll song. Most famously, Phillips's studio was the site where Elvis Presley launched his career in rock and roll with his recording of Arthur Crudup's song "That's All Right." Johnny Cash and Jerry Lee Lewis were on the Sun Records roster as well. Phillips distributed some of these recordings under his own label. Others were sold to more established big-city labels like Chess and Modern. One of these pass-through artists would go on to have the longest-running career in the blues, a man at the top rung of blues royalty—B. B. King.

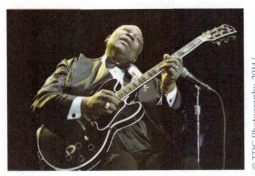

B. B. King

© TDC Photography, 2014/ Shutterstock, Inc.

Riley "B. B." King

In a career that has spanned more than seven decades, **Riley "B. B." King** has positioned himself as the most steadfast messenger of the blues. He is an eclectic artist who, instead of retreading his Delta roots, incorporates influences from other musical styles. B. B. was inspired by Texas bluesman T-Bone Walker, but he also reached into the vernacular of jazz—particularly guitarists Charlie Christian and Django Reinhardt—and the broader scope of rhythm and blues. In the 1960s his versatility enabled him to reach beyond the regular blues audience and deliver the sound of the blues to a diverse demographic.

B. B. King's Characteristics:
- Guitar style—single-line lead guitar
- Humorous, engaging lyric delivery
- Accompanied by horns instead of slide guitar or harmonica

King laid the foundation for such versatility in his childhood listening tirelessly to records growing up in the central Mississippi Delta. He

was inspired early on by Texas blues musician Blind Lemon Jefferson and Lonnie Johnson, a guitarist who also recorded with Louis Armstrong and Duke Ellington (listen to Armstrong's "Savoy Blues"). And in addition to the regular cast of Delta blues guitarists, King was exposed to Duke Ellington's and Benny Goodman's jazz, Bessie Smith and Ma Rainey's classic blues, and Jimmie Rodgers, one of the founders of country music. He once snuck into a live performance of the Count Basie Orchestra in Indianola, Mississippi, captivated by guitarist Freddie Green, tenor saxophonist Lester Young, and singer Jimmy Rushing. He was inspired by the current popular music of Nat Cole and jump swing star Louis Jordan. King's second cousin, **Booker "Bukka" White**, was an important Delta guitarist who had written and recorded a blues standard "Shake 'Em On Down," so King was introduced first hand to the professional blues life during White's visits to their home.

Another Tough Life in the Delta

At age fourteen, King witnessed an atrocity that would shape his character. He had already lost his mother and grandmother, and lived nearly a decade alone in his grandmother's house. His father had moved him to Lexington where, walking through the courthouse square on a Saturday afternoon, he saw the corpse of a black man hanging from a platform. The gruesome sight of the lynching frightened King away from his father's home and he entered a life of hard farm work in the Delta.

The blues always had a strong connection to religious music, even when the church decried the evils of the guitar and the loose-living encouraged by its lyrics. The cadence of a preacher can be heard in the hollering of Son House and Charley Patton, and even the formative musical experiences of John Lee Hooker's childhood revolved around the church. B. B. King is no exception. Early in his life he felt a calling to minister through music, and in his teens he joined the Famous St. John Gospel Singers, a fine group who were well-received at church performances and on radio broadcasts.

The Road to Memphis

In 1946, King made his way to Memphis with the plan to become a successful musician. Even though Bukka White found him a job, bought him a guitar, and let him stay at his home, King's first trip to Memphis was unsuccessful. He returned to Indianola for more farm work and gospel singing until, in 1948, he made a move to West Memphis, Arkansas. Here, he connected with **Sonny Boy Williamson II (Rice Miller)**, who gave him the opportunity to sing a song on his radio show. This awakened King to the power of radio. His next move landed him in downtown Memphis again, walking with his guitar through the pouring rain to radio station WDIA. He passed an audition to advertise Pepticon tonic on a daily broadcast. On his show he played records of boogie woogie piano, Texas blues of T-Bone Walker and Lowell Fulson, along with plenty of Louis Jordan's jump swing music.

Along with his steadily developing career as a disc jockey, he worked the Memphis scene and performed at the weekly amateur contests at the Palace Theater on Beale Street. Riley King became known as the "Beale Street Blues Boy," shortened to "Blues Boy" and then "B. B. King." He

caught the attention of Ike Turner, who was acting as a talent scout for the Bihari's Modern Records at this point. Ike brought B. B. into Sam Phillips's studio to record for the company. Not long after this first session he recorded "Three O'Clock Blues" which became a number one hit on the R & B charts. B. B. King shows the influence of T-Bone Walker and Robert Lockwood on the slow and sleepy blues with his opening single-line guitar melody. This song and his follow up "You Know I Love You" feature his silky voice backed by a small horn section, simple drums, and Ike Turner on piano. But the real magic of "Three O'Clock Blues" is in the duet between B. B.'s voice and his guitar solo lines. His singing is confident, sung in the upper register and full of cascading **melisma** (multiple pitches sung on one syllable). He comments on the lyrics with a brief vocal aside, "that's where the mens hang out," drawing the listener's attention to the story and linking him to the Delta's style of dialogue often heard in Robert Johnson's songs. B. B.'s guitar sound is strong and soulful, fuller than Lowell Fulson's original version of the tune. He tiptoes over the pulse with his out-of-time solo licks, a trait that would become textbook B. B. King. Interestingly, Robert Lockwood would say of his student B. B. that, in their lessons, he had a hard time fixing King's sense of time. Throughout the 1950s B. B. demonstrated his versatility with dance hits, tear-jerking slow blues, and a doo-wop number "On My Word of Honor." He toured constantly, buying a tour bus in 1955 and playing almost every night in a new location.

At a performance in Arkansas, King risked his life in an incident that gave his famous Gibson guitar its name. Two men in the audience knocked over a kerosene heater in a fight over a woman. The heater set fire to the venue and everyone fled the room. But when King realized he had left his guitar inside, he rushed in and saved it from becoming kindling. To remind himself to never again risk his life for a musical instrument, King named the guitar after the woman who had been the object of the fight—"Lucille."

Surviving the 1960s

In the 1960s, King joined ABC-Paramount records. The '60s were a turning point for the music industry. Where singles had been the highest-selling format of the '50s, the 1960s listener bought long-play albums. Blues and R & B had lost prominence in the industry when rock and roll took the spotlight. ABC took an approach with their new artist that might have given his fan base a case of whip-lash by following trends to repackage B. B. with rock, Latin, and gospel-sounding tracks. But in 1964, the company put together a setting for B. B. that would shape the remainder of his career, a return to blues-based music on the live stage. His recording *Live at the Regal* documents King at the peak of his abilities with top-notch playing and singing, and well-timed banter in front of the Chicago audience. The album is a succession of blues after blues after soulful blues, bringing B. B. back to his roots. At the same time his band sounded contemporary and fresh.

The album codified a couple of traits that were becoming part of the B. B. King brand. The high-energy band was outfitted with a horn section that played swing figures and sometimes stepped into the spotlight to solo. In his band, the horns took on the role the harmonica had held in music that grew from the West Memphis and Chicago traditions.

B. B.'s lyrics were romantic and humorous. This marked a new phase in the progression of blues lyrics. Blues lyrics progressed from the

downtrodden feeling linked to the woes of sharecropping and poverty ("High Water Everywhere," "Hard Time Killin' Floor Blues"), to the more romantic love-lost ("Love in Vain") and devil-conjuring travel songs ("Hellhound on my Trail") of Robert Johnson, to the macho songs about sexual prowess and blessed birth ("Hoochie Coochie Man") of Muddy Waters and Howlin' Wolf. B. B. King was more likely to take his audience through a series of stories that explore the ups ("Sweet Little Angel") and downs ("How Blue Can You Get") of romantic relationships, often advising couples in the audience with a preacher's voice, and bringing in an element of comedy at well-timed moments. B. B.'s comedy-tinged romantic blues spoke to what was relevant in his listeners' lives, and blues musicians of future decades used the same formula to connect with their audiences. The songs on *Live at the Regal* became mainstays in his repertoire for the next few decades as he continued to tour constantly and record albums at various live venues.

But King still played to an almost completely black audience. To satisfy his record label and his own aspirations, he wished to reach a universal audience. Within a few years of his *Regal* release, the tastes of the diverse public began to shift toward music felt was more authentic than run-of-the-mill pop rock. On February 26, 1967, King had what he called a "breakthrough." At the suggestion of Mike Bloomfield, a Jewish guitarist for the popular Paul Butterfield Blues Band, B. B. was booked at the **Fillmore Ballroom** in San Francisco, playing to an audience of young hippies (including popular musicians Carlos Santana and Steve Miller). This was the beginning of B. B.'s transition from playing only black clubs to playing theaters and even stadiums filled with the diverse audience he had hoped for. His career was taking off, and he was spreading the message of the blues outside the black community. The word was spread about King's exciting live performances and he began to be programmed on bills paired with white rock bands for white rock crowds. He was celebrated in these settings. The success of King's rock hall concerts led concert promoter Bill Graham to pair rock bands with other blues artists such as Muddy Waters, Howlin' Wolf, Albert King, and James Cotton.

King's Contemporary Blues

King began incorporating soul and funk sounds into his late '60s and '70s recordings, leading to the top-seller of his career "The Thrill is Gone." On "Thrill" King incorporates a soul drum and bass groove along with the new timbre of the electric piano in a way that modernizes his sound without losing his identity. From the 1970s until today he has found himself in the top echelon of pop icons, collaborating with rock band U2 and Eric Clapton, performing for large crowds and helping to expand the blues to a worldwide scale. In the 1980s he won Grammy awards for his albums *There Must Be a Better World Somewhere*, *Blues 'n Jazz*, and *My Guitar Sings the Blues*. He has won a total of 17 Grammys over the course of his career, including a Lifetime Achievement award and a Hall of Fame award for his performance of "The Thrill is Gone." He has performed in China, Brazil, Australia, Spain, the Soviet Union, the White House, and the Vatican, and has recorded albums at Cook County Jail and San Quentin.

No other blues artist has put together the kind of career B. B. King has enjoyed. And though he worked extremely hard to achieve such heights, he has been fortunate that the public tastes have either followed or shifted in

Music Analysis

B. B. King, "It's My Own Fault"
(1965)
Personnel: B. B. King, vocal/guitar; Duke Jethro, piano; Leo Lauchie, bass; Sonny Freeman, drums; Johnny Board, tenor saxophone; Bobby Forte, tenor saxophone; Ken Sands, trumpet; Henry Boozier, trumpet; Pluma Davis, Trombone

Live at the Regal was a pivotal album that charted a new course for B. B. King's music. It showcased King's ability to connect with a live audience with his expressive singing and playful vocal asides. The album highlights the talents of his backing band and walks the live audience through a variety of blues settings. This track is one of the album's standard blues songs, a guilty blues. B. B. uses a full arsenal of vocal sounds to express the blues—falsetto, gospel melisma, full-voiced holler, and guttural growl. He plays his guitar in a conversational style, teasing the audience at times with his use of space and playing full and loud at other times. The pianist seems to lead the harmony forward with a variety of accompanimental textures and passing chords. The rest of the band rises and falls with B. B. King's energy level.

0:00	**Introduction:** the track begins in segue from the previous tune. B. B. is finishing a story about a guy who "loses his girl" and plays a melody "like this." Then he plays a lead-in solo on his guitar that avoids the pulse of the song and moves up and down in volume.
0:17	**Verse 1:** the bassist plays staccato notes, the drummer plays a quiet hi-hat and cross stick groove, and the pianist rolls chords.
0:35:	Tenor saxophone answers B. B. King's phrases intermittently, playing a role more often held by harmonica or lead guitar.
0:59	**Verse 2:** B. B. introduces the verse about money saying "This is the part I like!"
1:40	**Verse 3:** The backing band has built the volume and energy to a breaking point, foreshadowing the guitar solo.
2:20	**Guitar Solo:** B. B. plays a variety of blues phrases, but all of them return to the tonic (a C#) as a kind of home base for the solo.
2:48:	The band builds in volume to climax at the beginning of the next chorus, a segue into the next song. They modulate the key up a half step to D.

his favor. His ability to adapt his sound to various stylistic settings has been a great asset. B. B. King's significance is that he elevated the blues into the general sphere while maintaining its emotional content and its musical character. B. B.'s "pop blues" is not a watered-down blues, it is a modernized form translated into the language of generations and ethnicities that had no connection to the Delta. He has incorporated the often jubilant sounds of Texas and Memphis blues sounds into his Delta roots along with jazz, soul, and boogie. He has played the chameleon without losing his integrity.

CHICAGO'S WEST SIDE SOUND

Chicago was one of few cities where the black audience did not neglect the blues in the 1960s. Instead the Chicago blues continued to evolve with a group of musicians who developed the so-called "West Side Sound." Otis Rush, Magic Sam, Jimmy Dawkins, Albert King, Buddy Guy, and others built on the electric blues tradition formed by southern singers Muddy Waters and Howlin' Wolf, and incorporated the modern blues of B. B. King and other styles of black music. The style moved further toward electricity and rocking sounds, with electric bass replacing the acoustic bass and with

Music Analysis

Albert King, "Born Under a Bad Sign"
(1967)

Personnel: Albert King, vocals/guitar; Donald "Duck" Dunn, bass; Booker T. Jones, organ/piano; Al Jackson, Jr., drums; Steve Cropper, rhythm guitar; Isaac Hayes, piano; Wayne Jackson, trumpet; Andrew Love, tenor saxophone; Joe Arnold, baritone saxophone, flute

This West Side Chicago cut is a staple of not just 1960s blues but also classic rock, recorded later by the rock group *Cream*, Paul Butterfield, Jimi Hendrix, Etta James, and several others. The song does not follow the typical 12-bar blues form, rather it is driven by its bass line. The song features Albert King's husky voice and teeth-grinding guitar solos. King produced a unique sound on the guitar. Unlike most left-handed guitarists who set up their strings reversed from right-handed guitars (with the thickest, lowest string on top), King's guitar was simply flipped over so that the highest strings were on top. He tended to use minor keys and scales, which may have led rock guitarists like Jimi Hendrix to gravitate toward him more naturally than the major scales of most bluesmen. The talented group Booker T. and the MG's along with the Memphis horns accompany King on the album with a powerful groove that draws from the soul music of the day.

0:00	**Introduction:** Guitar, electric bass, and horns begin the song's eighth-note riff in unison.
0:08	**Chorus:** Horns lay out while Albert King introduces the title of the song. Piano locks in with the drums playing strong straight eighth notes. Horns enter with the bass for the second half.
0:28	**Verse 1:** Guitar answers every melody statement.
0:38:	Chorus
1:00	**Verse 2:** Piano simplifies, playing straight quarter notes.
1:10:	Chorus
1:30:	Guitar solo with background figures played in the horns.
1:41:	King sings the last part of the chorus, repeated.
1:48:	The band drops out briefly while drums fill in.
1:58:	Verse 3
2:08:	Chorus
2:30	**Out chorus:** King improvises during a fade out along with rolled chords in the piano and organ and background horns.

a louder and more distorted guitar sound. Many West Side groups replaced the harmonica with a saxophone or a small horn section, and West Side groups were among the first to incorporate rock and soul rhythmic grooves, expanding the swinging rhythms of country blues. New rhythmic styles and instrumental colors gave blues artists more choices and resulted in more diverse set lists and track listings. **Magic Sam's** *West Side Soul*, **Albert King's** *Born Under a Bad Sign*, and **Otis Rush's** *Mourning in the Morning* are standout recordings in the West Side style.

Buddy Guy

Of all the musicians who developed the West Side Chicago sound, **Buddy Guy** has most successfully managed to bring the style to a widespread audience. His career has taken him from traditional blues into rock and roll and popular music, and has spanned from the 1960s into the 21st century.

Guy hailed from a Louisiana share-cropping family and, upon recommendation from Otis Rush, he began working the Chicago club scene as soon as he arrived.

Buddy Guy

During his first couple of years in Chicago, he defeated Rush and Magic Sam in a blues battle and was offered the chance to record for Artistic records. Muddy Waters took Guy under his wing, and soon Guy was appearing on Chess recordings accompanying Waters, Willie Dixon, Koko Taylor, and the like. He also made blues recordings as a leader ("Stone Crazy" was a #12 R & B hit) and partnered with harmonica player **Junior Wells** on albums that particularly influenced the budding group of white blues fans and musicians. Junior Wells's *Hoodoo Man Blues* is a classic recording that recreated the sound of the band's live shows at Theresa's blues bar. The album features Junior Wells at his singing and harmonica-playing peak and captures Buddy Guy's tasty style of accompaniment. Guy's work with Wells and the groups he led himself (heard on *A Man and the Blues*) solidified his stance as an original voice of contemporary blues.

Buddy Guy's improvisational style was full of surprises on these first recordings. He often exaggerated typical blues gestures like over-bending a blue note or repeating a standard blues melodic phrase faster and for a longer time than blues listeners had come to expect from more conventional guitarists. He was known for covering a lot of stylistic ground in live shows, sometimes impersonating Howlin' Wolf, performing stunts like playing the guitar behind his back, and then settling into slow blues. Guy's work was particularly influential to Eric Clapton, who originally sought to model the band Cream after the sound of Guy's band.

Now one of the elder statesmen of the blues, Guy continues to perform and record albums that garner critical praise. His Grammy-winning albums demonstrate the range of his mastery. *Damn Right, I've Got the Blues* was among the finest heavy-hitting electric blues albums of the early 1990s. His song "Rememberin' Stevie" paid his respects to Stevie Ray Vaughan soon after his death with a guitar solo that evoked the sound and spirit of the guitar dynamo. Guy went the opposite direction in 2003 with his traditional blues album *Blues Singer*, singing classics like Skip James's "Hard Time Killing Floor" and John Lee Hooker's "Sally Mae."

THE PAUL BUTTERFIELD BLUES BAND

Since its earliest days, the blues was performed almost completely by African American groups. But the 1960s were an era of wholesale racial change in America, and all areas of society—music, politics, and education—were primed for integration. One of the first significant examples of integration in the blues occurred in Chicago, when a young white harmonica player emerged as the leader of a bonafide multi-racial blues band.

Paul Butterfield grew up emulating the great Chicago harmonica players, particularly Little Walter. In his teens he sat in with Howlin' Wolf, Magic Sam, and Otis Rush in Chicago clubs, and was able to win over the predominantly black clubs with his skill and his reverence for harmonica tradition. Butterfield formed a group with a mixture of white and black musicians. Bassist Jerome Arnold and drummer Sam Lay were alumni of Howlin' Wolf's band. His white musicians were enthusiastic disciples of the blues—guitarists Elvin Bishop and **Mike Bloomfield**, and keyboardist Mark Naftalin. Bloomfield had developed a particularly deep understanding for the blues by forming friendships with Muddy Waters, Otis Spann, and Big Joe Williams, and sitting in with Howlin' Wolf at a West Side club.

Blues Offshoots

The Paul Butterfield Blues Band released their debut album in 1965 and received a great deal of attention in both the blues and rock genres. At the Newport Folk Festival in 1965, the band's performance marked a turning point in the changing aesthetic of the blues. At a workshop titled "Blues: Origins and Offshoots," Butterfield was scheduled to follow Son House who had recently been rediscovered and was making a triumphant return in front of Newport's discerning audience. Son House's acoustic blues clearly fulfilled the *origin* part of the program, while Butterfield's integrated electric band was supposed to represent the *offshoots*. The audience of thousands would have included a variety of perspectives on folk (and blues) music. Purists believed folk music must be played on acoustic instruments and should stay close to its roots. More adventurous listeners were open to hear how bands like Butterfield's framed the folk blues with a fresh electric sound that paid homage to Chicago blues roots. After Son House's inspiring solo performance, Alan Lomax (one of the directors of the festival) gave a sour introduction for Butterfield's band, complaining that the youngsters used too much equipment to play the blues convincingly and saying "Let's find out if these guys can play at all." While Butterfield began to play, Albert Grossman, the band's manager (and Bob Dylan's), began an argument with Lomax for his insulting intro. As the argument built into a wrestling match, it became a visual metaphor of what was happening in society's taste for the blues. A market was created for old folk blues, and so artists like Muddy Waters were recording albums that returned to their country roots. At the same time, the new guard was excited by new music, and ready to embrace electric sounds that had been stewing for years in Chicago. Later, the Butterfield band joined Bob Dylan for a concert that became a famous turning point for folk music, bothering folk purists by introducing electric instruments to Dylan's formerly acoustic folk style.

After the Butterfield band's impressive debut recording and historic events at Newport, Butterfield recorded a number of albums that often moved away from his blues foundation, incorporating R & B horns, jazz, rock, and Eastern sounds. His band would profoundly influence the rock world when they became a regular presence at San Francisco's Fillmore, where the first psychedelic rock bands such as Jefferson Airplane and the Grateful Dead would hear their authentic Chicago blues and virtuosic improvisational style, in effect raising the bar for the San Francisco music scene. Butterfield's career continued until his death from a heart attack in 1987, when his excessive use of drugs and alcohol finally took its toll. Butterfield's band created a legacy during their time that opened doors for white musicians to create real blues music, not just to incorporate it into other styles like rock and country. Butterfield's music also influenced an American rock scene that was moving in a direction of more openness, creativity, and improvisation.

THE BRITISH INVASION AND PSYCHEDELIC ROCK

On February 7, 1964, The Beatles crossed the Atlantic from Liverpool, arriving in New York after months of heavy media coverage in the United States. The band's unmatched popularity among the youth, made clear on their *Ed*

Sullivan Show appearance, led to a stampede of British bands who found success in the American pop music marketplace—called the "British Invasion." Although The Beatles were mainly influenced by early blues-tinged rockers like Elvis Presley, Chuck Berry, and Little Richard, their music was an outgrowth of a period of heightened interest in the blues happening in Britain. British rock musicians had grown up on a folk/blues hybrid during the 1950s called "**skiffle**." As young boys **Keith Richards**, **Jimmy Page**, **Paul McCartney**, and **Eric Clapton** all listened and learned to play skiffle music from records like Lonnie Donegan's cover of Lead Belly's "Rock Island Line." Some of these skiffle fans unearthed the roots of the music, and soon blues listening parties were taking place in teenagers' homes across Britain. Many of the famous bands who followed The Beatles in the British Invasion were devoted fans of the American blues, and used the blues as the foundation for their sound. The Rolling Stones were among the most reverent of these British blues fans. In fact, **Mick Jagger** and **Keith Richards** first united when Richards spotted a copy of *The Best of Muddy Waters* under Jagger's arm. They would soon borrow the title from a Muddy Waters song to name their band. They took a car ride to Croydon in 1962 and 1963 (the first year accompanied by Jimmy Page of the Yardbirds and Led Zeppelin) to attend the American Negro Blues Festival, a collection of authentic bluesmen from the states that included Waters, Lightnin' Hopkins, and Howlin' Wolf. During their 1964 U.S. trip they visited Chess Records, recorded a cover version of Muddy Waters's "I Can't Be Satisfied," and proclaimed their admiration for Waters in the press. Later, their giant hit "(I Can't Get No) Satisfaction" would echo Muddy's "Satisfied." The Stones showed respect for Howlin' Wolf, as well. When they were programmed to play "Satisfaction" on an American TV program *Shindig!*, they demanded that Howlin' Wolf be featured as their guest.

The infusion of blues into Britain was no accident; it was handed directly to them by the traveling blues artists. Giorgio Gomelsky, one of the early businessmen attached to British blues-rock, told a story of an intriguing scene from one of the European blues tours. He remembered sitting in his living room with Howlin' Wolf, Rice Miller, and Willie Dixon sitting on the sofa. Jimmy Page and Eric Clapton sat on the floor listening to Willie Dixon and Rice Miller singing and playing harmonica to some new songs Dixon had written. Some American blues artists even collaborated with British bands on their visits. The Yardbirds backed harmonica player Sonny Boy Williamson II; John Mayall's Bluesbreakers backed John Lee Hooker.

The Rolling Stones, The Who, the Yardbirds, John Mayall's Bluesbreakers, Cream, Led Zeppelin, and Fleetwood Mac all covered blues songs by the earliest country bluesmen and crafted their own songs that showed heavy influence of the modern blues of Albert King, B. B. King, and Freddie King. In the British Invasion, these blues-rock bands were invading American soil with modernized versions of American folklore during a time when the most popular American rock had moved away from the blues. British rock bands essentially reintroduced blues to the nation where it had been invented, challenging American rock bands to incorporate blues into the next wave of rock.

The San Francisco Scene

This next wave would emanate largely from San Francisco, where the Fillmore Auditorium was buzzing with new sounds. San Francisco jam bands

were playing a style at that time called "**psychedelic rock**," a term that referenced the influence of psychedelic drugs (LSD) on the music. But just as strong as the effects of acid was the influence of Paul Butterfield and Mike Bloomenthal's Chicago blues-rock, and other blues-drenched and improvisational music styles. The roster of performers at San Francisco-area's Monterey Pop Festival in 1967 was filled with bands that had varying degrees of blues credentials. **Janis Joplin**, lead singer of Big Brother and the Holding Company, had grown up near Houston and attended college in Austin, singing the music of Lead Belly and Bessie Smith. **Steve Miller** had worked as a sideman in Buddy Guy's band when he lived in Chicago. Before co-leading the blues-rock band Canned Heat, **Alan Wilson** sat down with Son House during his return to music, training House on his own music. **Carlos Santana**, who originally called his band "Carlos Santana Blues Band," formed a group that presented a fresh hybrid of blues and jazz-influenced guitar rock flooded with Latin rhythms.

The blues-rock trend would breathe new life into the careers of the blues masters. **Bill Graham**, who booked concerts at San Francisco's Fillmore (and later, at Fillmore East in Manhattan), was advised by guitarist Mike Bloomfield to expose the Fillmore's primarily white audience to the blues of B. B. King, Albert King, Howlin' Wolf, and other black artists like the Staple Singers and Otis Redding. Graham began to program concerts with blues and rock acts on the same bill. B. B. King has been outspoken about his Fillmore show as a breakthrough that brought him the acclaim of a universal audience. Other blues artists were having similar results and playing bigger shows as this practice spread to concert venues across the country.

Jimi Hendrix

More than any other rock artist, **Jimi Hendrix** incorporated blues into his sound in a way that impacted a universal music audience. He "preached" the blues to his fellow rockers while he gave back to the blues by influencing younger generations with a harder-edged sound and new heights of virtuosity.

Hendrix was born in Seattle, Washington, and learned to play the guitar as a teenager. He was determined to play music professionally, even during the brief period that he served in the military. He recorded and performed with R & B performers Little Richard, Sam Cooke, and the Isley Brothers, and explored the active music scene in Greenwich Village, New York City, with a band that he led playing primarily blues covers by artists like Muddy Waters, Robert Johnson, Jimmy Reed, and others. He connected with Chas Chandler, bassist for the rock group the Animals, who offered to manage Hendrix in London. Hendrix relocated to London and formed his trio, the Jimi Hendrix Experience, with bassist **Noel Redding** and drummer **Mitch Mitchell**. Hendrix caught the attention of Eric Clapton and members of the top British rock bands The Beatles, The Rolling Stones, and The Who. His fans were dazzled by his technique and his ability to wow the audience with theatrics like playing with his teeth or behind his head.

The Jimi Hendrix Experience emerged as one of the greatest rock bands of all time with their first album *Are You Experienced?*. The album showcased an incredible level of interaction between Jimi and Mitch Mitchell, who was heavily influenced by jazz drummers like Elvin Jones. The

debut album became a huge success for Hendrix with several guitar-driven hits that would inspire countless guitarists and shape the sound of psychedelic rock. Most of his songs did not follow blues chord changes or copy traditional riffs, but his original songs derived their melodic material from blues patterns and channeled the feel of the blues. The Experience played with a level of musicianship and interplay that was more commonly heard among jazz and blues bands than in the rock world. Hendrix actively featured his band's improvisational abilities by playing long, extended jams in his concerts. The most legendary of these live performances was the 1967 Monterey Pop Festival, where Jimi poured lighter fluid on his guitar and set it on fire.

Nearing the end of the 1960s, Jimi formed a new trio called the Band of Gypsys with bassist **Billy Cox** and drummer **Buddy Miles**. He continued to tour with his new personnel, and recorded a large catalog of tracks at his Greenwich Village recording studio. Much of this material would only be released after his death in various compilation albums. In addition to working with his core group, he experimented with jazz, collaborating with fusion guitarists John McLaughlin and Larry Coryell. He was planning a recording project with Miles Davis and Gil Evans around the time that he was found dead in London, having died in his sleep after consuming barbiturates. The early death of Jimi Hendrix ended a career that appeared full of immeasurable potential. Hendrix had already revolutionized the guitar and the sound of rock and roll. Given his success in rock and his explorations in jazz, music lovers today often return to Hendrix's death as the ultimate "What if?" If an album with Miles Davis and Gil Evans had materialized, it would have almost certainly brought throngs of new listeners to jazz and impacted rock and popular music as well. Still, his legacy in rock and blues has thrived in the decades since his death,

Music Analysis

Jimi Hendrix, "Red House"
(1967)
Personnel: Jimi Hendrix, guitar/voice; Mitch Mitchell, drums; Noel Redding, bass

This track is an example of blues songs Jimi Hendrix included in his repertoire, demonstrating his blues roots. Although the band plays relatively simply here, the ability of Jimi's trio to interact with one another and to create a "vibe" is evident. Jimi's guitar sound is clearly designed for a rock audience, but his approach to the blues is well-grounded in tradition.

0:00	**Introduction:**	Solo guitar, possibly with bass quarter notes.
0:09	**Break:**	Single note guitar solo with entering drum fill.
0:16:		Drums and bass play along with Jimi through the remainder of the intro. Bass plays two notes at once.
0:44	**Verse 1:**	Jimi sings the lyric, answering himself with super-charged guitar licks.
1:29	**Verse 2:**	Drums and bass continue to keep time behind Jimi.
2:13	**Guitar solo:**	Bass plays louder and drums move from hi hat to ride cymbal, bringing the energy level up behind Jimi's solo.
2:57	**Verse 3:**	Drums and bass return to timekeeping.
3:32:		Drums and bass break for Jimi's last lyric line, a standard blues song-ending device.
3:35:		Drums and bass re-enter for the closing figure.

inspiring power blues guitarists like Stevie Ray Vaughan, Gary Clark Jr., and countless others.

PSYCHEDELIA INFILTRATES THE BLUES

The collision of rock and blues and commercial success of psychedelic rock encouraged blues record labels to cash in on the trend. In 1968, the Chess label planned a couple of albums that would embarrass Muddy Waters and Howlin' Wolf, but would also bring new listeners into the fold. The experimental rock band Rotary Connection was brought in as a backup band for Muddy's *Electric Mud* and Wolf's *The Howlin' Wolf Album.* Both albums revamped classic staples of Muddy's and Wolf's repertoire along with some new material including Muddy Waters's version of The Rolling Stones' "Let's Spend the Night Together." By most accounts from blues lovers, both albums were low points in the blues giants' careers. The Delta vocals sounded unnatural over the busy jams of the backup band. Both artists heavily criticized their own albums as failures. But young people were exposed to a new incarnation of the blues. Jimi Hendrix and Led Zeppelin claimed to have been influenced by *Electric Mud.* For rapper Chuck D, the album was a gateway into his further study of earlier Muddy Waters music.

Discussion Questions

1. The career revivals of Son House, Skip James, and other country blues artists coincided with the rise of folk music in the 1960s. What aspects of the blues artists' style, message, and/or general aesthetic may have drawn the folk crowd to their music?

2. Contrast the blues style of B. B. King from the country blues artists who made their music in his homeland, the Delta. What musical genres did he incorporate to build his sound?

3. West Side Chicago blues musicians built on the sound of earlier electric Chicago blues and stayed relevant. How did West Side Chicago blues differ from the music of Muddy Waters and the like?

4. The Jimi Hendrix Experience created music that was an eclectic mixture of stylistic influences. Where in Hendrix's music do we find evidence of jazz and blues influences?

5. Make connections: This chapter described a number of meetings between important blues and rock musicians, and between important black and white musicians. List several connections between important rock icons with blues artists.

1959: A Watershed Year for Jazz

A watershed is a dividing line, a turning point in history. Since the end of the 1940s, jazz had lived through a period when the ground shifted under modern jazz at an accelerated rate and the broad genre of jazz had become something new. A jazz mainstream coalesced from the bebop, cool, and hard styles. Several albums were released during 1959 that documented this tectonic shift. The lion's share of classic jazz recordings—albums that jazz musicians and educated listeners refer to as "must-haves"—were created in the 1950s and '60s.

In this chapter, we will cover:

- Miles Davis's *Kind of Blue*—modal jazz
- John Coltrane's *Giant Steps*
- Bill Evans's *Portrait in Jazz*
- Dave Brubeck's *Time Out*
- Charles Mingus's *Ah Um*
- *The Cannonball Adderley Quintet in San Francisco*
- Ornette Coleman's *The Shape of Jazz to Come* and his arrival in the NYC scene at the Five Spot

Record companies focused on the personalities of the featured artists to market these albums (look at album covers for Sonny Rollins's *Saxophone Colossus* [1956], John Coltrane's *Blue Trane* [1957], and Art Blakey and the Jazz Messengers' *Free for All* [1964]). Jazz musicians today speak of recordings made during this period by Miles Davis, John Coltrane, Art Blakey, Sonny Rollins, Bill Evans, Charles Mingus, Dexter Gordon, and Cannonball Adderley with reverence usually reserved for sanctified things. The year 1959 seems to have had a magnetic force that drew a high concentration of pivotal recordings to it.

Of course, this notion downplays the creative processes of each musician who spearheaded a 1959 classic. The reality is that most of the artists discussed in this chapter were already in the process of making recordings at an unbelievable pace. Today, more than one album per year is considered impressive. Miles, Trane, Bill Evans, and Cannonball played as sidemen on each other's albums at the same time that they were touring. When answering the question, "Why 1959?" we cannot ignore this flurry of activity, of several simultaneous musical projects. Each of these albums is a result of perseverance and trial-and-error over the course of previous recordings.

Returning to the idea of the watershed year, what other turning points have we passed through? 1935 marked the arrival of swing, when Benny Goodman's band arrived at the Palomar Ballroom and Bennie Moten died in Kansas City, leaving his orchestra musicians looking for work and ready to join Count Basie. 1945 marked the end of the second World War and a year earlier the AF of M ban on recording had just ended, finally allowing the bebop greats Charlie Parker and Dizzy Gillespie to be exposed on disc to a broad public. We could also argue watershed status for 1948 and 1954 as starting points for cool jazz and hard bop, respectively.

In 1959, seven albums were recorded and/or released that again sent the jazz idiom in a new direction. Some of these were commercially successful, others only found their way into the record

collections of the jazz intelligentsia and musicians looking for inspirational new material. But each album pointed in some way to the future of jazz with experiments that created new standard repertoire and re-wrote the rules of the game. This chapter will take a close look at one or two tracks from each of these important albums:

- **Miles Davis** *Kind of Blue*
- **John Coltrane** *Giant Steps*
- **Bill Evans** *Portrait in Jazz*
- *The Cannonball Adderley Quintet in San Francisco*
- **Dave Brubeck** *Time Out*
- **Charles Mingus** *Ah Um*
- **Ornette Coleman** *The Shape of Jazz to Come*

Some were the high water mark of their sub-genre, others pointed forward to new possibilities.

But 1959 was also tinted by tragedy. Both Lester Young and Billie Holiday died that year, marking the end of an era of their lyricism and expression grounded in blues melody just as the 1959 experiments were unleashed. The careers of both icons had waned with health and legal problems causing performances and recordings to become more rare, but jazz listeners and musicians still held them in high esteem. To the jazz community, Lady Day and Pres were patron saints who represented a healthy tradition that would never lose relevance. Case in point, Charles Mingus's song "Goodbye Pork Pie Hat" was a dedication to Lester Young. The death of Lady Day and Pres would have affected jazz fans' thinking as they listened to new releases in 1959, framing the new music with reverence for the past.

MILES DAVIS—*KIND OF BLUE*

Throughout the '50s, Miles recorded prolifically, moving back and forth from straight-ahead hard bop to orchestral collaboration with Gil Evans. In live performances Miles played a set list of standards in the quintet format with a revolving door of excellent sidemen. During two days in 1956, he recorded four albums of standards that would become a "how to play jazz" instruction manual, and the musicians on the albums would be called Miles's "First Great Quintet." John Coltrane played tenor saxophone, Red Garland played piano, "Philly" Joe Jones played drums, and Paul Chambers played bass.

His motivation for the recording marathon was a new recording contract. In order to upgrade to Columbia Records, Miles had to fulfill his commitment to Prestige. After the Gil Evans collaborations—*Miles Ahead* and *Porgy and Bess*—and a couple of excellent albums documenting more personnel changes in the drums, piano, and front line (*Milestones* and *'58 Sessions*), Miles hit a homerun for Columbia with an album that eventually sold more than 4 million units, making it the top-selling jazz album of all time. Also important to jazz history was its completely new harmonic approach. Most of the album's five tracks were based on a modern harmonic concept called "modality."

Modal Jazz

Modal jazz is composed not on rapidly changing chord progressions, like in bebop, but over one or two modes (or "scales") that shift at a glacier's pace by comparison. Miles liked how the slower harmonic motion affected his musicians. It freed them from the brainwork of navigating chords and let them explore fresh ideas. The modal theory was based on an approach to music that referenced the ancient Greeks, where a single group of pitches would be used in a piece. The favorite mode of Miles and others who followed him down the modal path was the **dorian mode**, a set of pitches that sounded like the natural minor scale, but with a raised 6th scale degree.

> **Dorian mode**—The group of pitches most often used in the style known as "modal jazz," consisting of all pitches of the minor scale except the major 6th. A Dorian scale in C has the pitches C, D, Eb, F, G, A (instead of Ab), and Bb.

Music Analysis

Kind of Blue
"So What"
(1959)
Personnel: Miles Davis, trumpet; Julian "Cannonball" Adderley, alto saxophone; John Coltrane, tenor saxophone; Bill Evans, piano; Paul Chambers, bass; Jimmy Cobb, drums

"So What" is the classic example of Miles's modal approach. After a mysterious sounding piano solo (probably composed by Miles's frequent collaborator Gil Evans), Paul Chambers plays the melody on his bass, an unconventional instrument to lead the piece. Miles's sketches of songs and his preference for static harmonies gave the sidemen a great deal of freedom on the sessions. The highlights of this track are the rhythm section's deep swing feeling and the contrast between the three soloists.

0:00	**Piano and bass introduction:** Bill Evans hints at the song's horn part in his upper notes, but his movement through various chords and key centers creates a feeling of ambiguity.
0:33	**Head:** Paul Chambers's bass melody is answered by a 2-note figure on the piano, mimicking the sound of background vocalists singing "So what!"
0:50	**Head:** The trio of trumpet, alto, and tenor take over the background singing role. The harmony moves from D dorian, up a half step to Eb, and back down to D.
1:31	**Trumpet solo:** Miles plays a lyrical solo using space, colorful tones, and occasional blues material. The rhythm section maintains a cool and calm mood without losing the feeling of forward motion. Paul Chambers varies the bass line, Bill Evans changes piano colors, and Jimmy Cobb stays active underneath his always-swinging ride pattern. Listen for Cobb's **shut-down phrase** hanging over into the beginning of the next soloist (3:25–3:28).
3:25	**Tenor saxophone solo:** John Coltrane changes the direction of the piece when he enters with his intense sound. Trane moves quickly into double time ideas and explores the full range of the instrument. Jimmy Cobb punctuates Trane's phrase endings with snare and tom tom phrases.
5:16	**Alto saxophone solo:** "Cannonball" Adderley opens with a series of double-time ideas that reference Coltrane's ending measures. Then he moves into standard time material, less free and more upright than Coltrane's playing.
7:08	**Piano solo:** Bill Evans plays a simple solo with backgrounds in the horns. He uses block chord voicings that emphasize clusters of notes.
8:00	**Head out:** The group repeats the opening arrangement of the melody.
8:58	**Tag:** The rhythm section finishes the song repeating the "A" melody.

Music Analysis

Kind of Blue
"Blue in Green"
Personnel: Same as on preceding page

Bill Evans claimed to have composed this song, although it is attributed to Miles Davis. Its impressionism and chord progression that seems to double over on itself are more akin to Evans's work on previous albums (listen to Evans's introduction to "Alone Together" on Chet Baker's album *Chet*). It is worth noting that Davis claimed authorship of "Flamenco Sketches" as well, a song that sounds cut from the same mold as Evans's song on a 1958 recording "Peace Piece." This process of collaboration (or thievery, depending on how you see it) had been around in jazz since at least Duke Ellington who regularly wrote his band members' contributions into the copywritten work.

"Blue in Green" is a brooding ballad that sets Miles's Harmon muted trumpet sound against a backdrop of tentatively meandering chords.

0:00	**Introduction:**	Bass and piano set a tranquil mood for the song, again with Evans's quiet cluster piano voicings.
0:18	**Head:**	Jimmy Cobb enters with nearly inaudible brushes. Miles Davis performs an understated, yet dynamic conception of the melody. His use of space is particularly effective.
1:47	**Piano solo:**	The first of Evans's two solos is a gradual step up from Miles's minimalistic statement. Evans uses dense chord voicings and melodic contour to create ebbing and flowing motions.
2:27	**Tenor saxophone solo:**	Coltrane maintains the tranquil mood in his upper register with very little vibrato, and primarily long notes. Occasionally, a fast upward flourish interrupts the otherwise serene tones.
3:09	**Piano solo #2:**	Evans takes a solo for one chorus only, launching briefly into double-time feel.
3:30	**Head out:**	Miles enters with the closing melody, two times through. He embellishes it a great deal.
4:55	**Outro:**	Bill Evans takes a closing cadenza in **rubato** tempo. Paul Chambers subtly uses his bow on the bass.

JOHN COLTRANE—*GIANT STEPS*

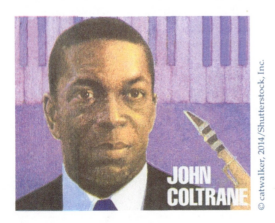

Before *Kind of Blue*, Coltrane had played the past three or four years as a sideman with Miles Davis and Thelonious Monk, two of the most consequential bandleaders in jazz. He had already released a number of albums as a leader, most famously *Blue Trane*, his only Blue Note release. During the same year Coltrane was exploring modal jazz with Miles in *Kind of Blue*, Trane released his most important album to date—*Giant Steps*, a record that went the opposite direction. The title track, "Countdown," and other songs on *Giant Steps* pushed harmony further up the scale of difficulty. Others, like "Syeeda's Song Flute" and the gorgeous ballad "Naima" put an intensely personal spin on more conventional composition styles. Virtually every song on *Giant Steps* has since joined the standard repertoire of jazz.

Music Analysis

Giant Steps
"Giant Steps"
(1959—released 1960)
Personnel: John Coltrane, tenor saxophone; Tommy Flanagan, piano; Paul Chambers, bass; Art Taylor, drums

"Giant Steps" used a chord progression Coltrane had been practicing as an exercise. The chord movements were completely foreign to the typical jazz musician, revolving around key movements by an interval of a major 3rd. Conventional chord progressions tend to move in 4ths and 5ths. "Giant Steps" changes are still considered challenging by today's jazz musicians, particularly at the fast tempos heard on the album. Although Coltrane's mastery of this tune can be mystifying, listen for phrases he tends to repeat on each repetition through the form. Tommy Flanagan was not so lucky to practice this chord progression as an etude over several days. His stumbling solo on "Giant Steps" is one of so many unconfirmed stories in jazz. Most likely, Flanagan saw the chord changes before the recording session but expected the song would be played as a slow ballad. That would explain his difficulty during the early choruses and his block chord approach during the last chorus.

0:00	**Head:** The entire quartet plays rhythmically in unison with Coltrane's half-time melody, then jumps into the burning tempo with walking bass and ride cymbal. The head is played twice.
0:26	**Tenor saxophone solo:** Coltrane plays a tour-de-force solo almost completely made up of steady streams of running eighth notes moving up and down the full range of the tenor saxophone. He returns often to an ascending four-note figure. Art Taylor fuels the soloist with a consistent groove on the ride cymbal and off-beat strikes on the snare drum. Like Jimmy Cobb in "So What," listen for Taylor's **shut-down phrase** bleeding over into the opening measures of the piano solo (cross-stick triplets and bass/cymbal hits).
2:52	**Piano solo:** Tommy Flanagan opens his solo with broken eighth note phrases, comping the chords steadily underneath. The strength of Paul Chambers's walking bass line is exposed here. Flanagan finds his footing in the 3rd chorus with slower phrases, then shifts to a ballad style of soloing with chords.
3:44	**Tenor saxophone solo #2:** Coltrane is relentless in his second solo, using some of the material that appeared in his first solo.
4:10	**Head out:** The band plays the melody twice, ending with a held note on the last pitch of the song.

Music Analysis

Giant Steps
"Syeeda's Song Flute"
(1959—released 1960)
Personnel: Same as above

"Syeeda's Song Flute" is built on chords that harken back to early Monk ("Well You Needn't") and Gillespie ("A Night in Tunisia") by essentially moving up and down between two chords with roots a half step apart. Its multiple melodies are simple and extremely repetitive. What makes this song particularly effective are alternating textures between a pattern made of **staccato** (short) notes in the A sections and a long, soaring melodic line in the B and C sections. Listen for call and response in both textures.

0:00	**Introduction:** The rhythm section sets up the groove that accompanies the A section of the tune. A swing hi hat pattern is punctuated only by a short, syncopated note in the piano and bass.

(continued)

Music Analysis *(continued)*

0:10 **Head, A section:** Coltrane enters with the walking melody, accenting every beat. The melodic shape has an Eastern sound as it leaps up to two half-step pairs.

0:20 **Head, B section:** The saxophone melody leaps up to a long note while the rhythm section answers with kicks.

0:30 **Head, A section:** Repeat of the earlier section.

0:40 **Head, C section:** A new call and response sequence played with long saxophone notes and rhythmic kicks.

0:51 **Tenor saxophone solo:** The band plays walking swing style for all sections except the C while Coltrane improvises using a variety of melodic styles, primarily switching between lyrical eighth note lines and arpeggiated triplets.

2:32 **Piano solo:** Coltrane fades out during the opening measures of Tommy Flanagan's solo. Flanagan plays swinging eighth note lines through most of his solo, occasionally launching into double-time.

4:15 **Bass solo:** Like Flanagan, Paul Chambers mainly plays lines of swinging eighth notes.

5:58 **Head out:** The opening sections are repeated, including the introduction. This time, Coltrane plays the introduction pattern over the first A section.

BILL EVANS—*PORTRAIT IN JAZZ*

By the time Bill Evans arrived on the elite jazz scene, he had a unique sonic identity. Evans is most known today for his legato touch and colorful chord voicings borrowing from French impressionist composers such as Claude Debussy and Maurice Ravel. But his musical conception is far more broad than one recognizable timbre. Evans could improvise Bud Powell-esque running bebop lines with the best of them (listen to "What is this Thing Called Love" on *Portrait in Jazz*). Contemporary European classical masters Debussy, Ravel, Béla Bartók, Sergei Prokofiev, and Alexander Scriabin influenced his compositional approach. He drew influence from the singular improviser Lennie Tristano. Particularly interesting was his rhythmic concept. Evans experimented with *threes*, playing three notes over two beats or exaggerating the typical **hemiola** rhythms that accent every third eighth note.

> **Hemiola**—A specific kind of polyrhythm that continuously accents every third subdivision of a duple pulse, rather, a pulse divided by two. This creates a rhythm that lands alternately on strong, weak, strong, and weak beats.

Like so many of Miles Davis's sidemen, Evans went on to impact the future of jazz as a bandleader. Before *Kind of Blue* Evans had already recorded critical albums in the jazz trio format, but 1959's *Portrait in Jazz* was a coming of age album for his particular conception of jazz. Bill Evans's trio, with bassist **Scott LaFaro** and drummer **Paul Motian**, demonstrated a new level of rhythm section interaction. The band left the time-keeping function to the listener's imagination. LaFaro avoided conventional walking bass lines for long stretches, instead providing a countermelody to Evans's solo. Motion broke up the time between his ride cymbal and snare drum. Forward-thinking rhythm sections of the 1960s, most famously Miles Davis's next rhythm section of Herbie Hancock, Ron Carter, and Tony Williams—drew from the conversational conception of Evans-LaFaro-Motian.

Music Analysis

Portrait in Jazz
"Autumn Leaves"
(1959)
Personnel: Bill Evans, piano; Scott LaFaro, bass; Paul Motian, drums

0:00	**Introduction:** This intro demonstrates Evans's triplet concept from the first second. The first four bars are a typical syncopated rhythm used in big band swing. The second four bars switch the rhythmic feel to what sounds like a quarter note triplet rhythm.
0:08	**Head, A section:** Bill Evans embellishes on the melody against subtle underlying chords. A conventional bassist would either walk the pulse or play kicks along with Evans's left hand. Instead, LaFaro plays a melody in repetitive rhythm that contrasts Motian's steady pulse in the brushes.
0:28	**Head, B section:** LaFaro joins Motian with a walking bass line.
0:38	**Head, last A section:** LaFaro references the idea played in the first A section, but keeps the pulse, then the full trio plays LaFaro's rhythmic kicks together at 0:42.
0:45	**Bass solo to collective improvisation:** Piano and drums drop out and LaFaro solos alone. He opens with a bluesy sliding-pitch blues lick. After the first A section, Bill Evans joins with his own improvisation. Motian sneaks in at the bridge with his own solo, still with brushes. Collective improvisation continues for a second chorus.
2:02	**Piano solo:** Bill Evans takes prominence as LaFaro and Motian relent to typical time-keeping roles. Evans's solo is a model of melodic and rhythmic structure. The standard bebop sound is a baseline, but he explores contemporary scales and pitch choices along with triplet rhythms.
3:53	**Piano solo, fourth chorus:** Evans uses a trademark texture called "**planing**" where he fills in a full chord voicing underneath his upper solo melody. This increases the volume and intensity of the solo, signaling the conclusion.
4:31	**Collective improvisation:** Evans's solo becomes more abstract while LaFaro begins improvising and Motian eventually lays out.
5:06	**Head out:** As in the opening head, Motian plays steady time with brushes on the snare drum while Evans and LaFaro share the melodic function.
5:43	**Coda:** The arranged ending repeats the rhythmic kicks that close the head, modulating through a series of chords until it lands on a surprising subdominant chord.

CANNONBALL ADDERLEY—*THE CANNONBALL ADDERLEY QUINTET IN SAN FRANCISCO*

Julian "Cannonball" Adderley was yet another contributor to *Kind of Blue* to find immediate success as a front man. Before his time with Miles, Adderley was a studious musician from Florida. His nickname had evolved from "cannibal," so named for his appetite. He graduated from Florida A&M University in Tallahassee and taught high school music in Fort Lauderdale. Adderley led army bands at Fort Knox, Kentucky, and later in Washington, D.C., throughout the early 1950s, joined by his cornet-playing brother Nat. The brothers moved to New York in 1955 and earned a solid reputation among the musician community. They arrived in the city the same year Charlie Parker died, and already Cannonball was being called "the new Bird." The title was not far off. Cannonball's mastery of double-time echoed Charlie Parker, but his sound was more conventional, less harsh than Bird's.

In his improvisations, he tended to draw more from blues-based forms than Bird, whose blues crept out under abstract and angular melodies.

During their first few years in New York, Nat Adderley toured with the likes of J. J. Johnson and Woody Herman while Cannonball joined Miles Davis, expanding the First Great Quintet to a sextet. On the 1958 recording *Milestones* Cannonball's well-crafted sound and metronomic rhythmic approach served as a middle ground to Miles's reserved conception and John Coltrane's no-holds-barred intensity. Comparing Trane and Cannonball on both *Milestones* and *Kind of Blue*, one can detect the influence Coltrane had on Cannonball's playing, with occasional sheets of sound sneaking into his more traditional phrasing.

After *Kind of Blue*, *The Cannonball Adderley Quintet in San Francisco* heralded a subgenre of jazz called "Soul Jazz" that became a major force in the

Music Analysis

The Cannonball Adderley Quintet in San Francisco
"This Here"
(1959)
Personnel: Julian "Cannonball" Adderley, alto saxophone; Nat Adderley, cornet; Bobby Timmons, piano; Sam Jones, bass; Louis Hayes, drums

This song written by Bobby Timmons became an early anthem of soul jazz. Timmons' song is written in three beats per measure, rather than the typical four. In soul jazz fashion, the rhythm section repeats a steady groove throughout the piece with Louis Hayes' strong beat two anchoring the meter.

0:00: Cannonball announces the tune, ascribing African American dialect to the title and effectively linking the song to black gospel music and, thereby, black music as a whole. The unabashed "blackness" of the music is typical of soul jazz.

0:58: **Introduction:** The song's composer begins the vamp on piano, gradually joined in by bass and shuffling drums. The mid-register piano chords are common church voicings.

0:23: **Head, A section:** The jarring sounds of staccato, upper register alto saxophone and cornet increase the intensity of the gospel introduction. Throughout the head and solo sections, the bass and drums return to the beat of this opening A section.

1:38: **Head, B section:** The quintet brings the volume down and the Adderley brothers play a simple legato phrase, then return to the opening mood.

2:00: **Head:** The full melody is repeated.

2:38: **Alto saxophone solo:** Cannonball plays blues phrases over the A section and bebop eighth-note phrases over the more harmonically active B section. During his subsequent choruses, Cannonball relies more on bebop phrases then blues, but one of Cannonball's strengths is the blues, or soul, that finds its way into melodic ideas not based on blues scales.

5:27: **Cornet solo:** Nat Adderley opens with a simple phrase that, when moved to a higher pitch class, clashes with the background chord. From there he alternates between blues and bebop ideas, but, in contrast to his brother, he relies on the blues and on the high register of his horn to build momentum.

7:44: **Piano solo:** Bobby Timmons simply plays the vamp during the first A section of his solo and begins improvising gospel language at the bridge.

8:43: **Piano solo, third and fourth chorus:** Cannonball and Nat enter with simple gospel background figures.

9:48: **Piano solo, fifth and sixth chorus:** Timmons launches into an additional two choruses with a rolling triplet figure, now without background horns. Sam Jones supports the build-up of momentum by breaking into a walking bass line.

10:57: **Head out:** The quintet repeats the opening arrangement.

12:10: **Live fade:** The rhythm section mimics the fade out ending en vogue on studio pop recordings.

mid-1960s. The Adderley brothers built upon the hard bop sounds of Art Blakey with an additional measure of gospel music that linked it with the transition occurring in black popular music from R & B to soul. Like the new soul music, Adderley's soul jazz thrived on piano and bass vamps and drum grooves that also looked toward bossa nova. "This Here" also features Cannonball's abilities as an emcee, playing the audience in a manner few jazz frontmen were able to accomplish.

DAVE BRUBECK—*TIME OUT*

The biggest hit of 1959 came from an unlikely territory on the west coast. San Francisco and the northern part of California had not been a center for forward-thinking jazz. Dance halls up and down California supported the swing craze of the 1930s and '40s, but modern jazz growing out of bebop had built its western headquarters around Los Angeles in southern California. Dave Brubeck's *Time Out*—at the same time the most popular jazz recording of 1959 and one of its most experimental—may have actually benefitted from that lack of connection with the main stream of jazz. The sound of Brubeck's quartet was unlike any other. They retained the reserved, light touch of the cool jazz era but stood out from the pack by employing thoughtfully experimental harmonic and rhythmic concepts.

Dave Brubeck grew up in a rural area of northern California, unconnected from city life. He was a talented jazz composer ("In Your Own Sweet Way" and "The Duke") with an easy touch at the piano and a healthy penchant for experimentation. In college, he studied composition from classical modernists Darius Milhaud and, briefly, Arnold Schoenberg. As early as 1946, before the Miles/Gil nonet collaborations around *Birth of the Cool*, Brubeck led an eight-piece group of like-minded musicians interested in composition, both in the jazz and classical sense. The Dave Brubeck Octet included his future musical partner and sometimes antagonist, **Paul Desmond**, and experimented with mixture of classical/jazz before the new subgenre was dubbed "Third Stream." A surprising outcome of these modernist experiments was one of the most popular jazz recordings of all time.

By 1959 Brubeck had been performing in the quartet format throughout the '50s, always with Paul Desmond on alto saxophone but with a few different drummers and bassists. A number of Brubeck's quartet recordings for the Fantasy record label were well received, and a change to the powerhouse Columbia records coincided with a change of drummers to the spellbinding technician **Joe Morello**. Morello was in many ways an ideal drummer for Brubeck's vision of jazz. *Time Out* was an album dedicated to exploring time signatures other than the standard four beats per bar. Morello navigated odd time signatures in five and nine with ease and performed meter changes with impressive precision. He was also one of the best drum soloists of all time. Joe Morello's melodic conception at the drum set rivaled that of Max Roach.

Music Analysis

"Kathy's Waltz"
(1959)
Personnel: Paul Desmond, alto saxophone; Dave Brubeck, piano; Joe Morello, drums; Eugene Wright, bass

Each track on *Time Out* played a different rhythmic game. In "Kathy's Waltz," that game was **metric modulation**. The description "Waltz" sounds like a mistake at the beginning of the track when the band is playing in four. The waltz is a dance with three beats in every bar. But at the alto saxophone solo, Morello reveals the waltz tempo by playing in three. What qualifies this as metric modulation is the mathematical relationship between the two tempos. The slow four tempo places two beats in the space of the waltz tempo's three beats, so it sounds like the tempo speeds up when they enter the waltz. To make matters more complicated, Morello is hinting at a measure of six by accenting every second beat instead of every third. See the example below. The standard waltz ride pattern (played here with brushes on the snare drum) is on the top line, Morello's "six" rhythm is below, and on the bottom is the opening slower tempo in four.

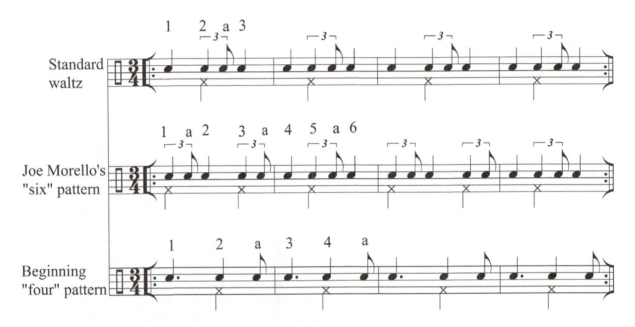

0:00	**Head:** The quartet opens with a false tempo, modulating the "real" waltz tempo to a slower four beats. Morello occasionally hints at the real tempo in the spaces between Brubeck's melodic phrases. Eugene Wright plays a two feel throughout.
1:06	**Transition:** In a few bars, Brubeck and Morello modulate the tempo into the faster waltz tempo. Wright mainly plays a long note on every downbeat on the bass.
1:10	**Alto saxophone solo:** Paul Desmond plays with a characteristically smooth tone, using a variety of eighth note lines and long notes.
2:19	**Piano solo:** Brubeck plays a chorus in the waltz tempo. Toward the end of his first chorus he fills out his single lines with fully-voiced chords.
2:53	**Piano solo, second chorus:** During the first eight bars, Brubeck shifts to the slower four feel, this time in contrast to Morello's stubborn waltz feel.
3:27	**Piano solo, third chorus:** Brubeck returns to single line texture again but deepens the swinging four feel against the waltz. At the second section of the chorus (3:42), Brubeck's left hand plays a stride pattern on the off-beats.
4:01	**Head out:** Brubeck joins the waltz time finally, playing the melody in its intended feel for the first time in the performance.
4:32	**Coda:** Drums and bass lay out as Brubeck concludes with a rubato closing.

Music Analysis

"Take Five"
(1959)
Personnel: Same as on preceding page

Paul Desmond composed the breakaway hit of the album, one of the most requested jazz standards of all time. As the title hints, the challenge of this song is its five beats to the bar. Desmond's melody is played over a piano/bass vamp through the A sections, and a brief B section propels harmonic motion forward. Solos occur over only the repeated A section. Licensing fees from just this song could have set up the Desmond estate with considerable income for years after his death, but when Desmond passed away in 1977 he had no surviving relatives. He chose to leave the proceeds to the American Red Cross, effectively bequeathing millions to charity.

0:00	**Introduction:** Joe Morello begins the "five" beat, joined four bars later by Brubeck's and Wright's vamp. The role of the bass is minimal on this song since Brubeck doubles Wright's notes in his left hand throughout.
0:20	**Head, A section:** Desmond enters with the melody.
0:35	**Head, B section:** The bridge works its way through a few keys while the melody repeats a melodic shape and transposes it down to match the chords, a compositional technique used in European classical music of the Baroque era called **sequencing**.
0:49	**Head, A section:** Desmond returns to the A section.
1:04	**Alto saxophone:** Desmond opens his solo by leaping up an octave above the endpoint of the melody. He is among the most lyrical of soloists, constructing an improvisation that could lend itself to a new composition due to its melodic strength. Joe Morello maintains the five groove.
1:50	**Transition to drum solo:** The rhythm section continues the vamp while Morello builds the anticipation of the listener by postponing his solo. (This section may have been spliced in from another take since an audible disturbance occurs at 1:50 and the cymbal changes color slightly.)
1:59	**Drum solo:** Morello begins by complicating the snare drum comping underneath the steady ride cymbal vamp.
2:11	**Drum solo:** Morello mixes drum sounds with cymbal sounds, using standard bebop and swing drumming vocabulary.
2:28	**Drum solo:** Morello evades the cymbals for measured phrases on the snare drum, bass drum, and tom toms. He toys with the five meter with the series of phrases beginning at 2:31, setting up the expectation of hearing beat one on the bass drum and then moving it to off-beats. Morello takes a melodic approach throughout the remainder of his solo, drawing from Max Roach but incorporating space as a more essential ingredient.
4:21	**Head out:** Paul Desmond returns somewhat unexpectedly while Morello is drawing down his solo.
5:03	**Coda:** The band repeats the final phrase of the head, a **tag** ending.

CHARLES MINGUS—*AH UM*

Charles Mingus was a New York jazz bassist, bandleader, and composer known for his virtuosic playing, his volatile temper, and a surprising range of musical expression in his performances and compositions. With Duke Ellington and Thelonious Monk, he is among the elite class of jazz composers to have composed a large number of jazz standards with a highly personal style. Mingus drew from panoply of musical influences including blues and gospel, classical music, and the full history of jazz styles. Growing up in the Watts district of Los Angeles, Mingus studied music seriously performing on trombone and cello, eventually leading to the double bass.

CHARLES MINGUS

© catwalker, 2014/Shutterstock, Inc.

Mingus took jazz bass lessons with Red Callender at the suggestion of notable Los Angeles woodwind player Buddy Collette and studied classical technique with Howard Rheinschagen. In the 1940s and early '50's Mingus made a name for himself on the west coast performing in bands led by Bubber Miley, Louis Armstrong, Lionel Hampton and Red Norvo. He moved to New York in 1951 and built an independent record label with drummer Max Roach. The company's strongest contribution to the jazz lineage was a live concert recording in Toronto called *Jazz at Massey Hall*. The concert reunited Bird and Diz in front of an all-star bebop rhythm section that included Bud Powell, Roach, and Mingus. *Massey Hall* is hailed to this day as a highlight of the bebop era.

Mingus found an outlet for his compositional voice with Jazz Composers' Workshop, a group of jazz musicians including trumpeter Art Farmer and future producing icon Teo Macero. The Jazz Composers' Workshop met regularly to rehearse and perform each other's experimental works, often incorporating blues, bebop, and avant-garde classical compositional techniques. Mingus became acquainted with Thelonious Monk through his association with the JCW. He began recording his own compositions for a variety of record labels in the mid-1950s, often with members of the JCW. *Mingus Ah Um*—his first album for Columbia—is a collection of some of Mingus's best compositions. Mingus recorded three noteworthy albums in 1959 (the others are *Blues and Roots* and *Mingus Dynasty*) but *Mingus Ah Um* warrants attention as a cornerstone album of 1959 jazz because of the broad range of styles and the sheer number of memorable songs on the album that became jazz standards.

Music Analysis

"Better Git It In Your Soul"
(1959)
Personnel: John Handy, alto saxophone; Shafi Hadi and Booker Ervin, tenor saxophone; Jimmy Knepper, trombone; Horace Parlan, piano; Dannie Richmond, drums; Charles Mingus, bass

This song echoes the sounds of gospel singing that provided much of the soundtrack to Mingus's youth. A fast song in three (too fast to be called a "waltz"), "Better Git Hit in Your Soul" thrives on extreme repetition of short blues riffs in the trombone and saxophones. The AABA form has a 24-bar blues (each measure in typical blues is doubled) at each A section and a simple gospel bridge. Solos forego the bridge and instead just cycle through fast blues. Listen for Mingus's and other band members' sanctified shouts. Mingus was known in Jazz Composers' Workshop performances to shout through the cacophony of the band.

0:00 **Introduction:** Mingus enters with the basic riff on his bass joined soon after by piano, drums, and Jimmy Knepper's trombone.

0:16 **Head, A section:** The full horn section plays the melody in harmonized fashion. The opening tune wavers between two pitches, then dives down an arpeggio and steps up. This idea is repeated until a long held pitch. Danny Richmond fills in spaces between melodic phrases on his drums.

0:30 **Head, 2nd A section:** This time the alto saxophone breaks from the other horn players in call and response with short improvised statements.

Music Analysis *(continued)*

0:43 **Head, bridge:** An alto and tenor saxophone play the folk song-like B melody while trombone and other saxophones improvise.

0:55 **Head, last A section:** The band repeats the A section in the style of the 2nd A.

1:08 **Tenor saxophone solo:**

1:25 **Tenor saxophone solo:** Trombone and saxophones enter with backgrounds, sustaining the tonic pitch.

1:58 **Bass solo:** Mingus is among the loudest bass players during his solos. Other bassists would get lost in the busy piano texture and backgrounds (entering at 2:15).

2:30 **Alto saxophone solo:** The saxophonist begins his solo over the same backgrounds heard previously.

2:48 **Rhythm section chorus:** No soloist enters here, so the rhythm section is exposed.

3:02 **Head:** Trombone and tenor saxophone play the A section melody.

3:18 **Rhythm section chorus:** Again, the droning tonic is continued by piano and bass.

3:34 **Tenor saxophone solo:** Booker Ervin improvises as the rhythm section drops out and claps in gospel church fashion. The rhythm section returns at (4:06) to propel Ervin forward.

4:37 **Drum solo:** Dannie Richmond solos in the basic "three" feel, moving around the drums.

4:52 **Ensemble section:** The band plays two choruses of the drone figure, moving up and down in volume.

5:25 **Drum solo #2:** Richmond plays another chorus in similar style as his first solo.

5:39 **Ensemble section:** Richmond continues to solo while the horns play the complete introduction figure.

5:56 Drum solo #3

6:11 **Head out:** The melody is repeated in its entirety, ending on a **ritard** to a final pair of held chords, evoking the "Amen" in a church hymn.

Music Analysis

"Fables of Faubus"
(1959)
Personnel: John Handy; Shafi Hadi; Booker Ervin, tenor saxophone; Jimmy Knepper, trombone; Horace Parlan, piano; Dannie Richmond, drums; Charles Mingus, bass

Orval Faubus, the longest-serving governor of Arkansas, attempted to block federal desegregation of Central High School in Little Rock in 1954 by bringing in the Arkansas National Guard. To Mingus, who had been outspoken about the mistreatment of African Americans, Faubus provided inspiration for a highly original, torturous piece of music. The song is endemic of Mingus's compositional style, using a polyphonic texture either completely composed or asking members of the band to improvise.

0:00 **Introduction:** Tenor saxophones and trombone play an eerie figure reminiscent of Duke Ellington's "East St. Louis Toodle-oo" while Mingus leaps downward through triplet arpeggios.

0:16 **Head, A section:** Three melodic parts weave together a circus-like polyphonic texture.

0:32 **Head, B section:** The melody is played in unison over increased chordal activity in the rhythm section.

0:54 **Head, repeat A and B sections:** The second time through the head is essentially the same as the first, with an added closing section of swinging kicks (1:22).

1:30 **Head, C section:** Alto section plays the main melody while tenor saxophone and trombone interject ideas that intensify the eerie circus feel of the song.

1:46 **Head, D section:** The rhythm section shifts to double-time followed by an abrupt return to the original tempo. The saxophones and trombone improvise collectively throughout this section.

(continued)

Music Analysis *(continued)*

2:01 **Head, closing A and B section:** This is modeled after the repetition of A and B at 0:54 with added closing section.

2:37 **Alto saxophone solo:** The rhythm section plays an accompaniment figure that hints at metric modulation to waltz time.

3:48 **Piano solo:** During this solo, the rhythm section switches back and forth between the established medium swing feel, double-time feel, and the waltz idea played during the first alto saxophone solo.

4:52 **Tenor saxophone solo:** The rhythm section returns to the waltz time figure during the A sections of this solo.

6:01 **Bass solo:** Mingus plays a solo with the same oscillating rhythm section feels heard during the piano solo.

7:04 **Head, C and D sections:** The band returns to the head omitting the first two A and B sections.

7:35 **Head, closing A and B section**

ORNETTE COLEMAN—*THE SHAPE OF JAZZ TO COME*

In 1959 Ornette Coleman was perched on a precipice, about to turn jazz upside down with a revolutionary new style of improvisational music that came to be known as "free jazz." So far in his career Coleman had paid dues touring with R & B bands and landed in Los Angeles where, for about five years, he worked day jobs and at-

Pocket trumpet

© Richard Peterson, 2014/ Shutterstock, Inc.

tended jam sessions at night. In 1956 he assembled the group of progressive musicians that would make waves in 1959 with *The Shape of Jazz to Come.* Bassist Charlie Haden, drummer Billy Higgins, Ornette, and trumpeter Don Cherry (who played a tiny **pocket trumpet**) rehearsed for days on end in Ornette's apartment.

 Ornette connected with west coast record label Contemporary and fulfilled a two-album contract with *Something Else!!!!* and *Tomorrow is the Question!* Most striking about these early recordings is the strength of the compositions. Ornette showed a penchant for writing melodies that connected with blues-based jazz tradition, but had interesting twists and turns. In 1959 John Lewis convinced the major label Atlantic to record Coleman's group in Los Angeles and bring him to New York City. Martin Williams, a *New York Times* critic, interceded with the owners of the Five Spot—the club made famous by Thelonious Monk—to hire the Coleman Quartet for a two-week stint. The jazz world was aquiver in anticipation of the man whose vision threatened to remake jazz. Well-known New York musicians such as Miles Davis, Leonard Bernstein, and Charles Mingus were in attendance at their Five Spot opening and the quartet's performance caused a stir. *Time* magazine reported on the Ornette Coleman quartet's Five Spot performances and opinionated musicians weighed in

on the validity of Coleman's concept. Coleman's two weeks at the Five Spot were extended to 10 weeks, and the group returned for another long engagement within the year.

Things happened fast for Ornette. Almost as soon as *The Shape of Jazz to Come* was released, the interest it generated urged Atlantic to make more recordings. Atlantic released six Ornette Coleman albums within the next three years, each with a unique concept. In the next chapter, we will cover the free jazz movement that ensued in detail. Here we focus on the album that announced Ornette's arrival.

Music Analysis

"Lonely Woman"
(1959)

Personnel: Ornette Coleman, alto saxophone; Don Cherry, pocket trumpet; Charlie Haden, bass; Billy Higgins, drums

Like Dave Brubeck's *Time Out*, Ornette Coleman employed time experiments in some of his compositions. With Brubeck the experiments were metric resulting in mathematical correlation between two different tempos. With Coleman, time was more flexible and random. "Lonely Woman" is an example of the expressive power of Coleman's rhythmic conception. Also remarkable about *The Shape of Jazz to Come* is the lack of a chordal instrument. Without piano or guitar, the harmony is only defined by the soloists and Charlie Haden's bass line. Ornette's conception of intonation and tone quality are also departures from the jazz sounds of the day. Ornette and Don Cherry sound out of tune to the traditional ear, but Ornette was purposefully playing **microtones**, pitches between the twelve tones of Western music.

0:00	**Introduction:** Charlie Haden and Billy Higgins establish a racing tempo for the piece. Higgins plays an extremely fast ride pattern while Haden plays two notes simultaneously, a technique called a **double stop**. The lower note holds a drone, or a sustained pitch while the other plays a melody.
0:18	**Head:** Don Cherry and Ornette Coleman play the melody in a completely different time feel than bass and drums. The contrast between fast and slow evokes a feverish contrast between two characters. The alto saxophone and pocket trumpet are out of tune with each other, and the grating contrast amplifies the tension expressed in the melody.
0:31	**Head:** After three unison phrases, Coleman splinters off from the basic tune with an answering phrase. Then the two horns play two phrases harmonized in thirds.
0:43	**Head, second A section:** The first A section is repeated.
1:08	**Head, B section:** The horns intersect with the bass/drums tempo. The trumpet plays a slow ascending line while Coleman plays a moving line that stays loosely in tempo.
1:21	**Head, last A section:** The horns repeat the opening A section again.
1:41	**Alto saxophone solo:** Ornette plays a yearning solo in the mood of the tune that stays primarily in half time, compared to the drums. Don Cherry plays a brief background figure at the bridge.
2:54	**Head:** Alto saxophone and trumpet repeat the opening arrangement of the melody with some extra embellishment.
4:19	**Coda:** Alto saxophone and trumpet play a rising and falling gesture, then drums and bass gradually fade out in the fast tempo.

Discussion Questions

1. Compare and contrast Miles Davis's *Kind of Blue* with John Coltrane's *Giant Steps* using specific musical elements.

2. Miles Davis's *Kind of Blue* is the best-selling jazz album of all time, but was it the best album of 1959? Which of the seven albums described in this chapter is your favorite, and for what musical reasons?

3. Make connections: Of the important 1959 jazz albums, only Charles Mingus's *Ah Um* made an explicit political statement, with "Fables of Faubus." What are the implications? Why did almost all of the important albums ignore political events?

4. Which of the seven albums covered in this chapter was the most rhythmically adventurous, and why?

5. Ornette Coleman's *The Shape of Jazz to Come* signaled the free jazz movement of the 1960s, but what elements of "Lonely Woman" connect to past jazz styles?

Jazz on the Forward Fringe

In this chapter, we will cover:

- Avant-Garde Jazz
- Ornette Coleman
- Cecil Taylor
- Eric Dolphy
- Chicago Free Jazz—Muhal Richard Abrams, AACM, Art Ensemble of Chicago, Sun Ra, Anthony Braxton
- Post-bop—John Coltrane and Miles Davis

AVANT-GARDE JAZZ

The **avant-garde** is a broad movement in the arts that has taken hold at various points in history and looked forward past readily accepted norms to find new standards of creative expression. Avant-garde signifies experimentation and practices that move upstream against popular tastes. It looks *beyond*. The term "avant-garde" was used in French military operations describing the scouts who moved out ahead of the company in order to see what was before them, to seek out dangers and aid in charting the path ahead. This is an apt metaphor for the experimental jazz styles that came into view during the 1960s. Avant-garde jazz became linked with the free jazz movement, a form that strives for freedom from conventional notions of music. Bebop, to some extent, can be seen as an avant-garde style compared with the music it challenged—swing. Bop players challenged norms of riff-based melodies and tight arrangements meant to appeal to dancers and instead created a style that challenged its audience with fast tempos, angular melodies, and long periods of improvisation. Avant-garde jazz musicians challenged cool jazz and especially hard bop templates, assaulting the neatly-packaged small-group styles with a tenacious bent toward musical freedom.

Characteristics of Avant-Garde "Free" Jazz

- Harmony—Chord progressions are either non-existent or occurring naturally through random combinations of pitch choices by instrumentalists.
- Melody—remains the central idea and can take on a wide variety of characters and shapes. It may exaggerate characteristics commonly found in more traditional melodies, relying on more repetition, more wide leaps, or increased use of chromatic pitches.
- Rhythm—completely fluid in free jazz, disguising the pulse or completely avoiding any feeling of a steady pulse.
- Form—Traditional forms, such as blues and 32-bar song form, are avoided in favor of free improvisation, which may or may not be organized by brief structural guideposts.
- Timbre—becomes a central part of the improvisational process. Musicians manipulate the sound of their instruments to exaggerated degrees in order to create new expressive sounds. Squeaks, squawks, honks, and growls are fair game. Musicians often play out of tune on purpose to create a new color.
- Instrumentation—Can include any group of musical instruments, but most common are the typical jazz quartet or quintet setting (saxophone and/or trumpet, drums, bass, piano and/or guitar).

Avant-garde jazz took on many titles—the New Thing and Energy Music—but one term came to be used most often, and appropriately so. **"Free jazz"** describes the musicians' objective to cast off musical rules and explore new territory. There was also a societal meaning that identified with progressive social philosophy that linked jazz to the African-American story during the Civil Rights Era. In fact, the element of freedom in jazz had always been a metaphor for the plight of Negroes in American society at large. Now an argument came together among avant-garde jazz musicians that white businessmen and critics had controlled jazz over the course of the 20th century and had judged the musicians by Anglo-American standards. For many, free jazz was a way to shake off the expectations of the music business.

In the late 1950s and '60s, forward-thinking jazz musicians made a renewed commitment to the notion of art for art's sake. This was not art meant to entertain crowds of dancers or to subtly highlight the ambience of a room (when was the last time you heard free jazz playing in the background at your favorite restaurant or coffee shop?). As bebop is often compared to the modernist painters Pablo Picasso and Georges Braque, whose experiments in cubism twisted visual reality, avant-garde jazz moves further toward the abstract, seemingly trying to create something from nothing like the controversial New York City drip painter Jackson Pollock. In classical music, we find a parallel to free jazz in the composers whose works espoused atonality, or the avoidance of resolution to any particular tone. Arnold Schoenberg devised a system called **serialism** wherein the composer would construct a set of pitches before starting a composition. The set of the pitches avoided the repetition of any single pitch, thereby equalizing the importance of all pitches in the set. The composer then based his or her melody and harmonic background aspects of the piece on the original set of pitches, resulting in a musical work that avoided any sense of major/minor mode or central pitch while it maintained unity across the composition by using the set throughout the work. It avoided the established musical values in order to attempt to create new ones.

Avant-garde jazz represents a re-evaluation of fundamentals of music, set forth in Appendix A and the first couple chapters of this book. It is true; we do make judgments about jazz music based on classical standards of melodic construction, harmonic progression, and the quality of sound. But jazz scholarship today encompasses standards of raw expression and freedom, largely as a result of the work of artists like Ornette Coleman, Cecil Taylor, and Albert Ayler, and more mainstream artists like Miles Davis and John Coltrane who incorporated the experiments of the avant-gardists into their performances and musical recordings under the auspices of blue-chip record companies.

The **Five Spot** was a nightclub in New York City that, in 1959, had become a gathering space for avant-garde musicians, artists, and those who appreciated their work. The Five Spot hosted important cutting edge musicians like Cecil Taylor, Thelonious Monk, John Coltrane, and Ornette Coleman's Quartet for extended residencies.

ORNETTE COLEMAN

Ornette Coleman had a productive 1959. His acclaimed album *The Shape of Jazz to Come* and controversial appearances at the **Five Spot** in New York City were catalysts for the budding avant-garde movement. Hailing from Los Angeles, his quartet performed with an instrumentation similar to Gerry Mulligan's piano-less quartet, but the collective sound produced by Coleman's plastic alto saxophone, Don Cherry's pocket trumpet, and

bassist and drummer Charlie Haden and Billy Higgins couldn't be further removed from Mulligan's refined bebop approach. Coleman's band seemed to play *against* each other more than they played *with* each other. Although the music was rehearsed and organized to some extent, Ornette's band was full of jagged lines and ragged edges. The sound of Coleman and Cherry playing in quasi-unison could be offensive to anyone with an ear remotely trained to appreciate good intonation, in-tune playing. But with patience, the listener could appreciate the great emotional depth hidden in the imperfections. This was music linked to African-American roots, to the blues, but in a different form than the hard bop and soul jazz artists

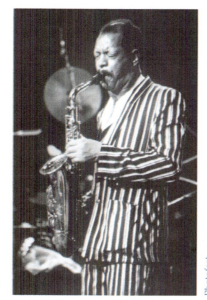

Ornette Coleman

had propagated. Howls emitted from Coleman's horn that seemed to channel the untarnished Texas blues of yesteryear. And up-tempo, bop-like melodies sounded like a reimagining of the catch-me-if-you-can lines of Charlie Parker. So he was in the tradition at the same time that he was out of it. Reactions were harsh from Miles Davis, Roy Eldridge, and other established jazz musicians, but enough informed listeners were so refreshed by Coleman's "New Thing" that he was encouraged to push on forward. Coleman's album titles indicated his willingness to double down on the avant-garde—*Change of the Century, Tomorrow is the Question.* Indeed, it is hard not to read the title of the album recorded after the Five Spot gig—*This is Our Music*—without stubborn emphasis on the "our." As in, "not your."

Free Jazz: A Collective Improvisation

In December of 1960, about a year after his pivotal gig at the Five Spot, Coleman entered the studio with a new idea. Called *Free Jazz: A Collective Improvisation*, the album consisted of just two tracks, one for each side of an LP—the main "Free Jazz" track, and an alternate take. Although not completely devoid of structure, the vast majority of the album is a free improvisation between members of a **double quartet**. The two quartets were separated between the left and right stereo channels. There were two drummers, two bassists, two trumpets, and Coleman's woodwind counterpart, Eric Dolphy, played the bass clarinet, an instrument rarely heard in jazz. The music reaches our ears like some kind of a game, and in fact, that may be the best way to enjoy it. The musicians respond to each other, sometimes in truly collective improvisation, sometimes by playing improvised background figures to a counterpart's solo. The drummers create a wash of urgent noise, sometimes responding and sometimes ignoring. Listening closely, a medium-fast pulse unifies the players throughout the piece, but it is hard to tell who is laying down the pulse at any given moment, who is playing double-time, and who is making an ornery attempt to obscure the pulse altogether.

Music Analysis

"Free Jazz"
(1960)
Personnel: split between two stereo channels

Left channel: Ornette Coleman, alto saxophone; Don Cherry, trumpet; Scott LaFaro, bass; Billy Higgins, drums
Right channel: Eric Dolphy, bass clarinet; Freddie Hubbard, trumpet; Charlie Haden, bass; Ed Blackwell, drums

"Free Jazz" requires patience of the listener. At thirty-seven minutes, it is almost inconceivable that today's listener would be able to focus on the work, but if you can make it, the musical pay-off is great! The play-by-play below will only provide you some landmarks, naming which musician has the focus. The structure of this composition is held together not with a melody, but with a series of shapes played at the outset of the recording. The listener will hear a few seconds of fast, collective improvisation. Then the horn players play long, gliding notes that create extremely dissonant sonorities. The musicians are playing rhythmically together but each is choosing his own pitch.

Throughout the work, listen for the drummers' and bassists' pulse. Listen for the **collective backgrounds**. (During solos, other instruments enter freely with musical commentary on the solo, sometimes arriving at interesting junctures).

Ask yourself the following questions as you listen: Does this music swing? Do I hear the blues?

0:00	**A Theme, part 1:** A shape, or gesture, of fast and random notes come together at 0:06 with a long string of high, dissonant, sustained pitches.
0:06	**A Theme, part 2:**
0:20	**Bass clarinet solo:** Eric Dolphy, with occasional background improvisation from other players.
5:09	**Theme:** Long, dissonant notes based on the opening material. Fast, intense collective improvisation. Then a final long tone.
5:39	**Trumpet solo:** Freddie Hubbard.
9:40	**B Theme:** After another series of long, dissonant notes, a new theme is introduced, played in unison by the horns.
10:03	**Alto saxophone solo:** Ornette Coleman.
19:34	**B Theme:**
19:44	**Pocket trumpet solo:** Don Cherry.
25:18	**B Theme:** A fragment from the last portion of the melody.
25:24	**Bass solo:** Charlie Haden.
29:49	**A Theme:** Just one long note refers to the opening material.
29:59	**Bass solo:** Scott LaFaro.
33:44	**A Theme:**
33:59	**Drum solo:** Ed Blackwell emphasizes the drums, not the cymbals.
35:16	**A Theme:** Again, just one long note.
35:25	**Drum solo:** Billy Higgins emphasizes the cymbals.
36:30	**A Theme:** Played in its entirety to end the piece.

Harmolodics and Coleman's Lifetime of Experimentation

After *Free Jazz*, Coleman retreated from the limelight. He continued to record and perform music in the line of *Free Jazz* and *Shape of Jazz to Come*, but he tried his hand at a number of other outlets as well. Coleman made attempts at setting up his own publishing company and opening a jazz club. He practiced the trumpet, violin, and guitar. He composed music for woodwind quartet and string quartet. He composed an orchestral work "Inventions of

Symphonic Poems," funded by a Guggenheim fellowship. These orchestral pursuits resulted in an ambitious album, *Skies of America*, recorded with the London Symphony Orchestra in 1972. In the liner notes, he introduced a theoretical concept of his invention titled "**harmolodics**," a word that combined harmonic, melodic, and motion. Harmolodic theory represented the movement of melody, harmony, instrumentation and other musical aspects in such a way that none of them had primacy over another. The concept could apply both to orchestration and improvisation. Musicians were encouraged in harmolodic music to transpose written music to other keys or registers. [It is important to note that *Skies of America* does not render Coleman's harmolodic music exactly as he intended it. His record company allowed only Coleman to appear with the symphony orchestra, but Coleman wrote the piece for his entire jazz quartet backed by the orchestra. The piece was only heard in its completion during concert productions.]

Coleman formed a quartet with electric instruments in the 1970s called Prime Time. Members of Prime Time went on to make their mark on the avant-garde in unique ways, players such as drummer Ronald Shannon Jackson and guitarist James Blood Ulmer. *Dancing in Your Head* (1975) features his unique take on jazz-rock fusion. *Song X* (1985) is among Coleman's most notable works in the later part of his career. The collaboration with top jazz guitarist Pat Metheny brought the two masters together with an interesting cast of sidemen. Bassist Charlie Haden had made the trip to New York from Los Angeles with Coleman more than twenty years earlier, and drummer/percussionist Denardo Coleman had accompanied his father on his recordings since the 1960s. Drummer Jack DeJohnette was a first-call studio jazz musician who, since his work with Miles Davis and Bill Evans in the '60s and '70s, had come to embody the bridged gap between the avant-garde and mainstream.

Coleman remains a towering figure of influence. In 2007, he was awarded a Grammy Lifetime Achievement Award and received the Pulitzer Prize for his recording *Sound Grammar*.

CECIL TAYLOR

Although Ornette Coleman is often considered the "Father of Free Jazz," pianist **Cecil Taylor** was making real waves while Coleman was pulling together his first rehearsal sessions. Taylor's upbringing in music was totally different from Coleman's. While Ornette was largely a self-taught musician from Texas who improvised and composed captivating works that operated outside the fundamentals of western European music, Cecil Taylor was raised in the Corona neighborhood of New York City, the jazz capital of the world. He took piano lessons at age five and studied percussion as well. He attended the New England Conservatory of Music and, although embittered by the school's indifference to African-American music, he persevered and graduated. He focused on traditional classical piano repertoire such as the works of Bela Bartók, Arnold Schoenberg, Anton Webern, and Igor Stravinsky, all of whom explored atonality and other advanced musical concepts. He worked as a freelance jazz pianist during vacations from the Conservatory, hired at one point by Ellington's alto saxophonist Johnny Hodges, but he had difficulty finding other musicians who understood his eccentric style. One bandleader said Taylor couldn't play

the blues. Truthfully, he sounds on early recordings as if he is striving to force together the classical and jazz traditions.

Taylor has claimed that his style was formed in 1954, and in 1956 we hear evidence of an avant-garde piano style deeply influenced by contemporary classical piano repertoire on *Jazz Advance*, a live album recorded in Boston. His solos explore **polytonality**, the superimposition of multiple keys simultaneously, and a staccato touch that reminds the listener more of classical piano virtuoso than a jazz piano player like a Oscar Peterson or a Bill Evans. *Jazz Advance* and a 1956 stint at the Five Spot won him a showcase at the 1957 Newport Jazz Festival. But until 1960 he largely had to support himself with dishwashing jobs while he experimented in the Greenwich Village club scene. He began working with like-minded musicians in the '60s who helped push him further outside the box, musicians like alto saxophonist Jimmy Lyons, drummer Sonny Murray, and future John Coltrane collaborator, tenor saxophonist Archie Shepp.

> **Polytonality**—The simultaneous existence of more than one tonal center.

Taylor's style reached a mature state on his 1966 album *Unit Structures*, titled for Taylor's theoretical concept. Taylor used an unconventional method to compose and distribute music to his musicians. He avoided the traditional system of musical notation, preferring instead to sketch out musical ideas in shapes and fragments. Then, he did not show the shorthand sheet music to the musicians. He played each fragment (or "unit") for the players and expected them to remember and improvise on the material. Taylor believed Western musical notation took musician's focus away from the actual process of making music. His **unit structures** were a series of melodic shapes through which the band would progress in its own time. A composition might involve several of these units, in contrast to the structure of conventional jazz and even Ornette Coleman's music, which typically began with a head melody and moved on into a series of solos based on that melody or its chord progression.

After recording *Unit Structures* and a follow up album *Conquistiador!*, Taylor largely disappeared from view, moving to the Midwest to take college teaching positions. He found his way back to New York in 1973, resuming musical performance activity supported by grants from the National Endowment for the Arts and a Guggenheim fellowship. He has continued to perform in the ensuing years in solo and small group settings.

ERIC DOLPHY

Eric Dolphy emerged as a leading musician and composer after working with Ornette Coleman on *Free Jazz*. A child prodigy on the clarinet with extremely diligent practice habits, Dolphy won a scholarship to study music at the University of Southern California while still a junior high school student. He played jam sessions with Charles Mingus and pianist Hamilton Hawes, played alto saxophone in the notable big bands of Gerald Wilson and Roy Porter, and toured with Chico Hamilton's small group performing on flute and bass clarinet.

He moved to New York City in 1959 and began working with Charles Mingus and John Coltrane. Dolphy's contributions to the avant-garde were an expansive range, featuring extremely wide intervals in his solos and compositions. After recording albums whose titles *Outward Bound* and *Out There* made clear his avant-intentions, his 1964 recording *Out to*

Lunch was a triumph, one of the definitive albums of the genre. Dolphy's compositions leave plenty of room for playful experimentation for his all-star line up of musicians.

Eric Dolphy's death was a surprise to everyone who knew him. While on tour in Europe with Charles Mingus just a few months after recording *Out to Lunch*, he fell unconscious and went into a diabetic coma, dying at the age of 36.

Music Analysis

"Hat and Beard"
(1964)
Personnel: Eric Dolphy, bass clarinet; Freddie Hubbard, trumpet; Bobby Hutcherson, vibraphone; Richard Davis, bass; Tony Williams, drums

From *Out to Lunch*, "Hat and Beard" is Eric Dolphy's tribute to Thelonious Monk. The song is based on an ostinato of nine quarter notes that delineates the song's meter into 9/4 time. The head is a series of variations on the ostinato, then soloists improvise freely over the tune's two chords.

0:00	**Head, part 1:** Richard Davis plays the ostinato as a walking bass line. Tony Williams plays a basic ride pattern while the remaining members play interruptive gestures.
0:16	**Head, part 2:** Dolphy joins the bass line and Williams plays a drum solo, thoughtfully orchestrating ideas around the drums. After Williams fades, Hutcherson's vibraphone plays the ostinato loudly.
0:55	**Head, part 3:** Hubbard and Dolphy play a harmonized, circus-like theme, still based on the ostinato. Then they play the ostinato repeatedly in short notes.
1:26	**Bass clarinet solo:** Dolphy blasts into a barrage of extremely fast lines reaching to the lowest and highest ranges of his bass clarinet at the onset of his solo. He continues the exploration of extremes of the range throughout the solo and uses split tones and other various effects.
3:15	**Trumpet solo:** Hubbard's solo contrasts Dolphy's, surprisingly showing a bit more restraint. He opens with long tones and works his way into a frenzy of melodic phrases. Tony Williams interacts with soloistic drumming ideas to the point of collapse.
5:19	**Vibraphone solo:** Hutcherson picks the momentum where Hubbard and Williams left off. Tony Williams switches from using sticks to brushes and Richard Davis bows double stops on the bass.
7:30	**Head, part 3:** The horns bring back the closing section of the head, then cycle through other versions of the ostinato.

THE CHICAGO FREE JAZZ SCENE

In the mid-1960s, organizations sprang up in New York, Los Angeles, and Detroit to advocate for the avant-garde in jazz. By far, the most successful support group was the **Association for the Advancement of Creative Musicians** (AACM) in Chicago. In 1965, the AACM began helping to organize and promote performances and rehearsal spaces, provided funding for recordings, and gave music lessons to children. Its leader, pianist Muhal Richard Abrams, founded the movement with a large collection of musicians called the Experimental Band. Several of the most important free jazz musicians of the coming years like Lester Bowie, Anthony Braxton, Joseph Jarman, and Roscoe Mitchell got their start in AACM groups. Generally speaking, the Chicago approach to the avant-garde was inclusive to

extremes. An eclectic mixture of musical styles and other performance arts found their way into Chicago free jazz performances. Blues, minimalism, R & B, various instrumental sounds, dance, stagecraft—anything was fair game in the Chicago field of expression.

The **Art Ensemble of Chicago** was a flagship band that emanated from the Chicago support group. Lester Bowie's trumpet was the most prominent force in Art Ensemble performances, playing a panoply of musical styles from early New Orleans to bebop and beyond. The Art Ensemble typically performed with a host of percussion instruments on stage, and the members dressed in costumes and wore face paint, adding a visual component to their work. The group won international fame in Paris during a 1969 tour.

Sun Ra's brand of avant-garde music had an interplanetary element. Originally named Herman Blount, Sun Ra formed a highly eclectic band in Chicago called the Myth-Science Solar Arkestra, or the Astro Infinity Arkestra, and claimed to have either come from, or been abducted to, the planet Saturn. The Arkestra played a mixture of swing, R & B, free, electronics, and world music styles, often with costumes, dancers, and various facets of multi-media. Surprisingly for such a bizarre figure, Blount was grounded in the swing tradition, having worked briefly as a pianist for Fletcher Henderson. His body of work until his death in 1993 is impressive in its breadth and its bravery.

Anthony Braxton is an extremely prolific composer, writing for a wide variety of instrumentation settings that includes music for four orchestras, one orchestra, string quartet, two pianos, five tubas, jazz quartet, a duo with Muhal Richard Abrams, and that only scratches the surface. Braxton joined Chick Corea in the mid-1960s playing with his free jazz group, *Circle*. A saxophonist, Braxton benefitted from the AACM's policy that all members should be composing new music, as opposed to performing standards.

POST-BOP

The term "post-bop" is somewhat a catch-all phrase used to classify small-group jazz from the 1960s and beyond that incorporates a broad array of advanced musical concepts. Built on the foundation of bebop, post-bop reflects various aspects of the avant-garde without abandoning tradition completely. It largely grows out of the paths taken by Miles Davis, John Coltrane, and a few others associated with them in the 1960s that incorporated various elements of new music. Harmonies were built on modality and a new library of harmonic structures like **slash chords**, which imposed a bass note other than the chord root. Rhythm sections addressed the flexible, **open time** feel introduced by Paul Motian and Scott LaFaro with Bill Evans. They used open time as a departure point for new exploration in time and pulse, often using rhythmic ambiguity as a way to build tension in the music. Post-bop bands were particularly influential to other jazz musicians. A significant proportion of today's modern jazz artists look to the John Coltrane Quartet and Miles Davis Second Great Quintet as high water marks in the evolution of jazz artistry and return to these bands' recordings time-and-again for inspiration.

Slash chord—A harmonic structure that consists of a conventional chord played on top of an alternate bass note, usually a note not in the chord.

Open time—A rhythm section style in which a drummer, bassist, and chordal instrumentalist will play rhythms that obscure the underlying rhythmic pulse.

JOHN COLTRANE'S JOURNEY INTO THE AVANT-GARDE

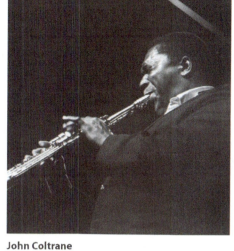

John Coltrane

Coltrane's embrace of the avant-garde was a controversial step in his career, and a validation of sorts for the avant-garde movement. Coltrane forged a career in mainstream jazz beginning in the mid-1950s as an MVP sideman performing with Miles Davis and Thelonious Monk and a top-shelf recording artist whose work as a leader culminated with *Giant Steps* in 1959. On subsequent recordings, his style began to shift toward an open approach. *My Favorite Things* (1961) documents this turning point in the title track, a Rogers and Hart song from the musical *Sound of Music*. Concert videos of the new John Coltrane Quartet performing the song display the band's ability to inject an incredible amount of intensity into the originally pleasant song.

"My Favorite Things" is just one of several occasions that Coltrane uses ordinary musical material as a springboard for his emotionally intense brand of musical virtuosity. The band lopes and lilts across the 3/4 meter, and the chord progression of the original song is largely reduced to a series of shifting **pedal points**, chord motion that occurs over one long bass note. Coltrane's use of pedals in his music draws him closer to the modal jazz approach he helped define with Miles Davis on *Kind of Blue*. He also introduces the straight soprano saxophone on this recording, an instrument that had been somewhat of a novelty and not used in a notable capacity since Sidney Bechet. The shrill timbre of the soprano saxophone maximizes Coltrane's intense, heavy-blowing tone.

Coltrane signed with a new record company in 1961, Impulse! records, and became the second highest-paid jazz musician of the day behind Miles Davis. He recorded highly acclaimed albums in collaboration with Duke Ellington and vocalist Johnny Hartman. In 1965 he released a capstone album that solidified his approach on *A Love Supreme*, an album dedicated to his Creator, whom he credited with being his inspiration for escaping his struggles with drug addiction earlier in his career. Spurred on by a new group of sidemen, the John Coltrane Quartet played jazz with unmatched conviction and originality. **McCoy Tyner**, a pianist from Philadelphia, first played with Coltrane as a teenager. Tyner, whose contributions to the art of modern jazz piano elevate him to the precipice shared by Bill Evans and Herbie Hancock, ushered in a wholly new sound in jazz piano. His two-handed approach landed heavy sustained chords, often with open fifths in the bass and **quartal** voicings in the top. He superimposed chords from outside the key and took flights of angular Coltrane-esque lines in his right hand, exploring eighth-note, triplet, and double-time rhythms with a high degree of mastery.

Elvin Jones added fuel to the fire from behind the drum set. Like Tyner, Jones had a completely singular approach to drumming characterized by a loose and varied ride cymbal beat, dense comping rhythms and rolls between his snare and bass drum, and joyous polyrhythms that thundered across bar lines. Growing up around Detroit, Elvin Jones's brothers—trumpeter Thad and pianist Hank—had both established themselves among the elite jazz groups around New York before Elvin arrived

> **Pedal point**—A pitch sustained during active musical material. The term refers to the pedals of pipe organs, which can be held down while the player's hands continue on the keyboards above. In contemporary music, bassists often use the pedal point as a device to create musical tension.

> **Quartal**—Melodic or harmonic structure comprised of intervals of a perfect 4th.

Photofest

in 1956. More than either of his brothers, Elvin seemed to delight in rewriting the rulebook of how his instrument should be played. Like McCoy Tyner, Elvin Jones is one of very few instrumentalists whose sound is instantly recognizable. Bassist **Jimmy Garrison** was an often-unheralded member of Coltrane's quartet, but his solid and forceful playing provided an invaluable anchor to the fluid rhythms and adventurous play of the other three.

Music Analysis

A Love Supreme: "Part 2 – Resolution"
(1965)

Personnel: John Coltrane, tenor saxophone; McCoy Tyner, piano; Elvin Jones, drums; Jimmy Garrison, bass

In this second movement of the *A Love Supreme* suite, Coltrane's band swings vociferously underneath his folksong-like melody, a form consisting of three very similar eight-bar phrases. Coltrane creates some remarkable special effects on his instrument, using the high **altissimo** register of the saxophone (at 5:30), and wailing long tones that split his tone in to two pitches with **multiphonics** (at 4:30 and 5:30). Both Coltrane and Tyner use an "inside-outside" approach in their solos, creating tension by moving outside the key.

0:00	**Bass solo introduction:** Jimmy Garrison plays a series of **double stops**, two notes at once, that establish the key and rhythmic feel of the song.
0:20	**Head:** Elvin Jones and McCoy Tyner come crashing in with an open swing feel as Coltrane plays the melody with intense passion. He then improvises over two eight-bar sections, then bringing back the full head a final time.
1:47	**Piano solo:** McCoy Tyner slows the momentum in the beginning of his solo, but follows with a succession of single-line phrases and chordal patterns substituting new harmonies over the song's basic mode.
3:56	**Tenor saxophone solo:** Coltrane covers a wide range of ideas in this simple setting, playing over basically one mode. He constructs lyrical melodies, builds acrobatic patterns on just a few notes, plays both inside and outside the key, and plays the full range of the horn.
6:24	**Head:** Coltrane signals the ending returning to the soaring melody.
6:53	**Tag ending:** The band repeats the last two bars of the melody and then arrives at a final sustained chord. Jones punctuates the end with a press roll into a cymbal crash.

Not long after recording *A Love Supreme*, Coltrane renewed his commitment to the avant-garde. Where *A Love Supreme* brought the quartet to the edge of free jazz, *Ascension* (1966) had complete freedom as its starting point. It signaled the stylistic shift of Coltrane's late period, a musical style wherein the saxophonist seemed to meditate through his instrument (indeed, one of Coltrane's late recordings was titled *Meditation*). This was not experimental music for the sake of experimentation; it was a transformative music. Coltrane was particularly influenced by the dissonant and unrestrained music of Albert Ayler, a saxophonist whose avant-garde works had an explicit spiritual component. Coltrane studied a wide variety of religious traditions and philosophical schools of thought. Music, for him, was an outlet of his search for truth. The *Love Supreme* quartet joined Coltrane on *Ascension*, but he augmented the group with Art Davis, a second bassist, and a large group of winds that included some of the prominent free jazz musicians of the day, most notably tenor saxophonists Archie Shepp and Pharaoh Sanders. Coltrane recorded extremely frequently

during the last years of his life, making so many recordings during the couple years of his life that Impulse! was still releasing new material several years after his death from liver cancer in 1967. Coltrane's influence looms large on the contemporary jazz field as one of the patron saints of spirituality coupled with virtuosity in music.

Music Analysis

Ascension: "Edition II"
(1965, released 1966)
Personnel: Freddie Hubbard and Dewey Johnson, trumpet; Marion Brown and John Tchicai, alto saxophone; John Coltrane, Archie Shepp, and Pharaoh Sanders, tenor saxophones; McCoy Tyner, piano; Elvin Jones, drums; Jimmy Garrison, bass; Art Davis, bass

MILES DAVIS'S SECOND GREAT QUINTET

One of Ornette Coleman's most outspoken critics, Miles Davis surrounded himself with a new crew in 1963 that helped him to stay on the cutting edge by referencing the work of Ornette Coleman without diving into the disorder he so disliked in free jazz. He proved his talent for discerning great potential in his sidemen when each of his new musicians turned out to be a cornerstone artist on his instrument. The four newcomers were far younger than Miles and kept him on his toes. Drummer Tony Williams was the youngest member, joining at age 16. The oldest member of the rhythm section, bassist Ron Carter, was in his mid-twenties.

Miles's new rhythm section completely reshaped the style of jazz for the post-bop generation. Pianist **Herbie Hancock**, drummer **Tony Williams**, and bassist **Ron Carter** started by jamming in Miles's home, and soon they appeared on half of the tracks on Miles's new album *Seven Steps to Heaven*. Although the playing on *Seven Steps* is timid compared to their later work, the new rhythm section was clearly on to something, and on the road they would develop an adventurous approach to rhythm section interaction. Schooled in bebop and hard bop styles and able to replicate the sound of Miles's previous rhythm sections, they were an incredibly innovative group with un-

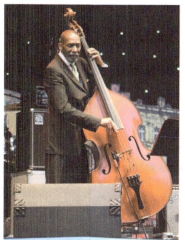

Ron Carter

PhotoHouse/Shutterstock.com

canny telepathic powers. At live performances, Miles only played a few of the compositions featured on the new studio recordings and instead preferred to form most of his set list from the well-worn standards he had been playing for several years, songs like "If I Were a Bell," "My Funny Valentine," and "Walkin'." Hancock and Williams could line up rhythms together like no other piano/drums pair, and the three rhythm section players could rearrange Miles's standard repertoire with a slew of

rhythmic grooves and chord substitutions. During a break at a nightclub gig in Chicago, Tony Williams proposed that the band should break away from the style of previous quintets with Wynton Kelly and Red Garland on piano, instead playing "anti-jazz." The goal was to avoid hooking-up with each other rhythmically and create tension and contrast instead.

Herbie Hancock was recognized as a prodigy in his hometown of Chicago, performing a Mozart piano concerto with the Chicago Symphony Orchestra at age eleven. Before joining Miles, he had already performed with Eric Dolphy, Donald Byrd, and recorded an album *Takin' Off* under his own name for the Blue Note label. He was influenced by modern pianists Bill Evans and Oscar Peterson and infused the quintet's sound with impressionistic chord voicings and a refined rhythmic approach that complemented Tony Williams's progressive drumming. Under Miles's leadership, Hancock experimented with the pianist's role, laying out for extended periods of time and incorporating ultra-modern harmonic concepts.

Miles Davis recorded compositions by every sideman, but tenor saxophonist **Wayne Shorter** composed the vast majority of the quintet's recorded output. Shorter had honed his composing craft while he served as musical director for one of Art Blakey's finest lineups. He said that Miles reworked each of the young composers' pieces in the studio, usually dissecting and preserving only the essence of a song, its most important musical features. Miles and Wayne Shorter played on the frontline together in a fashion that echoed the loose unison approach of Ornette Coleman and Don Cherry. They tended to begin and end melodies at different times, each playing only a part of the written melody, and played slightly out of tune from one another. These had been hallmarks of Ornette's groups, heard on *The Shape of Jazz to Come* and *Free Jazz: A Collective Improvisation*. But unlike Coleman and Cherry, Miles and Wayne had both developed approaches to improvisation that, while intensely personal, sounded more in touch with the hard bop norm. The quintet recorded an impressive array of recordings between the years 1963–1968—*E.S.P.*, *Miles Smiles*, *Sorcerer*, *Nefertiti*, and *Filles de Kilimanjaro*.

"Footprints" was a composition Wayne Shorter wrote when Miles asked him for a song he could play live, a song that was simple to play and easy to memorize. It is a conservative, but highly original piece that packs great potential for expression and improvisation. Written in 6/4 time (with six pulses in every bar), the work is actually a minor blues with a repeated bass ostinato and a haunting, hovering melody. The track shows the quintet at its most interactive and responsive. Listen, in particular, to the rhythm section's move from one meter to the next, a technique called "**metric modulation**." The pulse moves faster or slower using a mathematic relationship, fitting four beats or eight beats in the space of six. Metric modulation had technically been used since jazz musicians began playing double-time, or a 2:1 ratio of time. But the Miles Davis Quintet took the idea much further in its incessant quest to disguise the pulse.

Metric modulation is an aural *illusion*. The division of the measure is changed by mathematic relationships so that beat "1" arrives at the same rate, but the other beats shift to a faster or slower rate. For example, quarter note = 120 beats per minute to quarter note = 80 beats per minute. Ratio 3:2.

Music Analysis

"Footprints"
(1966)

Personnel: Miles Davis, trumpet; Wayne Shorter, tenor saxophone; Herbie Hancock, piano; Tony Williams, drums; Ron Carter, bass

"Footprints" is one of the most often performed jazz standards. Instances of metric modulation add an element of surprise to this recording, but listening carefully, we can hear a kind of game plan emerge. The ninth bar of every 12-bar chorus acts as a pivot point where one or more players introduce a new tempo and is either joined by the other players, or rebuffed to return to the original tempo.

0:00 **Introduction:** Ron Carter repeats the bass line of the song. Williams and Hancock enter at 0:07 with floating straight eighth ride cymbal and colorful piano voicings.

0:23 **Head:** Miles and Shorter play the head in parallel fourth intervals, repeating twice. Tony Williams increases activity on the cymbals, opening and closing the hi hat and eventually shifting to a double time ride pattern.

1:12 **Trumpet solo:** Davis leaves a great deal of space between melodic phrase, exposing the rhythm section. Ron Carter maintains the bass line, but uses the ninth bar of each chorus to shift briefly to new tempos, first to double-time (1:29), then to 4/4 swing (1:54). Williams forces a full metric modulation into a double time four feel (8/4) at the next chorus (2:18), which remains the pulse for most of the remainder of the song. All the while, Miles and his rhythm section respond to each other through color and volume changes. Miles quotes Duke Ellington's "Rockin' in Rhythm" at 3:34.

4:15 **Tenor saxophone solo:** Miles plays a few bars into the beginning of Wayne's solo. The rhythm section maintains the 8/4 pulse using Latin-tinged grooves, occasionally dropping back to half time 4/4.

6:12 **Piano solo:** Hancock plays a brief solo full of his unique chord voicings, with offbeat rhythms, at times playing what sounds like an atonal, a-rhythmic Cuban piano pattern called "montuno."

7:17 **Head:** Davis and Shorter return with the melody and play it three times. Williams stays aggressive this time, maintaining the 8/4 feel. The horns stretch the rhythm of the melody out of its place on the third repeat.

8:24 **Drum solo:** What sounds like a miscued ending becomes a chance for Williams to break for the Latin rhythms and play a solo of various textures, crashing cymbals and rolling tom-toms.

8:59 **Head out:** Davis and Shorter return.

9:23 **Closing vamp:** Each member of the rhythm section morphs and slows his pattern, causing it to collapse and fade out.

Name _____ Date _____

Discussion Questions

1. In what ways did Ornette Coleman's music go against the conventional jazz style of the day?

2. How did free jazz relate to the classical music concept of serialism?

3. Listen to Eric Dolphy's "Hat and Beard" and Ornette Coleman's "Free Jazz." How did their avant-garde approaches differ from one another?

4. Who were the key musicians in the Chicago avant-garde scene, and what did each contribute to the style?

5. Compare and contrast the free jazz of Coleman and Taylor with the post-bop of Coltrane and Davis.

PART VII

Post-Modern Shake-Ups— (1970s–1990s)

CHAPTER 19

Rock, Funk, Psychedelic Music, and the Jazz Reaction

FUSION

Since the beginning of jazz, the genre has evolved by incorporating separate musical traditions into one. As the decades have passed, crossroads have seemed to have appeared at an accelerated rate. African music fused together with European in the days of slavery; spirituals, the vocal forms of slaves, blues, ragtime, and several other styles fused together to create jazz; bebop jazz fused together with soul and R & B to create soul jazz. Jelly Roll Morton said in his 1938 interview for the U.S. Library of Congress with Alan Lomax that a Spanish tinge was an essential ingredient, pointing to a Spanish or Caribbean element in the compound of early jazz.

In this chapter, we will cover:

- Fusion
- Miles Davis's *Bitches Brew*
- **Tony Williams** Lifetime
- **John McLaughlin**—Mahavishnu Orchestra
- **Wayne Shorter, Joe Zawinul, and Jaco Pastorius**—Weather Report
- **Herbie Hancock**—Headhunters
- **Chick Corea**—Return to Forever and Elektric Band
- Other developments in the 1970s
- Music Analysis—**Dexter Gordon**

In the late 1960s and early '70s, jazz musicians again incorporated what they heard around them into a new form. The American teens and college students were listening to rock and funk music, following their favorite bands with great fervor. Meanwhile, jazz seemed to be dying. Miles Davis feared it was "withering on the vine." Not since the Swing Era had a critical mass of listeners and patrons bought enough jazz records to pull it into the popular sphere. At least, not for long. Dave Brubeck's and Paul Desmond's "Take Five" had been a huge jazz hit, and bossa nova had knocked off a number of mainstays on the Billboard charts. But jazz largely survived on the fringe of the music industry. Since bebop it was viewed as an elite artistic triumph, but only briefly found its way onto the soundtrack of everyday American life. Miles was seeing his audiences dwindling. Columbia Records was making moves to cater to the young record-buyers and concert-goers by making contracts with jazz-influenced rock bands Chicago and Blood, Sweat, and Tears. The motives for jazz's fusion with rock and funk in the 1970s were a healthy mixture of commercial and artistic.

In the new jazz of the seventies, the mixture of styles was broadcast loud and clear. It was named "**fusion**," borrowing its name from the field of nuclear physics where the term describes a process that creates energy from fusing one hydrogen nucleus with another. Like in jazz, the scientists who developed nuclear fusion were gaining ground and accelerating toward new discoveries throughout the 20th century. The ultra-destructive nukes of WWII had provided a springboard for experimentation that led to the *tokamak* in 1968, a device in Russia that pointed the way forward for humankind's ability to control the fusion process and create unprecedented amounts of energy. The musicians who created jazz fusion must have been struck by the incredible energy put off when jazz collided with the electric sounds of funk.

But not all critics were impressed. Even though anyone who studied jazz history with an ounce of depth could have predicted the tendency of the music to evolve through a mixture of styles, this new sound shocked a conservative class of critics and musicians. Jazz had sold out, they said. It valued virtuosity and showmanship over melody. For them, the new jazz style too quickly shelved the acoustic instruments and swinging rhythms of swing, absorbing the electronic instruments and repetitive rock beats heard in pop music. The new debate between the fusion crowd and the protective classicists largely echoed a similar one that happened in the 1940s between the Moderns (those who embraced bebop) and the Moldy Figs (those who didn't).

The Moldy Figs had a point. The sound of fusion was not a gradual move forward of creeping evolutionary steps. It was a brave new art form. If the central characteristics of jazz, set forth in Chapter 2, were a list of five commandments, some of them were bent, if not broken, by the new aesthetic. (It is important to note that the list of central characteristics of jazz has been rewritten over the decades to accommodate stylistic changes.) Most striking, *swing rhythm* was replaced by the teenage rhythm section approach of funk rock. Gone was the triplet-based stomp and bounce. Now, drummers pounded downbeats and backbeats and rhythm section improvisation happened inside a rock framework, leaving behind the bebop vocabulary that had become cliché to many young jazz musicians. Jazz forms led by harmonic changes were avoided in favor of bass lines that repeated to the point of hypnosis. And the timbre of jazz changed drastically from the warm sounds of acoustic bass and piano to the cutting edge of electric keyboards and electric bass. Drummers had already been increasingly soloistic, but now they beat the drums with force that had not been heard in jazz, and seemed (to the new Moldy Figs) to assault their eardrums. This was **fusion**.

MILES AGAIN—*BITCHES BREW*

Miles found himself at the forefront of the new trend, yet again. He did not invent fusion. Looking back at the 1960s several harbingers to fusion mixed rock, funk, and jazz in various ways. **Eddie Harris** emphasized *soul* more than most other soul jazz musicians in the mid-sixties. Vibraphonist **Gary Burton** and guitarist **Larry Coryell** released albums that incorporated rock sounds in varying degrees. Miles's drumming dynamo Tony Williams recorded his Lifetime band in 1969, and claimed to have invented fusion before Miles Davis. Count Basie's *Basie's Beatles Bag* (1966) did not pull the Basie band's style any closer to rock, but it certainly represented the willingness of even swing royalty to take new ideas from rock and capitalize on its ballooning record sales.

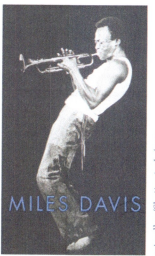

Miles Davis

Miles's music, however, is seen as the start point for fusion in part because his celebrity and musical legacy made him a lightning rod for public attention. Miles's penchant for fashion demonstrated his will to keep up with the hot trends of the day. He was jazz's trendsetter. He had defined *cool* in the 1950s, and he wanted to stay in front of the always-changing meaning of that word. Miles was ready to shift musical styles when he heard change in the air.

Miles's wife Betty Mabry introduced him to the guitar hero **Jimi Hendrix**, and the two developed a famed relationship of mutual respect and

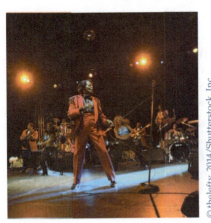

James Brown

planned musical collaboration. Listen for echoes of Hendrix's "The Wind Cries Mary" in Miles's "Mademoiselle Mabry" from his album *Filles de Kilimanjaro*. Miles was also listening in the late '60s to the funk music of **James Brown**, a style that complicated the incessant pulse of rock music with layers of rhythmic parts played by drums, bass, guitar, and a horn section that might only join up "on the one." The downbeat of every bar—the "one"—was strong in funk, but just about anything could happen in between. (Miles Davis stretched this idea to the max in his "Gemini/Double Image" heard on *Live Evil*, where off-beat rhythms are set up as rhythms where everyone must line up. Between those landmarks, everybody stretches out together in improvisation.) Syncopated 16th notes were split up between different members of the band, creating a popping popcorn background rhythm brought together by the full collective of the band. In jazz, inner rhythms had been passed between drummers, pianists, and guitarists for decades. But the jazz rhythm section improvised and changed its rhythms throughout a song. Funk was more akin to the approach of Latin bands that assigned a part to each instrument that would be repeated for long periods of time, not improvised. Miles talked in his autobiography about being struck by the audience size at a **Charles Lloyd Quartet** concert at the Village Gate in Greenwich Village, New York City. Lloyd's music was an early vamp-based style that featured his own young and talented sidemen, most notably pianist **Keith Jarrett** and drummer **Jack Dejohnette**. Both would soon join Miles Davis.

Rock festivals also encouraged Miles's stylistic shift. The Newport Jazz Festival, established by promoter George Wein as an anchor of high-quality jazz art, looked to rock and funk in 1969 to fill the seats. The festival's program that summer caused panic among the jazz community bringing Led Zeppelin, Jeff Beck, Sly and the Family Stone, Jethro Tull, John Mayall, and Frank Zappa & The Mothers of Invention into the fold along with blues acts B. B. King and Johnny Winter; and jazz groups led by Miles Davis, Dave Brubeck, Bill Evans, Sun Ra, Herbie Hancock, Gary Burton, Kenny Burrell, George Benson, Freddie Hubbard, Phil Woods, Anita O'Day, and Art Blakey. Pop and rock festivals were bringing in huge numbers that woke up the record industry to the potential of big bucks. Newport Pop Festivals in southern California drew in hundreds of thousands of people, and the 1969 festival at Woodstock, New York, drew 400,000.

Miles entered the studio in late summer 1969 to record *Bitches Brew*, an album that became the first largely successful fusion recording to date. Its first year sales figures of 400,000 were more in line with the expectations of the new rock music business. Even more impressive was the fact that *Bitches Brew* was released as a double album, a tough format to sell.

Miles had been signaling a move to R & B, vamp-based music on earlier albums (listen to 1968's *Miles in the Sky* and 1969's *In a Silent Way*, and even the simple chord changes used throughout *Kind of Blue* in 1959). But *Bitches Brew* was something new. A remarkable combination of instruments appears on the album—**Bennie Maupin** on bass clarinet, **Wayne Shorter** on only soprano saxophone, **Don Alias** and **Jumma Santos** on percussion, **John McLaughlin** on electric guitar, both acoustic and electric basses played by **Dave Holland** and **Harvey Brooks** respectively. **Jack Dejohnette**, **Lenny White**, and **Don Alias** shared the drum chair, and often

two drummers played at the same time. As many as three electric keyboards can be heard at any given time, played by **Chick Corea**, **Joe Zawinul**, or **Larry Young**. This massive band is expertly panned between left and right speakers to create a multi-dimensional sound. Producer **Teo Macero** worked with Miles almost as an equal partner. He would take several hours of studio recordings and splice them together into tracks that might last anywhere from four minutes to half and hour. He enhanced Miles's bare trumpet sound with cutting edge audio effects like reverb, echo, and slap delay. Miles's finger snaps on the title track at 2:51 reveal Macero's looping technique. The snaps mark time to the song's central bass line, then they stop while bass and bass clarinet play on. Macero repeats this material in a couple different ways—sometimes the repetitive snaps show up, sometimes only a snap on beat one. This illustrates how Teo Macero took a candid moment in the studio and created an extended vamp. **Looping** is commonplace today, particularly in hip hop music where a short rhythm section phrase is repeated underneath the rap.

> **Looping**—A technique utilized in urban musical styles—rap, hip hop, acid jazz, etc.—whereby a short sample of recorded music is repeated as an ostinato background.

Music Analysis

"Spanish Key"
(1970)
Personnel: Miles Davis, trumpet; Bennie Maupin, bass clarinet; Wayne Shorter, soprano saxophone; John McLaughlin, guitar; Dave Holland, bass; Harvey Brooks, electric bass; Lenny White, drums (left channel); Jack Dejohnette, drums (right channel); Don Alias, congas; Jumma Santos, shaker; Larry Young, keyboard (center channel); Joe Zawinul, keyboard (left channel); Chick Corea, keyboard (right channel)

0:00:	Drums set up the basic groove for the track. Listen for the eerie sound of Bennie Maupin's bass clarinet.
0:37:	The groove now established, Miles Davis's trumpet enters with the rising melodic line of six pitches, shadowed by echo effects.
1:16:	The harmony transitions to a new key during the last note of the melody.
3:14:	The band has built over a long two minutes, now arriving at a melodic hook that sets up the guitar solo.
5:18:	The melodic hook arrives again, and Miles enters with a bit of the melody.
5:40:	Wayne Shorter's soprano saxophone solo.
9:21:	Miles's melody returns, this time in its entirety.
9:50:	The band "stews" and plays off of each other. Miles plays a "di-dit" in the high register that is picked up by guitar and keyboards, spinning out a section of rhythm section jamming.
10:48:	Miles enters with part of the melody again, then plays another solo. (This time the band moves through the tune's key centers more quickly.)
13:53:	Form-ending melodic phrase is played again. This time, the keyboards play a kind of group improvisation, mostly dominated by Chick Corea.
15:06:	The rhythm section brings the volume down, setting up a solo from the bass clarinet.
16:53:	Miles enters quietly with the final head.
17:32:	The rhythm section stops somewhat abruptly. Miles can be heard talking to Teo Macero at the end of the track.

Miles's general concept of fusion slowed harmonic change to an extremely slow pace. Much like the music of James Brown would stay for several minutes on one chord and change to a second chord on Brown's "1, 2, 3, 4" cue, harmony in *Bitches Brew* is static. The pace of melody also slowed. Hyperactive melodies of bebop and singable blues hooks of hard

bop gave way to the other musical elements. Melody was still important, but it was often extremely simple and sparse. In fusion, rhythmic groove—ostinato—was the driving element. Momentum was created and tension built with texture, with a layering of instruments and sustained sounds. With *Bitches Brew* and his subsequent fusion recordings of the 1970s, Miles showed a path forward that held onto the creative edge of jazz and the suspense created by improvisation without allowing the music to be completely eclipsed by the music the new generation wanted to hear.

MILES'S SIDEMEN

Like Art Blakey's Jazz Messengers, Miles Davis's group acted as a prep-school for jazz bandleading. Miles's sidemen went on to front the most successful fusion bands of the 1970s. Keyboardists Herbie Hancock, Chick Corea, and Joe Zawinul all eventually left to front their own projects. John McLaughlin, Tony Williams, and Wayne Shorter did the same. Each one carried the Miles Davis sound to their next projects, but each of the major fusion bands had a unique sound and approach. Some carried the music further into the heavy rock sphere, some incorporated music from across the globe. Paramount with all the fusion groups was a high level of musical virtuosity and intense interaction among the musicians. Where Miles liked to create a group sound with thick textures and sustain hypnotic vamps that would sit for long periods of time, the youngsters tended to arrange intricate rhythms and show off their capabilities as individual musicians. Fusion quickly became a broad musical style due to the work of these Davis alumni.

We should also be careful not to pigeonhole these artists into only the fusion sub-genre of jazz. Each of these bandleaders made important albums in other styles of jazz as well, and many of them are still actively making music today. Some of those non-fusion projects will be discussed here.

Tony Williams's Lifetime

Tony Williams was a major force in Miles's bands of the mid to late 1960s. In his autobiography, Miles described Tony as the nucleus of the group. Even though Miles left plenty of room for experimentation, Tony's vision put the drums and percussion completely out front. In 1969, Williams formed a group of like-minded players, creating a drum-heavy and guitar-driven approach informed by the music of Jimi Hendrix, Cream, and early punk band MC5. Tony deliberately embraced the forceful approach of these rock bands into his new drumming style.

Williams's sidemen choices were striking. He formed the first Lifetime group as a trio with **Larry Young** on organ (covering the bass and chordal roles), and on a tip from bassist Dave Holland he brought guitarist John McLaughlin from England. The organ trio instrumentation was standard in the soul jazz subgenre, but instrumentation is where the comparison ends between Lifetime and the popular soul jazz groups led by Jimmy Smith and Jack McDuff. Larry Young's jazz records in the '60s showed a brilliant originality (his *Unity* is a classic recording); and McLaughlin would prove to be hugely innovative in the new jazz, playing with Miles Davis and forming his own groups. Young provided diversity in his

Music Analysis

"Spectrum"
(1969)

Personnel: Tony Willams, drums; John McLaughlin, guitar; Larry Young (Khalid Yasin), organ

From Tony Williams Lifetime's first release *Emergency!*, this track is a model of punk angst transported from fast funk to faster bebop tempos. The winding, disjunct melody (composed by John McLaughlin) is rhythmically off-putting and extremely challenging to play on guitar and organ. Listen for the influence of Jimi Hendrix in the jam sections between melodic statements. (Is this a sped up "Foxy Lady"?) Also listen to the way Williams drives the music forward in the fast solo sections with his "pulse" style, slamming the hi hat shut on every beat to free up his hands. Williams essentially solos behind the soloist in a dialogue that causes a dramatic arc with numerous rises and falls.

0:00	**Head:** The first melodic strain is played in unison by organ and guitar, over stoptime drums. The short snippet is followed by a few bars of aggressive funk, with crunchy guitar chords on the backbeat and soloistic drums.
0:06	**Head:** The second melodic strain transposes the opening melody upward the interval of a minor third, followed by another four bars of jamming.
0:11	**Head:** If the song has a bridge, this is it. A new melodic line is spun out of the opening material, rising like the first strain but then falling gradually with a four-note pattern. This style of composition (called **sequence**) was common to Baroque-era classical composers like George Frideric Handel, who would build a short melodic pattern from a few notes and then move it upward or downward in pitch.
0:18	**Head:** After four bars of jamming, the sequence returns from the last melodic line, placing a period at the end of the head.
0:20	**Guitar Solo:** McLaughlin opens the guitar solo with an ascending eighth-note line, then fluidly moves through a variety of melodic styles. He plays with motives of few notes, holds high shrill pitches, and winds through bebop-style melodic inventions. Williams drives the music with his hi hat on every pulse, and off-kilter licks played around the drums.
2:27	**Head:** McLaughlin abruptly leaves his solo behind and plays the opening melody.
2:46	**Organ Solo:** Larry Young opens his solo with triads that move in and out of the tune's established tonality. As in the guitar solo, Williams's constant exploration on the drums spurs Young's solo along.
5:19	Head: Young brings the melody back, completed by the rest of the band.
5:38	**Funk Collective Improvisation:** The band moves into a new key and extends the funk jam that split up the head. A straight-eighth bass line played in organ and guitar is reminiscent of bass lines that appear in Jimi Hendrix's music. Williams solos over the funk feel.
6:12	**Funk Collective Improv:** Larry Young sustains an upper voice **pedal point**, a common texture heard in soul jazz that also hearkens back to Baroque-era compositional techniques. John McLaughlin walks the eighth-note basslines up to a series of sustained oscillating chords. Williams builds the texture to a collective climax, bashing cymbals and rolling on the snare drum.
6:48	**Funk Collective Improv:** The tension is released by a return to the funk feel with off beats in the guitar. Williams briefly simplifies his playing, but launches into more soloistic ideas.
7:25	**Funk Collective Improv:** The band resets at a soft dynamic level and begins building toward another climax on a new sustained chord with pounding eighth-notes in Williams's drums and cymbals.
8:00	**Funk Collective Improv:** Jimi Hendrix guitar back beats return over a final drum solo.
8:26	**Head Out:** John McLaughlin signals the final return of the melody, joined by Williams and Young. The track ends on a short final note that resolves the tense melody.

approach to timbre and texture, surrounded by Williams's thunderous drumming and McLaughlin's high-flying guitar work and psychedelic effects.

The trio's first record was entitled *Emergency!* because, as Williams put it, "It was an emergency for me to leave Miles and put that band together . . . to play an emerging music that was my own." Like several other musicians who left Miles, Williams was driven by musical aspirations to create something new. *Turn It Over*, the second release, was purposely antagonistic toward various factions of the public. Jazz critics proclaimed their disgust at what they saw as a dumbing down of the style to pander to a broad audience. Fans of Williams's work with Miles Davis did not flock to the Lifetime camp in large numbers. Williams was disappointed at muted audience reactions. At the same, he was affronted by blacks who questioned his choices to hire white musicians John McLaughlin and later, bassist Jack Bruce, who had recently split from *Cream*. Williams aimed to disrupt society and point toward a post-ethnic ideal, one that embraced diversity for its artistic rewards. But he wanted to challenge society without being explicitly political, instead making artistic music and letting the work speak for itself. Williams's music was not a commercial success, but it impacted the aesthetic of upcoming fusion bands. Most of them would be racially integrated, and would avoid making overt political messages.

John McLaughlin: Mahavishnu Orchestra

John McLaughlin moved to the United States from England to join Tony Williams's Lifetime in 1969. McLaughlin was armed with musical influences from the American blues of Muddy Waters to Spanish flamenco guitar, preparing him with a substantial measure of expression and virtuosic technique. Before heading to the United States, he had worked with bassist Jack Bruce and drummer Ginger Baker, who made up two thirds of the singular improvisational rock band *Cream* with Eric Clapton.

After about a year of working with Williams's and Davis's groups, McLaughlin's interest in Indian music and spirituality directed him toward new musical combinations. He formed a fusion band called *Mahavishnu Orchestra*, the band's name taken from the title given him by Sri Chinmoy, an Indian guru who had also mentored Carlos Santana. The band's concept was more hard-edged than the Miles Davis fusion projects, using odd time signatures and grating, distorted timbres and special effects more akin to the forerunners of heavy metal music, like Led Zeppelin and Black Sabbath. The iteration of Mahavishnu was fronted by the sonic clash of McLaughlin's guitar, Jan Hammer's electric keyboards and Jerry Goodman's amplified violin, supported by Rick Laird's electric bass and spearheaded by Billy Cobham, an amazing drummer and brief alum of the Miles Davis band who beat the drums as hard as any rock drummer.

The band pushed rhythm to new limits that would challenge listeners who crossed over from rock music. Compositions were based on Indian counting systems that organized beats into odd groupings like nine or eighteen. The band's first album *The Inner Mounting Flame* had songs in 12, 7, 9, and 20. "Awakening" shifts from 8 to 7 beats per bar, and in "You Know You Know," one of the only songs that can be heard in a 4 meter, Billy Cobham experiments with the beat throughout the song's open spaces, displacing and obscuring. On the other end of the sonic spectrum,

however, the group also specialized in ballads that bordered on classical chamber music. "A Lotus on Irish Streams" features McLaughlin on acoustic guitar, along with violin and piano, on a collectively embellished lyrical melody.

Music Analysis

"Vital Transformation"
(1971)

Personnel: John McLaughlin, guitar; Billy Cobham, drums; Jan Hammer, keyboard; Rick Laird, bass; Jerry Goodman, violin

This piece creates a palpable kinetic energy with its mixed meter and dense rhythmic groove, its biting timbres, and its shift between fast and slow tempo. Drummer Billy Cobham drives the song, unleashing his heavy touch on the drums and his "barking" hi hat. The aggressive feeling behind this track places it furthest to the rock side of the jazz-rock fusion spectrum.

0:00	**Introduction:** The drums enter with fast hi hat and snare drum work. A tambourine is layered in after a few repetitions of the pattern. The beginning section of the piece is in an odd meter—4 ½ beats, or 9 double-time pulses.
0:14	**Head, A Section:** The melody is based on the drum groove, and is played here in unison by guitar, violin, keyboard, and bass.
0:43	Guitar and violin play the vamp more freely, and piano and bass essentially comp in the fast funk style.
0:58	**B Section, part 1:** This brief section is still in 9 pulses, but beats are arranged in a waltz, three groups of three beats each. Guitar and violin play a slower melody over the new groove.
1:11	**B Section, part 2:** The dynamic level is reduced, but builds over the next guitar/violin melodic phrase.
1:27	The band arrives at a held chord (a **fermata**) before launching into solos.
1:33	**Guitar solo:** McLaughlin solos over the A section, spurred on by Cobham's drumming. McLaughlin focuses on blues and pentatonic material. He begins with a bit of space, but soon builds up the density of his lines.
2:07:	Cobham drives the momentum of the guitar solo with a drum fill that falls over the bar line, then opens up the rhythm section sound by moving to his ride cymbal. McLaughlin responds by extending his melodic line over seven or eight bars, moving further up the neck to higher pitches.
2:26:	McLaughlin repeats a short riff in the upper register, which seems to call Cobham to raise the intensity yet again.
3:55:	The band gradually comes in with the opening vamp, first heard in the violin.
4:16:	Jerry Goodman leaves the vamp and takes a brief solo.
4:34	**B Section, parts 1 and 2:** The band returns to the slower tempo of the B section and lands again on a fermata.
5:11	**Coda:** Billy Cobham returns to the opening vamp. This time Jan Hammer's keyboard is featured over the studio fade out. His solo is more of an exploration of strange timbres than melodic improvisation.

The Mahavishnu Orchestra reached a level of commercial success in line with the world of pop and rock, selling 700,000 copies of their first two albums. The personnel of the band would change completely over the next few years, and a new group of musicians backed McLaughlin in a 1980s Mahavishnu. McLaughlin has formed a dizzying array of projects since the end of Mahavishnu Orchestra. He explored a fusion of jazz and Indian

music in his band **Shakti**, playing acoustic guitar and bringing in violin with Indian percussion instruments *tabla* and *mridangam*.

Tabla

Mridangam

He performed flamenco guitar music with guitarists Al Di Meola and Paco De Lucía, and played in a jazz trio setting with a number of configurations. A couple of the highlight recordings are *Live at the Royal Festival Hall* with electric bassist Kai Eckhardt and extremely unique Indian percussionist Trilok Gurtu, and *After the Rain* with organist Joey DeFrancesco and legendary drummer Elvin Jones.

WEATHER REPORT

Joe Zawinul was never a full-time member of Miles Davis's band. In fact, although his contributions to recordings were substantial (he composed the title track of the album *In a Silent Way*), Zawinul did not tour with Miles. His steady gig was with the Cannonball Adderley Quintet, to whom he contributed soul jazz hit "Mercy, Mercy, Mercy." About the time **Wayne Shorter** left Miles, Zawinul was planning to leave Cannonball. The idea for the two to collaborate may have begun back in 1959 when Shorter and Zawinul connected working for trumpeter Maynard Ferguson's big band. After their time of apprenticeship with Ferguson, Wayne had become the musical director for Art Blakey and the Jazz Messengers and had reformed jazz with the Miles Davis Quintet. Zawinul had worked with vocalist Dinah Washington and then moved into Cannonball's band, remaining with him for nine years. All of these were among the top positions a jazz musician could hold in those days, but both were ready to lead a band, or as Shorter put it, to be "sidemen of a corporate body." Both were remarkable composers and individualistic players. They began a partnership that would draw from their contrasting personalities in one of the most unique fusions of 1970s jazz.

Weather Report was the only major fusion band with more than one leader, and the musical outcome of the collective leadership was an ever-evolving concept and sound. **Joe Zawinul**, an Austrian immigrant to the United States, was almost a polar opposite of Shorter. Though Shorter was a musical visionary, he was an introvert who led quietly. He was more likely to speak in metaphor and use abstract images to communicate his musical ideas, where Zawinul was more likely to give direct orders. Zawinul has been characterized as the taskmaster of the group, the impetus behind many of the personnel shifts the band went through (most notably, the replacement of the band's third founding member, bassist Miroslav Vitouš). Zawinul was fascinated with the new keyboard technology of the time, but he also liked to modify his keyboards to create a wide range of timbres and approaches. The keys of his ARP 2600 keyboard were inverted

so that the low notes began on the right end of the keys, and the pitch got higher as he moved from right to left. To the typical jazz fan that followed the substantial careers of the two all-stars, Wayne and Joe, the sound of Weather Report was peculiar. Wayne had been a strong, high-profile member of his previous groups, his sound leading much of the action. Joe's layers and layers of keyboards took over the sonic texture in Weather Report, with Wayne only piping up for brief melodic statements. But to listeners who followed the band's concept, this was a new musical formula based more on composition and a collective creation of timbres. Like Duke Ellington, Zawinul and Shorter's band explored new instrument combinations, in this case between various keyboards, bass, and primarily soprano saxophone.

Weather Report released a new album every year throughout the '70s that documented its evolution. The first couple of albums favor spacey textural soundscapes and Miles-like hypnotic grooves. In interviews, Shorter and Zawinul each described the band's initial musical conception as a "soundtrack," meant to evoke images in the mind. By the time *Sweetnighter* was recorded in 1973, the band was making a transition away from the atmospheric music, toward more grounded funk grooves energized by Latin percussion, a world-funk fusion conception. With *Mysterious Traveller* (1974), the band solidified the change to a dance-oriented rhythmic background. A major part of this change was the change in the bass chair—from acoustic to electric. Miroslav Vitouš was replaced first by Alphonso Johnson. But on a couple of tracks of the album *Black Market* in 1976, a bassist would take over who would reshape the sound of the band yet again.

Jaco Pastorius

By the time he introduced himself to Joe Zawinul, **Jaco Pastorius** had already developed a reputation as a young leader on the bass, with fresh conception and chops that backed up his claim as "the greatest bass player in the world." Pastorius grew up in near Miami, Florida, a center of cultural diversity with a heavy Cuban population and panoply of musical styles. Jaco studied drums until, after a serious injury, he switched over to the bass. He customized his Fender Jazz Bass by removing the *frets* from the neck, making it less like a guitar and more like an upright acoustic bass. Without frets, he was able to drastically bend the pitch. A strong soloist on the instrument, Jaco brought the bass "out front." Instead of the supportive role the instrument typically played, Pastorius's bass cut through the texture even when he wasn't playing solos. In spellbinding moments during his solos, he would leave the midrange solo line, leap up to play a high sustained chord with **harmonics** (false pitches produced by pressing lightly on the string in a manner and placement that an overtone is produced instead of the fundamental pitch fingered), then jump back down to the bottom string to pluck the chord's bass note.

In 1976, Pastorius had already recorded an important album as a sideman with Pat Metheny's ECM trio *Bright Size Life*, and a solo record for the Columbia album that awakened electric bassists to the possibilities of their instrument. On *Jaco Pastorius*, he recorded the fast and agile bebop standard "Donna Lee," showcasing his speed, improvisational strength, and unique sounds on the bass. Before Jaco, the electric bass was not considered a legitimate jazz instrument. But he expanded the soloist role of the

Music Analysis

"Medley: Badia/Boogie Woogie Waltz"
(1979)

Personnel: Joe Zawinul, keyboards; Wayne Shorter, soprano saxophone; Jaco Pastorius, electric bass; Peter Erskine, drums and percussion

This live recording from the album *8:30* is a picture of Weather Report in its most stable—and many would say its finest—lineup of musicians. The players masterfully rise to the super fast tempo, particularly spurred on by drummer Peter Erskine (from the progressive big bands of Maynard Fergusson and Stan Kenton) and bassist Jaco Pastorius. The song's slow, soaring melody contrasts the racing under-pulse, and the band creates sonic images with rising and falling dynamics, and sampled sound effects. Note the simplicity of the composition, a melody of very few pitches. No soloist seems to be featured at one time; rather, the main voice is passed seamlessly between the four players.

0:00	**Introduction:** The long introduction is a smattering of various percussion instruments and synthesizer tones.
0:30	**Introduction:** Zawinul sneaks in with a swinging vamp in "3," with sleigh bells probably played by Wayne Shorter.
1:01	**Introduction:** Crotales (bells) and two chords from the keyboard introduce the signal that will return at major moments in the piece.
1:07	**Introduction:** Erskine plays 16th notes on the hi hat, which will continue through most of the piece. Accelerated human speech is played from a sample above the vamp.
1:42	**Introduction:** Zawinul plays an electric Rhodes piano sound, with jarring utterances from Shorter's soprano saxophone.
2:00	**Introduction:** Zawinul's timbre changes to something like an African marimba. Then he returns to the Rhodes piano sound. He begins playing chords and groove builds.
2:39	**Introduction:** Bass keyboard enters while Jaco creates a percussion affect on his bass, fanning the strings.
2:58	**Introduction:** Jaco's bass enters on leaping octaves.
3:05	**Head:** Wayne Shorter's soprano saxophone brings in the simple melody, parroted by Jaco on the bass. The two-chord signal appears. Shorter completes the head with just four notes. The band builds briefly, then settles to a quiet dynamic—a false alarm that foreshadows the build that happens later.
3:35	**Head:** The band repeats the head. This time instead of a false alarm, the band launches into a frenzied new section.
3:49	**Head, part 2:** Soprano saxophone and keyboards play an unsettled minor melody over bashing drums and Jaco's leaping octaves.
4:05	**Solo section:** Jaco plays his trademark 16th note bass line, with Erskine's fast hi hat samba. Zawinul moves between various percussion instruments and synth sounds, playing a solo that constantly shifts timbres.
5:13	**Transition:** A new chord progression provides a break in momentum.
5:22	**Transition and Breakdown:** The band builds over Zawinul's new rhythm keyboard part. Shorter hands off 16th notes to Zawinul, and all but keyboards drop out.
6:30	**Part 3:** Zawinul introduces a new quarter note melody, and the band builds underneath. Jaco's 16th notes and Erskine's dense, thrashing groove build remarkable intensity.
7:42	**Head:** The opening melody returns, this time the build up is sustained and moves into the new section.
7:56	**Head, part 2:** As before, soprano saxophone and keyboards play the minor melody over bashing drums and leaping octaves in bass.
8:11	**Coda:** The final chord is a third below the expected tonic chord, and most musical sound is covered up by a sampled steam train sound.

instrument, and proved that the guitar-looking instrument could swing when playing walking bass lines.

Now with Weather Report, Jaco quickly reshaped the band. He became an equal partner in composition, contributing three of the eight tracks on his first album as a full-time member *Heavy Weather*. He often played the melody, or part of the melody of a song (somewhat of a novelty in 1959 on Miles Davis's "So What"). He was the most flamboyant performer in the band—going shirtless, wearing headbands, and leaping across the stage. He participated in the production side of the album-making process. And he infused a new kind of groove into the band's rhythm section concept—running 16th-note lines popularized a few years earlier by the Oakland funk band Tower of Power. Where TOP's running 16ths were repeated as an ostinato, Jaco was able to improvise new 16th note ideas measure-to-measure but still maintain the song's identity.

With the addition of **Peter Erskine** in 1978 the band's personnel solidified and played concerts that would rival those played by rock bands in terms of intensity, volume, and in attendance numbers. Pastorius also carried on a number of side projects including his own *Word of Mouth* big band (featuring the sounds of harmonica and Bahamian steel drums) and several albums with singer-songwriter Joni Mitchell. Pastorius met an unfitting end, however, as mental instability was exacerbated by drug use and eventually resulted episodes of erratic behavior. He was badly beaten by a nightclub bouncer in his hometown of Ft. Lauderdale and succumbed to the injuries soon after.

Herbie Hancock and the Headhunters

While **Herbie Hancock** performed with Miles Davis, he made a number of recordings now considered post bop essentials of any serious jazz album collection. *Takin' Off* (1962, before his time with Miles), *Emperian Isles* (1964), *Maiden Voyage* (1965), and *Speak Like a Child* (1968) revealed his penchant for experimentation with existing harmonic and rhythmic conventions. He developed a distinctive conception of jazz harmony that blended the modal approach fashionable at the end of the 1950s with **slash chords**, a chord constructed by substituting an "incorrect" bass note below a typical major or minor triad or seventh chord. Slash chords would form much of the harmonic language ushered in by the post bop and fusion movements. Beyond harmony, a broad range of musical styles appeared on each album, from avant-garde to funky pop. "Watermelon Man" was purposefully composed to crossover to a wider audience, at the advice of former bandleader Donald Byrd.

> **Slash chord**—A harmonic structure that consists of a conventional chord played on top of an alternate bass note, usually a note not in the chord.

After leaving Miles Davis, Herbie Hancock released a few albums under the *Mwandishi* moniker. The music was a wandering mixture of experimental synthesizer sounds, African grooves (each band member chose a Swahili name for himself), free form improvisation, and straight up funk. The music was a fascinating chapter in Hancock's oeuvre, but it did not strike gold, and Hancock wanted to move toward funk.

Hancock surrounded himself with a new group of collaborators, this time from outside the jazz community. He found musicians who could impeccably improvise within the funk context. His new music would mean that he had to leave swing behind, but Hancock's interest in new music carried him forward. More than any other 1970s fusion band, the

Headhunters focused on rhythm section grooves—bassist **Paul Jackson** (one of the few electric bassists who could compete with Jaco Pastorius's level of mastery), drummer **Harvey Mason**, and percussionist **Bill Summers**. The group had a remarkable ability to lay down deep grooves and the band's first album, *Head Hunters*, was a clinic in simple melodic hooks and funky rhythms. Catapulted by the catchy hit "Chameleon," *Head Hunters* went platinum, a first for jazz. The updated version of "Watermelon Man" is the most effective at layering various vamps and sounds on top of each other. Nearly the first two minutes are essentially an introduction, hiding the original melody from view until it first appears on the bridge. The intro begins with the sound of Bill Summers vocalizing and blowing over the top of a beer bottle, imitating a sound he heard in the Pygmy music of Central Africa. A spacious bass line is added underneath, with a dialogue between low chord roots and rising thirds. A sixteenth note drum groove layers on, followed by a simple rhythm keyboard part. 1:45 into the track, Herbie's fully harmonized keyboard and **Bennie Maupin's** soprano saxophone finally bring in the bridge of the song.

A remarkable album, *Thrust*, followed *Head Hunters* with replacement drummer **Mike Clark**, who tended more toward open improvisational funk than his predecessor. Jazz purists, who feared that the piano genius behind Miles's Second Great Quintet was selling out, had heavily criticized *Head Hunters*, and *Thrust* may have been an attempt to placate the disgruntled fans, at least to some extent. The music of *Thrust* is still funky, still youthful, but is driven by second-to-second interaction among the players, instead of the deep, repetitive vamps heard in *Head Hunters*.

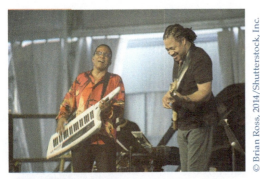

Herbie Hancock playing the "keytar," an instrument he made famous on his song "Rockit."

© Brian Ross, 2014/Shutterstock, Inc.

From the Headhunters, Herbie found success in broad realms of the music industry. He continued delving into film scoring, formed a jazz quintet called V.S.O.P. that continued the legacy of the Miles Davis Quintet (only Miles was absent, replaced by Freddie Hubbard), and recorded an arresting duo album with pianist Chick Corea. In 1983 he reintroduced jazz again to the absolute widest audience possible. His album *Futureshock* was a collaborative project with eclectic electronic musician Bill Laswell and a hip-hop group called Material. An MTV video caused the song "Rockit" to explode in the American mainstream and made Hancock a household name. Herbie took more flack for "Rockit" than any of his previous projects, including a notably bitter tirade from Wynton Marsalis—then a young keeper of the flame of integrity in jazz—published in *DownBeat* magazine. Still, Hancock has maintained a balance over the course of his career between commerce and art, between extroversion and introversion. He has released excellent records that satisfied the forward-looking jazz crowd such as *Gershwin's World* (1998), *Directions in Music: Live at Massey Hall* (2002), and *The New Standard* (1995) with the all-star lineup of Michael Brecker, tenor saxophone; Dave Holland, bass; John Scofield, guitar; Jack DeJohnette, drums; and Don Alias-percussion. At the same time he reaches out to potential new jazz listeners with albums like electronic dance music infused *Future2Future* (2002) and superstar duet albums *Possibilities* (2005) and *The Imagine Project* (2010). *River: The Joni Letters* (2007) won Hancock a Grammy for Best Album, demonstrating recognition by the music industry at large for Hancock's body of work. A running

Music Analysis

"Butterfly"
(1974)
Personnel: Herbie Hancock, keyboards; Bennie Maupin, woodwinds; Paul Jackson, bass; Mike Clark, drums; Bill Summers, percussion

From the album *Thrust*, Bennie Maupin's song "Butterfly" is a vehicle that sets the fusion band in a slow, R & B or soul ballad setting. The track demonstrates a great deal of range, although the first impression may have given rise to the idea that Hancock was only placating to young anti-jazz audiences. The groove and the timbre are the two main "sell out" ingredients. Slow jams from drums/bass/percussion, and Hancock's Rhodes piano and synth violin sounds set up a bedroom ambience more suited to *Soul Train* than the Village Vanguard. However, the song merges a great deal of sophistication with its commercial traits. Hancock hides some very hip harmonies and rhythmic hooks along with Bennie Maupin's overdubbed soprano saxophone and bass clarinet melody, a melody that is as well constructed as any jazz standard. This approach is representative of the album *Thrust*, keeping one foot in pop and the other in art.

Also, like some of the other songs on the album (listen to "Actual Proof"), offbeat rhythmic kicks provide a framework for each chorus. In typical jazz the chord progressions alone guide the form, but these rhythmic kicks are arrival points that clarify the form to the listener. The band seems to approach the rhythmic kicks as a kind of game, getting creative with the way they set-up, lead-in, or play against the figures. Solo sections in "Butterfly" are arranged in a **vamp/bridge** format, where the opening vamp groove repeats (without the stops in every bar). This amounts to an extended A section. The soloist or bandleader cues the bridge and either continues his solo or plays the bridge melody over the new chord changes.

0:00	**Introduction:** Electric piano, bass, drums, percussion play a slow funk vamp with a stop halfway through every bar. Bill Summers's finger roll on the conga fills the rest with a "woooh" sound. An *Arp* synthesizer string sound fades in over the intro.
0:16	**Head, A section:** A simple melody floats in pseudo-free time above the continuing groove. Bass clarinet and soprano saxophone are blended, playing the melody two octaves apart from each other.
0:33	**Head, A section:** On repetition of the first rising melody, Maupin's woodwinds connect with the rhythm section on an off-beat kick. Mike Clark's drums continue over the silence until the next melody statement.
0:48	**Head, Bridge:** The same three-note rising, sustained melody brings in the short bridge, this time raised to a new key.
1:01	**Intro/Interlude:** The Intro returns, this time as a middle section between heads. Maupin plays the top line of the keyboard figure this time.
1:18	**Head, A section:** The second time through the head, Bennie Maupin plays more freely on the melody with his soprano saxophone, headed toward his solo section. This is typical of a straight ahead jazz approach, where the first soloist will foreshadow their solo during a second head by playing in the spaces.
2:02	**Soprano saxophone solo:** Herbie Hancock shifts the ambience with new synthesizer sounds in the brief break after the head. In his solo, Maupin exploits the different sounds of low, middle, and high register on the instrument. He played the melody in the instrument's low range, and in his solo he gradually works his way up through the middle of the saxophone, using the floating, out-of-time phrasing set forth in the head.
2:37	**Soprano saxophone solo:** Maupin enters a second phase of his solo, now blowing harder into the instrument, giving it an edgier sound and gliding up a scale to the upper register. Hancock layers on additional keyboards with an abstract melody that acts as a background melody.
3:07	**Soprano saxophone solo:** In phase three, Maupin plays blues material over Hancock's Latin-tinged rhythmic ostinato in the electric piano. Maupin builds to double-time rhythms and more frantic movement around the horn.
3:36	**Soprano saxophone solo, bridge:** On a cued rhythmic kick (drums/bass/keyboard), the band moves to the bridge tonality, signaling the end of the solo. Maupin continues to build momentum over the new key.

(continued)

Music Analysis (continued)

4:08 **Soprano saxophone solo, end:** The band builds to a sustained chord, and Hancock creates a striking sonority with layers of synthesizers and effects.

4:19 **Keyboard solo:** The band returns on the slow funk groove, essentially pushing the reset button for Hancock's solo. On his electric piano, with a panning effect that continually shifts between left and right channels, Hancock begins with harmonic exploration in the kind of free rhythm set out by Maupin. He moves briefly into blues material, and shifts to European impressionistic ideas.

4:49 **Keyboard solo:** Hancock shifts to double time ideas. He hooks up with a background keyboard figure. The figure interrupts him, breaking up this middle part of the solo.

6:11 **Keyboard solo:** An eerie keyboard enters, as it did in the soprano saxophone solo, with a background melody that threatens to cover up Hancock's electric piano.

7:00 **Keyboard solo:** Hancock moves to a clavinet and plays a double-time ostinato, completely stopping his piano solo. This signals the drums, bass, and percussion to shift to a double-time feel.

7:23 **Keyboard solo:** The electric piano reenters over the new groove, playing double-time rhythms in a variety of textures: single-line blues material, chromatic blocked chords, broken chords.

8:33 **Keyboard solo, Bridge:** The same cued rhythmic kick that signaled the bridge for soprano saxophone appears here. The band exits the double time groove and returns to the opening tempo, while Hancock explores more synthesizer sounds. The bridge ends again with a sustained chord, this time cut short by a loud return of the opening vamp.

9:10 **Introduction:** The intro vamp is repeated, signaling the return of the head.

9:26 **Head:** The melody is played out as in the beginning.

10:12 **Intro/Interlude:** A repeat of the opening interlude.

10:28 **Head:** A repeat of the 2nd head, with abrupt ending.

theme through all of the diverse projects has been fusions of various influences with jazz.

Chick Corea—Return to Forever and the Elektric Band

Chick Corea stands out with Herbie Hancock today as one of the most diverse and prolific musicians to create jazz at the piano. He has made his mark on several jazz styles—the piano trio, piano solo, duets with various instruments, avant-garde, straight ahead jazz, and Third Stream music blending symphony orchestra with small jazz group. His approach to the piano blends colors of modernist classical composers Béla Bartók and Dmitri Shostakovich with the bebop influence of Bud Powell and Horace Silver in an extremely percussive and precise touch. And his voice as a composer is as recognizable as his piano playing. Before working with Miles, Corea built an impressive resumé playing in bands led by Cab Calloway, Mongo Santamaría, Sarah Vaughan, Stan Getz, and Dizzy Gillespie. In 1968, he entered the studio with a piano trio—Miroslav Vitouš on bass, Roy Haynes on drums—and the resulting album *Now He Sings, Now He Sobs* is a masterpiece of post-bop and avant-garde jazz, one of the most important piano trio records of all time.

Corea joined Miles Davis in 1968 and played electric piano on *Filles de Kilimanjaro, In a Silent Way,* and *Bitches Brew.* After just a couple of years with Miles, he left with bassist Dave Holland to form a free jazz group

called **Circle**, with saxophonist Anthony Braxton and drummer Barry Altschul. The group only lasted a year or so, but several recordings were made and the experimental music that ensued was compelling in its use of texture and timbre. Still, Corea was not satisfied with the music's effect on the audience, and he pivoted toward the building fusion trend.

The first band that Corea called **Return to Forever** was a lighter brand of fusion than what was coming out of Miles's or McLaughlin's bands. The band's second album *Light as a Feather* mixed jazz timbres of Joe Farrell's flute and Stanley Clarke's acoustic bass with Brazilian singing and rhythms provided by Flora Purim and her husband, drummer and percussionist Airto Moreira. After a couple of albums with this Latin-Jazz band he was inspired by what he heard from the Mahavishnu Orchestra and hired electric guitarist Bill Connors and drummer Lenny White to contend with the powerful sounds of the other fusion bands. The new Return to Forever pulled closer to Mahavishnu in timbre and volume, but Chick Corea's strong compositions, many of them now jazz standards, anchored the band's sound.

Return to Forever disbanded in 1978, but Corea formed another fusion band that would last through the 1980s and '90s—the **Elektric Band**. The concept behind the Elektric Band was essentially the same as Return to Forever, only drawing from newer keyboard and guitar sounds and drawing from the strengths of individual musicians. In the first version of the Elektric Band, Eric Marienthal played saxophones, Scott Henderson played electric guitar (later replaced by Frank Gambale), John Patitucci played bass, and Dave Weckl played drums. Each was considered a phenomenon on his instrument, and pushed virtuosity forward. A second version of the Elektric Band was also full of impeccable musicianship—again, Marienthal on saxophones, Gary Novak on drums, Jimmy Earl on bass, and Mike Miller on guitar.

The last couple of decades have allowed Corea to both revisit his earlier successes and to forge ahead with new explorations. He collaborated with all-star jazz groups in a number of settings (listen to his *Remembering Bud Powell*) and formed a new original band called **Origin** with cutting edge jazz musicians of the 2000s—Avishai Cohen on bass, Jeff Ballard or Adam Cruz on drums, Steve Wilson on alto saxophone, and Tim Garland or Bob Sheppard on tenor saxophone. Most recently he has collaborated in duo settings with banjoist Bela Fleck and vibraphonist Gary Burton (a longtime musical compatriot), reunited with the Clarke/White/Al Di

Chick Corea

Meola lineup of Return to Forever, and released a critically acclaimed album of fusion music called *The Vigil*. In a career that has spanned at least 50 years, Corea has covered more ground than just about any other musician on Earth. His artistic choices do not seem to be reactions to any particular outside influence; this is music for music's sake. He describes his compositional process as "building a game for the band to play." Corea's groups are outlets for his compositional ides and his love of music making. With the release of *The Vigil*, Corea emphasized the importance in society for the relationship between the performers and the audience in a live setting.

Music Analysis

"Captain Señior Mouse"
Return to Forever
(1973)

Personnel: Chick Corea, keyboards; Lenny White, drums and percussion; Stanley Clarke, bass; Bill Connors, electric bass

This track was recorded by the second lineup of Return to Forever for their *Hymn of the Seventh Galaxy* album. The head teeter-totters between blistering fast rock feel and a half-time Latin groove, and solos happen in half-time rock.

0:00	**Introduction:** A keyboard riff opens the song.
0:04	**Introduction:** Guitar, bass, and drums join Chick Corea on the riff. Corea takes a brief solo using multiple keyboard sounds.
0:36	**Head, A section:** The riff returns, and the melody arrives in Bill Connors's guitar. The melody has a folk-like quality with rising sixth interval in a major key. The short group of pitches becomes a *sequence*, a classical composition technique whereby a short melodic idea is repeated, moving or down in pitch.
0:55	**Vamp:** This time Connors plays a John McLaughlin-esque guitar solo over the riff.
1:30	**Head, repeat of A section:** The head returns with the original melody.
1:45	**Transitional fragment:** The band plays in *unison* (the same notes and rhythms at the same time) a lick that ends on a standard "da dat" Latin rhythm, pulling the song into a salsa feel.
1:47	**B section:** Guitar and keyboard play a syncopated, unison Latin melody over an off-beat rhythm in the bass called a *tumbao*, and Lenny White's cowbell.
1:57:	The frantic Latin rhythm lands briefly on a held chord.
2:00	**B section, part 2:** Similar melody is played.
2:06	**Transition:** The band lines up on rhythmic kicks underneath the winding melodic line.
2:14	**A section:** Like before.
2:34	**B section:** The band repeats the full Latin section with the original hits.
3:01	**Keyboard solo:** The transition leads into a new riff in bass and lower range of the keyboard that introduces solos. The band's dynamic level finally subsides. Chick Corea floats into a keyboard solo over the new bass riff.
3:49	**Keyboard solo:** Drums and bass escape the riff on Corea's short downbeats. Improvisation becomes freer at this point, and momentum begins to build. Corea plays fast Latin rhythms and stretches triplets across the bar.
4:38	**Keyboard solo:** Lenny White builds the drum sound along with Corea's solo, and eventually crashes on the cymbal.
5:00	**Keyboard solo:** Chords change every two measures, building momentum.
5:21	**Keyboard solo:** The solo section's riff returns to close the keyboard solo, and is extended to longer held ensemble kicks (with bass echoing the solo riff at 5:32).
5:35	**Interlude:** A new composed ensemble passage divides the keyboard from the guitar solo at a softer volume. The keyboard's change to a brittle, harpsichord-like timbre and modulating melody are reminiscent of Baroque era orchestral music.
5:40	**Interlude:** Timbre shifts as the Rhodes piano sound re-enters with a melody that counters the harpsichord melody creating a *polyphonic texture*. The added complexity builds momentum.
5:51	**Guitar solo:** A variation of the riff that introduced the keyboard solo opens the guitar solo, but only briefly. The accompanying musicians enter the groove again and build quickly with the soloist.
7:48	**Guitar solo:** The pre-interlude material (chord changes every two bars) signals the end of this solo, as it did in Corea's keyboard solo.
8:08:	The riff returns as it did in the keyboard solo, with long ensemble kicks.
8:23	**Interlude:** The full interlude this time moves to the ending material.
8:39	**Coda:** The tempo slows and three final chords arrive.

OTHER DEVELOPMENTS IN THE 1970s

Although fusion virtually crowded the market for jazz in the '70s, a few important musical insurgents took place that would have a lasting impact on the music moving forward, and several important jazz musicians continued to make recordings in styles that had been prevalent in the '60's. The avant-garde was alive with Ornette Coleman's captivating blend of free jazz with the London Symphony Orchestra, and brain-bending projects by the likes of Anthony Braxton, Dave Holland, Cecil Taylor, and the Art Ensemble of Chicago. The fusion craze did not last forever. In the closing decades of the 20th century it would resign as a fringe style enthusiastically cheered on by die hard fans and other musicians mystified by their jazz-rock idols. Fusion is still alive and well today but its audience is small, albeit enthusiastic.

Pat Metheny

The 1970s saw a significant increase in the globalization of jazz. As more and more musicians were moving from Europe (Joe Zawinul, John McLaughlin, and harmonica player Toots Thielemans), the Caribbean (Billy Cobham), South America (Airto Moriera), India (Trilok Gurtu), and other nations to participate in United States jazz, the music was spreading overseas. A far-reaching network of European jazz festivals was being built up since the mid-1960s, and jazz was becoming a world music style as much as an American export. The German **ECM** label, run by Manfred Eicher, released several influential albums by artists who dominate the jazz genre of recent years. Pat Metheny's *Bright Size Life* (1975), Dave Holland's *Conference of the Birds* (1972), and pivotal albums by the Gateway trio, Keith Jarrett, Kenny Wheeler defined a signature sound characterized by straight-eighths rhythms, rich harmonies, and a melodic approach that bridged the gap between avant-garde jazz and contemporary classical music with a balance of consonance and dissonance.

Big bands now operated on a new set of incentives, not far removed from bebop. After the format lost its ability to capitalize a broad popular market by touring and playing dances, it was transformed into an art-for-art's sake medium. Recordings now catered to a smaller, more musician-oriented audience. That audience was tied to university music programs now taking jazz seriously. Serious music programs at North Texas State University (now University of North Texas), University of Miami, and several other locations across the United States focused on the art of improvisation and jazz composition. The progressive big bands now fed an academic and artistic need for compositions that challenged the ears and the fingers. Early progressive bands included the Stan Kenton Orchestra, Thad Jones & Mel Lewis Orchestra, Toshiko Akiyoshi, Carla Bley, and even some of Duke Ellington's music, particularly the suites, had a progressive slant.

Dexter's Homecoming

The return of **Dexter Gordon** was a triumph of mainstream, straight ahead jazz. After the bebop years in the 1940s, straddling the two coasts performing with the icons of modern jazz, Gordon's career was in serious trouble. Like so many of his contemporaries, Dexter had a horrible heroin habit that landed him in prisons in Texas, Kentucky, and the maximum security

facility, Folsom Prison, near Sacramento. His appetites had caused him a lost decade in the '50s. After a number of successful recording sessions for the Blue Note company, and a bit of moonlighting as an actor in a West Coast play, Gordon moved to Europe. The expatriate traveled the continent and spent a great deal of time in France and Denmark. In 1977, after a decade and a half abroad, Dexter returned to New York to a flourish of media attention and a recording contract with CBS that resulted in pivotal recordings in straight ahead jazz (essentially built upon hard bop). *Homecoming: Live at the Village Vanguard* was well received, and has since become a classic recording that reestablished the relevance of swinging jazz after a decade of jazz-rock. On the recording, Dexter's full-bodied sound is front-and-center. Improvisation is the main ingredient, absent of complicated compositional aspects or special effects. Gordon's solo on the opening track is a model of melodic development, phrasing, and momentum.

Dexter Gordon received numerous accolades for his musical work in the 1980s, and surprised many in the music world when he won a Grammy for his portrayal of an American jazz star that moves for a time to Paris in *Round Midnight*.

Music Analysis

"Gingerbread Boy"
(1976—released 1977)
Personnel: Dexter Gordon, tenor saxophone; Woody Shaw, trumpet; Ronnie Matthews, piano; Stafford James, bass; Louis Hayes, drums

This analysis focuses just on Dexter Gordon's solo, just after the opening melody. The song's form is a standard 12-bar blues. Without the aid of technological advances in electronic musical instruments, Gordon builds an engaging solo over 24 choruses that sounds current even today. His rhythms swing hard throughout, and his melodic material reveals a level of logical organization and creativity that were matched by only the best soloists. He moves between deliberate melodic shapes, **quotes** (recognizable melodies), and **bebop common language** (eighth note material that primarily steps up and down scales). Admittedly, a lot of the language in the analysis below gets very technical, dealing with concepts and terms common to advanced music theory. The non-music expert may not grasp all of the concepts presented, but deep analysis at the very least provides the impression that something genius was happening at the Village Vanguard that night. It is doubtful that Dexter Gordon incorporated compositional tools like "rhythmic diminution" to impress music theorists. Instead, these concepts emerge out of a natural, organic process of melodic storytelling. Listen for Gordon's sly wit: he quotes "Here Comes the Bride" in Chorus 5, then mutates it three minutes later in Chorus 22.

Chorus 1
0:41: Gordon opens with a 5-note phrase that becomes a *motive* for the rest of the chorus. He repeats it, changing a note here or there to match the passing chords, adds to it.

0:50: Common bebop language finishes out the last four bars of the chorus. Note the last two notes "doo dit," a typical bebop phrase-ender.

Chorus 2
0:53: Recognize that melody? Gordon quotes "Mona Lisa," a song made popular by Nat King Cole in 1950. By "speeding up" the last half of the melodic phrase, he engages in what classical music composers would call *rhythmic diminution.*

0:55: Common bebop language.

1:01: An oscillating two-note figure picks up the momentum, pushing forward to the next chorus.

Music Analysis (continued)

Chorus 3

1:03: A rising pentatonic figure becomes a *motive* that gives this chorus its identity, like Chorus #1.

1:13: Common bebop language.

Chorus 4

1:15: Gordon uses the material from the end of Chorus 3 as a motive in this chorus. Falling leaps in intervals of 4ths (called a *quartal* figure) are used in various forms throughout this chorus. Listen for *rhythmic diminution*, or speeding up the motive, on the second appearance of the falling motive.

1:22: Gordon sustains a pitch—the 9th—changing the timbre with alternate fingerings and embouchure changes (the shape of the mouth). Then he returns to eighth-note common bebop language.

Chorus 5

1:26: Gordon quotes "Here Comes the Bride," which energizes the rhythm section eliciting mid-chorus drum fills.

1:31: Gordon bounces between two pitches again, keeping the bottom pitch but nudging the top pitch down and up by half step. Then he returns to more bebop common language.

Chorus 6

1:38: The first notes of this chorus are a continuation of the last, but soon he finds a rhythmic identity for Chorus #6, stubbornly playing only off-beats.

1:44: Midway through the chorus Gordon brings in blues ideas. This chorus can be seen, then as a transition toward blues material from the earlier ideas in major mode.

Chorus 7

1:48: This chorus is mainly *chromatic* (moving by half-step). Gordon's opening idea uses the cluster of half steps in the blues scale (the 5th, ♯4th, and ♮4th), then he sticks with half step movement.

Chorus 8

2:00: This chorus has a minor pentatonic character, descending down all five notes of the scale.

2:07: After "revving his engine" over several repetitions of the falling five notes, Gordon extends the idea down to the low register of his horn. He ends with a standard blues lick that carries over into the next chorus.

Chorus 9

2:11: Gordon opens with a typical "Dexter" melody, something that appears in several of his solos. From there, he returns to the major bebop common language of earlier choruses.

Chorus 10

2:22: The repeated rising 4th interval links this chorus to the end of the previous. The melodic cell becomes this chorus's *motive.*

2:30: The last four bars return to bebop common language.

Chorus 11

2:34: Gordon moves *outside* the chord changes briefly with a sequence of triads that alternate between primary chord tones and altered tones. Then he continues upward with a scale.

2:37: Gordon returns to blues material.

Chorus 12

2:45: On this chorus, Gordon turns a corner to a new phase of development. A rising 4-note cluster of half notes establishes this chorus's chromatic identity. He sequences the 4-note cell downward. Then he pivots between low-register half steps and higher, single pitches.

Chorus 13

2:56: Gordon continues to develop the low-high idea set forth in the previous chorus.

3:04: The top two notes of the previous idea becomes a kind of "broken record," as Gordon repeats them across a few bars. Note how the rhythm section responds to this as a call to action. Piano repeats a high, altered chord with a cross rhythm, and drums increase activity.

(continued)

Music Analysis (continued)

Chorus 14

3:07: Gordon sounds like he's patting himself on the back for the victory of the last two choruses. He descends a major scale, moves briefly into minor pentatonic ideas.

3:14: Then Gordon honks the tonic pitch (a B♭) changing the timbre with alternate fingerings (a single note idea that will be developed later).

Chorus 15

3:17: Gordon reduces his melodic ideas down to just two notes—the "honked" tonic and blue 3rd. Rhythm becomes the dominant element. This chorus pulls the performance into the simplified soul jazz territory.

Chorus 16

3:29: The same tonic B♭ is the basis of this chorus. Gordon again changes timbre with alternate fingerings, rises briefly to a major 3rd (in contrast to the lowered 3rd of the last chorus), and alternately moves downward about the same distance.

3:36: He returns to the same B♭ that opened the chorus.

Chorus 17

3:39: Gordon drops an octave to his low B♭ then leaps up again to the original B♭. This becomes the new *motive*.

3:47: The motive becomes a six-note pattern with the sound of alternate fingerings, repeated to close the chorus.

Chorus 18

3:50: The previous motive is moved up by an octave, with the same notes played in the upper register. He then uses the high B♭ in the same manner in which he used the same pitch in mid-range, as a launching pad for movement to and from other pitches.

3:58: A four-note group is used in sequence, repeating its shape and moving downward chromatically.

Chorus 19

4:02: Gordon opens this chorus moving in the direction opposite the last idea of the previous chorus, with upward chromatic movement. He uses bebop common language throughout the rest of this chorus.

Chorus 20

4:12: Gordon quotes a bugle call in triplets then develops the quote further.

4:19: Gordon plays a B♭ an octave higher than the last, moving into the *altissimo* range.

Chorus 21

4:22: An *altissimo* melody of five notes surrounds the tonic then Gordon plays an idea based on the previous on lower pitches.

4:31: Gordon returns to a sustained altissimo B♭.

Chorus 22

4:33: Gordon moves downward to a dissonant pitch (the ♯4th) played with a harsh timbre. In a hilarious moment, albeit quick, he blends this ugly note into a re-quote of "Here Comes the Bride." He continues exploring alternate fingerings and other manipulations at this point.

4:38: He returns to consonant material with a falling pentatonic scale.

Chorus 23

4:45: One of Gordon's favorite quotes appears here, "Anything You Can Do" from Irving Berlin's music in the musical *Annie Get Your Gun*. He continues with bebop common language.

Chorus 24

4:54: Gordon brings back echoes of previous material—a four-note chromatic sequence and oscillating two-notes—then finishes his solo with bebop common language.

Discussion Questions

1. Explain what musical styles and influential musicians contributed to the creation of fusion music. How did it differ from conventional jazz?

2. Compare and contrast Miles Davis's "Butterfly" from James Brown's "Mother Popcorn."

3. What musical traits made Jaco Pastorius a good replacement bassist in Weather Report?

4. Which of the fusion bands discussed in this chapter showed the strongest influence of Latin music, and what musical details lead you to that conclusion?

5. "Butterfly" leans heavily toward Herbie Hancock's pop-soul-R&B sensibility. Should the song be categorized with jazz? Why or why not?

6. How did the following drummers differ from one another: Tony Williams, Billy Cobham with the Mahavishnu Orchestra, Lenny White with Return to Forever, and Peter Erskine with Weather Report?

The 1980s Blues Revival and Contemporary Blues

1970s DOWNTURN

Over the course of the last century, the blues has surfed the ebbing and flowing tides of popular taste, benefitting sometimes from widespread exposure to millions of listeners and at other times retreating to the workshops of local music scenes. All the while, a steady stream of talented artists and outspoken advocates has kept the genre moving forward. At the beginning of the 1970s, any blues aficionado might have predicted that the flood of public attention in the 1960s would hold on through the next decade. Blues artists young and old had proved vital to current corners of the market—the college folk crowd admired the elderly practitioners of country blues, British rockers constantly paid homage to their blues heroes from Chicago and the rural South through cover tunes and television appearances, and the new psychedelic blues-rock scene befriended B. B. King and others. King's mainstream hit, "The Thrill is Gone," demonstrated the potential for a new level of commercial success reaching number 15 on the *Billboard* pop charts. The 1960s revival took place even while blues was losing its black audience to soul music.

But just after 1970, the blues experienced a downswing. Blues-rock was no longer exciting to a rock community moving toward heavy metal and punk styles (although both styles had the blues in their DNA). Important blues musicians and the rockers who rallied for them died of drug use and tough lives near the end of the '60s. Jimi Hendrix and Janis Joplin died within a few weeks of each other in 1970, and Jim Morrison of the Doors died the following year, all at age 27! Mike Bloomfield and Paul Butterfield both surrendered their careers to overindulgent drug use. Skip James succumbed to cancer. Magic Sam and Little Walter both died before the age of 40. Chess Records was sold before Leonard Chess died in 1969. The young black audience had moved on from soul to funk. Blues musicians found themselves playing little gigs in clubs, restaurants, and bars across the South—often called the **Chitlin' Circuit**—and in blues clubs in Chicago's south side and other urban centers. (Muddy Waters was an exception to the fall of most blues careers, often joining Eric Clapton on tour as an opening act.) The 1970s were a slow time for the blues, but like every other blues recession, a revival was on its way as a new class of blues artists laid the groundwork for new developments.

In this chapter, we will cover:

- 1970s downturn
- Alligator Records, **Johnny Winter**
- **Taj Mahal** and eclectic blues
- 1980s Revival
 - Texas—**Albert Collins, Jimmie Vaughan,** and **Stevie Ray Vaughan**
 - **Robert Cray**
- North Mississippi Hill Country Blues—**Otha Turner**
- Music Analysis: Three settings of Junior Kimbrough's "Meet Me in the City"

ALLIGATOR RECORDS

A few smart entrepreneurs were able to build and maintain record labels during the 1970s that fed the blues legacy with a new class of great artists, and with a few resuscitated careers. **Alligator Records** in Chicago was the most significant of these small labels. Bruce Iglauer started Alligator in 1971 when he failed to convince his boss at **Delmark Records** to sign eleven-fingered slide guitarist Hound Dog Taylor to a record deal. He believed in Taylor enough to build Alligator Records on his own dime and record Taylor's first album. Alligator moved slowly through the '70s, recording little more than one album per year until, in 1978, Iglauer began recording more established blues artists Albert Collins and Koko Taylor. Collins's *Ice Pickin'* was nominated for a Grammy, and several other recordings by the small label were also given critical acclaim. Alligator later solidified their success by adding Son Seals, Johnny Winter, James Cotton, and zydeco king Clifton Chenier to their roster.

Johnny Winter

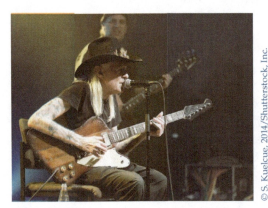

Johnny Winter

Before he signed with Alligator, albino guitar phenom **Johnny Winter** produced Muddy Waters's recording *Hard Again*, an album for Columbia's Blue Sky label, followed by a few other Waters/Winter pairings in the same vein. A great guitarist in his own right with the touch for the blues, Winter had made a career for himself in blues-rock up to that point. But collaborative recording with Muddy Waters was his chance to work with the deep blues music that he loved. *Hard Again* was a new framing of Muddy Waters's specialized sound that sounded heavier and more pristine than his earlier material, yet still held on to the grit and vigor of his Chess blues recordings. In addition to Winter's intense and heavily distorted guitar playing, *Hard Again* featured James Cotton's firebrand harmonica playing, bombastic drumming of Willie "Big Eyes" Smith, and special guest Pinetop Perkins on piano. *Hard Again* and subsequent Winter/Waters collaboration *I'm Ready* were awarded Grammys in 1978 and 1979. After his successes with Muddy Waters, Winter's activity has mostly stayed focused on the blues, producing several Grammy-nominated albums.

TAJ MAHAL AND ECLECTIC BLUES

Taj Mahal's body of work has both honored the blues of the past, and looked forward to a trend of stylistic diversification. Mahal emerged from the folk scene in Boston, Massachusetts, and made his way to Los Angeles, joining a cadre of music enthusiasts focused around the Ash Grove venue and briefly forming a band and recording with Ry Cooder. Many of his recordings of the 1960s evinced strong ties to the blues legacy, including his own versions of blues standards like "Sweet Home Chicago" and "Good Morning Little School Girl." In the 1970s he expanded his stylistic palate to create a more cosmopolitan sound that incorporated reggae and other

Caribbean styles. Throughout his career of more than 40 years, he has continued to explore various genres, more than just honoring the grandfathers of the blues. His desire to avoid becoming stagnant has kept him experimenting with various musical ideas from different genres throughout his career.

1980s BLUES REVIVAL—DIVERSIFICATION AND VIRTUOSITY

The 1980s blues revival brought with it a new diversification of the blues. The genre had been sustained through decades of hills and valleys, almost completely by black men with strong ties to the South. Paul Butterfield, Mike Bloomfield, and a small number of serious white blues players signaled a more open landscape in the 1960s, but these anomalies encouraged the blues-rock hybrid more than they directly influenced the blues. It's no surprise that a musical genre that began as a messenger of the woes of the poor southern black man would be sung by poor southern black men. But with the passing of time the blues had become far removed from its sharecropping roots, its subject matter became less specifically about southern blacks, and there was now plenty of room for singers with little to no connection to this tradition.

Three primary blues artists—**Stevie Ray Vaughan**, **Albert Collins**, and **Robert Cray**—brought a critical mass of public attention back to the blues and made innovations that strongly impacted the genre. None of these men had grown up in the Mississippi Delta. Vaughan and Collins were from Texas, and Robert Cray had lived most of his formative years in the Pacific Northwest, an unlikely origin for a bluesman. Stevie Ray Vaughan was the lightning rod of the new class, and many of his compatriots in Austin, Texas, were white Americans schooled in the sounds and techniques of black blues musicians. Momentum for white Americans playing black blues had built up through the '60s and '70s. Many of the blues-rock bands, like Canned Heat and the Allman Brothers, played the blues with authenticity, showing that they had paid attention to subtle details of phrasing and timing in their heroes' music. Johnny Winters mastered the genre from within, collaborating with Muddy Waters. Blues albums were also incorporating more and more musical styles, moving away from basic shuffles and toward soul and Latin-tinged sounds. The blues was primed to embrace diversity both in race and in musical style.

Albert Collins

Texas blues had come a long way from Blind Lemon Jefferson's days in Deep Ellum, Dallas, and Lightnin' Hopkins's important recordings added Houston as a playing center. Hopkins's cousin **Albert Collins** laid a lot of the groundwork that would lead to the resurgence of blues in the '80s. Growing up in Houston, he was immersed in the Texas guitar tradition of Hopkins, T-Bone Walker, Guitar Slim, and Clarence "Gatemouth" Brown. He tended to let his guitar do the talking, with an intense guitar tone and a capo placed high on the instrument's neck. A **capo** is a guitarist's tool that holds the strings down at a particular fret, effectively shortening the instrument and raising its pitch by a number of half steps. Collins had a

very personal improvisational style that varied from deep blues licks to off-kilter stream-of-consciousness ideas, sometimes singing along with them.

Collins was already recording as early as 1958 for Kangaroo and other small labels in Texas. Although he was a fine blues singer, he composed and recorded a great deal of instrumental songs, often with "icy" titles like "The Freeze" and continuing with "Frosty," "Sno Cone," "Thaw Out" and others. He moved to Kansas City and then Los Angeles recording for various labels until 1977, when he formed a relationship with Alligator Records that brought his career and the company's profile to new heights. On his first Alligator record *Ice Pickin'*, Collins continues a couple of trends that had been developing over several decades. His music incorporates new styles of popular black music; the tracks alternate between contemporary funk styles and typical electric blues shuffles. Collins's lyrics also continue a trend toward lighter subjects that had been developing in the blues over several decades, and can be traced in the music of Lightnin' Hopkins, B. B. King, and others who took a more comic approach. The topics of Collins's lyrics on *Ice Pickin'* vary from humorous complaints about his woman ("Honey Hush" and "Mastercharge") to romantic songs of lost love ("Cold, Cold Feeling") to poverty blues ("When the Welfare Turns its Back on You"). Collins's guitar playing is at top form on the album's instrumental songs. He uses a variety of textures, phrases his solo lines playfully but intensely, and can be heard singing along with his guitar solos from time to time.

Music Analysis

Albert Collins, "Too Tired"
(1978)
Personnel: Albert Collins, vocals/guitar; Aron Burton, bass; Larry Burton, guitar; Allen Batts, keyboards; Casey Jones, drums

From Collins's first recording with the Alligator label, this track showcases his intense guitar playing and his witty lyric style. He can be heard moaning behind his guitar lines, especially while he trades the opening phrase with the keyboardist. The tight arrangement of this blues song lends itself to a more open approach in live performance.

0:00	**Introduction:** An opening guitar riff is echoed by the organ/keyboard.
0:09:	Drums, bass, and piano enter with a fast shuffle while Collins solos over the remainder of the blues form.
0:25	**Verse 1:** Collins sings over the band's classic stop-time figure. The first blues phrase (normally four bars) is doubled in this verse.
0:40	**Verse 1, 2nd part:** The band brings in the sustained shuffle through the rest of the verse. Collins occasionally answers his voice, filling in the holes with simple guitar licks.
0:53	**Verse 2:** Structured like Verse 1, except this time the first phrase is not doubled. The band brings in the sustained shuffle after just four bars.
1:15	**Guitar Solo:** Collins plays his first chorus over the band's stop-time figure, followed by a chorus without stop-time. Collins tends to play phrases that begin with a long sustained note ending with a fast, clipped gesture of a few notes.
1:57	**Verse 3:** The stop-time returns for this 12-bar blues.
2:18	**Guitar Solo 2:** The band pushes on into a closing chorus of solo.
2:35	**Ending:** Like the introduction, the band stops while the organ echoes Collins's guitar riff. Collins slows down his last repetition of the riff, and cues the band to come in for a final chord.

In addition to Grammy nominations for *Ice Pickin'*, *Frostbite*, and *Frozen Alive!*, Albert Collins won a W. C. Handy Award for best contemporary blues with his 1983 album *Don't Lose Your Cool*. In 1985 Alligator pitted Collins against two contemporary blues contenders—Robert Cray and Johnny Copeland—on the album *Showdown!* The record impressed blues fans and attracted the attention of the guitar community and a wider public to the blues. His performance at Live Aid in 1985 with George Thorogood put him in front of an incredibly large television audience. Up to two billion people tuned in to various TV and radio stations to watch the 16-hour mega-concert that raised funds to fight famine in Ethiopia.

Austin and The Vaughan Brothers

Austin, Texas, is a unique creative center that is home to the Texas capitol and has been branded the "Live Music Capital of the World." The enormous University of Texas campus and a number of other colleges supplied the city with tens of thousands of young people, who in turn created a demand for live music at parties and bars. This environment captivated musicians who gravitated to Austin from other locales. The importance of Austin music grew from the mid-1960s to the '80s, and blues was an integral part of the developing musical culture. Armadillo World Headquarters followed the Fillmore's practice of booking blues and rock bands together on the same bill. Threadgill's was the venue where Janis Joplin forged her sound with set lists full of blues material. And a number of clubs on Austin's East Side with primarily black clientele (Victory Grill, Charlie's Playhouse) booked national blues acts such as Bobby Bland, B. B. King, and W. C. Clark. **Clifford Antone** opened a club called "**Antone's**" on 6th street near the center of the city, and earned a reputation for bringing Chicago blues legends like Muddy Waters, Buddy Guy, and James Cotton to town. Guy credited Clifford Antone with inviting Chicago blues into Austin. Antone's also provided an environment where local Austin musicians could mingle with these legends, and develop an informed approach to the blues. The riches of the Live Music Capital of the World were its creative musicians and the listeners and venues that supported them. The experimentation and real work that took place in the 1970s helped Austin blues musicians to create an identity and make a mark on the national stage.

Jimmie Vaughan

Jimmie and his younger brother **Stevie Ray Vaughan** spent their childhood in Dallas, learning the blues guitar trade and playing in various bands. Jimmie moved to Austin at nineteen years old, soon after forming a blues and soul band called "Texas Storm." The Storm accompanied blues acts that swung through Austin from other cities, allowing Vaughan to share the stage with guitarists who had formed the basis of his sound like Chicago guitarist Freddie King.

Together with harmonica player Kim Wilson, **Jimmie Vaughan** formed the Fabulous Thunderbirds in 1975, a group that was instrumental in raising the profile of Austin blues and elevating the blues to the national stage. The Thunderbirds gained a reputation for hard work and fine playing among Austin's young college crowd and East Austin's primarily black and Hispanic crowd. They became the house band at Antone's, developing

close relationships and earning the respect of their heroes Muddy Waters, Hubert Sumlin, and Albert King.

The title track of the Thunderbirds's fifth album *Tuff Enuff* reached number 10 on the Billboard Hot 100 chart, giving the blues a rare appearance in Top 40 radio. Vaughan left the Thunderbirds and began recording with his brother in 1990, finishing an album called *Family Style* for Epic Records. But touring plans were cut short, and Jimmie's career took a hiatus when Stevie Ray was killed in a helicopter accident. Since his brother's death, Vaughan has emerged as a solo artist with Grammy nominations, guest appearances on several recordings, and receiving accolades from Eric Clapton, B. B. King, and other important bluesmen.

Stevie Ray Vaughan

After dropping out of high school to pursue a music career, Stevie Ray Vaughan joined his brother in Austin and played bass with Texas Storm. An active member of the Austin scene, he also played with several other groups such as the Nightcrawlers and the Cobras, and later formed Triple Threat Revue. Triple Threat featured vocalist Lou Ann Barton and played blues and R & B around the Austin bar scene. When Barton left in 1978, Triple Threat became Double Trouble. The trio's personnel settled as Stevie Ray Vaughan developed a rapport with drummer Chris Layton and Johnny Winter's former bassist, Tommy Shannon. The band primarily played blues standards and Vaughan's originals, augmented by Vaughan's technical virtuosity and a style that channeled Jimi Hendrix.

Double Trouble soon found themselves playing among an elite class of blues and pop society. Before they recorded an album, Mick Jagger was impressed enough by an amateur recording of the band during a Texas visit that he hired them to play a private party in New York. The band was invited to play the Montreux Jazz Festival in 1982, with David Bowie and Jackson Browne in the audience. On the urging of the famous musical matchmaker John Hammond (who had jumpstarted the careers of Benny Goodman, Count Basie, Bob Dylan, and several others), the Epic label signed Double Trouble to a record deal. Their first album *Texas Flood* was recognized both for its songs and for Vaughan's exceptional guitar wizardry. The album was nominated for two Grammys and Vaughan was awarded "best electric blues player" for several years running. The guitar community was awakened to a new Jimi Hendrix, the blues was given its next superstar, and Double Trouble managed to bring blues-drenched music back on to the popular stage.

Vaughan was a superstar for many of the same reasons the blues had been resuscitated in the 1960s. The '80s pop scene was rife with slick, processed music with electronic instruments replacing their acoustic equivalents (drums and keyboards). A large swath of music fans craved authenticity and a looser, more organic approach rooted in acoustic sounds. For many, Stevie Ray Vaughan was the answer. His band impacted the commercial music world with successful album after successful album of music that was at the same time new and old. He pleased the blues crowd and regularly performed with blues legends like B. B. King, Albert Collins, and Albert King. He also brought the blues a completely new audience of guitar lovers who tended to follow other genres of music.

But while his career flourished, substance abuse put his life in jeopardy. He developed a serious cocaine and alcohol habit that reached its

peak in 1986 when he collapsed on stage in Europe. He checked into a rehabilitation facility and cooled off for a time, then returned in 1989 with the release of his last solo studio album *In Step*, which was awarded a Grammy. The next year he collaborated with his brother Jimmie on their album *Family Style*. Before the album was released, the brothers played a concert in Wisconsin along with Eric Clapton, Robert Cray, and Buddy Guy. Tragedy struck after the show when Stevie Ray's helicopter crashed on its way to Chicago, ending his life at just thirty-five years old. Like so many musical artists who had been catapulted to early fame, his career was cut far too short.

But Stevie Ray Vaughan's legacy was remarkable. He revolutionized guitar playing, leaving behind legions of followers who emulate SRV (much like he channeled Jimi Hendrix). He brought the blues back into the public consciousness, revitalizing its link with rock and roll with his power trio and their striking covers of Hendrix's "Voodoo Chile (Slight Return)" and "Little Wing." He composed a number of songs that have become standard blues repertoire. He is primarily responsible for putting Austin on the

Music Analysis

Stevie Ray Vaughan and Double Trouble, "Pride and Joy"
(1983)
Personnel: Stevie Ray Vaughan, vocals/guitar; Chris Layton, drums; Tommy Shannon, bass

The album *Texas Flood* won Stevie Ray Vaughan an amount of attention from the guitar community that had not been bestowed since Jimi Hendrix's death. To many traditional blues fans, the hard-edged sound of Double Trouble may have sounded closer to rock than blues. But tracks like "Pride and Joy" contained plenty of soulful melodies, rhythmic swagger, and supercharged blues guitar licks to make a strong impression on both traditional and contemporary listeners. "Pride and Joy" showcases Chris Layton's rock-solid shuffle groove, Tommy Shannon's walking bass, and Vaughan's unfailing guitar chops. Notice the opening lyric's reference to the Sonny Boy Williamson II classic "Eyesight to the Blind."

0:00	**Introduction:** Vaughan's teeth-shattering guitar tone sets up the song in swinging rhythm.
0:07:	Drums and bass enter, playing a chorus of 12-bar blues with guitar emphasizing the off beats. Chris Layton plays a classic shuffle rhythm on the drums, and Tommy Shannon plays a walking bassline.
0:30	**Verse 1:** Vaughan's voice locks in with the shuffle rhythm. His husky voice lands on low notes at phrase endings with quick vibrato. Brief guitar licks sneak into the holes between the verse's busy lyrics.
0:40:	Rhythmic kicks from guitar and drums answer the lyric "sweet little thing," then the band returns to the original groove.
0:53	**Verse 2:** Proceeds like the first verse.
1:16	**Verse 3:** A classic stoptime figure, the band plays on the "1" of every bar and rests in between.
1:24:	The groove continues, this time without the rhythmic kick after "sweet little thing."
1:39	**Guitar Solo 1:** Bass and drums back up Vaughan's fiery solo for two choruses with louder volume and increased activity. Instead of the more typical blues approach of leaving space between phrases, Vaughan unleashes a flurry of non-stop sound.
2:25	**Verse 4:** Stoptime again for this verse.
2:47	**Verse 2 repeated:** No stoptime, the band plays this verse like the first time.
3:10	**Guitar Solo 2:** Vaughan builds the opening by moving his chord voicing upward to a series of blues licks.
3:28	**Ending:** The band plays a unison figure resting on a final chord. Vaughan uses a tremolo, or whammy bar on the last chord.

map as a top destination for live, soulful music. Today, Austin influences the global music scene through Austin City Limits—a television show featuring live performances by various artists of contemporary music—and its famous music festivals—South By Southwest and the Austin City Limits festival.

Robert Cray (from the Pacific Northwest)

Along with Albert Collins and Stevie Ray Vaughan, **Robert Cray** played an important role in the re-emergence of the blues in the 1980s. He is one of the only blues artists to have grown up outside the South and make a strong impact on the music. Cray's contribution was to infuse new sounds of soul, rhythm & blues, and current pop into the blues, charting a way forward that many blues artists would follow in the next few decades. He credits the diverse mixture of musical styles for his success.

Robert Cray was born in Columbus, Georgia, to a military family. Throughout his childhood the family moved to various locations including California and Germany. Tacoma, Washington, was his home in his midteens, and the region became his jumping-off point for a successful music career. He was most influenced by soul artists in his youth—Ray Charles and Sam Cooke—and played both piano and guitar. Albert Collins spurred his interest in the blues when they met in 1969. Still in Tacoma in 1974, he formed the Robert Cray Band and honed his sound by backing visiting blues artists, much in the same way the Vaughan brothers' Texas Storm had done in Austin.

Cray recorded an album for Alligator records in 1978. He then moved to Hightone Records for his second album *Bad Influence*, a recording that showed potential for crossover success. Alligator's triple-threat album *Showdown!* (with guitarists Albert Collins and Johnny Copeland) proved Cray's solid blues credentials and established him as an original voice of the guitar. In the following year he recorded his biggest success, *Strong Persuader*, an album that won him another Grammy and was certified a double platinum seller (more than 2,000,000 copies sold) in 1996. Though critics would bemoan that Cray's fusion of contemporary styles was not rooted enough in traditional blues, *Strong Persuader* presented a new formula for success. The landscape of blues recordings today has become a mixture of the most traditional country blues and recordings that frame the music in a more contemporary format.

After the general public and the blues community were introduced to Cray's unique brand of blues, he toured the world and collaborated with notable rock and blues icons like Eric Clapton, Jimmie Vaughan, Buddy Guy, Chuck Berry, and Keith Richards. He maintains a busy touring and recording schedule today, and continues to create music that incorporates various styles with the blues.

THE NEW DOWNHOME—NORTH MISSISSIPPI HILL COUNTRY BLUES

Largely a continuation of widespread public interest in early blues after the 1960s revival, ethnomusicologists and music connoisseurs increasingly turned their research toward the North Mississippi Hill country region just outside the Delta. The renewed interest in Hill Country blues resulted

in the discovery and fascination in elderly musicians whose music seemed to reverberate with the sound of people who lived hundreds of years ago and oceans away. The new spokesmen of the blues made their music at casual gatherings, picnics, and juke joints, and typically kept a day job of farming and other menial jobs until a series of discoveries took place.

Some of the music found by the researchers was played on fife and drum, instrumentation common in the Union Army during the Civil War, and possibly as early as Colonial times. During his trips to the region in the 1940s and 50s, Alan Lomax recorded **Sam Hemphill**, a multi-instrumentalist who also made his own instruments. His music (heard online at the Global Jukebox project) reveals a strong connection to African roots. In his performance of the song "The Devil's Dream (II)," Hemphill alternates between singing syllables and playing short notes on reed panpipes called "quills." His phrases are loosely repetitive, using syncopated rhythms that interlock with the accompanying drum pattern. The melody that results from the voice/quills combination is based on a 5-note scale that is not the typical pentatonic scale but is reminiscent of African music. Lomax was struck by the singular nature of this music that seemed virtually unaffected by contemporary American influence. He unearthed several other traditional musicians, many of whom played fife and drums, and led other researchers to continue the rediscovery of North Mississippi Hill Country music.

One of the most important of these discoveries was **Othar (Otha) Turner**. Born in 1907, Turner is credited with preserving the folk music of the North Mississippi Hill Country. Throughout his life he was visited by researchers who wrote about, recorded, and filmed his music. He was awarded a National Heritage fellowship by the National Endowment for the Arts and released his first album at the age of 90 to much acclaim. *Rolling Stone* magazine listed the album *Everybody Hollerin' Goat* as one of the top five blues albums of the '90s. The attention given Otha Turner, a musical mentor to most of the region's music community, elevated the North Mississippi Hill Country style and built momentum that has continued since Turner's death in 2003.

Music Analysis

Otha Turner, "Station Blues"
Key Personnel: Turner, fife

On his album *Everybody Hollerin' Goat*, 90-year-old Turner performs a collection of songs from several genres. "Station Blues" is a good example of Otha Turner's unique perspective on the blues, set with his Rising Star Fife and Drum Band's special instrumentation. The organic performance seems to be casually thrown together as the various elements of the song (fife, sung melody, drums) come together gradually. The traditional blues song has been performed under the name "Sitting On Top of the World" by the Mississippi Sheiks, Howlin' Wolf, Cream, and countless others.

- **0:04:** Turner plays the song's melody twice on his cane fife.
- **0:35:** Turner repeats the melody while the sound of drums emerge from the background noise.
- **0:52:** Bass drum begins a quiet background rhythm while Turner speaks.
- **1:00:** Verse 1 sung by Turner.
- **1:16:** Verse 2 begins, soon followed by the drum beat.
- **1:38:** Turner plays the melody one last time, before an abrupt ending.

Fat Possum Records

In the 1990s, the popular audience seemed to shift again toward a desire for authenticity in music. Although plenty of polished bubble-gum pop and "hair band" hard rock acts maintained their grip on much of the listening public from the 1980s, alternative rock experienced a flurry of attention from listeners who valued rough-edged punk values and emotional depth. The term "alternative rock" (or "alt rock") had been used to describe underground bands often released on independent labels that managed to garner wide-scale attention, but still typically remained on the margins of mainstream popularity. Debut releases from Seattle bands Nirvana and Pearl Jam in 1991 sold unprecedented numbers from the alt rock category, bringing the genre into vogue and renaming it "grunge rock." The craze for grunge either caused or benefited from a new aesthetic among young people. Like the college crowd that fed the folk and blues revival of the 1960s, an audience was growing for music that sounded real and rough-around-the-edges, music that spoke to the problems they perceived in society. This return of the "realness aesthetic" also demonstrated the potential for a new audience for the country blues.

Perhaps more than any other independent record label, Fat Possum Records has been committed to promoting the indigenous music of Mississippi. With the help of blues historian Robert Palmer, Matthew Johnson created a record label that produced highly acclaimed blues albums by artists whose careers would have remained hidden without his intervention. Johnson has said that he felt the blues had become too overproduced, removing the grit that made him excited about artists like Howlin' Wolf.

R. L. Burnside and **Junior Kimbrough** were among Fat Possum's most important artists of the 1990s. Each has a unique take on the blues that sounds loose and homegrown. The albums put the artists in a variety of settings including full band, solo guitar/voice, and even techno-like samples and loops. R. L. Burnside's first album (also Fat Possum's first album) fused a casual rural approach with the soul and rock beats of contemporary blues. It blended his original songs with covers of John Lee Hooker, Willie Dixon, and Howlin' Wolf. Fat Possum later paired R. L. Burnside with the Jon Spencer Blues Explosion, an alternative rock band that was causing a stir with its grungy blues, or bluesy grunge. The resulting album, *A Ass Pocket of Whiskey*, sounds far from traditional blues with its guitar loops and thundering drums, but it introduced Burnside's music to the followers of Jon Spencer. Burnside was later exposed to an even wider audience opening concerts for the rap group, Beastie Boys.

Junior Kimbrough's approach to the blues is not far from John Lee Hooker's. Songs like "Do the Romp" focus on rhythmic boogie with persistent, throbbing bass lines and brief licks in the guitar's upper register. Kimbrough tends to leave open strings ringing, creating a kind of trance-inducing drone. His album *All Night Long* provided a boost to the North Mississippi Hill Country scene when *Rolling Stone* magazine gave it a rave review. The album was recorded by Robert Palmer at Kimbrough's own juke joint, and backed by R. L. Burnside's son Garry on bass and Kenny Malone on drums.

Music Analysis

Junior Kimbrough, "Meet Me In the City"
(1992)

Personnel: Junior Kimbrough, guitar/voice; Garry Burnside, bass; Kevin Malone, drums

With an unhurried shuffle feel and swampy drone of Kimbrough's open strings, "Meet Me in the City" has a hypnotic quality that seems to channel everything from country blues to hippie rock. Like so many Mississippi bluesmen, Kimbrough doubles his vocal melody with the guitar, breaking away from the basic rhythm pattern. His drummer punctuates the melody with offbeat snare drum hits and cymbal crashes. The bassist holds onto the basic line, except during a couple of "jam" sections of the song. The song seems formless, with a random stream-of-consciousness verse structure broken up by instrumental jam sections. Each jam section is signaled with a lyric line that starts "Please ...," and then the full band connects on a rhythm that propels them forward.

0:00	**Intro:** Kimbrough's guitar sets up the song with the end of the vocal melody.
0:05:	After a snare/cymbal hit, drums and bass enter with a steady shuffle rhythm that feels just shy of a medium tempo.
0:11	**Verse 1:** Kimbrough's falling pentatonic melody emphasizes the shuffle feel with a rhythm that stays completely off-beat. His guitar doubles the entire melody.
1:27	**Instrumental Jam:** The drummer plays a long drum fill and opens the hi hat, while the bassist plays a new bass line on higher notes.
1:44	**Verse 2:** Drums and bass settle back into the opening groove. This verse, or group of melodic lines is completely different from Verse 1, consisting of swinging eighth notes instead of off beat quarters.
3:09	**Instrumental Jam:** Again the drummer becomes more active and the bassist moves to higher notes. Kimbrough plays a full-fledged guitar solo this time that sounds similar to the melody of Verse 1.
3:54	**Verse 3:** This verse has a different structure from both verses 1 and 2.
4:49:	Instrumental Jam.
5:06	**Verse 4:** This verse again contrasts from the first 3 verses.
5:45:	Instrumental Jam.
6:02	**Guitar solo:** The drummer and bassist settle into the verse groove again, but this time Kimbrough plays a guitar solo.
6:40:	Kimbrough signals the end and the band connects on the melody's final rhythm.

The rich tradition of the Fat Possum artists has been promoted in recent years by a younger generation of rock musicians who give credit to Otha Turner, Kimbrough, Burnside and the others while they update the material for younger crowds. The **North Mississippi Allstars** are led by the sons of well-known Memphis producer Jim Dickinson. Luther and Cody formed their band in 1996 using the songs of North Mississippi Musicians such as R. L. Burnside and Otha Turner, often collaborating with them. Their blend of rock and blues has garnered respect in both worlds, resulting in Grammy nominations for many of their records in the "Best Contemporary Blues" category.

The Black Keys have reached the pinnacle of commercial success, creating a buzz among the rock and pop worlds for achieving a unique sound. The Black Keys first recorded as a Fat Possum band, even though guitarist Dan Auerbach and drummer Patrick Carney are from Akron,

Music Analysis

North Mississippi Allstars, "Meet Me in the City"
(2003)
Personnel: Luther Dickinson, Cody Dickinson, Chris Chew, and others

The Dickinson brothers' version of Junior Kimbrough's song is a clear example of how a blues song can be rearranged to reach a new audience. This version is aimed at rock and pop fans with its slick production quality, tight arrangement, layers of guitars, and background vocals.

0:00	**Introduction:** Guitars play a pre-arranged melody line based on the contour of Kimbrough's melody. The rhythm section plays a tight shuffle.
0:25	**Verse 1:** The rhythm section settles on its shuffle while Dickenson sings the Kimbrough melody. Background vocals support the lead singer at times. Slide guitar fills between melodic statements.
1:08:	The band stops on a sustained chord, accentuating the lyric "honey don't" and foreshadowing the song's chorus fragment.
1:21	**Chorus:** The Allstars' arrangement adds new chords behind Kimbrough's "please" lyric, making the section a clearer chorus.
1:32:	The rhythm section settles back into the shuffle to set up the 2nd verse.
1:38:	Verse 2
2:21	**Chorus:** Again, the new chords enter.
2:32	**Instrumental Jam/Guitar solo:** Lead guitar plays a solo with busy piano behind it.
2:48	**Introduction:** The rhythm section repeats the opening section.
3:09	**Verse 3:** Slide guitar and the rest of the rhythm section play more actively through the remainder of the song.
3:32:	Chorus
3:43:	Instrumental Jam/Guitar Solo

Ohio, not Mississippi. Like the North Mississippi Allstars, they repackage the blues in a way that is more accessible to a young generation of rock fans. Both bands manage to hold onto the grit and creative drive of the blues artists they cover. These groups point to the potential for yet another blues revival by bringing the music into the rock world.

The Black Keys

© Mat Haywardr, 2014/Shutterstock, Inc.

Music Analysis

The Black Keys, "Meet Me In the City"
(2006)

Personnel: Dan Auerbach, guitar/vocals; Patrick Carney, drums

In the Black Keys' version of Kimbrough's song, they take a more stripped-down approach than the North Mississippi Allstars. The instrumentation on this record is the same as Kimbrough's version (drums, bass, guitar/vocal), but the thundering drums pull the song further into Led Zeppelin territory than the North Mississippi All-Stars version. Rock and roll bands tend to place less emphasis than blues and jazz on interaction during improvised solos. Instead, the solos serve as a texture change that gives variety to the song. Listen to the texture changes in both rock versions of this song, and how the various sections provide a kind of progression that tells a succinct story.

0:00	**Introduction:** The bassist and guitarist start the song with simple time, followed by a guitar lead line similar to the Allstars' version.
0:28	**Introduction:** After a short guitar fill, the drums come in with crashing cymbals. The Black Keys' version uses a half time feel in the drums.
0:36	**Verse 1:** The drummer moves from the cymbal to a low tom with a crisp off-beat high hat.
1:27	**Chorus:** The "please" lyric in this version happens over a softer pattern in the band, with high quarter notes in the bass, ride cymbal only from the drummer, and guitar doubling the voice.
1:41	**Instrumental Jam:** The drummer comes in strongly with the original groove under the guitar solo, resolving the tension that was created by the soft chorus.
1:56	**Verse 2:** The band returns to the verse texture.
2:35	**Chorus**
2:50	**Instrumental Jam/Guitar Solo:** In this final section, the guitarist plays a more elaborate solo.
3:26:	The band arrives at a final chord while the guitar solo trails off.

Discussion Questions

1. The three different recordings of "Meet Me in the City" highlight stark differences between contemporary approaches to the blues. Contrast each version by Junior Kimbrough, North Mississippi Allstars, and The Black Keys, pointing out specific musical elements.

2. How does the music of North Mississippi Hill Country musician Otha Turner differ from the music of the Delta bluesmen?

3. Compare Otha Turner's "Station Blues" with early country blues and with the African musical elements discussed early in this book. What does Turner's music have in common with the roots of blues music?

4. Describe Stevie Ray Vaughan and Double Trouble's musical style in terms of their connection with blues of the past and its development.

5. Chart the course of the blues throughout the chapters of this textbook. What trends emerge when we take into account the geographical location of the important blues artists and the development of the musical style?

CHAPTER 21

Conflicting Values: Jazz in the Late 20th Century

Over the course of jazz history, from Buddy Bolden and Freddie Keppard to Miles Davis and Chick Corea, jazz developed into an increasingly kaleidoscopic spectrum of styles and approaches which, by the late 1970s, gave musicians endless options for legitimate expression. The definition of jazz was expanded to include just about any improvisation-based music and could come from the rural South, urban cities in the Northeast and on the West Coast, or from nations around the globe. Jazz bands were becoming more racially diverse, too. The old divisions between white and black musicians were far subtler. It became absolutely common in the late 20th century to see large and small bands comprised of white, black, Hispanic, and Asian musicians.

Some of the experiments in bop, the avant-garde, and fusion burrowed further underground, appreciated primarily by a small group of musicians and critics who were destined to be accused of having elitist tastes. Others brought new listeners to the fold of jazz audiences. By 1980, jazz had undergone so much change so quickly that all bets were essentially off. From a musician's perspective, the possibilities must have seemed endless. He or she could incorporate funk, play historical swing styles, inject ethnic musics from other nations, reinvent big band music, tinker with cutting-edge technology, or build upon the mainstream acoustic jazz styles perfected by Dexter Gordon and Sonny Rollins. But these endless stylistic options posed a conflict of values within the jazz community. More than during earlier periods, the jazz artist struggled to answer some pressing questions. "How can I say something significant with my music?" Copying the clichés of earlier jazz forms, a new musician runs the risk of being redundant. What approach can an artist take in order to remain faithful to the masters of the past without duplicating his or her work? Or put another way, "What is jazz?" "What elements must it include?" "How elastic or rigid should my definition of jazz be?"

In the 1980s, several important artists grappled with these problems successfully and created vital new jazz styles. In their work, we can see a number of new trends emerge—Historicism, Neo-Traditionalism, Globalization, Glocalization, and a return to new kinds of fusions. Over all these loomed the phenomenon of Commercialization, arriving in a neatly packaged jazz style aimed at the easy listening pop radio format—smooth jazz.

COMMERCIALISM AND THE ONSET OF SMOOTH JAZZ

Fusion rewrote the jazz musician's rulebooks in many respects. It flooded the jazz sphere of the 1970s with new levels of virtuosity and pyrotechnics. It also re-emphasized the dominance in jazz of

instrumentalists over vocalists. Vocal jazz continues on until today, but the popularity of fusion eclipsed those artists who made their living singing standards. Just like bebop had brushed off the dancing crowd that had supported swing bands, the guitarists and saxophonists and drummers who pushed fusion into the limelight largely alienated audiences that connected with lyrics and songs. Jazz was becoming music for instrumental musicians, especially those musicians who played rhythm section instruments. Drummers, guitarists, keyboardists, and bassists flourished in a musical environment that rewarded heavy amplification and technical wizardry. Fusion also became a boon to musical instrument companies. Musical instrument companies provided an incentive, through endorsement deals, for fusion artists to show off what amazing feats could be accomplished on their axes. In this case, commercialism provided a situation that was mutually beneficial to the world of music business and musicians, and it encouraged groups and band leaders like Chick Corea, Herbie Hancock, Tribal Tech, and Dave Weckl to keep making music for an audience largely comprised of amateur musicians who aspired to build careers like their idols.

On the other side of the commercialism coin was **smooth jazz**, a style more financially successful than any other jazz sub-genre, but also one that brought more controversy than any other. Smooth jazz artists either incorporated or placated pop music styles, motivated primarily by profit. Smooth jazz musician George Benson confirmed as much in an interview with Robert Palmer, published in the *New York Times* ("Jazz Pop—A 'Failed Art Music' Makes Good," February 13, 1977, *New York Times*).

Smooth jazz—A popular blend of jazz-rock fusion and soul/R & B, characterized by electric instruments, rhythmic grooves borrowed from R & B music, and consonant pitch selection in improvisation and chords.

On the way to smooth jazz, a number of soul jazz musicians inched their repertoire further toward contemporary R & B by making feel-good, improvisational music based on funky rhythm section grooves (and sometimes based on covers of popular R & B songs). **George Benson** and **Grover Washington, Jr.** were important harbingers of the smooth jazz style. Benson had recorded some of the most heavy-hitting and forward-looking jazz of the 1960s and '70s with Freddie Hubbard (*Straight Life*) and Miles Davis (*Miles in the Sky*), and he was featured in concerts with the Count Basie Orchestra. But in 1976 he hit paydirt with the album *Breezin'*, buoyed by the title track and his cover of Leon Russell's "This Masquerade." He began to showcase his singing voice over his guitar skills and wrote songs meant to woo R & B audiences. This is what is known in the record industry as a "crossover hit," when an artist from one genre crosses over to another, or one style becomes a hit in a different genre category. "This Masquerade" rose to #10 on the pop charts. Other important crossover hits of early smooth jazz were Grover Washington, Jr.'s "Mister Magic" (1975), Chuck Mangione's "Feels So Good" (1978), and Spyro Gyra's "Morning Dance" (1979). Kenny G (named Kenneth Gorelick) made the soprano saxophone famous again and brought smooth jazz to its commercial zenith with multi-platinum selling albums throughout the 1980s, culminating with *Breathless* (1992), which sold more than 12 million copies! Still, do record sales confirm artistic significance? Of course not.

Randy Miramontez/Shutterstock.com

George Benson

Smooth jazz sharply divided the audience of jazz into two camps. On one hand, the audience for jazz music expanded by encompassing R & B

fans interested in an instrumental version of the music they already enjoyed. On the other hand were the fans of jazz based in bebop and swing, many of whom were insulted when the smooth style was labeled "jazz." To these (including most scholars and musicians), smooth jazz should have been labeled a different type of music entirely. But the success of smooth jazz, and the shrinking audience of what they would call "real" jazz, tempted jazz musicians of all sorts to nudge their music toward the smooth. Others adamantly turned away from the processed, sterile, bland sound of smooth jazz and avoided various elements of smooth jazz. The trends of the 1980s and 1990s in jazz can be viewed, to some extent, as various ways to grapple with the problem of smooth jazz. A number of approaches emerged in the mid-1980s. A new group of leaders and a few jazz legends offered alternate pathways for the development of jazz. Perhaps none of them resisted smooth jazz more stubbornly than Wynton Marsalis.

SOMETHING BORROWED, SOMETHING BLUE—NEO-TRADITIONALISM AND THE YOUNG LIONS

Wynton Marsalis

The career of **Wynton Marsalis** presents a dichotomy of artistry. Like so many creative jazz musicians in the 1980s and later, his recordings as a leader have spanned an eclectic range of styles. He reflected the influence of post-bop Miles Davis and even the avant-garde approach of Ornette Coleman on his Grammy award-winning album *Think of One* (1983) and *Black Codes (From the Underground)* (1985) with his brother Branford at his side playing tenor and soprano saxophones. These recordings also introduced drummer **Jeff "Tain" Watts** and pianist **Kenny Kirkland**, a pair who innovated considerable new approaches on their respective instruments by as-

Wynton Marsalis

Jonathan Feinstein/Shutterstock.com

similating and personalizing techniques of their forerunners. Watts, for example, mastered Tony Williams's bombastic style and metric modulation and peppered his sound with Elvin Jones's elastic time feel. After these forays into fresh and sometimes experimental jazz, Marsalis seemed to have converted to a dogmatic approach, a new traditionalism that stubbornly protected jazz's essential elements—swing rhythm, the blues, and a commitment to acoustic instruments (album liner notes bragged of the band's rejection of contemporary recording techniques.)

The most iconic jazz celebrity to rise after Herbie Hancock, Marsalis has been notorious for making controversial statements about elements of contemporary jazz that he deemed unacceptable. He landed a piercing (if supercilious) blow in an argument with Herbie Hancock in *Musician* magazine (March, 1985). Hancock's recording "Rockit" introduced jazz fusion to the first MTV generation by incorporating a turntable played by Grandmixer D.ST, but Wynton accused Hancock of selling out, of betraying the foundational values of jazz.

PhotoHouse/Shutterstock.com

Wynton Marsalis

Roots of Neo-Traditionalism

So what was the root of Marsalis's dedication to a traditional jazz approach? At least a large share of influence came from Marsalis's friend, jazz critic and former free jazz drummer Stanley Crouch. Crouch's liner notes to Marsalis's albums read like a jazz manifesto. He describes the decisive turn toward neo-traditionalism in liner notes for *The Majesty of the Blues* (1989), an album that traded Marsalis's earlier modernist quintet approach in the ilk of Miles Davis for a 10-piece New Orleans ensemble (with spoken word performed by Reverend Dr. Jeremiah Wright). Crouch had experienced his own conversion of sorts, influenced by black jazz writers LeRoi Jones (Amiri Baraka), Ralph Ellison, and particularly Albert Murray's *Stompin' the Blues*, a book that initially laid out the tenet that legitimate jazz must be based on blues sounds and swing rhythm. This view also seemed to fit the emergent notion of jazz as "America's Classical Music," espoused by Billy Taylor in 1986 (*The Black Perspective on Music*, Winter, 1986). By clinging to the roots of jazz, the neo-traditionalists hoped to emphasize and re-elevate the music as an art form, rather than something seeking for commercial appeal. The jazz community criticized Crouch and Marsalis for having monopolized public perception of jazz with their leadership of Jazz at Lincoln Center and their ubiquitous presence on Ken Burns's 10-part PBS documentary *Jazz*. Today Marsalis is the figurehead of a historicist trend in jazz. However, his definition of jazz has seemed to broaden over the years, programming everything from Jelly Roll Morton to Chick Corea to Duke Ellington.

Ever since the broadcast of Ken Burns's *Jazz*, television and other media outlets have called on Marsalis as the chief spokesman for jazz. It's a remarkable story, how he earned his ambassadorship, how he dominated the jazz scene of the early 1980s through prodigious musical talent and a penchant for controversy, how his art progressed through new and old styles, and how he stands today as the keeper of a kind of moral compass for jazz. A purist, an eclectic, a neo-traditionalist, and a diplomat, these are the faces of the contemporary jazz leader.

The Marsalis Pedigree

Marsalis was raised near New Orleans in a dynasty of professional musicians. His father, professional pianist Ellis Marsalis, produced an astounding number of talented sons. Besides Wynton, saxophonist Branford (the oldest brother), trombonist/producer Delfeayo, and drummer/vibraphonist Jason Marsalis all have had fruitful careers in jazz. The National Endowment for the Arts named the four brothers and their father *Jazz Masters* in 2011.

Marsalis joined Art Blakey's Jazz Messengers in 1980, prompting fellow trumpeters Terence Blanchard and Brian Lynch to credit him with raising the standard for jazz trumpet technique at the age of eighteen. Wynton's meteoric rise on the New York jazz scene in 1980 was followed shortly by acknowledgment of his immense talent by Grammy voters. He was awarded two Grammys in 1983, one for an album of standard classical trumpet concertos and the other for his jazz quintet recording *Think of One*. He repeated the feat the following year with *Baroque Music for Trumpet* and *Hot House Flowers*, a jazz album with strings. Marsalis further deepened his credentials by playing with Herbie Hancock's V.S.O.P. quintet, essentially a new Miles Davis quintet (Freddie Hubbard had been the stand-in for Miles before Wynton). Marsalis's first few jazz albums reflected a post-bop influence, a cutting edge approach with modern compositions. (*Black*

Codes from the Underground, from 1985, is a highlight.) Most of the recordings featured his brother Branford on saxophones along with a new group of remarkable players that included Kenny Kirkland on piano and Jeff "Tain" Watts on drums.

Marsalis's *Standard Time, Volume 1* (1987) reworked several jazz standards like George and Ira Gershwin's "Foggy Day" and Juan Tizol's "Caravan" in a number of re-arrangements that capitalized on the skills of his backing band—drummer Jeff Watts, bassist Robert Hurst, and pianist Marcus Roberts. It is not a stretch to compare this rhythm session to Miles Davis's Second Great Quintet's team of young, mad innovators. Watts and Roberts maintain a dangerous balance, a moving target of polyrhythm versus deep swing. Hurst's warm tone and thoughtful bass lines anchor their explorations.

Music Analysis

"Autumn Leaves"
(1987)
Personnel: Wynton Marsalis, trumpet; Jeff "Tain" Watts, drums; Robert Hurst, bass; Marcus Roberts, piano

Drummer Jeff "Tain" Watts's presence is felt strongly in one of the finest Wynton Marsalis recordings of the 1980s. He arranged the common jazz standard to showcase his mastery of **metric modulation**, where the large pulse (beat one) remains constant but the subsequent beats are sped or slowed to create a kind of stratified acceleration and deceleration.

0:00	**Head, A section:** Underneath Marsalis's rigid delivery of the melody, the band plays 1 note that lasts 8 real beats, then 2 notes per 8 beats, then 3, 4, 5, 6, 7, and finally reach the fast 8 beat pulse. Watts and Robert Hurst keep simple time and Marcus Roberts playfully jabs at syncopated rhythms.
0:14	**Head, B section, 1st half:** The rhythm section stays at the fast "burn out" tempo while Wynton plays the melody more freely than before. He leaves the melody at the second half of the bridge and plays a blast of bebop eighth note lines.
0:22	**Head, B section, 2nd half:** The rhythm section regresses through the metric modulation sequence, playing 6 beats, then 4, then 3, then 2.
0:27	**Head:** A repeat of the arrangement of the head.
0:55	**Piano Solo:** Marcus Roberts opens his solo with a folk-like melody, but leaves it soon for blazing bop lines that weave in and out of the tonality. Watts spurs him on. Listen for a climactic rhythmic "hook-up" at 2:27.
3:16	**Bass Solo:** Hurst's sound is partially buried by Tain's ride cymbal and Roberts's staccato comping, but listen through the chatter for some captivating solo work.
5:12	**Trumpet Solo:** Marsalis plays a brief solo that builds off of the polyrhythmic ideas played earlier by Marcus Roberts. He plays a soaring slur in the upper register before landing on the melody.
5:32	**Head:** The band plays the opening arrangement again.
5:58	**Tag:** The band repeats the last few bars before holding a final chord (a minor-major thirteenth).

Marsalis Hailed for Historicism

The New Orleans brass band sounds in *The Majesty of the Blues* (1989) marked a sharp turning point toward the traditionalist approach that has characterized much of his work since. ***Blood on the Fields***, a large-scale work of Ellingtonian proportions (released on 3 CDs in 1997), culminated

Music Analysis

"Work Song" from *Blood on the Fields*
(1997)
Personnel: Wynton Marsalis, conductor/trumpet; Jon Hendricks, Cassandra Wilson, Miles Griffith, vocals; Victor Goines, soprano/tenor saxophones, clarinet, and bass clarinet; Walter Blanding, soprano saxophone; Wess Anderson, alto saxophone; Robert Stewart, tenor saxophone; James Carter, baritone saxophone, clarinet, and bass clarinet; Russell Gunn, Roger Ingram, Marcus Printup, trumpet; Wycliffe Gordon, trombone and tuba; Wayner Goodman, Ron Westray, trombone; Michael Ward, violin; Eric Reed, piano; Reginald Veal, bass; Herlin Riley, drums/tambourine

Though his detractors accused Marsalis of taking the music backward, this movement of Pulitzer-award-winning jazz oratorio is a brilliant mixture of New Orleans-inspired timbres, gritty vocal work, and rhythms that draw from Latin styles, and even perhaps hip-hop. Listen to the progression of instrumental colors, interlocking melodies, and rhythmic grooves.

Marsalis's foray into historicist jazz and reminded listeners of America's violent history marred by southern oppression. The work combined sung and spoken vocals with a large band of fifteen musicians. It was awarded a Pulitzer Prize, the only jazz composition to receive the award (Duke Ellington almost won in 1965, but was snubbed by the Pulitzer board.) Marsalis is one of only a few artists in jazz to have spanned the wide gulf between traditionalism and modernism. He has built a career on relating the importance of jazz and its primary artists to the greater public, and his position as a spokesman and an ambassador has held considerable sway among young jazz artists who hoped to forge their own careers in contemporary jazz.

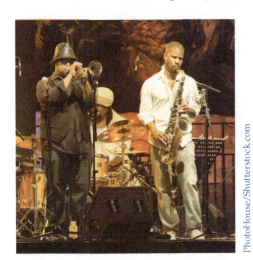

Nicholas Payton (trumpet) and David Sanchez (tenor saxophone)

Young Lions

Marsalis was the de facto leader of the next generation of jazz virtuosi, a new class of recording artists ushered in by Columbia records and other companies that hoped to strike while the kettle was hot. Marsalis brought considerable attention to jazz, and musicians were hungry to make their mark. The Young Lions of the late '80s pushed jazz through its next phase of development. Trumpeters Roy Hargrove, Terence Blanchard, and Nicolas Payton; saxophonists Joshua Redman and Kenny Garrett; bassist Christian McBride; pianists Cyrus Chestnut and Eric Reed; guitarist Russell Malone; and drummer Brian Blade made some of the finest recordings of the age and adopted Marsalis's traditionalist ideology in varying degrees. In line with the rules of neo-traditionalism, their music swung, had elements of blues, and used acoustic instruments. But listening to the best of these albums, it's clear that these artists were not simply following Wynton's lead. They seemed to genuinely cherish the warmth of real instrumental sounds and to sense the depth of rhythm inherent in swing.

A lesser-known term, **"burn out,"** describes the aesthetic of high-wire interaction and improvisation during this period. Young Lions delighted

in ramping up their solos to a fever pitch and then crashing through to the next soloist. Tunes tended to be extremely fast, as fast as the fastest bebop performances, and emphasized modal chord changes and melodic styles. Drummers took control of the band with aggressive drum fills and a new-found love of **dropping bombs**. Pianists and drummers traded rhythmic kicks and polyrhythms behind the soloist, pushing the intensity toward climax.

Music Analysis

"2 Down & 1 Across"
(1997)

Personnel: Kenny Garrett, alto saxophone; Kenny Kirkland, piano; Nat Reeves, bass; Jeff "Tain" Watts, drums

While Kenny Garrett apprenticed with trumpeters Woody Shaw and Miles Davis, he garnered attention as masterful solo in command of a soulful melodic vocabulary and an ability to maintain palpable intensity. Drummer Jeff "Tain" Watts eggs him on throughout this recording, as he did with both Marsalis brothers. Listen for the band's ability to bring their collective music to a climax using chromatic, outside melody and rhythmic abandon.

0:00	**Introduction:**	The rhythm section holds a progression of chords underneath Garrett's four-note statement.
0:15	**Head, theme:**	Watts leaves the last held chord (fermata) and sets up the pulse of the tune with driving swing feel. The head is structured in an uncommon way. It moves between a written, angular melody, an open section of improvisation over one chord, and a closing melody. The rhythm section stays at the fast "burn out" tempo while Wynton plays the melody more freely than before. He leaves the melody at the second half of the bridge and plays a blast of bebop eighth note lines.
0:36	**Head, variation:**	Garrett's melody arrives at a different key center this time for its one-chord improvisation, before returning to the home chord.
1:00	**Alto saxophone solo:**	Garrett comes right out of the gate with biting tone and intense melodic figures. He and Tain build the energy to a boiling point at about 2:30 that borders on free jazz. Garrett's solo ends with the final melody statement of the head.
2:43	**Piano Solo:**	Kenny Kirkland explores a variety of keys in his solo, in the same fashion McCoy might have done with John Coltrane. Like Garrett, he plays off of the constant energy coming from the drums.
4:06	**Head, variation:**	Garrett re-enters halfway through the original head.
4:21	**Outro:**	The band ends with held chords that bring back the idea of the opening.

Keith Jarrett

Ideologically, **Keith Jarrett** represents the antithesis to Wynton Marsalis and the neo-traditional slant. A virtuoso pianist, Keith Jarrett shrugged off a couple of opportunities for education, turning down the chance to study under the famous French composition teacher Nadia Boulanger and getting himself expelled from the Berklee College of Music after just a year. Like Marsalis, the virtuoso pianist apprenticed for a time with Art Blakey's Jazz Messengers. He moved quickly through the bands of Miles Davis, Charles Lloyd, and Gary Burton at the beginning of the 1970s, uniting with drummer Jack DeJohnette in a partnership that would continue for decades. In 1971 he began recording solo piano albums for ECM (most

famously, the *Köln Concert* recording of 1975). His quartet recordings during the mid-1970s for Impulse/ABC and ECM companies reflected a commitment to acoustic jazz, including acoustic bassists Charlie Haden and Palle Danielsson, drummers Paul Motian and Jon Christensen, and saxophonists Dewey Redman and Jan Garbarek. At the same time the long and exploratory improvisations on an open, floating time feel reflected the aesthetic of the avant-garde. Add to this Jarrett's tendency to inject gospel and soul-tinged keyboard patterns and Keith Jarrett's musical style represents a truly eclectic standard for the day. Jarrett's work of the 1970s represented a true freedom in music, one that was not relegated to atonal and arrhythmic sounds, but instead, could draw freely from swing, from the blues, from free jazz, or from more contemporary sounds in order to create music of great depth.

Since 1983, Jarrett's primary ensemble has been his Standards Trio. The group's immoveable personnel (Jack DeJohnette and Gary Peacock have been the group's only drummer and bassist) have released a long series of highly acclaimed live recordings for ECM, reimagining the most well-known jazz standards. Most often, the band's arrangement follows a typical progression of introduction (often piano solo)-head-solos-closing head. Their repertoire is a collection of Tin Pan Alley favorites of decades past. But it is the improvisational approach that makes the trio's sound instantly recognizable. DeJohnette and Peacock play an organic style of **broken time**, hinting at two-feel and four-feel swing without actually playing it until optimal moments. Jarrett trails his extremely dexterous bebop-laden melodic lines with a pinched humming voice and occasional loud grunts. Although plenty of listeners complain of his distracting sounds, his vocalizations intensify the notion of tension and release produced in the music. By committing the later half of his career to the Standards Trio, Jarrett is a unique bridge between a historic, traditional approach and the avant-garde aesthetic.

THE NEW FUSION—ECLECTICISM AND ELECTRIC JAZZ

A number of artists put forward some alternate directions for fusions with funk, R & B and other "urban" styles. Although the urban styles contemporary popular musical trends, the most significant urban jazz artists of the mid-1980s were careful to craft their stylistic concepts with tenets in line with this book's defining aspects—improvisation, interaction, creative edge, and unique approaches to sound and rhythm.

The **M-Base Collective** began around 1985 as an influential group of young musicians in New York City led by alto saxophonist **Steve Coleman** that produced an eclectic style that blended jazz rooted in bebop and post-bop with contemporary black rhythmic grooves. M-Base is an acronym that stands for "Macro-Basic Array of Structured Extemporizations." Coleman explains that M-Base is a way of thinking about music, not the music itself. But it involves an "array" of improvised musical inventions, a way of channeling one's experiences through creative music so that the styles that emit from the M-Base movement are malleable and broad. Much of this music draws from bebop, funk, and free jazz. The music explores odd meters and compositions with gestural melodies (emphasizing shapes rather

than lyricism). On the group's first full-length album *Anatomy of a Groove* (1992), electric bass guitar and modernized R & B drum timbres are paramount in contemporizing the band's sound, borrowing grooves from go-go and new jack swing rhythms that were popular at the time. Several of the members of the collective have become key figures since their association with the group. Pianist Geri Allen, saxophonist Greg Osby, drummer Martin "Smitty" Smith, and vocalist Cassandra Wilson were among the first members of the collective, and the M-base website lists tenor saxophonist Ravi Coltrane (John Coltrane's son), trombonist Robin Eubanks, trumpeters Roy Hargrove and Ambrose Campbell-Akinmusire, pianists Jason Moran and Muhal Richard Abrams, drummers Terri Lyne Carrington and Marcus Gilmore, and bassists Dave Holland and Meshell N'delecello among its personnel over the years.

Music Analysis

Anatomy of a Groove
(1993)

Personnel: Steve Coleman and Greg Osby, alto saxophone; Cassandra Wilson, vocals; Jimmy Cozier, baritone saxophone; Graham Haynes and Mark Ledford, trumpet; Andy Milne and James Weidman, keyboards; Reggie Washington and Kevin Bruce Harris, bass; David Gilmore, guitar; Marvin "Smitty" Smith, drums

https://www.youtube.com/watch?v=ol8acY0QpVY

Find the M-Base Collective's first full-length album at the YouTube link above (currently not available on Rhapsody).

One of the central members of the M-Base Collective, **Cassandra Wilson**, turned out to become the most recognizable singer of her generation. Her low range is enriched by a smoky and rustic tone, lending a naturally blue shade to the unique brand of funk and hip-hop in M-Base. Wilson rose from the underground band to embark on a successful solo singing career in the 1990s. One highlight was her 1995 Blue Note release *New Moon Daughter*, on which she sang highly-personal cover versions of Billie Holiday's grotesque anthem of southern lynching, "Strange Fruit," Son House's "Death Letter Blues," "Love is Blindness" by U2, Hank Williams's "I'm So Lonesome I Could Cry," and a number of her original songs. Her debut Blue Note recording *Blue Light 'Til Dawn* included a couple of remarkable versions of Robert Johnson songs "Come On In My Kitchen" and "Hellhound On My Trail." But more than her eclectic and blues-rooted selection of songs, what

Cassandra Wilson

makes her solo recordings unique are the instrumental settings that accompany her voice. Captured by Blue Note's high definition sound quality, each track on a Cassandra Wilson recording has its own sonic universe that may include Lonnie Plaxico's reverberant bass, Kevin Breit's Resophonic guitar, Brandon Ross's acoustic guitar, pedal steel guitar, Steve Coleman's alto saxophone, light percussion, muted trumpet, or vibraphone.

Marcus Miller

Miles Davis played an important role in the new fusion, largely in collaboration with bassist **Marcus Miller** who produced his definitive album *Tutu* (1986). Through the period, Miles continued challenging himself with a new group of sidemen including alto saxophonist Kenny Garrett, soprano saxophonist Bill Evans (no relation to the pianist), guitarists Mike Stern and John Scofield, and drummer Al Foster. Miller directed Miles's sound toward urban styles of the day, with synthesizers and drum machines, and the band brought popular songs into its repertoire, such as Michael Jackson's "Human Nature" and Cyndi Lauper's "Time After Time" recorded on his *You're Under Arrest* album (1985). Until his death in 1991, Davis continued his tendency of keeping his sound in line with the teenage generation, going so far to incorporate hip-hop in his last album *doo-bop* (1992).

Acid jazz was yet another approach to a fusion between jazz and urban styles. The style initially became popular in London clubs during the mid '80s when DJs (most notably **Gilles Peterson**, who coined the term "acid jazz") mixed recordings of classic jazz with techno, or electronic dance music. Us3 scored the most recognized hit of acid jazz with their rap resetting of Herbie Hancock's "Cantaloupe Island," called "Cantaloop (Flip Fantasia)." The band's recording for the Blue Note label in 1993 included samples of Horace Silver's "Song For My Father" and Thelonious Monk's "Straight No Chaser."

Jam bands, such as the festival favorites **Medeski, Martin, and Wood**, introduced jazz-rock fusion to a new post-hippy generation attracted to rock and funk music with long vamps and lots of room for improvisation. Rock bands that crafted their sound in a Grateful Dead mold began introducing jazz-like melodic lines into their improvisations on the jam band scene. In this way, jazz-tinged jam rock acted as a gateway style into a Coltrane aesthetic, even going so far as to incorporate free jazz and bebop. Among several of these jam bands Medeski, Martin, and Wood, and **Charlie Hunter** stand out as having a solid foundation in advanced jazz music. Hunter is famous for playing a custom-built instrument that combines guitar and bass strings, plucking the bass with his right thumb and strumming and picking guitar strings with his remaining fingers. Much of his music typically hovers on long vamps in styles that may extend into funk, soul, Latin, and reggae (listen to his quartet album *Natty Dread*).

John Medeski, Billy Martin, and Chris Wood formed their MMW trio after performing with various participants on the New York City jazz scene in the 1980s. The trio garnered considerable press activity and built an impressive following at live concerts on the heels of their self-released album *Notes from the Underground*. Initially, the band blended a free, avant-garde approach with grooves and textures borrowed from James Brown-rooted funk, swampy New Orleans R & B popularized by the likes of Professor Longhair and the Meters, hip hop, and techno music. On successive recordings, their sound swung widely between free jazz collaboration with members of Phish and funk-hop collaborations with guitarist John Scofield.

The trio's eclectic musical tastes contrast a decidedly traditional concept of instrumentation, with Wood's acoustic bass plugging away at

normally-electric bass lines, Medeski's Hammond B-3 organ, and Martin's unprocessed drum sounds. By injecting bona fide jazz into the jam band scene, MMW has introduced jazz to thousands of concertgoers whose appetites for musical depth would otherwise be fed by formless, aimless improvised vamps.

Music Analysis

"Southern Pacific"
(1997)
Personnel: John Scofield, guitar; John Medeski, keyboard/organ; Billy Martin, drums; Chris Wood, bass

Medeski, Martin, and Wood have a comfortable rapport with jazz guitar legend, John Scofield, on his recording *A Go Go*. The album moves through a variety of funky jazz styles, influenced by soul, R & B, and above all, New Orleans-flavored funk. This track is a good example of the band's ability to phrase elastic rhythms together, and to keep a groove moving forward while maintaining a laid back mood. Far less wild than on MMW records, Medeski is kept at bay on the organ, providing a percolating rhythm bed behind Scofield's tip-toeing phrasing.

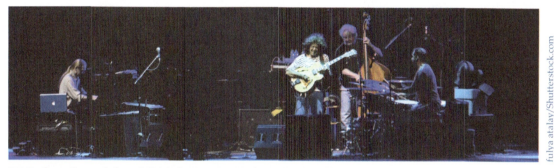

Pat Metheny Group (left to right): Lyle Mays, Pat Metheny, Steve Rodby, Antonio Sanchez

Pat Metheny

Pat Metheny continued to be a major force in the pan-global jazz scene of the 1980s and '90s. After making an impact with recordings for the ECM label, several high profile sideman stints in the late '70s, and a standout quintet recording with Ornette Coleman entitled *"Song X,"* Metheny's subsequent recordings for the Geffen label settled into an approach that blended Brazilian rhythms and percussion instruments, lush pop-oriented harmonies, and melodies often doubled with wordless vocals. **Lyle Mays's** contemporary keyboard sounds provided a soundscape around Metheny's tuneful-yet-virtuosic improvisations that bridged the gap to commercial smooth jazz.

But more than kowtowing to the pressures of the pop music market, Metheny's work of the 1980s and '90s transports the listener through a progression of changing instrumental sounds and surprising key centers, all built on a foundation of bebop improvisation. Metheny does little to disguise his debt to Wes Montgomery with his octave-doubled lines and blistering double-time licks. What separates Metheny's Geffen recordings is the consonance of sounds. He is able to maintain surprising intensity without resorting to a great deal of dissonance or harmonic ambiguity. His

Music Analysis

"Have You Heard"
(1993)
Personnel: Pat Metheny, guitar; Lyle Mays, keyboards; Steve Rodby, bass; Paul Wertico, drums/percussion; Armando Marçal, vocals/percussion; Pedro Aznar, percussion, melodica, saxophone

This is a track from Metheny's live album, *The Road to You*. Brazilian rhythmic patterns form the foundation for this vibrant tune, but the percussionists and drummer constantly maintain a double-time feeling. The instrumental timbres used are akin to sounds used in pop music, but the focus is on Metheny's blistering solo and the artistry of construction and orchestration that permeates the piece.

0:25	**Introduction:** After the crowd noise, the band sets up the double-time Brazilian groove in a mixed meter that oscillates between 6/8 time and 4/4 time.
0:37	**Head:** Metheny plays the melody alone, later joined by a synthesizer, probably Lyle Mays. A bongo break occurs before the final harmonic cadence at 1:13.
1:25	**Head:** This time Armando Marçal sings along with Metheny's guitar melody. Mays plays a countermelody at 1:30. Another bongo break and cadence at 1:58.
2:13	**Send off:** A striking new set of chords modulates through a few key centers over a floating rhythmic feel.
2:27	**Guitar solo:** Metheny solos over the long form of the tune. He maintains double time throughout, playing syncopated rhythms, blues phrases, and **melodic sequences**, or repetitive patterns of slightly changing shapes (listen to his sequence at 3:30).
4:42	**Interlude:** Mays leads the band through a modulating chord progression that lands on the melody in a new key (D minor instead of the original key, C minor).
4:53	**Head:** Metheny takes a rest while Mays and Marçal play the melody.
5:48	**Closing Riff:** The band arrives at a rhythmic figure while Paul Wertico builds energy with a drum solo.
6:07	**Coda:** The band repeats a chord and decelerates, finally arriving at an unexpected chord.

group's live album *The Road To You* (1991) demonstrates just how naturally the Pat Metheny group is able to produce its pristine sounds, and the intensity of its opening track "Have You Heard" makes it clear that Metheny still walks the tightrope of break-neck bebop speeds even within the context of contemporary instrumental sounds.

Metheny has kept one foot in the realm of more traditional, acoustic jazz even while he has explored contemporary electric jazz. He has performed as a sideman with notable tenor saxophone giants Michael Brecker and Joshua Redman, teamed up with fellow guitarists John Scofield and Jim Hall, recorded in small groups with drummer Roy Haynes, a living legend of bebop. Since 2000 he has repeatedly performed in the guitar trio setting—first with bassist Larry Grenadier and drummer Bill Stewart, and later with bassist Christian McBride and drummer Antonio Sanchez. He has formed a quartet with Brad Mehldau, a primary voice among contemporary pianists, and recorded a remarkable duo album with bassist Charlie Haden entitled *Beyond the Missouri Sky (Short Stories)*. His current quartet, the Pat Metheny Unity Group, is comprised of today's most exciting jazz artists—Chris Potter on saxophones and bass clarinet, drummer Antonio Sanchez, and bassist Ben Williams. On one of his most recent projects, *Orchestrion*, he uses technology to program with his guitar an entire roomful of instruments to play intricate accompaniment parts, a true

one-man band. Surprising his legions of fans once again, he has taken his roomful of orchestrion instruments on tour to cities around the world. As we look toward the future of jazz, Metheny is one of the most prominent leaders of a new century capable of guiding the music to its next evolutionary phase.

Michael Brecker

Another singular artist of the late 20th century was Michael Brecker. Brecker was a product of intensive musical practice and at least a flirtation with commercialism. He grew up in a musical family along with his brother Randy, himself a leading trumpet player. He focused on the clarinet, but changed to the tenor saxophone when he was brought under John Coltane's spell. He relocated to New York City with his brother after the pair attended Indiana University. They joined Horace Silver's quintet in 1973 and co-led an influential fusion band called *The Brecker Brothers*. The brothers worked as a team on studio sessions and concerts with the Average White Band and scores of other rock groups. Michael Brecker's mastery of saxophone technique made him a top-call session musician on the

Music Analysis

"Original Rays"
(1987)
Personnel: Michael Brecker, tenor saxophone; Pat Metheny, guitar; Kenny Kirkland, piano/keyboards; Charlie Haden, bass; Jack DeJohnette, drums

From Michael Brecker's debut release for the *Impulse!* company, the band reflects Brecker's eclectic background in both commercial styles and hardcore jazz. After the EWI introduction, the tuneful melody is framed by a harmonic progression that emphasizes major keys, an uncommon setting for jazz. Most jazz musicians prefer minor-sounding keys. Jack DeJohnette drives the groove forward with a kind of "broken rock" feel.

0:00	**Introduction:**	Brecker opens in monophonic texture with his EWI.
1:18	**Intro, and A melody:**	Brecker plays the basic keyboard pattern for the song on his EWI while Jack DeJohnette comes thundering in.
1:58	**EWI solo:**	Brecker solos over Kenny Kirkland's keyboard pattern, then brings back the basic melody.
2:44	**Vamp:**	Kenny Kirkland plays a new riff in a new key.
2:54	**A melody:**	Brecker plays the main melody, this time on his tenor saxophone. Charlie Haden and the chordal instruments play a modulating sequence of chords behind him.
3:35	**Guitar solo:**	Pat Metheny begins his solo over the final chord of the head.
3:46	**Guitar solo, vamp:**	Kirkland returns to the new-key riff. A striking new set of chords modulates through a few key centers over a floating rhythmic feel.
4:06	**Guitar solo, A melody:**	Metheny plays over the chords for the main melody.
4:53	**Tenor saxophone solo, B section:**	Brecker plays over a new set of chords, relying primarily on his vocabulary of double-time patterns and long tones played in the upper altissimo register or in multiphonics.
6:06	**A melody:**	Brecker and the group repeat the main strain. Brecker and Metheny phrase the melody in a manner similar to smooth jazz artists, but are surrounded by an energetic and ever-changing rhythm section.
7:08	**Intro riff:**	The band vamps quietly and then fades out gradually while Brecker returns to the EWI.

New York Scene, appearing on albums by Paul Simon, James Taylor, Aerosmith, and Frank Zappa.

But on his leader recordings and in concert appearances, Brecker adopted an artistic approach akin to many of his post-bop contemporaries. His first release (1987) paired him with Jack Dejohnette, bassist Charlie Haden, guitarist Pat Metheny, and pianist Kenny Kirkland. His original compositions were both a vehicle for him to showcase his outstanding technical skill and a rich exploration of contemporary sounds, chord changes, and rhythmic concepts. The albums also received a great deal of attention among the musician community (much like the fusion bands of a decade earlier) for his astounding technical stunts on the tenor saxophone, such as **altissimo** and **multiphonics**. He also became the most visible exponent of the **EWI—the Electronic Wind Instrument**—a kind of synthesizer that brought the saxophone into the information age. Brecker's albums and the *Brecker Brothers* recordings with Randy were some of the favorite albums of the era among musicians. Michael Brecker's sidemen played an integral role in the sound of his recordings, A-list jazz musicians like Pat Metheny, Jack DeJohnette, McCoy Tyner, Elvin Jones, Jeff "Tain" Watts, drummer Bill Stewart, keyboardists Joey Calderazzo and Don Grolnick, and bassist James Genus.

Toward the end of Brecker's career, his improvisational style reflected a commitment to mainstream tenor saxophone players of past, primarily John Coltrane. His reliance on pattern-based solos and his remarkable multiphonic feats settled in his later years into a more melodic approach and more selective use of space. He was also in the process of delving into a kind of Third Stream chamber jazz style. Brecker died of cancer at the beginning of 2007. Having emerged from pop and rock and making an unmistakable mark on contemporary jazz, Brecker stands as one of the most towering figures of the tenor saxophone since John Coltrane.

Altissimo—The highest range of pitches on a woodwind instrument, used most notably in jazz by John Coltrane and saxophonists who followed him.

Multiphonics—Sounds created on a single musical instrument consisting of more than one distinct pitch. Most often associated with the tenor saxophone.

Music Analysis

"Delta City Blues"
(1997)
Personnel: Michael Brecker, tenor saxophone; Joey Calderazzo, piano; Jeff "Tain" Watts, drums; James Genus, bass

Although clearly a gimmick of saxophone acrobatics, this is a tune you just have to hear! Brecker's technical wizardry is incredible, but the playing of the other members of the quartet is also incredible. The band changes back and forth between a rumba-like groove, likely influenced by New Orleans styles, and double-time swing. Note the development of Brecker's improvisation style between "Original Rays" and "Delta City Blues." His solo (at 2:36) is more thoughtfully constructed. We can hear a stream of logic between his ideas, and he draws from a wider variety of sources.

GLOBALIZATION AND GLOCALIZATION

Globalization—the spread of jazz to other parts of the globe—has always been happening to some extent. Jazz went international as early as 1918, when a Swiss conductor Ernest Ansermet recognized the genius of Sidney

Bechet after having heard him solo at a London concert with Will Marion Cook's Southern Syncopated Orchestra. This early trip overseas would have impressed European musicians and fans and encouraged them to start playing jazz. Burnet Hershey wrote in 1922 of traveling the globe and hearing jazz-like music performed, customized to some extent to suit local tastes in China, India, and Paris. This speaks to the concept of *Glocalization*, in which a local culture absorbs the American jazz style and adapts it to its own practices. The phenomena of globalization and glocalization might present the most potential for future development of jazz, a notion that will be explored more in the next chapter. But international jazz has fed American jazz since the beginning, when immigrant musicians enriched American jazz by bringing their ethnic musical systems with them to the United States. This is essentially a continuance of the process that created jazz and blues in the first place, where African elements merged with Euro-American elements and created a greater whole.

The trend of globalization picked up during the fusion era of the 1970s. The Mahavishnu Orchestra had members from Panama, Prague, Ireland, and England. As the organizational leader of Weather Report, Joe Zawinul (himself an Austrian immigrant) hired several band members from outside the borders of the United States. The group's first bassist, Miroslav Vitous, was from Prague and percussionist, Airto Moriera, was from Brazil. Years after the breakup of Weather Report, Joe Zawinul continued forming bands that advanced his pan-global concept. The **Zawinul Syndicate** is a model for the panoply of world music styles being incorporated on one stage under the wide umbrella of jazz. It began as a primarily American band, with star guitar soloist Scott Henderson and session bassist Abe Laboriel. But over years, Zawinul came into contact with musicians from Africa largely through association with Salif Keita, a truly original singer from Mali for whom Zawinul produced the Grammy award-winning album *Amen* in 1991. His recordings of the following decade would feature bassist Richard Bona (Cameroon), drummer Paco Sery (Ivory Coast), and other international musicians.

A number of representatives from other nations brought their own unique perspective to American jazz. **Jan Garbarek** used folk melodies from his native Norway, and fans point to a noticeably Scandinavian character in his sound in solo work, as well as in collaboration with Keith Jarrett and Ralph Towner. **Trilok Gurtu's** work with John McLaughlin and his own groups have injected Indian rhythms and a mixture of percussion sounds from around the world into the standard jazz drum set. Belgian harmonica player **Toots Thielemans** was the first to bring significant attention to the instrument in a jazz setting. His collaborations with pianists Bill Evans and Oscar Peterson, and the Word of Mouth Big Band led by bassist Jaco Pastorius, showed that the harmonica was capable of many of the same acrobatics and melodic clarity as the saxophone. These and countless other international musicians demonstrated the tremendous potential for globalization in jazz.

LATIN JAZZ

The most fruitful instances of globalization and glocalization have occurred in the various genres of Latin jazz. **Salsa** blends jazz with Afro-Cuban traditions, and **bossa nova** blends jazz with Afro-Brazilian samba

music. Bossa nova was discussed in Chapter 14 and reached its peak in the 1950s and '60s.

Poncho Sanchez (playing conga drums)

The craze for Cuban music began in the United States during the 1930s and hitched its wagon to various dancing trends. In the 1930s the rumba was most popular. Mambo dominated the 1940s. The cha-cha-cha became a popular dance in the 1950s. **Salsa** music is a conglomeration of these and other Caribbean dance styles. Both musical styles were built primarily on percussion-based rhythmic grooves, and in the hands of jazz musicians they became vehicles for captivating improvisation. From the time of Dizzy Gillespie's and Stan Kenton's first experiments in the mid-1940s combining Cuban rhythms with their forms of jazz, Latin jazz continued to develop as an independent entity. In Cuba, the marriage between their folk music and jazz was developed at **descargas**, or jam sessions, where the musicians could experiment and hone their craft. Several important artists arrived to move Caribbean jazz forward throughout the last half of the 20th century.

Afro-Cuban salsa music is based on a rich combination of rhythmic patterns. The most basic of these rhythms is called **clave**, or "key."

> **Clave**—A background rhythm in Cuban music that unifies all other rhythmic patterns played by other percussion and melodic instruments.

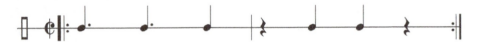

The clave rhythm (traditionally played on the percussion instrument called the "claves") unifies the patterns played on congas, timbales, bongos, and a variety of maracas, cowbells, and other instruments. Each rhythm tends to line up on the clave rhythm, along with piano **montunos** and other instruments' patterns. Here is an example of a cowbell rhythm called cascara (or "shell," traditionally played on the side of a timbale drum). Note how many of the rhythms line up with the clave rhythm.

> **Montuno**—A repeated melodic pattern that creates the basic rhythm in Latin music. Most often associated with the piano.

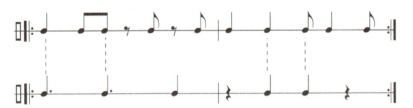

This exemplifies the relationship between the different parts of a Latin percussion ensemble, which translates into the style of salsa music.

The 1990s were a Renaissance of a new generation of Spanish-tinged jazz musicians. Latin artists from various parts of South and Central America produced musical styles that integrated jazz with the music of their homeland more intimately than ever before. Panamanian pianist Danilo Perez, Dominican pianist Michel Camilo, Puerto Rican saxophonist David Sanchez, Brazilian pianist Eliane Elias, and Steve Turre, a trombonist of Mexican and Sicilian ancestry, have been some of the top jazz musicians to emerge from the late 20th century's trend of Latin jazz fusion.

Leading Latin Jazz Performers

Organized by the decade during which they became prominent:

1930s
Xavier Cugat, vocals and violin (a precursor to Latin Jazz)

1940s
Machito, vocals and percussion (maracas)
Mario Bauza, percussion (congas)

1950s
Israel "Cachao" López, bass
Tito Puente, percussion (timbales)
Mongo Santamaria, percussion (congas)
Willie Bobo, percussion (congas and timbales)
Ray Barretto, percussion (congas)
Cal Tjader, vibraphone

1960s
Eddie Palmieri, piano

1970s
Poncho Sanchez, percussion (congas)

1980s
Paquito D'Rivera, alto saxophone
Chucho Valdez, piano
Arturo Sandoval, trumpet
Gonzalo Rubalcaba, piano
Dave Valentin, flute

1990s
Michel Camilo, piano
Eliane Elias, piano
Danilo Perez, piano

Discussion Questions

1. Explain the problem of commercialization for jazz. Why is it an important issue? What role did fusion play in commercialization?

2. What were the literary and musical roots of the neo-traditionalist movement in jazz?

3. What has made Keith Jarrett an important force in jazz since the late 20th century?

4. Listen to "2 Down & 1 Across," "Have You Heard," and "Original Rays." Which of the three seems to have the strongest ties to jazz tradition? Which has the least? Why?

5. How did salsa and Latin jazz develop into the styles we know today?

PART VIII

The Future of Jazz and Blues

Blues Today

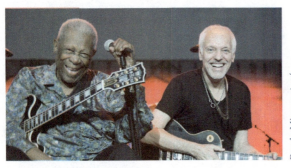

B. B. King with Peter Frampton

Randy Miramontez/
Shutterstock.com

The blues has fed the development of other styles (rock and jazz) and it has benefitted from the attention of mainstream popular music throughout its history. The finest blues musicians typically stay just out of the reach of the mainstream music media, but a steadfast audience supports them with enough record and ticket sales to keep the style moving forward. The pages of *Living Blues* magazine advertise hundreds of blues festivals taking place in America, as well as festivals in Canada, Australia, South America, and across Europe. Many of the blues artists of yesterday, such as James Cotton, Buddy Guy, and Taj Mahal are still actively touring and recording. B. B. King only recently retired, but was active on the scene through the first part of the 2000s. The future of the blues is always uncertain, but its stature as a cultural institution will play a role to sustain it. In addition, several high profile recording artists have pointed the spotlight at the blues in recent years.

THE MARRIAGE BETWEEN ROCK AND BLUES

The general public does not buy anywhere near the number of albums, mp3s downloads, or tickets for blues shows compared with the hottest pop stars, but there is an often unspoken appreciation of the blues as a root of American music. That knowledge is widespread, in part, due to the outspoken appreciation of famous musicians in more popular genres. Rock superstars, in particular, have helped bring new listeners to the genre by exposing young people to the blues, either by recording albums of their own blues-drenched material, playing classic blues songs, or collaborating with a blues icon. Every high-profile homage reinvigorates the blues with a healthy flood of exposure and new fans.

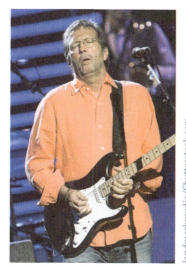

Eric Clapton

In the last few decades, no rock star has done more work to promote the blues (and particularly blues guitar) than **Eric Clapton**. Clapton has kept at least one foot firmly planted in blues tradition ever since his early years playing in John Mayall's Bluesbreakers, when "Clapton is God" was famously spray painted across London. He was among the young British rockers who sat admiringly with Howlin' Wolf, Rice Miller, and Willie Dixon and absorbed their style during the American Blues Folk Festival. Clapton brought the blues front and center in the seminal rock jam band Cream by quoting Albert King's guitar solos and covered blues standards on his albums as a leader. Clapton invited Muddy Waters to open for him on tour and invited Buddy Guy to perform with him as a special guest. In 1992, his album *Unplugged* was a huge commercial and critical success, largely due to the popularity of the pop ballad—"Tears in Heaven"—that was dedicated to his son Connor after his tragic death. But several of the other songs on that album were blues standards by Robert Johnson, Big Bill Broonzy, and Muddy Waters. He followed up *Unplugged* with a string of recordings aimed firmly at the blues genre. His 1994 album *From the Cradle* was comprised completely of blues songs set in electric blues style. It sold three million copies. In 2000 he honored B. B. King, bringing him aboard as a guest artist on *Riding with the King*, a recording that sold two million copies. His 2004 release *Me and Mr. Johnson* sold half a million copies. All along in interviews, he has expressed genuine humility and gratitude to his blues heroes, especially Robert Johnson and Buddy Guy. Focusing on guitar virtuosity, his Crossroads Guitar Festivals have explored the link between blues, rock, country, jazz, and world music styles by featuring a long list of guitar heroes. Today, as an elder statesman of rock and roll, Clapton reminds the public of the importance of American blues music.

More recently, pop star **John Mayer** paid homage to rock-infused blues music by unveiling his own serious guitar chops, first in live shows, then in recordings. After his extremely successful pop album *Room For Squares* won him a huge following of fans from young teens to 30-somethings, Mayer's musical activity has increasingly taken him toward American roots music. His 2005 release *Try!* and follow-up video drew from the power blues-rock trio in the style of Stevie Ray Vaughan's and Jimi Hendrix's bands, bringing on board top notch musicians Pino Palladino on bass (The Who) and drummer/producer extraordinaire Sonny Emory. Mayer exposed his enthusiastic audience to Buddy Guy, bringing him onstage as a special guest at several high-profile concerts.

John Mayer

Jack White

Jack White, formerly of the White Stripes, is the newest of rockers to bring considerable attention to the blues. White has introduced the next group of youngsters to the blues with his band, the White Stripes, by covering songs by Robert Johnson, Blind Willie McTell, and most famously, Son House's "Death Letter."

SOUTHERN ROCK AND BLUES

Southern American rock bands like the Allman Brothers, ZZ Top, the Edgar Winter Group, and Lynyrd Skynrd have participated in the give-and-take between rock and blues since the late 1960s. These bands blur the line that separates the two styles, often seen as blues messenger groups that deliver the sound of blues to a primarily young and white crowd. The legacy of southern rock has stretched into the 21st century as well. **Derek Trucks**—slide guitarist and nephew of Allman Brothers' drummer Butch Trucks—formed the Tedeschi-Trucks Band with his wife **Susan Tedeschi**, herself a talented singer and blues guitarist. Since their debut album in 2011, their group has caused a stir with an eclectic mix of blues, gospel, funk, soul, and jazz. Although the blues is shrouded inside a cloak of other genres, influenced by the Staple Singers as much as Muddy Waters, both Tedeschi and Trucks have solid blues credentials. They represent the continued repackaging of the blues for a broad audience.

Derek Trucks

So, perhaps this is the immediate future of the blues. Rock and roll may continue to "give back," to draw attention toward the origins of the music and support the ideal of the blues as a historic style. The drawback is that a museum piece will not continue to grow and develop. In order for an art form to live, new artists must participate in new creations. New blues must be created with new takes on the music and returns to historic styles. The blues is America's folk music, but through the spread of rock and other styles of music, it has become entrenched in the fabric of *world* music.

Keb' Mo'

A number of current blues artists replenished the style with new original sounds. **Keb' Mo'** has been active on the blues scene since the late '90s.

Surprisingly, he grew up in Los Angeles, a city not known for producing great blues talent. Keb' Mo' was a gigging musician playing primarily R & B, and he first won notoriety as an actor. He played a Delta blues musician in an L. A. play called *Rabbit Foot.* From there he was called to play the role of Robert Johnson in the documentary film *Can You Hear the Wind Howl?* But since the time of these acting roles, Keb' Mo' has worked to popularize the blues, tending to alternate between pop-blues and a more downhome style of blues akin to the Delta. His pop tunes, such as "More Than One Way Home," couch his blues-laden guitar and vocals in an R & B instrumental setting.

Keb' Mo'

Adam Ziaja/Shutterstock.com

Gary Clark, Jr.

Gary Clark, Jr. takes a harder approach than Keb' Mo'. Hailing from Austin, Texas, Clark seems to have positioned himself in the lineage of heavy blues-rock guitar showman that began with Jimi Hendrix and progressed through Stevie Ray Vaughan. His high, cooing voice is in sharp contrast to his muscular fuzz-tone. His recordings so far [*Blak and Blu* (2012) and *Gary Clark Jr. Live* (2014)] have represented a wide range of styles including psychedelic rock, heavy rockabilly, contemporary R & B, and even hip-hop. If Gary Clark, Jr. represents the foreseeable future of the blues, then it will most likely remain linked with rock and roll, drawing upon its popularity and infusing it with soulful improvisation and depth of expression.

Jazz Today

Headed into the second century of jazz, the form has progressed through several stages of evolution at a remarkably fast pace, with a new style cropping up every five to ten years or so. In the 21st century, it is really anyone's guess what subgenre or guiding trend will come next. We can look to the recent past to see which trends took root most firmly, but given jazz's tendency to change based on prominent performers (Louis Armstrong, Charlie Parker, Miles Davis, and a number of recent trailblazers), the landscape is truly open. Unlike the blues, which has maintained visibility in the most popular of circles through the advocacy of rock musicians, jazz largely became entrenched in the arts during the '80s and '90s, sharing its aesthetic with the classical music framework of America. Coffee shops and nightclubs became centers of new culture, as the Five Spot, Village Vanguard, and several other venues in urban centers had been in the '50s and '60s.

> **In this chapter, we will cover:**
> - International Jazz Musicians
> - Women in Jazz
> - Institutionalization of Jazz
> - Repertory Orchestras
> - Jazz in Universities
> - New Life for Jazz?

THE INTERNATIONAL PERSPECTIVE

Focus on Glocalization

In his book, *Is Jazz Dead (Or Has It Moved to a New Address?)*, Stuart Nicholson proposes that the transculturation of the music, its movement to other locales and the trading of musical traditions, is an underemphasized subject in the broad scope of jazz history. He borrows the term "**glocalization**" from the economics field to describe what happens when jazz takes root in a foreign land, and the native people customize it to fit their traditional musical practices.

An early example of glocalization was the development of Gypsy-jazz with Django Reinhardt and Stephane Grapelli and their Quintette du Hot Club de France during the 1930s and '40s. Reinhardt and Grapelli absorbed the music of Duke Ellington, Louis Armstrong, and Joe Venuti from recordings and created a new string-based style of jazz using sounds common to Parisian surroundings and melodies borrowed from Reinhardt's Romanian heritage. This is how a new style was born. In the 21st century, new jazz styles have sprung up all over the world. Nicholson focuses, for example, on a blend of jazz that is unique to Scandinavian countries. He identifies a feeling of melancholy that parallels the blues, but emits from the musical tradition of Nordic classical and folk music instead of the African-American experience.

Globalization and glocalization are now more than just trends. In this post-fusion, post-neo-traditionalist age, the music is international. More than ever, jazz reaches outside the borders of the United States, finding its most appreciative audiences in Europe and Asia. At the same time, many of its key musicians learn to play jazz in their home nations and either move to the United States or keep their headquarters at home in Russia, Japan, Spain, Belgium, France, Sweden, and Israel.

Avishai Cohen, an Israeli bassist, has found a unique voice in jazz that bridges a gap between mainstream jazz and Middle Eastern styles, perhaps an untapped resource for the next generation of jazz. After performing with Panamanian pianist Danilo Perez in 1996, Cohen recorded his first album entitled *Adama* for Chick Corea's record label, Stretch. Corea offered Cohen the sought-after bass chair in his new small group, Origin, and in his piano trio with drummer Jeff Ballard. Today, Avishai Cohen tours worldwide locations with trios and other small groups under his own leadership. Listen to "Dror," from *Adama*. The song is based on an **ostinato** that *stretches* a zigzagging bass line across the bar line and shifts meters just about every bar. Notice the Middle Eastern character of the piece. It is based on a scale heard in much of the Middle East (a minor scale with lowered 2nd scale degree). After Cohen sets up the ostinato, he is joined by an **oud**, a guitar-like instrument heard throughout the Middle East. Though Cohen is comfortable playing jazz standards in a mainstream jazz setting, what he has done with the music of his own culture enriches jazz with something new.

Avishai Cohen

Olga Besnard/Shutterstock.com

THE ASCENT OF WOMEN IN JAZZ

Today, it is no longer a novelty for women to appear in and lead their own jazz groups. Jazz has been one of the most masculine of art forms since its inception. For decades, women have been largely relegated to sideman (or sidewoman) positions—Lil Hardin with Joe Oliver and Louis Armstrong, Mary Lou Williams with Andy Kirk and in the background of the bebop movement, Melba Liston with Dizzy Gillespie. A number of "all-girl" groups like the International Sweethearts of Rhythm, although certainly swinging, were largely viewed as a novelty. Female singers have always been promoted in jazz as personalities and as celebrities, but they haven't been credited fully for the range of their musical contributions. Women today have garnered full acceptance in jazz. Like international participants in the music, they present an emerging demographic on the creative and the spectator sides of the equation. Today, women stand shoulder to shoulder with the finest and progressive improvisers and bandleaders. Recently, **Terri Lyne Carrington** won a Grammy award for "Best Jazz Vocal Album" (2012) for her *Mosaic* project with a band comprised of top female musicians (vocalists Dianne Reeves, Gretchen Parlato, and Cassandra Wilson; bassist/vocalist Esperanza Spalding; pianist Helen Sung; trumpeter Ingrid Jensen, and others).

Dianne Reeves

S. Kuelcue/Shutterstock.com

Chilean tenor saxophonist **Melissa Aldana**, winner of the 2013 Thelonious Monk Competition, stands to make a profound impact on today's jazz scene. Her sound is crafted in the lineage of the great saxophonists

players (she lists Charlie Parker, Don Byas, and modern tenorist Mark Turner among her chief influences). Her recent group, the Crash Trio, performs a contemporary repertoire that is an extension of post-bop in a piano-less setting.

Maria Schneider's Jazz Orchestra has been at the pinnacle of contemporary big bands since the release of her debut release, *Evanescence* (1994). An apprentice of Gil Evans, Schneider developed a truly original voice in her instrumental timbres and her voicing of modern harmonies. Schneider writes her pieces using straight-eighth note rhythms and a variety of meters. She selects soloists from among the top players in New York City, musicians such as saxophonists Tim Ries, Rick Margitza, and Rich Perry; trumpeters Tim Hagans and Ingrid Jensen; pianist Kenny Werner; drummers Dennis Mackrel and Clarence Penn; and guitarist Ben Monder. She also shades her instrumental colors with wordless vocals, accordion, and various percussion sounds. Watch a performance of the piece "Evanescence" at the following link: https://www.youtube.com/watch?v=s34Oj_za7ZU, (but be aware that YouTube addresses change as videos are removed and posted. You may have to search for another example. As of the date of this publication, Maria Schneider's music is not available on Rhapsody.com.)

Another tell-tale sign of Maria Schneider's pulse of today's music market is her reliance on **crowd-funding** website Artist-Share to finance and promote her albums. In recent years major and minor artists alike have severed ties with traditional recording companies and reached out to their fan base directly to raise funds for their recordings through various crowd-funding sites.

Esperanza Spalding took the jazz community by storm playing bass with tenor saxophone stalwart Joe Lovano in his unique band Us Five (a jazz quintet with two drummers). She won the first Grammy award for Best New Artist ever awarded a jazz musician in 2011. Her projects as bandleader so far have alternately reflected a commitment to acoustic jazz and reached out to electric pop and R & B sensibilities. Her *Chamber Music Society* (2010) showcased her compositional talent along with her unique voice and acoustic bass, and combined stringed instruments with typical small-group jazz instrumentation. Her *Radio Music Society* (2012) focused on electric bass and pop sounds.

Esperanza Spalding

THE INSTITUTIONALIZATION OF JAZZ

Jazz is now an institutionalized artifact of American culture. Since the 1980s the idea that jazz is "America's Classical Music" has taken hold, culminating in a pronouncement by the 1987 United States Congress that jazz was a national treasure. Congress pledged to support and fund jazz performance in order to protect it and educate the American public on its significance.

The institutionalization of jazz has manifested in a number of ways. Firstly, jazz has been completely assimilated into the halls of academe. The University of North Texas in Denton, north of Dallas, initiated its jazz

performance degree as early as 1947 and became a veritable factory of finely tuned musicians, ready to fill the ranks of working bands across the nation. The Berklee School of Music began educating jazz musicians in the mid-1960s and Indiana University offered a bachelor's degree in jazz studies in 1969. Today, major jazz schools matriculate floods of jazz majors at the University of Miami, the University of Southern California, the Eastman School of Music at the University of Rochester, UCLA, the New England Conservatory, the University of Texas at Austin, handfuls of universities in Chicago and New York, and institutions in every major urban center and several sparsely populated regions of the nation. American jazz is a cornerstone of the curriculum at music conservatories in Europe, Asia, and most of the industrialized world.

Outside the academic setting, the big band has been preserved largely in the form of **repertory orchestras**, big bands that perform classic jazz music and pay homage to major jazz masters. Although Wynton Marsalis's Lincoln Center Jazz Orchestra, for example, has ventured into the music of John Coltrane and Chick Corea, the orchestra has been the chief ambassador of the music of Duke Ellington and Billy Strayhorn. A number of jazz orchestras today resuscitate the music of masterful jazz composers. The **Mingus Big Band** revamps the compositions (and carries on the rough-edged aesthetic) of Charles Mingus. The **Vanguard Jazz Orchestra** is a unique combination of the forward and the backward. The band was founded as the Thad Jones/Mel Lewis Orchestra and performed every Monday night at the Village Vanguard in New York City. Some of Jones's music was originally written for the Count Basie Orchestra. Long after the death of both Jones and Lewis, the VJO continues to celebrate its litany of composers in its past—Jones, Bob Brookmeyer, Bob Mintzer—and promotes new music by Jim McNeely, Slide Hampton, and other standout voices in contemporary jazz.

NEW LIFE?

So, the question remains, what is the future for jazz? Surely the repertory orchestra will run its course if the form is not replenished by new great works. Each new artist to emerge and each jazz recording seems to be an attempt to redefine and repackage the genre for the 21st century.

Integration with Electronics

A number of artists have relied on integration with electronics to forge a new sound, and with some success. Pianist **Jason Moran** is a leading creative in the jazz sphere. He has looked both backward (his solo rendition of James P. Johnson's "You've Got To Be Modernistic," for example) and forward, incorporating electronic sounds in various ways. From Moran's 2003 album *The Bandwagon: Live at the Village Vanguard*, his piece "Ringing My Phone (Straight Outta Istanbul)" uses a device known as *musique concrete* in contemporary classical music circles. *Musique concrete* incorporates and manipulates recordings of non-musical sounds that can be found

Jason Moran

360b/Shutterstock.com

in any environment out in the world. Some pieces of *musique concrete* involve recordings that are spliced together and replicated in various ways. For Moran's "Ringing My Phone," he recorded a Turkish woman's voice while she spoke on the phone. Moran was drawn to the melodies and rhythms of her speech, so he used the recording, itself, as a musical piece. In performance, Moran and his trio (with Taurus Mateen on bass and Nasheet Waits on drums) play along to the recorded conversation with uncanny accuracy. At one point in the conversation (0:22-0:24 on the recording), Moran found a segment that he wanted to repeat, so he "**looped**" the recording (at 3:28), creating an ostinato, also called a **vamp**, that provided an improvisatory section of Moran's piece. Moran returned to this technique on his recording *Artist in Residence* (2006).

The electronic approach has proven to be a pathway to new musical sounds, particularly in an age when popular music is so influenced by **EDM** (Electronic Dance Music) and hip-hop music. Another trailblazer and pianist, **Robert Glasper** has built a following for his music by marrying jazz with a hefty helping of hip-hop and R & B synthesizer and drum machine sounds. But at what point does the music lose touch with the roots and richness of jazz?

NEW STANDARDS

Perhaps one problem with the jazz of today is that the audiences do not know the songs played by instrumental jazz combos. In the Swing Era, jazz audiences danced to instrumental music, and therefore, the music was part of a grander social experience. Bebop musicians challenged their audiences with abstraction of melody, but listeners likely recognized the pop chord changes that followed underneath from the Broadway show tunes to which they belonged. To most 21st century ears, the jazz standards have no basis in familiar music. Listening to jazz is a challenge. It's a challenge that truly enriches the listener, but nonetheless, there is not much to grasp onto if you don't know the tune the performance is based on.

Another successful strategy for today's jazz musician might be to codify and canonize a new book of standards, comprised of music people will recognize. In fact, we see more than a handful of today's jazz artists doing just that. Robert Glasper's version of the Nirvana tune "Smells Like Teen Spirit" from his 2012 album *Black Radio* replicates the electronic sounds of 21st century hip-hop and robotizes the singer's voice with a **vocoder** effect. **Brad Mehldau** has included songs by influential rock band Radiohead in his repertoire, launching into poignant solos over the songs' carefully-crafted chord progressions [listen to "Exit Music (For A Film)" and "Paranoid Android"], and the Beatles' "Blackbird," "She's Leaving Home," and "Dear Prudence."

Herbie Hancock looked ahead at this new approach in 1995 on his album *New Standard* with an all-star band that included tenor saxophonist Michael Brecker, guitarist John Scofield, drummer Jack DeJohnette, bassist Dave Holland, and percussionist Don Alias. The re-arrangements of Peter Gabriel's "Mercy Street," "All Apologies" by Kurt Cobain, and "Love is Stronger Than Pride" by Sade, breathed new life into the radio-worn songs. Don Henley's "New York Minute" and Stevie Wonder's "You've Got It Bad Girl" became vehicles for intense improvisation.

> **Vocoder**—A device used to synthesize human speech.

Maybe what jazz needs is a new set of standards to bring the young people of today into the fold, an approach that begins with the processed, digitized pop hits of the iTunes era and applies jazz ingenuity—its creative edge—to elevate American popular culture. Maybe, but jazz has always benefitted from a kaleidoscope of approaches. There is room for the historic approach, the electric, the international, and the traditional. There is room for big bands and trios, for collective improvisation and Rollins-esque solo monologue, for the Miles Davises and the Benny Goodmans, for the Jason Morans and the Pat Methenys, for odd and even meters, for the atonal and the tonal, for the radical and the classical. Jazz will thrive on its past and on its present-day.

Introduction to the Foundational Elements of Music

Listening to music with a deep level of understanding requires at least an introduction to some basic musical principles. Music is essentially organized sound. Musicians produce tones with their instruments or voices, and the combination or arrangement of those tones creates music which can then be listened to, enjoyed, studied, discussed, and even judged. All music can be described in terms of two foundational elements—*pitch* and *rhythm*—because every song or large-scale composition is made of variations of these two basic ingredients. This appendix introduces the foundational elements as they apply to all musical styles. Both jazz and blues treat the foundational elements in a unique fashion. In Chapters 1 and 2, we explore more specifically how these elements interact with various musical instruments, textures, and forms in the context of jazz and blues music.

THE STAFF

The musical staff is a tool musicians use to write pitches and rhythms so they can be passed from person to person. Get to know the staff . . .

The Grand Staff

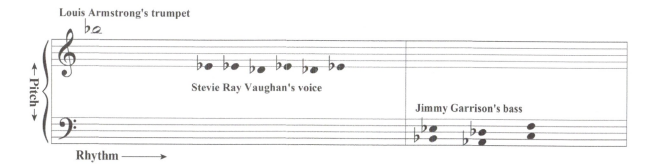

The staff works much like a graph used in mathematics. Just like graphs have a vertical (x) axis and a horizontal (y) axis, the musical staff shows the two foundational elements of music—pitch and rhythm. Each axis represents one of the two foundational elements. First, we will look at the element that deals with the vertical axis—pitch. **Pitch** is the perceived height—or level—of a sound. Have a look at the musical staff again. The notehead represents a pitch played by any instrument. A notehead placed high on the staff is a high pitch. The first pitch on the staff above is the pitch Louis Armstrong plays to bring the audience to its feet in "West End Blues" (2:33). The notes in the middle

of the staff are sung by Stevie Ray Vaughan in "Pride and Joy" (0:30). The lowest notes on the staff are those played by bassist Jimmy Garrison at the opening of John Coltrane's "Resolution."

Notice that there are two sets of five lines on the staff, and each set of five lines has a different symbol at the far left. The symbol—called a **clef**—shows what range of pitches are indicated on its staff. The 𝄞 is a **treble** clef, which means its staff has high pitches on it. The 𝄢 is a **bass** clef, indicating low pitches. Since our staff is actually a combination of treble and bass clef staves, it is called a **grand staff**, and is capable of indicating pitches across the full range of the piano.

Frequency

Scientifically speaking, what affects the pitch of a sound is its *frequency*, or the rate at which the air vibrates. When we sing a note, vibrations occur in the air. When the air vibrates fast, the ear hears a high pitch; when the air vibrates slowly, the ear hears a low pitch. So, the trumpet—a high-pitched instrument—makes the air vibrate quickly to produce its high pitches. The string bass—a low-pitched instrument—creates slow vibrations. Vibrations are measured in the unit **hertz (Hz)**, which expresses the number of vibration cycles per second. The higher the hertz number, the higher the pitch. Most musicians do not speak in terms of frequency, rather, they use musical terms to describe the level of pitch.

Rhythm

Now back to the staff. If the staff's vertical axis represents pitch, the horizontal axis (moving left to right) represents rhythm. **Rhythm** is a term that describes how the sound moves forward in time. Does it move fast like Coltrane's "Resolution," or does it move slowly like Armstrong's "West End Blues")? Are there silences (B. B. King's guitar solos in "It's My Own Fault") or are all the holes filled in with sound (Stevie Ray Vaughan's guitar solos in "Pride and Joy")?

Now let's look at each of these broad musical elements in more detail. . . .

PITCH: MELODY AND HARMONY

The foundational element of pitch can actually be broken down further into two more specific elements. The first—**melody**—describes a progression of single pitches. Melody is the main character of a song, the primary voice. A song's "melodic line" is actually not a straight line at all. Upward and downward movements, step-by-step and with wide leaps, create a contour that is an important part of the melody's character. The second element—**harmony**—is a group of pitches played simultaneously. Harmony provides the framework, or background, to the melody. Listen to blues musician Robert Johnson (on "Hellhound on My Trail"). We hear the melody in his voice and we hear the harmony in the guitar's six strings. Actually, Johnson's guitar sometimes takes a melodic role, answering his singing with guitar licks, but the instrument's main role is to provide harmonic background to the vocal melody.

Pitches are given letter names from A to G. If a musician moves from A to B, the pitch moves up one step. Each letter name refers to a white key on the piano, and a line or space on the staff. On the diagram of the piano keyboard below, you will see that there are several C's, several A's, etc.

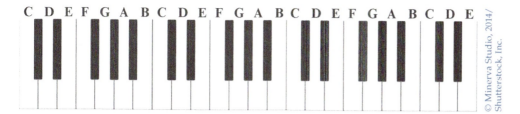

All the C's sound similar to each other, but each one is in a different *register*. So, the highest C will sound like a higher version of a middle C, or a low C. Think about the last time you sang the American national anthem with a group of men and women. When the group sings "The Star-Spangled Banner," the men will need to sing the song in a lower register than the women because men have deeper voices than women. In musical terms, the men are singing the melody an *octave* lower than the women. An octave is the distance of eight steps from one note to the other, and that distance (or *interval*) results in the same pitch being sung in different registers.

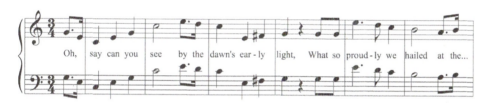

Oh, say can you see by the dawn's ear-ly light, What so proud-ly we hailed at the...

(In the example in the Rhapsody playlist of "The Star-Spangled Banner" by Scott Kempner and Take 6, the first line is sung by one singer in a high range. Beginning on "Whose broad stripes and bright stars . . . " at 0:26, octaves appear as the original singer is joined by a lower group of singers.)

Accidental—An **accidental** is a symbol that adjusts the pitch of a note slightly. The sharp (♯) moves the note up a half step, and the flat (♭) moves the note down a half step. On the keyboard, an accidental usually moves the pitch up or down to the nearest black key. So, the black key to the right of the F is F♯. It is also named G♭ because the same black key is directly to the left of G.

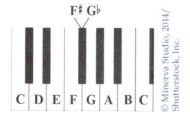

F♯ G♭

Key—A **key** refers to the group of pitches that are used for a particular song, all organized over a **tonic** pitch, kind of a home base. Since there are 12 different pitches within an octave (including white keys and black

keys on the piano), there are 12 possible tonic pitches. In addition, a key has one of two **qualities.** The quality is the color, or mood, of a key created by the make-up of pitches in the key. The two common qualities are **major** (a bright or happy sound) and **minor** (a dark or sad sound). With two qualities and 12 different pitches to choose from, there are a total of 24 keys, named for their tonic and their quality (C major, F♯ minor, etc.). If a song is written in E minor, the bass instrument will very often play an E, the E minor chord will be used prominently, and oftentimes the melody will be centered around E.

Scale—A **scale** is the pattern of pitches starting on one note (tonic) and moving step-by-step through the pitches of the key up to the next highest tonic pitch. The pattern of notes starting with A and moving to B, C, D, E, F, G, A is known as the "A minor scale." A, B, C♯, D, E, F♯, G♯, A makes the "A major" sound. Here is the sequence of pitches in the A major scale played on the keyboard . . .

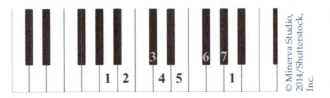

. . . and here is the same scale notated on the staff . . .

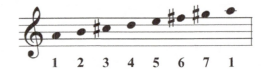

Songwriters write melodies using notes from a particular scale, and improvising musicians use scales to create ideas that use the right pitches.

Chord—A **chord** is the basic harmonic unit in music. It consists of two or more pitches played simultaneously and serves as the background to the main melody. The most basic chord has three pitches, a **triad**, with each note an interval of a third from the next. An A minor chord, then, has A as its **root** (or base), and has C and E as its upper pitches. These pitches are derived from an A minor scale, but every other pitch (B and D) is skipped. Therefore, a triad based on the key's tonic is comprised of the 1st, 3rd, and 5th notes of the scale—or *scale degrees*. Minor chords are made of pitches from the minor scale, and major chords are made of pitches from the major scale.

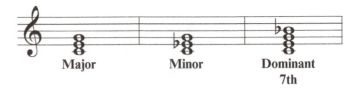

Most jazz and blues music uses **seventh chords** which add one pitch to the top of the chord, another third above the triad's top note (a seventh above the root). The most common kind of seventh chord is the *dominant*

seventh, really the sound of the blues. The dominant seventh chord has a major triad with a minor seventh on top.

Chord Progression—Most music uses a series of chords called a **chord progression**. A chord progression forms the basis of a song's identity and provides a framework for the melody. Most progressions emphasize the chord that has the tonic as its root. Musicians discuss chords based on Roman numerals. Just like each pitch in a key or scale is given a number, the chord that corresponds to each of those pitches is given a Roman numeral. The chord that has the tonic pitch (1) as its root is called the "I" chord, and the chord whose root is the 4th pitch is called the "IV" chord. In the key of C major, the C major chord is called the "I" and the chord built on F is the IV. Each scale degree can be the root of a chord.

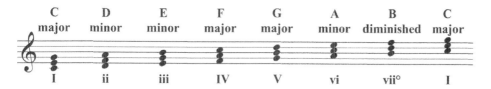

Why all the brain games? Why use Roman numerals? The use of Roman numerals is not meant to complicate things, it is actually a way to clarify how chords tend to work in most musical styles and make it easy to change keys, or *transpose*. For example, if a musician wants to learn to play the blues, they need to learn the blues in every key. That's 12 possible keys with 12 different chord progressions! But if they understand how the Roman numerals work, once they know the numerals behind a chord progression in one key, they automatically know the same progression in another key. In C, a I-IV-V-I progression is C-F-G-C. To play the same progression in E, the I-IV-V-I progression is E-A-B-E. That progression can easily be transposed, or changed, to F♯, F, G, or D. If you, the student, have even a basic understanding of how Roman numerals relate to the key of a song, it can help you to understand how the music works, and how to make enlightening connections between disparate styles and compositions.

The blues is based almost completely on dominant seventh chords, but it has been enriched through its history by the use of additional or alternate chords. Chapter 1 addresses the specific chords used in the blues. Chords tend to move more quickly in most jazz music and may move in more directions than the blues.

Beyond the triads and seventh chords presented here, musicians use several other kinds of chords that have different qualities (major or minor) of intervals between the notes, and expand the seventh chord to ninths, elevenths, and thirteenths. Jazz pianists and guitarists also mix up the notes of the chords to shape the sound of the chord. This special approach is called the chord's **voicing**. Jazz chord voicings usually omit the bottom pitch, the root, leaving that pitch for the bass player.

A student who wishes to gain understanding of this more advanced musical theory should study music theory in addition to a jazz and/or blues history course. Several great books have been written on the subject, and seventh chords are just the tip of the iceberg. It is important that readers of this book understand the basis of a seventh chord in order to grasp what is behind the chord progressions they hear.

RHYTHM

Chapters 1 and 2 explain how rhythm relates to jazz and blues in detail. But first, here are some basic rhythmic concepts.

Pulse—All music has some kind of **pulse**, or steady beat. It is a good idea to always find the pulse of a song by moving your body, tapping your feet, or clapping your hands. Think about listening to a traditional marching band or listening to dance club music. Since those musical styles are meant to coordinate people marching or dancing, they have a very definite steady beat, usually played on a bass drum. "Boom, boom, boom, boom," is the pulse of the music. Some music—like march and dance music—has a very definite pulse. Other styles have a weaker or less definite pulse. For example, free jazz tends to disguise the pulse, or do away with pulse altogether.

Tempo—The **tempo** indicates the speed of the pulse. It can be fast like Charlie Parker's "Ko Ko" or slow like Billie Holiday's "Fine and Mellow." Music for dancing tends to have a medium tempo, but different cultures and generations like to dance to music at different tempos. Tempo is measured using a number of beats per minute (bpm), so that if the music moves at 60 bpm it moves as fast as the second hand on a clock. 120 bpm moves twice as fast as a second. (60 bpm x 2 = 120 bpm).

Subdivision—The pulse is divided into faster units called **subdivisions**. Inside each pulse is a division that moves usually twice as fast. When we listen to music with an even subdivision, we can tap our feet on the beat, or we can tap twice per beat. Jazz and blues typically use a "swing" subdivision, which divides the beat into threes instead of twos. This is called "triplet" subdivision.

How rhythm is notated—A student does not have to completely know how music is written on paper to understand the music covered in this text. However, it is helpful to at least be exposed to the notation so we can visualize it as well as listen to it. Musical symbols consist of noteheads with or without stems and those symbols represent different rhythmic values or lengths.

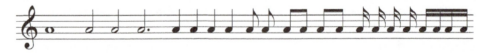

Usually a quarter note (♩) stands for the pulse. Notes with one flag (♪♪) or one beam (♫) move twice as fast as the pulse, and two flags (♬♬) or beams (♬♬) double the speed yet again. Latin music and funk tend to use lots of fast rhythms that are notated with double flags and double beams. On the other end of the spectrum, clear noteheads stand for notes that move slower than the pulse.

Rests—Silence is an important element of music. **Rests** are the rhythmic symbols used to indicate specific lengths of silence or pause. A quarter rest (𝄽) stands for silence that lasts as long as a quarter note, usually the same length as the pulse.

Meter—A song's **meter** is the pattern of strong and weak pulses that organizes the rhythmic feel. Most music has a meter consisting of four beats. The first beat, called the "downbeat," is strong, and the remaining three ("upbeats") are weaker. Find the downbeat of a song by listening for

the strong beats or by listening for the chord changes. Chords tend to change on the down beat.

Measure—A **measure** or **bar** is the actual unit of strong and weak beats that create the meter. Measures are indicated in musical notation with a long straight **bar line** that divides the staff. The first symbol to the right of a bar line is the down beat (beat 1). In the following example, notice that every measure has four beats. The rhythms vary widely from medium, to fast, to slow, but the meter is consistent from bar to bar.

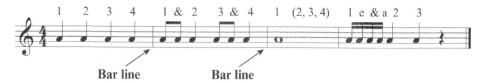

Again, students who truly wish to understand how rhythms are written on paper should take an introductory music theory class above and beyond reading this book. Learning to play an instrument is also helpful. The concepts listed in this appendix should aid the non-music major in understanding how musicians describe their music. Music is a life-long pursuit and in many ways, learning to read and write music is like learning another language. Students should not expect to master complex musical concepts within a few days, but being exposed to the concepts can help anyone to better appreciate the music they listen to.

How to Write a Concert Report
(Submission Through Blackboard—SafeAssign)

- Choose a concert performed by a professional jazz or blues group. You may choose something from the Pre-approved list of concerts, or ask the instructor to approve another performance that strongly fits the guidelines.
- For full credit, you must turn in a program or other paper **signed** by a musician who performed in the concert you attended. In this age of smart phones, it is also acceptable to attach a photo of the performance to the paper, instead of the signed program (paste into the paper). **Minus 5 points** if proof of attendance is missing.
- Format: Your concert report should be typed, Minimum 1 ½ pages, maximum 2 pages. It must be saved as ".doc" or ".rtf" format.
 - Double spaced, 12 point font—Arial, Times New Roman, and other "reasonable" fonts

- If it helps to get the ball rolling, think of this assignment as a concert review for a newspaper or music magazine.

Form:

- Paragraph 1 should describe the basic information about the performance:
 - Date of performance
 - Location
 - Name of ensemble performing
 - Instrument(s) used
 - Genre (how they would describe themselves), etc.

- Middle paragraph(s) should describe 2–3 tunes or pieces performed. Talk about:
 - Name, composer (if the performer announced this info)
 - Play by play—describe the melody, describe the soloists
 - Quality of each tune performed (you can also save this for the last paragraph)

- Closing paragraph: Summary. Give your opinion of the group performing, particular soloists, or particular tunes/pieces. What did you learn from the experience? How does it tie into what you've already learned in class?
- Tone—Please use "grown up" language. It is not necessary to be extremely formal, but I want you to make clear observations about what you see and hear.

- Musical Observations—these are clear statements about musical "moments" in a performance. It's a good idea to take notes during a performance then turn some of the notes into musical observations (i.e., "The tenor saxophonist brought his solo to a climax with a long, loud, high note. The drummer increased his activity to support the soloist's musical high point.").

- Revise—Papers should be well-*revised*. No first drafts, please. If writing college-level papers is not your strong suit, I suggest working with someone at the Writing Center in the LRC. Another option is **Smart Thinking**. You can find a link to this tool at your "My MSJC" page under "Tools." (The icon looks like French Fries.) You can submit papers to this company and they will give you revision notes for free. You must give them a bit of lead time, but I've heard good things about their service.

Details:

- ○ Song titles should be written like this: "The Days of Wine and **Roses**." In quotes, with any punctuation put **inside** the closing-quote.
- ○ Please use the same verb tense throughout (usually all past tense verbs).

- HOW TO TURN IT IN:
 - ○ In the assignment folder, you'll see the Safe Assign icon . . .
 - ○ Click the **View/Complete** link to go inside the page.
 - ○ Click the "Browse" button to find the file you want to attach and select it.
 - ○ When the Safe Assign Blackboard page shows the document you want to attach, click "Submit."
 - ○ Find your saved document in the file upload window and double click or click "Open."
 - ○ Hit "Submit" back at the Blackboard page.
 - ○ Your completed report should now be uploaded.

How to Complete a Playlist Project
(Submission Through Blackboard—SafeAssign)

Create a playlist using Rhapsody.com, Spotify, or another web music source. You may need to read the instructions on creating a playlist at the website you choose to use. Here are the rules for this playlist:

- The playlist must have 10 tracks.
- None of the tracks can come from the same album.
- Each track should connect to the next in any of the following three ways:
 1. **Musician/personnel:** same musician/technician worked on both tracks. Producers, recording engineers also acceptable. (Example: Teo Macero produced music by Miles Davis and Thelonious Monk. Follow a Miles/Teo track with a Thelonious/Teo track.)
 2. **Stylistic Evolution:** the 2nd track stylistically grows from the 1st. (Example: a 1920s/30s Delta blues artist could proceed a 1940s/50s Chicago blues artist)
 3. **Year:** tracks were recorded in the same year.

Use www.allmusic.com or www.discogs.com for recording and release information. Don't use Rhapsody's release dates, since many are incorrect. For example, many early jazz recordings were not released as albums. They were released as two-sided 45's or singles. Oftentimes, several singles are compiled together decades after the fact into what is essentially a "Best of" album. The date on that compilation can be misleading.

Next, either **type** a paper (using our report-writing guidelines) or **record** your voice narration using Audacity, Garage Band, or other recording software, describing the connections between the tracks. Narrate the journey from track to track with comparison/contrast, historical background, and/or your educated opinion. **Be sure to point out which of the three ways you used to connect your tracks.** Use specific musical observations instead of non-specific adjectives. Good example: "Robert Johnson accelerates the tempo in his recording, where Muddy Waters . . ." Bad example: "Robert Johnson is awesome, and Muddy Waters is more awesome." Feel free to discuss the cultural significance of your tracks.

Papers should be free of careless mechanical writing errors; voice recordings should be polished and absent of careless speaking errors.

Point Breakdown: (your instructor may or may not choose to use this rubric)
15 points: online playlist created and linked
25 points: completion of 10-track playlist using appropriate tracks
40 points: descriptions of connections between tracks
20 points: writing or recording quality of your paper or voice narration (style, correctness)

How to turn in the Project:
You must turn in a document (saved as .docx or .rtf) that includes:

- a list of the 10 tracks
- a link to the playlist online (web address typed and—if you know how to hyperlink—hyperlinked)
- your typed commentary on the connections between the 10 tracks, or if you chose the voice recording, a separate audio file with your spoken voice.

To submit, just like the concert reports, find the Safe Assign icon for this project on Blackboard. Click View/Complete to enter the submission page. Browse your computer to find your paper and submit. If you choose the voice narration option, turn in your voice recording .mp3 by emailing to your instructor as an attachment.
Here's a short 3-track example:

Jeremy Brown's Jazz and Blues Playlist

http://www.rhapsody.com/members/g8nc1/playlists/mp.158326524

1. John Coltrane, *Giant Steps*, "Giant Steps"
2. Miles Davis, *Kind of Blue*, "So What"
3. Ornette Coleman, *Shape of Jazz to Come*, "Eventually"

John Coltrane's "Giant Steps" was the title track to his 1959 album and featured Coltrane's most ambitious playing and compositions to that date. The harmonic progression moves to unexpected places, keeping the musicians on their toes. The fast tempo makes the improviser's job even more difficult. Coltrane showed his ability to navigate difficult chord changes, yet, in my opinion, still managed to express more than just a technical exercise.

Miles Davis's "So What" from another album recorded in 1959 has an almost opposite conception of jazz artistry. *Kind of Blue* operated on the belief that fewer chords would open up the improvisers to create new sounds. Unlike "Giant Steps," the improvisers have the challenge of expressing themselves without the help of a harmonic progression. Instead, they have only two static chords to work with. This track connects with "Giant Steps" by more than just its birth year. John Coltrane plays on this one, as well. His expressive powers are magnified by the simplicity of the harmonic background here.

My final choice is another track recorded in 1959 with, again, an almost completely different sound that grew from a completely different philosophy. Ornette Coleman's "Eventually" pre-dates the music that we can truly call "free jazz," but Ornette's maverick, melody-first conception of music is apparent here as well. The melody is frantic and awkwardly syncopated, played in unison between saxophone and trumpet. Piano is absent. After the melody is played, solos seem to follow no harmonic guidelines. What is striking to me on this track is how the improvisers can create melodic ideas and vary them, creating a sense of structure to in their solos.

Glossary

12-bar blues—A musical form used in the blues style made up of twelve measures, normally grouped into three sections of four measures each. Although there are a variety of blues forms, the most basic focuses on the I chord on the first four-measure phrase, the IV chord on the second phrase, and its third phrase includes a turnaround with more rapidly-changing chords.

12-string guitar—An acoustic guitar with six pairs of strings, each pair pitched an octave apart.

2/4 pattern—A rhythmic pattern in which every first and third beat of a four-beat measure is accented. Typically, the bass dictates the feel by playing half notes on beat one and three. (See also, "two feel.")

4/4 pattern—A rhythmic pattern in which every beat is played in a four-four measure. Typically, the bass dictates the feel by playing a note on every beat. (See also, "four feel.")

AAB lyric form—A three-lined lyric form used most commonly in the blues. The first two [A] lines are the same, and the last [B] line contrasts and completes the idea laid out in the [A] lines.

AABA form—A common structure used in American popular songs. The cyclical form most often consists of 32 total measures, arranged in four phrases of eight measures each.

accompaniment—The harmonic and rhythmic background of a musical piece or performance that supports the primary melody. In jazz and blues, accompaniment styles can vary widely, but are most often provided by a piano and/or guitar, bass instrument, and drums.

acid jazz—A musical style that emerged in London dance clubs in the mid-1980s and blended jazz, hip-hop, and funk.

aerophone—Any musical instrument that makes a sound when the player blows air into it.

aesthetic—A set of values that characterize the artistic work and societal thought patterns during a particular period or movement by which the notions of beauty and quality are judged.

alternate fingerings—A technique used primarily by saxophonists. The instrument can produce the same pitch using a variety of different fingerings, and each different fingering has a different tone color. Soloists use these color changes in their solos.

altissimo—The highest range of pitches on a woodwind instrument, used most notably in jazz by John Coltrane and saxophonists who followed him.

arpeggio—A series of ascending or descending pitches that outline a chord.

arranger—A musical professional who adapts and customizes a song or other musical work to a specific instrumentation with varying degrees of personalization.

avant-garde—A term used in the arts to describe works that are out ahead of the conventional state of the art.

backgrounds—Musical figures played or sung behind a soloist to provide variety and contrast.

ballad —a. a song played at a slow tempo
 —b. a storytelling song

bass—A stringed instrument, either electric or acoustic, that plays low pitches.

bass clarinet—A musical instrument in the clarinet family that is most commonly pitched an octave below the common Bb clarinet.

bebop—A jazz style that emerged in the mid-1940s in New York jazz clubs. Bebop was most often performed by small groups of four to six musicians and was characterized by angular melodies and extremely syncopated rhythms.

big band—A standardized instrument group that developed in the Swing Era of the 1930s and has continued to adapt to stylistic changes in jazz. Big bands typically have three to five trumpeters, three to five trombonists (one on bass trombone), five saxophonists who may play a variety of woodwinds, drums, bass, piano, and/or guitar.

Black Codes—A variety of laws enacted in the United States during the Reconstruction period that followed Emancipation, limiting the actions of black Americans.

black-and-tan—A nightclub that caters to multi-racial patrons.

blackface—A type of theatrical face makeup commonly used in minstrel shows. Blackface was used to portray a comedic and exaggerated African-American appearance.

block chord voicing—An orchestration—or voicing—of a chord that includes each pitch of a chord.

blue notes—A bent, or flexible pitch, most often used in blues music to evoke a blues feeling.

blues—A musical genre originating with post-Emancipation African Americans, characterized by a twelve-bar form and melodies that utilize the blues scale and blue notes.

blues scale—A sequence of pitches that evokes the blues sound, specifically the 1 - minor 3 - 4 - augmented 4 - 5 - minor 7.

blues shouter—A singer in the blues idiom who projects his or her voice without amplification over the volume of a band.

boogaloo—A rhythmic style that has appeared in different forms of Latin, jazz, funk, and soul music. Most often, boogaloo combines Puerto Rican and Cuban rhythms with other African-American elements, such as gospel keyboard patterns and soul melodies. Exponents of the boogaloo style included Herbie Hancock, Mongo Santamaria, Ray Barretto, the Meters, and James Brown.

boogie—A term used specifically by John Lee Hooker to describe his specialized rhythmic feel and repetitive accompaniment patterns. "Boogie Chillun'" is an example of John Lee Hooker's boogie.

boogie-woogie—A piano style characterized by running eighth-note patterns in the low register and blues-based chordal figures in the upper register.

bossa nova—A combination of Brazilian samba and American jazz that reached widespread popularity in the 1960s with the work of Antonio Carlos Jobim, João Gilberto, Stan Getz, and Charlie Byrd.

bottleneck slide guitar—A style of guitar playing that makes use of a plastic, metal, or glass apparatus on the guitarist's little finger that allows him or her to slide with little effort from one fret to another.

bow—An object made of wood with animal hair stretched from one end to the other, which stringed instrument players draw across their instruments to produce sound. Jazz string bassists sometimes play "bowed" solos.

brass band—A marching band consisting of only brass and percussion instruments.

brass instruments—Aerophonic musical instruments made of brass that produces sound when the player blows a buzzing sound into a metal mouthpiece.

break—A musical passage during which the rhythm section rests while the soloist continues playing in tempo.

bridge—A section of a musical form where a new set of chords contrasts the primary material.

broken swing—A rhythm section style during which a drummer, bassist, and chordal instrumentalist will purposefully obscure the pulse by omitting some of the typical rhythms played in a swing pattern.

broken time—In any musical style, a series of rhythms that avoid repetition, instead obscuring the pulse with constant variation and intermittent musical spaces.

brushes—Drummers' tools that provide variety to the conventional sound of drumsticks. Brushes are normally made of several strands of metal wire and create a sustained, smooth sound when drawn across a drumhead.

burn out—A style of jazz performance that became prominent in New York City during the 1980s and 1990s. Burn out music was most often played at extremely fast tempos and featured extremely advanced levels of virtuosity and interaction between soloists and rhythm section members.

cabaret card—A professional license to perform in New York nightclubs.

cadence—A progression of chords that signals the end of a section.

cadenza—A solo performed without accompaniment from any other instrumental group.

cakewalk—An African-American dance that mimicked slave owners and white bosses.

call and response—A common phenomenon observed in religious and musical aspects of life (religious and musical, for example) that involves a leader or leading group's statement followed by the response of a follower or following group. Especially prominent in African-American communities, call and response exists in the improvisational and compositional styles of jazz, blues, and other African-American musical styles.

capo—An apparatus that raises the base pitch of the instrument when attached to its fretboard.

chalumeau—The lower range of the clarinet.

chordophone—Any musical instrument that makes a sound when its strings vibrate.

chorus —a. In jazz and blues, a repetition of the form and chord progression of a song.
　　　　—b. In verse-chorus-verse form, the part of the song whose melody and lyrics are exactly the same at every repetition.

clarinet—A woodwind instrument with a straight shape and it has a single reed attached to its mouthpiece. An aerophone.

clave—A background rhythm in Cuban music that unifies all other rhythmic patterns played by other percussion and melodic instruments.

coda—End. The finishing musical passage of a piece.

collective backgrounds—Musical figures played behind a soloist by a group of instruments, which come together in an improvised manner.

collective improvisation—A dense musical texture created by multiple improvising instrumentalists, most identified with New Orleans and Chicago jazz styles of the early 20th century.

common language—A collection of musical phrases commonly used in the vocabulary of basic jazz improvisation.

comping—Short for "accompanying," comping refers most specifically to the syncopated chord accompaniment played by jazz guitarists and pianists.

composer—The person who invents the melody, chords, and other basic elements of a musical work.

concerto—An extended musical passage during which a soloist plays, most often without a consistent tempo, while the rhythm section rests.

Congo Square—The location in New Orleans, Louisiana, where African-American slaves congregated to make music and dance in the early 19th century.

cool jazz—A subgenre of instrumental jazz that grew out of the bebop era during the early 1950s. Cool jazz performers played with a more mellow, understated sound and explored various techniques of composition and arrangement.

cornet—A musical instrument in the brass family that plays in the treble register (most often above a middle C, or C4). The coronet is similar to the trumpet in its melodic range and its manner

of playing, but its tone is mellower and the shape of its tubing is conical, in contrast to the cylindrical bore of the trumpet.

counterpoint—A polyphonic musical texture in which two or more important melodies are played simultaneously and interact with one another.

creole—An ethnic group common to New Orleans whose ancestors (and often parents) originated in France or Spain.

creole of color—An ethnic group common to New Orleans that blended creole and African-American lineage.

cross-sectional voicing—An arranging texture used in jazz big bands that creates a unique timbre by grouping together instruments from different sections (trumpets, trombones, saxophones), instead of the common practice of grouping together instruments of the same section. The instruments may be grouped in unison or they may voice a chord using different pitches.

crowd-funding—A method of raising money to pay for artistic (and musical) projects that has become prevalent in the 21st century. Artists use social media and internet websites to encourage their fans to contribute to the project in advance of its release.

cutting contest—A musical setting that involves multiple soloists improvising against each other in a competitive manner.

descarga—An informal musical setting that originated in Cuba as a means for musicians to improvise.

diddley bow—A musical instrument created primarily in African-American communities in the Southern United States that consisted of a single string stretched across a wooden piece. The diddley bow would have acted as a preliminary instrument to the guitar for many Southern African Americans.

dirge—A musical piece performed at an extremely slow tempo, most often to invoke a feeling of seriousness and sorrow.

dissonance—An unpleasant or disagreeable sound.

dominant 7th chord—A common chord used in blues and jazz comprised of four pitches: the root, major 3rd, 5th, and minor 7th. In blues, the dominant 7th chord can serve nearly any function, either as the tonic, subdominant, or dominant. In other styles of the music, the dominant 7th is most commonly used to build tension immediately before returning to a tonic chord.

Dorian mode—The group of pitches most often used in the style known as "modal jazz," consisting of all pitches of the minor scale except the major 6th. For example, a C Dorian scale has the pitches C, D, Eb, F, G, A (instead of Ab), and Bb.

doubling—When an instrumentalist performs on a musical instrument other than his or her primary one. For example, a tenor saxophonist in a big band might "double" on flute and clarinet.

double quartet—An uncommon instrumentation of eight total musicians, consisting of four pairs of the same instrument or instrument group.

double stop—An instrumental technique in which the performer plays two pitches simultaneously.

double-time—A musical technique that involves the doubling of tempo. Most often in jazz, a soloist plays twice the original tempo while the rhythm section remains at the original tempo, creating a "double-time feel" without actually speeding up the pulse.

drawbar—An apparatus on an electric organ that adjusts the timbre of the instrument.

drum set—A collection of percussion instruments that is most commonly used in contemporary American musical styles. Most drum sets include a snare drum, bass drum, tom-toms, hi hat cymbals, and any number of additional ride, crash, Chinese, and splash cymbals.

dynamics—The level of volume described in relative terms, often using Italian designations such as mezzo forte (medium loud), forte (loud), piano (soft), and pianissimo (very soft).

ECM style—A style of jazz fashioned after the ECM record company, characterized by straight eighth note rhythms, rich harmonies, and a melodic style that bridged the gap between avant-garde and contemporary classical music with a balance of consonance and dissonance.

EDM (Electronic Dance Music)—A popular style of dance music that evolved from disco, techno, and other DJ-led styles, arriving at a high point of popularity in the early 21st century.

embouchure—The shape of a brass and woodwind player's mouth, which affects the tone of the instrument.

ensemble—Any performing group.

etude—Literally, a "study" (French). Etudes are composed in order to provide a means for a musician to develop one specific technique (for example, speed, leaping arpeggios, long tones, awkward fingerings, or coordination).

EWI (Electronic Wind Instrument)—A specialty instrument shaped like a soprano saxophone that gives the player the ability to play any number of synthesized sounds.

falsetto—A "false" vocal range sung primarily by males above their normal range.

fermata—To sustain a note for a longer duration than the notated symbol designates.

field holler—A solo song improvised by a worker in free tempo.

flapper—A stereotypical teenage girl in the 1920s, known for dancing to jazz music, party-going, and sexual promiscuity as contrasted from more rigid behavioral standards of the preceding Victorian era.

flugelhorn—A mellow version of a trumpet that is shaped with a larger bell.

flute—A woodwind instrument that produces sound when air is blown across the top of the hole on the mouthpiece. The flute is rarely used in jazz or blues, but is a common doubling instrument for saxophonists.

four feel—A jazz rhythmic pattern that emphasizes all four beats of a four-four measure, using steady walking bass and a ride pattern in the bass and drums, respectively.

free jazz—A term that described the avant-garde jazz of the late 1950s and '60s, represented by Ornette Coleman's recording *Free Jazz: A Collective Improvisation*.

French horn—A brass instrument pitched between the ranges of the trumpet and the trombone, which is most commonly used in European classical orchestral music. The instrument has valves and its brass tubing is shaped in a coil with a wide opening at one end.

frequency—The rate at which the air molecules vibrate to create a sound. (See also, "pitch.")

front line—In a standard New Orleans jazz ensemble, the group of wind instruments that are not a part of the rhythm section, typically comprised of a trumpeter or cornetist, a clarinetist, and a trombone.

funk—A musical style that emerged in the late 1960s from a combination of soul and other forms of rhythm and blues music, characterized by bass, drums, and other rhythm section parts that are extremely repetitive, syncopated, and constantly energetic.

genre—Musical style defined by characteristic melodic, harmonic, and rhythmic elements, historical setting, instrumental setting, and conventions of the music industry. For example, "jazz," "blues." (See also, "subgenre.")

ghost band—A jazz band that continues to tour after its leader has passed away.

glissando—A continuous upward or downward slide from one pitch to another.

Greenwich Village—A neighborhood of Manhattan in New York City known as a center of an active arts community and a focus of musical turning points in folk and jazz.

griot—In West Africa, the title of a musical bard who preserves the historical record for their community.

grunge rock—A musical style that rose to prominence at the close of the 20th century, reflecting values and musical influences of punk, heavy metal, funk, and a wide variety of other musical styles. Grunge rock musicians rejected the polished sounds of the popular hard rock bands at the time.

guitar—A stringed musical instrument, either electric or acoustic, that is the primary sound in most blues and in a great deal of jazz music. The guitar has six strings, which are plucked with the fingers.

gypsy jazz—A genre of small group jazz with gypsy roots created in Europe. Gypsy jazz groups primarily consist of stringed instruments (guitars and violins) and emphasize solo improvisation.

harmolodics—A concept devised and loosely defined by Ornette Coleman that serves as a guiding philosophy for music and extra-musical processes. In music, the term refers to a balance between harmony, melody, instrumentation, rhythm, and other elements and each one's ability to guide the act of improvisation.

harmonic—A false pitch produced on a guitar or other stringed instrument by pressing lightly on the string in a manner and placement that an overtone is produced instead of the fundamental pitch.

harmonica—A handheld, rectangular instrument with small reeds that extend across the length of its body.

harmony—A foundational element of music that provides the aural framework for melody. The combination of two or more pitches.

head—A slang word for "melody" used in jazz.

head arrangement—A big band piece constructed without written music, instead with a progression and layering of improvised melodies, or riffs. Most often one section (for example, the saxophones) devises a melody, which is then repeated over subsequent choruses while other sections (trumpets and trombones) add their own melodies.

hemiola—A specific kind of polyrhythm that continuously accents every third subdivision of a duple pulse, rather, a pulse divided by two. This creates a rhythm that lands alternately on strong, weak, strong, and weak beats.

hoedown—Dance tunes created in early America and related to the dance songs of the British Isles. The songs are most often played in duple meter.

hokum—A style of music popular in the 1910s and '20s with lyrics characterized by humor and sexual innuendo.

homophonic—A musical texture with a single primary melody and harmonic musical accompaniment.

I chord (tonic)—The central chord in a musical key comprised of the 1st, 3rd, and 5th scale degrees. For example, in C major: C, E, and G.

ideophone—A type of musical instrument that produces its sound when the body of the instrument is struck. Pitched and non-pitched percussion instruments are ideophones.

improvisation—The act of composing spontaneously.

instrumentation—A composer's selection of musical instruments for a composition.

IV chord (subdominant)—The chord built on the 4th scale degree of a given key. For example, in C major: F, A, and C. The subdominant is a central component of the blues chord progression.

jam session—An informal musical gathering where musicians perform for an audience composed primarily of musicians and use the musical setting to practice their skills and network with other musicians.

jazz—A musical style developed in the United States in the early 20th century that emphasizes improvisation, musical interaction, and specialized stylistic components.

jazz standard—A song that has become part of the repertoire of the performing jazz musician. Often a distinction is described between a "standard" (a song written for voice and often composed by theatrical songwriters from the Tin Pan Alley Tradition) and "jazz standard" (an instrumental jazz piece that originated in instrumental jazz).

Jew's harp—A small metal instrument—an ideophone—that the player holds between his or her teeth and plucks to create sound. The instrument was used in early 20th century jug bands, but is also widespread in cultures around the world.

jillikea—A term for a musical bard (or *griot*) used in Africa by the Mandingo people.

juke joint—A privately owned bar in African-American communities where social activities such as drinking, dancing, gambling, and music take place. A setting important to the development of the blues.

jump blues—A popular style of music in the mid-1940s, most associated with Louis Jordan and other swing-era musicians who combined small group swing jazz, blues forms, and boogie-woogie.

jungle sound—A specialized sound of Duke Ellington's orchestra developed during their tenure at the Cotton Club that evoked exotic sounds with the use of muted trumpet and trombone, percussion, and harmonic centers alternating between major and minor sections.

key—A harmonic framework that consists of a central pitch (tonic) and a set of specific pitches (mode). A musical work's key is designated by its tonic and its quality, for example, "D minor."

lead sheet—An arrangement of a musical composition written in its most basic form, including the melody, chords, and structure of the piece written on just one or two pages.

Leslie speaker—An amplifier and loudspeaker used most often for the Hammond organ. The speaker is capable of producing a tremolo sound effect through an oscillating mechanism inside its cabinet.

lick—A short musical phrase played by an instrumental musician that forms a part of an improvised solo.

looping—A technique utilized in urban musical styles—rap, hip hop, acid jazz, etc.—whereby a short sample of recorded music is repeated as an ostinato background.

mainstream jazz—A term whose definition has shifted over several decades since the 1940s, but typically is used to describe small-group instrumental jazz that is neither avant-garde nor traditional. Mainstream jazz musicians typically record and perform a mixture of standard jazz songs and original compositions.

manual—One keyboard on an organ with multiple keyboards.

master drummer—In African societies, the leading drummer in a musical group.

measure (bar)—The basic organizing rhythmic unit in music, grouping together a series of strong and weak pulses.

melisma—A vocalist sings a series of pitches on a single syllable.

melody—A progression of single pitches; the main character of a song.

membranophone—A type of musical instrument that produces its sound when a membrane stretched across the instrument's body is struck.

metric modulation—A change in tempo in which the beginning and ending tempos are related by a mathematical ratio. For example, quarter note = 120 bpm to quarter note = 80 bpm. Ratio 3:2.

Mississippi Delta—A region spanning the area from Vicksburg, Mississippi north to a point just south of Memphis, Tennessee and encompassed on its west and east by the Mississippi and Yazoo rivers, respectively. The alluvial soil is rich ground for cotton farming.

modal jazz—A subgenre of jazz characterized by slow-moving or static harmony and improvisation based on modes, most often the Dorian mode.

mode—A set of pitches with specific arrangements of whole-steps and half-steps (tones and semitones) that forms the melodic basis of a composition. For example, major and minor modes; Dorian, mixolydian, Lydian, and aeolian modes.

modern jazz—A label used to describe the work of bebop musicians in the 1940s and later musicians who built upon their foundation.

modernism—A general term used in the arts to describe works created around the early 1900s. Modernist painting, sculpture, and music embodied a new set of values that sometimes favored unpleasant and thought-provoking works over the pleasant and genteel.

modulation—The change from one tonal center or mode to another.

monophonic—A musical texture with a single primary melody (either played or sung by a soloist in unison or in octaves) with no accompaniment.

montuno—A repeated melodic pattern that creates the basic rhythm in Latin music. Most often associated with the piano.

motive—A brief melodic idea that serves as the principal material for development in a musical composition.

multiphonics—Sounds created on a single musical instrument consisting of more than one distinct pitch. Most often associated with the tenor saxophone.

Musique Concrète—Music created by juxtaposing and manipulating recorded sounds. This approach to composition is attributed to French composer and radio broadcaster Pierre Schaffer who experimented with audiotape in 1948.

mute—An apparatus that, when added to a musical instrument, makes the sound softer and changes its properties in some way.

open time—A rhythm section style in which a drummer, bassist, and chordal instrumentalist will play rhythms that obscure the underlying rhythmic pulse.

oratorio—A large-scale musical composition for voices and instruments, usually based on a religious theme. The oratorio was a common musical setting in 17th and 18th century Europe.

orchestration—The composer's decisions regarding use of a selection of instruments to perform various roles in a composition.

organ trio—An instrumental grouping that consists of electric organ, guitar, and drums. The organ trio was a common instrumentation in soul jazz of the late 1950s and '60s.

ostinato—A melodic or rhythmic pattern that is repeated over an extended duration, forming a background character for the performance.

oud—An ancient stringed musical instrument (a chordophone) that is associated with music from the Middle East, Mediterranean, and North African regions.

pads—Sustained, slowly shifting chords that serve as a background color in a musical piece.

partido alto—A syncopated rhythmic pattern that serves as a foundation in some Brazilian musical styles such as samba.

pedal point—A pitch sustained during active musical material. The term refers to the pedals of pipe organs, which can be held down while the player's hands continue on the keyboards above. In contemporary music, bassists often use the pedal point as a device to create musical tension.

pentatonic—A scale that consists of five pitches.

piano—A keyboard instrument that is used in most Western musical styles, valuable for its wide range and its ability to operate as both a melodic and harmonic instrument.

piano-less quartet—A jazz instrumental grouping that omits the conventional role of a harmonic instrument, most often consisting of only bass, drums, and a pair of melodic instruments.

pitch—The perceived height—or level—of a sound. (See also, "frequency.")

pizzicato—The act of playing a stringed instrument without a bow, instead, plucking the strings with the fingers.

polyphonic—A musical texture in which multiple melodies are played simultaneously.

polyrhythm—A rhythmic texture constructed of two or more contrasting rhythms.

polytonality—The simultaneous existence of more than one tonal center.

post-bop—A subgenre of jazz that grew from the experimental music of Miles Davis's quintet in the 1960s and combined elements of bebop, modal jazz, and avant-garde movements.

press roll—A drumming technique in which the sticks are bounced extremely rapidly on the drumhead, creating a continuous noise. Often called a "buzz roll."

progressive big band—A large jazz ensemble that grew from the swing tradition but looked ahead at modern trends in jazz, incorporating bebop, contemporary, classical, and new rhythmic styles such as Latin and rock.

psychedelic rock—A style of rock and roll that emerged in the 1960s and was associated with counterculture movement of primarily young, white Americans. Psychedelic rock music utilized blues-influenced and jazz-influenced improvisation and sound effects in an aural reproduction of the affects of psychedelic drugs.

pulse—A steady rhythmic beat that serves as the underlying foundation in musical performances.

punk rock—A style of rock and roll that emerged in the 1970s and '80s with an anti-establishment message and raw sounds that raged against the increasingly polished production quality of pop and rock recordings.

quartal—Melodic or harmonic structure comprised of intervals of a perfect 4th.

quarter note—The symbol of music notation that represents the pulse in most musical settings. A quarter note is equal in duration to one fourth of a whole measure in 4/4 meter.

quoting—The act of using a known melody during an improvisation. For example, an improviser may play a nursery rhyme during Duke Ellington's "Satin Doll" for comedic effect.

R & B (Rhythm and Blues)—A popular musical genre marketed to African Americans beginning in the late 1940s that combined blues, jump blues, and typically a harder and more energetic beat than earlier blues and pop styles. (See also, "R & B.")

race records—A precursor of R & B, a genre of popular music marketed to African Americans beginning in the early 1900s.

ragtime—A genre of music most often performed on the piano and characterized by syncopated melodies and steady accompaniment figures. Ragtime was most often performed on the piano from the late 1800s to the early 1900s, and was also performed by wind bands and singers, serving as a bridge to the development of jazz.

Reconstruction—A social movement in the United States after the abolishment of slavery in the late 1860s, during which the nation underwent wholesale change in its labor market and African Americans experienced extreme gains and losses in social status and quality of life.

rent party—An informal gathering at a house or apartment where the hosts charge an entrance fee to attendees, presumably to pay their rent. Rent parties were settings for the development of boogie-woogie piano.

repertory orchestra—A musical organization created to perform historically significant works by important composers.

rhythm—A foundational element of music that involves the movement of sounds and silences forward in time.

rhythm section—A group of instrumentalists that provide the background setting of the main melody. Usually comprised of piano and/or guitar, bass, and drums.

ride pattern—A repetitive pattern played on the drummer's ride cymbal and hi hat that establishes a steady pulse.

riff—A short musical phrase that is repeated several times, either as the foundational pattern of a song or to build momentum over time.

ring shout—A dance performed by African-American slaves during religious gatherings. Its name comes from the rotating circles formed by the group of dancers.

ritard—A direction to gradually decrease the tempo.

rock and roll—A musical genre performed primarily by white Americans beginning in the 1950s that was strongly influenced by R & B and country music.

rubato—A direction to play with "free" rhythm, speeding up and slowing down at will.

salsa—A conglomeration of jazz with musical styles from Cuba, Puerto Rico, and other Latin American nations characterized by intricately-woven, syncopations played primarily on a variety of drums and other percussion instruments.

samba—A Brazilian musical style created by the country's traditional percussion ensembles.

saxophone—A musical instrument in the woodwind family that is constructed of a single reed on a mouthpiece, placed on a curved, metal instrument. The instrument was created more recently than the other woodwind instruments, and is thus identified with jazz and other contemporary music styles.

scat singing—The act of improvising with the voice using wordless syllables, imitating the sound of a jazz instrumentalist.

second line groove—A syncopated rhythmic pattern played in New Orleans funeral parades to enliven the music during the mourning party's return from the cemetery.

segue—To immediately move from one musical event to the next.

semitone (half-step)—The smallest unit of pitch in Western music. On the piano, from one key up or down to its immediate neighbor is a semitone. On a guitar, movement from one fret up or down to the next is a semitone.

sequence—A melodic phrase is played and then repeated at higher or lower pitch levels.

serialism—A compositional process developed in the early 20th century in which the composer arranged the twelve possible pitches in a series and could only deviate from the series in a number of prescribed ways (transposed to higher or lower pitches, played backwards, etc.) Serialism was meant to result in atonality because no single pitch was emphasized over another when all twelve pitches are used evenly.

shout section—In a big band composition, a section near the end of a piece when all instruments play simultaneously and the band plays at full volume.

shuffle—A drumbeat used most often in blues and hard bop that involves a continuous long-short long-short long-short pattern of swung eighth notes played on snare drum and/or ride cymbal.

shut-down phrase—A rhythm played by a drummer after the last chorus of an improviser's solo that "shuts down" the momentum of the previous soloist and resets for the following.

skiffle—A blend of jazz and blues that was popular in Britain during the 1950s. It originated along with jug bands and groups that played improvised instruments in the American South around the 1920s and '30s.

slash chord—A harmonic structure that consists of a conventional chord played on top of an alternate bass note, usually a note not in the chord.

smearing—A wide glissando, or pitch bend, famously used by alto saxophonist Johnny Hodges in Duke Ellington's band.

smooth jazz—A popular blend of jazz-rock fusion and soul/R & B, characterized by electric instruments, rhythmic grooves borrowed from R & B music, and consonant pitch selection in improvisation and chords.

soli—In a big band composition, a section that showcases a particular family of instruments playing flashy melodic lines in unison or in block chords. For example, a saxophone soli or a trombone soli.

solo break—An event in a jazz performance, at the end of the head, when the rhythm section stops for a few measures while the soloist plays alone, just before his or her first chorus begins.

song form—A form that was standardized in the songs of Tin Pan Alley consisting of 32 measures arranged in four eight-measure phrases. Most often, the phrases create an AABA structure with similar first, second, and last phrases and a contrasting third phrase (the "bridge").

song plugger—A professional demonstrator of current pop songs. Song pluggers were often composer/pianists working for publishing companies, playing their songs in music stores to sell sheet music to their customers.

soul—A music style that developed from R & B during the mid-to-late 1950s, characterized by wide emotional swings and outward expression of black pride and romantic love.

soul jazz—A subgenre of jazz that became popular during the 1960s and moved the R & B and blues-tinged style of hard bop forward to incorporate straight eighth rhythmic ostinatos and electric guitars and keyboards used in soul music.

spiritual—A sacred song form that originated from the blending of white American choral singing and African-American musical characteristics.

staccato—A direction to play short, or separated notes.

stock arrangement—Big band arrangements of popular swing hits that were available to any big band during the swing era, forming some of the common repertoire of the day.

stop-time—During an improviser's solo, the rhythm section stops on beat one and lays out for a short period (usually seven beats), then repeats the pattern throughout a chorus.

straight eights—Division of the pulse into two even parts, normally called "eighth notes."

subgenre—Musical style more specific than the "genre" label, often centered around a brief historical period. For example, "swing," "hard bop," "fusion." (See also, "subgenre.")

swing —a. a rhythmic feeling of bounce, or lift, conventionally created in jazz by swung eighth notes.

—b. a musical style—a subgenre of jazz—that emerged in the 1930s and emphasizes riff-based melodies, sectional arrangements, a progression through various solo and ensemble settings, and swung eighth notes.

swung eighths—Division of the pulse into two uneven parts, a long note followed by a short note. Conventionally, swung eighths are based on triplets, dividing the pulse into three parts, and then playing the first and third division of every beat.

syncopation—Rhythms that emphasize notes away from the established pulse.

synthesizer—An electronic musical instrument, most often a keyboard that has the capacity for generating and manipulating digital sounds.

tag—A set of chord changes (most often appearing immediately before the turnaround) that are repeated for an extended period of time in order to elongate a section of music.

tailgate trombone—A slang term for the practice, common among New Orleans trombonists, of playing wide glissandos from one pitch to another.

talking drum—A membranophone, a double-headed percussion instrument shaped like an hourglass with strands running vertically from one end to another. The player holds the drum underneath his/her arm and beats the head with an elbow stick that points its tip directly at the drumhead. The player manipulates the pitch of the drum by squeezing and loosening the strands on the sides of the drum.

territory band—A jazz group that performed at venues on various circuits (or territories) outside the urban centers around the time of the swing era.

Third Stream—A musical genre identified and named by jazz composer, French horn player, and musical philosopher Gunther Schuller that combines jazz with European classical music, often performed in the context of a string orchestra.

timbre—The quality, or tone color, of a sound. "Timbre" can refer to a specific instrument, group of instruments, or a variety of tone qualities a single instrument is capable of playing.

Tin Pan Alley—The name of the popular music publishing industry in America during the early 20th century. Tin Pan Alley began in the office buildings of a single Manhattan city block.

tone cluster—A group of notes played simultaneously that are separated by only whole steps and half steps.

tonic—The home tone, or key center, of a musical piece. The tonic is the first degree of a musical scale.

trad jazz—A musical genre that emerged in the waning years of the Swing Era, modeling itself after the early New Orleans and Chicago "Dixieland" jazz bands.

trading 8s—Two or more musicians trade solos of eight measures in length over the established chord progression. Most commonly, a small jazz group trades eights with the drummer, alternating between a melodic soloist and the drummer, another melodic soloist, the drummer, and so on. . . .

tri-tone substitution—A technique of reharmonization whereby the player (or arranger) substitutes a chord whose root is the interval of a tritone, or six half-steps, away from the original root. For example, a B7 chord may be substituted in place of an F7 chord.

trombone—A brass instrument pitched in the tenor range (below the trumpet but above the tuba). The trombone is one of the only instruments with a slide that lengthens and shortens the instrument, creating a gradual change in pitch.

trumpet—The member of the brass instrument family that plays the highest pitches. The trumpet produces sound when the player buzzes into a mouthpiece, and it changes pitches when its valves are depressed in various combinations.

tuba—The lowest instrument of the brass family, the tuba is rarely used in contemporary jazz or blues, but used in New Orleans brass bands and early jazz groups that stemmed from the New Orleans style.

turnaround—A series of chords at the end of a chord progression that propels the harmonic motion back to the beginning of the progression.

tutti—The full group of musicians in an ensemble plays at the same time.

two feel—A rhythmic pattern with emphasized first and third beats (in a four-beat measure). The two feel is defined by the bass playing a sustained note on beats one and three, and the drummer and pianist/guitarist respond to the simplified bass pattern in a variety of ways.

unison—More than one performer sings or plays the exact same melody.

V chord (dominant)—The chord built on the 5th scale degree of a given key. For example, in C major: G, B, and D. In jazz and blues, the dominant function is often referred to as a "turnaround," for its tendency to turn the chord progression back to the tonic chord.

vamp—A repetitive pattern played by a rhythm section that continues for a significant period of time.

vaudeville—A musical theater tradition popular in the United States during the late 1800s and early 1900s that featured a variety of musical and theatrical acts. Vaudeville largely replaced the popularity of the minstrel show, proving a better fit for the more genteel values of the middle class.

vibraphone—A keyboard percussion instrument—an ideophone—constructed of metal bars with rotating fans that open and close the space above the instrument's resonating tubes, creating an oscillating open/closed sound that mimics the traditional vibrato sound.

vibrato—A wavering in pitch, to greater or lesser degree, heard in a sustained tone.

virtuoso—Any musician who transcends the accepted norms of technical mastery.

vocoder—A device used to synthesize human speech.

voicing (chord voicing)—A pianist's or a guitarist's chosen structure of a chord. The performer may arrange the pitches of a chord in any combination, from low to high registers, and omitting or including certain pitches.

Volstead Act—In 1919, this United States congressional act prohibited the production and distribution of alcoholic beverages, ushering the Prohibition Era until the 21st Amendment to the Constitution was passed in 1933.

walking bass line—A style of bass accompaniment in which the bassist creates forward propulsion by playing a note on every beat, normally leaping up and down the pitches in each chord or stepping up and down the corresponding scale.

watershed—A point in time when a historically significant shift occurred, or oftentimes when multiple shifts converged during a single year.

whole tone scale—A scale comprised of only whole tones (or whole steps), unlike major and minor scales, which are made up of an arrangement of whole and half steps.

woodwind instruments—A family of aerophonic musical instruments that produce sound by either blowing across the instrument itself (such as flutes) or by blowing into a mouthpiece with a reed attached (clarinets, saxophones).

work song—A musical genre performed by groups of African-American slaves and sharecroppers to coordinate their work.

zydeco—A hybrid genre of Cajun and R & B music, zydeco uses the accordion common to traditional Cajun music, but is played more aggressively and uses electric guitar and bass guitar.

References

Armstrong, Louis. *Satchmo: My Life in New Orleans.* Prentice-Hall, Inc., 1954.

Berliner, Paul F. *Thinking in Jazz: The Infinite Art of Improvisation.* The University of Chicago Press, 1994.

Charters, Samuel. *Trumpet Around the Corner: The Story of New Orleans Jazz.* University Press of Mississippi, 2008.

Condon, Eddie. *We Called it Music: A Generation of Jazz.* Da Capo Press, Inc., 1992.

Crawford, Richard. *America's Musical Life: A History.* W. W. Norton & Company, Inc., 2001.

Crouch, Stanley. *Kansas City Lightning: The Rise and Times of Charlie Parker.* Harper Collins, 2013.

Davis, Miles with Quincy Troupe. *Miles: The Autobiography.* Touchstone (Simon & Schuster), 1989.

Ehrlich, Cyril. *The Piano.* Clarendon Press, 1976.

Gara, Larry. *The Baby Dodds Story: As Told to Larry Gara.* Louisiana State University Press, 1992.

Gelly, Dave. *Being Prez: The Life & Music of Lester Young.* Oxford University Press, 2007.

Giddins, Gary and Scott DeVeaux. *Jazz.* W. W. Norton & Company, 2009.

Gioia, Ted. *Delta Blues: The Life and Times of the Mississippi Masters Who Revolutionized American Music.* W. W. Norton & Company, 2008.

Gioia, Ted. *The History of Jazz.* Oxford University Press, 1997.

Gioia, Ted. *West Coast Jazz: Modern Jazz in California 1945–1969.* University of California Press, 1992.

Gitler, Ira. *Swing to Bop: An Oral History of the Transition of Jazz in the 1940s.* Oxford University Press, 1985.

Guralnick, Peter, Robert Santelli, Holly George-Warren, and Christopher John Farley (editors). *The Blues: A Musical Journey.* Amistad (Harper Collins Publishers), 2004.

Haddix, Chuck. *Bird: The Life and Music of Charlie Parker.* University of Illinois Press, 2013.

Haydon, Geoffrey. *Quintet of the Year.* Aurum Press, Ltd., 2002.

Kelley, Robin D. G. *Thelonious Monk: The Life and Times of an American Original.* Free Press, 2009.

Lyons, Len and Don Perlo. *Jazz Portraits: The Lives and Music of the Jazz Masters.* Quill (William Morrow and Company, Inc.), 1989.

Marquis, Donald M. *In Search of Buddy Bolden: First Man of Jazz*. Da Capo Press, 1980.

Mercer, Michelle. *Footprints: The Life and Work of Wayne Shorter*. Jeremy P. Tarcher/Penguin, 2007.

Milward, John. *Cross Roads: How the Blues Shaped Rock 'n' Roll (and Rock Saved the Blues)*. Northeastern University Press, 2013.

O'Brien, Timothy J. and David Ensminger. *Mojo Hand: The Life and Music of Lightnin' Hopkins*. University of Texas Press, 2013.

Palmer, Robert. *Deep Blues*. Penguin Books, 1981.

Peabody, Charles. "Notes on Negro Music." *Journal of American Folklore* 16, no. 62 (Jul.–Sep. 1903): 148–152.

Southern, Eileen. *The Music of Black Americans: A History*. W. W. Norton & Company, 1971.

Teachout, Terry. *Pops: A Life of Louis Armstrong*. Aurum Press, Ltd., 2009.

Terkel, Studs. *And They All Sang: Adventures of an Eclectic Disc Jockey*. The New Press, 2005.

Walser, Robert (editor). *Keeping Time: Readings in Jazz History*. Oxford University Press, 2014.

Waters, Keith. *The Studio Recordings of the Miles Davis Quintet, 1965-68*. Oxford University Press, Inc., 2011.

Work, John W. *American Negro Songs: 230 Folk Songs and Spirituals, Religious and Secular*. Dover Publications, Inc., 1998.

Index